Everybody
Thought We Were
Crazy

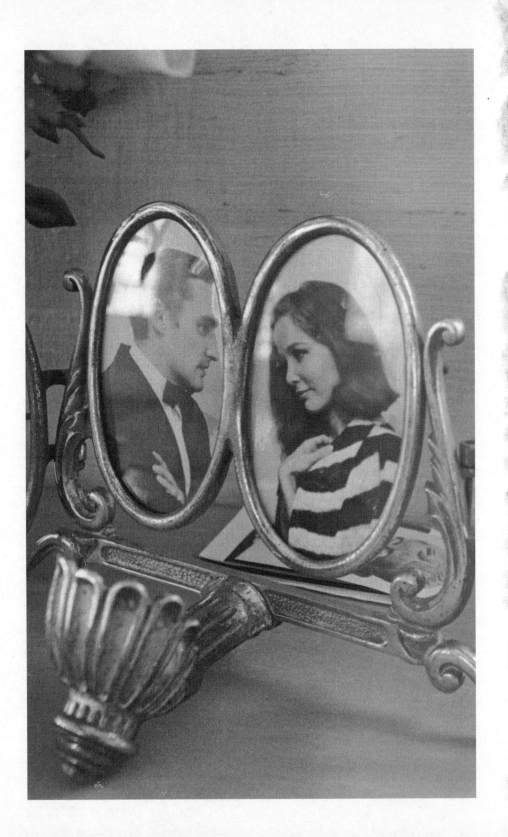

Everybody Thought We Were Crazy

Dennis Hopper, Brooke Hayward, and 1960s Los Angeles

Mark Rozzo

ecco

An Imprint of HarperCollins*Publishers*

For Valeria and Ines and Cecilia

And love comes in at the eye;
That's all we shall know for truth
Before we grow old and die.

—*WILLIAM BUTLER YEATS, "A DRINKING SONG"*

Live not for others but affect thyself
from thy enhanced interior—believing what thou carry.

—*MICHAEL McCLURE, "GHOST TANTRA 49"*

CONTENTS

PROLOGUE
LOS ANGELES, NOVEMBER 6, 1961

In the fall of 1961, Brooke Hayward was coming down with a case of what she called the "Transcontinental Blues." The air of Los Angeles turned brittle as the humidity level descended toward zero. The Santa Ana winds were rasping and harsh. A drought made the Santa Monica Mountains and Bel Air canyons tinder dry. It was the season, as Joan Didion would later write, of "suicide and divorce and prickly dread."

Pleased though she was about her recent shoot for *Life* magazine and her first appearance in a feature film, *Mad Dog Coll*, Brooke felt like an exile. "I missed the seasons, New York City, my apartment overlooking the planetarium, the theater, museums, friends," she recalled. In particular, she missed her father, who loathed LA almost as much as he loathed his daughter's new husband. He was enraged by the couple's move to the West Coast, just as he'd been by their hasty wedding in New York three months before. The tense emotional détente between father and daughter would endure for years. Brooke also missed her little sister. October 18 marked a full

year since her death. Now the second anniversary of the death of her mother was approaching, too.

It was just around Halloween that her new husband vanished. Brooke called all over town, but no one had seen him, or, if they had, they weren't telling. On the topic of marriage, he had once said, "I won't be easy to live with. I go off on strange tangents. Why, I might not even come home for three days." Three days stretched to a week, and there was still no sign of him. It pained Brooke, sitting in their little rental house at the top of Stone Canyon Road in Bel Air, to admit to herself that her father had been right—this man was pure trouble. She decided to move back to New York with Jeffrey and Willie, her toddler sons from her first marriage, and write this second marriage off. It was a disaster.

Her missing husband was Dennis Hopper, a fellow actor who had become a teenage movie star in the 1950s after he had appeared in *Rebel Without a Cause* and *Giant*. Dennis had a reputation for waywardness, and Brooke never would solve the mystery of his whereabouts that week. But one hot night in early November, under a moonless sky and with the Santa Anas whipping through the eucalyptus trees, Dennis slipped back into the house and got into bed next to Brooke. She pretended not to notice. She'd let him have it in the morning.

Brooke never had the chance. That Monday morning, November 6, a fire reared up in a patch of resinous brush north of Mulholland Drive. Driven by fifty-mile-an-hour gusts, the flames refused to be contained. Brooke was readying the boys for school when she saw a pair of fire trucks racing up Stone Canyon Road. While her husband slept, she watched the man across the street run out of his house and stand there, looking up toward Mulholland Drive through binoculars. He started loading his station wagon. Brooke shook Dennis awake. He opened his eyes to find a scene that was already tipping toward chaos.

SHE: I'll come back and get you!
HE: We gotta save something!

Brooke hurried Jeffrey and Willie into the car for their daily ride to the John Thomas Dye School on Chalon Road. They would be safer there. Dennis grabbed a Milton Avery painting—a reclining nude that had belonged to Brooke's parents—off a wall and, as Brooke was about to pull out of the drive, threw it into the car. "I thought he was nuts," Brooke remembered.

There was no time to save the Chinese tapestries that Dennis's father had given them or the books or the photo albums or the toys. What ensued was a day of surreal hell scenes, as the Bel Air Fire came roaring down the canyon roads—Stradella, Roscomare, Stone Canyon—on its way to consuming more than six thousand acres in the most destructive conflagration in the region's history. Burning shingles lofted through the air, picture windows crumbled, and carbonized patio furniture floated in swimming pools. Low-flying B-17s buzzed overhead in a rust-orange sky, dropping borate solution. Nearly every fire department in the city was dispatched to Bel Air, as the flames climbed fifty feet and the fire jumped from house to house, from road to road, from canyon to canyon. It swept across Bel Air and Brentwood, incinerating everything in its path at a rate of thirteen acres per minute, reaching as far west as Topanga Canyon. The fire department's official report described it as a "hurricane of fire."

The family's accounts of that traumatic morning are a Gordian knot of conflicting recollections, oft-told stories, and smeared impressions formed amid the chaos that was building on Stone Canyon Road. In the course of the day, Brooke drove through corridors of flame to retrieve the boys and return to Stone Canyon, while Dennis set out on foot, pulling obstinant neighbors out of their burning houses as he made his way down the hill toward Sunset

Boulevard. When Brooke made it back to Stone Canyon, she found the scorched street closed to traffic. Her husband was nowhere in sight.

In Nathanael West's novel *The Day of the Locust*, a painter toils day and night on an apocalyptic canvas called *The Burning of Los Angeles*. The Bel Air Fire made that cataclysmic vision real. It was responsible for the most devastating property losses in California since the 1906 San Francisco earthquake. And it was responsible for the destruction of Brooke and Dennis's house at the top of Stone Canyon, among the first of nearly five hundred houses to burn that day.

IF YOU WERE A BELIEVER in omens, it was not the most auspicious beginning for a marriage. But Brooke Hayward and Dennis Hopper, one an ingenue on the upswing and the other a self-sabotaging hard case, were soon to become, as one chronicler noted, "the coolest kids in Hollywood." Theirs was destined to be the emblematic love story of 1960s Los Angeles, that golden epoch of postwar California at its sunny apex. They were the prime catalysts and connectors during a brief, kaleidoscopic cultural moment when Hollywood upstarts, art-world superstars, and the emerging shaggy aristocracy of rock rubbed up against one another and threw off sparks. The concurrent revolutionary ferment in art, music, and movies made the city of Los Angeles, so often dismissed as a frontier backwater, into a cultural force. Brooke and Dennis, more than anyone else, connected those realms. "It was a great time to be in Los Angeles," Brooke said. No more Transcontinental Blues.

Beginning anew after the Bel Air Fire, the household they created on North Crescent Heights Boulevard, a sinuous byway in the Hollywood Hills above the Sunset Strip, became the repository of one of the era's greatest private collections of contemporary art: Lichtensteins and Warhols, Stellas and Ruschas, Rauschenbergs

and Kienholzes, even one of the last pieces that Marcel Duchamp, the twentieth century's provocateur in chief, would ever create. The house was an art piece itself, the so-called Prado of Pop, in which Brooke's design experiments and Dennis's eye for paintings, sculptures, and assemblages created an environment that left an indelible mark on everyone who stepped into it.

Jane Fonda, Brooke's best friend growing up, called it "a magical house." For Joan Didion, it was a place "of such gaiety and wit that it seems the result of some marvellous scavenger hunt." Andy Warhol loved it and compared it to an amusement park. When Michael Nesmith, a guitar-picking cast member on *The Monkees*, talked about his memory of the Hayward-Hopper house, he was emphatic. "It was a *tattoo*," he said. "I mean, it just burned into my mind." Irving Blum, the impresario of the Ferus Gallery, the epicenter of LA's emergent art scene, said of the trail the couple blazed, "They were virtually unique, you know? There was nobody else doing it in the way that they were doing it."

The house, at 1712 North Crescent Heights, became the era's unofficial living room. Brooke and Dennis helped introduce Warhol to the West Coast with a spectacular coming-out party, hosted Jasper Johns and Claes Oldenburg, entertained an entire Olympus of movie gods, and gave shelter to Hells Angels and Black Panthers. They befriended the futuristic fashion visionary Rudi Gernreich and his model-muses, along with the musicians who were the avatars of the day: the Byrds, Ike and Tina Turner, Jefferson Airplane, Brian Jones. They hung out with writers such as Didion, Terry Southern, and Michael McClure, and were among the New Hollywood generation of the Fondas and Jack Nicholson. Like Gerald and Sara Murphy, the Lost Generation expat couple who inspired F. Scott Fitzgerald's *Tender Is the Night*, Brooke and Dennis knew everyone, hosted everyone, ran a free-flowing salon, and transformed everyday life into the stuff of art. They made all those around them feel as though their lives were touched with art, too.

During their eight years of marriage, Brooke and Dennis embodied the collision of Old Hollywood and New, of chic bohemia and the burgeoning counterculture. They were as implausible a couple as ever existed. She was a Hollywood royal, the debutante daughter of the agent and producer Leland Heyward and the actress Margaret Sullavan, from whom Brooke had inherited a trademark steeliness and pinpoint wit. The young Brooke had been no princess; she was eccentric and rebellious and yearned to make a name as a writer or artist. Her upbringing had been peripatetic, bicoastal, and tumultous, punctuated by the broken marriage of her brilliant, distracted parents. Dennis came from Dodge City, Kansas, by way of the San Diego suburbs, incandescently talented and hell bent on saturating his life with creativity, from the inner sanctums of Hollywood studios to the outer fringes of the avant-garde. He had looks, imagination, acting skills honed on Shakespeare, and a boiling, fervid energy. By the late 1950s, he'd been jettisoned from the upper reaches of the movie business for being an all-around pain in the neck.

And so, thanks to a Nikon that Brooke bought him in 1961, Dennis became a photographer. He documented the civil rights marches in Alabama, the Sunset Strip riots, the Human Be-In. He shot gallery announcements, album covers, and images for *Artforum* and *Vogue*. He photographed artists, actors, writers, rock stars, and daily life at 1712 with Brooke and their children, leaving behind a vast visual archive of the decade—around eighteen thousand images—that was, for years, all but forsaken and forgotten. Dennis thought his photographs "represented failure," yet he also surmised that they might in time be seen as his lasting legacy, more so than acting or directing. His *Double Standard*—a cacophonous streetscape shot through the windshield of a Corvair convertible stopped at a red light—is in the Museum of Modern Art. It is one of the most remarkable visual evocations of Los Angeles ever created.

Brooke found a rich aesthetic outlet of her own, turning 1712

into a veritable design laboratory. Dennis marveled at her DIY gumption as she rolled up her sleeves and got to work painting, tiling, and raiding LA's antiques emporia, galleries, and junk shops for cast-off treasures. As omnivorous as Dennis was with his Nikon, so was Brooke as she hunted down a mad profusion of visual stimuli, from Belle Époque advertising posters to turn-of-the-century streetlamps. It was old and new, high and low. It was young and witty and camp when camp was barely a thing.

INSIDE THE STAGE SET OF 1712 North Crescent Heights, the drama of an entire era would play out: the artistic upheaval, the social jumble, the radical politics, and ultimately the instability and danger that Dennis reflected in the movie that made his career—and blew this inspired, combustible union apart.

The decade had ignited Dennis and Brooke's love and imaginations. There were new opportunities and new dangers. The counterculture beckoned, but so did three children—one of their own and two from Brooke's first marriage. How to reconcile freedom and responsibility, adventure and domesticity? The push-pull between macho outlaw energy and nascent feminism was relentless. Amid accelerating weirdness, the mood inside 1712 darkened. Dennis lost himself in drink, flew into rages, brought guns into the house.

By the late sixties, Brooke or Dennis might stand at the kitchen sink of their Pop Art house, surrounded by Lichtensteins and nineteenth-century French illustrations, and look out the wide window into a backyard full of tangled brush. A fiberglass Chevy that had once been part of a billboard sat out there, along with a rusting collection of old gas station signs leaning this way and that. The Byrds are on the turntable. A phone rings. The sounds of Rocky and Bullwinkle emanate from the den. After midnight, there are drinks and cigarettes and boisterous talk of revolution in the living room, while an enormous papier-mâché Judas strung with

firecrackers leers down from the ceiling. A coyote screams on a hill, a child wanders downstairs in pajamas. Another evening, the kids are at the dinner table, a husband bursts through the door, angry, threatening. The LA twilight has faded, and it's time to go.

"Those years in the '60s when I was married to Dennis," Brooke remembered, "were the most wonderful and awful of my life."

1

"ANY MAN WHO DOESN'T DEVELOP A CRUSH HAS NO SOUL"

For Brooke Hayward, the Method, which she had learned at the feet of Lee Strasberg, was not a religion. It was merely a tool to use when needed. She still couldn't believe that Strasberg had taken her on after she had auditioned at the Actors Studio in New York City in the fall of 1959. When Strasberg told Brooke, a young wife and mother who had rarely acted before, that she'd been accepted, she cross-examined him, ever wary of favoritism based on her parentage. Why had she, the daughter of Leland Hayward and Margaret Sullavan, gotten in when so many other actors ended up waiting years for an opening? "Your mother and father are very talented," Strasberg explained. "The odds are that you will prove to be more gifted as an actress than most other people with experience that I interview."

In December 1959, shortly after joining the Actors Studio, Brooke made her New York stage debut at the age of twenty-two, starring in John Whiting's *Marching Song* at the Gate Theatre downtown. Peter Kass, who directed the show, told the *Boston Globe*, "The kid's got one of the best raw talents I've ever seen." It was

only after Brooke got the part that Kass realized who her parents were. "I never asked and she never told me," he said. He considered Brooke to be a "gift" that Margaret Sullavan had bequeathed to the theater: a few days after *Marching Song* opened, Brooke's mother died at age fifty.

Walter Kerr reviewed *Marching Song* in the *New York Herald Tribune* and focused much of his attention on Brooke: "The girl is interesting." And she was. In later years, artists would attempt to capture her mystery and idiosyncratic beauty. The art critic Barbara Rose, in describing Andy Warhol's 1973 portrait of Brooke, wrote that Brooke "combines in actuality the dreamy distraction and worldly sophistication Warhol portrays." Reviewing a 1970 show of Don Bachardy drawings, a writer at the *Los Angeles Times* observed that the artist's rendition of Brooke "looks so soft that any man who doesn't develop a crush has no soul." If anything, Brooke was perhaps more conventionally beautiful than her movie star mother, of whom the director Joshua Logan once said, "She had from the very beginning that kind of incandescence, that magic, that indescribable quality that is just extremely rare. . . . She had a pulsing and husky voice which could suddenly switch, in emotional moments, to a high boy choir soprano. Her beauty was not obvious or even standard. It showed as she tilted her head, as she walked, as she laughed, and she was breathtakingly beautiful as she ran. . . . We were all in love with her." Logan was talking about Margaret Sullavan, but he could have been describing the young Brooke Hayward.

In early 1961, through her agent, Milton Goldman at Ashley-Steiner Famous Artists, the twenty-three-year-old actress tried out for and secured the part of Blanche, an alcoholic nymphomaniac, in Jack Kirkland's antebellum melodrama, *Mandingo*, set to open at the Lyceum Theatre in May. It would be Brooke's Broadway debut. She said it was a role she might never have taken had Margaret Sullavan still been alive: "Mother was from Virginia, i.e. Southern, i.e. rather prudish, and i.e. would have quite simply

choked me to death." It was also a role that would redirect the course of her life.

Mandingo, based on a novel by Kyle Onstott, was set in 1832 on an Alabama plantation called Falconhurst, which Kirkland—who had adapted Erskine Caldwell's *Tobacco Road* into one of the most successful plays in the history of Broadway—described as "not a Tara, magnificent and gracious and peopled by colonels and their ladies and their liveried black servants." Instead, Falconhurst was nothing but "a well disciplined, middle class, successfully managed operation"—a farm whose chief crops were enslaved men and women.

In the midst of the civil rights movement and a contentious Civil War centennial, *Mandingo* was positioned as an excoriating indictment of the Old South and its "peculiar institution," an answer to the Lost Cause romanticism of *Gone with the Wind*. Franchot Tone would lead the cast as Maxwell, the "gnarled and rheumatic" Falconhurst patriarch. The veteran actor had starred with Brooke's mother in the 1938 film *Three Comrades*, from a screenplay cowritten by F. Scott Fitzgerald. A twenty-one-year-old Off-Broadway actor, James Caan, was cast as Maxwell's sensitive son, Hammond, who marries Hayward's Blanche, a sullen and calculating sixteen-year-old southern belle (and Maxwell's distant cousin). *Mandingo*'s integrated cast featured several African American actors, including Maurishka Ferro as the slave girl Ellen and Rockne Tarkington as Mede, ostensibly the "mandingo" of the play's title, which referred to enslaved men revered for their aptitude as warriors. The men were trained, Brooke recalled, "to fight neighboring slaves to the death, like pit bulls or fighting cocks."

On April 17, as the Bay of Pigs invasion was underway in Cuba, the cast and crew of *Mandingo* assembled to begin work. "The first two weeks of rehearsal went swimmingly," Brooke recalled. "Everybody got along with everybody else. We all memorized our parts and got the complicated physical moves down." She thought that

Caan was brilliant as Hammond, the Falconhurst scion with a Byronic limp. "He taught me one of the two most difficult things I ever had to do on stage—to crack a bull-whip," she remembered. "The other, which luckily he had nothing to do with, required me to stand down stage alone in a chaste white ruffled gown and to have a vivid orgasm (without physically touching myself) as I imagined a rendezvous with the biggest and sexiest Mandingo."

Unfortunately for Caan, Tone had it in for him. The man whose Broadway career stretched back to the 1920s preferred another actor to play his son: Dennis Hopper, who had appeared with James Dean in *Rebel Without a Cause* and *Giant* and, more to the point, had previously played Tone's son in episodes of the television dramas *Studio One in Hollywood* and *Pursuit*. In 1960, Hopper had tried to book his first Broadway role, in *Invitation to a March*, coproduced by Leland Hayward. He hadn't landed the part, and Brooke's father had dropped out.

Tone managed to cut a deal with the director, Louis MacMillan, whereby Caan would be replaced after two weeks of rehearsal if Tone decided he wasn't cutting it. When the two weeks had elapsed, the cast and crew were sitting around on their lunch break when Tone announced that Dennis Hopper was flying in from LA the next day to replace Caan, with only two more weeks to go before opening night. The cast was outraged and Caan burst into tears. Dennis never felt right about it. "It was really unfair to Jimmy Caan," he said.

The new Hammond showed up for rehearsal the next morning. He was unshaven, unprepared, too cool for school. Brooke loathed him on sight. It was a warm spring day, with no air-conditioning, which amplified the feeling of sticky discomfort as the ensemble worked through the play with their new, not particularly welcome colleague. When they finally reached *Mandingo*'s last line, Dennis leaned in close to Brooke and told her, "I'm going to marry you."

DENNIS WAS KNOWN AS a maverick and a troublemaker—eccentric, headstrong, combative. In a word, difficult. "He terrified me," Brooke said. *Mandingo's* stage manager, Pierre Epstein, a French-born Holocaust refugee who became a fine character actor, also had misgivings. "Dennis, he made me nervous," he remembered. "He was a bit of a loudmouth." Epstein made sure to give Dennis plenty of elbow room.

Brooke's discomfort, even rage, was conspicuous enough that it prompted Tone to intercede. "Franchot, with whom Dennis was conveniently staying," Brooke remembered, "immediately took matters into his own hands and insisted that for constructive purposes the three of us forthwith have breakfast, lunch, and dinner together." As was surely the plan, Brooke's initial revulsion gave way to fascination; Dennis radiated danger even as he mounted, with Tone's help, a full-on charm offensive. Brooke remained convinced that Caan was the better Hammond, but she began to enjoy the adventure of working with Dennis as they engaged in the combative *pas de deux* of playing contentious newlyweds. "Improvisation being his favored modus operandi," Brooke recalled, "it was impossible to predict where he might or might not be on the stage or even what he might say."

Dennis would have mentioned to Brooke that he'd also studied with Strasberg at the Actors Studio. For Dennis, the Method, with its gospel of sense memory and being in the moment, was, in fact, a religion. It was also what connected him to his late mentor James Dean, whose legacy—Hollywood iconoclast, doomed romantic, dynamic creative force—Dennis felt compelled to honor and carry on. In emulating his sullen hero's uncompromising approach to everything, Dennis had gotten himself virtually banished from the movie business. On the 1958 western *From Hell to Texas*, he'd run afoul of the director, Henry Hathaway, and hadn't had a role in an important Hollywood film since. He had drifted into a career

Sargasso. "I was influenced by Jimmy and I believe my friendship with him hurt my career," he said. Yet he habitually turned down Dean-like roles. "The worst thing that can happen to a young actor," he said, "is to remind his audience of someone else."

Brooke found Dennis to be unlike anyone else she'd ever known. His profile—the long, straight nose, the sharp brow, the forceful chin—reminded her of a Greek statue. When he talked about plays, art, movies, and books or cracked goofy jokes, his voice rang with an adolescent fervor, at times a plaintive whine, and his electric blue eyes beamed with an ecstatic, otherworldly light, fierce and yearning at the same time. He ping-ponged between uproariousness and a childlike gentleness. He was, Brooke said, "a free spirit in every sense of the word."

It became a classic case of opposites attract—"Oil and water," Brooke said. She had been a debutante, a Vassar dropout, a *Vogue* cover girl, a wife, and a mother, all before she was twenty. He had been a wide-eyed boy in Kansas and suburban San Diego with a talent for dramatic monologues and trouble, arriving in Hollywood at eighteen to become a star. Their friendly flirtation stoked up into a full-blown romance in what seemed like a matter of days. Tone's efforts to get the young *Mandingo* costars onto the same page had succeeded perhaps beyond his imagining. Cast member Vinie Burrows, playing the enslaved woman Tense, remembered it as a "lightning romance."

Brooke and Dennis began exploring Manhattan together, discovering their shared ardor for visual culture—art and photography—as they roamed from gallery to gallery, museum to museum. Brooke was struck by a collection of Magrittes at the Alexander Iolas Gallery on East 55th Street. "There wasn't a painting amongst them that I didn't crave," she recalled. "The most expensive was priced at $1,500, which, alas, neither of us could afford." One afternoon, as they were walking along Madison Avenue, Dennis came to a sudden halt, formed his hands into a kind of picture frame, and invited

Brooke to look through it at some graffiti on the sidewalk. Brooke liked what she saw in Dennis's impromptu viewfinder. He shrugged and said, "I wish I could afford a camera. I know I could take good photographs."

May 17 was Dennis's twenty-fifth birthday. Now "madly in love," Brooke was determined to get him a camera and called her father to get advice on buying one. Leland Hayward was an avowed camera nut who had dropped hundreds of dollars at Peerless Camera on Lexington Avenue near Grand Central Terminal, not far from his Madison Avenue office. He told Brooke to go there. She picked out a 35-millimeter Nikon F single-lens reflex camera, plunking down $351 and nearly depleting her checking account. It was a whopping gift, and it left Dennis astounded. "He never ever, ever, ever put it down," Brooke remembered.

She was ecstatic about helping Dennis achieve his vision as a photographer. As she would later conclude, "Dennis had the greatest eye of anybody I've ever known."

EVERY DAY AT REHEARSAL, Brooke and Dennis flung *Mandingo*'s overheated, sexualized dialogue at each other as their characters, Hammond and Blanche, clawed their way to an ugly standoff.

> HE: God, I wish I never seen you.
> SHE: Think I wish I ever seen you?—lovin' up that slut every night, never pleasurin' me?

The slut in question is the slave girl Ellen—Hammond's secret love, who turns out to be carrying his child. Brooke's Blanche is a hideous caricature of a southern belle wronged, firing insults at her limping husband and working a bullwhip on Ellen. Dennis's Hammond is unrepentant in his love for Ellen and his friendship with Mede, the fighting slave. He is race blind and therefore, according

to lurid antebellum logic, must be martyred. At the final curtain, Hammond is murdered by his own father, Tone's Maxwell, in a last flourish of plantation brutality.

Mandingo's exploration of race and civil rights had resonance for Brooke and Dennis. Her grandfather Colonel William Hayward had recruited and led the all-Black 369th Infantry Regiment—the famous Harlem Hellfighters—during the First World War. Brooke had barely known her father's father, but she took pride in his legacy and kept a small bronze statue of him on horseback. Dennis's family were progressive Democrats who found racism of any kind abhorrent. "The one thing about Kansas," he said about his boyhood in Dodge City, "was that I was brought up to think that the only thing you should be prejudiced against are people who are prejudiced." Dennis would talk all his life of meeting with Dr. Martin Luther King, Jr., at the Chateau Marmont in Hollywood shortly after Rosa Parks's act of resistance against bus segregation in Montgomery in 1955.

Yet *Mandingo* turned out to be a drama whose depiction of race in American history was more about kitsch than conscience, and it made for a rough acting assignment. "I didn't think *Mandingo* was that good," Brooke said plainly. The premiere was pushed back five days to allow for more rehearsal time, but no amount of rehearsing could make a difference.

Mandingo opened at the Lyceum on May 22, joining a Broadway slate that included *My Fair Lady*, *Camelot*, *An Evening with Mike Nichols and Elaine May*, and *The Sound of Music*, produced by Brooke's father. Opening night was reportedly attended by Langston Hughes and Malcolm X, with such luminaries as Adam Clayton Powell, Jackie Robinson, Leontyne Price, and Louis Armstrong on the guest list for subsequent performances. Brooke's father missed the premiere; he was in London, opening *The Sound of Music* there. She was relieved. "My worst memory," Brooke said of the show's run, "was of a night the tip of my bullwhip fastened itself around

the ankle—thereby flaying it—of one of the Mandingo slave girls." For Brooke, that hideous moment symbolized the disaster that was *Mandingo*.

The *New York Times* called the play "a crude, sensationalized effort to capitalize on a newsworthy theme." Walter Kerr, in the *Herald Tribune*, suggested that it be retitled "Ten Nights on a Stud Farm." And so it went from critic to critic, with one exception, albeit unpublished, being Langston Hughes, who sent coproducer Billy "Silver Dollar" Baxter a letter of support: "Why most of the New York critics found it unbelievable, I do not know, unless the critics have never been to Alabama and do not read today's front pages, either."

Being the daughter of Leland Hayward and Margaret Sullavan might have given Brooke a boost with the critics—or it might have placed a target on her back. To her relief, the only silver linings among the brutal reviews were the mentions of her performance. *Newsday* praised Brooke for valiantly making something compelling from material so "repellent and ridiculous" that it could hardly be overcome. John Chapman, the *Daily News* critic known as "Old Frost Face," said Brooke had given an "exciting performance." Dennis received polite, if scant, attention. Despite the balance of praise going to Brooke, one young man who caught a performance of *Mandingo* found the experience of watching Dennis Hopper onstage galvanic: the sixteen-year-old Robert De Niro, who was then enrolled in the Stella Adler Conservatory. Hopper's performance ratified his dedication to the craft of acting.

Michael Lindsay-Hogg, the twenty-one-year-old son of the actress Geraldine Fitzgerald and an aspiring theater director, attended a matinee of *Mandingo*. Afterward, Dennis, whom he'd previously met in Los Angeles, pulled him backstage. "You have to meet Brooke!" he said. It was clear that Dennis wanted to show off the woman he was now officially crazy about.

At the Actors Studio, Strasberg spent a session praising the

performances of his former students. It was perhaps the most encouraging review that Brooke and Dennis could have imagined. Yet Brooke could not banish her ambivalence about *Mandingo* whenever she walked onto the Lyceum's stage. Watching from the wings, Pierre Epstein found Brooke absolutely lovely, but he could see that she had no confidence in the hopeless role. Among Brooke's supporters in the audience, Peter Davis, the husband of Brooke's girlhood friend Johanna Mankiewicz, recognized that Brooke was out of sorts in *Mandingo*. "She didn't look at home on the stage," he said.

There was plenty of discomfort all around. *Mandingo*, which Brooke deemed "misbegotten and ill-conceived," closed five days after it opened.

DENNIS DECAMPED FROM FRANCHOT TONE'S place on East 62nd Street and moved into Brooke's ninth-floor apartment at 15 West 81st Street, where she lived with her sons, Jeffrey and Willie, ages four and three, and their Scottish nanny, Marion McIntyre, a trim, middle-aged woman with a pile of red hair who was known to all as "Miss Mac." Brooke had moved into the apartment—9D—about a year before, after living for four years in Connecticut with her first husband, Michael M. Thomas.

She loved being in the stately 1930 building designed by Emery Roth, who had also created its sibling, the Beresford, around the corner on Central Park West. The apartment's southward windows looked across West 81st Street at the American Museum of Natural History, whose wildlife dioramas contained specimens that, according to Brooke, had been "shot and donated by Grandfather Hayward." The building's lobby was a tiled oasis, complete with a fountain, that welcomed Brooke home after long hours of rehearsing or running around to auditions. The only downside was that her ninth-floor neighbor always had a pot of cabbage boiling, leaving

Brooke and the boys to occasionally feel that they might choke on the cruciferous fumes.

In 1959, Dennis had lived three blocks away, at 14 West 84th, so he knew the neighborhood. With his arrival, Brooke's kitchen underwent a transformation as Dennis turned it into a painting studio, filled, as Brooke recalled, "with huge canvases covered in thick gobs of black paint." On their gallery crawls, in diners, and at home, they poured out to each other their thoughts on the nature of art and what was required to pursue a daring, creative life. They debated what made a great artist. "By my family's modus operandi," Brooke remembered, "success was based on a whole lot of grinding hard work. For Dennis, at that time, at least, artistry was far more about a special, mysterious gift." Dennis thought the gift was innate, not acquired. And it might not even be inherited in the strict sense. In his case, how could it be? There wasn't a whit of artistry in his family, as far as he could tell.

"Dennis and I were an extremely unlikely couple," Brooke later reflected. As she and Dennis delved into their personal histories, as lovers do, they discovered huge divergences. They also discovered unexpected commonalities, all the more unexpected considering their differences in geography, class, and circumstances. More than anything, the fascination they had for each other, for where they had come from and where they might be heading, was total.

2

"THIS IS THE REASON WE'RE ALL CRAZY"

I followed the light changing on the horizon," Dennis recalled of his boyhood in Kansas during the Depression and war years. "I watched the hard rain in puddles. I collected bugs in the mornings by picking up leaves and putting them in a fruit jar with nail holes in the top. I lay in the ditch and watched the combines come along the dirt road." He was proud of his heartland roots, which came in handy when he cast himself as a salt-of-the-earth, iconoclastic outsider from the great American steppe. He did genuinely seem to consider himself a Kansas farm boy, something his mother found amusing. "Dennis, of course, thinks he was a farmer," Marjorie Hopper said, "because my folks had three acres and Mom always had a cow and chickens."

Marjorie had, in fact, been raised on a farm, south of Dodge City. By the time Dennis was a boy, her parents, Lonnie Davis and the former Nellie Bly McInteer, lived on the western outskirts of Dodge City with those cows and chickens and no neighbors for about a half a mile in any direction. Sixty miles away, near Garden City, they farmed 1,400 acres of wheat. Marjorie also had two

uncles farming out there, with fourteen sections between them: 8,960 acres, all wheat. Dennis might not have been raised on a farm, but the Davis clan was proud of the dirt under its nails, and the ruler-straight horizon of Kansas, with those oceans of wheat that in the autumn shimmered gold like a lion's mane, embedded itself in Dennis's consciousness.

His parents were essentially Dodge City townies. Marjorie Mae Davis was a teenage swimming phenom; she was known in the family lore as being a state backstroke champion who had aspirations to compete in the 1936 Summer Olympic Games in Berlin. In photographs, Marjorie is lithe and athletic, with apple cheeks, vivid eyes, and a broad smile. Dennis's father, Jay Millard Hopper, worked at a grocery store, Busley Brothers IGA, and eventually rose to manager. A picture of the young Jay shows him with upswept hair and a full beard, standing beside a Coca-Cola delivery truck and wearing a clerk's apron. He made this workaday outfit dashing with an Art Deco–patterned shirt, a neckerchief, and a proud grin. (Jay's father had been a grocery store clerk as well, eventually making a living as a meter reader for the Kansas Power Company.) Marjorie and Jay were good-looking kids, and they got married in a hurry, on August 21, 1935.

Their son, Dennis Lee, was born almost exactly nine months later at St. Anthony's Hospital in Dodge City on May 17, 1936. Marjorie and Jay named him after Dr. Foster Leonard Dennis, the hospital's chief of staff. His middle name came down from Marjorie's maternal grandmother, Lee Masters McInteer, known as "Mammy Mack"—intense, eccentric, funny, given to strange habits. She practically lived off Sucrets throat lozenges and liked to carry a shillelagh, whacking people if they crossed her. Jay liked to tease Marjorie that she took after Mammy Mack. He was nineteen years old and Marjorie eighteen. Marjorie would say of their young family, "We all grew up together."

The baby had black hair covering a head that Marjorie noted was

"round as a ball." Dennis was talking at eight and a half months, amusing his parents and grandparents with the phrase "It been I." At ten months, he was walking—busy acquiring the signature Dennis Hopper gait, jaunty and slightly bandy-legged—and he liked greeting passersby with a disarming "How do!" Marjorie and Jay both had dazzling blue eyes, and Dennis had inherited a pair that lit up like an electrical device. The trait went back generations, as evidenced by a photograph taken during the Civil War era of Marjorie's paternal grandmother, Sophronia Edwards, who fixed upon the camera lens an incandescent gaze remarkably like Dennis's. By three years of age, as Marjorie noted in his baby book, Dennis had developed a taste for two things that would become trademarks of his adult life: guns and cowboy outfits. Around that time, in May 1939, Olivia de Havilland and Errol Flynn swung through town to promote their movie *Dodge City*. Jay's grocery produced floats for the big parade. It was the closest glimpse of Hollywood the family had ever had.

They lived in a tiny house at 505 1/12 10th Avenue, not far from Wright Park with its zoo and enormous municipal swimming pool, where the aquatically inclined Marjorie went to work, eventually managing the facility. On September 9, 1941, Dennis began kindergarten at Lincoln Elementary School, the school Marjorie and Jay had attended. Their five-year-old son had already acquired an outsize vocabulary that Marjorie believed was the result of her and her mother reading to Dennis "every child's book" they could find. The Dick and Jane–style books that Dennis encountered at Lincoln left him cold; he'd already surpassed them. In later years, he would say, "I don't care about reading. . . . It means nothing," positioning book learning as lesser than, or even in opposition to, the creative drive. It was an anti-intellectual artist pose that he could lapse into at will (and he would occasionally confess that it was indeed a pose). Nevertheless, he staked his creativity on direct experience and emotion.

In Mrs. Anders's kindergarten class, Dennis's creativity made itself manifest. His first artwork for the class was a crayon drawing of that perennial kindergarten subject, a tree, pulled off with a brio that borders on violence; the boughs are a spiraling, saturated mass of green. At the age of three, he had performed as an angel in a church pageant, with halo and wings. "He liked the applause," Marjorie remembered. Now he found himself happily front and center when his class dressed up like an orchestra, with Dennis as the leader, complete with top hat, cane, and a swallowtail coat that Marjorie had sewed for him. To see a photograph of Dennis in this costume—John Philip Sousa by way of George M. Cohan—is to see a canned ham in the making.

On July 5, 1943, the day his future wife Brooke Hayward turned six, Dennis's brother David was born. The Hopper brothers looked almost eerily alike, but in time it would become apparent that David's nature was of a quieter cast. He took more after the reticent Jay, whereas Dennis was in the mold of Marjorie, whose outsize, chatty personality filled any airtime left empty by her retiring husband.

Marjorie would say that she hadn't been brought up with much religion, at least of the old-time sort. Yet that didn't prevent her and Jay from establishing a Methodist household that was rigid with the expectation that their two imaginative, intelligent boys would grow up to be upstanding citizens, models of convention, stability, and success, as gauged by a pair of youthfully assertive, naive parents from western Kansas. The result was that the Hopper household would increasingly oscillate between contentious and stultifying as the boys grew older. "My parents were very strict and very fundamental," David Hopper recalled. "And no fun at all."

But Marjorie instilled in her boys a profound sense of family history and pride, even a certain kind of destiny. "You guys are real special hillbillies," she'd say, spinning tales of the Davises and McInteers of yore who had lived in a hog-waller area of Kentucky

known as Davis Bend on the banks of the Green River near Canmer, seventy-five miles south of Louisville. If you're looking at a map of Kentucky, it's somewhere between Black Gnat and Horse Cave. Marjorie told Dennis and David about her father's father, John Crittenden Davis, who had allegedly been the first "white man" to see Yellowstone Falls, and of their tangled lineal connections to pioneers and poets—the trailblazer Daniel Boone and the writer Edgar Lee Masters, of the famous *Spoon River Anthology*. There were stories of Jamestown plantation, the Stuarts in Scotland, and, as Marjorie got deeper into armchair genealogy, the Knights Templar in the south of France, a hereditary saga that, for all its grandeur, suggested to the brothers that, as David put it, "We'd been farmers—wheat farmers, with chickens. Forever." There was also a deep strain of feistiness, of raw individualism and even blood feuds—the old Scots-Irish ways that shaped the contours of American culture from the Alleghenies down to Alabama and out to the West. Those tendencies traced back to ancient Scots kings—tribal, power mad, often decadent. Dennis absorbed the stories from his mother and told his brother, "This is the reason we're all crazy."

The Hopper clan, by contrast, was distant and taciturn. "They were town guys," David said. "Small, wiry, dark guys. A lot of Cherokee Indian blood. I didn't really know them."

To escape Marjorie and Jay's strictures, Dennis gravitated toward Marjorie's parents, Lonnie and Nellie Davis, and David followed suit. Lonnie and Nellie had grown up in Kentucky, come to Kansas a year apart, and married in the town of Larned in the summer of 1906. According to David Hopper, the Davises leased their wheat farm from the Clutter family, from whom the boys got their first English sheepdog. Four of the Clutters would be murdered years later—the 1959 quadruple homicide chronicled in Truman Capote's *In Cold Blood*. In that book, Capote described the landscape of that part of Kansas: "The land is flat, and the views are awesomely extensive; horses, herds of cattle, a white cluster of grain

elevators rising as gracefully as Greek temples are visible long before a traveler reaches them."

Dennis and David found in Lonnie Davis a kindly man with a depth of wisdom and patience that could make the most complex problems appear simple. He was an unabashed progressive in conservative Kansas, when that part of the country seemed constantly ready to blow away in a cloud of dust. He registered for Republican primaries in order to cast votes for the least electable candidates, thereby boosting the chances of the Democrats he preferred. He was opposed to oil speculation and the concept of private land. If Marjorie was overbearing and Jay inscrutable, Lonnie Davis, as David put it, had "an infinite capacity for love." He never seemed to get angry.

"My grandfather and grandmother Davis were my best friends," Dennis later wrote. He loved his time with them, whether at their house on West Park Street on the edge of Dodge City, wedged between the Santa Fe Railway tracks and the Arkansas River, or off at the farm, where he and David might help with the autumn harvest. "Most of the time I spent alone, daydreaming," Dennis said. "I didn't do much; occasionally I cleaned out the chicken house. I watched more than anything else. Wheat fields all around, as far as you could see. No neighbors, no other kids." Boyhood took on a dreamy cast as Dennis wandered alone, shooting BB guns at crows, playing on rope swings, and acquiring the nickname "Clodhopper." There was the occasional youthful miscreancy, as when Dennis killed a pet owl belonging to his Uncle Cal, Lonnie's brother, with a .22, which must have incited no small amount of wrath. Dennis would look back in adulthood and see his young self as lonely, shy, and not well understood. But with the Davises there were always comfort, security, and love.

If it was a Saturday, Dennis remembered, his grandmother Davis would gather up into her apron some of the eggs their chickens had laid, sell them, and use the money to buy tickets to the matinee

at one of Dodge City's movie theaters, such as the Crown or the Dodge. In that way, Nellie Davis might have had the most fateful influence on young Dennis of anyone in the family. The boy gorged himself on the westerns of Gene Autry, Smiley Burnette, Roy Rogers, Gabby Hayes. "We did that over and over," Dennis said of those excursions with his grandmother. "It was sort of a ritual thing in the summer."

"In Kansas, I just had a horizon line to deal with," he remembered. "So I didn't have any sort of outside information at all. Your whole fantasy world and your whole sort of morals and whatever, strange as it seems, came from those westerns." The movies Dennis saw would play on a loop in his mind throughout the week, until the next matinee. The bright light flickering on the screen felt like the sun finally breaking through the clouds of the Dust Bowl. He would find himself acting out what he'd seen sitting in the balcony: "I saw a war movie, I dig fox holes. If I saw a sword-fighting picture, I'd fight with the cow." Or, channeling the swashbuckling Errol Flynn, he might terrorize the very chickens that laid the eggs to pay for his matinee tickets. "Furry little balls, die! That was a lot of my life as a kid," he said.

The immersion in Hollywood fantasy had a curious effect on the boy, who decided that the artifice he saw onscreen had more palpable actuality than his Dodge City life of school, church, parents, and lonely meanderings. "The world on the screen was the real world," he decided, "and I felt as if my heart would explode, I wanted so much to be a part of it. Being an actor was a way to be part of it. Being a director is a way to own it." Kansas was a dream. Hollywood was real.

"DENNIS IS PARTLY TRUTH and partly fiction," David Hopper said decades later, alluding to a Kris Kristofferson song, "The Pilgrim, Chapter 33," which had been inspired in part by his older brother.

"He's got a tremendous imagination. I think he always thinks he's telling the truth. But sometimes the fantasy becomes more interesting."

At the age of seven, Dennis thought it would be a good idea to sniff gasoline vapors from his grandfather's truck. He gazed up at the sky and saw clowns and goblins in the clouds. "I ODed on the fumes," he recalled, "and smashed up his truck with a baseball bat, thinking it was a monster." That incident—with its combination of self-exploration, intoxication, impulsiveness, and violence—was an early augury of so many notorious scenes in Dennis's life and an anecdote that became a staple of his biography, with variations. When asked about the episode in the 1980s, Marjorie Hopper readily acknowledged it—but outlined a very different, and considerably less dramatic, story, in which her three-year-old son had gotten his hands onto a knife and made a hole in the upholstered ceiling of Lonnie Davis's truck.

Throughout his life, Dennis would speak of the trauma he had experienced when his father went off to war. Jay Hopper enlisted in the army on January 20, 1944. By then David was six months old, and the family had relocated to Newton, outside Wichita. (They would move back to Dodge City in short order.) Jay didn't ship out until December, an occasion the Hoppers marked with a family portrait. Marjorie dressed the boys in crisp uniforms, with Dennis looking like a cadet and David like a miniature navy seaman. Jay wore his own uniform, and everyone was smiling but Dennis, who stared into the camera glassy eyed, as if he were on the verge of a meltdown. Marjorie marked the back of the picture in ballpoint pen: "Dennis was very sad!" She underlined the word "sad" three times.

Jay was tapped for the Office of Strategic Services, the forerunner of the CIA. For his sons, Jay's being part of that select branch of the military underscored another dimension of his personality, one that wasn't all that mellow or retiring. "He was a master sergeant in

the OSS," David Hopper said. "He was, you know, a *killer*. He was a tough guy. And he was extremely competitive."

Not long after Jay shipped out, horrific news arrived. As Dennis told it, Marjorie said there had been an accident and he would never see his father again. "We should just presume that he was gone," Dennis recalled. "She never really said he was dead—there had been an accident—but that was what we inferred. I would hear her say to other people, 'Oh, he was killed in basic training.'"

Dennis always insisted that he'd been led to believe that his father had been killed in the Second World War. When he was eventually told that Jay would in fact be returning home to Kansas alive, it turned him upside down. "Now wouldn't that make you a paranoiac?" he asked. It left him with deep feelings of betrayal and distrust, along with a seething hostility toward authority, from parental to governmental. Jay's "death" had to have been a grisly fib invented as a cover for his secret OSS activities.

Again, Marjorie remembered it differently. "He knew all the time that his dad was alive," she insisted. She recalled her hyperimaginative son becoming upset over the arrival of a yellow government envelope, believing it to be a death notification. "Daddy's dead, Daddy's dead!" Dennis wailed as Marjorie tried to calm him, showing him that the envelope merely contained a financial statement.

"As far as him not hearing from his dad," Marjorie said, "that's just a figment of his imagination." On March 24, 1945, Jay did write to his son from his post in India. "Mother said that you wanted a letter to take to school to read to the other boys and girls," he began. "This is very beautiful country. There is jungle all around us." Dennis's father went on to describe, in Kiplingesque fashion, the "tigers, leopards, elephants, deer, porcupines," and other animals populating the area and the wonderful costumes the local villagers wore. He signed the three-page letter "Love, Daddy."

With his flair for hyperbole, Dennis would extol his father's

wartime activities and top secret intrigues, placing him in proximity with Mao Zedong, Chiang Kai-shek, and the heroes who had liberated the highest-ranking American POW, General Jonathan Wainwright, in Manchuria. In fact, Jay's unit had been tapped to free Wainwright, but they hadn't done so due to a bridge washout. According to Marjorie, her husband had served as a surgical technician; he might have seen Mao once but hadn't had anything to do with him or Chiang Kai-shek. Jay, for his part, would remain mum about his experiences in the OSS for the remainder of his days, leaving his sons to conjecture whether or not their father, while unassumingly going about a postwar career in the postal service, was in fact a CIA spook. (For David Hopper, the ruse of his father's wartime death, supposedly enacted in the interest of secrecy, still sounds plausible. "I think that was a real deal," he said.)

The memories of gas-huffing hallucinations and being told that his father had been killed in the war suggest a boy as much at home in the airy realms of the imagination as in earthbound reality. Dennis's recollections of his mother during the war occupied similar terrain, somewhere between truth and fantasy. He was certain that Marjorie, working every day at the giant municipal Dodge City pool in Wright Park, with its vast white clubhouse and big slide, was playing around while Jay was overseas. According to Dennis, Marjorie, riding out the war in a swimsuit, was living a "Dear John" scenario, one that might not have been far-fetched considering that she was still an alluring, athletic woman in her twenties. After moving into a residence at the pool and handing over her sons to the Davises, Marjorie played the single girl, introducing Dennis as her kid brother and making time with the Free French Air Force pilot trainees stationed at the Dodge City Army Airfield. "She was quite wild then," Dennis insisted—drinking and smoking, raising the hackles of her parents, and having "a great love affair with a concert pianist from Marseille who was killed actually in training."

Later in life, Dennis told his children that their respectable midwestern grandmother had been a floozy during the war.

David believed that Marjorie's French lover was no more than a friend. But Dennis's conviction that his Methodist mother "entertained rather well at the swimming pool" transformed his view of the opposite sex. "Booze, drinks: A sort of point of view about women," he said. "Not to be trusted necessarily."

A COUPLE OF YEARS AFTER the war ended, the family moved to a Craftsman-style house in Kansas City, Missouri. Jay had taken a job with the Railway Mail Service, sorting letters and guarding mail aboard trains on the Atchison, Topeka and Santa Fe Railway. An Orthodox rabbi and his wife lived next door, and their two sons became Dennis and David's closest friends. The four boys would ally themselves in battle against the German American kids in the neighborhood, which had hills big enough for sledding on—a novelty for the brothers from Dodge City.

Marjorie signed Dennis up for weekend art classes at the Nelson-Atkins Museum of Art, where he studied watercolor. "I learned to do this little mountain and the tree with the roots and the water coming by," he remembered. One day, Thomas Hart Benton sauntered through the museum and ducked into the children's class. The famous painter, with his piled-up hair and craggy face, made his way around the room and eventually stood over the eleven-year-old Dennis, studying his work. "You're not gonna understand what I'm saying right now," he told the boy, "but some day you're gonna have to git tight and paint loose." The recommendation to combine creativity and intoxication was one that Benton may have passed along to his star pupil, Jackson Pollock. And it was one that Dennis would, in fact, understand in time.

David remembered his older brother, now approaching teenhood, boxing for money and hanging out, as boys do, with delinquents.

There was "a whole gangster scene," he said. "Dennis was already doing all kinds of crazy things." There's no record of Marjorie or Jay being alarmed, but plans were made to move the family again—to California. The move would ease David's asthma and bring them close to Marjorie's older sister, Doris, and her husband, Jim Hanratty, who lived in La Mesa, a scrubby suburb east of San Diego. Doris had been something of a flapper in her younger days, and Jim had been a sonar man on the USS *Missouri*, upon whose deck the Japanese had surrendered. Unlike Jay and Marjorie, they liked to drink and have a good time. Dennis and David naturally loved them.

In the spring of 1949, the Hoppers packed up their new Ford and hit the road for San Diego via US Route 80. Dennis bade farewell to his Kansas friends. He told them he was going to be in the movies.

THE HOPPERS SETTLED INTO A little house at 3224 Massachusetts Avenue in suburban Lemon Grove, adjacent to La Mesa. Marjorie volunteered with the Red Cross and found work at the Camp Gillespie swimming pool on a former military base in El Cajon, while Jay continued his postal service career in downtown San Diego, working as a clerk in the main post office. The move wasn't quite as radical as Dennis had envisioned. "I didn't know what I thought I would see when I looked out at the ocean, but I thought I'd see something different," he said. "But then, looking out at the ocean, it was the same perspective I had looking out at a wheat field. I remember thinking that the ocean looked very similar to our wheat fields. The Pacific was the horizon line in my wheat field."

The eastern suburbs of San Diego, self-advertised as "the best climate on Earth," reminded Dennis of Kansas in other ways. They were dusty and drab with modest, squat houses that tended to be populated with transplanted heartlanders, who, like the Hoppers, had brought their midwestern values and agrarian ways with them.

The family's property was barely a quarter of an acre, but it was packed with lemon and avocado trees, not to mention a robust population of great horned lizards. Young David became infatuated with the creepy-crawlies of Southern California—lizards, insects, snakes—occasionally putting them into his brother's bed for a laugh, which Dennis did not find amusing.

As Dennis's thirteenth birthday approached, Marjorie had the idea that her son, a dedicated Boy Scout who eventually earned his Eagle badge, might like a sleeping bag for camping trips. "I don't want a sleeping bag," Dennis told her. "I want to take dramatic lessons." Through a friend, Marjorie found a vocal and drama coach, Lee Whitney, who performed at the San Diego Civic Light Opera Association, known as the Starlight, and took Dennis on as an acting student at five dollars an hour. Again Nellie Davis's eggs came in handy; she dutifully sent her egg money out from Dodge City to help cover the cost of Dennis's dramatic lessons.

At that point, Dennis, aside from church and school pageants, had practically zero acting experience. But Marjorie, who had taken dramatic declamation lessons as a child, had always given her son verses to memorize and recite. Dennis had shown an aptitude to absorb and entertainingly declaim such hokum as Edgar A. Guest's "Castor Oil," a bit of homespun doggerel written in tribute to that gag-inducing panacea:

> An' I ain't kickin' much—but, say,
> The worst of parents is that they
> Don't realize just how they spoil
> A feller's life with castor oil.

Whitney found the Boy Scout from Kansas to be a remarkably quick study. After working with Dennis for six months, she felt that the traditional student-teacher dynamic was being overturned. "The rest of the time," Whitney said, "I was learning from him."

The following year, the fourteen-year-old Dennis won a dramatic declaration contest at San Diego State University, the first of a raft of titles he would win, proudly bringing home trophies, ribbons, and plaques from that and other theatrical contests. He pushed himself obsessively, sometimes not sleeping the night before such performances. Marjorie noted her son's determination and felt that there was no way to stop him once he had his mind set on something.

At some point, likely during his declamation days, Dennis added to his repertoire a thirty-two-line poem that would remain a show-piece for the rest of his life, the Rudyard Kipling chestnut "If," written around 1895. In a cascade of stiff-backed Victorian stanzas, the boy who had recited "Castor Oil" now dilated grandly on the dreams and responsibilities of adulthood:

> If you can fill the unforgiving minute
> With sixty seconds' worth of distance run,
> Yours is the Earth and everything that's in it,
> And—which is more—you'll be a Man, my son!

"I WAS A VERY SENSITIVE young boy," Dennis said of his adolescence. "When you don't receive the type of love you want from the world you look someplace else for it. For me, acting was the way to get the other things. I guess that sounds pretty sick, but it's true, in a way."

As Dennis gravitated toward acting, along with painting and poetry, he understood that he wanted to pursue a creative life. Marjorie and Jay might have been proud of the steady accumulation of Dennis's drama trophies, but they were alarmed to behold their son transforming into a bohemian under their suburban roof. "My parents were against me being an actor as a profession, thinking it meant I'd end up a bum," Dennis said. "They saw it as akin to being

a poet or painter—these were not jobs, but hobbies. They wanted to know why I didn't aspire to be a doctor, lawyer, or a teacher. They wanted to know when I was going to get serious and start an engineering degree. Finally, they wanted to know why I couldn't get a job in a grocery store, or do just anything other than acting. It was so alien to them: I might just as well have said I want to explore the jungle or mine diamonds."

Jay Hopper warned his son, "Creative people end up in bars—and *behind* bars." At the San Diego post office, one of Jay's coworkers razzed him about Dennis's thespian exploits: "What kind of kid you got, anyway?"

"We neither one knew where we ever got Dennis," Marjorie later said. As Marin Hopper, Dennis and Brooke's daughter, put it, "Marjorie loved her children but couldn't understand them at all." Marjorie may have meant well, but she was intense, overbearing, controlling. Dennis, her adored older son, was caught between an ardent desire to please and impress her while loathing the hold she had on him. Resentments festered. Dennis even suspected that Marjorie had never forgiven him for having been born in the first place—for derailing her Olympic hopes. "That was one that I was never really allowed to forget," he said. He remembered Marjorie as wild, emotional, a yeller.

"My mother was a monster," David concurred. "If you took a shower very long, she'd start screaming, 'Turn off that water! Turn off that water!' One time she opened the shower curtain and pelted Dennis with raw eggs." In the family lore, there are hairier scenes of Marjorie blowing her top and chasing Dennis around the house with a butcher knife. Both of the Hopper boys found their father, a Thurberian husband jawboned into silence by his loquacious wife, infinitely easier to deal with than Marjorie. "He was really a decent guy," Dennis said of Jay. "I just didn't know him." Yet every so often Jay subjected Dennis and David to lashings from a belt. "He was a bad son of a bitch," David said, adding that Dennis's

ways—expressive, bold, unpredictable, charismatic, intelligent, unconventional—scared their straitlaced father to death. In order to get relief from Marjorie and Jay, the boys often escaped to Aunt Doris and Uncle Jim's house. Or, after their Davis grandparents moved to the San Diego area in the mid-1950s, to their house—or, as they got older, to Tijuana, where they could leave all of the uptightness behind and cut loose. The brothers developed an adoration of Mexican culture that remained with them the rest of their lives.

Dennis would come to feel that the tension in the Hopper household had powered his determination to make something of himself. "They were always screaming," he said of Marjorie and Jay. "I swore to myself I'd show them." In later life he would wax lyrical about that period of alienated adolescence, "when you couldn't identify with your parents and you couldn't identify with anyone, any of your surroundings, so you wanted new surroundings and new dreams and new ideas and new people, new things."

There was another worrisome dimension in Dennis's home life, of shadowy Oedipal undertones amid the sunny groves of 1950s California suburbia. As Dennis came into puberty, he began to find Marjorie, with the proud athletic figure she showed off at the pool, physically alluring. "My mother had an incredible body, and I had a sexual fascination for her," he admitted. The adult Dennis would expand upon that forbidden theme from time to time, describing his adolescent yearning, which seemed hopelessly twisted up with the lack of understanding, even love, that his mother had come to represent. Those dark erotic drives left him wracked with guilt. Whether it was hyperbole intended to shock interviewers or an attention-grabbing way of self-dramatizing his complex emotional makeup, Dennis expressed those feelings with self-lacerating frankness. "I really wanted to have sex with my mother, no question about it," he told his friend Jean Stein in 1987, describing a mother-son relationship gone extremely awry. "She was another woman I wanted to fuck. A great piece of ass."

DENNIS WAS GRAVITATING TOWARD TABOO, outlandishness, excess. He claimed to have read a biography of John Barrymore while he was growing up, which had set the tone for his eventual career as an actor. In the 1940s and '50s, the standard book on Barrymore was Gene Fowler's purplish *Good Night, Sweet Prince: The Life and Times of John Barrymore*. Barrymore's aristocratic artistry and decadence, as Fowler described them, were fascinating for a boy growing up under Jay and Marjorie Hopper's roof. Dennis would have imbibed the words Fowler ascribed to the English actress Constance Collier that celebrated Barrymore as the greatest of actors: "He had a wild soul, and no one could discipline him." Being the best and being unmanageable fused in Dennis's mind. Collier had also said that Barrymore "had something in his eye, an almost mystic light, that only men of genius have." It's an observation that many encountering Dennis would share and that he himself was perhaps conscious of—those wild, glinting eyes that had traveled down the Davis generations. He would also have taken note of Greta Garbo's dictum, which Fowler also recorded, that "a great artist cannot work or live" without "divine madness."

For the adolescent Dennis, divine madness extended mainly to blowing off French class in order to read plays, acting the part of the teen rebel, and being a cutup. By his own account, he began working and acting at the Old Globe Theatre in San Diego's Balboa Park when he was thirteen, not long after beginning his lessons with Lee Whitney. He had played an urchin in *A Christmas Carol* at the Old Globe in 1949, and by eighth grade, he had Hamlet's "To be or not to be" soliloquy down cold.

In 1952, Dennis was continuing with the Old Globe and acting in productions at Helix High School, in La Mesa. His sophomore yearbook was studded with inscriptions from drama pals, one of whom testified that life at Helix would have been "dull" without Dennis. Whitney added an inscription of her own to "Dennis, who will be tops." In the fall of that school year, he'd played the villain

in *Charley's Aunt*, Brandon Thomas's Oxford farce. He had appeared alongside two hams of the senior class, Tom Hernandez and Bill Dyer. Bill was a talented singer as well as an actor, with a bright, open face and a cheerful manner. Performing was everything to him. En route to UCLA, Bill wrote a passionate inscription to his "best friend" Dennis about the future: "We know what we want it to hold but getting it is a matter of luck & hard work. . . . One of us has to make it, but most of all I hope we both do! . . . I know you'll make it & I hope I do because, really, we *have* to. There's nothing else we know. . . . About 20 years from now you'll read this either on a backstage on Broadway or in a shack in Lemon Grove. There is no in between."

While Bill prepared to meet his destiny in Los Angeles, the sixteen-year-old Dennis headed up to Pasadena for the summer to work at the Pasadena Playhouse. It was, Marjorie admitted, "Practically over my dead body." But she and Jay let him go. Dennis flipped burgers in the theater café and appeared in a play called *Doomsday*, about the Third Reich. Marjorie was amazed by her son's precocious ability to summon up tears onstage, nearly as much as she was by the fact that he didn't blow the $50 he had taken with him or call her and Jay to come bring him back home.

The following summer, 1953, Dennis signed on as an apprentice at the La Jolla Playhouse, the summer stock theater established in 1947 by Mel Ferrer, Dorothy McGuire, and local hero Gregory Peck. That summer, McGuire and her husband, *Life* magazine photographer John Swope, were running the theater. Dennis's responsibilities, as he recalled them, involved "driving a prop truck, pulling curtains, cleaning out the toilets." Sixteen-year-old Susan Kohner, the daughter of the actress Lupita Tovar and the producer Paul Kohner, was the other apprentice that summer. Dennis made $25 a week and lived in a room across the street from the theater; Marjorie and Jay came every week to see the latest production and

pick up Dennis's dirty laundry. "Just think," he told them, "they're paying me to do this, and I'd gladly pay them."

In July, the photographer Robert Vose, on assignment for *Look* magazine, came to the theater. He shot McGuire and Don Taylor rehearsing a scene; sets being built; costumes being sewn; Susan Kohner at the beach; and handyman Dennis Hopper working behind the scenes. (The photos eventually ran in a feature called "Summer Star Dust.") The La Jolla Playhouse was heaven for Dennis, who was even given a couple of walk-on roles. That summer was arguably the best season the La Jolla Playhouse had ever had, with a string of eye-opening productions, including *The Postman Always Rings Twice*, *Stalag 17*, and *The Dazzling House*, which starred Olivia de Havilland in a major casting coup. "There were all these movie stars," Dennis said. "I had never seen a movie star before. I was actually cleaning their toilets." Some of the relationships he forged at La Jolla would be long lasting, including one with twenty-something Hank Milam, who designed sets and lived in Los Angeles at the imposing, art-filled Spanish Colonial home of Vincent Price and his wife, the costume designer Mary Grant Price.

One morning at La Jolla, Dennis was asleep in the theater after working all night. José Ferrer woke him up, shouting, "Give me a dime!" The exhausted apprentice flashed anger—a glimpse of the impetuosity he would someday be synonymous with. "I make twenty-five dollars a week," Dennis told Ferrer. "I don't have a dime." The veteran actor apologized, saying he'd only wanted to use the pay phone, and handed Dennis a five-dollar bill. The astonished Dennis took the handout, thinking to himself, "Some day I'll be an actor, too."

Senior year at Helix High was a comedown. "I was antisocial and amoral," Dennis said. He starred in the school production of *Harvey*, but Marjorie felt that the drama teacher, John

Schwendiman, known as Schwendy, didn't know what to do with Dennis; she even suspected that the teacher was working against him. Her son—with his imagination, impatience, and experience in the working theater—had gone beyond anything Helix could offer. Dennis managed to win another declamation contest that year and kept up his end on the rowdy Helix party circuit. His hell-raising buddies knew that their actor friend, who liked to paint and wrote Beat-inspired poetry, had a different kind of life ahead of him. "You could tell he was going to be great," his friend Dianne Leirsey said of him decades later. "You could tell where his heart was; it wasn't in school." In spite of Dennis's mediocre grades and need to take correspondence courses in order to graduate, he was voted, along with Dianne, Most Likely to Succeed in the class of 1954.

After graduation, Dennis was back at the Old Globe, with roles in *Othello*, *Twelfth Night*, and *The Merchant of Venice* that were typically reserved for college students. "He was one of the most brilliant young actors we ever had," said Craig Noel, a director who supervised the summer Shakespeare festival at the theater. McGuire and Swope went one night to see their young Pasadena Playhouse apprentice onstage. As Dennis always told it, it was they who made connections for him in Hollywood. After the Old Globe's season closed in September, he went to LA against Jay and Marjorie's wishes, moving into the apartment Bill Dyer was renting at 6212 La Mirada Avenue, a block from the Hollywood Ranch Market at Fountain and Vine. His father handed him $200 and told him, "When that runs out, come home." Before too long, David Hopper recalled, Dennis came home "in a brand new Cadillac convertible and gave us our first TV."

AFTER DENNIS ARRIVED IN Los Angeles, Bill drove him down Sunset Boulevard, showing off Beverly Hills, Bel Air, Westwood. "I just couldn't imagine the wealth," Dennis remembered. "It just

seemed like too much to surmount for an 18 year old . . . Looking at it, it seemed impossible."

A young, hungry agent named Robert Raison took Dennis on and managed to get him a tiny part as a Civil War amputee in an episode of ABC's *Cavalcade of America* called "A Medal for Miss Walker." Dennis wrote home about the experience, telling his parents that the director, Wilhelm Thiele, "couldn't believe it was my first time. Wanted to know why and I said I couldn't get a job. He said people are crazy. He told my agent that not only did he love me the cast loved me and the audience will love me." Dennis found the work "*really* easy"—a breeze compared to acting in the theater. "Just think," he wrote, "$75.00 for 45 minutes work that's almost 2 dollars a minute."

Dennis told his family that he had a good shot at getting cast in *5 Against the House*, starring Kim Novak, at Columbia Pictures. He then pulled off the coup that sparked his Hollywood career: during an audition for the role of a seventeen-year-old orphan with epilepsy in NBC's *Medic*, he faked a seizure in the casting office. He had consulted with an expert in grand mal seizures at UCLA, and his fit was so convincing that he got the part. The episode aired on January 3, 1955, and Dennis looked like a guy who was born to be a movie star, all cheekbones and pleading eyes, sweet yet troubled—a smooth-faced teenage Montgomery Clift.

Dennis claimed that five movie studios wanted to sign him. On January 5, *Variety* printed a front-page item reporting that he had gone with Columbia Pictures. Raison had, in fact, taken him to meet Columbia's titan, Harry Cohn, but it had not gone well. Cohn's very presence—bald head, cigar, brusque manner, office full of Oscars—caused Dennis, wearing his best suit and visiting a movie studio for the first time, to break out in a sweat. "Come on in, kid!" Cohn shouted with gruff bonhomie. "You're the most naturalistic actor I've seen since Montgomery Clift. What have you been doing recently?"

"Well, I've been down in San Diego, playing Shakespeare," Dennis said.

Cohn grimaced. "Shakespeare? Oh, no," he said. He turned to Columbia's head of casting, Maxwell Arnow, the man who had discovered Humphrey Bogart and Katharine Hepburn. "Send him to school for a while. Take all that Shakespeare out of him! We don't do that in movies!"

Dennis stopped sweating and looked Cohn straight in the face. "Go fuck yourself," the teenager from Lemon Grove told the head of Columbia Pictures. And that was that.

Raison then took Dennis to meet with the Warner Bros. talent scout Solly Biano, who said that the director Nicholas Ray was working on a movie for the studio that might be a good fit for him. Like Dennis, the star was a boy from a farming community in the Midwest; his name was James Dean, and the picture was called *Rebel Without a Cause*. Ray agreed to cast Dennis. Ten days after he had appeared on *Medic*, Hedda Hopper announced in her syndicated column that Dennis Hopper had gone under contract with Warner Bros.

3

"THE MOST BEAUTIFUL, THE MOST BRILLIANT, THE MOST CREATIVE"

I f, for Dennis, the prospect of being in the movies required a Tom Joad–like odyssey from dusty Kansas to the paradise of California, Brooke, as the firstborn of Margaret Sullavan and Leland Hayward, was literally a child of Hollywood. On July 7, 1937, two days after Brooke was born at Cedars of Lebanon Hospital in Los Angeles, Leland's friend John Swope pointed his Leica Elmar 90-millimeter lens at baby Brooke just as her face squinched into a lopsided yawn. Swope included the portrait of the celebrity infant in his photography book *Camera over Hollywood*, which conveyed both sunny California glamour and dark Nathanael West cynicism. Captioning the photograph, Swope wrote, "Two days old and already a star's daughter is registering emotion for the camera."

A year before Brooke was born, Margaret Case Harriman had profiled Leland in *The New Yorker*, describing him as "thin, with graying hair which he wears close-cropped, and a manner at once haggard and debonair." At the age of thirty-four, and only five years after setting up his own shop, Leland was already a walking movieland fable: the Hotchkiss-graduated, Princeton-dropout son of a

First World War hero who could sell the proverbial iceberg to a polar bear. As a Hollywood and theatrical agent, his clients included Fred Astaire, Jimmy Stewart, Dashiell Hammett, Katharine Hepburn, Ernest Hemingway—and Margaret Sullavan.

Leland's father, Colonel William Hayward, had led the Harlem Hellfighters in the trenches of France and had later become the US attorney for the Southern District of New York. His grandfather was a Nebraska senator, Monroe Leland Hayward, who had died nine months into his single term. A colleague said that Leland possessed "a highly organized mind—and the energy of a Diesel." The playwright George Axelrod called Leland the "Toscanini of the telephone" for his ability to ply that device with virtuosic dexterity, whether from the sofa in his antiques-filled office, on a studio lot, or at Jack & Charlie's restaurant on West 52nd Street, later known as "21," where he had once reportedly phoned Myrna Loy, Lily Pons, and Sam Goldwyn successively on long-distance lines during the course of a single dinner, something of a feat in the mid-1930s. He was known to work three or four handsets simultaneously as he wheedled what were then considered ungodly sums for his clients.

You can imagine Leland in a dialing frenzy to announce the birth of Brooke, the most beautiful baby he'd ever seen. Her arrival was noted in the July 19, 1937, issue of *Life*. According to the item, Brooke had weighed six pounds, five ounces at birth, but the joke around Hollywood was that her actual weight was six pounds, seven ounces, Leland having taken his customary 10 percent cut. It was also noted that the arrival of the baby had caused *Stage Door*, the hit Broadway play by George S. Kaufman and Edna Ferber (another Leland client), in which Margaret had been starring at the Shubert Theatre, to close. Five months later, the *Los Angeles Times* covered the Hollywood baby's first taste of transcontinental air travel as Brooke sat in Leland's lap aboard a TWA flight from LA to New York. Leland was a pilot himself and often made the seventeen-hour run between the coasts in the cockpit of his own plane. He

was also on the board of directors of TWA, would later establish Southwest Airways (which became Pacific Air Lines), and, during the Second World War, was a prime mover behind the creation of Thunderbird Field, the flight training center in Glendale, Arizona.

Brooke's name descended down the maternal line: her mother was Margaret Brooke Sullavan, whose great-grandmother had been Priscilla Brooke Lee Smith. They were Virginians through and through, and Margaret had been born in 1909 in Norfolk, where her father, Cornelius Sullavan, worked as a produce broker. In later life, his idea of a gift for his grandchildren was Confederate currency. Brooke's mother possessed "deep pride about her Southern ancestry and customs," Brooke wrote in *Haywire*, "offset by a rebelliousness against that pride, as if any feeling so ingrained must also be pompous."

The young Margaret had an older half sister and a younger brother, was given to tomboyism, and adored hunting with her father. Boyishness would always be a quality of her beauty; her senior class portrait, from 1927, shows an androgyne. "Inwardly, I was an anarchist of the deepest dye," she recalled. She discovered that she liked having an audience and gravitated toward drawing, dance, and drama. In short order, she went from acting in community theater to joining up with the University Players on Cape Cod, an Ivy League–centric troupe that included Henry Fonda, John Swope, Joshua Logan, and Jimmy Stewart, and then to Hollywood in 1933, becoming the incandescent star of such films as *Three Comrades* (for which she was nominated for a Best Actress Oscar) and *The Shop Around the Corner.*

Margaret Sullavan was no 1930s Hollywood doll with varnished eyelids and peroxide blond hair. She was sylphlike and blue-eyed, with a weak chin, a crooked tooth on the left side of her mouth, and hair the color of straw. She was known to her friends as Maggie and showed up for shoots in corduroys and tennis shoes. "I don't want to be a perfect woman," she said, a veritable heretic.

Her unusual, even otherworldly, appeal radiated from brains and sass, and it cut deep. "I had photographs of Margaret Sullavan all around me for many years," Tennessee Williams said, "and I think she seeped into my blood." Louise Brooks loved "that wonderful voice of hers—strange, fey, mysterious—like a voice singing in the snow." Her daughter Brooke would inherit that voice. Ogden Nash set the beauty of Margaret Sullavan to verse: "The fairest of sights in twinkling lights/Is Sullavan with an A."

Henry Fonda perhaps fell the hardest for Maggie. "If I've ever known anyone in my life, man or woman, who was unique, she was," he said. "There was nobody like her, before or since. Never will be." They married in 1931, and their relationship was a Category 4 hurricane. "Time after time that slender girl's words stung me like a wasp," he wrote in his memoir. "We were at each other constantly, screaming, arguing, fighting." He said that Maggie was "cream and sugar on a dish of hot ashes." They divorced in 1933. After a fling with the Broadway producer Jed Harris, Maggie married William Wyler, the German-born film director, in late 1934; that lasted about a year and a half. Maggie and Henry Fonda considered re-marrying, had another fight, and broke it off.

Then came Leland Hayward. Margaret married her agent in November 1936, in Newport. There, his father, Colonel Hayward, and stepmother, the former Mae Caldwell Manwaring Plant, known as Maisie, owned Clarendon Court, a house she'd inherited from her previous husband, the railway tycoon Morton Plant. The Gilded Age villa achieved notoriety decades later as the residence of Claus and Sunny von Bülow. Maisie had gained her own notoriety in 1917, when she had arranged with the Cartier jewelry company to trade her Fifth Avenue mansion for a double strand of pearls valued at a million dollars. (The pearls depreciated to a value of about $150,000 by the time Maisie died in 1957; the house remains Cartier's Manhattan flagship store.) Two years after Maisie's trade, she married Colonel Hayward. Leland's mother, Sarah Coe Ireland, known to

Brooke as Grandsarah, had divorced his father in 1911. Leland was their only child.

The Newport wedding was the third for Leland. He had already been married twice, to the same woman, a Texas debutante named Inez Gibbs, known as Lola; the first of those was an elopement when he was nineteen. In order to marry Maggie, he had broken off an affair with another of his clients, Katharine Hepburn. Or perhaps he hadn't. When the incensed Hepburn learned of the marriage, she sent a telegram to the bride: "Dear Maggie—You have just married the most wonderful man in the world." The recipient set fire to the cable as Leland watched. "He *loved* it," Brooke said. "He told that story all the time." Brooke believed that her father continued to oscillate between the two headstrong actresses in defiance of his marriage vows. She recalled once finding herself on an elevator with Hepburn when a mutual acquaintance introduced them. "*You* are Maggie and Leland's daughter?" Hepburn asked, sizing the girl up with mock horror. "I remember thinking, 'This is a nightmare.'"

By the time of the wedding in Newport, Maggie was pregnant.

MAGGIE AND LELAND'S GIRL was precocious, chatty, luminously cute, and given to mischief. Around the time Brooke turned three, Leland wrote to the colonel extolling her all-around splendidness. Brooke already possessed a vocabulary of a "couple thousand words," Leland reported, and knew "forty or fifty songs and is quite a girl." In another letter, he proudly informed his father that "Brooke is talking her head off."

Words would prove to be one of Brooke's gifts, a predisposition that was fed by her tutor, Miss Brown, who, under Maggie's directive, expunged the standard school curriculum—the one that had bored Dennis in Kansas—and gave the child such tomes as Nathaniel Hawthorne's *Tanglewood Tales*, illustrated by the great

French artist and designer Edmund Dulac, to gorge herself upon. The book not only introduced Brooke to the sonority of Hawthorne but was a feast for the eyes. Brooke would come to feel that her expectations about life and the world were "shaped by the sensuous textures and sinuous lines of Dulac's fantasies." In 1940, *Vogue* ran a John Swope photograph of Brooke sitting in Leland's lap with just such a volume open before her. Her immersion in illustrated books—including Eugene Field's *Poems of Childhood* ("Wynken, Blynken, and Nod" et al.), with Maxfield Parrish's dreamy color plates—would spur her imagination toward what she envisioned as her future self. "I wanted to be a writer and an artist," she said.

The Haywards lived in Brentwood, at 12928 Evanston Street, wedged between the rival greenswards of the Riviera and Brentwood country clubs. The house was a big white clapboard Colonial with bay windows set amid acacia and pepper trees, with a terrace, swimming pool, and velvety lawn. The emphasis inside was Early American—rag rugs, folk-art dolls, and chintz. *Vogue* called the homely home life of the Haywards "thoroughly undramatic." Maggie and Leland were determined to take an unpretentious, down-to-earth approach to their Hollywood household—with the help of a live-in butler, cook, nurse, and maid. (The butler and the cook, Brooke remembered, were eventually arrested as German spies.)

The bachelors John Swope and Jimmy Stewart, both of them Brooke's godfathers, lived nearby. So did Maggie's ex-husband Henry Fonda, along with his wife, Frances, and their growing family, who would feel a lifelong siblingesque bond with the Hayward clan. Fonda loved visiting Evanston Street, where he sometimes ended up doing cartwheels with Maggie on the lawn. The high-spiritedness they shared did not endear Maggie to Frances. It didn't help that at one dinner party, Maggie, always given to provocation, announced with a guffaw, "In the sack Hank comes very fast."

Brooke's little sister, Bridget, was born in February 1939. She was a towheaded sprite, ethereal and radiant, with skin so pale it

was practically blue. In Swope's photographs, the toddler Hayward sisters look cherubic as Leland and Maggie lift them out of the swimming pool after a round of skinny dipping. In March 1941, Maggie gave birth to another blond baby, the boy that Leland had been waiting for. ("God knows I hope it is a boy for my own sake," he'd written to Maisie.) They named him William Leland III, and he was invariably called Bill. The sisters treated him like a special piece of property. The movie star, her agent-husband, and their three beautiful children—the Hayward aura was Hollywood storybook through and through.

Around the time Bill was born, Leland and Maggie built another structure on their property, a two-story red barn in which the occupants were not to be horses or cows but rather their own children. On the surface, the idea was enchanting: a quaint dwelling that would function as a nursery. It would be a realm of fun, games, and tutoring at the hands of Miss Brown. Maggie, having given the Brentwood Town and Country School on Chalon Road a brief tryout, had decided that the Hayward children would be better educated at home. ("Mother," Brooke said, "didn't approve of school.") The barn was outfitted with Americana, including an enormous trestle table and a wondrous six-by-nine-foot needlepoint alphabet that the colonel, of all people, had crafted for his grandchildren, a vast tapestry of animals from A to Z. Jill Schary, the daughter of the director and producer Dore Schary, was one of Brooke's best friends; she lived two blocks away and loved visiting Brooke at the barn. In a memoir of her childhood, Jill wrote of the spirit of the place: "Each of their rooms had a different colored door which corresponded with the color of the gingham-bedecked interior." She remembered that Brooke designed the sets for their marionette shows. One day, Jill and her sister, Joy, were banished from the Hayward barn after the kids were discovered having a frank dialogue about procreation.

The main house on Evanston Street, connected to the barn by a

thirty-foot-long open breezeway, became known to the children as the Other House. It was the adult realm—of cocktail soirees and of Maggie and Leland's own life together, now cordoned off from the children. In *Haywire*, Brooke described life in the barn as eccentric and gay, the lunatics taking control of the asylum, with lawless parties, Bill dressing up as a girl, and tricycles incessantly wheeling back and forth across the floor. "We derived an enormous sense of pleasure from the possession of something so large, a *house*, entirely tooled to meet our needs," she wrote. But she also described the apartness of being a child relegated to an outbuilding. She was rambunctious and willful (*Vogue* described Brooke as "volatile"), but she had deep sensitivity. When she was taken to see *Bambi*, she needed to be removed from the theater. She had recurring nightmares of a ferocious *Tyrannosaurus rex* showing up on the doorstep. On the occasions when she woke up in the middle of the night in the barn, she felt the distance to the Other House acutely. She would force herself to traverse the breezeway in darkness in search of a safe haven in the adult world—not so much with Maggie and Leland as with the staff, particularly the nanny the children adored, Emily Buck. Years later, Brooke spoke with a friend about the seeming child's paradise of the barn. "I was alone," she said. "It was terrible."

IN 1944, WITH THE SECOND World War in full stride, Maggie was in New York, starring in *The Voice of the Turtle*, considered the first long-running Broadway hit with a female lead. Her absence took a toll on the family; Leland missed his wife and reported to her that Brooke was acting up. Toward the end of the year, Leland brought *A Bell for Adano*, adapted from the John Hersey novel, to Broadway, which marked the beginning of his move from agenting toward producing and from movies to theater. He sold his agency to MCA; the merger created the largest agency in the world. Maggie had been pushing him in that direction. To her, being an agent—even the

best one the business had ever known—was beneath him. Brooke recalled that Maggie had taunted her father with the phrase "flesh peddler" when he took to his battery of telephones to make another deal. Maggie had decided that she loathed Hollywood and would leave motion pictures; she was even threatening to retire from the stage. Leland, the suave eastern patrician, may have had his own ambivalence about show business, but he loved the game and cared about bringing quality projects to fruition. Even so, he told Brooke that he would have been happier as a full-time pilot, working the levers of an airplane cockpit rather than the dial of a telephone.

In October of that year, the household received a telegram from Maisie, in New York, informing them that Colonel Hayward, who had been suffering from lung cancer, had died. Changes were afoot. On impulse, Maggie bought a rambling eighteenth-century clapboard farmhouse amid woods and fields near the village of Brookfield, Connecticut. The property, outfitted with three barns, was called Stone Ledges. In the spring of 1945, the Haywards left Evanston Street forever, packing up and leaving for what Maggie envisioned to be a New England idyll. The faux Americana of Brentwood would be made real in the Berkshire foothills of Fairfield County.

The move east was a clear manifestation of Maggie's disdain of Hollywood fakery: the movie business was grubbing, déclassé. It was an ambivalence that Brooke would inherit. Maggie dreamed of creating a perfect domestic tableau for her children, far removed from stardom and fame—a normal life. "I don't want them to know anything about films or stars, or being the children of celebrities," she said. Now it would be farm life: walks in the woods, crafts, animals.

Ever game, the Hayward kids loved adventuring around Stone Ledges among the pine thickets, raspberry brambles, and fields of tall, silky corn. Brooke adopted a squirrel and named him Mr. Duchin, after Eddy, the bandleader. Maggie was in heaven, even

when it came to whacking the head off a chicken, an act that terrified and revolted Brooke. Leland tried to get with the program, baking bread, taking up carpentry, and generally trying not to lose his marbles. But country living was not for him. As usual, the phone was Leland's lifeline, and the calls coming into and going out of MILFORD 1155 surely drove Maggie mad. Soon enough, Leland was looking for any opportunity to be away from Stone Ledges, doing business in New York or LA, whether it meant making deals for his show business clients or helping to run Southwest Airways.

THE FOLLOWING YEAR, MAGGIE AGREED to put the Stone Ledges experiment on hold, and the Haywards, mostly for Leland's sake, moved back to LA, taking up residence in a house at 9301 Cherokee Lane, way up above Sunset Boulevard in Beverly Hills, among scrub oak and sagebrush. A few years before, the Fondas had also moved north of Sunset to 600 Tigertail Road, a bucolic nine-acre spread with a Pennsylvania-style farmhouse at the foot of the Santa Monica Mountains. The property came with orchards, a henhouse, rabbit hutches, and a playhouse for the children, likely inspired by the Haywards' barn on Evanston Street.

The Haywards and the Fondas, Brooke noted, "were united in the most abstract but intricately woven pattern." They were linked by careers, marriages, friendships, and geography. (Hank and Leland had both been born in Nebraska.) Over on Tigertail, there were little Frances, known as "Pan," Frances's daughter from her previous marriage; Jane, about five months younger than Brooke; and Peter, almost exactly a year younger than Bridget. "I feel like a comet traveling between two solar systems," Peter told Brooke when she interviewed him for *Haywire*, "the solar system of your family and the solar system of my family." The Hayward and Fonda kids made for a roving tribe, with the to-be-expected bouts of japery, from rock fights to brush fires to smoking cigarette butts fished out

of ashtrays, an episode that got the Haywards booted out of Tiger-tail. As the oldest, Brooke was the ringleader of this unruly band of conspirators.

"We were the *real* Old Hollywood," Peter said of the Haywards and the Fondas. "The bloodlines were really fine and true." To him, Brooke was the "troublemaker," Jane the "ingenue." The two girls were best friends, a status they would maintain for decades even as they pursued sometimes uncomfortably overlapping ambitions. The Fonda and Hayward kids liked to imagine the romance that Hank and Maggie had shared before they were born, conjecturing that they were still in love. Peter found Maggie "likable and dreamy" and would one day claim that he remembered her better than his own mother, a remote, saturnine figure. He got up to no good with Bill and marveled at Brooke's "beautiful, shiny dark hair." And at some point, he fell for the angelic Bridget, who he said personified "the best qualities that were in all of us." Brooke, for her part, liked Hank Fonda despite finding him "tense and aloof and strange" and was amazed by the grief Jane would give him at the dinner table with her verbal provocations. Like Brooke, the girl had spark.

But despite all of the advantages, the Hayward and Fonda children were often miserable about their lot: being shuffled from place to place, inconsistent or even nonexistent schooling, parental distractions and solipsism amid the pressures, travails, and narcissism of Hollywood. It was the dark side of the glittering childhood they shared with many friends who were, like them, the offspring of the movie aristocracy, such as the Scharys, the Selznicks, and the children of Herman and Sara Mankiewicz—Don, Frank, and Johanna, known as "Josie," a girlfriend of Brooke's who also loved to write. It was a world of catered kiddie birthday parties serviced by uniformed waiters, and it was not destined to last. "Our Hollywood with its private nobility, its reigning monarchs, devoted subjects, and ever-toppling crowns was bound to go," Jill Schary later wrote. "But all through history, every object of mass devotion eventually

falls out of favor. It may take a war, a major revolution, or a little machine, like the first cross-bow, or the television set."

Jane would grow up with a professed distaste for privilege, while Peter would feel, on balance, frowned upon by fortune to have been brought up the way he was. "It's very difficult to have one powerful parent," Brooke observed of her own family, "but to have two equally powerful parents is a real problem for kids."

For all of his charm and drive, Leland had his issues. He seemed to be perpetually living beyond his means, always needing the best of everything, and collecting—hoarding, even—with manic intensity: everything from cufflinks to watches to shoes to photographic equipment. He was a confirmed workaholic, lost in his own affairs and disengaged from others, which, Brooke thought, led to a propensity for unthinking, casual cruelty. He took his failures—inevitable in an industry that manufactured hits and flops—hard. His health was a mess, requiring him to be hospitalized at various times for elusive yet debilitating maladies that might have been ulcer related or might not. He smoked dozens of Camels a day and preferred only the whitest and blandest of foods, the chicken hash from the Beverly Hills Hotel being a favorite. He looked to the medicine cabinet to find a decent night's sleep and the energy bursts he needed to keep up with the demands he placed upon himself. Amid the growing marital turbulence with Maggie, Leland sought the ministrations of an analyst, who, according to Brooke, informed her father, "There's no question that you're crazy."

"I would be the first to say that father was not a very good father," Brooke said. Leland's friend George Axelrod thought that Leland was essentially a child. "He was childlike until the day he died," Axelrod told Brooke. "If the core, sole part of you, the interior thrust of you, which is probably what makes an artist as well, is a child, it's damned hard to be in the father role."

Brooke placed Leland's paternal deficiencies at Maggie's feet. After all, Brooke took more after her father, at least in terms of per-

sonality, than Bridget or Bill did. "In a sense he was a hag-ridden man," Brooke confided to Truman Capote in the 1970s, "and I think that Mother is certainly more to blame than Father." Capote said that Maggie was "totally neurotic," a term Maggie herself deployed when describing the psychological shortcomings of actors in general; she considered them uniformly unhappy, maladjusted, self-absorbed, ego saturated, and incapable of mixing career and family. Those were all the reasons Maggie was so fixated upon making a picture-perfect home for her family—and all the reasons it seemed impossible for her to do so. As Hank Fonda had painfully discovered, Maggie could be sharp tongued, quick tempered, withering in her scorn. She was tyrannical yet needy, entirely sure of her point of view yet entirely unsure of herself.

"My mother," Brooke said, "was utterly insane. A nightmare."

IN 1947, MAGGIE'S CAREER HAD been gearing down—mostly by design—while Leland's was going full tilt, per usual. They were on diverging paths, with Maggie spending more time on her own at Stone Ledges, her Connecticut haven. Then an opportunity came along for her, one that would mean another protracted absence, perhaps as long as six months. "She foolishly decided to star in *The Voice of the Turtle* in London," Brooke said.

The timing could not have been worse. With Maggie gone, Brooke remembered, "Father began dating Slim Hawks," the energetic, Mainbocher-clad socialite wife of the director Howard Hawks. Slim had been the model for Lauren Bacall's character in Hawks's *To Have and Have Not* and was one of the most exalted swans of mid-twentieth-century America. The infidelity infuriated and humiliated Maggie. Leland pleaded his case to Brooke: "What the hell did she expect? I told her not to go . . . I told her how vulnerable I was."

In October, Maggie returned to Beverly Hills; the London

production of *The Voice of the Turtle* had been battered by the critics. Brooke believed that her father was looking forward to the reunion and to putting their problems behind them. "But," she remembered, "when Mother got back—she was always an emotional wreck—she said, 'All right, I'm getting a divorce,' which was stupid. Father was shocked. But she proceeded." Maggie claimed in her divorce testimony that Leland had in fact told her, "I'm not meant for marriage. I'm not meant for home life." According to Slim, Leland confided to her that the morning he had woken up in Newport after marrying Maggie, he'd cried, realizing that he'd made a mistake.

In April 1948, a couple of months before Brooke's eleventh birthday, the divorce was granted. Maggie took custody of the children, along with Stone Ledges and the house on Cherokee Lane. The following June, at Bill and Babe Paley's Kiluna Farm in Manhasset, Leland and Slim were married.

The divorce split Brooke's young life into two—one part full of color and hope, the other a haze. Echoing words she remembered her father speaking, she later told an interviewer, "Divorce, it's the most awful thing in the world."

IT WAS BACK TO CONNECTICUT for Maggie and the kids. Determined not to be left in the dust by Leland, Maggie had taken up with a new man: Kenneth Wagg, a British businessman, Etonian, divorced, a renowned player of rackets (a kind of hardball version of squash), and a chairman at Horlicks, the malted milk company. Brooke and her siblings, although still in a daze from the breakup of their parents, felt that their mother had struck gold in finding this partner, who had seemingly come to the rescue out of nowhere. Ken might not have been as glamorous as their father, but he was decent, stable, and passionately in love with Maggie. The two would marry in 1950.

They left Stone Ledges behind and moved to Greenwich, where,

as if by fate, the Fondas had relocated when Hank had signed on to play the lead in *Mister Roberts* on Broadway, with Leland producing. (It would prove to be Leland's third hit in a row, following *A Bell for Adano* and the Pulitzer Prize–winning *State of the Union*; *South Pacific* was on the horizon.) Emily Buck, the Haywards' beloved nanny, had stayed behind in Los Angeles. The departure, which Brooke took hard, had a silver lining: she would enroll in an actual school. Entering the all-girls Greenwich Academy was heaven to Brooke, marking a new phase of her life. "I loved it," she said. "And one of my oldest friends was there in my class—Jane Fonda." Peter and Bill landed at the all-boys Brunswick School. Maggie, worried about money, occasionally groused to her ex-husband about the cost of tuition. "It even looks as if I'll have to put the children in public schools," she threatened during one financial impasse, "but before that I'll sell my jewelry."

In Greenwich, the Hayward and Fonda kids continued their California misadventures. Brooke and Jane shared a love of spitballs and mayhem; they were Brownies together and managed to get thrown out. In one hair-raising incident, Peter came close to shooting Brooke with a .22-caliber pistol while using a willow tree for target practice; the bullet lodged in the bark less than an inch from Brooke's ear. In another, in January 1951, Peter did accidentally shoot himself in the stomach, dying, as he often told the story, three times on an operating table before pulling through. It was perhaps no surprise that the delicate, aloof Bridget was now withdrawing from those and other questionable activities. Unlike Brooke, she was no tomboy provocateuse. With her spectral beauty and timidity, she was Beth March to Brooke's Jo.

When she wasn't blowing spitballs, Brooke took to her desk and created. "She was enormously talented," her admiring stepmother, Slim, wrote in a memoir. "She could paint, she could draw, and she could write extremely well." (Brooke returned Slim's affection: "She was gorgeous. And she loved people. She was a wonderful

stepmother.") Jane Fonda remembered her best friend in her teen years as "the most beautiful, the most brilliant, the most creative, the best writer. Brooke, to the marrow of her bone, is an artist."

When Brooke was in seventh grade, she wrote a novel with her friend Susan Terbell called *The Riders of Red Devil*, illustrating it with her own watercolors. It was the story of twin jockeys who together rode a horse to victory in the Kentucky Derby, and the manuscript and paintings had charm enough to persuade an editor at Simon & Schuster, an acquaintance of Ken's, to make an offer to publish it. At twelve years of age, Brooke was on the verge of becoming a published author—her dream. She fantasized about the recognition and riches coming her way.

Maggie quashed it. "It wouldn't be healthy for me," Brooke said, explaining her mother's reasoning, "because there would be a lot of attention and it would be because of *her*. So I should wait until I was twenty-one. I was furious." Maggie added an admonishment. "If you ever write again—and you will," she told her daughter, "write about something you know." There is no extant copy of *The Riders of Red Devil*; Brooke destroyed it.

"Mother was very strong-willed and she was very possessive," Brooke remembered. "On top of it she was an actress. On top of it she was famous." As Maggie began coping with the setbacks that come to actresses of a certain age, her fraught emotional state was tipping over into something more rococo. The situation was made still more complicated by a developing condition, otosclerosis, which was causing Maggie to lose her hearing. Entering puberty, Brooke was feeling increasingly squashed down by her mother.

"When I was thirteen," she remembered, "I was a nightmare"—a not unnatural state for a thirteen-year-old. She was winning prizes for her writing, enrolled in dancing school, becoming more independent, developing into a beauty. "Mother was irritated with any boyfriend I had," she said. Jane observed that Maggie seemed to be competing with Brooke in that area, flirting with the boys who

came around to see Brooke, as if she needed reassurance that she was still attractive. Maggie's parenting became more stringent, and she incessantly guilt-tripped Brooke for forcing her to play "policewoman." In the eternal way of teenagers, the nagging only triggered more outré behavior: Brooke ate a live centipede to amuse her friends; she sold tickets for the Greenwich Academy production of *Pirates of Penzance* to the town prostitute. And so on: a proper rebel.

Then, in June 1953, a month before her sixteenth birthday, Brooke found herself on the cover of *Life*, looking every bit the fresh-faced Greenwich wonder girl in a strapless dress, having been photographed for a bright feature on the daughters of Hollywood celebrities, including those of John Wayne and Joan Bennett. To Brooke, it was astonishing that Maggie, given her extensive rules about celebrity, had allowed it to happen. The cover photograph prompted John Swope to write Leland from La Jolla Playhouse, saying, "What a wonderful girl Brooke is." Nearby, a seventeen-year-old aspiring actor from Helix High School, Dennis Hopper, was busy working as the theater's prop boy, handyman, and gofer.

THE *LIFE* COVER BOOSTED BROOKE'S popularity at the Greenwich Academy and among the local population of adolescent boys. It was a welcome ray of sunshine, as life in Greenwich often had a shadowy cast. In April 1950, Jane and Peter Fonda's mother, Frances, undergoing treatment for mental illness, had ended her life at the Craig House Sanitarium in Beacon, New York, slashing her throat with a razor. Frances and Hank had been heading toward a divorce; he would marry Oscar Hammerstein II's stepdaughter, Susan Blanchard, later that year. The tragedy gave Jane and Peter a staggering dose of the familial turbulence that the Hayward kids had been enduring. Hank kept the cause of Frances's death a secret from his children. "I'll never forget the day Jane found out,"

Brooke said. "We were sitting in art class at school, surreptitiously reading a movie magazine, and there was a story, 'Why Henry Fonda's Wife Cut Her Throat.' I remember turning the page fast. Jane reached out her hand and turned the page back. It was an awful moment."

The Hayward and Fonda kids would soon be split apart. In 1953, Maggie decided that her children would be sent away to boarding school that fall whether they liked it or not. Brooke did not. "My sister and brother were not getting along well with Mother," she remembered. "It was very difficult. Mother had suggested that we were going to boarding school abroad, so that we could learn, preferably in a place like Switzerland, to speak French. I had no intention of doing that." Instead, she proffered the idea of attending the all-girls Madeira School in McLean, Virginia, which passed muster with Maggie thanks to the Old Dominion connection. Bridget, relieved to escape Maggie, headed off to the Institut Montesano in Gstaad, while Bill, who was not particularly enamored of school, ended up bouncing from Lawrenceville to Eaglebrook and back to Lawrenceville.

At Madeira, Brooke cast herself as an "artistic eccentric, outside the bourgeois concerns that governed the rest of the student body." Her tastes ran to cigarettes and J. D. Salinger. She worked at oil painting, her magnum opus being a canvas titled *Nervous Breakdown*. She starred as the pleurisy-afflicted Laura Wingfield in a school production of *The Glass Menagerie*, which aroused in her the first stirrings of a desire to explore a career on the stage—a notion that alarmed Maggie, who naturally forbade it.

The girl's inspiration, and object of desire, was Marlon Brando. In the summer of 1954, while visiting Leland and Slim in Los Angeles, Brooke drove around town with Jane, Jill Schary, and Josie Mankiewicz, trying to hunt down Brando, "that hulking brute with the poet's face," as Jill described him. They were not successful. But Brooke did get to watch James Dean filming the Ferris wheel scene

for *East of Eden* and went to a party hosted by David O. Selznick and Jennifer Jones in Malibu, at which Cole Porter handed her a cigar. It was perhaps during this trip that Brooke and Jane found themselves with Selznick in his limousine when the bespectacled legend who had produced *Gone with the Wind* made a pronouncement that neither of the best friends would ever forget.

"Brooke will be the movie star," he declared, "not Jane."

THE NEXT SUMMER, BROOKE WAS preparing to go to Vassar, where she would again be reunited with Jane, her chief coconspirator. It was then that Maggie rashly and inexplicably decided that Bridget would no longer attend Montesano. "Mother dragged her back," Brooke said. Bridget, who loved being in Gstaad, was distraught. "That's when she and my brother—my brother who was always crazy and loathed Mother—both decided to leave home. They left Mother and went to live with Father, in California, which did not please Father, because he was in Europe when this was happening, and he had to come back to take them." The entire affair, Brooke said, "sent Mother into a complete mental breakdown."

The familial blowout and dispersal of the children created a ripple effect across the rest of the decade: Bridget would get into Swarthmore, drop out, undergo psychiatric treatment at the Austen Riggs Center in Stockbridge, Massachusetts, and, in a few years, be discovered to have epilepsy, a condition she would manage to hide from her family. Bill would be sent to the Menninger Clinic, a psychiatric hospital in Topeka, Kansas, eventually joining the 82nd Airborne Division as a means of escape. Maggie would endure increasing psychological distress, which was only exacerbated during rehearsals for a 1956 live television performance when she overheard a producer on a talk-back microphone remarking "We'll never make that old hag look 40." She checked into Austen Riggs for a two-and-a-half-month time-out.

Brooke weathered the beginnings of this storm at Vassar. During the Christmas season, she had her debutante moment, being presented at the Grand Ballroom of the Waldorf-Astoria during the annual Debutante Cotillion and Christmas Ball. At some point during freshman year, she met a clever, loquacious Yale sophomore named Michael Thomas, the son of Joseph A. Thomas, a partner at Lehman Brothers. Michael possessed *Mayflower* roots, had been educated at Buckley and Exeter, and had set his cap for literary and artistic attainments. He was well read, well funded, charming, opinionated, hilarious, and studying to become a museum curator. According to Jane, "He wrote such beautiful love letters." Brooke was captivated. "He was brilliant," she remembered.

For Michael, the combination of Brooke and Jane was heady: the beautiful, mischievous, sophisticated, highly intelligent daughters of Hollywood, a two-headed feminine force. He remembered Jane as "beautiful and icy and . . . extremely promiscuous." Rumor had it, he said, "that she had broken a taboo and once fucked in the hallowed halls of Skull and Bones." But Michael had fallen for the willowy Brooke, who, in April 1956, called her father in California to seek advice on a "problem," a communication that Leland acknowledged with a telegram back to Vassar. The problem may have been the oldest known to young couples in love: Brooke was pregnant.

She and Michael decided to marry. Michael invented a press-and-society-friendly story in which the two of them had romantically eloped to Tours in France, where they were wed in the summer of 1956. (Brooke had been in Europe that summer.) Hedda Hopper reported the fable in her gossip column. In fact, the two of them quietly sneaked across the Hudson to Jersey City, where a clerk married them in September of that year. "When the time came to say my father's name," Michael remembered, "I blurted out, 'James Thomas.' This was an age, leave us not forget, when out-of-wedlock pregnancy was grounds for social excommunication." There was no such banishment from Maggie or Leland, but there was irritation at

seeing their talented daughter married in the same hasty way they had been in 1936. Despite Michael's intellectual promise and Social Register pedigree, "He was a disaster both to Mother and Father," Brooke said.

Brooke dropped out of Vassar. The newlyweds took up residence in the Traymore Apartments in New Haven, as Michael continued his undergraduate career. In January 1957, the baby arrived—their first son, Jeffrey. He was joined by his "Irish twin," Willie, in November. Brooke was determined that their sons would know that they were "the product of a relationship between two people who cared for each other," even if those people were barely out of adolescence. During their cocooning period with the boys, Hank Fonda would occasionally phone, searching for Jane, who had the habit of telling her father she was staying with the Thomases when she was somewhere else at Yale, overnighting. "She's not back yet, Hank," Michael would politely inform Hank, running interference. "I did study physiology," Jane later joked of her college days. "I just didn't get a degree in it."

After Michael graduated in 1958, they moved to a house tucked into the woods of Greenwich, on Husted Lane, close to Maggie and Ken, and Michael commuted to a curatorial job at the Metropolitan Museum of Art. He managed to get along with Leland, who introduced him to the expensive hobby of photography. He was struck by Leland's avidity for collecting, his need "to have two of everything." But he was alarmed by the overall dynamic of the Haywards and the distressing impact it had on his wife. "This family," he said, "was characterized by a total lack of love. Gestures were made, but I think it was impossible for Maggie or Leland to focus on any of their children for more than ten seconds without thoughts of themselves breaking in."

Leland's mind was certainly elsewhere. His marriage to Slim had frayed beyond repair. She'd begun having affairs—with Frank Sinatra and the screenwriter Peter Viertel—while the workaholic

Leland poured his energy into his business, bringing *The Old Man and the Sea* to the screen and pursuing the rights to produce *The Sound of Music* on Broadway. "I'm spinning like a top," Leland told Lauren Bacall in the summer of 1959. In July, for Brooke's twenty-second birthday, Leland took her to Le Pavillon, where, after a few drinks, he made a surprise announcement. "I want you to meet my new bride-to-be," he told Brooke, who was mystified. "But, Father, you're already married," she said.

Leland said he would be marrying Pamela Churchill, the British ex-wife of Winston Churchill's son, Randolph, and the mother of Winston Spencer-Churchill. Pamela was known as a social mountaineer and accomplished manizer—bounteous red hair, flawless white skin, and the throwback figure of a Gibson Girl. While Leland went on about the wonderful new stepmother who would replace the one his daughter admired, Brooke thought Pamela "sounded like a mixture of Brenda Starr and Mata Hari." The coupling of Leland Hayward and Pamela Churchill created a schism in New York society. "I am a Slimmite to the death," Truman Capote declared.

When Brooke met Pamela, she was not reassured. "She didn't know about politics or the theater," Brooke remembered. "She was a banal milkmaid, a little plump, certainly not beautiful. She wore expensive clothes but she didn't have flair." Brooke worried that Pamela's central preoccupation was expensive things and how to obtain them. In time, Brooke became impressed, if grudgingly, by Pamela's can-do ways: Pamela learned the show business ropes and deftly charmed Jeffrey and Willie. "She was like some bizarre mutant," Brooke noted, "doing what it has to do despite all the dreadful things around it." Brooke never would trust Pamela; she found her motivations suspect, her taste questionable, and her phoniness impossible to stomach. "She behaved badly when Pamela came along," Michael remembered of that summer. And then his and Brooke's marriage exploded.

While Brooke had been in Greenwich with Michael and the boys, Jane Fonda had tamped down her fears of inadequacy and set out to follow the course of her movie star father. In 1958, she'd been accepted into the Actors Studio, and by 1959 she had begun auditioning for movies. Now Brooke was wrestling with her own ambitions, on hold since 1957. She began testing the waters that Jane had waded into, hoping that she might find a way to be a mother as well as an actress and model—the very life that Maggie had found impossible to maintain. "She wanted to be a star," Michael said. It was a desire that Brooke would find difficult to express, but it was no doubt real and nagging. Michael didn't think his wife had the stuff to make it; she was no Maggie. Besides, the boys needed their mother.

But Brooke already had bookings. One day while Michael was at work, she zipped into Manhattan, was photographed for *Vogue*, went back home, and announced that she had just had her first job as a model. "I told him that I'd just been shot for the cover of *Vogue*," she remembered, fairly astonished by her instantaneous ascent. "That made Michael furious. He did *not* want to be married to a woman who was working." The fait accompli prompted a blowout argument and an ensuing impossible standoff. "We were both too young and hot-headed," Brooke said. As the situation between Brooke and Michael became increasingly toxic, the persuasive Maggie made her opinions known. According to Brooke, Maggie found Michael "difficult" and had never approved of their marriage. "Mother insisted on us getting a divorce," Brooke said—the most awful thing in the world.

IN MID-AUGUST 1959, THE *VOGUE* cover appeared: Brooke, shot by Horst P. Horst. The girl from the *Life* cover was now styled with dazzle-red lipstick and a black-and-tan zebra-skin coat—smart, chic, and suitably marvelous. Come October, *Life* devoted a two-

page spread to Brooke, "The Latest Sullavan Style-Setter." She was admitted to the Actors Studio, where the likes of Paul Newman and Steve McQueen sat on folding chairs and listened to Lee Strasberg dispense the secrets of the Method. The Ashley-Steiner Agency picked her up for representation. On December 28, she made her stage debut at the Off-Broadway Gate Theatre in *Marching Song*, a play that Michael found "awful." (Their divorce would be finalized in 1960.)

That same night, Margaret Sullavan opened in *Sweet Love Remember'd* at the Shubert Theatre in New Haven. Ken had tried to persuade her not to take the job; he'd seen her become happier and more stable, even as Bridget was then residing at Austen Riggs and Bill at Menninger's. But Maggie had been smitten by the play, about a husband-and-wife playwright team. "I'll be miserable if I don't do this script," she said. "And it will probably kill me if I do."

The 1960s began on a Friday. New Year's Day was swirling with snow and brutally cold as Brooke made the commute from Greenwich to the Gate Theatre at Second Avenue and East 10th Street. The career she had willed into being less than six months before—at age twenty-two, a suburban mother with two children in the midst of a marital breakdown—had achieved enviable momentum. "Miss Hayward," Walter Kerr wrote in the *Herald Tribune*, "is lovely to look at, cocks her chin over her shoulder in a manner that has always done credit to her mother." Stepping off the train at Grand Central Terminal, Brooke found a pay phone and dialed Maggie and Ken at the Taft Hotel in New Haven to wish them a happy new year. Ken picked up. He told Brooke that her mother had just died.

In *Haywire*, Brooke described the terrible dome of silence that descended upon her in that moment. She could think of nothing else to do but push herself out of the phone booth and rush to the Gate before curtain time. On the downtown IRT, an indigent reveler who had probably not stopped drinking since the night before

offered his boozy greetings. "My mother died tonight," Brooke replied, watching as tears gathered in the man's eyes.

At the Gate, director Peter Kass informed Brooke that her father had called, requesting that the theater go dark for the night. Kass had agreed. Brooke was livid: it was her duty to go on. Then Pamela swept in, wearing black sable. She enclosed Brooke in a bear hug and escorted her to a waiting limousine that conveyed her uptown to Leland and Pamela's apartment in the Carlyle Hotel. Maggie's death was determined to have been caused by an overdose of barbiturates, an accidental suicide. Leland took to the phones. "Ya, ya, this is a real bitch," he told Joshua Logan, who was in Boston, directing the tryout of a play starring Jane Fonda at the Colonial Theatre. Upon hearing the news, Jane and Hank Fonda found a bar, went in, and sat there, unable to speak; it was an awful reprise of Frances's death ten years before.

On January 4, the funeral was held at Christ Church in Greenwich; Maggie's ashes were to be interred near her parents in a churchyard close to the banks of the Rappahannock in the Northern Neck of Virginia. Before flying home from Kansas for the funeral, Bill attempted to buy a suit for the occasion using Leland's credit card. Pamela blocked the purchase.

THE YEAR 1960 WOULD PROVE to be Brooke's *annus horribilis*. She left Greenwich and Michael and, after a stint in a brownstone apartment on the Upper East Side, found the ninth-floor apartment at 15 West 81st Street with its view of the Natural History Museum's Hayden Planetarium dome. "Father was furious with me for being on the West Side," she said. She set up house with Jeffrey, Willie, and the trim and energetic Scottish nanny, Miss Mac, who, Brooke noted, had a way with a lamb chop. "I was exceedingly lucky to have Miss Mac," she remembered. "I felt like she was a staple of life, like food or electricity." Brooke paid Miss

Mac about as much as she made from her acting and modeling gigs, realizing that it would be impossible to pursue any kind of career at all without her.

"She worked hard," Miss Mac remembered of her employer, who was constantly running around town auditioning and trying to scare up modeling jobs. "I wanted her to be confident that when she was gone all day her boys were in good hands and not to worry about anything. I admired her greatly, she had a lot of sorrow at that time."

On May 4 in Carson City, Nevada, Leland and Pamela went through with the marriage that Brooke had been dreading. (The couple had stayed in Las Vegas for the requisite six weeks for Leland to obtain a Nevada divorce from Slim.) Three days later, Bill married a pretty girl from Ames, Kansas, named Marilla Nelson, also a Menninger's resident. At the wedding in Topeka, Peter Fonda was captivated by Bridget. "The color of her eyes was a mysterious blue, shivering blue, silver blue," he remembered. "I loved her."

That summer, Bridget left Austen Riggs and apprenticed at the Williamstown Theatre Festival, working alongside Josie's cousin Tom Mankiewicz, a Yale undergrad who fell in love with her, and Bill Francisco, a talented young director from the Yale Drama School with whom she fell in love (and who was likely gay). At Williamstown, she had an epileptic seizure, tumbling down a flight of stairs and calling out for Maggie. She moved to New York and found a fourteenth-floor apartment at 135 East 54th Street, a handsome yellow-brick building on the northwest corner of Lexington Avenue, diagonally across from St. Peter's Church. Jane visited Bridget and was alarmed at how conventional her taste had become, as if Bridget were willing herself to be another person—Maggie or Slim, Jane thought—and leaving the spirit that everyone loved behind. Tom visited one day and found Brooke and Bridget discussing a couple of small Ludwig Bemelmans paintings in the apartment that had originally belonged to Leland and Slim. Brooke was

angling to trade—something, anything—for them. "The only way you're going to get these paintings is when I die," Bridget told her.

THAT FALL, BROOKE EARNED HER first movie role, in a skeevy noir gangster movie called *Mad Dog Coll*, based on the real-life Vincent Coll, a machine-gun-toting scourge whose murder of a five-year-old boy in 1932 had made him the most reviled person in New York. In the film, Coll, played by John Davis Chandler with demented glee, muscles in on Dutch Schultz and makes a hash of it, becoming increasingly violent and unhinged, not unlike Joe Pesci's character in *Goodfellas* thirty years later. Brooke played what Coll called the "Hard to Get Kid," a violin-playing class act named Elizabeth, who, for unknown reasons, is slumming with Coll's murderous gang. She looked as though she'd made a wrong turn on the way to finishing school but brought sass and spark to the production.

Mad Dog Coll is notable now as a minor cult movie that allows intrepid viewers to witness the beautiful young Brooke Hayward in action, along with early performances by Jerry Orbach, Gene Hackman, Telly Savalas, and the pinup-worthy Joy Harmon, later to become infamous as the bosomy "carwash girl" in *Cool Hand Luke*. "It was marvelous," Brooke said in an interview, barely disguising her scorn for her ridiculous character and the gruel-thin script. "I had to be raped and shoot a machine gun at the rapist while he's raping me. It didn't deter him." In the coming decades, Brooke would cringe whenever *Mad Dog Coll* was shown on late-night television.

On October 18, Brooke was watching one of her costars, Kay Doubleday, perform a raunchy burlesque on a downtown soundstage. Uptown, at Lexington and 54th, Bridget had taken some of the Di-Sed sleeping pills that Leland had bought her for insomnia, fell unconscious, and died, an overdose. As with Maggie, whether Bridget intended to die by her own hand has never been proven; she may have gambled with fate and lost.

Bill Francisco found her. Earlier in the day, Brooke had gone to Bridget's apartment for a breakfast date; Bridget had previously told Brooke that she was in love (with Bill?), possibly even pregnant. But Bridget hadn't answered the door. That evening, Pamela once again escorted a stunned Brooke via limousine, this time from 15 West 81st to her and Leland's fifteen-room, tenth-floor apartment at 1020 Fifth Avenue overlooking the Metropolitan Museum.

Peter Fonda recalled that Bridget had been meant to go to the theater with him that night but hadn't showed up. When he got back to his father's place at 12:30 in the morning, Hank was awake, sitting in his library, distressed. He told his son what had happened. "I heard him say, 'Poor Leland,'" Peter recalled. "I got up, looked at him with tears streaming down my face, and said, 'Poor Leland? Poor Bridget.'"

The funeral was held at St. Peter's Church, across Lexington Avenue from Bridget's apartment. Maurice Ravel's "Pavane for a Dead Princess" was played, a fitting tribute to a young woman who, as Truman Capote said, had worn her sadness like a halo. Brooke, Leland, and Bill sat together, their shoulders touching. Joshua Logan read Psalm 23, while Tom Mankiewicz kept his head low and cried. After refusing to come out of his room for days, Peter sat in the back of the church next to Slim, who had always thought Bridget was destined to grow up to be one of the era's great beauties, a swan like herself, perhaps one who would surpass her. "She was not of this earth," Slim said, "that sprite of a girl."

"It was hard to determine how my sister and I had become friends," Brooke reflected, meditating on the nature of sibling love. "Always, always bloody tides of love and hatred had pounded away at us with such relentless fury that the cutting edges of our feelings had been ground down and worn smooth by the very oceans that produced them." In the end, she understood, quite simply, "I loved her. I was heartbroken."

After the funeral, the mourners gathered at Leland and Pame-

la's apartment. Tom Mankiewicz came and stood by Brooke at a window; they could see the Metropolitan Museum of Art below and the Great Lawn of Central Park, all the way to the Museum of Natural History and Brooke's own block, where Miss Mac was keeping Jeffrey and Willie cozy and secure. In words that would achieve some level of fame, Brooke, as if thinking out loud, said to Tom, "I'm the daughter of a father who's been married five times. Mother killed herself. My sister killed herself. My brother has been in a mental institution. I'm 23 and divorced with two kids." Tom acknowledged that Brooke had the worst family history he'd ever heard of. He then suggested to Brooke that she faced a choice: open the window and jump out, or live.

Brooke was determined to live.

4

"HE SAW THESE MIRACLES
EVERYWHERE"

W hen I went under contract at Warner Bros. at 18, it afforded me the possibility of never having to stop making art," Dennis said. "I could live a cultural life." For now, he didn't need to think about flipping burgers or working construction, clocking in at a post office or municipal pool, or living up to Marjorie and Jay's hopes that he might someday become a white-collar professional. His brother thought there was no way that Dennis could ever live that way. "Dennis was a genius, you know?" David said. "He was an artist on a conceptual level. He wasn't a worker." While his Helix High friends were making their way through college or taking lunch-pail jobs, Dennis was setting out on a very different journey.

That was clear from about the first day he began work on *Rebel Without a Cause* in early 1955, cast in the minor but conspicuous role of Goon. Nicholas Ray asked Dennis to read with various actresses trying out for Judy, the female lead to be played opposite James Dean's Jim Stark. The next day, he and Bill Dyer were sitting around the apartment when the phone rang. Bill grabbed it and

told Dennis that Natalie Wood was on the line. "Who is Natalie Wood?" Bill asked. "Oh, she's a star—*Miracle on 34th Street*," Dennis said as he raced to the phone; she was one of the actresses he'd read with. When Dennis answered, Natalie asked, "Do you remember me?" He did. "I would like to have sex with you," she told him, adding "I want you to know that I don't do anything but just straight fucking."

"I was astonished," Dennis remembered. "I came from a very conventional, middle-class family . . . and this was the 1950s, when girls who'd turned sixteen only a few months earlier just didn't do things like that." He was perhaps more accustomed to the ways of Diane Phillips, whom he had dated toward the end of his time at Helix High. While he had been doing Shakespeare at the Old Globe after graduation, she had showered him with flowery missives, which he had saved: "I love you and I want you."

Dennis picked Natalie up that night, and they drove to Mulholland Drive, a prime necking spot. As Dennis remembered it, he gamely attempted to go down on her. "Oh, no, no, no you can't do that!" Natalie said. "Why not?" "Because Nick Ray just fucked me." It was an education.

Natalie officially got the part of Judy after she and Dennis survived a car wreck on a rainy night coming down the steep and snaking Laurel Canyon Boulevard. They'd been drinking, and Dennis was behind the wheel. Natalie had proven she wasn't that cute girl from a Christmas movie anymore. But the love triangle between the director and his two teenage actors—which had begun during preproduction, conducted in Bungalow 2 of the Chateau Marmont—created acute tension on the set of *Rebel Without a Cause*. While they were shooting the famous "chickie run" scene, with a pair of drag racers speeding toward a cliff, Dennis confronted the forty-three-year-old Ray about the deplorable fact that he had seduced a sixteen-year-old girl. "Someday you are going to have to start learning how to use your head and not your fist," Ray told him. Dennis

was in his first credited film role and already found himself perceived as a troublemaker on the set—difficult, a threat.

Just as worryingly, he had been watching James Dean at work, and it was causing him to come unglued. "I didn't think there was anyone to top me," he remembered of his overconfident eighteen-year-old self. "Watching Dean act was like watching someone pull miracles out of the air." Natalie, too, was freaked out by the twenty-four-year-old Dean, fearing she wasn't good enough to appear on a movie screen with him. When the chickie run scene wrapped, Dennis confronted the aloof Dean, who hadn't been giving him the time of day.

"I see an actor that's acting so far over my head I don't know where I am," Dennis recalled. "So I'm really confused." He grabbed Dean, pushed him into a car, and implored, "What the hell are you doing? I thought I was the best actor I'd ever seen until I saw your work, and here you are doing things I can't even comprehend!" At first Dean was coy: "I would read a script, you know . . ." Dennis was reading a script, too. But everything he was doing was technical and preconceived, while Dean was expressionistic, improvisational, electric. "He was doing everything differently every time," Dennis said. "He was doing things that weren't written on a page. And it was just amazing to me." In Dean's hands, the script seemed *alive*. Dennis, steeped in Shakespeare, was desperate to crack the code. "I want to know what you're doing," he begged.

"Why?" Dean responded coolly.

"'Cause I want to be a great actor."

"Why do you want to be a great actor?" It began to resemble a Socratic dialogue.

"He said he wanted to know my motivation for wanting to be an actor," Dennis recalled, "and he asked me if I had problems with my parents and if there was an anger there. And I said, 'Yeah, I hate my parents.' And he asked if that was one of the reasons I wanted to go into the theater, and I said, 'Well, yeah, I always felt I could get my

anger out there and I could express myself and communicate with the audience.' And he said, 'Well, we have similar drives. Mine come out of hate, too. That's the drive. My mother died, and I used to go out to her grave and cry and say, 'Mother, why did you leave me?' And that turned into 'I hate you,' 'I'm gonna show you,' 'I'm gonna beat somebody' . . . So that's the drive."

It was a moment that Dennis remembered vividly for the rest of his life, one that had more influence on him than the Shakespeare he'd been doing since he was thirteen years old and certainly more than anything Schwendy had laid on him at Helix High. He wanted to know if he should study with Lee Strasberg at the Actors Studio in New York, as Dean had. Dean calmed him down: Not necessary. Just be natural. "Do it, don't show it," he said. You want to smoke the cigarette? Smoke it, don't act it. "It'll be very difficult to do the simplest things at first," Dean told him, "but you must start at that simple of a reality."

It was Method Acting 101, Stanislavski via Strasberg, what Tom Wolfe would deride as the "pop-eyed gasper school of drama." Yet it was all earth shattering for Dennis, inviting a level of raw emotion and art into acting that made sense to him as a kid who, like Dean, made paintings, wrote poems, listened to jazz—wanted to be involved in every creative thing that was going around. "I really thought acting, painting, music, writing were all part of being an artist," he said. "I never saw them as separate." Just as consequentially, the two actors had now broken the ice. "We found we were so much alike," Dennis remembered, "both from farms, this early loneliness, unable to communicate at home."

"You know, we're sensitive people," Dean told Dennis as he spun a metaphor about the giant sequoia. The mighty tree, he said, was actually frail inside. Its thick bark protected it from the ravages of fire and pests. The vulnerable interior of the sequoia was not easily reachable or knowable. As actors, Dean said, their job was to pull open the bark and expose their unprotected insides to the world.

"But you must close that bark back up and protect yourself or they'll destroy you," Dean admonished. "They'll destroy you."

"IT WAS A WHOLE GROUP of us that sort of felt like the earlier group—the John Barrymores, Errol Flynns, Sinatras, Clifts—were a little *further out* than we were," Dennis said of being young in Hollywood in the 1950s. "I mean we heard of the orgies that John Garfield used to have, the Hollywood roulette. It seemed wilder. So we tried to emulate that life-style."

Dennis and Natalie, along with their friend Nick Adams, another young actor in the *Rebel Without a Cause* cast, decided to create their own Left Bank on Sunset Boulevard. Hollywood was their university, and they bonded the way undergraduates do: they watched art-house movies, traded books, stayed up all night, and talked about life and art over coffee and eggs at Googies, the playfully modernist diner designed by John Lautner, wedged up against Schwab's Pharmacy on Sunset. It was their Les Deux Magots. When they got bored with that, they headed over to Villa Capri and sipped wine under a ceiling hung with Chianti bottles. Both establishments were favorites of James Dean, and they were unabashed Dean disciples. It wasn't enough to be stars; they wanted to be *serious*. Dennis openly worried that perhaps he wasn't neurotic enough to be a true artist. "What we used to talk about was how unhappy we were," he said. "Whoever was the unhappiest, whoever came closest to suicide the night before, he was the winner." He described a kind of adolescent rationale to their decadence: "If people did drugs and alcohol and were nymphomaniacs, then that must be the way to creativity."

It was determined that they would enact an orgy. "Natalie says, 'O.K., but we have to have a champagne bath,'" Dennis recalled. "So Nick and I went and got all this champagne and we filled the bathtub full of champagne and we said, 'O.K., Natalie, we're ready

for the orgy.' Natalie takes off her clothes, sits down in the champagne, starts screaming. We take her to an emergency hospital. That was our orgy, you understand?" The alcohol in the champagne had burned her crotch. "Set her on fucking *fire*, you know. It was a very expensive burn."

Dennis and Natalie lapsed into a hard-to-define relationship. "I wasn't in *love* with Natalie, I loved her," Dennis said. "She was my best friend." Natalie, ready to bust out of the strictures of child stardom, was on an adolescent rampage to stake out her identity and independence. Like Marjorie and Jay, her Russian immigrant parents tended to keep everything clamped down. Dennis was blown away by her moxie. "It's one of the best relationships I ever had in my life," he would remember. "I mean she really had balls." She told Dennis that Zelda Fitzgerald was her inspiration. She also shared the heartbreaking secret that a Hollywood star, married and twenty years her senior, had raped her. (Natalie never publicly revealed the identity of her assailant; decades later, her sister, Lana, alleged that it was Kirk Douglas.)

Amid all of the soul baring, there were inevitable spats. "Those two fight like cats and dogs," Adams told a reporter from *Modern Screen*. "I spend all my time patching them up!" Dennis blamed himself. "We can't get along because I can't be a follower," he said in words that would come to define many of the relationships in his adult life. "I have my own thoughts and I can't agree with hers."

Yet Dennis was destined to be a Dean follower. As soon as shooting on *Rebel Without a Cause* concluded at the end of May, the two of them began work on *Giant*, an adaptation of Edna Ferber's Texas oil epic starring Elizabeth Taylor and Rock Hudson. The director was George Stevens, who had directed *A Place in the Sun*, one of the two movies Dennis said had most inspired him, the other being *Viva Zapata!* As Dennis put it, seeing Montgomery Clift and Marlon Brando back to back in those pictures when he was sixteen had "totally destroyed any concept I had of acting." Now Dean, who

was able to channel Clift and Brando simultaneously, continued to reorder Dennis's thoughts on acting, life, and art.

"He was the most talented guy I've ever seen," Dennis remembered, "and I mean in every area; Jimmy was a talented writer, a talented sculptor, a talented actor—there didn't seem to be *anything* he couldn't do." Natalie, too, had fallen in love with Dean's polyglot autodidacticism: "He can talk about carburetors in one breath, discuss William James' pragmatic philosophy in another and be off on the subject of design in two minutes." He and Dennis talked about photography. Dean told him not to crop his shots should he take up the medium, because he might become a director someday and it would be too expensive to crop motion-picture film. They sparked up joints together, doing their best to contain the skunky aroma by placing paper bags over their heads while they toked and then swishing Pine-Sol around their mouths. After Dennis shot one of his key scenes in *Giant*, playing the part of Jordan Benedict III, the tender-natured son of a powerful patriarch, Dean praised his work and Dennis cried.

While shooting on location in Marfa, Texas, Dennis watched in goggle-eyed wonder as Dean prepared for his first scene with Elizabeth Taylor: the actor walked off the set toward a perimeter of onlookers arrayed on Marfa's dry plains and, as Dennis remembered, "got halfway, took out his cock, peed, dripped it off, and zipped it up, and walked back into the scene." Dean explained to Dennis that if he could pull a stunt like that, he could do anything in front of a camera. The writer and critic Don Graham observed that "Dean came to Texas wanting to be a Texan for the duration of the film, and Hopper came wanting to be James Dean for the rest of his life."

Stevens didn't find Dennis's hero worship endearing. As Ray had done on *Rebel Without a Cause*, the director marked Dennis down as a problem case, all too willing to be a Dean manqué, a Hollywood rebel in training. Dennis found himself in the position of scapegoat,

much to his dismay. "Everything that Dean did was somehow my fault," he said. He was also distressed by the meddlesome presence of studio president Jack Warner, who would come onto the Hollywood set, on the Warner lot, poke his head into dressing rooms, and do what Dennis called "terrible black-face" routines: "Got de watermelon, got the pork chop, got de black-eyed peas!" It offended Dennis to the core and reinforced his growing antipathy toward Old Hollywood authority figures.

When Dennis's family came to visit the lot, he introduced them to Elizabeth Taylor. "You're his *real* mother!" she said to Marjorie, all charm, noting how much David looked like his big brother. David was amazed when Stevens invited him to spend an all-expenses-paid day at the newly opened Disneyland with his grandson. (Dennis and Natalie had participated in the park's official opening ceremonies in July.)

On September 30, with the filming of *Giant* behind him, Dennis was attending a play with his agent, Bob Raison, when the news broke that Dean had been killed in a head-on collision while driving his Porsche Spyder on Route 466 in San Luis Obispo County. "It was really a heavy number and screwed me up for years afterwards," Dennis said. "After Jimmy died it was as if somebody who'd been protecting me was gone—I was on my own now and had my own fights." Dennis would always point out that his relationship to Dean had been that of an apprentice to a master, with the requisite deference and distance. They had not been blood brothers. But the effect of Dean's death was no less shattering. "The whole experience broke my heart," Dennis remembered. "I used to feel so angry, so goddamned wretched and alone in a fuckin' hostile world."

After Dean died, Dennis started riding dirt bikes with Steve McQueen and racing go-carts with Paul Newman. He clung to a canvas that Dean had painted, a moody, primitive portrait of the actor Bill Gunn holding an alto sax. Dennis was then living in a tiny house in Laurel Canyon with the actor and writer John Gilmore, af-

ter he and Bill had had a falling-out. Gilmore remembered Dennis "chain-smoking reefers" and insisting that fate had decreed that he must now wear Dean's mantle. In his memoir, *Laid Bare*, Gilmore wrote that Raison was worried about his young client. "Dennis has undergone a metamorphosis," he told Gilmore. "He's lost who he was, and he's being replaced by this troubled, unbalanced person."

Rebel Without a Cause came out a month after Dean's death. "It is a violent, brutal and disturbing picture," Bosley Crowther wrote in a *New York Times* review that gave no hint that the film would ultimately be considered a defining motion picture of the 1950s, one that had marked the rise to prominence of a new bête noire for respectable America: the teenager. As Goon, Dennis was a minor player, but he infused the character with so much oddball energy— sweetness tinged with juvenile delinquent malevolence—that he stole many of the scenes in which he appeared. In a publicity still that was destined for icon status, Dennis, Natalie Wood, and James Dean are aligned in profile, a veritable triptych of teen.

LOUIS MENAND WROTE OF THE 1950s as a time "when people started talking about 'alienation' and 'conformity' and 'the youth culture'—the time of 'Howl' and 'Rebel Without a Cause' and Elvis Presley's first records." Dennis, now recognizable as Dean's sidekick from *Rebel Without a Cause*, was in the thick of it. He hung around with Elvis, who'd become friends with Nick Adams. Dennis was amazed to discover that the Hillbilly Cat from Memphis, in Hollywood to begin his dubious side career as a movie star, had no idea that fistfights in movies were faked. (Dennis also claimed to have been present at 20th Century Fox's studios in Hollywood when Elvis recorded "Love Me Tender" in August 1956.) For her part, Natalie Wood was amazed that Elvis didn't drink, smoke, or swear; it is alleged that she introduced him to cunnilingus.

Dennis consumed Allen Ginsberg's works, including "Howl."

"That just tore my head off," he said. He gobbled up most anything associated with beatnik and bohemian culture. "When he isn't working, Dennis rises about 10 o'clock, reads Nietzsche (and modern plays)" was how a press release described his daily activities. "He's intense about everything he does." To an interviewer from *Photoplay*, Dennis described his life: "I go on kicks. I'll shut myself up . . . reading or painting."

Stewart Stern, who had written the *Rebel Without a Cause* screenplay and wanted Dennis to play Dean in a biopic, said that Dennis always had his antennae up for aesthetic stimulus wherever it might be found: "He saw these miracles everywhere." Natalie's friend Jackie Eastes said that Dennis had a "wonderful little-boy quality that melted your heart." Yet he could turn sulky and abrasive, as if he had a Dodge City–sized chip on his shoulder. The novelist Gwen Davis, in her pulpy *Naked in Babylon*, transformed Dennis into a character called Linus, a young actor from Kansas who knows how to make a memorable entrance: "I crashed this party," Linus says at a gathering of Hollywood swells. "Fuck everyone." The two sides of Dennis, the angelic and the devilish, would be noted by nearly everyone who ever came into contact with him.

For now, it was a time of thumping on bongos, lazing around coffeehouses, rolling joints, reading poetry, thinking about art, listening to jazz. For Dennis, the 1950s were "a great melting pot for the races," and he got to meet some of his Black musical heroes: Count Basie, Duke Ellington, Ben Webster, and Miles Davis, who became his sparring partner in a boxing gym. Miles would taunt Dennis with profundities as they shot jabs at each other, to which Dennis would spit back, "So what? So what?" Davis used Dennis's retort as the title of one of the most revered compositions on *Kind of Blue*. Dennis would say of his aesthetic foundations, "I'm really from jazz."

Soon enough, Dennis had what he viewed as a life-changing first encounter with the Los Angeles art scene in its primordial phase, as it was being developed by outsiders and rebels three thousand miles away from the art-world cauldron of New York. He often recounted how James Dean had loved a street performer called Mr. Chang, who liked to stand on Hollywood Boulevard reciting Shakespeare in a Chinese accent while wearing a Confederate uniform. "It was fucking outrageous," Dennis said. The way he remembered it, Mr. Chang was scheduled to perform at Stone Brothers Printing, an art-press workshop run by the artists Wallace Berman and Robert Alexander that the lanky, bespectacled curator Walter Hopps hosted in a shopfront on Sawtelle Boulevard. Dennis and Dean went along to see Mr. Chang there; for Dennis, it was yet another fateful course alteration that he credited to Dean: "He was the one that got me there."

The recollection was a bit balky. Stone Brothers didn't open until 1957, after Dean had died. But Hopps remembered first meeting Dennis when he showed up at his gallery, Syndell Studio, one day in 1955—with Dean. However it went down, Dennis, who was habituated to making paintings in relative isolation, had now made contact with one of the more colorful fringes of the contemporary art world, what Hopps later called "the obstreperous, deadly serious underground of vanguard art hanging on in the middle fifties in Los Angeles."

Berman was the force behind *Semina*, a loose-leaf art journal printed at Stone Brothers and distributed via US mail. It functioned as a Beat-inflected literary grab bag that was simultaneously a miniature art exhibition on paper. Featuring the latest by Ginsberg, William S. Burroughs, and Charles Bukowski, *Semina* catalyzed LA's 1950s bohemia. Working with furniture scraps and other detritus, Berman also became the godfather of Los Angeles assemblage art. Berman, Dennis said, "filled the void for all of us.

It was more about living the life of an artist than necessarily *being* an artist." In his view, the Berman circle embraced the freedom to make it up as they went along, letting things happen. It was a lot like what he'd picked up from Dean. Berman was compact, with long hair and a hawklike profile; he was a gentle soul who possessed the prowess of a killer. Dennis loved him. Hopps said that going to see Berman at his place—10426 Crater Lane in Beverly Glen— was like going to see Paul Bowles in Tangier, an indispensable art pilgrimage. "When you couldn't get a joint anywhere else," Dennis said, "you could always go to Wallace's house and get a joint—so we hung out there." He saw Crater Lane (and Berman's later residence, in Topanga Canyon) as a meeting place for the avant-garde tribes of the 1950s: East Coast and West Coast; Southern California and Northern California; poets and painters and film experimenters, from Michael McClure to Bruce Conner. "It was sort of an underground network of people who just came through," he said. "I stayed in that group. I sort of never left."

The Berman circle also attracted a smattering of young Hollywood; in addition to Dennis, the actors Russ Tamblyn and Dean Stockwell would be inspired by Berman to pursue visual art in careers that ran parallel to their work in Hollywood. Dennis had initially run into Stockwell at Vons Café Galleria, a bohemian spot in Laurel Canyon, finding him aping Dean's hairstyle and mannerisms, even his Porsche. "God, what an asshole," Dennis thought. Naturally, they became friends. Stockwell said of Dennis, "The spirit of James Dean is in him."

Dennis drifted into and out of the scene according to the demands of his acting career. In 1957, he discovered that Hopps had begun a new venture with the artist Ed Kienholz, called the Ferus Gallery, at 736A North La Cienega Boulevard. (They cemented their partnership with a one-line contract scribbled on a container from a hot dog stand.) Ferus would become the gallery most synonymous with the art of Los Angeles, the best-known gallery west

of the Hudson River. Dennis remembered it when it was a fledgling affair, supported, barely, by Hopps's sporadic employment and by Kienholz, a Mr. Fix-It type, who did the basic grunt work.

In June, Dennis went to the opening of Berman's solo show at Ferus, which had the honor of being shut down by the LAPD vice squad after an anonymous tipper complained about the alleged pornographic nature of the work. A pair of cops showed up, couldn't find much that seemed offensive ("Where's the art?" one baffled officer allegedly asked), and were about to head out the door when Kienholz mischievously handed them an erotic drawing by Marjorie Cameron, known simply as Cameron, the surreal occultist who had appeared in Kenneth Anger's hypnagogic art film *Inauguration of the Pleasure Dome*. The drawing, which Berman had incorporated into one of his assemblages, depicted the Sun God and the Moon Goddess engaged in intercourse. Dennis recalled Kienholz asking the cops, "Oh, is this what you're looking for?" Berman was busted and convicted. Stockwell floated him $150 to pay the fine. The artist left LA and lived in San Francisco for the next four years.

AS DENNIS REMEMBERED IT, the Cameron drawing was called *Peyote Dream*. He had been developing into an enthusiastic psychonaut. "There was a period of time in the fifties," he said, "where I had an apartment and there was peyote cooking on the stove all day and night like it was a pot of coffee, and people would come by and we'd partake." He claimed to have started taking peyote when he was around eighteen and kept at it until he had a bad trip. "I saw the whole world charred and burnt and people hanging off trees," he said. He excitedly read about psychedelic fungi, encountering what was likely Robert Gordon Wasson's 1957 *Life* magazine article "Seeking the Magic Mushroom." Wasson told of his sojourn to the Mixteco mountains of Mexico, where he had participated in an ancient rite of "'holy communion' where 'divine' mushrooms were

first adored and then consumed." Dennis set out on a mushroom hunt of his own, scouring the canyons and inevitably ending up at Berman's house.

During that time of exploration and experimentation, Dennis had returned to Dodge City with his family to celebrate Lonnie and Nellie Davis's fiftieth wedding anniversary in June 1956. He was shocked to discover that some of this old Kansas friends already had children of their own: "This part of life had passed me by." David Hopper remembered that the two brothers had to return to Kansas again later that year to help with what would be the Davises' final wheat harvest. Nellie had suffered a stroke, and she and Lonnie were packing up and moving out to San Diego to be close to their daughters. They did chores together while Rosemary Clooney's "This Ole House" played incessantly on the radio, annoying and fitting: "Ain't a-gonna need this house no longer/Ain't a-gonna need this house no more."

Back in Hollywood, someone had the cute idea that Dennis and David should double-date with Natalie Wood and her little sister at the premiere of *Giant* at Grauman's Chinese Theatre on October 18. The thirteen-year-old David was put into a white tux and paraded around with the ten-year-old Lana Wood. A glad-handing interviewer pointed a microphone at the foursome, prompting the usual inane chitchat about what everybody was up to. Lana had just appeared in John Ford's *The Searchers*. When the interviewer got to Dennis's brother, he asked, "What about you, David?" The boy glanced nervously at Dennis and replied, "Well, I'm a paperboy."

"I thought it was all very phony," David said. "The people who ran the industry were absolute thugs. They were not creative people. And Dennis was a very, very sensitive, creative person who went up against this element. I think he balled all their wives. But it really didn't help him out much."

Joanne Woodward was Dennis's date when *Giant* premiered in

New York. "Dennis is a genius," she said. "I'm not sure of what, and I'm not sure if Dennis knows of what."

AFTER *GIANT,* DENNIS FOUND HIMSELF cast in cheeseball movies such as Irwin Allen's *The Story of Mankind,* in which he played Napoleon Bonaparte alongside Harpo Marx as Isaac Newton and his friend Vincent Price, whom he'd met during his time at La Jolla Playhouse, as the Devil. Warner Bros. was putting Dennis into guest-star spots on assorted television series, with the vague hope that he might then star in a spinoff as, say, Billy the Kid. It never happened. Dennis didn't want that anyway, not after starting his career with *Rebel Without a Cause* and *Giant.* He began to grouse in the press about not getting more traction. He even ambushed Jack Warner early one Monday morning at the studio lot in order to lobby for a part in *Lafayette Escadrille.* The company president was not pleased by the ill-timed display of chutzpah from one of his contract players. "I've been away for three days!" he barked. "I've been fucking in Palm Springs. What are you talking to me about, being in a movie?" Dennis didn't get the part.

Then the studio loaned Dennis out to 20th Century Fox for Henry Hathaway's *From Hell to Texas* (originally titled *The Hell-Bent Kid*), filming in the rugged Owens Valley of California. It was an opportunity to work with a veteran director. Yet Dennis had his misgivings. "The part was the weak son of the bad man," he said, "and I didn't want to do it." Hathaway, who had begun his career close to the dawn of talking pictures, was a known hothead. "He would lose his temper at the drop of a hat," said Harry Carey, Jr., who played a ranch hand in the film. Dennis and Hathaway tangled from the get-go. "I walked off the picture three times," Dennis remembered. "And then he'd take me to dinner and be real charming. The next day he'd come on the set and say, 'Forget that, it's fucking dinner talk.' On the set he was a monster, screaming and yelling."

Don Murray, in the lead role of a cowboy wrongly suspected of murder, watched as the relationship between Dennis and Hathaway unraveled, with Dennis, during one impasse, calling the martinet director "a fucking idiot" to his face.

What ensued during the making of *From Hell to Texas* would prove to be a Rubicon in Dennis's acting career. As he told it, Hathaway's insistence on insultingly microscopic direction only egged him on in his pursuit of Strasbergian greatness. It was as if James Dean's honor were at stake. The final showdown came during the shooting of a minor scene in which Dennis was to deliver a straightforward, informational line. "He insisted on doing it his way," Dennis said. "I insisted on doing it my way." The number of takes mounted as the hours went by. Around lunchtime, Jack Warner got Dennis on the phone: "What the fuck is going on? Do what fucking Hathaway says." Hathaway pointed to an imposing stack of film canisters. "I have enough film in those cans to work for a month," he snarled at Dennis. "We're just going to sit here until you do this scene exactly as I tell you." It went on all day and into the night, until Dennis finally broke down, crying. "We shot it 85 times," he remembered. "Finally, on the 86th take, I cracked and did it his way. When it was all over, he came up to me and said, 'Kid, there's one thing I can promise you: you'll never work in this town again.'"

That was how Dennis Hopper got himself blackballed from Hollywood. The story of his eighty-six-take martyrdom at the hands of Henry Hathaway is one of the central adornments of his outsider, rebel image: the impressionable Dodge City boy—under the spell of his hero, James Dean—broken on the wheel of Hollywood.

Hathaway was mystified by Dennis's characterization of what had transpired between them. "He's made a villain out of me," he protested. The director was not oblivious to the incursion of Method acting into Hollywood, but he thought that Dennis, whose work in *Giant* he'd loved, was losing himself in sense-memory rabbit holes, slowing the production to an infuriating crawl. According to Ha-

thaway, Dennis had a simple line about horses to deliver, but he insisted on having his character look around before uttering the line, a bit of business that slowed the scene. Hathaway wanted to just get on with it. After a couple of takes, certainly not eighty-six, he gave the line to another actor so the production could keep rolling.

That night, Hathaway got a call from the manager of a local motel saying he'd better come over; one of his cast members was trashing a room. Hathaway found the culprit: Dennis, drunk and maudlin. "You humiliated me," Dennis moaned. He accused the director of trying to end his career. "There's only one way for you to get blackballed in the industry," Hathaway warned him, trying to settle him down, "and that is for you to tear up a room." Hathaway then asked Diane Varsi, one of the film's costars, to soothe Dennis and get him into bed. The two had been having an on-set fling, which was complicated by the fact that she was married to the music producer Jim Dickson, who, when he visited the location shoot, found them in bed together and attacked Dennis. (Varsi and Dickson divorced after the filming was completed.)

For the rest of his life, Dennis insisted that he hadn't worked for seven or eight years after Hathaway had blackballed him, ruining his career before it got off the ground. That wasn't quite the case. There were still roles—television, intermittent films. Dennis bounced between Los Angeles and New York, where he spent time at the Actors Studio, absorbing the Method from Strasberg. He took a part in a TV production of *Swiss Family Robinson*; auditioned unsuccessfully for *Disenchanted*, a Budd Schulberg play on Broadway; checked out galleries and museums; and couch-surfed at an apartment John Gilmore had downtown, where, as Gilmore recalled, Dennis's marijuana intake continued to impress. Yet there was nothing at the level to which Dennis had been accustomed when he was Warner Bros.' hot new property, the heir apparent to Brando, Clift, and Dean. "I started out fast but didn't get the breaks I wanted," he told a reporter in 1959. "I was hurt and disillusioned."

As David Hopper put it, his brother was reduced to "working for bums—*with* bums. He couldn't get out of it." Dennis may not have been banished from the industry, but he would not appear in another major Hollywood production until 1965.

When Dennis saw the finished *From Hell to Texas*, in 1959, he had an epiphany: "I was the worst thing in the movie. I may have been doing my best work, but it was completely out of context with the rest of the film." He wrote to Marjorie and Jay plaintively from New York: "I stink." He added some advice for his little brother: "Tell David not to be an actor. It ain't worth it."

DENNIS DRIFTED FROM PART TO PART, painting his pictures, writing his poems. In 1960, he finally landed a lead in a movie—a fringy, low-budget production shot in Santa Monica and Venice, the areas he knew from hanging around the Berman and Hopps crowd. This was *Night Tide*, directed by Curtis Harrington. Dennis had met Harrington a few years earlier, when the director had shown his lyrical avant-garde movies at a Sunset Boulevard coffeehouse and Dennis had loved them. Cameron, the artist who had made *Peyote Dream*, was also in *Night Tide*, bolstering the project's connection to the LA art underground.

Unlike Hathaway, Harrington found Dennis "totally cooperative and wonderful to work with." The only hiccup occurred when Dennis drank too many martinis at lunch, hopped onto a motorcycle, got into an accident, and landed in the hospital, halting the production for two weeks. For Dennis, working on Harrington's atmospheric seaside gothic suggested that it might be possible to make movies infused with art-world spirit in the United States without huge budgets or the uptight interventions of Hollywood; no Harry Cohns or Jack Warners or Henry Hathaways throwing their Zeuslike lightning bolts around: it was a source of wonderment and relief.

Dennis played a sailor from Denver who looks as though he's hardly begun shaving. It's five years after *Medic*, and Dennis is still a pretty boy. The sailor meets a beguiling girl at a jazz club. She may or may not be a male-devouring aquatic succubus—a real mermaid, who, rather suspiciously, enjoys fresh mackerel for breakfast and lives above the Santa Monica Pier carousel in an apartment decorated with conch shells and sea fans. *Night Tide* was an unabashed B movie, a kind of gauzy *Twilight Zone* episode stretched to feature length that Harrington imbued with hypnotic style, finding poetry in its very trashiness. Dennis came to feel that it was as pioneering as anything John Cassavetes was doing.

Yet as 1960 turned into 1961, it seemed uncertain when or if *Night Tide* would ever be released. (It was eventually paired with Roger Corman's *The Raven* for distribution in 1963.) The film would never be a classic. It was barely even a cult item, despite the approval of Truman Capote and Dwight Macdonald and a review in *Time* that lauded its "uncommon glow of freshness and originality." *Night Tide* had found the winding path to cinematic purgatory, much like its intriguing star, Dennis Hopper, who went back to spinning his wheels.

His frustration would occasionally boil over, even among his dearest friends. Around this time, Dennis lost it at a birthday party that Stewart Stern was giving for Joanne Woodward. He got plastered and began loudly reciting his poetry, earning the ire of Joanne, who conked him over the head with an antique bed warmer to get him to shut up. When Paul Newman attempted to calm the situation, Dennis turned on him: "I'm a better actor than you are!" Newman, whom Dennis adored, calmly replied, "Dennis, get well soon." Harrington drove Dennis home. "He did not stop crying the entire way there," Harrington remembered.

Then one day Franchot Tone called and told Dennis to get himself to New York right away if he ever wanted to have a shot at Broadway. A role in *Mandingo* was his for the taking.

5

"HURRICANE OF FIRE"

I n the spring and summer of 1961, Brooke was still emerging from the fog of grief following Bridget's death, not to mention her mother's, topped off with a divorce. But she was ready to venture forth into the new. Her acting career was going well, and the signs were pointing to more and greater opportunities. Falling in love with Dennis was like recovering lost time—flipping the calendar back to 1956 and taking another run at adult life. After divorcing Michael, she had been seeing Jones Harris, the son of the actress Ruth Gordon and Jed Harris, the producer Maggie had been in love with before marrying Leland. Harris was not pleased to discover that Brooke had fallen for Dennis. After all, Dennis had a reputation as a Hollywood satyr, never able to settle down. To be sure, he had an untamed aura, fierce curiosity, and a flair for nonconformity—but those were all qualities that Brooke had also exhibited in her youth.

For Dennis, Brooke's patrician beauty, penchant for wisecracks, passion for art and design, and air of personal tragedy added up to something that, at last, felt like a potential life partner and soul

mate. (His relationship with Natalie Wood had burnt out pretty fast; she married Robert Wagner in 1957.) It probably wasn't lost on him either that a marriage with Brooke, a Hollywood royal, might help him regain the industry cache he'd lost. Brooke and Dennis, like so many couples, may each have seen in the other the opportunity for a valiant emotional rescue mission. Dennis, the all-American maverick, would bring inspiration, feeling, and comfort to the high-born, emotionally attenuated Brooke, while she, in turn, would help the wayward, romantic, risible Dennis channel his quicksilver ambitions while meeting his aching need for trust and understanding.

One impact that Brooke had upon Dennis was immediate. In the weeks following the close of *Mandingo*, Dennis took to the streets of Manhattan with the Nikon F camera she had given him. Setting out from 15 West 81st Street, often with Brooke, he shot summer saunterers in Central Park, workmen laying asphalt, stickball players on brownstone stoops. He took his camera to the Central Park Zoo, the Adams on the Park restaurant at 86th Street and Fifth Avenue, and the Guggenheim Museum, shooting Brooke against Frank Lloyd Wright's nautilus-shell architecture, then not quite two years old. Dennis would always remember the joy of his Nikon honeymoon with Brooke in New York, an urban photographic expedition in which he shot "people on the streets, sort of West Side Story kind of photographs, of people jumping, catching balls." Brooke would remember it, too. "He was born to have that camera somehow," she said.

In addition to his street photography, Dennis was drawn to found imagery, filling roll upon roll of Kodak Tri-X film with Aaron Siskind–esque abstractions, shooting the many-layered patterns created by peeling paint on walls or blurry reflections in the glass doorways of Manhattan. "I started being drawn to the idea of shutting off perspective and trying to shoot flat on," he recalled, "so the picture has no depth of field; it becomes like the surface of

a painting." The pictures had the unmistakable aura of abstract expressionism, as Dennis ran around town practicing what became a personal credo: "Art is everywhere, in every corner that you choose to frame and not just ignore and walk by."

In Brooke, Dennis finally had a partner to share his credo with, perhaps to share his life with. As they got to know each other, Brooke and Dennis would have discovered that they had both been oppressed by their mothers, that their fathers were remote and self-involved, and that John Swope had been weirdly instrumental in their young lives. Brooke might have described the first visit to New York City that she could remember, at Christmas 1943, care of a transcontinental journey aboard the Santa Fe Super Chief, all the way from Los Angeles. Dennis would have pointed out that the Super Chief had rumbled through Garden City, Dodge City, and Newton, where the Hoppers were then living. "I wondered where the trains went," Dennis later remembered. They went to the places Brooke knew.

THAT SUMMER, AS THE COUPLE explored New York and looked for acting work, Dennis's fondness for cannabis would have been revealed to Brooke. "He observed quickly that I was not up for that stuff," she recalled of her indifference to marijuana. But she was intrigued by another substance that promised mind expansion. "Dennis made me read Huxley's *Doors of Perception*," she remembered, "and it did sound a bit thrilling." She agreed to sample some mescaline. "It was a nightmare!" she said. "I didn't like drugs after that. I never would have done that if it wasn't for Dennis, who was very heavily attracted to whatever happened to the mind when he had drugs. I just remember that I hated it and I couldn't sleep. I was awake for twenty-four hours." It would be her one and only psychedelic experience.

Toward the end of June, the Hayward-Hopper romance went

public when Dorothy Kilgallen reported it in her syndicated gos-sip column: "Two of the leading players in the ill-fated 'Mandingo' are continuing their romance without script—Brooke Hayward and Dennis Hopper." As Michael Thomas readied to take Jeffrey and Willie with him to his family's place in Southampton for the sum-mer, Dennis and Brooke decided to head to Los Angeles. Dennis wanted to get back to his home turf, and the two of them would line up auditions. In early July they flew out.

"Dennis was living in half of a small duplex house just below the Strip," Brooke remembered, "every wall and floor, indeed every surface of which was totally submerged in drippings and swirls of variously colored paint. Imbedded in the two-to-three-inch-thick clumps were thousands of cigarette butts and empty beer cans. I was amazed and amused by the lifestyle I had never imagined ex-isted. Dennis had many fascinating and adoring friends from one world or another and, liberated from the normal, I enjoyed myself enormously."

Brooke moved into this latest of Dennis's bachelor pads, at 1435 North Havenhurst Drive, conveniently close to Schwab's and Goo-gies. David Hopper, who was getting ready to enter UCLA in the fall, remembered it: "He was *really* living like a bohemian—candles in holes in the wall, paint everywhere. It was unbelievable." David noticed a painting his brother was working on that had a pair of shoes stuck onto it, indicating Dennis's interest in assemblage and the influence of Ed Kienholz, who affixed bits of wood and other objects onto his canvases.

Brooke was thrilled by Dennis's out-there existence as she settled into a very different version of her hometown. Dennis might have taken her to Venice and Topanga, to Ferus, to Barney's Beanery; you can imagine them tooling around together on Dennis's gray Vespa scooter, his sole conveyance after he'd piled up enough infractions to result in the revocation of his driver's license. David recalled that the Vespa tended to run like magic—until it didn't. His brother had

the unfortunate habit of treating the thing like a dirt bike, joyriding on the fire roads in the Santa Monica Mountains.

Brooke's father and stepmother came to LA during the last days of July, staying in Leland's preferred suite at the Beverly Hills Hotel. "It was really quite dramatic," Brooke recalled, "because the hotel, only a few miles away down Sunset Boulevard, was light years away physically from the pleasant bohemian mess we were inhabiting." While Brooke and Dennis had been living in Dennis's paint-splattered bachelor pad, Pamela had been going to town on a major renovation of her and Leland's fifteen-room apartment at 1020 Fifth Avenue, throwing thousands of dollars at furniture upgrades and framing the Rouaults and Whistlers they'd purchased from the Knoedler Gallery. Throughout 1961, there would be no end to it: Baccarat goblets, clocks restored at La Vielle Russe, a sweep of Manhattan antiques dealers that netted everything from a scarab-shaped amethyst snuff box to curtain hardware. *Town & Country* compared Pamela's acquisitiveness to that of "a squirrel storing away nuts for a rainy day." There was also the all-important storage of her furs (four minks, one otter, and one nutria, with two more nutria liners), the regular upkeep of a brimming liquor cabinet, and the constant flow of fresh flower arrangements.

Lunch had been arranged at the Beverly Hills Hotel for Dennis's first encounter with Leland and Pamela, who was horrified when the free-spirited couple buzzed up the hotel's circular drive on a sputtering Vespa. Leland was openly displeased about the courtship, not wanting his daughter to be involved with an actor, particularly one as eccentric as Dennis. He'd even tried, unsuccessfully, to get Tom Mankiewicz to intercede. "This is going to be a disaster," Leland told him. Yet at that icy lunch, Dennis would not be cowed. He was, after all, the same young man who had told Harry Cohn to go fuck himself. He now formally stated his intention to marry Brooke, as the couple had planned. "I'm madly in love with your daughter," he told Leland. "I want your permission to marry her."

"He just put that out there, which was gallant," Brooke said. It was like a reprise of his forthright proposal the day they had met in *Mandingo* rehearsals. Leland was not charmed. "There's no way on earth I will permit my daughter to marry an actor," he said as he parried every entreaty from the determined couple. "You guys can't do this. This is a big mistake. You barely know each other. I think you've got to come back to New York!" Brooke understood that for Leland, "Dennis was worse than Michael, because he was an actor and Father did not approve of actors. Having worked with them, he didn't think they would make good husbands. You don't marry a young actor." Leland had done precisely that, and it had not worked out well. In a soul-searching 1959 letter to Richard Avedon, Leland—already past four marriages—wrote, "What do American women want? Why are they so unhappy? Where do men fail them?" Considering that rumination on the inability of men and women to ever settle into true domestic bliss, which so clearly reflected his own marital disappointments, it's not hard to imagine Leland finding his daughter's pairing with an unconventional, quasi-employed maverick unsettling.

Brooke and Dennis might not have been surprised by Leland's reaction, but they suspected Pamela of having had a say in it. She'd been trying to pair Brooke with John Frankenheimer, the television director who was getting set to make *The Manchurian Candidate* and who had directed Dennis in a 1958 episode of *Studio One in Hollywood*. The matter with Dennis Hopper was now derailing her plans. Brooke was revolted by the idea of Pamela playing matchmaker on her behalf. She was still recovering from the misfortune of having seen the redheaded Pamela unclothed the summer before at Imspond, the property Leland and Pamela were borrowing from Irene Selznick, in Westchester. "Father took us out to the swimming pool and there was Pamela standing for our benefit on the diving board—totally naked," Brooke said. "You could see her perfectly beautiful white skin and, important, her red crotch."

Pamela treated Dennis so shabbily at lunch that he came to the conclusion that she was laying the groundwork to have Brooke cut out of Leland's will. It was a grim suspicion that Brooke gradually came to accept as likely true. Whether or not it was, Dennis got the picture that Pamela would never view him—a nothing from Kansas—as an acceptable human being. "She was a class-conscious person," he said, "and I was riffraff. She never made an effort to be nice to me." Dennis and Pamela's relationship would only devolve over time. "She was one of the most despicable people I have ever met," he said. "I'm in a pretty rough business, the movie business, which doesn't breed angels, and I have never seen anything like her. She was mean-spirited." Dennis concluded that Pamela lived to play power games and had become so confident of her hold on Leland that she felt she could do whatever she pleased. At the earliest opportunity, Dennis and Brooke hopped onto the Vespa and scooted away from the miserable situation. They would get married anyway.

When, at some point, they visited Jay and Marjorie Hopper, the meeting was considerably less contentious. Yet Brooke, surely primed for antipathy thanks to Dennis, was dismayed by Marjorie. "She never could stop talking," Brooke said. "She would just talk and talk and talk." She found Jay sweet and quiet, but it was a struggle to relate to those conventional Kansans. It made her even more in love with Dennis. "I don't know how he evolved, having been their child," she marveled. "You'd *never* have known that he could come out of that family."

"IT WAS JUST 'LET'S GET on with it,'" Brooke said of their determination to marry. "I was not a particularly religious person, but Dennis wanted to be married in a church." And so they did on August 9, a Wednesday, back in New York at the hulking Christ Church, Methodist, on Park Avenue at East 60th Street.

It was one of those typically sticky August days in the city, ninety

degrees and humid. At six o'clock that morning, the ringing of the phone had shaken Brooke and Dennis awake. It was Leland. The Toscanini of the telephone implored his daughter not to get married. "There's no reason to go through with this," he said. "You are going to end up hating each other."

The Reverend John Bartle Everts officiated the sparsely attended ceremony in the arcaded side chapel of the Romanesque Byzantine church. Under the soaring ceiling, amid gold mosaics and green marble, the small group that assembled on that muggy day seemed even smaller. In the end, Leland and Pamela had deigned to come, along with Pamela's son, Winston. A smattering of friends attended, including Jane Fonda, cousins Tom and Josie Mankiewicz (whose husband, Peter Davis, was away in the army), and the screenwriter James Costigan. Jeffrey and Willie were with their father in Southampton. No Hoppers flew out from California. As Brooke readied to proceed up the aisle, Leland materialized by her side. He whispered in her ear: there was still time to back out.

Leland and Pamela bolted as soon as it was over. Dennis remembered that his new in-laws "left us outside the church, just standing there!" Josie, who had signed the marriage certificate, recalled, "The wedding bouquet I brought with me was the only single festive note. . . . No music, not another flower. NOTHING." There was an awkward moment on the sidewalk in front of the church when no one knew what to do, until Jane piped up, "Oh, why don't you come over to my place and we'll have a little something?" Her apartment was close by, so they headed that way for sandwiches and drinks. It was there that Dennis met Jane's brother, Peter, who had seen Dennis in *Giant*. The two of them hit it off. "I thought, this guy is a looney tune," Peter recalled. "But he sure is interesting."

When Brooke and Dennis got back to 15 West 81st Street, flowers, champagne, and caviar were waiting for them, compliments of Leland and Pamela. Miss Mac was there with her mother, who'd flown in from Scotland; they were preparing to head to Southamp-

ton to join Jeffrey and Willie. They'd bought roses and set out a bottle of wine for the newlyweds, along with four glasses. "We drank a toast and wished them well," Miss Mac remembered. "I don't think my mother had tasted wine before."

SOON AFTER THE WEDDING, Dennis and Brooke flew to Los Angeles to begin their life together. On the upper fringes of Bel Air, they found a modest rental house at 1590 Stone Canyon Road for $600 a month. Built in 1948, it was the last house on the right as Stone Canyon curved left and snaked up toward the reservoir. "As far as you could see were forests," Brooke said. "It was a beautiful little piece of property, and very private." The living room had high, beamed ceilings; brown carpeting ran throughout the house. There were two bedrooms upstairs, including one just big enough for bunk beds for Jeffrey and Willie. Miss Mac would be installed in the downstairs bedroom, outfitted with frilly white curtains, pink wallpaper, and a TV that Brooke situated at the foot of the bed. Behind the house, a hillside banked sharply upward, massed with scrub, wild geraniums, and fuchsia. There was an orange tree outside the kitchen window. A lemon tree grew beside the gate to the small swimming pool. That fall it was heavy with ripening fruit.

The house was a refreshing change from Brooke's Upper West Side apartment and a huge upgrade over Dennis's Havenhurst pad with its beer-can and cigarette-butt decor. It was likely the first time since leaving home, in 1954, that Dennis had had a proper house of his own. His art-world bohemian friends—Hopps, Berman, Kienholz—might have found it improbable. Here was Dennis, beatnik and mescaline gobbler, inside the preserve of Hollywood moguls and old money—old by Los Angeles standards, anyway. Bel Air had once been arid ranchland, but since the 1920s it had become an irrigated Eden of azaleas, oleanders, and Italian cypresses. Its serpentine roads were lined with faux Mediterranean

villas and country clubs. Writing about the neighborhood in *Esquire* a few years later, Candice Bergen called it the "Happy Valley of the American Dream."

It must have felt that way to Brooke and Dennis as they went about setting up house. Brooke had inherited Margaret Sullavan's Colonial American furniture. It was well made, familiar, and just about the only remaining physical connection she had to her mother. Her treasures were a trio of family artifacts: a Milton Avery painting of a reclining nude, a small bronze statue of her grandfather, Colonel Hayward, leading the Harlem Hellfighters, and the giant needlepoint zoological alphabet tapestry the colonel had made for her, Bill, and Bridget when they had been living in the barn on Evanston Street. Maggie had kept it, and, after she died, Brooke claimed it. Jeffrey and Willie would now have this heirloom from their illustrious great-grandfather, whom Brooke recalled meeting only once in her life.

Dennis's father had come home after the Second World War with a cargo of tapestries from the Far East. "He had given us these things as a wedding present," Dennis remembered, "because they were the only things of real value that he had." They went up onto the walls, alongside the Avery. Dennis also trucked in the hoard of canvases he'd been working on, as many as three hundred of them according to what sounds like a hyperbolic estimate, turning the garage into a painting studio where he might work on his heavily impastoed abstract expressionist canvases. Jeffrey and Willie were enrolled in the John Thomas Dye School, on Chalon Road, a school Brooke had briefly attended when it was called Brentwood Town and Country. It was ten minutes away via Bel Air's twisting canyon roads.

When they arrived at their new home after flying cross-country with Miss Mac, Jeffrey and Willie were excited by the novelty of bunk beds, arguing over who would get to sleep on top. A solution was alighted upon: they would alternate nightly. Miss Mac was

impressed by her quarters. Brooke told her that a milkman would come every day, a pool cleaner every third day, and a maid named Betty Jo twice a week. The nanny was amazed at the lack of humidity and mosquitoes. It was ideal, this little house up in the hills, where the lushness of Bel Air gave way to native chaparral.

Jeffrey and Willie now had the opportunity to get more comfortable with their fascinating new stepfather. "I'm a compulsive creator so I don't think of the children first," Dennis once admitted. But the boys found him enormously companionable, perhaps more like a buddy or big brother than a father figure. "Dennis would hang out with us kids," Willie remembered. "We loved Rocky and Bullwinkle and *Fractured Fairy Tales*, and he'd imitate all the voices. We thought it was the funniest thing ever."

By mid-October, Dennis had booked a guest-star role in an episode of NBC's *87th Precinct*, based on Ed McBain's novels, called "My Friend, My Enemy." But more exciting was the show of his photography that Barry Feinstein would mount at his gallery in November. It was an opportunity for Dennis to unveil the pictures he'd taken in Manhattan, the streetscapes with flat, painterly surfaces and the shots of kids playing. He showed some prints to Miss Mac, who found them delightful.

Brooke landed a part in an episode of *Bonanza*—a leap for her acting career, given the massive popularity of the show. On a sun-saturated October day while the boys were at school, Dennis took his Nikon outside when Gjon Mili came to photograph Brooke for *Life*. He was excited to meet the Albanian-born photographer, whose best-known work was a Duchampian homage from 1950 called *Nude Descending a Staircase*. In Dennis's photographs of the occasion, the portly, avuncular photographer sets up his tripod behind the house while Brooke goofs around, flexing like Charles Atlas or lying flat on the grass. Mili hands her a white spider chrysanthemum and has her put it up to her face. She looks out from behind the flower, bathed in light, an image Dennis would later

appropriate when he photographed an artist in New York. When Mili packed up his camera case to leave, Brooke kissed his cheek.

The next images on Dennis's contact sheet show a trip to Ralphs supermarket in Westwood Village, with Brooke in white sneakers holding a shopping list and gazing quizzically at the loaded shelves.

THEN THE SANTA ANAS STARTED blowing, the humidity dropped, and a drought parched the canyons. This was the time when Brooke came down with her "Transcontinental Blues"—missing New York, her old life, her family. Around Halloween, Dennis disappeared for a few days, providing no explanation and leaving not a clue as to his whereabouts. Walter Hopps claimed that he and Dennis had become "blood brothers" in late 1961: "We sliced each other's arm with a knife and exchanged blood." Perhaps that fraternal ritual was performed during Dennis's truancy, which stretched to a week as Brooke pondered leaving him and returning to New York with Jeffrey and Willie. Or maybe Dennis had fled to Tijuana, as he'd liked to do when he'd needed to escape the strictures of Marjorie and Jay's household. No one would ever know. But just as suddenly as he had vanished, he sneaked back into the house one night in early November, went to sleep next to Brooke, and, after his wife shook him out of his dreams, woke up to the Bel Air Fire.

The conflagration began as a small brush fire at 8:15 in the morning, November 6, just north of Mulholland Drive. Workmen tried to put it out, but it was already too late. As Brooke got Jeffrey and Willie into the car to drive them to the John Thomas Dye School, Dennis threw the Milton Avery painting—perhaps the only object of value they possessed—into the car. When Brooke and the boys arrived at the school, a large column of smoke could be seen rising to the north. Shortly after nine o'clock, the school's three hundred students were led outside into an adjacent field. Willie, a week away from turning four, stood there wondering what would happen next;

Jeffrey kept his eyes on the smoke column. Half an hour later, the Los Angeles Fire Department radioed the first report of a house on fire on Stradella Road, adjacent to Stone Canyon Reservoir and six-tenths of a mile from the boys' home. What fire officials called a "hurricane of fire" was now moving down the winding canyon roads south of Mulholland, incinerating everything in its accelerating path.

Brooke managed to return from the school run, and Miss Mac remembered Dennis climbing up onto the roof of the house. A neighbor's gardener told them to get out of there as fast as they could: nearby houses were already on fire. "We just started to fling everything into the car," the nanny wrote to her family after the fire. "Mrs. H. was crying and I had to keep calm." Miss Mac grabbed as many of the boys' clothes as she could, but there wasn't time to collect much of anything. "I saw thick smoke on the other side of the mountain," she wrote, "and when I looked from the window a few minutes later the dark red flames were almost at the back door and the house by this time was full of smoke, because the whole canyon was ablaze and our little house just stood in its path defenseless."

In a flurry of logistics, they decided that Miss Mac would drop Brooke off at the Beverly Hilton on Wilshire Boulevard, so she could use the phones and figure out their next moves at a safe distance from the fire. Miss Mac would retrieve the boys from school and swing back to rejoin Brooke at the hotel. Dennis would do his best to secure the house and then head down Stone Canyon on foot, meeting them at the Hotel Bel-Air, a little more than halfway down the road to Sunset Boulevard.

At the John Thomas Dye School, Jeffrey, Willie, and the other students were evacuated to a church in Westwood. The school burned to the ground. Miss Mac found Jeffrey and Willie and drove them to the Beverly Hilton, where Brooke took the wheel and sped back up toward Stone Canyon to retrieve Dennis. She made it to the Hotel Bel-Air, from which a hundred guests were being evacuated,

including Gore Vidal and Otto Preminger. Dennis was nowhere to be found. Brooke was now almost overcome with worry, thinking that her husband might be trapped in the fire. Against Miss Mac's objections and despite the police turning cars back, she managed to drive farther up Stone Canyon, straight into the heart of the fire. "The flames were on either side of the car," Miss Mac wrote, "and we couldn't see." Fire officials finally prevented Brooke from continuing any farther. "The whole street had been closed," she said. "It had totally burned down."

Their house was among the first of 484 to burn that day, a level of destruction never before experienced in Los Angeles. Burt Lancaster's house on Linda Flora Drive was incinerated, but his art collection survived; it happened to be on loan to the County Museum. In Brentwood, Richard Nixon hosed down his roof ahead of the fire; he and his wife, Pat, then set off on foot with nothing but suitcases and Checkers, their cocker spaniel. "I have seen trouble all over the world," he said, "but nothing like this." Zsa Zsa Gabor compared the experience to the bombing of Budapest during the war. Fred MacMurray brought home a team from the set of *My Three Sons* to help save his house and family. The old Fonda place on Tigertail Road burned to the foundation.

It was said that the Bel Air Fire produced the richest class of evacuees since the 1917 Bolshevik revolution. Wealthy or not, the evacuees fleeing along Bel Air's twisting lanes might be carrying an infant, a pet Chihuahua, a stamp collection, a baked ham. Dennis joined the stampede, sprinting from door to door and getting people out of their houses, along with their artworks, as he made his way down Stone Canyon. "There was a double-page picture of me in *Paris Match*—'Unidentified man, hero of Bel Air fire,'" he recalled, "with a Juan Gris in one hand and a Picasso in the other."

Dennis found one woman perched on a toilet inside her house, refusing to budge. The roof was already blazing. "You've got to

leave!" he pleaded. He managed to get her out and continued down Stone Canyon Road. He was still running when Brooke, once again near the Hotel Bel-Air, spotted him.

BROOKE CALLED HER FATHER in New York to ask his advice about what to do next. They had nowhere to go, and almost everything they owned had burned in the fire. "Goddamn it!" Leland Hayward barked as Brooke imagined him in his 655 Madison Avenue office, with his feet up on his desk. "Why only Bel Air? Why didn't the whole goddamn city burn down?"

He gave his daughter the numbers of two friends to call—David O. Selznick and 20th Century Fox cofounder William Goetz, who was on the board of Leland's Pacific Air Lines. Selznick and his wife, Jennifer Jones, had a guesthouse at their place on Tower Grove Drive, and the Goetzes had an outsize estate on Delfern Drive. But, as the fires continued to burn that afternoon, the distraught family ended up at Vincent and Mary Price's house, 580 North Beverly Glen, a place Dennis knew thanks to his La Jolla Playhouse friend Hank Milam, who lived on the property. Vincent, who took delight in anything related to the kitchen, made them soup. It was decided that Brooke and Dennis would stay with the Prices for the time being while Miss Mac and the boys would stay with the Goetzes, whose house was conveniently around the corner. And then the Selznicks would take them all in.

The day after the fire, David Hopper rode Dennis's old Vespa from his Westwood apartment over to Stone Canyon. He'd developed a habit of joyriding through Bel Air and knew his way around the twisting canyon roads. At a roadblock, he found Nick Adams, who had somehow gotten himself into a firefighter's uniform and was directing traffic. Dennis had brought Nick home to the Hoppers' for one Thanksgiving dinner. He hadn't endeared himself to

Marjorie and Jay, mashing his food together and cheerily insisting "It all goes down the same place." Recognizing David, Nick waved him through.

David ascended through a corridor of destruction—leveled houses, charred cars, swimming pools full of black water, the occasional fireplace standing amid the devastation. He eventually located his brother. "He was walking down the road, like totally blown away," he said. Dennis and Brooke's house didn't exist anymore. The antique furniture, the Chinese tapestries, Brooke's photo albums of the boys, Dennis's paintings and poems—all gone. The colonel's needlepoint tapestry was no more, and the statue of him had melted, twin losses that were heartbreaking for Brooke. Aside from the Milton Avery painting, the Nikon, the boys' coats, and whatever had been in their pockets or haphazardly thrown into the car, everything had been devoured by the fire. Or just about; as the brothers kicked around the scorched ruin, they discovered a single ceramic pot among the ashes.

The annihilation of his painting studio forced Dennis to rethink his ambition of becoming a latter-day abstract expressionist. He claimed to have lost reams of original poetry as well, later recalling one lost poem that had contained the lines "I go outside in my garden to pee/Green leaves side me that sweat and rain." If he hadn't handed off his negatives to Barry Feinstein for the gallery show scheduled for November 15, his early photography would have been lost. (The show was canceled in the fire's aftermath.) Thankfully, the Nikon had been saved, either tossed into the car or worn around Dennis's neck as he escaped on foot. For Brooke, having survived the liquidations of beloved childhood houses as her family moved from coast to coast, not to mention the still recent deaths of her mother and Bridget, the Bel Air Fire was the latest in a procession of domestic traumas.

The night after the fire, David O. Selznick and Jennifer Jones hosted a dinner party at their house on Tower Grove Drive that

had been arranged before Bel Air had become a ruin. The hosts and their guests, who included the producer Dominick Dunne and his wife, Lenny, wanted to talk about the fire, but Dennis did his best to steer the conversation toward other subjects. When yellow dessert plates were placed on the table, Brooke picked one up and studied it in silence. "My mother had plates like this," she finally said, and then broke into a sob. "They burned in the fire yesterday."

Brooke was taken out to the living room so she could lie on a couch and regain herself. "Her crying became hysterical," Dunne remembered, "but the dinner party conversation in the loggia went on." Jennifer comforted Brooke while David O. phoned Leland in New York, begging him to fly out to Los Angeles for Brooke's sake. Leland refused. Shortly thereafter, David O. crumpled to the floor, suffering an apparent heart attack, while the guests looked on. Rex Kennamer, the doctor who had been summoned to see Brooke, examined the stricken sixty-two-year-old producer and reassured the party that it was merely a case of indigestion.

IN TIME, BROOKE AND DENNIS would declare themselves glad to have been forced by terrible circumstances to begin anew. "It was a major tragedy," Dennis said of the Bel Air Fire, "and at the same time if it hadn't happened, we couldn't have cleaned out our lives." Brooke agreed. "It's very important to be able to start over again," she said. "Not everyone knows that." Willie's memories of the fire would remain vague, Jeffrey's vivid. "The past," Jeffrey recalled, "was completely wiped out." (Incredibly, not one soul perished in the Bel Air Fire.)

The homeless family found temporary shelter in three households that were among the most exalted in Los Angeles. Each of them had some influence upon the way Brooke and Dennis eventually created a household of their own. Inspired by the Prices, Goetzes,

and Selznicks, not to mention the postfire insurance adjusters who recommended that they invest in paintings, sculptures, and antique objects, the rebuilding of their lives would be centered around visual art, the thing that had first bonded them.

As Brooke remembered it, the odd situation of having their family split between two houses, the Goetzes' and the Prices', was brief—a week at most. (In one of her letters, Miss Mac implied that it had been just one night.) Dennis and Brooke might not have known Bill and Edie Goetz well, but they would have been aware of the couple's reputation as the highest-ranking hosts in Hollywood. Billy Wilder, who won five Oscars with *The Apartment* that year, said, "The Goetzes had the best food, the best people and the best things on the wall!" Their Georgian Revival manse at 300 Delfern Drive had been designed in 1938 by Gordon B. Kaufmann, the architect of the Hoover Dam. At seventeen thousand square feet, the house had an imposing, quasi-institutional heft. Miss Mac was impressed by the hugeness of it, along with the luxurious cream satin draperies that enveloped the family in comfort and safety.

When the Hayward-Hoppers arrived at the house that day, they would have found themselves under the basilisk gaze of a Vincent van Gogh self-portrait of disputed authenticity called *Study by Candlelight*, which hung above a fireplace. The Goetzes went all in on Impressionists and Postimpressionists, amassing upward of sixty-five works by Cézanne, Gauguin, Degas, Manet, Monet, Matisse, and the like, and displaying them around their house in museum-like profusion. (The couple held fast to their taste for sure bets, declining to get into the market for contemporary art.) The collection must have left Dennis and Brooke agog, as it surely had Leland and Pamela when they had stayed with the Goetzes for a few days the previous June.

Bill Goetz was the opposite of a cartoony, tyrannical Hollywood mogul. The fifty-eight-year-old executive had had a hand

in making a hundred movies, had discovered Natalie Wood, and was the consummate industry operator. He was decidedly unpompous, and his sense of humor ran in the direction of cornball. "I'm going to Madrid to see that naked broad," he might say, referring to Goya's *Naked Maja* in the Prado. Edie once remarked, "On our first date, I laughed more than I'd laughed in my entire life." With her flame-red hair and high-wattage smile, she was the queen of Hollywood society. "Whatever Edie wants, Edie Goetz" was the well-traveled joke. She and her sister, Irene, David O. Selznick's first wife, were the notoriously feuding daughters of MGM founder Louis B. Mayer, who actually was a cartoony Hollywood tyrant. (He'd had his share of history with Brooke's parents. Maggie Sullavan rattled him: "She was the only player who outbullied Mayer," said one MGM executive.)

Unlike the Goetzes, with their appetite for full-on Hollywood opulence, Vincent and Mary Price brought a goodly dose of idiosyncrasy to their connoisseurship. Vincent professed to like cozy and small, but their Spanish Revival house on Beverly Glen Boulevard was elaborate and gargantuan. Ninety-two steps swept up to the front door. The living room was forty-five feet long. The property had its own paddle-tennis court, swimming pool, parakeet aviary, pigeon dovecote, pottery kiln, and guesthouse, where Hank Milam lived with his wife, Marin. The Prices had done a lot of the work themselves—painting, making their own tiles, installing this or that. As Harry Mullen, the billiards whiz who was the Prices' resident steward and handyman, put it, "It was like we were building the City of Light in Cordoba." Brooke thought it was the most beautiful Spanish-style house she'd ever seen.

Vincent was from St. Louis, a heartlander like Dennis. In the fall of 1961, the fifty-year-old actor was enjoying the success of his latest Poe-inspired movie, *The Pit and the Pendulum*, directed by Roger Corman and shot by Floyd Crosby. He was not only Hollywood's creepiest actor but a symbol—perhaps even a parody—of

the cultivated midcentury male, given to global travel, the joys of flaming German pancakes, and suits cut as sharply as his pencil mustache. He was a Yale man, imposingly tall, and his passion for good things was driven by genuine curiosity and a desire to share. That extended to his and Mary's art collection. In 1957 it had been the seed of the Vincent Price Art Museum in Monterey Park, making Vincent the most visible collector in Hollywood, lauded by the *Los Angeles Times* for his "enthusiasm plus discrimination."

When Dennis first visited the Price house in the 1950s, he encountered the abstract expressionist William Brice firing swimming pool tiles in the Prices' kiln. It was also the first time Dennis had seen contemporary abstract painting in the flesh. "It just tore me apart," he remembered of his first glimpses of works by Richard Diebenkorn, Jackson Pollock, and Franz Kline. "I didn't know anyone that was collecting abstract painting in Los Angeles before Vincent," he said. The Prices enjoyed having Dennis around. "He was intense in his determination to discover everything," Vincent said. He and Mary often invited Dennis over when they were hosting an artist, such as the Mexican muralist Rufino Tamayo. "It was fun having him there," Vincent said, "because he represented a new generation." He viewed Dennis as something of a protégé. "At one point," Dennis remembered, "Vincent gave me a painting—of a head I think, I'm not sure by whom—and said he thought I would eventually become a collector." Vincent also predicted that the young actor would someday play villains. "That's bullshit," Dennis replied. "I'm a leading man, are you kidding me?"

Dennis must have been excited to have Brooke in that space, perhaps the one that had most inspired him toward art when he had been a teenager in Hollywood. Brooke understood. The Price house, she later recalled, was "very inspirational to Dennis." It was surely inspirational to her, too, as she studied the superabundance of art and objects that the Prices had marshaled together. They not only collected contemporary art but placed their bold acquisitions

amid a riotous array of antiques and folk art. In the cavernous living room, you might find an Indonesian Batak figure, a Congolese Babembe statue, and a rainbow assortment of ceramic Mexican fruits on an ancient table beneath a six-foot-high ocher-and-black Diebenkorn from the artist's *Albuquerque* series. A massive gold-leaf cross—Mexican, from the seventeenth century—hung near the Spanish chest that Mary had bought with money she'd earned from working on *The Sweet Smell of Success*. Throughout the house, there were drawings by Modigliani and Rembrandt and paintings by Clyfford Still, along with Navajo rugs and other New World artifacts, such as a giant stone Huastec figure that was perhaps a thousand years old.

The Prices' friends—a mix of Hollywood types, bohemians, artists, and writers—generally seemed to love it, but not all visitors did. "We opened our house one time to a charity," Vincent recalled. "Some woman came up to my wife and said, 'Now look at that great big abstract picture. It's hideous. You know, what a big mess of colors. Has it got a title?'" She was talking about Diebenkorn's *Albuquerque*. Mary responded, "Yes, it's called We Like It."

In the 1950s, Dennis had been welcome to ply his craft as a would-be abstract expressionist at the Price house, occasionally putting his canvases out to dry on the driveway, where Harry once accidentally ran over them. The photographer William Claxton, a friend of Dennis's, remembered Vincent's indulgent attitude toward Dennis's painterly efforts. He and Vincent were meeting about a book project at the house one day when Harry informed them that Dennis had unexpectedly arrived at the front door. "Oh, Lord, Dennis again," Vincent said, according to Claxton. "He most likely wants me to critique one of his paintings. His work is dreadful, but do you mind? It will only take a few minutes." Dennis hauled in a stack of canvases, requiring of Vincent a bit of diplomacy. "Well, Dennis, you do show progress," he told his friend. "Try working a little more on your colors and a bit more on your overall composition . . .

shall we have some coffee?" After the Bel Air Fire, Dennis would continue picture making, but he reassessed his approach. "The fire didn't stop what I was thinking," he said. "It just destroyed a lot of my work."

For now, the Prices, Milams, and Hoppers hunkered down on Beverly Glen. Vincent kept their spirits up with his rococo approach to hospitality, which tended toward after-dinner brandy and impromptu performances—his own—of German *Lieder*. It was perhaps during that postfire interlude, Brooke remembered, that she shared some important news with her husband.

"I discovered I was pregnant," she said, "which made Dennis deliriously happy."

WILLIE, WHO TURNED FOUR THAT NOVEMBER, remembered 1400 Tower Grove Drive as "something out of a Raymond Chandler novel—this huge old mansion house. You could see all the way to the water from up there." That was where the evacuee family landed next, reunited and welcomed by the man who had created the hugest inferno in movie history—the burning of Atlanta in *Gone with the Wind*. David O. Selznick and Jennifer Jones's house was an imposing pile that John Gilbert, the silent-screen star, had had built in 1925—a Spanish Mission hideaway with brooding timber-beamed interiors. Gilbert described 1400 Tower Grove as "one of those places where you can see everything and there isn't a sound to disturb." He rivaled Rudolph Valentino as a screen heartthrob and had the habit of continually redecorating according to the taste of his latest lover, including, most famously, Greta Garbo. (He died of a heart attack in the house at the age of thirty-eight.)

In 1949, Selznick had offered Brooke's father the first crack at buying his prior residence on Summit Drive when he put it on the market in order to buy the Tower Grove house. The asking price was $80,000. Leland declined. "I haven't got any money," he said.

In the 1920s, during their lean years as would-be players struggling to make it in Hollywood, Leland and David O. had gotten to know each other as neighbors in the Mayfair Apartments on North Wilcox Avenue. Whenever money got particularly tight, they availed themselves of free breakfasts by drinking from the bottles the milkman had left for their unsuspecting neighbors in the building. David O. still peppered Leland with pitches, trying always to light a spark under the next potential project, usually involving Jennifer. He pitched a remake of *Casablanca*, which would star Jennifer and Spencer Tracy. In the summer of 1961, he floated the idea of a musical version of *Rebecca*, the movie he'd made with Laurence Olivier and Joan Fontaine in 1940. Neither of those would-be projects was ever made.

When David O. and Jennifer moved into 1400 Tower Grove with Jennifer's two sons, Robert Jr. (known as Bobby) and Michael Walker, from her marriage to the actor Robert Walker, they hired Tony Duquette to redo the place. A projection room was installed behind a wall of bookshelves so they could screen movies in the living room. A vast porch was glassed in, and it became the spot for lunches and dinner parties. The Walker boys, looked after by Brooke and her siblings' former nanny, Emily Buck, discovered a secret passage in their room that Garbo was conjectured to have used for her comings and goings with Gilbert.

The on-site gardener from Gilbert's day, John Bruin, lived in a green wooden trailer across the street and Garbo still popped around to pay him a visit every now and then. Miss Mac found John delightful, and Brooke was impressed when he invited the nanny to socialize with him in the trailer, pointing out the rarity of the honor: "You and Greta Garbo, Miss Mac, are welcome in John's caravan," she said. John spun tales of Gilbert going on benders and having breakdowns, appearing naked in the windows of 1400 Tower Grove and screaming "Hollywood, you have crucified me!" at vast, aloof Los Angeles, twinkling below in mute, indifferent darkness.

The house's nooks and crannies breathed Hollywood Gothic. Dennis sponged up the atmosphere and regarded his hosts, Hollywood icons both, with awe. "I looked at them as monoliths," he recalled. For him, living there was practically overpowering. "I kept thinking 'You're going to remember this, because this is a really exceptional moment,'" he said.

"As a child of Mother and Father, I was able to get along with people like David O.," Brooke remembered. "We were treated like old members of the family and remained for six or seven weeks." The guesthouse accommodated all five of them. The Walker boys were grown and gone, but David O. and Jennifer's seven-year-old daughter, Mary Jennifer, was a ready playmate for Jeffrey and Willie. "David and Jennifer became like our parents," Dennis said. Sheltering with the Selznicks meant that Dennis and Brooke were swept into the older couple's formidable social whirl, where they would remain in the coming years, like honorary offspring.

"All the dinner parties!" Brooke said. "We were always the youngest people there." Sunday gatherings at the house started with tennis or swimming in the afternoon and rolled along until dinner. David O. and Jennifer liked mixing Old Hollywood fixtures such as Cary Grant and Gary Cooper with the cool kids—say, Natalie Wood and Warren Beatty. Of the latter set, Dennis and Brooke— given their intimate relationship with the Selznicks—were the king and queen of the prom. John Swope and his wife, Dorothy McGuire, were often at Tower Grove, and that fall Swope wrote to Leland, "We have seen Brooke several times of late and she is without doubt one of the most beautiful, attractive, charming and intelligent young ladies I have ever met. We are both crazy about her . . . it is hard to believe she is YOUR daughter." (He tactfully omitted mention of Dennis.)

"Unlike most of the great houses of the period, which adhered to the caste system," Dominick Dunne remembered, "the Selznick house welcomed newcomers, played charades, mixed groups, had

fun." Selznick's biographer David Thomson compared the parties to the producer's best films: "grand, extravagant, exuberant, sentimental." He and Jennifer, whether they knew it or not, were continuing a tradition that Gilbert had started in the 1920s, when the likes of Charlie Chaplin, Anita Loos, and David Ogden Stewart had converged on the house every Sunday.

Selznick dinners, which were frequent, were black tie, with as many as forty guests. The enormous porch was arrayed with four-top tables. Brooke remembered that each one came equipped with its own twin-barreled wine dispenser, one half filled with red and the other half with white. Waiters kept them topped up with the best possible vintages. "We were just guzzling it," Brooke said. "Everybody was so erudite, and so witty, and so funny," Bobby Walker said. "And they were all drinking like fishes, just entertaining themselves and each other in such extravagant fashion."

David O. was always the host. That was perhaps because Jennifer, as Brooke put it, "was nowhere to be seen until we would be practically halfway through dinner. She was always coming in at least an hour and a half after everybody had seated and we were eating. She would sit at one table in one kind of evening dress, and then she would get up and leave and put on another and come back, three or four times, always in three or four different outfits." Jennifer's well-used dressing room was lined in nineteenth-century boiserie; outside her bedroom was a waterfall she could turn on and off with a switch. She spent her days doing yoga, having massages, and getting her hair done. Brooke could barely remember Jennifer ever leaving the compound, and she never appeared before six in the evening.

Dennis was starstruck. The woman who had won an Oscar at age twenty-five for *The Song of Bernadette* was one of his favorite actresses; he had loved her in *Duel in the Sun* (written by David O.) and *Beat the Devil* and found it difficult at first to relax around her. He discovered that Jennifer had been born Phylis Isley in Tulsa and

thus was a fellow escapee from the plains who, like Dennis, often felt like an outsider in Hollywood. But her charm and sweetness put others at ease. "She was totally supportive," Danny Selznick, David O.'s son, said. "If you wanted to smoke three packs of cigarettes a day, it was all right with her." Dennis required a long leash, so that was ideal.

Dennis found David O. to be surprisingly sympathetic, unlike the other Old Hollywood lions he'd tangled with. There was none of the Henry Hathaway temper, the Harry Cohn bullying, the Jack Warner crassness, or the Leland Hayward disdain. That was new to Dennis, who always seemed to find a way to alienate Hollywood's powers that be. "The older generation in the industry," Brooke said, "all thought he was a piece of shit." But here was the greatest producer of them all taking a genuine shine to him. "He *loved* Dennis," Brooke remembered.

In David O., Dennis discovered an improbable mentor who would dispense advice and listen to ideas. David O. had an openness to daydreams and visions; he had shaped the careers of Ingrid Bergman and Vivien Leigh, and he injected showmanship and artistry into everything he did. He had predicted that Brooke would be a Hollywood star back in 1954, and he now bestowed his attention and imagination upon Dennis. "He knew that Dennis was talented," Brooke said. "He figured it out." Dennis worried that he was being a "royal pain in the ass," but David O. gladly met with him every day. When Dennis said he wanted to direct movies someday, David O. presented him with yellow legal pads, counseling that they should be used to catch inspiration as well as to communicate with his Hollywood peers. "I want you to always write notes down," he instructed Dennis. "Write notes and send them to everybody—it's very important!" David O. would occasionally conclude their meetings with an encouraging sign-off: "Keep truckin' it, Dennis!"

IT WAS SUCH A CONTRAST to Dennis's typical relations with the movie business establishment. "He'd go to these parties where you'd have the crème de la crème of Hollywood," Brooke said, "and he'd tell them that when he ran things heads were going to roll, they'd be in chains. Someday he'd make a movie and the old dinosaurs would be slain."

Dennis now understood that Selznick, of all people, was experiencing his own career frustrations, an identification that made him love the old man even more. It had been two decades since *Gone with the Wind*, and David O. didn't have the power or magic he'd once had. He was hyperconscious of his rise and fall. "Hollywood's like Egypt," David O. told a friend. "Full of crumbling pyramids." In 1957, he had produced a remake of *A Farewell to Arms*, another vehicle for Jennifer, and it had bombed. Since then, there had been little action, and so he, like Dennis, was in Hollywood limbo. "It was a really strange time in his life," Dennis recalled, "because he was getting turned down by everybody."

Despite the convivial atmosphere at 1400 Tower Grove, David O. had much to worry about. While Dennis and Brooke were living in the guesthouse, David O. was watching his bank account drain away. He considered selling the massive house and moving east. His relationship with Jennifer wasn't always as bubbly as it appeared, either. He had Pygmalioned her to stardom, and her general mania about her appearance was no doubt driven in part by Selznick's dreams of perfection. Dennis thought that the ethereally delightful Jennifer could never live up to her husband's expectations. "He was a brilliant, unbelievably terrific guy," Bobby Walker said of his stepfather, "but the biggest micromanager in history." David O. had shaped his mother into a Hollywood queen, yet Bobby thought his overweening care might ultimately have stunted her career.

Jennifer occasionally threatened suicide. There had been rumors

of violence earlier in the marriage; in 1947, she had showed up on the set of *The Paradine Case* with a black eye. Two years later, on the set of Michael Powell and Emeric Pressburger's *Gone to Earth* in Shropshire, England, she had denounced "Mr. Fucking Selznick" for wrecking her marriage to Robert Walker—who would die of an overdose in 1951—and controlling her career. In those days, David O. was said to play around, which amped up her feelings of insecurity. What Dennis and Brooke saw at Tower Grove was a loving, laughter-filled marriage; any distress was hidden behind Jennifer's incessant costume changes and yoga lessons.

Jennifer had recently completed filming *Tender Is the Night*, from the F. Scott Fitzgerald novel. She starred as Nicole Diver, with Jason Robards as her husband, Dick; the screenplay was written by Ivan Moffat, who had cowritten *Giant*. (Jane Fonda had tried out for a part in *Tender Is the Night* but hadn't been cast.) David O. had instigated the project, but he had grown to have misgivings about the production. Like Dennis, he bemoaned the fact that commercialism trumped creativity in Hollywood. The film was panned when it came out in January 1962.

Nicole and Dick Diver were based, in part, on the 1920s American expats Gerald and Sara Murphy, friends of Scott and Zelda Fitzgerald. They were a golden couple who were friends with seemingly everybody: Pablo Picasso, Ernest Hemingway, Igor Stravinsky, Cole Porter. Archibald MacLeish said of the Murphys that "person after person—English, French, American, everybody—met them and came away saying that these people really are masters in the art of living." Gerald's dabblings in visual art had gone way beyond dilettantism; he had managed to create a handful of museum-worthy works that turned out to be decades ahead of their time. At 1400 Tower Grove Drive, a nexus of creativity, glamour, and high-end sociability, one could discern a Hollywood echo of the Murphys' storied Villa America at Cap

d'Antibes. Yet the lessons in living imparted by the Murphys, who were soon to be the subject of a celebrated *New Yorker* profile by Calvin Tomkins called "Living Well Is the Best Revenge," would come to be best embodied not by David O. Selznick and Jennifer Jones but by their young houseguests Brooke and Dennis.

6

"WHAT IN THE HELL? WHERE ARE WE GONNA PUT IT?"

As Christmas 1961 approached, Dennis appeared on a short-lived CBS drama series, *The Investigators*, and Brooke on another short-lived drama series, *Target: The Corruptors!*, on ABC. In January, Brooke's high-profile guest-star role on *Bonanza* aired. The episode was called "The Storm," and Brooke played a beautiful but sickly young woman, the love object of Michael Landon's Little Joe Cartwright. In the kind of period garb she had worn in *Mandingo*, Brooke radiated freshness, fragility, and doom.

Continuing a blitz of prime time that month, Brooke and Dennis were seen together on an episode of the CBS anthology series *General Electric Theater*, hosted by Ronald Reagan, called "The Hold-Out." Echoing their real selves, Brooke and Dennis played a pair of twentysomething lovebirds plotting their marriage in the face of resistance by the girl's wise-owl father, portrayed by Groucho Marx. The episode opens with the couple coming down the steps of a courthouse. You assume that they've just signed a marriage license. The camera zooms in, and they stop. They're all-American attractive and can't keep their hands off each other.

SHE: How do you feel?
HE: [*Laughs.*] You want the truth?
SHE: Uh-huh.
HE: I'm scared. How 'bout you?
SHE: [*Plants a kiss on him.*]

"The Hold-Out" aired between *The Ed Sullivan Show* and *The Jack Benny Program* on Sunday, January 14, 1962, and was destined to be one of the rare occasions when Brooke and Dennis appeared together onscreen. It's unknown whether they tuned in with Jeffrey and Willie to watch the episode, but if they had, they would have done so in their new house, a 1920s-era rental at 7959 Hollywood Boulevard, near the bottom of Laurel Canyon, where they had moved the Saturday after Thanksgiving from Tower Grove. "It was just an ugly little house that was furnished," Brooke recalled. In a bit of serendipity for Dennis, a photographer had once lived there—the wonderful and semiforgotten Viroque Baker, who, in the 1920s, had photographed the flowering of Los Angeles architecture. The Metropolitan Opera soprano Marie Rappold later lived in the house.

In early February, Dennis sent off some of the photographs he had taken in New York the previous summer to be included in the *Photovision '62* exhibition scheduled for May at the Museum of Modern Art Australia in Melbourne. Again, Miss Mac was impressed by the pictures and wrote home about them: "They are all very good and I hope he gets some notice." Dennis's work would achieve Commended status at the show.

That month, rainstorms began buffeting Los Angeles and did not let up for nearly two weeks. Three months after the Bel Air Fire, another disaster was now unfolding, as mud slid down the hills above Hollywood Boulevard, flowed into Brooke and Dennis's backyard, and oozed through the French doors. But they were spared the worst. The mudslides caused damage exceeding $4 mil-

lion around LA; in a few horrific instances, the muck smothered children as they lay asleep in their beds.

WHILE DENNIS AND BROOKE'S FACES were beaming from television sets, they were also frequently seen along North La Cienega Boulevard, the city's gallery row. Brooke recalled the two of them going to "every single opening of every single show," as they went into aesthetic overdrive. They had become regulars at the Monday-night "art walk" on North La Cienega, a weekly event that Brooke called a "wonderful party." The art walk had a gala atmosphere, with promenading art lovers crowding the sidewalk, roving from gallery to gallery, leaving handwritten messages for one another by affixing them to a sculpture of a female nude in front of one of the galleries, an impromptu bulletin board. The mixture of art, commerce, and social visibility anticipated the eventual rise of such fairs as Art Basel. And there were plenty of galleries to visit on La Cienega, perhaps even, as the *Los Angeles Times* claimed with boosterish pride, the "world's largest concentration of art galleries on one street."

The art walks were said to have been started by two gallerists, Esther Robles and Bertha Lewinson, in 1958. The Esther Robles Gallery, established in 1947, was one of the pioneer La Cienega galleries, if not the first. The Bertha Lewinson Gallery was fronted by a jaunty painted-steel sign that resembled an Alexander Calder mobile. Irving Blum, the charming, well-dressed director of the Ferus Gallery, who in 1958 had bought Ed Kienholz out of his share for $500, brought in the deep-pocketed art patron Sadye Moss, moved the operation across the street to a more polished space at 723 North La Cienega, and was invariably compared to Cary Grant for his plummy voice and overall suavity, recalled helping to establish the art walk. The idea, he said, was to make gallery hopping easier in the nonpedestrian town. In Los Angeles, unlike in New York, you

couldn't easily stroll out of your office at lunchtime and find yourself face-to-face with, say, a René Magritte or a Jasper Johns. But you could enjoy balmy, festivity-friendly evening air all year round.

The art walk began, in short order, to resemble Mardi Gras. "After I can't tell you how many years," Blum said, "it was a nightmare. A nightmare! Thousands and thousands of people. The galleries gave out wine, one thing or another, but you couldn't *talk* to anybody; you were too busy hoping the paintings weren't going to be damaged! It became intolerable. People would come in with slices of pizza, you know? It was like a circus." (Brooke rolled her eyes at Blum's recollection. "He loved it! He absolutely adored it.")

The galleries would eventually put an end to it. But in the early 1960s it was a full-on party. In terms of weight class, La Cienega was fairly bantam compared to New York's Madison Avenue or 57th Street. But Brooke and Dennis were ignited by LA's underdog spirit, as exemplified not only by the galleries but by the local artists, many of whom Dennis had known since the 1950s. "Most of these guys in L.A. were not being funded by anybody: they were just out on their own," Dennis observed, comparing West Coast to East. "It wasn't about whether it was going to sell or not, it was about making it." There was less money but more soul. Brooke, having grown up in households with Mondrians, Soutines, and Mirós, shared the feeling that Los Angeles was doing something fresh and new. As the decade progressed, she was convinced that it "was more of an art world than any other place in the country at that time." The emerging California painters, sculptors, and assemblers—who would include Ed Kienholz, Wallace Berman, Billy Al Bengston, Robert Irwin, Ed Moses, John Altoon, Craig Kauffman, Jay De-Feo, Judy Chicago, Ed Ruscha, Larry Bell, Joe Goode, Kenneth Price, George Herms, Ed Bereal, and Ron Miyashiro—seemed to revel in working at the continent's edge, far from the art-market hothouse of New York.

The art happenings around town weren't confined to La Cienega.

One Sunday in March, Dennis went to a vacant lot behind the Everett Ellin Gallery on the Sunset Strip to witness Niki de Saint Phalle performing one of her *Action de Tir* pieces, the first one in the United States, in which she blasted away with a .22-caliber rifle at mounted packets of paint to create *Tir Tableau Sunset Strip*, a kind of a jerry-rigged assemblage mural. The event was part of a show of work by Saint Phalle and her partner, Jean Tinguely, the so-called "Bonnie and Clyde of the art world." Tinguely and Kienholz also took part in the performance, Dennis's old friend Bill Claxton showed up with his camera (Dennis apparently forgot to bring his), and Walter Hopps ended up acquiring portions of the resulting piece, including a paint-spattered vacuum cleaner. Saint Phalle, with her regal bearing and sylphlike figure, made an impression on a Hollywood crowd immersed in image consciousness. Dennis loved watching the paint exploding everywhere and found the French American artist to be "very, very sexy in her white pants" as she leveled the .22 and brought new forms into being in front of his eyes, an explosive parody of abstract expressionist machismo. (He would later photograph Saint Phalle in action as she created a mural in Venice Beach.) That evening, over at the Dwan Gallery in Westwood Village, near the Ralphs where Dennis and Brooke had done their grocery shopping in the Stone Canyon days, a Robert Rauschenberg show opened. There's no record of whether or not Brooke and Dennis attended, but there's a better than good chance that they did: an art-saturated Sunday in Los Angeles.

The following night was art-walk Monday, and Brooke and Dennis were back on North La Cienega. At the Ferus Gallery, an impromptu sign reading ROXYS hung out front. The gallery's generous picture window, ideal for showing off the wares within, was draped with curtains, giving the place a seedy, red-light district feel. Dennis and Brooke squeezed their way into the gallery, past the income tax preparer's office next door, and landed in the midst of Kienholz's *Roxys*, an infernal tableau evoking a 1940s bordello. A

film crew working on a David Wolper–produced television documentary called *Story of an Artist—Edward Kienholz* had staked out the gallery, and Dennis and Brooke had likely been prepped for what would be their second, and last, prime-time appearance together after *General Electric Theater*. Amid the swirl of a typically clamorous Ferus opening, with a jostling crowd that included the twenty-two-year-old Larry Bell puffing on a cigar a couple of weeks ahead of his first Ferus show, the camera located the couple, standing with Blum and Hopps.

"Is that *John Doe*?" Dennis, in gee-whiz mode, asked Blum, referring to a standing six-foot-tall figure consisting of one and a half conjoined mannequins with a blue pedal car mounted at chest level, a representative of a Kienholzian species that might be called *Auto sapiens*. Blum delightedly projected his voice for the TV crew, pointing out that Dennis and Brooke were, in fact, examining a work called *Boy, Son of John Doe*. *John Doe*, he indicated, was the piece made up of the upper half of a mannequin mounted on a baby stroller sitting nearby. Brooke, in midpregnancy, smiled and laughed and chatted, looking beatific in a floral dress. She and Dennis moved around the party, studying the other denizens of Kienholz's brothel, including *Five Dollar Billy*, a female mannequin mounted on a sewing table whose foot pedal could be used to create movements that were as macabre as they were obscene.

Assemblage—whose lineage includes Rauschenberg's "combines," Cornell's boxes, Duchamp's readymades, and the oddments of the Dada movement—is effectively created with whatever is within reach. Kienholz was a master at buzzing around to the various junk shops and scrapyards of Los Angeles, finding cast-off whatever, and driving tough but good-natured deals with the proprietors. "That's one of the reasons I like Los Angeles," he said, "because Los Angeles throws away an incredible amount of value every day. I mean, it's just discarded, shitcanned." He gathered up doll heads, mannequins, stroller parts, sewing tables, broken furniture—the

forsaken detritus of consumerism—and tossed them in the back of an ancient pickup truck, headed back to his house and studio on Nash Drive in Laurel Canyon, and banged together pieces that had a confrontational, almost adolescent ugliness. They were as creepy as they were impossible to take your eyes off of. When the *Roxys* tableau was later shown in New York at the Iolas Gallery, Marcel Duchamp had a look. "Marvelously vulgar artist. Marvelously vulgar. I love the work by that vulgar Californian," he reported to Walter Hopps, who relayed that stunning bit of praise to Kienholz. "Well, that's nice," Kienholz responded. "I like his work too."

Like Dennis, Kienholz came from a rural, wheat-growing environment. He was an eastern Washington farm boy. He seemed most comfortable in a white T-shirt and khakis, and his aura—goateed, pulling on a cigarette—signaled "Don't mess with me." "He was great," Billy Al Bengston, his fellow Ferus artist, said. "You played ball with him, he'd shove the bat up your ass." The Kienholz vibe was something like Ed "Big Daddy" Roth meets Paul Bunyan, and, in fact, the author William Hackman came up with one of the best lines about him when he wrote, "You half expected a giant blue ox to be trailing behind him." The estimable critic and historian of West Coast art Peter Plagens wrote of Kienholz, "His almost naïve moralism, his patchwork, untheoretical method, and the outright, complex junkiness of his 'look' are anathema to a New York mainstream." They were also anathema to Henry J. Seldis, the hidebound art critic of the *Los Angeles Times*, who, unlike Duchamp, found assemblage revolting and pronounced Kienholz's contributions to have "no aesthetic value whatsoever."

Dennis photographed Kienholz at what looks like the Hollywood Boulevard house, his face in an elfin grin and his eyebrows swooping upward like wings. He tagged along with Kienholz on his junk hauls, snapping on-the-fly portraits of the artist in his Angeleno element. Blum began using Dennis's photographs for Ferus's advertising and announcements, as Dennis took to documenting

the artistic ferment around the gallery with his Nikon. "He was very close to the gallery," Blum remembered, "tried bringing people"—meaning Hollywood people—"by from time to time. Didn't work very well." Brooke and Dennis's movie industry friends just weren't into it. Blum had attempted to engage Vincent Price to invest in the gallery or to collect, but Price, Hollywood's self-styled champion of contemporary art, wasn't interested. He'd already formed his tastes around Diebenkorn and the American vanguard of the 1940s and '50s. Hopps wrote that it was Dennis who "was the first person in the film industry to get involved with the new abstract art." He was impressed that Dennis tooled around Los Angeles with a THE ONLY ISM FOR ME IS ABSTRACT EXPRESSIONISM bumper sticker on his car. "Sometimes there was an almost manic enthusiasm when he started talking to you about art," Hopps remembered.

That enthusiasm extended to the artists themselves. Dennis wanted to be among them, watch them work, photograph them, be their peer. "Dennis was a pushy bitch," Billy Al Bengston said of his friend's excitement. "He imposed himself upon me." Bengston, the King Cool of the Ferus crowd, lived in Venice Beach, surfed, raced dirt bikes, and wore flashy clothes plucked from the racks of thrift stores—an archly masculine Angeleno pose toying with every expectation of what a "serious" artist should be, an attitude that was contagious at the gallery. (The 1964 Ferus group show *Studs* said it all.) When he and Dennis met in the late 1950s, in the earlier days of Ferus, they bonded over the fact that they were both from Dodge City. "I knew him from the movies," Bengston recalled, "and he comes to a party, comes up and tells me, 'I'm from Dodge City, Kansas!' I said, 'I know. I used to swim in your mother's pool. But I never saw *you* there!' He told me, 'I didn't swim!'"

HAVING LOST ALMOST EVERY ONE of his own artworks in the Bel Air Fire with the exception of one blobby, almost cloacal canvas

encrusted with black, brown, and orange paint that looked like a relief map of existential dread (he had given it to Jay Hopper as a present), Dennis tried to continue working in a studio he'd set up in the Hollywood & Western Building, also known as the Central Casting Building. One day Hopps swung by to see what Dennis was up to. Hopps had decided to take a curator job at the Pasadena Art Museum and was handing over his share in Ferus to Blum. There had been growing tension between the two partners. As Dennis saw it, Hopps was the intellectual oak from which the various branches of Los Angeles art had grown. "There's no tree without Walter," he said. Blum, on the other hand, was the front-of-house man, the salesman, the savvy operator who made Ferus functional: finding collectors and sharpening the roster to showcase the best LA artists with select notables from New York. Yet Hopps didn't always think Blum was so great to the artists, a feeling that some of the artists themselves shared; there would be sniping forever after. Ferus was a fractious, male-dominated clubhouse. Bengston described it as a "macho intellectual gang bang."

As Dennis and Hopps were chatting, Dennis announced, "That's it. I'm finished. I can't paint anymore. That's the last painting I'm doing. I'm going to make machine art now." Hopps pointed to whatever Dennis was messing around with and asked if he could have it, since his friend wouldn't be needing it anymore. "Sure, take it out of here," Dennis told him. "I said that I was finished with painting and wanted to start assembling objects using blown-up photographs," he remembered.

"We have the great IBM machines and, you know, we have science that is orbiting satellites around the world," Dennis explained. "Painting has always thought of itself as being one step ahead of science, or at least aesthetically ahead, but now we are heading into a period where science is taking such a great leap forward that painting has sort of become frivolous." He acknowledged that there was a fear that machines would end up running things instead of

human beings, but he didn't see it that way. "A man, when he orbits a satellite, he is the one who is pushing the button, he is the one who builds the rocket, he is the one who puts the thing into orbit," he said, "in the same way that the artist will learn how to use the machine to do what he wants, because he is an artist." For Dennis, those technological tools—photocopiers, cameras—were modern versions of the paintbrush.

He was becoming obsessed with the idea of a "return to reality"— art grounded in the now, depicting everyday American life in the jet age. Abstract expressionism, with its brushy and brooding explorations of the self, was done, but it wasn't clear what, exactly, would replace it. It was an issue that he brooded over in his attempts to find a visual language for himself and in conversations with Brooke, as the two of them considered the right moment to begin collecting art. They had lately been intrigued by a resurgence of figurative painting in San Francisco.

Then one day, Dennis ducked into Ferus to see what was doing. He found Blum at his Formica-topped desk in the gallery office. There was a Jasper Johns light-bulb piece back there; Dennis found the figurative approach to a common, banal object fascinating. Blum told Dennis that if he liked the Johns he should take a peek at a couple of transparencies he'd been mulling over. He handed the viewer to Dennis. One transparency showed a comic-book painting by Roy Lichtenstein, the other a Campbell's soup can painting by Andy Warhol.

"That's it!" Dennis shouted, practically jumping out of his skin. "That's the return to reality!" As he would later remember that moment, "I went totally nuts." Here, finally, was something entirely new: Pop Art.

Blum remembered that Dennis "took the viewer. He looked, looked, looked, looked, looked, put the viewer down, said, 'I've got to run.' He ran out to his car, was gone. Several days later came again."

"Irving, come with me," he said.

"Where are we going?" Blum asked.

Dennis told him to just hop into his car. He drove Blum across town to the Foster & Kleiser billboard works on Washington Boulevard at Vermont Avenue. Foster & Kleiser created outdoor advertising for everything from Coca-Cola to the latest Chevrolets. "He had ordered two or three billboards," Blum said, not recalling precisely what they had depicted. "They were folded so they were easy enough to deal with. He put them in the back of his car, he dropped me off back at the gallery, he went on home." Dennis became obsessed with those colorful, supersized Pop Art readymades, turned out in a factory by unsung commercial artists using projections, electric pencils, and huge amounts of paint, not to mention expertise; the Foster & Kleiser artisans sometimes employed similar techniques to the ones Michelangelo had used in the Sistine Chapel. The American roadside was their gallery, their museum.

"I thought, *Whoa*," Blum said. "He somehow—before there *was* a sensibility—he caught that part, that sensibility. He had it. I was astonished. And it helped me understand what I was doing."

DENNIS TOOK A GORGEOUS SHADOWY portrait of Brooke sitting on concrete steps at what appears to be the Hollywood Boulevard house with an antique doll's head perched on one knee. Brooke recalled that Dennis, as he pivoted toward assemblage and made the junk rounds with Kienholz, got into collecting assorted heads, including those used for training surgeons. He liked to deposit them in the bathtub, creating an impromptu, macabre tableau intended to shock. "Thirty heads, in the bathtub, piled up," Brooke said. "He would take people in there, and they would go, '*Aaagh!*' And he would be thrilled." Dennis also collected glass eyes, mounting them on wires affixed to blocks of wood. He gave one of those pieces to a couple who had moved from New York in May and settled into a

house not far away on North Crescent Heights Boulevard, Bob and Toby Rafelson.

The Rafelsons were an ebullient, attractive couple working in the movie business, with a son and a second child on the way. "They were fabulous," Brooke said. Toby had studied at Bennington and, like Brooke, had a literary bent. She was interested in the design aspects of moviemaking, while Bob was a screenwriter and story man who had come out of Dartmouth, a soon-to-be producer and director. Brooke and Dennis hit it off with them immediately. As an outsider to Los Angeles, Toby found in Brooke someone to relate to and admire. "We sparked together," she said. Her new friend's style and outlook made her stand out from the local crowd. "Brooke was never going to go the usual way that people would want to go in Hollywood," Toby said. "She'd been there, done that. She'd gone to college, she was educated, she had taste." Better yet, "Brooke had such original and off-the-wall ideas."

Brooke, often with Toby riding shotgun, began driving around town in search of treasures gathering dust in such antique shops and junk lots as Scavenger's Paradise in North Hollywood, and Don Badertscher, across the street from the Ferus Gallery on North La Cienega. "People in Los Angeles didn't want antiques," Brooke recalled. "They wanted *copies* of antiques. Because that way, they wouldn't be dirty and misused by other people. Nobody wanted anything that had ever belonged to anybody else." She encountered languishing stained-glass windows, Tiffany lamps, Victorian this, Art Nouveau that, none of it particularly fashionable but all of it wonderful. She dipped her toe into that deep well of aesthetic possibilities, but the fact that she and Dennis occupied a furnished rental was constraining. The house was temporary; a permanent one needed to be found. But with a baby due to arrive at the end of June, it wasn't the time for a move.

One day at the Hollywood Boulevard house, as Jeffrey recalled, a compelling figure came into his and Willie's lives. "We were inside

and we heard a police siren getting closer and closer and a rumbling sound," he remembered. "We went outside to see what the commotion was. The siren got closer and closer and there was a police car right in front of our house, with a Lotus race car right in front of it. It was Uncle Bill, who got pulled over. And that became our *idée fixe*: this outlaw character that we loved to the end, Uncle Bill."

Brooke's wayward brother, ostensibly pulled over for some infraction such as driving with a broken muffler or speeding, had divorced Marilla and moved to town. He would spend the next few years going from address to address, usually in North Hollywood, getting work at a car dealership, and occasionally providing Leland Hayward with a credit card debt headache. The boys worshipped him. It didn't hurt that Uncle Bill had bought himself a boat and sometimes took them out on the water. Bill's outlandish spirit appealed to Dennis, and Miss Mac found him devilishly handsome. Brooke shook her head. "He was always extremely unstable," she said.

ON JUNE 4, FERUS OPENED a Bruce Conner show, the first at the gallery for the protean Bay Area sculptor, collagist, assembler, and filmmaker. Dennis called it "a revelation to me on a number of levels." Like Dennis, Conner—a tall, thin, slightly gawky polymath given to round spectacles and tomfoolery—was from Kansas, having grown up in Wichita with the poet Michael McClure, who was something of a kid brother to the Beats. Conner's nylon-and-black-wax collages made a major impression on Dennis, coming after the Kienholz show. They were even darker and creepier. ("I would hate to be his wife" was a phrase overheard at one of Conner's openings.) For Dennis, Conner's movies, including one called simply *A Movie*, were an even bigger revelation: jittery, scrambled, erotic, playful, eyeball searing, as if the editing machines had become sentient and were now running the show. Yet those bite-sized movies somehow

seemed more human and handmade than any Dennis had ever seen. As Curtis Harrington had done with *Night Tide*, Conner showed how to make the medium of film do things the studios would never allow. Inevitably, a friendship began.

One morning three weeks later, Brooke went into labor. She tried rousing Dennis as her water broke, gave up, and called a taxi, which took her to St. John's Hospital in Santa Monica, where their daughter was born on June 26. They named her Marin, after Marin Milam, the journalist wife of Hank. Stewart Stern visited the hospital and photographed the tousled Dennis, and Toby, six months pregnant, showed up to wish parents and baby well. Brooke remembered having the feeling that life with Dennis—who was delirious with joy—was finally snapping into place after the trauma of the Bel Air Fire.

While Brooke was laid up in the hospital, Dennis burst in one afternoon, excited to tell her about a painting he'd just committed to buy from Blum: a twenty-by-sixteen-inch canvas by Andy Warhol, the New York painter whose work Blum had shown him in the Ferus Gallery office, along with Lichtenstein's. It depicted a can of Campbell's tomato soup.

SHE: What in the hell? Where are we gonna put it?
HE: We're gonna put it in the living room!
SHE: No, no, it's going in the *kitchen*!

For all intents and purposes, it was the first Warhol soup can painting ever sold. Blum, Dennis explained, was going to show the strange picture—and others like it—at Ferus in July.

Earlier in the year, Blum had been to New York, making the gallery and artist-studio rounds. Ivan Karp, the associate director of the Leo Castelli Gallery, had showed him Roy Lichtenstein's comics-inspired work. Blum was agog. They had made an arrangement for Lichtenstein to show his paintings at Ferus. In exhilaration, Blum

had then run uptown to see if Warhol, whom he recalled doing similar work, had anything interesting happening at his house and studio on Lexington Avenue, near the corner of East 89th Street. When Blum stepped into Warhol's town house, he noticed three paintings leaning against a wall, nearly identical: Campbell's soup cans. Blum asked why the artist had bothered to make three of these paintings. Warhol replied, "I'm going to do thirty-two."

"You're kidding—thirty-two? Why?"

"There are thirty-two varieties," Warhol said.

He had set out to tackle the thirty-two varieties of Campbell's condensed soup available in 1962, from Bean with Bacon to Vegetarian Vegetable. Watching Warhol work while pop songs and arias blared simultaneously from a record player and radio, Blum invited him to show the entire set at Ferus—Warhol's first solo exhibition as a fine artist. Warhol hesitated. LA was terra incognita. Blum took note of a photo of Marilyn Monroe—a soon-to-be Warhol subject—that the artist had clipped from a magazine. "I thought he was a tiny bit movie struck," he recalled. "So I said, 'Andy, movie stars come into the gallery.' And he said, 'Wow! Let's do it!' The truth was that movie stars never came into the gallery. Except Dennis Hopper"—accompanied by his wife, Brooke Hayward.

The thirty-three-year-old Pittsburgh-born commercial artist had been trying to get traction with a high-end New York gallery for years, to no avail. The fine-arts world viewed him as a preposterous character better suited to producing colorful drawings, as he did, for *Glamour.* Warhol had just ended his long-running, lucrative association with the shoe company I. Miller, for which he'd created award-winning, nubbly lined illustrations. Billy Al Bengston, who showed in New York in addition to Ferus, had befriended Warhol in the 1950s and remembered him always hanging around the margins. "He was a creepy son of a bitch," he said. "I liked him." One of Warhol's heroes, Truman Capote, was less generous, labeling him a "hopeless born loser."

Warhol knew that Lichtenstein had beaten him to the punch with comic-book paintings. "He did it so much better," he admitted. Then the interior designer Muriel Latow came up with a new idea for Warhol, charging him fifty dollars for it: make paintings of money. She tossed in a second idea for free: paint Campbell's soup cans. The suggestion came at just the right moment. When Blum invited Warhol to take a chance on his little gallery in Los Angeles, the Pop Art Express was about to leave the station. Lichtenstein, James Rosenquist, and Claes Oldenburg were already on board, taking on subjects from commercial culture: Dennis's return to reality.

On July 9, less than two weeks after Marin was born and four days after her own twenty-fifth birthday, Brooke attended the opening of Warhol's thirty-two Campbell's soup can paintings show at Ferus, a typically raucous occasion. It was a balmy Monday night, the same week the United States conducted a high-altitude nuclear test over the Pacific Ocean. It would prove to be an indelible chapter in the cosmology of postwar American art—a big-bang moment for Pop Art. It was also a big-bang moment for the artist himself, the night Warhol became Warhol.

Dennis and Brooke found their tomato soup can painting arranged on a gallery wall among the other varieties, hung single file on narrow ledges that, to some, evoked supermarket shelves. Hanging them that way had also been a hell of a lot easier than getting out a bubble level and evenly hanging thirty-two identically sized pictures. Blum priced the paintings at $100 each; Warhol would get $50. The artist didn't go to the opening, but a number of emerging LA artists did. Ed Ruscha found the exhibition "shocking." The stark red-white-and-gold design, which Campbell's had introduced in 1898, inspired by Cornell University's football uniforms, seemed to glow—blank, goofy, sinister—on the gallery walls. "They were meant to be bad and they were meant to be badass," he said. "They were *jarring*." He was desperate to buy one but couldn't afford the

$50 in-house discount price. Larry Bell was lit up. "It was fantastic," he said. "How did he do something as silly as this and do it so beautifully? It couldn't have been further from anything I was interested in doing, but it was a great challenge to emotionally adjust to this thing." Blum recalled Billy Al Bengston announcing that he'd already "done soup cans" in art school and stalking out of the gallery. Bengston said that there was no way that had happened. But he hadn't thought much of the pictures: "just boring."

The thirty-two paintings arrayed on the gallery's stark white walls looked to be machine made, yet no two—*Scotch Broth*, *Pepper Pot*, *Green Pea*, *Black Bean*—were exactly alike. Warhol's fastidious craft—the clever use of projections, hand-applied casein paint, a stamp cut from a gum eraser for the cans' gold fleur-de-lis pattern—had created something that looked eerily like mechanical production but not quite. Warhol liked to deploy the catchy sound bite "I want to be a machine." If this was an artist's exercise in being a machine, it was one in which the artist's hand had made the machine human. Dennis had vowed to make "machine art." Now here he was on a Monday night, with a newborn at home, staring at it.

The press, predictably, went nuts. The *Los Angeles Times* ran a cartoon with one Beatnik art lover saying to another, "Frankly, the Cream of Asparagus does nothing for me, but the terrifying intensity of the Chicken Noodle gives me a real Zen feeling." It did make for easy parody. The Primus-Stuart Gallery, up the street from Ferus, stacked actual Campbell's soup cans in its window, topped with Turkey Vegetable and affixed with a sign: DO NOT BE MISLED. GET THE ORIGINAL. OUR LOW PRICE—TWO FOR 33 CENTS.

The young Australian critic Robert Hughes pondered the stance of the Pop artist. "His tribute to the blank uniformity of mass culture," he wrote, "is a cool, detached reflection of it." It's a spot-on appraisal of the sphinxlike Warholian gaze. But Hughes didn't mean it kindly. He saw the Pop pose as a dereliction of the artist's contrarian duty. That night at Ferus, as Dennis and Brooke circulated

among the paintings and their friends, the eternal oscillation of Warhol's work was set into motion: Is it a celebration of consumerism and its shallow shadow world of manufactured appearances? Or a damning critique? Warhol seemed to want it both ways—and got it, blithely tossing that dichotomy into the art-history recycling bin like an empty can of Minestrone. And if he was trying to say that art itself was becoming a commodity, he nailed it. When a friend asked Warhol why he had chosen to paint soup cans, the artist supposedly said, "I wanted to paint nothing. I was looking for something that was the essence of nothing, and that was it."

Walter Hopps was as fascinated by the paintings as Dennis and Brooke were. He asked Warhol about them. "He gave me a funny smile," Hopps recalled, "and he said, 'I think they're portraits, don't you?'" It was a sly conflation of humans and the products they consumed. And Warhol certainly consumed the stuff. "The same lunch every day, for 20 years," he said. Dennis and Brooke had cans of it stacked in their own pantry. Who didn't?

THE SHOW CLOSED ON AUGUST 4, the day before Marilyn Monroe died of an overdose. Five of the soup can paintings had found buyers. Aside from Dennis and Brooke, they were formidable Angeleno collectors: Donald Factor, Edwin Janss, Jr., Betty Asher, Robert Rowan. But despite Blum's unwavering excitement, there were no further sales. He then got the notion to keep the thirty-two paintings together as a set, securing Warhol's blessing. Blum, known for his charm, needed to pour it on in order to persuade his buyers to back off—particularly Factor, who also claimed to have put dibs on *Tomato*. (He would always remain sore about the canceled sale.) Blum prevailed, which didn't surprise Brooke. "He could sell the birds out of the trees," she said.

Blum sent Warhol ten monthly installments of $100 for the paintings—$1,000 total, $31.25 a painting. A story that Hopps

floated, about the paintings being walled in at Ferus to prevent their premature sale, was, Blum insisted, "a total fabrication." Instead, they went straight onto the wall of Blum's dining room, "a constant source of stimulation and pure pleasure," he told Warhol. Dennis and Brooke were frequent guests at Blum's apartment on Fountain Avenue, and Dennis snapped photographs of him standing in front of the impressive grid. By keeping them together, Warhol and Blum had pulled off a kind of collaboration via checkbook: the thirty-two cans could now be considered a single work, the first example of the seriality and repetition that became Warhol's calling card. Blum didn't know it then, but in 1962—an *annus mirabilis* for both Ferus and Pop Art—he had the prophetic last laugh about the soup can paintings when he told the *Los Angeles Times*, "Of their importance in the history of art—we shall have to wait and see." (In 1996, he arranged a combined gift and sale of the thirty-two "Ferus type" Campbell's soup cans to the Museum of Modern Art for $15 million, $468,750 a can.)

Dennis and Brooke did get their tomato soup can painting in the end, but not from Blum. Some weeks later, a one-off version of one of the "Ferus type" soup can paintings showed up at the Dwan Gallery. Dennis was visiting there one day, chatting with the young dealer John Weber; to his surprise, the painting was hanging above Weber's desk. Dennis inquired about the picture, and Weber gladly sold it to him for $75—25 percent off the Ferus asking price.

And thus, as Brooke remembered, "Dennis purchased our first painting—with my money, of course."

THAT SUMMER, JEFFREY AND WILLIE made their annual departure from Los Angeles to join their father in Long Island at the Thomas family's Southampton summerhouse. Dennis and Brooke likely flew back east with them, as Marjorie Hopper recalled borrowing Marin for a brief stretch when she was about six weeks old.

She and Jay were rapturous. "I wanted to keep her," Marjorie said. "She was an awful cute little girl." The Hoppers found their grand-daughter to be "an outstanding baby." (Some months later, Brooke and Dennis dutifully took Marin down to the Lemon Grove Methodist Church for her christening, with Hank and Marin Milam as godparents and various of Dennis's relatives attending.)

It was perhaps during their brief stay in New York that Dennis and Brooke met up with Leland and Pamela for dinner at the old Theater District steak house Frankie & Johnnie's. The occasion proved to be even less of an exercise in comity than the disastrous Beverly Hills Hotel lunch had been. Pamela explained that it was too high risk to take the uncouth Dennis to a civilized restaurant, such as the Colony, the preferred dining room of Upper East Side swans and swells. Dennis had bought a new Brooks Brothers suit in order to preempt Pamela and Leland's skepticism about his fitness as a husband and human being. But Pamela took the opportunity to muse aloud about what might have happened had they walked into the Colony with Dennis, who, despite the new suit, was wearing what she deemed to be a subpar raincoat. "She really insulted me," Dennis remembered. At some point before the check came, Pamela advised Leland to arrange to leave his collection of paintings to a museum, thereby signaling to Brooke and Dennis that they should not assume that Leland would include them in his will. Brooke's father remained passive throughout. "It was her show," Brooke said. They couldn't wait to get out of there.

Autumn brought the Cuban Missile Crisis and with it nearly two weeks of uncertainty and terror in October. "The world has been frightened as it had never been frightened before," Richard Rovere wrote in *The New Yorker*. Angelenos were told that their city was likely not a target for Soviet missiles but that fallout from a nuclear strike, if it came, could put LA on lockdown for weeks. Panic buying ensued at the supermarkets, and Brooke procured so much food that Miss Mac thought the haul could sustain an army. With

the top headline of the *Los Angeles Times* reading "Fateful Hour Near" and the superpower standoff in Cuba looking increasingly perilous, Dennis lost his temper and lashed out over some of the pantry items Brooke had bought: "Who would want *little sweet onions in sauce* during an emergency?" Miss Mac smiled to herself, but she felt sympathy for Brooke, who was doing her best and seldom asked for any personal help. ("I could have made her a cup of tea," Miss Mac remembered, "but she always said, 'Oh, no thanks, Miss Mac.'") Dennis talked about packing up and moving the family to New Zealand or Australia, somewhere safe. He settled for filling their gas tanks in case a nearer escape would prove necessary. Miss Mac didn't see any point in panicking. After all, she thought, if Armageddon came, "it would be the end *whether the gas tanks are filled or not.*" The crisis passed.

A FEW WEEKS BEFORE THE WORLD teetered on the brink, the major exhibition that Walter Hopps had been working on in his new capacity as a curator at the Pasadena Art Museum opened. It was titled *The New Paintings of Common Objects*, and it was the first museum show devoted to the new art that represented Dennis's "return to reality." This art, sometimes described as Neo-Dada, had a frank approach to commercial objects that recalled Gerald Murphy's paintings from the 1920s. Here, barely three months after the Warhol show at Ferus, was another big bang for Pop Art. (The term had been coined by the British critic Lawrence Alloway.)

Hopps put together a slate of eight American artists from both coasts who exemplified this new sensibility. Out of the East, there were Lichtenstein, Warhol, and Jim Dine; from the West, there were Phillip Hefferton, Robert Dowd, Wayne Thiebaud, Joe Goode, and Ed Ruscha, who, at twenty-four, was the youngest of the bunch. With five of the artists having settled in California, *The New Paintings of Common Objects* heralded the unique position of Los Angeles

in the emergence of Pop. The connection was obvious to Dennis. "L.A. was Pop," he said. "I mean, L.A. was the billboards. L.A. was the automobile culture. L.A. was the movie stars and L.A. was the whole idea of what 'Pop' was about—commercial art. It was really Los Angeles much more than New York!" Los Angeles was so Pop, in fact, that it was almost tautological. "The question for Southern California," Peter Plagens noted, "is not so much whether the area was/is ripe for Pop, but whether the whole ambience is . . . not pre-emptively Pop in itself."

Seeing this bold new work in the halls of a museum had a wake-up-call effect upon the art world. "The vulgarity of the image itself is shocking in the way the howl of the Beat poets is," the British artist and critic John Coplans wrote of a Lichtenstein piece depicting a can of hair spray in the artist's comic-book style, all primary colors and Ben Day dots. His assessment applied across the board.

When Brooke and Dennis took in the show, Dennis was bowled over by the work of Ruscha, an artist who, it turned out, had grown up in Oklahoma City—yet another heartlander. He and Brooke had likely seen Ruscha at Ferus openings; he had glinting blue eyes and a movie idol's jawline, along with a laconic, wry manner. But the Pasadena show was their first exposure to Ruscha's work, including *Actual Size*, a split canvas showing the familiar yellow lettering from a Spam can in a field of blue on the top half, with a can of Spam, painted to match the dimensions of an actual can, in the bottom half—"Flying through the air," as Dennis put it, "like a rocket." The presentation of a word in painterly space, as if it were an object, was startling, and the connection to the soup can paintings was clear enough. If anything, Ruscha was plumbing tackier depths of the supermarket than Warhol had dared to venture. He made his very first sale at the *New Paintings of Common Objects* show when the family who had built the Space Needle in Seattle bought *Box Smashed Flat*, a painting that depicted a Sun-Maid raisins package, for $50.

The duality of *Actual Size*, teasing at the rich yet fraught connections between representation and actuality in its sardonic way, turned out to echo what Dennis had become preoccupied with in creating his own machine art. Over at his Hollywood & Western studio, Dennis found an outlet in combining his photographs, blown up, with actual objects, often the ones photographed. He was fascinated, he said, by the idea of "affixing the object itself to a record of the object." His *Chiaroscuro*, for instance, was a meditative photograph of three small wooden ovoids, accompanied by the items themselves. There was a pragmatic impulse behind those photo assemblages: Dennis wanted to show his photographs in art galleries. "The photographers were only showing in little photographic salons," he said. "They hadn't really broken the ice with the painters." The strategy worked. In December, in a satisfying homecoming, Dennis managed to get one of his pieces (the precise one remains a mystery) into the La Jolla Art Center Annual; the hard-to-please Henry J. Seldis of the *Los Angeles Times* pronounced Dennis's contribution to be a "tour de force."

If Irving Blum ever considered adding Dennis to the Ferus Gallery roster, the consideration was brief. "He understood that I wasn't that enthusiastic about what it was that he was up to," Blum recalled. "I thought he was a great actor, great photographer. *Enough*, you know? Enough for one guy." Instead, the La Cienega gallery that had poked fun at Ferus for displaying Warhol's soup can paintings—formerly Primus-Stuart, now rebranded as David Stuart—agreed to show Dennis's photo assemblages.

The opening, in January 1963, brought out Brooke and Dennis's friends from both the art world and Hollywood. Paul Newman and Joanne Woodward took a spin around the gallery, with Dennis guiding them; Bill Claxton brought his camera, taking pictures of the bubbly scene. (He also shot Brooke and Dennis setting up the installation together.) There was a Pop Art undercurrent flowing through Dennis's assemblages, as he combined cast-off objects

from the commercial world, snippets of language, and touches of nostalgia. That was no surprise, given the influence of the artists Dennis was personally closest to: Kienholz, Berman, Conner. In fact, Conner would remark on the similarities in his and Dennis's work and later came up with an amusing conceptual idea called *The Dennis Hopper One-Man Show*, which was to be made up of works not created by Dennis.

Chiaroscuro was included in the show. Another piece, *Jarred Connection*, was constructed of electrical wires and a glass jar connected to a photograph of a graffiti heart and another one of Richard Sinatra (the son of Frank Sinatra's second cousin Ray) altered in a grisly fashion. The most compelling of the works was *Wilhold Up the Mirror*, a large-scale photograph of a ceramic phrenology bust used as a promotional tchotchke for Schering Pharmaceutical's antipsychotic tranquilizer Trilafon, which Dennis paired with the head itself, housed in what looked like a clock case. (The title blended a line from *Hamlet* with the name of a brand of craft glue.) The viewer's gaze was drawn to the enigmatic inscriptions on either side of the bust: "full-range tranquilizer" and "outmoding older concepts."

Walter Hopps was certain that the pieces were "extraordinary and ahead of their time." Dennis found validation in the fact that the French artist Martial Raysse was having a show at the Dwan Gallery that month, in which he, too, mixed photographic imagery with solid objects. "We were doing pretty much the same thing," Dennis said. "He was doing it his way, a very French way, and I was doing it in more of an American way." But Seldis had changed his tune about Dennis, writing that the actor's art reflected "a pretentious, and at times offensive, philosophizing." Dennis had matriculated into the club of artists lambasted by the critic of the *Los Angeles Times*, whom they nicknamed "Henry Seldom" as he was, in their eyes, seldom correct.

Artforum came to the rescue. "This show of photo-assemblages is a black and white WOW!" wrote the magazine's reviewer, Rosalind

G. Wholden. She picked up on the horror and humor that Dennis was trying to channel—the bricolage playfulness, the Kienholzian social commentary. Wholden announced Dennis Hopper to be a promising presence in the field and ended her piece with a resounding salvo: "Welcome brave new images!"

7

"SOMETHING WAS STRANGE
AND WONDERFUL"

By early 1963, Brooke and Dennis found the house they had been looking for among the steep, twisting lanes of the Hollywood Hills. It was a Spanish Colonial at 1712 North Crescent Heights Boulevard, elevated above street level on steeply pitched ground and rimmed with crawling vines like a moat. It had a cross-gabled roof topped with red mission tiles. To Miss Mac, the house looked like a yellow bird perched on the side of a mountain. You walked through the sidewalk-level entrance and mounted a series of stairs encased in stucco walls, twisting right, then left, then up onto a long, open porch. At the left end of the porch, a heavy timber door studded with wrought-iron rosettes opened into a circular foyer, the base of a two-story turret with a double set of three long, thin windows, the house's most distinctive feature. There were three bedrooms upstairs, the two smaller children's rooms separated from the master suite by a hallway. Downstairs, there were a kitchen and dining room, a living room with a fireplace, a cozy den, and a bedroom for Miss Mac. Thanks to money that Maggie had left her, Brooke was able to buy this perfect family dwelling,

handsome and modest, for around $60,000. They moved in after the new year.

The house at 1712 North Crescent Heights had been built in 1927 by a journeyman architect named P. Brainerd Hale, who was said to have had eleven children, a wooden leg, and an illicit affair with a burlesque dancer that had led to his absconding to Mexico. The neighborhood was filled with actors, television writers, and record-business people. At one time, Marlon Brando lived down the street. Igor Stravinsky had a house nearby, as did the costume designer Bob Mackie, and Lee de Forest, the so-called Father of Radio. The CBS radio newscaster Hugh McCoy lived two doors up from 1712 in a house that had once belonged to the silent-film star Estelle Taylor. Brooke and Dennis's new house was within striking distance of the Sunset Strip and many of Dennis's favorite old haunts: Schwab's, Googies, Barney's Beanery, the Renaissance jazz club, owned by his friend Benny Shapiro, and the Unicorn coffeehouse, where he and Larry Bell, who worked the door, were both present one night in February when Lenny Bruce was pulled offstage by plainclothes officers and charged with obscenity.

Brooke's old friend Jill Schary—now married to the producer Jon Zimmer, the mother of two kids, and working in radio and print journalism—had written a book called *With a Cast of Thousands,* due out later that year. It was a memoir of growing up in Hollywood with parallels to Brooke's childhood on Evanston Road. In the book, Jill offered a knowing atlas of Los Angeles neighborhoods. She noted that Hollywood's attitude toward the Valley was "the same as that of the British to the American Colonies. It was all right to make one's fortune there, but not to live there." Santa Monica was for Iowa retirees, Pasadena for Republicans. The canyons— Laurel, Coldwater, Benedict—"Were for people who built their own houses and wore handmade ceramic jewelry." Brentwood, Bel Air, and Beverly Hills, particularly north of Sunset, were socially acceptable. The Hollywood Hills, where Dennis and Brooke had

decided to settle, were "considered smart and perfectly acceptable to 'in' people who did not have terribly much money, but who, on the other hand, had style and creativity."

That was Brooke and Dennis. They could now look out their new bedroom window and see the entirety of Los Angeles spread out below, like a diorama. During the long, smog-fed dusk, the trees and rooftops across North Crescent Heights deepened to black silhouettes against the violet sky and the tiny lights of the city glittered like a celestial carpet that rolled out for miles.

NOW THAT THEY HAD A PLACE of their own, Brooke was free to immerse herself in the junk and antiques emporia of Los Angeles. She made a safari of it, adventuring around town in their new white '63 Mercury Meteor station wagon, whose commodious wayback was ideal for hauling treasures. "You could buy amazing things for nothing because nobody else wanted them," she recalled of newness-obsessed Los Angeles. "Nobody wanted Tiffany lamps. Nobody wanted Oriental rugs. Nobody wanted antiques." Toby, as ever, often went along for the ride, as occasionally did Curtis Harrington, who, like Brooke, was besotted by anything Art Nouveau.

At Fire House Antiques, a converted fire station in Venice that Brooke described as "very unfashionable," she bought a towering turn-of-the-century streetlamp, ornate and moss green. There was also an old barbershop chair; she had it reupholstered in red patent leather and placed it in the den. The shop sold carousel horses for $175 a pop. It's unclear whether Brooke and Dennis bought one there, but buy one they did. It went into the foyer. Dennis photographed a Fire House Antiques invoice lying on top of a scrapbook of Victorian postcards and held down with a doll's head. The image was used as an announcement for the shop's installation at the California Home Show in May, a display that Dennis designed.

Another of Brooke's favorites was Don Badertscher, a rabbit war-

ren of narrow corridors teeming with antiques and junk located in a courtyard on La Cienega directly across from Ferus. She discovered that what she viewed as priceless was often considered to have no worth in Los Angeles, which perfectly suited her pocketbook and her taste. "I've only ever liked collecting things that weren't valuable," she said. "The minute they get valuable, I lose my interest totally." She seemed to love anything forlorn and forgotten.

Scavenger's Paradise was an architectural salvage yard favored by Vincent and Mary Price, a place full of antique stained-glass windows. Brooke bought stacks of them; they were used to enclose the open porch of 1712 and to replace any number of windows around the house. "We'd go along with her to every one of these dealers, full of junk," Willie remembered. "They were unbelievable, full of stuff from Hollywood in the thirties. Mom loved that stuff. She was a maniac about it." When Marin got older, she loved going to Scavenger's Paradise; she would pick up ostrich-feather fans and play among the velvet daybeds, pretending to be a girl in an old black-and-white photograph.

"What was banal can, with the passage of time, become fantastic," Susan Sontag wrote the following year in her landmark essay "Notes on 'Camp,'" an ode to a new sensibility that Brooke may have had no idea she was channeling. Her findings ran from the quotidian to the museum worthy. There were odd-job lots of nostalgic hooey—"Common objects" in Pop Art parlance—such as Coca-Cola advertising thermometers, which she gathered up by the bushel, along with Égide Rombaux's *Eglantine*, a two-foot-tall bronze bust from 1890 of a wistful woman with a proudly upturned head who had an unmistakably Brooke-like aura. At some place or another, she bought a bronze fountain for the backyard that turned out to have been sculpted by Daniel Chester French. At a shop on Sunset Boulevard, name forgotten, she encountered a trove of Louis Comfort Tiffany lamps that Warner Bros. had discarded. "They

were a couple of hundred dollars apiece," she recalled. In 2018, a rare Tiffany lamp sold for $3,372,500 at Christie's.

A Tiffany show at New York's Museum of Contemporary Crafts in 1958 helped bring those artifacts from the days of President Cleveland back from the dead. But the trend had not caught on in LA. For Dennis, the ornate lamps melded craft and industry in a way that spoke powerfully to his own time and to his obsession with machine art. "Tiffany made what I consider some of the greatest art made in America," he said. "He had a factory. He said, 'Do this.' Right? *He* didn't do it. He didn't lay glass in and make it. He said, 'Do this lamp, I'm removing myself. Do a hundred of them. I'll sign them. They're Tiffany.' They're Warhols."

Tiffany pieces ended up in many corners of 1712, in proximity to work by Bengston and Kienholz and Lichtenstein, whose *Mad Scientist*, inspired by a *Justice League of America* comic, they bought for about $500 from Irving Blum in April, when Lichtenstein had his first show at Ferus. Dennis said that when he and Brooke had bought the Warhol soup can painting, which they'd hung on a wall next to the dining room, "everybody thought we were crazy. And when we got the Lichtenstein cartoons they thought we were *really* nuts."

He and Brooke agreed on everything they bought. Dennis took the lead with the art and Brooke handled the procurement of antiques, furniture, prints, and objects. Watching his wife select this material was eye-opening for Dennis. "The art she really brought into my life," he said, "I was really happy about." He loved making the treasure-hunting rounds with Brooke.

The house became a kind of design laboratory as Brooke packed *objets* plucked from musty obscurity into the modest dimensions of 1712, where they lived in kaleidoscopic equilibrium with the futuristic art pieces. It was old and new, low and high, and utterly at odds with the prevailing midcentury-modern appeal to minimalism and

order. Toby Rafelson saw Brooke's aesthetic as uniquely vanguard in the setting of Southern California in 1963. "That sort of cultivated taste was just coming to Los Angeles," she said. "There was wealth, but people in Los Angeles weren't interested in the same way in those kinds of objects or in contemporary art." Brooke, Toby said, "was always attracted to the artistic, the imaginative, the unconventional. She took it to a different level in playfulness and imaginativeness."

One day, Dennis fetched his Nikon and photographed the bikinied Brooke tiling the front entrance of 1712 as he stood watching from inside the foyer with Marin. An adoring aura suffuses the image, as Brooke, in full DIY glory, leans into the grunt work. "Brooke did an amazing amount of work there," Dennis said, marveling at his wife's gumption. "She was constantly working on the house."

"As much as my father had a vision," Marin Hopper said, "she would make it happen. He'd say, 'I think some tile would be good here.' He didn't expect her to do the tiling." But she laid the tiles— hundreds of them, some brought back from Tijuana—all over the house. Jane Fonda knew that her friend had a special moxie. "No question—Brooke would roll up her sleeves and do it herself," she remembered. "And, being an artist, she could."

Month by month, year by year, Brooke and Dennis continued shaping 1712 into a singular environment. The house expressed their love of visual and material culture, of living in LA, and of each other. Dennis recognized that their spousal collaboration— twin sensibilities working equally, in tandem—was "very rare."

As Jane put it, "It really was a magical house."

BROOKE'S ACTING AND MODELING BOOKINGS had slowed with the birth of Marin, but in the spring she posed for *TV Guide* in a "Casual Clothes from California" feature. Dennis earned $2,250 (half the average annual American salary in 1963) to appear in an

episode of *The Twilight Zone* called "He's Alive," playing a feckless weakling named Peter Vollmer who is transformed into a neo-Nazi zealot by a phantom Hitlerian figure. Dennis remembered going to read for the director, Stuart Rosenberg, bringing along his sides, in which one character gave a speech, and the other one responded with a couple of lines. Dennis sat down and waited for Rosenberg to begin reading the speech. After an interval, Rosenberg asked, "Are you preparing?"

"Preparing what?"

"Read!"

"The speech?"

"Yeah, read the speech!"

"I thought I was going to do the two lines."

Rosenberg studied Dennis for a moment. "How long has it been since you've worked?" he asked.

"Five years," Dennis said. It was an exaggeration, of course, but it honestly expressed his feelings of disownment since he'd knocked heads with Henry Hathaway. Rosenberg gave up on the reading altogether. "You got the part," he told Dennis. The director was astonished that an actor of Dennis's caliber had assumed that he was auditioning for a bit part.

Dennis found Rod Serling, the series creator, a wonder to work with, and the part of Vollmer was both tender and terrifying, a developing Hopper trademark. The public's response was visceral. "He's Alive" generated more letters and editorials than any other *Twilight Zone* episode. Conservatives saw it as a luridly unfair critique of right-wing ideology: "The impression left by the program," an *Indianapolis Star* editorialist wrote, "was that people who warn against Communism and people who talk about getting back our freedom are probably secret Nazis." Serling responded forcefully, arguing that "bigotry, hatred, and racism" are "enemies no less real, no less constant, and no less damaging to the fabric of democracy" than communism.

Back at 1712, Dennis trained his Nikon on the television in the den, shooting the American Nazi Party's Leonard Holstein being interviewed after his arrest on April 30. Holstein and other neo-Nazis had attacked a pro-Israel commemoration at the Shrine Auditorium. It was a grim vindication for Dennis, who surely hoped his performance as Vollmer would help expose a canker in American politics.

IN JUNE, BROOKE AND DENNIS flew to New York, where Dennis was scheduled to shoot an episode of the CBS courtroom drama *The Defenders*. They stayed in a tiny West Village apartment, where Brooke's friend Josie Mankiewicz Davis lived with her husband, Peter Davis, a son of screenwriters who had grown up around the corner from Brooke in Brentwood and who was embarking on his own career as writer and director. (He would eventually win an Oscar for his 1974 documentary about Vietnam, *Hearts and Minds*.) Dennis and Brooke camped out in the living room. One afternoon, while the two couples drove around Manhattan in a convertible, with Danny Selznick squeezing in, pedestrians recognized Dennis at a stoplight and asked if he'd been in touch with the ghost of James Dean lately. Peter found Brooke's presence catalytic. "I was very fond of Brooke," he said, "because she was full, really full, of ideas—to do this or do that. She was a real spark in any gathering."

On June 10, Dennis and Brooke finally met Andy Warhol when they went uptown to the artist's town house at East 89th Street and Lexington Avenue. Irving Blum had arranged the rendezvous with the aid of Henry Geldzahler, the impossibly well connected curator in the Metropolitan Museum's Department of American Paintings and Sculpture who was also Michael Thomas's old friend from Yale. The Antwerp-born, gregarious, encyclopedically intellectual Geldzahler was among the few curators who was willing to stick up for Pop Art as a legitimate enterprise. During the proceedings,

which included a happy reunion for Brooke and Henry ("It's all wonderfully connected," she thought), two more artists showed up at Warhol's house: David Hockney, in from London, and his "sexy friend," the New York painter Jeff Goodman. As Hockney recalled, the artists, the curator, and the couple from Los Angeles hit it off so well that Dennis "invited us to come the next day and watch him shooting a television series he was working on." After Brooke and Dennis left, Hockney mentioned to Warhol, Goodman, and Geldzahler that *Night Tide* was playing at the Selwyn on West 42nd Street; they all piled into a cab and headed down to the theater to watch Dennis on a movie screen.

Dennis and Brooke had much to discuss that night. Warhol had taken them to the studio he'd begun leasing earlier that year, a 2,500-square-foot space inside an old firehouse, Hook & Ladder 13, on East 87th Street. There they discovered that Warhol had been daubing paint onto a silver silk-screened image of Elizabeth Taylor. *Cleopatra*, the over-the-top sword-and-sandals epic, with Taylor in the title role alongside Richard Burton as Mark Antony, would begin its much-anticipated run in theaters the next day. (Miss Mac was scandalized by the affair Taylor and Burton were having.) What Brooke and Dennis were seeing in the studio that day was Warhol's eureka moment as an artist. After the soup can paintings, he had gone all in on seriality and repetition, harnessing a commercial, mechanical process to machine-produce fine art. "Paintings are too hard," he allegedly told an interviewer by way of explanation.

Brooke was mesmerized by Warhol; she didn't see him as alien so much as otherworldly, almost saintly. She was thankful to be in his energy field. "There was something very extraordinary happening in this dark warehouse," she said. "The man had created, indeed tossed off, God knows what." She and Dennis saw silk-screen works depicting other iconographic subjects lying around the cavernous studio, including Leonardo da Vinci's *Mona Lisa*, which had been on a hysteria-inducing tour of the United States, including a stop

at the Metropolitan Museum of Art in February. One of these, a double image that the artist had cast aside, caught Dennis's eye. "That is fantastic," he said. "You've thrown it away. Give it to me. I want it."

"I will give it to you," Warhol told him, "if you take a photograph of me." It was an easy deal to make, and so Brooke and Dennis became the owners of Warhol's *Double Mona Lisa*, a twenty-eight-by-thirty-seven-inch black-and-white silk screen that made its way to the living room of 1712. (Warhol also gave a *Mona Lisa* to Geldzahler, who handed it over to the Met.)

Something else attracted Brooke's attention that night. Warhol, she noticed, "collected antiques of a bizarre nature. I mean, there were bits and pieces of merry-go-rounds, bits and pieces of buildings." The artist, it turned out, shared her passion for collecting what Warhol described as "American junk." For Brooke, it was a validating moment. Walter Hopps had noticed it, too, when he'd visited Warhol. Hopps thought of the gumball machines, barber poles, and the like as a particular "gay taste," distinct from what he was accustomed to encountering in the barren studios of other artists he knew.

Brooke's gaze narrowed upon a carousel figure gathering dust in a corner. She thought it was the best she'd ever encountered, a prancing silver centaur. "Andy," she ventured, "I'd like to buy that." Warhol responded, "No way."

THE DEFENDERS **WAS BEING SHOT** the following day at Film-ways Studio on East 127th Street in Harlem. The art-historical group from the night before—Warhol, Hockney, Geldzahler, and Goodman—reconvened there to observe Dennis playing the role of a murderer on trial faking insanity in an episode called "The Weeping Baboon," opposite Robert Reed and E. G. Marshall, who allegedly drank his way through the shoot. (Dennis told Peter Davis

that "it was such an easy show to shoot, it didn't matter.") The show business–besotted Warhol must have been in heaven. He'd loved seeing Dennis on screen, and now he was watching him in action. "I remember thinking how terrific he was," he said of Dennis's acting, "so crazy in the eyes." When the episode aired in September, a drifting miscreant named Charles Manson watched it, filing away the tactic of the nutjob defendant and eventually using it at his own trial.

Warhol would get his photograph—more than one, in fact. Dennis shot Warhol, Hockney, Geldzahler, and Goodman in the doorway of a bar, raincoated and smoking, an image among the best known that Dennis ever took. (It is in the permanent collections of the Metropolitan Museum of Art and MoMA.) On that day or another during Dennis and Brooke's stay in New York, some of the group went for lunch at Sign of the Dove, the voguish garden restaurant on Third Avenue at East 65th Street. Dennis took a seat across the table from Warhol, a single long-stemmed iris in a thin crystal vase between them. While the baby-faced Geldzahler sat next to him puffing on a cigar, Dennis lined Warhol up in the Nikon's viewfinder. He took several shots of the artist, eyes hidden behind sunglasses and face split in two by the iris. For Walter Hopps, the resulting photograph was the best that anyone would ever take of Warhol—the only one, he said, that caught the artist's hauntedness, "that kind of shadowy devil's head or death-stalking quality."

Brooke was captivated by the moment—the lunch, the photograph, the new artist friends. "I knew," she said, "that something was strange and wonderful."

WHEN LATE AUGUST ROLLED AROUND, Dennis was again on the move, this time to the March on Washington for Jobs and Freedom. Harry Belafonte had mustered a sizable show business

contingent to attend the march, deputizing Marlon Brando to lead the delegation from Hollywood, which included Charlton Heston, Ossie Davis, Paul Newman, Sidney Poitier, Joseph L. Mankiewicz, and Sammy Davis, Jr. "To mobilize the cultural force behind the cause—Dr. King saw that as hugely strategic," Belafonte said. "We use celebrity to the advantage of everything. Why not to the advantage of those who need to be liberated?" Heston assured skeptics that they were attending "as private citizens rather than public persons" to tamp down the suspicion that celebrities might be trying to upstage the event, which a Gallup Poll showed 63 percent of Americans disapproved of.

Having met Dr. King at the Chateau Marmont in the late 1950s and grown up in a progressive household, Dennis signed on, knowing it would make his family proud. He flew from LA aboard a flight with Belafonte, James Garner, Rita Moreno, and other members of the Hollywood group. On August 28, he joined a crowd that grew to upward of 250,000 people on the Mall in Washington, to hear Ossie Davis introduce a slate of performers including Joan Baez, Bob Dylan, Odetta, and Josh White, followed by a peaceful march to the Lincoln Memorial amid signs reading NO U.S. DOUGH TO HELP JIM CROW GROW and CIVIL RIGHTS PLUS FULL EMPLOYMENT EQUALS FREEDOM. The program culminated with Dr. King delivering his "I Have a Dream" speech.

Belafonte saw the participation of white actors and singers as a positive component. But some Black entertainers were not convinced. Dick Gregory told the writer David Hajdu, in words that could have applied to the Hollywood contingent that Dennis was part of, "What was a white boy like Bob Dylan there for? . . . If Bob Dylan and Joan Baez and whoever the hell stood out there with the crowd and cheered for Odetta and Josh White, that would be a greater statement than arriving in their limousines and taking bows." But the overall feeling was that something miraculous had happened that day. Dennis saw a remarkably peaceful demonstra-

tion, a throng made of up all types, all demanding that the American promise be delivered to every citizen. "Hope and harmony," the civil rights leader John Lewis said, "that was the music of the day, that was the message."

IRVING BLUM WAS ORGANIZING A second Ferus Gallery show for Andy Warhol, scheduled for September, that would showcase the new silver silk-screen works that Dennis and Brooke had seen at the firehouse studio. They fell into two series—one depicting Elizabeth Taylor in a publicity shot from *Butterfield 8*, the other Elvis Presley in a gunslinger pose from his 1960 film *Flaming Star*. Here were two celebrity icons of such stature that their very images projected the concept of fame—ultra Pop. The subjects, both friends of Dennis's from the 1950s, were tailor-made for a show in LA, and Blum assured Warhol that there would be great interest from collectors and the public alike. Learning that Warhol planned to travel west for the opening, Dennis and Brooke decided to help launch the show with a bash at 1712 North Crescent Heights—Warhol's West Coast coming-out party. It would also be a coming-out party for the house.

Brooke continued her station-wagon safari, now with extra impetus. A Victorian-era revolving Richardson's spool silk thread cabinet, an eight-foot-tall 1890s Apéritif Mugnier advertising poster by Jules Chéret, circus posters, an old-fashioned pipe organ, a giant plastic Coke bottle that looked like a free-standing sculpture, a smattering of Mexican folk art, a disco ball and Fresnel lights for the foyer—it is impossible to know precisely when such artifacts arrived at 1712, but Brooke and Dennis were pushing further to create an atmosphere worthy of their artist friend. Dennis, as besotted as ever with Foster & Kleiser, hit upon the idea of papering the downstairs bathroom with billboards. They were, after all, LA's native art. "To deprive the city of them," the British architectural

historian Reyner Banham noted, "would be like depriving San Gimignano of its towers or the City of London of its Wren steeples." Hand-painted billboards would take too long to produce, Dennis was told, so they settled on lithographed ones, which were cut this way and that in order to fit on the walls. Inside the snug bathroom, the Brobdingnagian scale of the sliced-up imagery—including a woman with a Crest-worthy smile and a guy holding a hot dog—had a mesmerizing effect: you felt as though you were stepping into a James Rosenquist painting every time you had to pee. ("Brooke hated it!" Blum said; Brooke insisted that she thought it was "brilliant.")

They decided it would be a cocktail party, but there still had to be food. Dennis floated the idea of a New York–style hot dog vendor. Brooke called around and found a guy with a cart who was willing to park on North Crescent Heights and serve chili dogs. Invites went out to friends in the art scene and in Hollywood, guaranteeing the kind of "movie star party" that Warhol dreamed about. It was set for Sunday, September 29, the night before the opening at Ferus. Wallace Berman's RSVP transformed the invitation into a borderline pornographic postcard, thanks to a cutout image of a pair of couples going at it that he glued on. That saucy bit of Berman mail art joined the growing collection at 1712.

Warhol had never been west of his native Pittsburgh. "Vacant, vacuous Hollywood," he said, "was everything I ever wanted to mold my life into." He decided to road trip to Los Angeles with his assistant, Gerard Malanga, who had begun working with Warhol the day of *The Defenders* shoot; the beefily handsome painter Wynn Chamberlain, who conveniently owned a Ford Falcon station wagon; and Taylor Mead, a native Michigander, recovering Merrill Lynch stockbroker, and droll provocateur who bore a resemblance to Droopy Dog. Having been introduced to Warhol by Geldzahler, Mead thought the artist was America's answer to Voltaire.

It took a few days to traverse the continent. "The farther West we

drove, the more Pop everything looked on the highways," Warhol noted. The Saturday before the party, they overnighted at the Sands Hotel in Palm Springs, and on Sunday they proceeded to Los Angeles. They cruised along Sunset Boulevard, which they found lined with Foster & Kleiser billboards and the kind of eye-grabbing signage—crazy parabolas, asters, and swooshes implanted with antic lettering and neon—that Tom Wolfe called "electro-graphic architecture." Soaking it all up, Warhol said, "Oh, this is America."

The travelers headed straight to 1712 North Crescent Heights, veering off Sunset and winding up into the hills. "It was like this invasion of creeps," Chamberlain said of their entry into the scene that awaited them. Warhol and his motley entourage were hardly household names in 1963, and now they were in a surreal fun house crowded with Hollywood players who looked like living Pop Art—Sal Mineo, Russ Tamblyn, Dean Stockwell, Bobby Walker, Peter Fonda (who struck Warhol as a "preppy mathematician"), and the It couple of the moment, Suzanne Pleshette and Troy Donahue. Warhol had used Donahue as a subject for his silk-screen artwork and even a T-shirt, one of which Blum had worn in the photo that had announced Warhol's Ferus show. "Andy and I were both stargazing," Malanga said. "I was pretty awestruck being a kid coming from the Bronx and landing in Hollywood." Malanga, a twenty-year-old poet with pop-idol looks, hung out with Berman and Tony Bill while Warhol reconnected with Bengston and Blum, mixed with the Ferus crowd, and saw his own work and that of his friends and peers on the walls of Brooke and Dennis's house. The whole scene caused Warhol, as Dennis recalled, to stand agog and emit the ultimate Warholian words of approval: "Ooh! Aah!"

"He loved it," Brooke said. "He was simply dazzled."

"Andy comes to Hollywood and sees an environment that actually accepts this kind of new art," Dennis remembered. "It was a very thrilling thing for everybody at that point. Because it was the first time anybody saw a collection like this together with antiques

and with the kind of outrageous stuff that we had found." To War-
hol, 1712 was a fun park: "This was before things got bright and
colorful everywhere, and it was the first whole house most of us had
ever been to that had this kiddie-party atmosphere." Ed Ruscha,
who'd had his first Ferus show a few months earlier, said, "It was
like walking into a carnival, with a candy-store energy." As for the
party itself, "That was *noisy!*" It was also sweltering hot.

Mead found the Hollywood crowd a little stiff, but that changed
soon enough as cocktails and other substances flowed. "Joints were
going around," Warhol recalled, "and everyone was dancing to the
songs we'd been hearing on the car radio." Chamberlain claimed
that Brooke got huffy when she discovered him smoking pot in
a closet with Ben Hecht's daughter Jenny. Malanga said that was
unlikely, and, given Dennis's long-standing devotion to cannabis, it
would have been more shocking had the party not been fueled by it.
As records spun on the Garrard KLH turntable in the living room,
Mead found a willing dance partner: Patty Oldenburg (later known
as Patty Mucha), the firecracker wife of Claes. Dennis and Brooke
had met the Oldenburgs in New York when Geldzahler had taken
them to a party at the couple's Lower East Side apartment, and now
they were reciprocating the hospitality. The Oldenburgs had since
moved to LA, finding a little house on Linnie Canal in Venice.

Taylor and Patty were fierce dancers—"I could dance five hours
straight in high heels in those days," she said—and as they were
twisting and mashed potatoing, Patty knocked into a creepy Kien-
holz assemblage called *The Quickie*, a female mannequin head and
hand planted on top of a roller skate and affixed with gold braid that
Brooke and Dennis had bought for $350. It was a favorite piece of
Brooke's, and it crashed to the floor, the head shattering. "It was a
high point of the party," Brooke said. She waved the incident away,
and the guests got back to partying. But Patty was mortified. "I
thought it was a monument to her beauty," she said of *The Quickie*,
"because the mannequin head was so beautiful and Brooke was so

beautiful and classy and fashionable and down to earth." (Kienholz repaired the piece.)

As the Hollywood Hills turned dark, Warhol, Malanga, Chamberlain, and Mead got into the Falcon and rolled back down to Sunset, heading over to the Beverly Hills Hotel, where Brooke had arranged for them to stay in Leland's preferred suite. "The Hoppers were wonderful to us," Warhol remembered. "This party was the most exciting thing that had ever happened to me." As a thank-you, he sent over an enormous heart-shaped flower arrangement on a stand, the kind of thing you might see at a funeral home out in the Valley. The card read, "Darling Brooke, Love, Andypoo."

"When I met Andy Warhol, who came to this party, who came to this house, to this weird scene with the strange bathroom that had been transformed," Brooke said, "the world began."

THE FOLLOWING NIGHT, DENNIS AND BROOKE showed up at Ferus to find the front window entirely filled with a silvery life-size image of Elvis Presley pointing a revolver out at North La Cienega Boulevard. Warhol arrived at the opening with a white carnation on his lapel, carrying the 16-millimeter Bolex film camera he'd recently bought at Peerless, where Brooke had bought Dennis's Nikon. He shot some footage of Irving Blum goofing around in front of the gallery. Brooke wore a white summer dress and smoked demurely, chatting with the people she'd been partying with twenty-four hours earlier at 1712. Billy Al Bengston, who kept up a side career as a dirt-bike racer and channeled that iconography into his work, turned up in a T-shirt from Jack Baldwin Motorcycle Sales in Santa Monica, a West Coast macho counterpoint to the fey and dapper Warhol. Everyone milled around, taking in the Liz Taylors arrayed around the front half of the gallery in rows, much like the soup cans the year before, and the giant Elvises in the back. If the Campbell's soup cans had posited commodities as viable subjects for

portraits, these portraits depicted their viable subjects as the commodities that they were. Larry Bell, for one, found this Warhol show to be as bracing as the one in 1962. He thought that Warhol's work expressed a "complete boredom" with aesthetics as they were then understood. It was a challenge to every other artist.

But compared with the festive atmosphere at 1712 the night before, the opening was anticlimactic. Many of the attendees were presumably hungover; Malanga sneaked off to have a drink with a friend. By the time he returned, Warhol had already left. The show itself was considered a dud. Blum managed to sell one piece, a Liz. As the writer Deborah Davis pointed out, "This crowd lived with Elvis and Liz every day. In their world, celebrity images were too familiar to be considered art." True to form, Henry Seldis dismissed the show as still more dreaded "Pop art banality." Warhol was bemused. "The press for my show wasn't too good," he remembered. "I always have to laugh, though, when I think of how Hollywood called Pop Art a put-on! *Hollywood??* I mean, when you look at the kind of movies they were making then—those were supposed to be *real*???"

"IT WAS A GREAT MOMENT to go to Los Angeles," Claes Oldenburg said, "because it hadn't been overwhelmed by the East Coast, and most of the artists that I met there were all very characteristic LA types. It was great to meet those originals."

Oldenburg's one-man show opened October 1 at the Dwan Gallery in Westwood with a number of outsized "soft sculptures": *Baked Potato, Good Humor Bars, French Fries with Ketchup,* and *Giant Blue Shirt with Brown Tie,* a six-foot-long-by-five-foot-high men's chambray button-down made of canvas, stuffed with kapok, outfitted with a tie, and hung on a chrome garment rack with wheels. Patty, whom Oldenburg liked to call "Poopy," had been responsible for sewing the sculptures. Leading up to the show, Dennis cruised around town with the tall, balding artist, taking pictures of him

and his pieces, which resulted in a particularly compelling image of *Giant Blue Shirt with Brown Tie* at a Mobil station looking as if it might be in for a fill-up or oil change—a perfect, and perfectly bizarre, Californian image. Dennis was dying to buy the piece, but for once Brooke said no. It was perhaps no surprise, as Oldenburg liked working at a scale and with materials that tended to leave would-be buyers scratching their heads. "My work makes a great demand on a collector," he said. "I have tried to make it in every way so that anyone who comes into contact with it is greatly inconvenienced."

Oldenburg's preoccupations transcended the Pop moment. If sculpture had always been the art of achieving fluidity and movement and expression with "hard" materials, such as marble, bronze, or wood, Oldenburg turned the equation upside down, using soft materials to evoke the hard forms of everyday living. "That Claes chose the hamburger as his first major soft sculpture is no accident," Patty Mucha later wrote. "It looked like him; it was a monument to himself. After the completion of the hamburger, alone one evening in the gallery, we christened it by making love on the meat, covered by the bun." It was an anecdote Dennis loved. At the Dwan Gallery, he shot a portrait of Patty embracing the fries in *French Fries with Ketchup.* "They *squoze!*" she recalled.

For all their apparent absurdity, the soft sculptures—reflecting the outrageous colors and commercialism of LA—were anthropomorphic, earthy, tactile, and irresistible, like the squishy toys of childhood blown up to monstrous size, comforting and happy yet odd and even vaguely menacing. "I thought he was the best," Dennis said, suspecting that it was Oldenburg—not Warhol or Lichtenstein or Johns or Rauschenberg—who might be the Picasso of the day.

IF OLDENBURG WAS PICASSO, DENNIS THOUGHT, Warhol was Thomas Edison. "Andy was like a guy who was sort of going back to

the beginning of the film," he said. Whereas Bruce Conner liked to shoot film and cut it into something jagged and hypnotic, Warhol, as he began to toy around with his Bolex, liked to just turn the thing on and let whatever happened happen. In time, that would mean a stationary camera trained forever on a single subject, as in *Empire*, a 1964 film starring the Empire State Building, which Warhol described as "an eight-hour hard-on." In the work of Conner and Warhol you could discern the axis along which art filmmaking would forever run.

The day after the Oldenburg opening, Warhol and Mead began working on *Tarzan and Jane Regained . . . Sort Of*, a silent film whose subject was suggested to Mead when they drove past an exit sign for Tarzana on the 101 Freeway. (In fact, the film begins with a shot of the sign.) The pantywaist Mead would star as the he-man Tarzan. That hilarious act of casting against type was the movie's main *raison d'être*, the joke that played out in every frame. It was heightened by the decision to cast an actual movie star as Mead's lowly body double: Dennis. He appears looking like a Hollywood prince in a leopard-print loincloth, beating his chest and flexing his muscles, unshaven and grinning. Mead thought that the offhand, madcap spirit of the film relaxed Dennis, even liberated him as an actor, taking him out of the Method and Shakespeare. After all, the film wasn't low stakes so much as no stakes. "It opened up new possibilities for him," Mead told Warhol. Dennis thought Warhol was wasting his time and should stick with painting.

Tarzan and Jane Regained . . . Sort Of was effectively Warhol and Mead's home movie of the LA trip, overlaid with a ready-made soundtrack of pop hits that sound as though they were recorded straight off a radio or record player: "The Wah-Watusi," "South Street," "Locomotion." It showed Taylor diving into the Beverly Hills Hotel pool, meant to be a crocodile-infested lagoon; a visit to the oddball Moon Fire Ranch in Topanga; a flyby at Watts Towers; an afternoon at the Oldenburgs' in Venice, with Claes spraying

Mead with a garden hose and Patty wrestling Mead to the ground, some of which Dennis photographed. They shot Ascot Park speedway, where Bengston raced his motorbike, and Wallace Berman's place in Topanga. There were close-ups of Brooke being silly and underexposed night footage of what appears to be the carousel at Santa Monica Pier, which Warhol had seen in *Night Tide* and where he and his crew threw a wild party. Like the one at 1712, this party suggested a new social dynamic that mixed artists, bohemians, and Hollywood types, including Brooke and Dennis. "There are a lot of famous stars in this sequence," Mead's hokey, half-assed voice-over intoned, "all underexposed . . . purposely!"

IT WAS A SEASON OF nonstop art and social activity, and it continued without letup. On October 7, Brooke and Dennis attended the black-tie invitational preview of the massive Marcel Duchamp retrospective at the Pasadena Art Museum, which Walter Hopps, now in the role of acting director, curated. He had managed to corral 114 works by Duchamp for a show that included some of the greatest hits of modern art: *Nude Descending a Staircase*; *The Bride Stripped Bare by Her Bachelors, Even*; *Bicycle Wheel*; and *Fountain*, the infamous urinal that Duchamp signed "R. Mutt." Coming half a century after Duchamp had made his splash at the 1913 Armory Show, the Pasadena exhibition was, as Henry Geldzahler wrote at the time, "probably the most important show in America this year." In fact, it was one of the most important museum retrospectives of the second half of the twentieth century. The artist himself, along with his wife, Alexina, known as "Teeny," flew out from New York to be in attendance.

The photographer Julian Wasser wandered through the crowd, capturing Taylor Mead chatting with Dennis and Brooke, who looked chic in sunglasses with two Maltese cross brooches affixed to her dress. In Wasser's photographs, the handsome Ed Ruscha

wanders the galleries with his pretty Oklahoma girlfriend, Patty Callahan; Brooke, Andy Warhol, and Virginia Dwan share a laugh; Irving Blum looks like the tallest guy in the room; and Billy Al Bengston goofs around with Warhol in front of Duchamp's *Network of Stoppages* while Dennis eggs them on. "We was having a fun time!" Bengston said. "We were pulling each other's noses. Andy would say, 'Oh, you're so crazy, Billy.'" As for Duchamp, Bengston had met him a few times already. "He was not a particularly charming guy to little farts like us," he recalled.

But Duchamp's mere presence ionized the atmosphere. At seventy-six, he was whippet thin, with deep-set eyes, a ready grin, and an aura of impish perspicacity. He'd seemingly given up art decades before, preferring to pursue chess and leisure, mostly in New York. When Duchamp was asked how he filled his days, the man who, together with Picasso, towered over modern art was likely to respond, "Oh, I'm a breather, a *réspirateur.*"

"Everybody was really in awe of Marcel," Blum remembered. Duchamp was a genial spirit to this new generation, which, like him, was dedicated to removing sanctimony from art. Assemblage, Pop Art, "happenings": those recent phenomena all had roots, one way or the other, in what Duchamp had been up to in the teens and twenties, when he had rebelled against what he called "retinal" art, i.e., Matisse and the like, in favor of art that occurred at the level of the idea. Being near him that night in Pasadena was, as Calvin Tomkins wrote, "a life-changing experience for some young artists." Ruscha, for one, loved the mystery around Duchamp's work, a quality he aimed for in his own art. "He's not giving us the answers," he said. "He's leaving the question out there. And I'm all there when I see that happen." In addition to Ruscha and Bengston, the roster of attendees included Claes Oldenburg, Ed Kienholz, Larry Bell, Robert Irwin, Ed Moses, and Richard Hamilton, the British Pop artist.

Dennis and Brooke didn't converse with Duchamp so much as

absorb the energy around him. "He was like a God to all of us," Dennis said, claiming Duchamp as a decisive influence. "He said the artist of the future will not be a painter but a man who points his finger and says, 'That's art,' and it'll be art." Dennis would adopt that Duchampian notion as his personal creative credo. He embraced the idea of the readymade and conceived of his own photographs as found objects, in part because he refused to crop them—they just *were*.

Dennis had brought his Nikon along that night. He shot Brooke straightening Warhol's bow tie; Duchamp and Hopps clustering together conspiratorially; Malanga and Warhol with little-boy grins; and Warhol pointing the Bolex at him while he pointed the Nikon back at Warhol. The vernissage at the museum was society-page stuff, with Pasadena burghers and their wives, high-end Angeleno collectors such as Donald Factor and Robert Rowan, and *Vogue*'s Baron Niki de Gunzburg milling around. Mead found it odd that Dennis and Brooke were the sole representatives of Hollywood.

Then everyone headed around the corner to the after-party in the ballroom of the Hotel Green, an enormous 1890s Spanish Moorish fantasia with domes and turrets, surrounded by palms and bubbling fountains. The hotel's heyday of hosting presidents and East Coast worthies dated to around the time Duchamp had been creating the work now on display in the museum. By 1963, it had gone musty. The Hotel Green would be threatened with closure the following year, making it something of an architectural castoff—the kind of neglected romantic object that Brooke loved, blown up to massive size. Duchamp loved it, too, and insisted on staying at the hotel, a place he'd known for decades. (A girlfriend of his had lived in the Hotel Green in the 1940s.)

As Brooke and Dennis approached the entrance, Dennis had a flash. "I saw the Hotel Green sign wired to a post," he recalled. "I recognized the image of the hand pointing to the entrance as exactly the same stencil Duchamp used in his 1918 painting *Tu m'*.

I told my wife to go inside. I went to my car, retrieved a pair of wire cutters, went back to the sign, and stole it." Dennis took the pilfered Masonite sign—weathered, green, two feet wide, with a pointing finger and the words HOTEL GREEN ENTRANCE—to Walter Hopps, asking if Duchamp would sign it. Duchamp did, inscribing his signature along the extended index finger, thereby creating—or cocreating—one of his final works.

Mead hadn't packed a tuxedo and was given grief at the door for showing up in a white cardigan borrowed from Wynn Chamberlain; the indignity triggered a diva fit. He managed to gain entrance and fell upon the lobby piano, coaxing out tunes and, as Hopps put it, "carrying on like a freak." A crackerjack orchestra was playing upstairs, which made dancing irresistible. As at 1712, Mead and Patty Oldenburg led the charge to the dance floor. "Don't ask me about the show," she said. "I don't remember it!" With his thrift store tuxedo, round shaded spectacles, and lush mustache, Larry Bell looked like Groucho Marx as he gulped down Myers's rum. He'd met Duchamp a year earlier at his Ocean Park studio, when Duchamp showed up among a small group of visitors. Bell had no idea who the old French guy was until he overheard somebody say, "Didn't you do something like this at one time, Marcel?" Bell froze, unable to speak for the rest of the encounter.

Duchamp thought of his California visit as *"une semaine de libations et de freeways"*—a week of drinking and freeways—and confided to Hopps that he was in the midst of a "sex maniac phase." Even so, the artist seems to have spent most of the party at his table, a benign observer. Gerard Malanga approached him and was invited to sit down. Duchamp gave Malanga the canny suggestion that he try writing a poem without actually writing it—the readymade concept applied to literature. Malanga subsequently clipped and rearranged sentences from a psychology textbook, giving the resulting poem the title "Temperature." He sent it off to Howard Moss, the poetry editor at *The New Yorker*, where it ran in 1964.

Duchamp likewise seemed pleased to chat with Mead, who was introduced to him as an important underground movie actor.

And so the evening churned on, with talking and dancing and partying and hordes of guests signing a pink tablecloth as a keepsake for Duchamp, who begged off to go upstairs to his suite with some brandy and a couple of friends. The party continued into the wee hours. Warhol drank too much pink champagne and barfed in the bushes. Bell wandered off and ended up being left behind in Pasadena. "I'm still hungover from that party," he said more than fifty years later. For Brooke, the Duchamp party was more glamorous, exciting, and fun than any movie business party she and Dennis had ever gone to. In her eyes, Hollywood, even at its most glittering, couldn't compete.

AFTER THE PARTY, BROOKE AND DENNIS somehow managed to get back to 1712 with their spur-of-the-moment Duchamp piece, which would be christened *Signed Sign.* They hung it in the living room. (In 2010, it sold at Christie's for $362,500.)

Inspired by Duchamp, Dennis went on an appropriation spree that fall, lifting signage—Mobil Oil, Dad's Root Beer, and the like—from gas stations and roadsides, often with the help of his wire cutters and with Kienholz along for the ride. The two of them found an almost-but-not-quite-life-size, three-dimensional 1950s Chevy from a billboard, and Dennis arranged his found signs around the phony car in the backyard, an outdoor assemblage that the kids treated like a playground.

While the one-year-old Marin spent her days at 1712, Jeffrey and Willie were continuing at the John Thomas Dye School. One Friday in late November, there was a knock on the door of Jeffrey's classroom. The teacher went to answer it and then broke down in tears. "It was the first time I'd ever seen an adult start to cry," Jeffrey recalled. "Something clearly was happening, and we didn't know

what it was. It was terrifying." President Kennedy had been assassinated in Dallas.

Brooke and Dennis absorbed the news, stunned like everyone else and concerned about the psychological well-being of their children. Warhol and Malanga were back in New York that day, working on a piece depicting Dracula biting a girl's neck. Malanga was struck by the contrast between the heaviness of the moment and the campy, tasteless thing they were working on. He and Warhol remembered the billboards they'd seen in Texas as they'd driven home to New York after the Duchamp party: "KO the Kennedys." The day after the assassination, Dennis took the Oldenburgs to a film and television studio in Culver City, where they met Joanne Woodward, sat in the canteen, and collectively grieved. The mood in that normally boisterous place was sepulchral. Patty felt a sharp-edged anger.

The Monday of the state funeral in Washington, Dennis sat in the den at 1712, aiming his Nikon at the television set. He clicked through a roll of Tri-X film as the somber imagery played across the screen: the flag-draped coffin on its caisson, the rows of graves at Arlington, the grieving family and dignitaries. The coffin and the TV: a box inside a box. Dennis was recording the birth of a new age of politics and communications, with every network rolling out the dire scene for days. The television, as Michael Arlen wrote in *The New Yorker*, had "the aspect of a national icon, a shrine." The country's grief was catalyzed and concentrated by it. Instead of the generally vapid shows that Dennis had been acting in—*Surfside 6* and the like—there were somber newscasts; instead of canned laughter, there was a catafalque. For Warhol, it was too much. "What bothered me was the way the television and radio were programming everybody to feel so sad," he said. "It seemed like no matter how hard you tried, you couldn't get away from the thing." He would embark on his Jackie Kennedy portraits, using funeral photographs as source material. In Dennis's own photographs, the subject is

dual: the brutal matter-of-factness of a televised presidential funeral and the jolting phenomenon of an entire country gazing in unison at millions of Zeniths and Magnavoxes.

CHRISTMAS SEASON ARRIVED, AND BROOKE prepared cards to send out, using a photograph of the kids that Dennis had taken one afternoon at Watts Towers, the enormous outdoor assemblage piece that Simon Rodia had constructed from refuse. "Wow, this is really cool," Willie remembered thinking when they visited. "It's like a giant playground." In New York, Leland and Pamela blasted through their Christmas gift list, choosing for Brooke and Dennis a pitcher and place mat set from the Jansen housewares boutique that Pamela had recently opened—a combination they also sent to several acquaintances, including Josh Logan and Ethel Merman. Brooke appeared in an episode of the CBS anthology series *The Alfred Hitchcock Hour* called "The Cadaver," about a college prank involving a human corpse, and Dennis showed up with his friend Dean Stockwell in an episode of ABC's *The Greatest Show on Earth*, a promising, splashy series that would be canceled after one season. An invitation arrived for traditional Christmas Eve festivities at the Selznicks' on Tower Grove Drive.

On the nights of December 9 and 10, Oldenburg mounted his *Autobodys* happening in the parking lot of the American Institute of Aeronautics and Astronautics on Beverly Boulevard, next to CBS Television City. It was a haunting automotive ballet that unfolded in five choreographed sequences that Oldenburg called "poems," staged in darkness and illuminated by the headlights of participating cars, all of them black or white, a sharp contrast to the Pop colors of the soft sculptures. *Autobodys*, with its emphasis on car culture, was a summing up of the Oldenburgs' experience in LA.

Dennis photographed the happening and the preparations leading up to it. In one of his images, two cars appear to be Brooke's and

Dennis's: her black Studebaker Lark and his white Corvair convertible. (Oldenburg had "auditioned" numerous vehicles, and it's unclear if these made the cut.) The twenty "players" in the happening included the artist Judy Chicago, John Weber from the Dwan Gallery, and Patty, who, in a black sweater and white slacks, began the ritual by removing milk bottles from the trunk of a white Plymouth parked amid the fish-skeleton white lines on the asphalt. She arranged the bottles on the blacktop and then emptied the milk into a bucket.

The ensuing action, such as it was, was as slow and patience trying as a traffic jam on the 101, which seemed to be the point. Cars rolled in, cars rolled out. Ice cubes were scattered on the pavement, glinting in the headlights of the spectators' cars, which formed a perimeter. A concrete mixer truck moved into the scene, parked, and turned on its drum. Horns honked, flashbulbs flashed, roller skaters drifted by, and headlights beamed out into the nothingness. The Gilmore Drive-In on West Third Street was faintly visible to the south, showing Elvis's *Fun in Acapulco*. One spectator was overheard saying "We're going to lose the next war. I know it now."

The procession of vehicles and the colorless palette made it seem as if the action were unfolding on a TV screen: Something about *Autobodys* spoke of the Kennedy assassination, so horribly fresh in everyone's minds. After about an hour, the cars drained out of the parking lot as if leaving a ballpark. Two vehicles didn't budge due to battery failure. "At the final moment," Patty remembered, "there we stood at attention, performers and viewers alike, watching the gentle and powerful rolling of a cement mixer, spotlit, white, and clean, like a robotic elephant, taking command."

And then it was 1964.

8

"HE TOOK IT EVERYWHERE HE WENT"

After the new year, a new resident moved into 1712 North Crescent Heights: a fourteen-foot-tall Mexican Judas figure with the face of a mad clown, made of papier-mâché, wildly painted, and festooned with firecrackers. It was a particularly well traveled Judas, having originated in Mexico City before roaming the world as part of the blockbuster *Master Works of Mexican Art* exhibition that, over the course of a few years, had made stops in London, Moscow, Berlin, Paris, Vienna, and other world capitals. The show included everything from colossal stone Olmec heads to nineteenth-century oils and arrived at the Los Angeles County Museum in October 1963. It was well timed with the new vogue for Mesoamerican art and for folk art in general. At 1712, Brooke and Dennis had been accumulating an ever-growing trove of Mexican objects that they gathered on their trips to Tijuana.

When the show was being packed up to return to Mexico City, it was decided that the folk art pieces, including the five massive Judases, would not be shipped home. Dennis and Brooke seized the opportunity to buy one of the orphaned Judases, a stunningly

phantasmagorical example of the Mexican craft known as *cartonería*, whose master, Don Pedro Linares, may have been the creator of the piece. When it came to Judases, Linares was Auguste Rodin; Diego Rivera and Frida Kahlo collected his work. In his prime, Linares and his family turned out as many as four hundred of the enormous Judases for Easter week, when, as Dennis liked to tell visitors to 1712, they were paraded through the streets of Mexico City and, in a cathartic act of devout ire, blown to smithereens or burned to ashes.

As it was too big to display any other way, Dennis and Brooke had their Judas installed on the living room ceiling. Leering down from above, surreal, gleefully sinister, and strung with explosives, the clown became a focal point at 1712, evoking gasps of wonder and surprise whenever anyone walked into the living room. It would hover above everything that was to come like a knowing omniscience, inviting the prospect of immolation at the touch of a match.

IN JANUARY, DENNIS APPEARED IN an episode of *Petticoat Junction* called "Bobbie Jo and the Beatnik," playing a wannabe poet from New York, a send-up of the pretentious, finger-snapping hipster. "My poetry is a cry of anguish in the tortured night," his character declares to the yokels. "Oh, you write jingles for them indigestion commercials!" is the down-home rejoinder that cues the laugh track. Dennis must have had a sense of humor about the role, but it hit rather close to home. He had been a Beat-inspired versifier himself.

Dennis always claimed that his output had been destroyed in the Bel Air Fire and that he had never written another line. In fact, a sizable sheaf of his poetry did survive, neatly typed and protected in a production binder from *Invitation to a March*, the Broadway drama he had auditioned for in 1960. (Brooke, a passionate writer in her youth, apparently gave up writing entirely during this phase

of her life.) One of Dennis's surviving poems is pure Pop Art, suggesting that he may have continued writing after the Bel Air Fire. It was "Ode to a Comic Book," a Roy Lichtenstein–esque word experiment: "Wham Blam Zoom/Crack Thud Knock Knock/Rat tat tat tat ta/Phfft Phfft . . ." His poems teem with references to Paul Cézanne and Max Beckmann, Charlie Parker and Hank Williams. They describe Sunset Boulevard and "neon Hollywood." And they boil over with frustration, the kind that thwarted adolescents feel. One couplet from an untitled poem could have been written by Dennis's *Petticoat Junction* character—or in reaction to his participation in the show: "I am an artist alone as always/in an unartistic world."

You might wonder what Dennis's artist friends thought of his life as a journeyman television actor. Kienholz, for one, was disappointed by the medium—it was totally jive. But he understood its role in society. "To Kienholz," Robert Hughes observed, "the TV set was both America's anus and its oracle." It was, after all, unignorable, as the JFK assassination coverage had demonstrated. To Dennis, television was a way to pay the bills until something better came along. For young Jeffrey, it was something to stare at "twelve hours a day."

In some weird way, being a semiemployed actor was more chic than being a successful one. It certainly afforded Dennis time to take photographs and make art. But there was always the nagging question of how to reconcile being a special guest star with being an artist. His poems, whether they dated from his beatnik days or from after the Bel Air Fire, expressed turbulent daydreams, written, as he put it, "In golden books of brown paper torn and shelved away."

As for Brooke, after the pause of early motherhood, her acting career appeared to be ticking up. A little more than a year after Dennis appeared on *The Twilight Zone*, Brooke had her own turn on one of the most memorably creepy episodes in the series, "The Masks," earning $750 to play the narcissistic granddaughter of an

elderly New Orleans millionaire. It's Mardi Gras, the old man is dying, and his conniving family gather around him, vultures circling a fortune. The patriarch insists that they all wear grotesque masks for the occasion. "Man is least himself when he talks in his own person," Oscar Wilde wrote. "Give him a mask, and he will tell you the truth." These macabre masks actually turn the wearers *into* the truth, a very ugly one, for in the end, their faces become permanent masks that betray their inner hideousness and distorted humanity.

"The Masks" was a series high point. The director was Ida Lupino, the only woman to direct a *Twilight Zone* episode. Brooke's challenge was to convey a self-involved character through gesture and attitude, as her face was covered for most of the episode by an ugly mask and prosthetic makeup. Her work was impressive, but it had a built-in downside: it didn't help make her any more recognizable to audiences. Toby Rafelson watched the episode when it aired. "That beautiful woman," she said. "The face that appeared when she was a girl on the cover of *Life* turns into a pig face in that scene. That she was willing to subject herself to that was amazing."

On Sunday night, February 9, Dennis guest-starred on an episode of ABC's *Arrest and Trial,* but the family tuned in to something else entirely: the Beatles making their American debut on *The Ed Sullivan Show*. Beatlemania now arrived in the den of 1712 by way of CBS. If Pop Art had been Dennis's long-awaited return to reality, this was the long-awaited return of rock and roll, courtesy of a four-headed youth-culture monster. Jeffrey and Willie were riveted, Miss Mac smitten. Ever the proud Briton, she wrote to her family in Scotland about the rapture she felt about the Beatles' invasion of America: "I love them. I love the haircuts."

Music, it turned out, played constantly at 1712, thanks to the Garrard turntable tucked into a closet in the living room. Dennis and Brooke listened to everything, including the jazz that made up a good chunk of Dennis's record collection. "They would *always* be listening to the total music of the time," Willie remembered.

When Brooke drove Jeffrey and Willie to school, making their way down Sunset to Bel Air, it was to a soundtrack of the latest *Billboard* hits—usually care of KHJ, 930 AM, a station that would rechristen itself "Boss Radio" in 1965. Dennis always remembered a musical moment early in his relationship with Brooke. "I was an avid rock 'n' roll fan," he said. "I had forgotten to change the station back to popular music or to classical, and she turns on the radio and it's rock 'n' roll, and I think, Oh, my God! And she says, 'Oh, how did this get on here? I love this music!' And I said, 'You do?' I was embarrassed about the fact that I liked rock 'n' roll."

Now, with the arrival of the Beatles, the spirit of rock and roll began to reinfuse the culture. The new sound was rawer and more aggressive than the big AM productions of Motown and Phil Spector, yet there was a weird artfulness to it. When Allen Ginsberg first heard the Beatles, he said, the sound "went right through my skull, and I realized it was going to go through the skull of Western civilization." Bob Dylan was driving along a California highway with a friend when he first heard "I Want to Hold Your Hand" on the radio. Folk music's leading troubadour articulated the spirit of the moment: "Fuck! Man, that was fuckin' great! Oh, man—fuck!"

In 1964, it felt as though the ground was beginning to shift under everyone's feet, the decade's heart rate quickening, hierarchies rearranging themselves. Dennis and Brooke felt the rumbles at 1712. "Hollywood," as the music historian Barney Hoskyns put it, "went rock 'n' roll and rock 'n' roll went Hollywood."

YET THE RITUALS OF OLD HOLLYWOOD continued to hold sway. On the last Friday in April, Brooke and Dennis went to a party thrown by Dominick and Lenny Dunne at their house on Walden Drive in Beverly Hills. The occasion was the couple's tenth wedding anniversary, and the engraved invitation requested black tie for men

and black or white attire for women. The "black-and-white ball" was inspired by the designs Cecil Beaton had created for the Ascot scene in the film version of *My Fair Lady*, which would open later in the year. Nick Dunne, who had worked with Maggie Sullavan on a TV presentation of *State of the Union* in 1954 and attended to Brooke at the Selznicks' after the Bel Air Fire, was an executive at Four Star Television—solid if not conspicuously swank employment. His full-time avocation was working to position himself and his wife at the apex of Hollywood society, which he did with admirable aplomb. Nick, from an Irish family in Connecticut, and Lenny, who had grown up in Arizona and had the ethereal mien of a countess, were like a younger version of David O. Selznick and Jennifer Jones, keeping old-school glamour alive in the jet age. They were ten years older than Brooke and Dennis, with three picture-perfect children, and they were party throwers par excellence. Brooke and Dennis were frequent guests at their weekend brunches, bibulous affairs that sprawled across the Dunnes' velvety lawn like something out of the pages of *Town & Country*, which occasionally did cover their doings.

In a white organdy dress from Jax—the boutique synonymous with the Hollywood set—Brooke looked youthful and fresh amid the sea of Balmain and Bugnand as 275 of the Dunnes' closest friends piled into the house. "There were trellises in every room," Brooke remembered, "with little sparkling lights and wisteria. A long red carpet covered the driveway, and all Hollywood turned up"—David O. and Jennifer, Ronald and Nancy Reagan, Billy and Audrey Wilder, Jimmy and Gloria Stewart, Alfred and Betsy Bloomingdale, Natalie Wood, David Niven, on and on. It was a testament to Dennis and Brooke's exceptional, perhaps even singular, mobility that they were able to party with Andy Warhol and Marcel Duchamp, embrace rock and roll, and then hang with this crowd, moving with ease from the fringes of bohemia to the heart of ultra Hollywood and back again. As Brooke noted, "We were in a unique

position to cross every strata of society." Her and Dennis's approach to social life was as off the cuff and free flowing as the Dunnes' was studied, with Nick keeping every invitation and social column clipping in a series of scrapbooks.

Nick and Lenny's anniversary party was a sparkling moment in early-sixties Hollywood. Dancing with everyone, Truman Capote stole the show. The writer was staying with the Selznicks on Tower Grove Drive; at a dinner there, he told Curtis Harrington how much he'd loved *Night Tide*. It was a year before *In Cold Blood* appeared in *The New Yorker*, but Capote brought along Alvin Dewey, the Kansas Bureau of Investigation agent who had solved the 1959 Clutter family murder case, to the Dunnes' party. Dewey and Dennis, whose grandparents had leased land from the Clutters, would have had much to discuss.

Two years later, Capote hosted a black-and-white ball of his own at the Plaza Hotel in New York—an over-the-top exercise in exclusivity that was impossibly glamorous and grossly anachronistic, like something out of the Gilded Age. Leland and Pamela Hayward went (they shared a table with Frank Sinatra and Mia Farrow), as did Andy Warhol and Henry Geldzahler, along with five hundred–something other celebrities, swans, and alpha personalities, from Tallulah Bankhead to Norman Mailer. Brooke had zero doubt that Capote had gotten the idea for his famous black-and-white ball from her friends Nick and Lenny Dunne—whom he had not invited.

ONE DAY IN 1964, ED RUSCHA drove up to 1712 to visit Dennis. "There was this garage door right on the street," Ruscha remembered. "He opened up this garage and it was crammed with all kinds of things—paintings and sculptures that he had done, really far-reaching things." Surveying the scene, Ruscha was struck by a piece of Dennis's that ended up in the living room of 1712, *Draw Me and Win an Art Scholarship*, a free-standing Plexiglas rendition

of the kind of ad you might see in the back of a comic book. "He was addressing popular culture in a head-on manner," Ruscha said.

Little Marin was drawn to the garage, her father's laboratory. "He was always in there making stuff or showing stuff," she recalled. "There was *a lot* of debris, which he'd put together for a collage or a sculpture or an assemblage piece. It wasn't where you stored your bikes! It was where you saw this incredible stuff to dig through, like a scavenger hunt. There was a padlock, and I'd pretend I was a magician trying to unlock it." She remembered Buck Henry, a screenwriter friend of Bob Rafelson's who had worked for Leland Hayward on the NBC satirical series *That Was the Week That Was*, coming by to say hello to her parents; she would beg him to help her pick the lock. "I wanted to get inside and look at everything," she said. Henry, for his part, remembered Brooke as "extraordinarily supportive" of Dennis's efforts. "She called every one of them a masterpiece," he said. "I didn't quite agree with her about a lot of it, but you would want her on your side."

That spring, Dennis had work in a group show at Mount St. Mary's College. Come summer, he was included in the *Los Angeles Scene* exhibition at the Quay Gallery, up in Tiburon, a show that also included the work of Ed Kienholz, Judy Chicago, John Altoon, Llyn Foulkes, and Ruscha's boyhood friend Joe Goode. *Artforum's* summer issue was devoted to "The Los Angeles Scene Today" and featured an essay by Donald Factor about assemblage that devoted a laudatory paragraph to Dennis's work. Yet there didn't seem to be another solo show in sight. Ruscha wondered why his friend wasn't showing more. "I think he was a target for people who thought the sanctity of art should be kept where it was," he said. "That somebody who's made a reasonable success in their own line, like in the film world, would come and try to invade the art world—maybe they didn't like that." As Dennis put it, "Photographers always thought of me as an actor, painters thought of me as a photographer, and

actors . . . well, Paul Newman would say to me, 'You should *really* concentrate on your painting.'"

The truth was that Dennis was concentrating more and more on his Nikon, plying the camera whenever and wherever he could. He'd been given the nickname "The Tourist" among his artist friends, owing to the fact that he carried the Nikon at all times. "He took it everywhere he went," Brooke said. "It was part of him." In fact, Willie drew a picture of his stepfather in which Dennis's head actually *was* a camera. His prints (done at a lab, as he never took to being in a darkroom) piled up in boxes on the living room mantel, next to an antique gumball machine and an old Pennzoil gas pump globe that had been made into a lamp. As an actor, Dennis found that he didn't like being photographed himself—and that he didn't like photographing actors so much. It was artists that he wanted to shoot—Warhol, Oldenburg, Bengston, Ruscha, and the rest. "I was really interested in it from a historical point of view," he told the curator and art historian Alexandra Schwartz, "because the photographs of the artists are really at the beginning of their careers." Frank Gehry, a thirtysomething Canadian architect who gravitated toward the Ferus crowd, said, "It was his part in being part of their scene. Dennis was really in it and I think the artists all considered him one of them. He *was* one of the artists."

That year, Dennis photographed James Rosenquist at the Foster & Kleiser factory, standing among the myriad painted panels that looked remarkably like the Pop artist's own celebrated work. Dennis and Brooke bought Rosenquist's *Study for Marilyn*, a glinting collagist composition—red lips and fingernails, drinking glass—that signaled glamour and disintegration in equal measure, a fitting homage to Marilyn Monroe. They hung it over the repaired *Quickie* at 1712.

Dennis shot Jasper Johns with Irving Blum erupting in laughter on the porch at 1712; Wallace Berman on a motorcycle looking

like a grown-up juvenile delinquent; George Herms and his family at their Malibu Canyon hideaway, Groove Grove; Robert Irwin atop a ladder with a light bulb in his mouth; John Altoon in a cloud of cigarette smoke; John McCracken at Frank Lloyd Wright's Storer House; Billy Al Bengston looking rakish in a straw hat on the beach in Venice. The polka-dot-bikini torso of Lynn Factor, the wife of Don Factor, was perfectly framed behind him. "They had much more money than anybody!" Bengston said of the Factors, who were Dennis and Brooke's friendly rivals among Angeleno collectors.

He photographed Larry Bell in mirrored aviators, the surface reflections of the sunglasses evoking the artist's iridescent glass cube sculptures, at the Feldman Glass Company and in a parking lot across from Mike the Tailor, a haberdashery near his Ocean Park studio. Bell was wearing the thrift shop finery that had earned him the nickname "Dr. Lux." The shoot, Bell remembered, was a cinch. "I put on the duds," he said, "and we went walking around the street and he took pictures." Dennis and Brooke bought one of Bell's earliest cubes, patterned with forty-degree ellipses inspired by the Andromeda galaxy. It went into the living room at 1712, and Dennis took stunning portraits of Brooke next to it.

The snapshot aesthetic wasn't for Dennis; he wanted formality of composition—without cropping. He might not have seen it as such, but he was practicing classic environmental portraiture, in the mode of, say, Arnold Newman, but with a casual offhand gaze and a peculiarly cinematic panache. "I take somebody somewhere and carouse them into having a photograph," Dennis said of his modus operandi. "I take them to a place or a location because generally I find that even if it's a bad photograph of a person, the place looks interesting and the person looks better." He would select a backdrop suggestive of the artist—a billboard for Rosenquist, a beach for Bengston—and let the chips fall. The artists grew to be fans of Dennis's work. "I think it's laughable how original it is," Ruscha

said. Brooke examined every proof sheet, helping Dennis select the best frames to print. His subjects, she said, "were always relaxed because he did not pose them."

Walter Hopps was fascinated by Dennis's approach. He saw Dennis as an American-vernacular Cartier-Bresson, and Dennis did love, as he put it, "the idea of the decisive moment"—when subject, action, and composition coalesce in the viewfinder like lightning in a bottle. Hopps was also fascinated by another side of Dennis's photography: the images of walls, signs, graffiti. They were a continuation of the first pictures Dennis had taken in Manhattan in 1961. Pointing his Nikon at spray-painted scrawls, torn posters, giant billboards, and highway signs was, for him, a way to come to grips with the blandness of Los Angeles, the fact that "there's only so much you can look at here. It seems like every historical thing is torn down to make a parking lot. Unless you really love palm trees, it gets pretty grim!" Walls, he said, "started really becoming my life, talking to me about dying, decay, forms of indifference. They became Duchamp, became the accident. They became the dangerous word beauty."

Hopps remembered taking Dennis to the ruined shell of an old hotel in LA whose crumbling walls were encrusted with layers of graffiti. They went crazy for one particularly in-your-face phrase that someone had painted in gigantic block letters: FUCK THE WORLD . . . AND FUCK YOU IF YOU DON'T LOVE IT. When Dennis went back to photograph it, the hotel had been razed.

IN 1964, DURING VISITS TO NEW YORK, Brooke and Dennis met up with Andy Warhol at his new studio on East 47th Street between Second and Third Avenues. It was an unprepossessing place that Warhol and Malanga had found after they'd returned from their trip to Los Angeles the previous fall. The space had been lined with aluminum foil, coated with silver Krylon spray paint, and

dubbed "The Factory." Brooke imagined Warhol himself with a silver halo, a kind of ethereal, glittering saint. At the Factory, Warhol shot Brooke and Dennis for his film *Couch*, which involved an array of semiunmentionable activities taking place on a ratty sofa. Brooke cavorted with Henry Geldzahler in footage that was ultimately not used, and Dennis again goofed around with Taylor Mead in footage that was.

Warhol also shot Brooke and Dennis for his series of short silent films that became known as the "Screen Tests." Two of Brooke's "Screen Tests" were included in the compilation *The Thirteen Most Beautiful Women* and two of Dennis's in *The Thirteen Most Beautiful Boys*. As Dennis remembered the procedure, Warhol, Malanga, or another of the Factory's minions mounted the Bolex on a tripod and pointed it at a distant stool, upon which the subject was to remain for the duration of a reel—about four minutes. It was Warhol at his most Edison-like. "Andy just told me the title and turned on the camera and walked away," Dennis remembered.

Warhol did four "Screen Tests" with Brooke. In the first, she appears against a white backdrop—a mug shot that occasionally blinks. In the other three, she is off center against a black backdrop, dramatically lit, her face moving through a series of subtle attitudes, happy to vampy to pensive. In Dennis's three "Screen Tests," he wasn't content to be a cipher. "Being the egomaniac that I am, I sat there and did a Strasbergian emotional memory," he said. His tests are performative; they are full of emotional swings and even have a narrative shape. In the first, he looks bored and edgy, singing lines of a song that might have been coming out of a radio. He felt that he had badly misjudged Warhol's intentions. "I'm sure that he didn't like that when he saw it," he said. "What he wanted was somebody just sitting." Dennis had given Warhol too much content; not that the artist ever seemed to care.

The use of a motion medium to create a "still image" appealed to Brooke and Dennis, given their dual presence in Hollywood and

the art world. Warhol did more than four hundred "Screen Tests" between 1964 and 1966 with such subjects as Susan Sontag, Bob Dylan, Marcel Duchamp, Allen Ginsberg, James Rosenquist, Niki de Saint Phalle, and the ever-rotating cast of Factory creatures, including Malanga and Mead. When Irving Blum sat for his "Screen Test," he had a giggle fit. Henry Geldzahler remembered his experience: "When someone turns the camera on you and doesn't tell you what to do or anything—Andy just goes off and plays rock 'n' roll—you find yourself making all sorts of faces and gestures just automatically. The film gives me away entirely." Brooke and Dennis's "Screen Tests" are similarly revealing. With twenty-eight minutes of close-up time, the films provide an intense feeling of being with Brooke and Dennis in 1964.

In September, Dennis was back in New York with Blum on an art-world sojourn. It's not clear if Brooke went along; she doesn't appear in Dennis's photographs of the trip. At the Factory, Dennis created an iconic image of Warhol, Malanga, and Mead, with the underground filmmakers Gregory Markopoulos and Jack Smith (who is holding the August 1964 *Harper's Bazaar*) arranged on the notorious Factory couch, which Dennis shot from above, possibly atop a ladder. A significant new Warhol work appears in the background—the lithograph *Flowers*, an idea Warhol had gotten from Geldzahler. (Dennis bought one of them and gave it to his family in La Mesa.) "Dennis wanted to document the Factory scene," Malanga said, "because he realized it was important and that it wasn't always going to be there." Malanga could already feel the Factory vibes changing, ultimately making it a place he said bordered on "a fascistic type of sensibility" thanks to the control and mind games that Andy—inscrutable, voyeuristic—exerted from the top. But in Dennis's photograph of the Warhol crew in 1964, we still see youth, collaboration, and friendship: the Factory as a louche haven of creativity.

Dennis and Blum bounced all over town, from the Museum

of Modern Art to a visit with the art-world couple William and Noma Copley, who were collaborators with Man Ray. One hot afternoon, Dennis fired off a flurry of shots inside a taxi while he and Blum rode along with Peggy Moffitt, the wife of Bill Claxton and model-muse of the fashion designer Rudi Gernreich, and the art critic Barbara Rose, who was married to Frank Stella. In the best known of these, Blum and Moffitt are entwined in mock seduction in the back seat. Moffitt remembered it: "We were going up to visit Jasper Johns and have lunch with him. It was a day where your heels stuck in the asphalt. Dennis, with his camera, was sitting by the cabdriver. He turned around, and we just did something campy." Visiting Johns was a holy pilgrimage. He was, after all, the artist whose encaustic paintings of flags and targets had inspired Warhol, Ruscha, Bengston—really everyone and everything that had led to Pop Art. Dennis had Johns, wearing a white undershirt to beat the heat, pose with Moffitt on the roof of his building with the Yuban coffee tins and Ballantine beer cans he kept his brushes in. Dennis and Blum also zoomed over to Roy Lichtenstein's West 26th Street studio, shooting the artist in advance of his November Ferus Gallery show. Various 1964 works are seen in those pictures, including the beautiful sunrise landscape called *Dawning*.

One other visit left a lasting impression on Blum. One day, he and Dennis went over to Leland Hayward's Madison Avenue office to make a son-in-law courtesy call. Sitting at a mahogany desk beneath a ceiling-mounted Calder mobile, Leland, ever the camera enthusiast, fixed a scrutinizing, skeptical gaze on the Nikon around Dennis's neck. Earlier that afternoon, as Dennis had stepped out of a cab, the camera's strap had broken and the machine had fallen to the pavement, acquiring some scuffs. Leland got up from the desk, fished around a closet, and pulled out a brand-new camera case. He handed it to his errant son-in-law and told him in meaningful tones, "You have to take care of your equipment, Dennis."

ED RUSCHA'S SECOND FERUS SHOW opened in October. On the gallery's back wall he hung an enormous painting, the biggest he'd ever done, ten feet long by almost five and a half feet high. It knocked everybody's socks off.

The picture was called *Standard Station, Amarillo, Texas*, and it depicted what was literally the most standard of stations; there was one, in fact, right at the corner of Sunset and North Crescent Heights, where Brooke and Dennis surely filled their gas tanks. The painting—depicting a brightly lit Standard Oil Company service station whose wafer-thin roof juts into an inky night sky—endowed a lowly specimen of roadside architecture with jarring monumentality. *Standard Station, Amarillo, Texas* was as breathtaking as it was improbable, as beautiful as it was banal. "It sort of aggrandizes itself before your eyes," Ruscha said. "That was the intention of it, although the origins were comic." The vaulting diagonals, which split the canvas in two, suggested the old Hollywood filmmaking trick of shooting an onrushing locomotive from a low angle: a masterful example of bringing machine-age velocity to a still image and a trick that Ruscha employed in a run of paintings, including one of Norm's, the diner down the street from Ferus. Brooke and Dennis had to buy *Standard Station* and did, paying $780 for what is considered an icon of postwar American art. "I was *floored*," Ruscha said. "I never knew that I would ever be able to move something like that through the gallery. I would make these artworks and I was doing it for sport. I never expected to make a career out of it."

In a decisive way, Brooke and Dennis had given momentum to Ruscha's viability as a working artist. *Standard Station, Amarillo, Texas* went into the den at 1712 over the couch, next to a Tiffany lamp or two, the red barbershop chair, a Cail-O-Scope peep show machine, and sundry other things. The painting spanned nearly an entire wall, as it had at Ferus. "That was the creepiest room," Willie recalled of the den. "A copy of *Barbarella* on the shelves! That house

was *not* childproof." Ruscha was proud to see it there and excited to know two young people in Hollywood with enough interest to champion—and just enough money to buy—the vanguard works he and his fellow artists were making. "They were high energy," Ruscha said of the couple.

When Dennis and Ed got together, they lapsed into the kind of talk they'd heard while growing up on the Great Plains. "We would slip into the dialect," the Oklahoma-born Ruscha said. They made a duo, both of them great looking, blue eyed, with nice-boy manners. Ed's girlfriend and soon-to-be wife, Danna Knego, noted the connection. "Sometimes I thought I'd be heading over to Ed," she remembered, "but it would be Dennis. They projected a similar vibe, so that one could mistake them at a distance." Yet their personalities diverged. Terry Southern, the literary bawd who had co-authored the gleefully salacious novel *Candy* and the screenplay for *Dr. Strangelove*, wrote of Dennis that "To walk down a city street with him is like being attached to a moving adrenaline pump." Ed, on the other hand, was Mr. Cool: calm, relaxed, inscrutable. His own mother called him a "master of evasion." Those were the qualities that suffused his enigmatic art.

The critic Dave Hickey called Ruscha a "Child of Pop from the Cities of the Plain"—a formulation that also applied to Dennis. When Ed was growing up in Oklahoma City, he loved not only the funny pages, which inspired him to take up pen and brush, but also Hollywood movies and late-night radio sweeping across the prairie. It was a kind of boyhood that Dennis knew well, having lived it himself. And just as it had for Dennis, abstract expressionism held sway over Ed in the late fifties. At that time, Ed was studying art at the Disney-sponsored Chouinard (now Cal-Arts), where Robert Irwin taught; it was a generator of the nascent LA art scene. Seeing Jasper Johns's *Target with Four Faces* in a magazine, he said, was an "atomic bomb in my training." He realized that he could work in a "premeditated" way—that is, by proceeding from a plan and paint-

ing actual things found in everyday life: proto-Pop. He began add-
ing words to his paintings, starting with place-names. Soon enough,
the words took over and became entire pictures—*Boss*, *Smash*, *Honk*,
and perhaps the best known, *Oof*, a trilogy of sans-serif block letters
in cadmium yellow against cobalt and Bellini blue from 1962. He
had found the sweet spot that would define his career: redirecting
words from the workaday realm of commercial art into the upper
stratosphere of art history. Like a nineteenth-century salon artist
fixated on a famous model, he took as his subjects the component
parts of the Information Age. His early word paintings played like
flat still lifes and also evoked the billboards and visual junk of LA
that Dennis was so fixated upon. "When I look at Los Angeles I
see Ed Ruscha," Dennis declared. He went further: "Commercial
America would not exist without the word. Pop Art would not exist
without Ruscha."

Thanks to the *New Painting of Common Objects* show, where
Dennis and Brooke had been wowed by *Actual Size*, his reputation
spread. Warhol marveled at the photos in Ed's 1963 book *Twentysix
Gasoline Stations*: "Ooh, I love that there are no people in them." In
time, Michelangelo Antonioni visited Ed's studio and John Lennon
bought a stark black-and-white word picture, *Jelly*.

Ed was a natural subject for Dennis's lens. One afternoon, Dennis
walked the artist from Ferus, on La Cienega, over to Santa Monica
Boulevard, just west of San Vicente, and had him stand in front of
the window of the venerable Koontz Hardware, with its TV RA-
DIO SERVICE neon sign and reflections of the Pacific Saw & Supply
Company across the street. It became one of Dennis's most repro-
duced photographs and arguably the best-known image ever made
of Ed Ruscha. So many of Dennis's preoccupations fused together
in that one picture, which was as crystalline as it was jumbled—the
heroic, handsome artist and the mad array of LA street typography,
flattened out like a billboard. Ed remembered Dennis going all out
when it came to his Nikon adventures, whether he was on the hunt

for graffiti, probing the essence of an artist, or finding new ways to photograph Brooke and the kids. "And then he was like, 'By the way, I got a call sheet that tells me I have to be gone at five in the morning for an acting job,'" he said. "Talk about a working man."

Another photograph Dennis had taken was used to promote Ed's Ferus Gallery show that fall. Like the huge painting Dennis and Brooke had bought, it depicted a Standard station, this one with a pair of STANDARD signs that opened out like eagle's wings. Dennis shot it from the driver's seat of a convertible heading east on Santa Monica Boulevard at the three-way intersection with Melrose Avenue and North Doheny Drive in West Hollywood. This was Dennis's *Double Standard*. It is his best-known and most celebrated photograph.

Double Standard plays with the relationship between depth and surface, a perennial Los Angeles theme and one of Dennis's aesthetic preoccupations. Santa Monica Boulevard and Melrose Avenue are seen vanishing toward a far-distant mountain horizon. Yet the cacophonous panorama—including the traffic Dennis saw behind him in the rearview mirror—is seen through windshield glass, giving the photograph the flatness that Dennis liked. There's little to anchor the composition except the winglike STANDARD signs, which gave the picture its punning title. Otherwise, it's full-on information overload, with a riot of signage, a billboard declaring "Smart women cook with Gas in Balanced Power Homes," traffic lights, power lines, a pedestrian at a crosswalk, and a westbound '61 Chevy Impala staring implacably across Doheny directly at Dennis's lens. Gerard Malanga thought that Dennis was particularly skilled at this kind of photograph, what he called "the grab shot"—a stand-alone image capturing an unrepeatable moment.

It was the perfect image to publicize Ruscha's Ferus show. The art historian Cécile Whiting described *Double Standard* as "the best distillation of Ruscha's visual sensibility . . . and of the L.A. art scene."

Double Standard is typically dated to 1961, but the contact sheet—not to mention the association with the October 1964 Ruscha show—indicates otherwise. It was taken on a day in which Dennis was driving the visiting Henry Geldzahler around Los Angeles, showing him the sights, including Foster & Kleiser. He popped the occasional shot of Geldzahler laughing in the passenger seat as they cruised along; the photographs reveal details of the car's interior, confirming it to be Dennis's 1964 Corvair. At the three-way intersection in West Hollywood, they caught a red light. Dennis might have pointed out the "Smart women" billboard, which he thought he might be able to buy for $700 once it was taken down. He raised his Nikon and got the picture: an overabundant Los Angeles tableau that existed for a flicker of a moment before the lights changed and the motorists, including Dennis, went on their way.

THAT FALL, *VOGUE* RAN GELDZAHLER'S essay "Los Angeles: The Second City of Art." It enthusiastically granted the supposedly cultureless city number two status, behind New York, in contemporary art. "The excitement," Geldzahler wrote, "is undeniable there; the ferment and the sense of the magnet or vital centre drawing artists from everywhere, from Oregon and Washington, from Kansas and Oklahoma, from Texas and New Mexico." San Francisco, by comparison, was phony; Chicago an also-ran.

Brooke and Dennis, Geldzahler noted, were significant LA collectors, alongside such heavy hitters as Robert Rowan, Donald and Lynn Factor, and Leonard and Betty Asher. After acquiring *Standard Station, Amarillo, Texas*, Brooke and Dennis, in quick succession, bought two more large-scale works that altered 1712 North Crescent Heights and bolstered their status as American art patrons.

The first was a Lichtenstein oil called *Sinking Sun* that Dennis had seen at the artist's New York studio. Blum included it in the Lichtenstein show at Ferus in November. The piece was over five

and a half feet wide and six and a half feet tall and depicted that most clichéd and redolent of Angeleno images, the sunset. In *City of Night*, John Rechy described LA as "the last stop before the sun gives up and sinks into the black, black ocean." With its foaming clouds and streaked sky, *Sinking Sun* is a comic-book version of a traditional academic painting, a perfect melding of high art and pop culture—much like Brooke and Dennis's house. The image stood out amid 1712's visual plenitude, a dazzling California statement, at once hopeful and nostalgic and bittersweet, evoking another famous line from the annals of Los Angeles literature, found in Nathanael West's *The Day of the Locust*: "The sun is a joke." Brooke said it was her favorite of all the pieces they had collected. "I just loved the idea of it," she said. According to her, they bought it for $3,000; Dennis claimed that the price had been $1,200. Either way, Brooke said, for her and Dennis, "It was a fortune."

The other was Frank Stella's *Tetuan III*, part of his Moroccan paintings series shown at Ferus in January 1965. These works were inspired by a trip Stella had taken to North Africa with Geldzahler; their hot colors and sharp diagonal patterns suggest Moroccan tiles. Six and a half feet tall and wide, the pulsating *Tetuan III* wasn't Pop, it was something different: minimal, optical, decorative, the fluorescent alkyd paint—slashing stripes in blue, red, and white—sitting up on the canvas like enamel on a fingernail. Together with *Sinking Sun*, *Tetuan III* dominated the front wall of the living room at 1712.

Dennis took some of his most alluring portraits of Brooke in front of *Tetuan III*. She looks dreamy, quizzical, and mischievous, with an aura of melancholy, even mournfulness. "I don't think there's anyone who knows Brooke who doesn't recognize that shadow," Jeffrey Thomas said. As Jill Schary put it, "there was a wistfulness about Brooke, a yearning." It had been only four years since the deaths of her mother and sister. Yet in that time, she had completely rebuilt her life. "She never wanted to be caught being sentimental or

emotional or self-pitying or out of control," Toby Rafelson observed of her close friend, "which is remarkable, particularly in light of the imaginative, playful, artistic side of her. She has all these elements inside of her that are seemingly disparate and contradictory. She's unpredictable and perhaps even unknowable."

On November 9, Leland sent Brooke a telegram: "Brooke darling I thought you were divine last night Much love Pop." He was refer- ring to her appearance on *The Rogues*, a stylish NBC series about three con men played by David Niven, Gig Young, and Charles Boyer. Nick Dunne was one of the show's producers. Brooke was at her best in the episode "Two of a Kind" as the sassy mod girlfriend of the son of a French Resistance operative (played by Ida Lupino, who had directed her in *The Twilight Zone*). George Hamilton played the son; his and Brooke's chemistry was wonderful: impish, flippant, even saucy. For Brooke, it was a performance that suggested she was ready to resume making movies, which she had not done since *Mad Dog Coll*. Her career was building, slowly and steadily, with the roles on *Bonanza*, *The Twilight Zone*, and *The Rogues*—"All that shit," as she later put it.

And then it stopped. While Brooke was working on *The Rogues*, an actor associated with the series—Brooke has steadfastly refused to name him—gave her a lift home when her car wouldn't start. Dennis became enraged. He was jealous, Brooke said, "that I was out there, with a career, with other people, like that actor." Dennis's career frustrations had bubbled over into something unanticipated and ugly. "He was very competitive," Brooke said. "And he was an- noyed that I was getting asked to do stuff." For Brooke, it must have felt like a flashback to her first marriage. Dennis had called his best photograph *Double Standard*, and here was a monstrous version of that concept, right at the center of an otherwise collaborative, coequal relationship. Brooke opted to keep the peace. "He was very resentful of me being an actress," Brooke said. "So I gave it up." Aside from a couple of cameos in future decades, her appearance

on *The Rogues* was the last acting job Brooke, at age twenty-seven, would ever take.

It was the first significant ripple in a marriage that had, from the start, been complex. "Two artists living together" was how Jill Schary described the relationship and its vulnerability to turbulence. She viewed Brooke and Dennis—"Crazy about each other"—as a bohemian version of Liz Taylor and Richard Burton, a dynamic and combustible melding of her elegance and his earthiness.

Dennis's outburst aside, Brooke never could shake her ambivalence about acting. Leland had not been encouraging. "He didn't really appreciate my idea of being an actress," Brooke said. "I mean, he was not stupid." She had absorbed Maggie's credo about the impossibility of being a Hollywood actor and running a family—the classic working-woman conundrum, which Brooke forever grappled with. Was it that impossibility that had led to her mother's death at age fifty? Should not such a fate be avoided? As the daughter of Leland Hayward and Margaret Sullavan, she was in a vortex of conflicting expectations. "Brooke had had such a hard childhood," Jill Schary said. "She didn't know who she was and how to be, except that she knew she was a great beauty. I don't think she knew exactly what to do with it." Was it Brooke's birthright to be a star? What if she failed? Michael Thomas had seen that inner conflict during his marriage to Brooke. Being the daughter of a great star, he said, had made Brooke feel like "a victim of who she isn't."

"Acting wasn't something that was ever *vital* in my life," Brooke later reflected, making the decision to give it up sound like an easy one. "It was obviously not the most important thing I would do." Eventually she would return to her adolescent passion, writing. For now there were other things to hold her attention: the art world, the house, the family. Inactivity was never an option. Toby Rafelson viewed Brooke's girlhood posse—Jane Fonda, Jill Schary, and Josie Mankiewicz—as a sisterhood of protofeminist doers. "These girls who were connected from birth, they all had a sense of agency, of

creativity," she said. "They all had a sense that they would be work-
ing, producing something aside from children." Jill and Josie were
journalists. Jane, free of family demands, already had eight movies
under her belt. It looked as though David O. Selznick's prediction—
that Brooke, not Jane, would be the Hollywood star—had been off
the mark.

For now, there wasn't much more to do than to keep moving
forward, which had always been Brooke's way. "I, for one, certainly
never paused for an instant of introspection," she later reflected. "It
was vital to keep swimming, even upstream; movement for its own
sake seemed imperative."

THERE WERE OTHER MOVEMENTS AFOOT at 1712 that month.
Miss Mac was leaving. She married her longtime beau, Stan Paul,
a rite the family attended. The beloved nanny's departure was not
without drama. Miss Mac griped that Brooke and Dennis were in-
considerate and self-centered, having not given her enough time off
to prepare for the wedding. She gave notice abruptly; she couldn't
handle the dueling demands of working for the Hoppers and be-
ing a new wife. When she presented the news to Dennis, he was
displeased. "We are stuck," he told her. "We've no one to take your
place."

Brooke took up the slack with the help of a revolving cast of sit-
ters, including Lael McCoy, a teenager up the street, who thought
Brooke was about the most beautiful woman she'd ever seen and
1712 the most fascinating, kaleidoscopic house she'd ever been in.
For Lael, it was a welcome escape; her father, the radio newscaster
Hugh McCoy, had died in a housefire in October after falling asleep
with a lit cigarette. At 1712, Lael would gaze at the Warhols, sit in
the barber chair and watch TV, play with the family's pit bull, Cas-
sius, and calico cat, Ellie. "I loved wandering around that house,"
she remembered, "the Art Nouveau, the furniture, everything. I

absolutely fell in love with it." She found Marin adorable and the boys sweet.

In December, *Artforum* ran a portfolio of Dennis's art-world photographs, with his Warhol flower portrait on the cover. He had booked a part on the series *Attorneys at War* (later renamed *Court-Martial*), which required him to fly to London early that month. The London visit gave Dennis an opportunity to expand his art connections. It was, he said, "a big trip for me." Just as he and Brooke had explored New York and the Factory scene, he now immersed himself in the Swinging London of Mary Quant, David Bailey, *Queen* magazine, and *Ready Steady Go!* He hung out with the dandyish gallerist Robert Fraser, met the Pop artist Peter Blake, went to the British Museum, and buzzed around with the brunette actress Helena Kallianiotes, clicking the Nikon constantly.

Dennis found a scene crackling with art, music, style, and fun. A current of creativity seemed to be flowing among Los Angeles, New York, and London. "The British," he remembered, "were much more aware of American culture than we were. I went over there and I got introduced to American music." In addition to the British beat and R&B groups—the Beatles, the Rolling Stones, the Kinks, and the rest—you could hear Otis Redding and Booker T. & the MGs on the radio and in clubs, or their music given a showman-like spin by the local heroes Georgie Fame and the Blue Flames, whose amalgam of ska, jazz, and American soul Dennis couldn't get enough of. During that trip, he also made a run to Paris with the gallerist John Kasmin and shot the Animals in performance at the Olympia. It all felt electric.

The timing of Dennis's London visit was perfect. Jasper Johns's first British show opened at the Whitechapel Gallery on December 6. It was augmented by a showing of Johns's work at the US Embassy, prompting some local agitation about the invasion of all-powerful American art. (The Whitechapel Gallery had hosted a well-publicized Rauschenberg show earlier that year.) Dennis met

up with Johns and photographed him riding the Tube. Another American artist friend, Bruce Conner, had an assemblage show at the Robert Fraser Gallery at 69 Duke Street, which brought out a flock of British artists, including David Hockney. Fraser possessed Etonian manners combined with a streetwise taste that ran toward rockers and rent boys. He had connections to the Ferus Gallery going back to the 1950s. "It seemed he had access to almost anybody," Conner said.

Conner documented the trip in his *London One Man Show*, a four-minute film that jitters and judders with frantic energy. At a minute and twenty-eight seconds in, a man comes abruptly into view, holding a camera in front of his face. It is likely Dennis. Earlier in the year, in Los Angeles, Dennis and Dean Stockwell had held the lights when Conner had made one of his most dazzling films, *Breakaway*. It featured Toni Basil, a choreographer and dancer with connections to LA bohemia, go-going in various states of undress against a black background. The lighting and edits had created a hypnotic, strobing effect, as if human physicality had become pure movement. *Breakaway* had been shot at a location Dennis knew well: an apartment above the Santa Monica Pier carousel that was the residence of James Elliott, a curator at the Los Angeles County Museum. "Who would have known that these films would become so iconic?" Basil said. "It was all guerrilla stuff."

"His are the most important films of the twentieth century," Dennis said of Conner's work. During the *Breakaway* shoot, Dennis had shot Conner holding a jigsaw puzzle up to his face. He had also taken a series of archly hilarious portraits of Conner as a playboy wannabe surrounded by Basil and a small gang of Californian beauties, some of them dancers on the musical variety show *Hullabaloo* (an Americanized *Ready Steady Go!*), including Ann Marshall and Teri Garr. One of them was taken in Garr's bathroom, with Conner enjoying a soak in the tub while the women nonchalantly stand around in their underwear.

In London, Dennis created another bath series—of a mystery brunette, nude. She fills the tub, gets in, throws a glance at the Nikon's lens. It's hard to say what reaction Brooke, who always pored over contact sheets with Dennis, might have had to these erotic images, let alone how her husband might have explained them: perhaps a lame excuse about the pursuit of art? Another double standard.

Upon Dennis's return to 1712, Marin excitedly told Marjorie Hopper that her daddy had brought back from Europe a big, beautiful bottle of "pu-ferme," ostensibly a present for Brooke.

9

"THEY WERE ALL KIND OF NAKED, DANCING AROUND HENRY FONDA"

At 1712, there was constant movement as Brooke relentlessly arranged and rearranged the house. In Dennis's photographs, the living room rarely looks the same twice. "Brooke had a great eye for objects," Irving Blum said, "and there was always something to look at that hadn't been there my previous visit." As Jeffrey Thomas recalled of 1712, "Mom never stopped working on it."

There was also a constant swirl of guests. Brooke organized parties, dinners, and children's birthdays with the same playful energy she brought to antiques, tiles, and paint. "She had extraordinary people," Blum said. "Jane Fonda was there very often. I remember I went to a dinner party with maybe twelve or fourteen people. There was a bang on the door and it was Buck Henry: came in, never said hello, walked down this passage into the kitchen, opened the refrigerator, took out a chicken leg, began gnawing on it, and left without saying a word to anybody"—a typical night at 1712.

Henry didn't recall that particular incident. "It sounds awfully rude," he said, "but it doesn't sound improbable." He was as

impressed by the hosts at 1712 as he was by the art. "Brooke and Dennis were *interesting*," he said, "and not like the rest of the people who were around." As a continuation of the Warhol party in 1963, Brooke liked to fete the artists she and Dennis collected: Ruscha, Lichtenstein, Stella, and the rest. "Everyone from the art world and Hollywood was there," Danna Ruscha said. "These were blowout parties. And Brooke was such a fashion plate, I couldn't wait to see what she would be wearing. It was all so fabulous." Curtis Harrington adored the dinners at 1712; Brooke and Dennis became the inspiration for his psychological thriller *Games*. The bandleader Peter Duchin, who had known Michael Thomas at Yale, came to a 1712 soiree in 1965. "It was a collection of very hip guests," he remembered, "among them, Terry Southern, Tony Richardson, Rudi Gernreich, Ed Ruscha, Peter Fonda, and Jack Nicholson. I arrived wearing a blazer and tie—very disappointing to Brooke."

You never knew who might be hanging out. "I would occasionally visit Dennis," David Hopper recalled, "which was really a trip." On one occasion, David drove up from San Diego to check out a Miles Davis performance. Finding it sold out, he decided to head over to 1712, where he found Miles and his band relaxing before the show.

In a sign that 1712 had acquired a reputation as a social nexus, Bill Claxton shot Brooke and Dennis's art-filled living room for *Cosmopolitan* as part of a fashion feature on the futuristic designer Rudi Gernreich. In 1964, Gernreich had given the world much to ponder when he had introduced the monokini, a topless bathing suit that Pope Paul VI attempted to have banned. He had inevitably become pals with Brooke and Dennis, who turned up at all of his shows. Brooke loved wearing his designs; Gernreich eventually employed Dennis as one of his collection photographers, alongside his mainstay, Claxton. (According to Moffitt, Dennis loved watching Claxton work. "He stood behind him to learn how to take pictures,"

she recalled. "My husband was very gracious about it, but probably a little annoyed!")

The *Cosmo* feature, which ran in the March 1965 issue, was a Gernreichian tour of Hollywood: James Coburn at Watts Towers, Terry Southern flying kites, and a brand-new singing group called the Byrds, all accompanied by Gernreich's models wearing his latest creations. And here was 1712, in vivid Pop Art color. In Claxton's photos you see the *Double Mona Lisa, Tetuan III*, the Hotel Green sign. There's Dennis's own *Draw Me* piece, the gumball machine, the Victorian spool table, and the standing figure in a white top hat by the folk artists Calvin and Ruby Black. Gernreich holds court with two of his models, Moffitt and Lydia Fields; Billy Al Bengston, Irving Blum, the producer Burt Berman, and Dennis drink Cokes with straws. In the middle of it all, down on the carpeted floor, is the eight-year-old Jeffrey in his red pajamas.

"There was a *constant* stream of people passing through," Jeffrey remembered. Their faces often looked bizarrely familiar: "They were on television—they were in the same room," he said. "But we never had any awe. In fact, I've never had any awe for any celebrity."

"Jeffrey was the kid who would be right in the middle of everything," Willie said. "If they were having a cocktail party, he'd be right there, sitting with everybody. I was the kid who was always hiding, trying to avoid being in trouble by staying out of the way." That year, Willie was diagnosed with diabetes; it contributed to his feelings of apartness. "He really retreated into his own mind," Jeffrey said. "But he was smarter than us because he couldn't do the social thing." Bespectacled and shy, Willie had a sagelike aura, observant and intelligent. The boy worried, though, that his illness made him not fully acceptable amid the glamorous bohemianism that swirled around him.

At 1712, that might mean Peter Fonda one night, Paul Newman the next, followed by Warholians or Ferus people. Yet Brooke and

Dennis also welcomed anyone they found fun or interesting. Andee Cohen was a stick-thin teenager who worked at the Jax boutique, where Gernreich had once been the designer. One night, as she and a date were driving up North Crescent Heights to attend a party in the neighborhood, a body hit the car with a bang and rolled onto the hood, practically giving Andee and her guy friend a heart attack. It was Dennis, pulling a stunt. "You don't want to go to *that* party," he told them. "You want to come to mine!" For Andee, walking into 1712 was life altering. "*These* are the people you want to be around," she told herself as she stood amid a candy-box assortment of fascinating grown-ups drinking martinis. "It just felt in sync, sophisticated," she remembered. "I think certain people are put here to *activate*—that was Dennis." As for Brooke, "She was like a sphynx—elegant and contained and refined." Like Dennis, Andee (later Andee Nathanson), became a photographer who chronicled her era, taking pictures of Marlon Brando, David Hockney, the Rolling Stones, Gram Parsons. She also shot Tiny Tim, the hirsute, ukulele-strumming pop sensation, in the backyard of 1712, much to Marin's excitement.

"It was all pretty fluid," Toby Rafelson said of the social flow of sixties Los Angeles, exemplified by 1712. "It wasn't a class thing, where you couldn't penetrate somebody's orbit. It was a big mishmash." She and her husband, Bob, ran a salon of their own at their new house, just off Sunset on Sierra Alta Way. The couples often hit the town together as well. "We could go out once our kids were asleep," she said. "So we'd do things at night—art shows, go out to dinner"—maybe at Dan Tana's, the new Italian hole-in-the-wall on Santa Monica Boulevard, or Cyrano, the show business playpen on the Sunset Strip, where the latest Hollywood gossip ricocheted.

Most often, though, they stayed in, gabbing and drinking underneath the giant Judas at 1712. They talked about movies, art, best sellers, the Beatles and the Stones, the Free Speech Movement, Vietnam, civil rights. The chatter continued long after Brooke

said good night—she needed to get the children to school in the morning—and ascended the staircase she had tiled herself, past a six-foot-tall Kienholz called *Black with White*, and up to the antique brass bed in her and Dennis's bedroom, where the voices and laughter filtered up through the floorboards.

EARLY IN DENNIS'S CAREER, he had read Richard Boleslavsky's 1933 classic, *Acting: The First Six Lessons*. It prescribed an ambitiously broad cultural mission for aspiring actors. "I need an actor who knows the history of painting," Boleslavsky wrote. As Dennis explained it, "I went off to find paintings because I thought it would enhance my life as an actor." For Dennis, the pursuit of art—as both a collector and a practitioner—had become a gratifying end unto itself. Yet there remained the nagging issue of his acting. What he had considered his primary art, and still one he wanted to practice and perfect, was languishing. A casting executive at 20th Century Fox had allegedly said of Dennis, "When he's older he might make an interesting character actor, but right now he is what we call 'dead meat.'" Dennis's movie career had cycled through the all-too-familiar phases outlined in an old Hollywood joke: (1) "Who's Hopper?" (2) "Let's get Hopper!" (3) "Let's get somebody *like* Hopper!" (4) "Who's Hopper?"

Ironically, the director who called Dennis in from the wilderness was his former tormentor, Henry Hathaway, who offered him a role in a western called *The Sons of Katie Elder*, starring John Wayne and Dean Martin. It would be Dennis's first job on a big Hollywood production since *From Hell to Texas* almost eight years before. "I got this part and I know you can do it," Hathaway told him. "Of course, this is with Big Duke, and Big Duke doesn't like that Method shit." Dennis said he'd go easy with the Method shit. On set in Durango, Mexico, in January 1965, he took all of Hathaway's direction, line by line, word by word, gesture by gesture. After Dennis did his first

take, the director was ecstatic to the point of tears. "That was great, boy, really great!" he said.

"Well, you see, Mr. Hathaway, I'm a much better actor than I was eight years ago," Dennis told him.

"You're not better, boy—you're *smarter!*"

Dennis always said that his marriage to Brooke was what got him the job. Hathaway and Wayne had both known Maggie Sullavan and appreciated that Dennis was the father of her grandchild. "So it was about time for me to go back to work," Dennis said. "That was Hathaway's way of putting it to me."

Set in northeast Texas at the turn of the century, *The Sons of Katie Elder* was about four brothers—Wayne played the oldest—attending to matters related to the recent death of their mother, Katie Elder. It is a tough, lean, and entirely watchable Technicolor western, spiked with the usual elements of murder, rivalry, feuding, and revenge. Dennis's character was the son of the Elders' villainous rival, a virtual reprise of his role in *From Hell to Texas*. "He played the cowardly son of the bad guy dying in John Wayne's arms," David Hopper said. "It was disgusting and he hated it." But Dennis soldiered through, happy to be on a movie again. There seem to have been no incidents of room trashing or multiple takes on *The Sons of Katie Elder*. Not that Hathaway's demeanor had softened. He would bark at the extras, "Tighten up! You're spread out like a widow woman's shit!"

Dennis thought he had figured out Hathaway's approach: the director relied on stationary shots, which meant that his actors needed to move a certain way within the frame. That was why Hathaway's directorial approach was so inflexible. Whether or not that theory held water, the realization that there was some kind of method to the director's madness gave him a newfound respect for Hathaway. "I learned more from him than from any other director," he would later say.

Wayne had been battling what he called "the Big C"—cancer. He

was working at half lung capacity and had to grab an oxygen mask whenever Hathaway yelled "Cut!" It didn't stop him from drinking all night with Dean Martin (and likely Dennis, too) at the Alamo Courts motel, where the cast was put up during the Durango shoot. Wayne seemed to like Dennis, and the feeling was mutual, despite the fact that they were at opposite ends of the ideological spectrum. "He thought of me as his house Commie," Dennis remembered. "He'd get agitated about something and shout, 'Where's Hopper, that little Commie bastard?'"

A writer from Los Angeles visited toward the end of the shoot, on assignment for the *Saturday Evening Post*. It was Joan Didion, Nick and Lenny Dunne's sister-in-law. In the resulting story, "John Wayne: A Love Song," Didion wrote of what she had found in incantatory terms: "Durango. The very name hallucinates. Man's country. Out where the West begins." Dennis, too, was captivated by the place. In addition to photographing Wayne, Martin, and Hathaway on set, he focused his Nikon on the desolate Durango landscape, a backdrop for so many westerns that it was practically Hollywood South. He photographed the studs and struts of a phony movie set mansion rising up in a voidlike, Edward Curtis–worthy desert, a comment on the hollow facade of motion-picture make-believe. The photograph documented the moment Dennis began to conceive a movie about the impact of a big western movie production on a dusty, outback village.

Dennis was fascinated by the fact that the people of Durango were actual western characters, some of them still wearing guns and riding horses. Pancho Villa's widow even came to visit; she gave Dennis one of the revolutionary's spurs. The cast and crew of *The Sons of Katie Elder*, meanwhile, were engaged in an elaborate, commercial act of pretend. "I was sitting there," Dennis remembered, "and suddenly I thought, 'What is going to happen to these people when we leave? These people, are they going to start acting out the violence of the movie that they saw here? And what are they going

to do with these sets? They still live inside these houses.' My fantasy started tripping on that." The juxtaposition between real and unreal summed up much that Dennis had brooded upon in his life and career: Hollywood fakery and exploitation, the relationship between art and reality, what it's like to grow up in a backwater.

After the Durango shoot wrapped, Dennis and another actor, Michael Anderson, Jr., who found Hathaway "a tyrant," sat together at an outdoor fireplace, passing a joint back and forth. "Hey man, I just had the best idea for a movie," he told Anderson. "It's about making movies and the effect it has on people, and what they do when a movie company leaves town." He resolved to call Stewart Stern, the screenwriter of *Rebel Without a Cause*, as soon as he got back to Los Angeles. He wanted to start working up a treatment right away.

A COUPLE OF MONTHS LATER, Brooke and Dennis were entertaining Terry Southern at 1712. Southern, the Texas-born renegade writer, who *Life* magazine's Jane Howard said "looks like a walking hangover," became a fixture at 1712 and in Dennis's viewfinder. Gore Vidal called him "the most profoundly witty writer of our generation" and Dennis and Brooke loved him for his erudition, outrageousness, and willingness to face down cant. "Where you find smugness you find something worth blasting," Southern said. "I want to blast it." He loved Dennis's crazy energy—usually calling him "Den"—and marveled at Brooke's Mona Lisa–like smile. "We'd go to the house for dinner," the actress Gail Gerber, Southern's long-term partner, recalled. "Brooke would serve something wonderful and wisely go to bed. Dennis and Terry would retire, with drinks in hand, to the living room." Gerber liked to curl up on the sofa and listen to the two of them talk—and talk and talk.

Dennis mentioned to Southern that Marlon Brando had invited

him to fly to Alabama to join the march with Martin Luther King, Jr., from Selma to Montgomery. "Hopper, take care!" Southern cautioned; having grown up in the segregationist South, he knew the potential dangers. "You are spreading yourself thin—in this case, perhaps down to the proverbial mincemeat!"

Dennis flew down, likely during the final phase of the march, two weeks after the Bloody Sunday melee at Selma's Edmund Pettus Bridge, when mounted police had brutalized the mostly Black marchers, sparking national outrage. As at Washington in 1963, a sizable contingent from the entertainment community arrived, most of them marching by day and then returning to a hotel at night, including Nina Simone, Leonard Bernstein, Joan Baez, Tony Bennett, Sammy Davis, Jr., Peter, Paul, and Mary, and Harry Belafonte, who organized a "Stars for Freedom" rally and concert the night of March 24. Dennis, aside from photographing Dr. King (a stunning shot of the leader speaking at a podium bristling with microphones), focused his Nikon on the rank-and-file marchers: African American boys carrying the Stars and Stripes, white marchers clustered beneath a makeshift U.S. HISTORIANS sign, folks gathered on the porches of shotgun shacks, a group under the airport's grimly ironic WELCOME TO MONTGOMERY sign. The images have the feel of photojournalism if it were practiced by Robert Frank or Walker Evans.

"Taking those photos was the very first time I felt that what I was doing was truly important," Dennis said. As he marched along with his camera, dodging white segregationists on the roadside attempting to urinate on the protesters or brandishing Confederate battle flags, he began to see his photographs as having a lasting documentary value. He'd stuck his neck out for a purpose, and King's words rang in his ears: "Let us march on ballot boxes until brotherhood becomes more than a meaningless word. . . . We're on the move now . . . How long? Not long, because 'no lie can live forever' . . . Glory, hallelujah! Glory, hallelujah!"

THREE NIGHTS BEFORE THE "Stars for Freedom" concert, the unknown band that Claxton had photographed for *Cosmopolitan* began an off-and-on residency at Ciro's, on the Sunset Strip. The moribund show business nightclub, which Billy Wilkerson, the Red-baiting *Hollywood Reporter* founder, opened in 1940, had been rebranded Ciro's Le Disc but wasn't getting much traction until the Byrds started playing multiset shows that blew Hollywood apart. The Beatles' press officer, Derek Taylor, who had recently relocated to Los Angeles, described what he saw at Ciro's that spring: "The dancefloor was a madhouse. A hardcore of Byrd followers—wayward painters, disinherited sons and heirs, bearded sculptors, misty-eyed nymphs and assorted oddballs—suddenly taught Hollywood to dance again." Taylor agreed to work with the band, who were making all of $50 a night.

The pioneering rock critic Lillian Roxon got it right when she observed that "*Newsweek* called them Dylanized Beatles when the whole point was they were Beatlized Dylans." The putative leader, Jim (later Roger) McGuinn, was a folkie twelve-string guitar virtuoso whom Larry Bell, also a twelve-string picker, knew from the Unicorn. McGuinn hooked up with fellow travelers (i.e., folk singers who, inspired by the Beatles, wanted to be rock stars) in the form of the songwriter Gene Clark, a soulful Missouri hunk, and David Crosby, a guitar strummer whose cherubic face and angelic voice masked—barely—the devil within. He was the son of the cinematographer Floyd Crosby, whom Dennis knew from *Night Tide*. These three were joined by Chris Hillman, a bass player who lived below Ed Kienholz in Laurel Canyon ("I could hear him working up there, pounding away," he remembered), and Michael Clarke, a drummer whose main qualification was that he looked like Brian Jones. Someone described them, accurately, as "five bland Apollonians"—a suitably California-cool bunch, a bit aloof, cerebral. Like Warhol, the Byrds were sphinxlike. They never broke a sweat, remaining magisterially removed from the frenzy they cre-

ated. The Byrds gave folk a big jolt of energy and rock an infusion of intelligence and social conscience. Thus the birth of folk-rock. When the Byrds put out their cover of Dylan's "Mr. Tambourine Man" in June, with McGuinn's Rickenbacker twelve-string crackling like pure electricity, the record hit number 1 and the genre became a global phenomenon, a counterculture harbinger, and America suddenly had its own Beatles.

"Ciro's was the cauldron where that all came together," McGuinn said. Dylan himself came by to blow his harmonica with the band. It was a scene that Dennis and Brooke were drawn to and one that changed Dennis forever. As a wee-hours explorer of Los Angeles, he would have been familiar with the free-spirited protohippie troupe known as the Freaks, who went by such names as Karen Yum Yum, Beatle Bob, and Johnny Fuck Fuck and had the habit of turning dance floors into zones of free-form frenzy. They were led by the fiftysomething beatnik Vito Paulekas, at whose ceramics studio the Byrds rehearsed. Collectively, the Freaks favored an ebullient style of dance that was nearly as convulsive as the seizures Dennis had performed in *Medic*. Now, thanks to the Byrds, Ciro's was their playground.

Ed Ruscha came, as did Larry Bell. Billy Al Bengston was transformed into a self-described "dance hall slut." The artist Craig Kauffman said that Ciro's "was a party every night." In fact, the Byrds were an aural version of the sleek, gleaming, so-called LA Look that Kauffman's work best exemplified, as the art critic Peter Plagens described it: "newness, postcard sunset color, and intimations of aerospace profundity." The Byrds' music had the streamlined shine of a jet fuselage.

Lines formed in front of Ciro's, and people who drove past wondered what in God's name could be happening at the sleepy, unfashionable club. Hollywood began showing up: Along with Dennis and Brooke, there were Peter Fonda, Jack Nicholson, Steve McQueen, Sal Mineo, Lenny Bruce. The women Dennis had

photographed with Bruce Conner—Teri Garr, Toni Basil, Ann Marshall—invaded the dance floor alongside the Freaks. It was as if a new version of Hollywood—and America—were revealing itself as the Byrds twisted the volume knobs on their Fender amps and joined voices on "The Bells of Rhymney" and "I'll Feel a Whole Lot Better"—ethereal, euphoric, total California. "They could have started their own church with that kind of music they were playing," said Carl Orestes Franzoni, Paulekas's deputy in the Freaks. "The Byrds were, in my estimation, the best dance band that Hollywood ever saw."

Dennis pivoted around the swirling mass at Ciro's to catch blurred faces and bodies in motion with his Nikon. He lined up various Byrds in the spaces between the dancers: McGuinn with his tinted granny glasses, Crosby with his grin, Clark with his tambourine. He prowled the stage, shooting the band from behind, looking out at the writhing dance floor. The photos have mad energy. It was as if the scene he'd witnessed in London had alighted in LA. Although Dennis may have ventured to Central Avenue, a major R&B and jazz mecca, he, like most of his friends, was more accustomed to the cool, laid-back grooving of coffeehouses. Up the street from Ciro's, the Whisky à Go Go had the very professional Johnny Rivers churning out a veritable jukebox of covers. But the sweaty, polymorphous scene at Ciro's was new. The crowd was young and old, Black and white, gay and straight, Hollywood stars and Ferus artists, and, front and center, Vito and his Freaks. "The floor was full of people who looked like they had just straggled out of Sherwood Forest," the Los Angeles Times noted. "Long-haired, loosely-fitted, who prithee might tell boy from girl?" As Kim Fowley, the inveterate, Ichabod Crane–like music-business hustler, put it, the Ciro's crowd was "virtually having sex on the dancefloor."

No wonder Dennis needed to participate in it, to document it: he, Brooke, and their friends were witnessing a social revolution. The Sunset Strip was where Dennis had come of age discussing ex-

istentialism with Natalie Wood and James Dean at Googies. It was the route Brooke took when she drove the kids to the John Thomas Dye School, cruising past the rotating Bullwinkle-and-Rocky statue at Jay Ward's studio across from the Chateau Marmont, past the Fred C. Dobbs coffeehouse and Ben Frank's diner, past the Aware Inn and Cyrano and the Largo burlesque club. Brooke would have known Ciro's from her girlhood as a place where Maggie and Leland and their Hollywood cohort drank cocktails. Now the reawakened Ciro's triggered an explosion of music clubs, cafés, and boutiques along the Sunset Strip, and the sidewalks were suddenly packed with flamboyant youths drawn from all over LA, all over America. As Franzoni put it, "From then on it was dance, dance, dance in Hollywood."

"That was a critical moment," Brooke remembered. "It was when all the barriers began to drop. People began to wear very short skirts and dance in this crazy way! You didn't need a partner; you could just go out onto the dance floor and dance alone."

Even so, the orgiastic, marijuana-perfumed youthquake of Ciro's was, for her, more of a curiosity. She was drawn to another club—sophisticated, charmed, private—where you could dance to the Byrds and not have the libidinous Freak Carl Franzoni grinding away next to you. It was called the Daisy. Jack and Sally Hanson, the couple behind Jax, had opened it the previous fall at 326 North Rodeo Drive in Beverly Hills, a building that had been, at various times, Romanoff's and the Friars Club. Brooke and Dennis coughed up the $240 to join and kept up the $12 monthly dues. Drinks were $1.50 a pop. "It was the place we all went to," Dennis said.

The Daisy was less like Ciro's and more like Annabel's in London. The screenwriter Harlan Ellison described the mix: "television producers, hungry starlets, clean-shaven hero actors, the children of Beverly Hills merchants, expensively coiffed hookers, lean-hipped models, fading sports stars and assorted kept types." He compared it to a Hieronymous Bosch painting, alive with "insults, gossip,

infidelities, violence, and moneymoneymoney." The centerpiece of the seven-room clubhouse was a giant dance floor, seventy feet by thirty, with a muscular sound system pumping out Motown, British invasion, and folk-rock. It was regularly crammed with upward of three hundred people doing the Hully Gully or Philly Dog. But unlike at Ciro's, nobody seemed to break a sweat; for all anyone knew, that was against house rules. The Daisy's crowd was a 1960s social anthropologist's fever dream: Telly Savalas, Leo Durocher, and Paul Newman shooting billiards in the pool room. Samantha Eggar, Governor Pat Brown, and Hoagy Carmichael at the bar. An assortment of Jax girls, Rolling Stones, Lynda Bird Johnson, Richard Pryor, Mike Nichols, and the Dunnes on the dance floor moving to songs the Byrds were playing live over at Ciro's. In 1965, it was hard to imagine as many famous people under one roof anywhere else in the world. "Compared to The Daisy," one reporter remarked, "all other discotheques are slums."

The melding of traditional Hollywood and the new scene didn't always gel. Gay Talese stopped in at the Daisy late in 1965, tailing Frank Sinatra for his famous *Esquire* cover profile "Frank Sinatra Has a Cold." Talese witnessed an altercation in the billiard room between Sinatra and Harlan Ellison, triggered by Sinatra's distaste for the Sunset Strip–worthy clothing Ellison favored. A brawl was averted, Ellison left, and Sinatra barked, "I don't want anybody in here without coats and ties." It was a losing battle.

ON JUNE 22, A DAY AFTER "Mr. Tambourine Man" came out, David O. Selznick had a fatal heart attack. He was sixty-three. Dennis believed that Selznick had gone into a Beverly Hills bank, asked for a loan of $500,000, been turned down, and gone into cardiac arrest, dying on the spot. It fit his idea of a grimly poetic end for a once-powerful Hollywood king. The standard telling was that Selznick, who was addicted to Benzedrine and smoked up to four packs of

Kents a day, had a heart attack in the office of his attorney, Barry Brannen, as they were discussing a possible distribution deal.

Either way, the news was crushing. Brooke and Dennis had been in a rhythm with David O. and Jennifer since their stay at Tower Grove in 1961. There were the black-tie dinners, the Christmas eves, the helpful advice David O. patiently dispensed to Dennis. The Selznicks were there as well for flashes of drama, as when Leland came to LA before David O.'s death to be feted with a dinner at the house on Tower Grove. During that trip, Brooke's father made his one and only visit to 1712. (Pamela remained behind in New York.) Dennis's photographs of his father-in-law in the living room with the kids climbing on him show a very ill-at-ease Leland Hayward. His disengagement from Brooke, Bridget, and Bill had been bad enough, but there is something about indifference to grandchildren that is heartbreaking. Leland even asked friends, "Why can't I get more excited about them?" At the dinner party, as the Selznicks toasted their old friend, Leland and Dennis got into a spat—over what, nobody knows, although it was a flammable situation: Leland's open disdain for his son-in-law versus Dennis's anger about Leland's neglectfulness and Pamela's toxicity. "Man, he was never on the scene when Brooke needed him," Dennis complained. Whatever the trigger, Brooke said that Leland had been "so rude to Dennis that I remember getting up from the table and saying, 'Father, I will not be able to sit with you any longer.' I left the table and went to another room." As Brooke recalled, Jennifer eventually brought her back to the table; Leland remarked that Dennis needed to visit a shrink. It is nearly certain that Dennis and Leland never patched things up, and Brooke, who kept a framed portrait of her father on her nightstand, would not see him for the rest of her marriage to Dennis.

Brooke said that David O. had been "almost like my own father"—a surrogate, and only a few miles away from 1712. In fact, she said, "It was the only time I cried about someone's death," a

remarkable admission considering her family history. She broke her self-imposed injunction against going to funerals, having had enough of them after Maggie and Bridget died, and attended David O.'s at Forest Lawn. Truman Capote provided a eulogy in absentia, which George Cukor read out: "Enchanting was his word, his presence, his life." Maggie Sullavan's old nemesis Katharine Hepburn came forward and read Rudyard Kipling's "If," the poem that Dennis had declaimed as a boy. Dennis knew every word as Hepburn moved through the stanzas about truth and lies, triumph and defeat, reaching maturity and creating a legacy, while the assembled mourners, including Joseph Cotten, Cary Grant, Alfred Hitchcock, Lauren Bacall, the Dunnes, and hundreds more, wept.

IN THE SUMMER OF 1965, as Brooke's acting career appeared to be on permanent hold, Jane Fonda's was surging. "I've never seen ambition as naked as Jane's," Brooke said. Even so, she never felt that the two of them were in a contest. "She's the only girl I know who's not a bitch," Brooke told a reporter, and the sentiment, for all its hyperbole, seemed genuine.

Jane and her partner, the French director Roger Vadim, who had been married to Brigitte Bardot, were renting Merle Oberon's former house at 23816 Malibu Road, right on the beach, for $200 a month. The couple had met on Vadim's 1964 film *La Ronde*. Jane's breakthrough movie, *Cat Ballou*, came out in June, and she was in LA working on an Arthur Penn–directed film, *The Chase*, with Marlon Brando. Brooke found Vadim fascinating, brilliant, and adorable. The kids liked him, too. On one occasion, Jeffrey put Willie up to asking him, "Do you have any hot pictures of Brigitte Bardot?," which caused Vadim to double over with laughter.

For Brooke, one of the benefits of having her oldest friend an hour's drive away in Malibu was that she and Dennis and the kids had an open invitation to hang out at the beach whenever they

pleased. A new scene was coalescing in Malibu, where shacklike houses lined a scruffy, unprepossessing beach, a walled city of sand and sun. "It was like a dream colony," Dennis said.

Jennifer Jones's son Bobby Walker and his wife, Ellie, lived next to Jane and Vadim in a house previously occupied by Rod Steiger. The shaggy, bearded, blue-eyed Bobby, a frequent television guest star in those days, shared Dennis's passion for photography. He took evocative pictures of Dennis on the beach teaching the three-year-old Marin how to use the Nikon. Terry Southern was often found at Bobby's, where Dennis photographed Brooke under the high, raftered ceiling, along with the English actor James Fox, one of Jane's costars in *The Chase* and the boyfriend of Andee Cohen, poring over the sheet-music songbook of Dylan's *Bringing It All Back Home*. Dennis's Malibu photos evoke an endless-summer idyll: Brooke and Jane in their bikinis, Bobby walking on his hands, Jane practicing archery, and a Byrds-inspired Peter Fonda strumming the Gibson twelve-string acoustic he had inherited from his late best friend, Stormy McDonald, who also happened to be a friend of McGuinn's. (Fonda, a lefty, played the instrument upside down.) Jane loved Dennis's pictures; he "knew how juxtapositions told a story and how to capture that," she said.

Toby and Bob liked driving out to Malibu with their kids; they would stay with the socialite Donna Greenberg. "She was the beach mama," Jeffrey Thomas remembered. He and Willie were impressed that Donna's son Matthew had an actual electric guitar. "That flat electric guitar case was the coolest thing ever," Jeffrey said, "right up there with a Hobie skateboard." The feeling you get is California at its golden apogee, fueled, as Bobby Walker remembered it, by a robust supply of Château Lafite Rothschild and Michoacán weed, which Southern liked to call "Wog-hemp." "The adults were all partying," Willie said, "while we were playing on the beach."

The Dunnes rented a place down the way, and Nick's photographs glow with a sunny haze, much like the silent home movies

that Roddy McDowall shot in Malibu that summer: languid after-
noons with icy drinks, crossword puzzles, cigarettes, and laughter,
with Lauren Bacall, Hope Lange, Tuesday Weld, the Beach Boys'
Dennis Wilson, Jane, Vadim, Dennis, and Brooke coming and go-
ing. The actor Larry Hagman kept things interesting by occasion-
ally parading down the beach in a gorilla suit.

Jane decided to throw a Fourth of July bash—dancing, dinner,
beach clothes. "I asked my brother who the music should be," she
recalled, "and he said the Byrds. I hadn't heard of them. So that was
my introduction to the Byrds."

She and Vadim put up a giant opaque plastic tent, with a stage
inside, right behind the house. Dennis and Brooke came in the af-
ternoon ahead of the party, and Dennis snapped pictures of the
band, with roadie Bryan MacLean, later of the band Love, setting up
equipment while a gang of fascinated kids swarmed around. (Jeffrey
and Willie were with Michael Thomas in Southampton; the Dunnes'
son Griffin, to his lifelong dismay, had been packed off to camp and
missed the big event.) Brooke wore a leopard-print bikini and chatted
with friends. McGuinn did himself up in a Carnaby Street–worthy
suit and wore his signature tinted granny glasses. When McGuinn
and Peter Fonda, in swim trunks, stepped out onto the sand to take
the air, Dennis photographed the two of them standing there while
a couple of middle-aged guys strolled by and gawked. The image
perfectly captured the collision of the old Hollywood and the new.

Jane's father roasted a pig in the sand, Nick Dunne snapped his
camera, and the party tent filled up. Warren Beatty, Steve McQueen,
Diahann Carroll, George Cukor, Sidney Poitier, Jack Nicholson,
MCA's Jules Stein, the producer Ray Stark—the show business
people kept cramming in. Jill Schary remembered Lauren Bacall
and Andy Warhol engaged in chitchat. Then Vito and the Freaks—
the "Byrd Heads," as Jane thought of them—showed up. Dennis's
lens focused on Carl Franzoni whirling on the dance floor. "They
were all kind of naked, dancing around Henry Fonda," McGuinn

said of Vito's gang, "and he was going nuts." The situation made Derek Taylor, the suave British press officer who was working with the Byrds, extremely nervous. "I still had this rather suburban view of life," he said. "And when Carl Franzoni and Vito came, I got into a terrible panic." Jim Dickson, the Byrds' manager and Dennis's old nemesis from the days of *From Hell to Texas*, reassured Taylor that all would be well; he thought Hollywood was good and ready for this kind of shake-up.

That remained to be seen. Henry Fonda was not fond of the volume level. "We're playing and somebody's pulling on my pant leg," Chris Hillman remembered. "I look down and it's Henry Fonda. 'Can you please turn that music down?' 'Yes, sir, right away!'" Hillman relayed Fonda's entreaty to David Crosby, whose response was basically "Fuck that." "We're not turning down, *man*," he said. McGuinn was concerned enough to check with Peter Fonda. "Don't pay any attention to him," Peter said of his father. "He's an old man!" The Byrds, who had played the Hollywood Bowl the night before, continued with their set, leaving the volume right where it was. Buck Henry remembered them doing "Mr. Tambourine Man" over and over. "Such a great song to dance to," he said.

"It was quite an amazing scene," Jane Fonda said. "There was a hippie who followed the Byrds in line at the buffet with a tie-dyed skirt and her breasts exposed, nursing a baby. Danny Kaye was behind her with his eyes popping out and George Cukor behind *him*, kind of gagging."

During a set break, Dennis and Peter went with Bobby Walker up onto the roof of his house to look at the sea and stars and blow a joint with the Byrds. "We were all feeling celebratory," Walker said, "like cosmic warriors." It was a moment to savor. "Everything was a 'wow,' everything was exciting, the atmosphere was just vibrating with potential."

"We were free!" Fonda recalled. "God bless grass!" He was determined to no longer accept the roles—virtual and literal—that

Hollywood wanted him to play. There were too many creative vibes in the air. "There was an artistic renaissance going on," McGuinn said, "and LA was pretty much the hub of it." Having paid his dues on the Greenwich Village folk circuit, McGuinn understood that Los Angeles had a brand-new kind of energy, "the wildness of the West Coast." For Hillman, LA "was fantastical. It was like there were no rules." Dennis discovered that the Byrds were tuned into the same wavelength he shared with the Ferus Gallery crew: they lived in a city rippling with possibilities.

Dennis seemed particularly fascinated by Crosby. Hillman noticed the connection. "They were both obnoxious, overly aggressive," he said. "They were very much alike. David could lead you into the abyss seven times a week. I'm sure David and Dennis shared the same operating methods." They even said the word *man* the same way. ("Dennis used the word like a trademark," Ed Ruscha said.) Peter was more in tune with McGuinn. They were doppelgängeresque, both of them laid back and lanky, calm and collected, all-American handsome.

But while those twentysomething men were enjoying their rooftop bonding session, there was a sinister undertow pulling at the edge of the moment. Unbeknownst to anyone at Jane and Vadim's party, Brooke's friend Jill Schary had meandered down the beach and passed out in the sand. Alcohol had gotten the upper hand in her life. She even thought she'd overheard George Cukor and David Niven talking about her drinking at the party. "I told myself, 'You will *not* drink tonight,'" she recalled. "Well, I drank." In the sand, four young men in surfer shorts sexually assaulted her. She somehow made it back to Jane's house. "They never believe women," Jane said, taking Jill in her arms. "We must not call the police," someone advised, thinking of bad PR. "That's beside the point!" Jane snapped. She later admitted that she hadn't wanted to believe what Jill was telling her.

Despite the beginnings of second-wave feminism and the feeling

of enlightenment in the air, the sexual revolution was tinged with misogyny and violence. It was the dark side of the macho renegade energy coursing through the era, the energy that had a hand in squashing Brooke's career. "There was *tremendous* misogyny," Jane Fonda said. "'Sexual liberation' and 'free love' meant that women were meant to please men. It was the dudes that ruled."

ON SATURDAY, AUGUST 14, 1965, Jane and Vadim were married in a suite at the Dunes in Las Vegas. Brooke and Dennis were among the small group that had flown in from LA on a chartered plane, along with Peter Fonda and his wife, Susan, and the Italian journalist Oriana Fallaci. "We looked down from the plane," Brooke remembered, "and Los Angeles was burning." The uprising in Watts had begun three days earlier.

In Las Vegas, the ceremony was quick. The couple didn't even bother with rings. Peter played Donovan's "Colours" on his Gibson, and most of the party gambled all night. Dennis was the impromptu wedding photographer; in his pictures, Jane and Vadim look fairly ecstatic. "He spent much of the time looking at her very intently," Dennis recalled. "Everybody was having just a good time." But at some point, Jane cried in the bathroom, suddenly unsure of elopement, marriage, the world.

Dennis was eager to return to Los Angeles and photograph Watts. The conflagration had begun in the distressingly usual way: brutality on the part of white police operating under Mayor Sam Yorty's and Police Chief William H. Parker's hard-assed directives in a Black neighborhood. Motorcycle cop pulls over two Black motorists, possibly intoxicated. They turn out to be brothers. One of them—Marquette Frye—doesn't want to be handcuffed, no fewer than twenty-six police vehicles arrive to assist, the billy clubs come out, the mother attempts to intercede and is pinned to the hood of a patrol car. The ensuing protest lasted six days. Thirty-four people

died, many of them shot by police, and more than a thousand were injured. One man, who had been lying in his bed with his wife minding his own business, was shot eleven times by police. (After an inquest, the murder of that innocent man, along with every other at the hands of the LAPD or National Guard, was ruled justifiable.) For African Americans, it was a rebellion. For whites, including the media, it was a riot. In a particularly lurid description, a *Los Angeles Times* columnist called it "an anarchistic holocaust of shooting and looting ominously reminiscent of the Mau Mau eruption in British East Africa."

The novelist Thomas Pynchon examined "L.A.'s racial sickness." Writing in the *New York Times*, he observed, "While the white culture is concerned with various forms of systematized folly—the economy of the area in fact depending upon it—the black culture is stuck pretty much with basic realities like disease, like failure, violence and death, which the whites have mostly chosen—and can afford—to ignore." It was a forty-five-minute drive from Malibu to Watts on a good day. The actual distance was incalculable.

The fires made what was happening in Watts difficult to ignore. They could be seen from North Crescent Heights; Lael McCoy, the babysitter, watched the smoke rising above the city. Teri Garr remembered seeing it from a restaurant on the Sunset Strip, where she met up with Wallace Berman. "This is terrible," she said. "What's going to happen?" Berman responded, "You can't put people in ghettos." Ed Ruscha felt that the "Watts riots nationalized sympathy for a gigantic racial injustice." He began incorporating fire, that elemental destroyer, into his work. "The city burning is Los Angeles' deepest image of itself," Joan Didion noted. "For days one could drive the Harbor Freeway and see the city on fire, just as we had always known it would be in the end." It was like a violent reprise of the inferno Brooke and Dennis had experienced in 1961.

Dennis hopped into his Corvair, rolled the top down, and drove through the flaming streets. His photographs of Watts document

the damage as well as community meetings and volunteer drives. President Johnson had just signed the Voting Rights Act into law; it seemed that what Dennis had witnessed in Alabama had pushed the country to finally keep its promises. But what unfolded in Watts proved that the work of fulfilling those promises was far from over.

Martin Luther King, Jr., arrived in Watts on August 17. "We won!" a local resident told him. "What do you mean, 'We won'?" King asked. "Thirty-some people dead, all but two are Negroes. You've destroyed your own. What do you mean, 'We won'?" The man replied, "We made them pay attention to us."

THE AUGUST ISSUE OF *VOGUE* contained "The Loved House of the Dennis Hoppers," a story Terry Southern had written about 1712 North Crescent Heights. It is intimate, affectionate, and shot from the hip. "The Den Hoppers are tops in their field," he declared. "Precisely what their field is, is by no means certain—except that she is a Great Beauty, and he a kind of Mad Person."

Southern saw Brooke and Dennis's house as "a harmonious nightmare of Gothic surrealism." The unsigned captions were the work of Joan Didion, who had learned that skill—the writing equivalent of crafting Fabergé eggs—as a staffer under the tutelage of the formidable *Vogue* editor Allene Talmey, who likely had asked her to tackle this assignment for her alma mater. "To visit the Hopper house," one of Didion's captions read, "is to be, at every turn, surprised, freshly beguiled by a kaleidoscopically shifting assemblage of found objects, loved objects, *objets d'art.*"

The accompanying photographs bear that out: *Tetuan III* and *Sinking Sun*; *Double Mona Lisa* and a Bengston chevron painting; the Apéritif Mugnier poster and the giant lamppost; the kitchen cabinets overlaid with old citrus-crate art from the Arlington Heights Fruit Company; the carousel horse, circus poster, antique organ, and disco ball in the entryway. And, of course, the Mexican

Judas. The color-saturated photographs were taken by Dennis himself, a rare departure from his customary black and white. He would continue to shoot for *Vogue* over the next couple of years, mainly in the front-of-book "People Are Talking About" section. "My lens is fast and my eye is keen," Dennis boasted to Southern. Léon Bing, the model (and later writer) who posed for Dennis when he shot Rudi Gernreich's collections, said that Dennis backed the statement up: "There is that instant when a photographer *must* take the picture—and not all do. He *never* missed."

Dennis documented life at 1712 in a kind of ongoing home movie strung out in a stream of still images: a painfully cute Marin climbing a chaise longue with *Double Mona Lisa* over her shoulder, Jeffrey sprawled on the floor of the den watching TV with an *Army Attack!* comic book beside him, Willie reading *Bennet Cerf's Book of Riddles* with a Band-Aid on his forehead. And always Brooke: Brooke in blurred motion as she rearranges the living room yet again; Brooke playing with the kids in the backyard; Brooke ascending the steep front steps, the ones she had tiled, a luminous dual portrait of spouse and house.

Southern wrote of the kids gamboling into the living room and knocking the accident-prone *Quickie* askew. Dennis loved it: "Let's try it like that for a few days." The house may have been filled with treasures, but it was no museum. It was well lived in, populated by a flood of visitors and three growing children. Marin, who was terrified of *The Quickie* ("I thought she was decapitated"), honed her hula-hoop skills beneath *Standard Station, Amarillo, Texas.* "My mother would say, 'Don't get so close!'" she said. "They were so casual about it." Jeffrey recalled a butter stain on *Sinking Sun*, presumably the result of a flying piece of toast. (Brooke found that amusing but implausible; Willie certified his brother's recollection.) Jeffrey also remembered a Bruce Conner piece that was pornographic enough to be declared off-limits to the children—but not enough to be removed from the household.

"It was embarrassing, frankly, to bring friends over," he said. "I didn't want people to see this house. Like everyone else, we just wanted to be normal." He was equally embarrassed by the Pop Art car his parents chose for the new family ride: a yellow Checker cab, bought at the recommendation of Uncle Bill Hayward. When they rolled up to the John Thomas Dye School, the other kids would chant, "Tax-i! Tax-i!" "All of these kids of scions and their parents would look at us like 'Oh, those are the weird kids,'" Willie recalled.

"I felt like Marilyn in *The Munsters*," Marin said. She came to see 1712 as a kind of stage set, an impression Willie picked up on. "It was a combination of the unreal and the real," he said. When the kids were taken to San Diego to visit Marjorie and Jay Hopper (often in order for Brooke and Dennis to go to Baja for a quick escape), they felt like extraterrestrials touching down on Planet Normal. "They were like a different species to me," Willie said of the elder Hoppers, "a whole different tribe." As Jeffrey recalled of his stepgrandparents' suburban household, "It just felt *tame*. Dennis was living in Technicolor and his parents were still living in black and white. It was a schism between the values of the 1940s and of the 1960s."

"They were both black sheep," Willie said of his mother and Dennis. "They were the outsiders in a lot of ways from their families." That, he said, is what bonded them, what gave them a shared perspective and an off-kilter sense of humor. "They would laugh together a lot," he remembered. Jeffrey was struck by how Brooke and Dennis constantly fed off each other. "They complimented each other's intelligence," he said. Marin agreed. "They opened each other's eyes," she said, "for the rest of their lives."

Dennis never got the highest marks as a hands-on parent, an issue that, for Brooke, could become wearing. "He was the emancipated male," Jill Schary noted. "He could do whatever the fuck he wanted." But the kids loved that Dennis would watch TV with them, crack jokes, be a goofball or sweetheart with them. He would sometimes take them along on his visits to artist's studios, excursions

that might be topped off by a meal at Diamond Jim's restaurant on Hollywood Boulevard. His rare, half-hearted attempts at enforcing discipline were borderline hilarious to them. "He spanked us once, I think," Jeffrey remembered, "and he really didn't feel good about it." Marin, all golden curls and wide blue eyes, wanted to be around her father constantly.

As for Brooke, there was always that coolness, that remove, even as she worked to hold 1712 together. "She was not exactly the maternal type," Willie said. "There's not a lot of *Ozzie and Harriet* in her." Having endured an emotionally atrophied childhood, Brooke said, she had striven for something different with her own family; she always knew that a traditionally maternal role would never come naturally to her. "I tried to create a climate of friendship and camaraderie," she said. "I felt more like a sister than a mother to them. And I really did raise them myself, and I battled things out with them." If there was a golden child, perhaps it was Jeffrey. "She really was a good mom," he said. "She tried really hard."

In one of Roddy McDowall's radiant home movies from 1965, there's a beautiful shot of Brooke. She's bent down to lawn level with Marin and a little friend, aglow with warmth and care. "You really see her mothering there," Jeffrey said. "You see her love."

IN LATE AUGUST, THE BEATLES arrived in Los Angeles, set to play the Hollywood Bowl. They rented a house owned by Zsa Zsa Gabor at 2850 Benedict Canyon Drive in Beverly Hills. On the twenty-fourth, Peter Fonda latched onto McGuinn and Crosby's invitation to swing by for a visit. The moment he walked in, Crosby gave him a dose of LSD. The two of them, along with McGuinn and three-quarters of the Beatles—Paul McCartney abstained—spent the rest of the day and night tripping.

This Los Angeles–London meeting of well-dosed minds is a landmark moment in psychedelic culture. (Acid was then still le-

gal.) It was the famous, or infamous, occasion on which Peter kept repeating "I know what it's like to be dead" as he yammered on about his boyhood gun accident. "He was showing us his bullet wound," George Harrison remembered. "He was very uncool." John Lennon told Peter to shut up. "Who put all that crap in your head?" he snapped. "You're making me feel like I've never been born!" The testy, surreal exchange landed, almost verbatim, in Lennon's song "She Said She Said," on *Revolver*.

Otherwise, the Byrds and Beatles got along fine as they floated in the pool. "I was swimming in jelly," Ringo Starr remembered. At some point, McGuinn showed Harrison some Ravi Shankar riffs; it was perhaps Harrison's first exposure to Indian music, which would prove to have a massive impact upon him—and, through him, upon Western popular culture as a whole. McCartney, meanwhile, had apparently not dropped acid because he feared a loss of control. He may have had an ulterior motive that day: the actress Peggy Lipton showed up at the house, and they disappeared together.

As evening came on and the LSD showed no signs of wearing off, someone showed up with a print of *Cat Ballou*, the recent Jane Fonda hit, to screen for the assembled rock stars. It was the drive-in version, with an irritating, dubbed-on laugh track. If the intention was to show the Beatles that Hollywood was cool, the mildly irreverent *Cat Ballou* did not have the desired effect. "I thought it was the biggest load of baloney shite I'd ever seen in my life," Harrison said.

Acid tended to heighten users' sensitivity to bullshit. Rock culture, it was clear, viewed Hollywood as mainstream and clueless—a veritable bullshit mill. As McGuinn told an interviewer, "Kids aren't so stupid as the people who make movies think they are." By 1965, a hierarchical shift had occurred: musicians such as the Beatles were more than just "stars"; they were avatars, artists, prophets. Hollywood's celebrity-making machinery pumped out movies like Coca-Cola, but the dream factory was creaky, perhaps even obsolete. The

Beatles might have been renting a movie star mansion in the hills, but they were already residents of Mount Olympus.

Brooke and Dennis surely got an earful about this outing from Peter. It is astonishing that Dennis, of all people, managed to miss it. He claimed to be a late adopter of LSD, citing his early explorations with mushrooms, mescaline, peyote, and the like: he'd already been there, done that. Regardless, it was a signal moment, one that brought Swinging London and the Sunset Strip into intimate contact. Dennis and Peter now yearned to push Hollywood filmmaking in the wild directions that the Byrds and the Beatles—not to mention Bob Dylan, the Stones, James Brown, the Beach Boys, and the rest—were exploring. In 1965, musicians were pop culture's aristocracy: they did whatever they pleased, and the world followed wherever they led.

DYLAN CAME THROUGH LA a few days later, playing the Hollywood Bowl on September 3, the Friday of Labor Day weekend. Dennis went; it's unclear if Brooke did. Dylan's epoch-making *Highway 61 Revisited*, "a rock and roll motorcycle trip through Dylan's America" in the words of the music critic and historian David Hajdu, had just come out. It contained the single "Like a Rolling Stone," six and a half minutes of relentless, exhilarating excoriation. The album and the single mounted the pop charts. Inspired by the Byrds and the Beatles, Dylan was now a full-blown rock star, disavowing the folk singer pose that Andy Warhol had always found to be corny. Dylan's message would now be transmitted via electricity; the signal reached 1712, where *Highway 61 Revisited* landed on the turntable. Dennis shot Dylan at the Hollywood Bowl, a stop on a tour during which the singer was alternately heckled and cheered, and, along with McGuinn, went to the boisterous afterparty at the home of Benny Shapiro, the founder of the Renaissance jazz club on Sunset Boulevard.

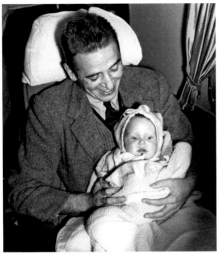

A five-month-old Brooke sits on her father's lap during her first flight, Los Angeles to New York via TWA, December 9, 1937.
THE EVERETT COLLECTION

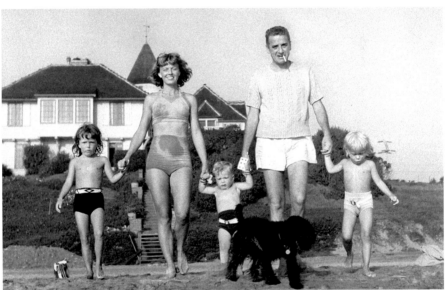

Hollywood's golden Haywards, photograph by John Swope: Brooke, Margaret Sullavan, Bill, Leland, and Bridget, early 1940s. JOHN SWOPE/© JOHN SWOPE TRUST/MPTVIMAGES.COM

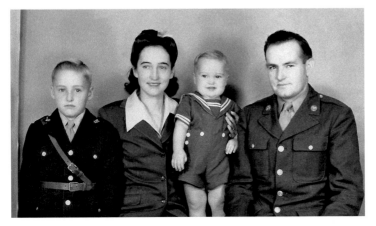

The Hoppers—Dennis, Marjorie, David, and Jay—pose for a family portrait on the eve of Jay's service in the Second World War, December 1944. Marjorie wrote on the back: "Dennis was very sad!"
HOPPER ART TRUST

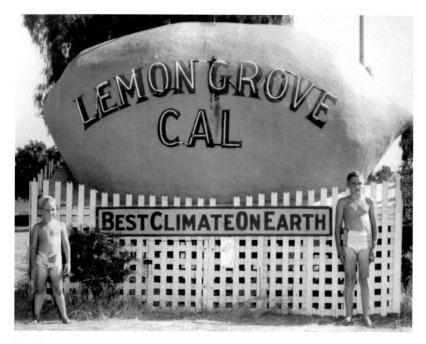

The Hopper brothers becoming Californian, Christmas 1949.
HOPPER ART TRUST

A triptych of teen: Dennis Hopper,
Natalie Wood, and James Dean in
Rebel Without a Cause, 1955.
THE EVERETT COLLECTION

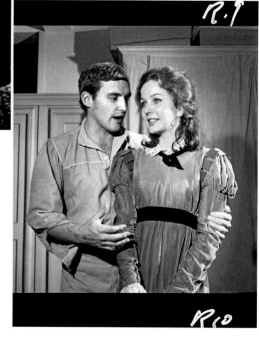

"I'm going to marry you": Dennis and Brooke
onstage in *Mandingo*, May 1961.
FRIEDMAN-ABELES/BILLY ROSE THEATRE
DIVISION, NEW YORK PUBLIC LIBRARY ©NYPL

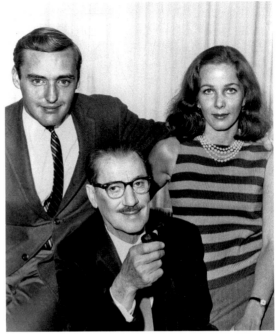

(Below) Dennis and Brooke as impetuous lovebirds, with Groucho Marx, in a January 1962 episode of *General Electric Theater*.

THE EVERETT COLLECTION

(Above) Brooke with *Life* photographer Gjon Mili at the house on Stone Canyon Road, fall 1961.

DENNIS HOPPER/HOPPER ART TRUST

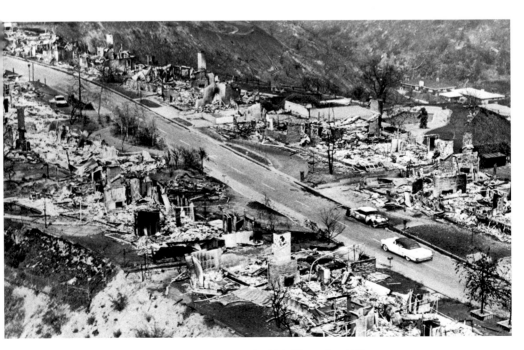

After the Bel Air Fire: Chalon Road reduced to ash and rubble, November 1961.
AUTHOR'S COLLECTION.

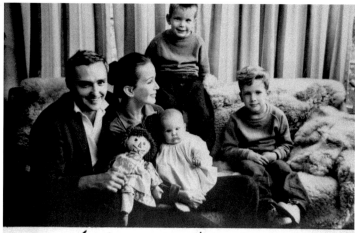

Holiday portrait, 1962: Dennis, Brooke, Marin, Willie, and Jeffrey.

HOPPER ART TRUST

Merry Christmas and Happy New Year

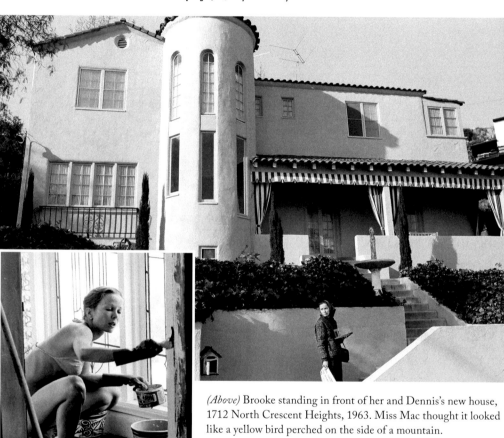

(Above) Brooke standing in front of her and Dennis's new house, 1712 North Crescent Heights, 1963. Miss Mac thought it looked like a yellow bird perched on the side of a mountain.

DENNIS HOPPER/HOPPER ART TRUST

(Left) "Brooke did an amazing amount of work there." Dennis photographed Brooke transforming 1712, 1963.

DENNIS HOPPER/HOPPER ART TRUST

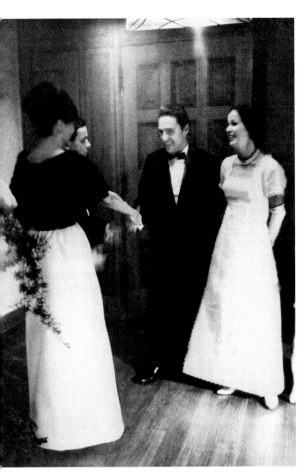

Dennis and Brooke arrive at Nick and Lenny Dunne's black-and-white anniversary party, April 1964.
COURTESY OF GRIFFIN DUNNE

"We just wanted to be normal": The kids with Brooke in the backyard of 1712.
DENNIS HOPPER/HOPPER ART TRUST

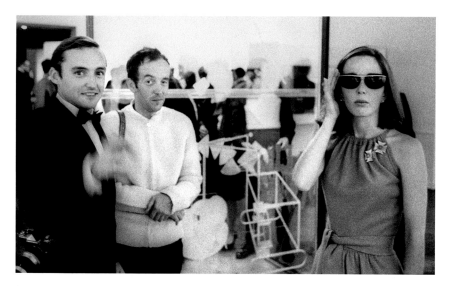

"Everybody was really in awe of Marcel": Dennis, Taylor Mead, and Brooke at the preview of the Pasadena Art Museum's Duchamp retrospective, October 7, 1963.
JULIAN WASSER

"A black and white WOW!": Dennis and Brooke install Dennis's photo-assemblage show at the David Stuart Gallery, January 1963.
PHOTOGRAPH BY WILLIAM CLAXTON/ COURTESY DEMONT PHOTO MANAGEMENT

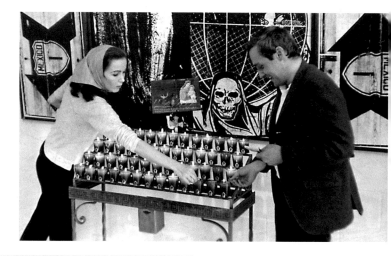

OCT • 63

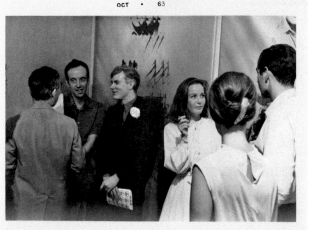

Taylor Mead, Andy Warhol, and Brooke at Warhol's Ferus Gallery opening, September 30, 1963.
PHOTOGRAPH BY JOHN WEBER/CARE OF THE ANDY WARHOL MUSEUM, PITTSBURGH, PA, A MUSEUM OF CARNEGIE INSTITUTE. ALL RIGHTS RESERVED.

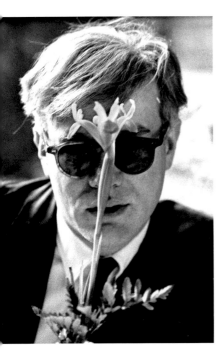

"Shadowy devil's head": Dennis's photograph of Andy Warhol at the Sign of the Dove restaurant, New York, June 1963.

DENNIS HOPPER/HOPPER ART TRUST

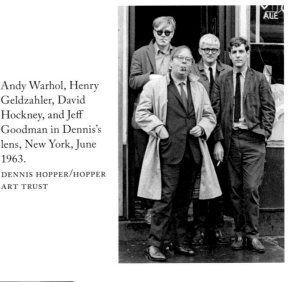

Andy Warhol, Henry Geldzahler, David Hockney, and Jeff Goodman in Dennis's lens, New York, June 1963.

DENNIS HOPPER/HOPPER ART TRUST

"Turned on the camera and walked away": Film still: Andy Warhol, *Dennis Hopper* [ST 155], 1964.

© THE ANDY WARHOL MUSEUM, PITTSBURGH, PA, A MUSEUM OF CARNEGIE INSTITUTE. ALL RIGHTS RESERVED.

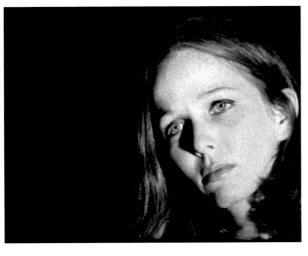

Film still: Andy Warhol, *Brooke Hayward* [ST 132], 1964.

© THE ANDY WARHOL MUSEUM, PITTSBURGH, PA, A MUSEUM OF CARNEGIE INSTITUTE. ALL RIGHTS RESERVED.

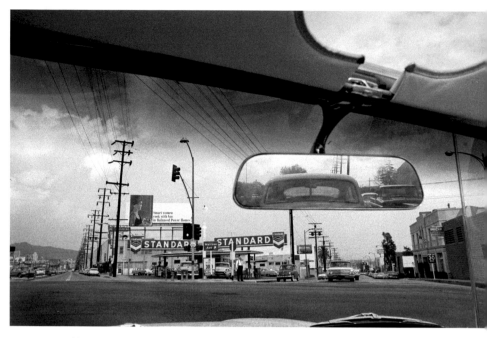

"The best distillation . . . of the L.A. art scene": At the intersection of Santa Monica Boulevard, Melrose Avenue, and North Doheny Drive, Dennis shot his most famous photograph—*Double Standard*—from the driver's seat of his '64 Corvair.
DENNIS HOPPER/HOPPER ART TRUST

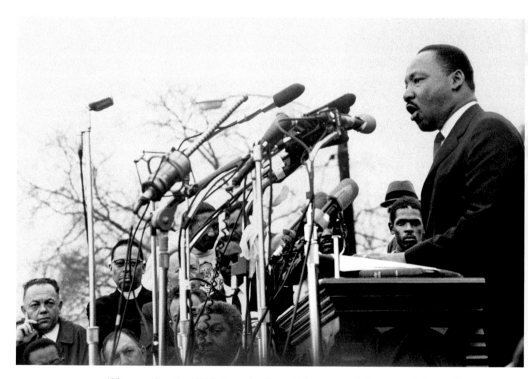

"The very first time I felt that what I was doing was truly important": Dennis's photograph of Martin Luther King, Jr., in Alabama, March 1965.
DENNIS HOPPER/HOPPER ART TRUST

It was around this time that Robert Fraser flew in from London for a couple of weeks, staying, at least for part of it, at 1712. Dennis served as the gallerist's native guide, taking him around to visit his artist friends, such as Ed Ruscha. Fraser was conceiving an LA-focused show, drawing upon the Ferus crowd, including Dennis. Brooke found Fraser, with his decadent charm, to be "a very seductive character." Over Labor Day weekend, they took Fraser to Malibu, where Dennis photographed him standing on the beach with Terry Southern and looking the dandy in a white suit. An American flag is planted in the sand behind them, and they're chuckling over a copy of Jean-Claude Forest's *Barbarella*, the randy French sci-fi comic that Vadim was using as the basis for his next film, with Jane in the title role. It's one of Dennis's most resonant Malibu photographs.

Brooke and Dennis also took Fraser to Mexico, so the Londoner could steep himself in the indigenous art they loved so much. The trip turned into a lost weekend. "It was the first time serious cocaine was brought in," Brooke recalled, "and Robert brought it." Fraser, she said, also brought along "some kind of weird speed, and we all got crazy, completely raving mad, and were unable to go to sleep for about three days. I was angry about it, because I had three children and really another life." Fraser had dosed her without her knowledge. "I felt terribly betrayed by it," she said.

The drugged-out excursion was a stark reminder for Brooke that she had responsibilities to attend to. "She was game for all the adventures," Marin Hopper said, "but in those roles at the time, the boys went off and did stuff and the women tried to keep it together on their end. My mom was trying to keep the kids together, and my dad was off with his posse of guys, being cool. The sixties still had these fifties expectations. And for women there were expectations to flow with the times—and yet be the mother, be the nurturer, and, oh, by the way, tile the staircase."

10

"MAN, NOW I DON'T HAVE A COMPLETE CAKE"

September 30, 1965, was the tenth anniversary of James Dean's death. As ever, a question that roiled Dennis's mind was how to deliver on the late actor's unfulfilled promise and legacy. The good roles that might have come his way after *The Sons of Katie Elder* had failed to turn up, and he was back to guest appearances on shows such as *Convoy* and *Court Martial*. He had the cover of *Artforum* again that month—a stunning photo of torn posters on a wall. The forward-pushing magazine had relocated from San Francisco to a space above the Ferus Gallery, and Ed Ruscha was on the masthead (styling himself "Eddie Russia"), doing layouts and production. The presence of *Artforum* in LA signaled that the city was proving itself to be the global art hub that Henry Geldzahler had described in *Vogue*.

For Dennis, the contrast between having his work in that esteemed publication and being relegated to acting roles that he little enjoyed and that generated few plaudits was brutal. It was no longer time to wait around for some great Hollywood opportunity that might never come. Instead, he pushed forward with the ambition of

making his own movies according to his own rules. If he succeeded, it would be not only the career breakthrough he'd been trying to achieve for years but a breakthrough in Hollywood filmmaking as well.

Dennis and Stewart Stern had entered into a "Letter-Agreement" for working together on *The Last Movie* (subtitled *Boo-Hoo in Tinseltown*), the meta-western film concept that had come to Dennis on the set of *The Sons of Katie Elder* in Durango. Stern found Dennis's premise "marvellously inventive." Brooke was excited enough about Dennis's notion for a film that would explore film itself—through the story of a Hollywood production in a dusty Mexican town—that she put up $4,000 of her own money for Stern's services in order to keep the project building.

"He fascinated me because he had ideas before anybody else did," Stern said of Dennis. Not that he thought that all of Dennis's ideas were good; at 1712, he scoffed at the art on the walls. "I would get infuriated because the art seemed to have no history, tradition, background," he remembered. "I felt many of the artists that he was admiring seemed to come from nowhere. I felt they were sort of starting from each other. History was suddenly being looked upon with great contempt." It's jaw dropping how utterly wrong Stern was about Dennis and Brooke's intentions as collectors and about Pop Art, which was, after all, entirely engaged with art history. Dennis often told the story of another Hollywood associate, an agent, who rebuked him for his and Brooke's collecting. "I can't believe the way you're squandering your wife's money!" the agent told him. "It is an embarrassment. And if you don't get rid of those things, I can't represent you anymore." Dennis fired him.

He didn't fire Stern. In fact, the two of them worked well together, turning out a ninety-seven-page treatment at Stern's house on Harold Way, above the Sunset Strip. "Dennis would stride back and forth in the room, and we'd spitball ideas," Stern remembered. "I sat at the typewriter, and he'd walk behind me with his joint and

he'd be raving. Then he said, 'I bet you could really write it if you had a little joint.' I said, 'Well, I just won't do it, it makes me hallucinate.'" But Dennis found a way around that. "I had my snorkel and mask at home," Stern said, "so I put it on while I typed, and every time Dennis had some excess, he'd blow it down my snorkel. I was nearly as stoned as he was." The lead character they created was a veteran stuntman and rodeo rider named Tex: "Wiry, hard, a little bent and beaten, forty-five maybe." Dennis envisioned Montgomery Clift in the role. They came up with another character named King Millard, who was clearly modeled on John Wayne. The collaboration took off.

Dennis had submitted a Tom Wolfean essay to *Vogue* about American moviemaking. It's a snapshot of Dennis's thinking in 1965. "Film is an art-form," he wrote, "an expensive art-form, it's the Sistine Chapel of the Twentieth Century, it's the best way to reach people." Everyone was looking for auteurship and independent filmmaking, he noted, but nobody in the business was actually doing it. He mentioned the experiments of Bruce Conner and Andy Warhol and relayed cocktail conversations typical of Hollywood and Malibu, of people sitting around racking their brains trying to remember old Busby Berkeley movies while bemoaning the current state of affairs. "What we need," he argued, "are good old American—and that's not to be confused with European—Art Films. But who delivers? Where do we find them? How much does it cost?"

It was a fascinating essay that might have worked well at *Esquire*. *Vogue* rejected it.

WHEN OCTOBER ROLLED AROUND, ED KIENHOLZ unveiled his latest tableau. It was arguably his most ambitious and possibly his best—*The Beanery*, a grimy, surreal, two-thirds scale re-creation of the art crowd's favored dive, Barney's Beanery, which he installed in

the parking lot of the actual Barney's on Santa Monica Boulevard. "I guess Barney's was our Cedar Bar," Ed Ruscha said, comparing the place to the storied Manhattan hangout where the abstract expressionists gathered. It was said that a grease fire at Barney's could wipe out the entire LA art scene. The same could be said of the rock crowd, which also adopted Barney's Beanery, joining a clientele that one contemporary observer described as "beatniks, neighborhood time wasters and unclassifiable types who could be radio talkers, TV writers, actresses and European tourists."

Dennis had a game he liked to play at Barney's with Kienholz: He'd order a beer for himself, and Kienholz would grab it and drink it down. So he'd order a whiskey, and Kienholz would take that, too. The pattern would continue until Kienholz was well toasted. It was perhaps no surprise that Kienholz used Dennis as a model for one of the plaster-cast barflies that populated the piece; their heads were clocks stopped at ten past ten. Dennis said the constricting experience of being cast in plaster was just awful.

Hollywood had been feeling just as constricting, and so Dennis made further moves to bust out. One day, he went over to Peter Fonda's place on Hidden Valley Road in Coldwater Canyon with a couple of friends to talk about independent filmmaking. The circa-1936 house had been designed by the Hollywood architect Roland E. Coate, who had built the Selznicks' pre–Tower Grove house on Summit Drive. It was shrouded in tall pines and sycamores on two acres, with a swimming pool and a tennis court—a proper movieland mansion, so unlike the eccentric 1712. He lived there with his wife and their one-year-old daughter, Bridget, named after Brooke's sister.

Like Dennis, Peter had had his quarrels with the Hollywood establishment. When he tried out for the role of JFK in the 1963 biopic *PT 109*, he refused to put on the Kennedy accent, perhaps fearing that he'd come across like Vaughn Meader. "That smug little asshole!" Jack Warner railed. Peter now told Dennis that he wanted

to make an arty, irreverent comedy about a guy in love with love. The "unsolved insanity" of *What's New Pussycat?* had impressed him. The kids hanging out on the Sunset Strip—there were no movies for them. Paraphrasing his aborted *Vogue* essay, Dennis said that everybody talked about making interesting American movies but nobody had the guts to do it. Dennis liked Peter's premise, and Peter liked Dennis's challenge. In short order, they roped in a gag writer, Don Sherman.

Sherman remembered his first encounter with Dennis and Peter, the one glinty and stocky, the other languid and lanky. "They came to my house in the pouring rain," he said. "It was two o'clock in the morning. They were knocking at the sliding glass door on my patio. I came to the door and there were these two guys soaking. They said this guy sent them to see me and they wanted to do this movie. The reason they came so early was because they wanted me to see the sun rise. They were on acid." If Sherman's impressions were correct, Dennis had gotten over his indifference to LSD. He and Peter took Sherman to Randy's Donuts in Inglewood. "They wanted to see the sun rise over this giant donut and that was going to be the opening shot of their movie," Sherman recalled. It was a visual conceit obviously inspired by Dennis's immersion in Pop Art and the Los Angeles streetscape he loved photographing. When the acid wore off, Peter put Sherman and Dennis on the payroll as screenwriters at his new production company, Pando. Sherman was paid a thousand dollars a week for the ten weeks it took to develop the screenplay.

By mid-December, the script was done. The movie centered around a Peter Fonda alter ego named Peter ("son of what's his name"). It opened with the words THE END emerging from a sunset (the Randy's Donuts concept didn't make the cut), had the Byrds performing "The Battle Hymn of the Republic," visited a billboard factory, set a dance number at Watts Towers, spliced in mock TV commercials for Alka-Seltzer, featured pies thrown in faces, and explored themes of "crass commercialism" versus "love." It was a

surreal send-up of Hollywood that, in its antic, comic-book way, anticipated the 1968 Monkees movie, *Head*, written and produced by Dennis's friends Bob Rafelson and Jack Nicholson. Peter claimed that the script made him laugh so hard, he cried. He and Dennis tussled over the title. Dennis suggested "The Ying and the Yang." Peter pointed out that the Chinese concept of dualism was actually *yin* and yang. Dennis countered that he liked the symmetry of "ying" and "yang." They came up with a compromise as awkward as it was absurd: "The Yin(g) and the Yang."

IN EARLY 1966, DENNIS ONCE again flew to London, this time for the January 26 opening of the *Los Angeles Now* show at Robert Fraser's Duke Street gallery. London was then swinging into its most glorious period, with men strutting around like Edwardian peacocks and LSD beginning to permeate. "There was such a revolution going on," he remembered of that visit, which was as eye-opening as the one he'd made in 1964. "The whole fashion world was on fire." He, too, was on fire in London, his creativity stimulated—along with his inconsistently regulated libido and incipient paranoia.

Dennis's photograph *Double Standard* was used to advertise the show, and a few of his sculptural works were included in it—huge polystyrene cacti and boulders. Whether they had been appropriated from a western movie set or commissioned from the people who make such things remains unknown. The foam sculptures—a Pop Art analogue of *The Last Movie*—were shown amid work by Ruscha, Conner, Kaufmann, Berman, Bell, and others. Ed Ruscha was excited to find that California artists were, as he put it, "treated almost like equals in England—not like Martians from outer space." Even so, the British press seemed determined to view the show as evidence that America, particularly LA, had gone off the rails. *The New Statesman* cited the show as "One of the more outré consequences of the open society."

For some reason, Fraser thought it would be a good idea to have Dennis stay with a young boutique owner, Pauline Fordham, in her Earl's Court flat. She was the recently ex-girlfriend of the artist Derek Boshier. "I was just getting myself together when Robert sent Dennis over," Fordham remembered. "That really shook me out of myself." Dennis arrived on her doorstep draped in camera equipment, telling her he needed to keep it on his person at all times lest he lose something and trigger Brooke's ire. Fordham became alarmed when Dennis planted himself at a window, keeping an eye on the street. FBI agents, he said, were tailing him. At 1712, Dennis had confided to his stepsons' grandfather, "Mr. Thomas, I think someone is following me." Joe Thomas, thinking of the young man's Hollywood career, replied, "Dennis, you should start to worry when they're *not* following you."

Fordham found Dennis's behavior genuinely troubling and decided that she couldn't handle having him at her flat. But not before they'd had a brief fling. "My biggest drive wasn't alcohol or drugs—it was sex," Dennis admitted in one of his moments of contrition in later life. "The idea was to break through inhibitions in order to become a better artist. I consider my sexuality to be a tremendous creative source, but at a certain point in my life I dealt with sex like I was drinking beer." The Lothario role he had assigned himself as a young star in 1950s Hollywood was one he could not fully relinquish.

Brooke was aware that her husband was occasionally seeing other women. "I'm *sure* he was," she said. For the most part, she turned a blind eye to Dennis's erotic explorations; it was the swinging sixties, after all. But that wasn't always possible. One night at 1712, Dennis, Jane, and Vadim trooped into the house and proposed a foursome, years before *Bob & Carol & Ted & Alice*. "This was ten o'clock at night," Brooke remembered, just around the time she might lie down with a book after getting the children settled. "They got into bed with me. I was just *furious*. I said, 'Get the fuck out.'" In a 1971

interview, Dennis admitted, "I do enjoy group sex." Vadim, for his part, insisted, "Sex has been an inspiration, the greatest inspiration, since art exists."

"Can you believe it?" Brooke said. "That's how things were." To her, free love was not about freedom or love—it was actually pretty grim, and it had the potential to disrupt precious relationships. "It was not exactly my idea of heaven," she said.

The jealousy Dennis had felt when Brooke returned home, innocently, with a male costar never seemed to prompt any behavior changes on his part. To look through his contact sheets is to occasionally encounter a subject identified only as "unknown woman." It might be a mystery girl undoing her garters and unbuttoning her blouse or a pair of blondes, whom Dennis said he'd met in 1967 at the Love-In in Los Angeles, stripping down. (No such photographs exist of Brooke.) "Whether it's Goya, Gauguin, Da Vinci, Michelangelo, or Degas," he insisted, "they all did pornography." Considering the thousands of photographs he took, the ones of this ilk are few. But they're unignorable, a restless playing out of Eros—and the sixties-era male gaze—on Tri-X film.

DENNIS AND PETER MADE THIRTY copies of their screenplay; Fonda had apparently prevailed, as it was now called *The Yin and the Yang*. They bought new suits in order to look successful and hip and flew to New York in February in search of financial backers willing to put up $450,000 for the production. "We were on our way," Peter later wrote of their optimism. "We were going to make our own pictures." They hung out with Dennis's art-world friends, including Andy Warhol, Henry Geldzahler, Larry Rivers, and the Oldenburgs, drove around town with Bill Blass and a retinue of fashion models, and dined with Mick Jagger at Orsini's. They met Salvador Dalí, who was preparing a show called *Dalí: A Happening*, at Lincoln Center; his mistress informed them that she was a witch.

It was possibly on that trip, at Max's Kansas City, that Dennis struck up a flirtation with Edie Sedgwick, the luminous and doomed Warhol superstar. Edie deflected Dennis, explaining that she had shot way too much speed that night to have any interest in sex. Dennis was repulsed by the idea of injecting drugs—it was masochistic, suicidal, a self-destructive sublimation of erotic drives. He interrogated her: "Why are you doing that? That's just a sexual hang up." Edie shot back, "Why are you so hung up on sex? Why are you so into *that* trip?" The argument went back and forth until Dennis finally called Edie a cab.

In their search for funding, Dennis and Peter made the rounds of just about everyone they knew within a reasonable degree of separation. They targeted "these cats who could have written the bread off their undershirts," as Dennis put it. They made their pitch to the *Paris Review*'s editor, George Plimpton, and the philanthropist party thrower Carter Burden. No dice. They visited the A&P heir Huntington Hartford, who in 1964 had established his kitschy, and already floundering, Gallery of Modern Art at 2 Columbus Circle. As Dennis remembered, "Huntington Hartford said to us, 'Levitate yourself and I'll give you the money,' and we thanked him and walked out into the snow, and we saw a pigeon with a broken wing, and then we saw a German band marching on the street, and then we met James Baldwin in a bar and he talked about black power." He and Peter joined up with Bobby Walker and dropped acid. In the lobby of a hotel they encountered a prostitute, who gave them a copy of *The Gospel of Thomas*, a Coptic text unearthed in Egypt in 1945 that was purported to be the lost sayings of Jesus Christ. "I was an atheist at that point," Dennis said, "and it was pretty far out, but we read it aloud, and I couldn't find anything in it I couldn't believe."

Holding the secret words of the savior in his hands was very attractive to Dennis, and he would quote or paraphrase them for the remainder of his days. "Don't lie and don't do what you hate,

because all things are manifest before heaven"—a goad for him to obey his ambition, as well as to generally do as he pleased. "What you hear with your ears, what you see with your eyes, all the secret wonders of the world will be revealed to you"—a license to indulge the senses in pursuit of knowledge, total validation for a young man immersed in Method acting and visual art. "Whoever does not hate their father and his mother as I do cannot become my disciple"—an easy edict for Dennis to accept, given his relationship with Marjorie and Jay. Thomas's Jesus was one he could get behind, far removed from the Methodist version he'd been taught in Dodge City.

The unexpected theological detour continued when Dennis and Peter, along with Walter Hopps, went to visit Darlene de Sedle, whose parents ran the venerable Madison Avenue jewelry and antiques shop de Sedle's. Hopps remarked that a painted panel hanging on de Sedle's wall was a remarkably good copy of one from the Mérode Altarpiece, the stunning fifteenth-century Northern Renaissance triptych by the painter Robert Campin that the Metropolitan Museum of Art had acquired in 1956 and exhibited in the Cloisters. De Sedle offhandedly replied that the panel they were looking at was, in fact, the original Campin; her father had bought it from the auction house Parke-Bernet in 1935. She said the other two panels were in a closet.

Hopps was stunned; he laid the three panels on the floor and studied them. Peter thought Hopps looked as though he might cry. Given the twisted provenance of the Mérode Altarpiece, there was, in fact, reasonable doubt as to whether the triptych attributed to Campin in the Cloisters was the original. Hopps estimated the value of that piece at $8 million. De Sedle told them that if her triptych turned out to be the real McCoy, she'd sell it, get the money, and, as a kind of commission, give Dennis and Peter the $450,000 they needed to make *The Yin and the Yang*.

De Sedle agreed to let them take the triptych, wrapped in pillowcases, up to Columbia to get the opinions of art historians. An

older curator, visiting from the Louvre, nearly collapsed when he saw what Dennis and Peter had brought in. He thought the piece might be authentic and requested that he and his team be allowed to X-ray it in order to help verify its provenance. The thought of the Mérode Altarpiece leaving their possession triggered Dennis's paranoia. He pulled Peter aside. "Don't you get it, man?" he said. "They're going to keep the painting, man, and when they find out it's the original, they'll keep the real one and give us back the counterfeit one, man."

He and Peter declined the opportunity, returned the panels to de Sedle, and left New York without securing any funds for *The Yin and the Yang*. The movie would never be made.

AT THE BEGINNING OF MARCH, the B-movie specialists American International Pictures released Curtis Harrington's sci-fi horror film *Queen of Blood*, starring John Saxon and Basil Rathbone, with Dennis in the role of astronaut Paul Brant. Harrington described the production: "I devised a tale in which the queen of the aliens— brought back to earth by a group of American astronauts—is a vampire creature who seeks a new food source for her dying planet. The food source, as it turns out, is the human race." Dennis, as Saxon recalled, "was trying very hard to keep a straight face throughout." It was perhaps even more absurd than *The Yin and the Yang*. Even so, as with *Night Tide*, Harrington had managed to inject a bit of art into a throwaway film. It was another filmmaking lesson that Dennis would remember.

A few days after *Queen of Blood* came out, Dennis popped around to RCA's recording studios on Sunset Boulevard across from the Cinerama Dome movie theater, to meet up with Brian Jones of the Rolling Stones. He brought his Nikon, and in the resulting photographs, Jones—in his paisley shirt, white vest, and flowing scarf— pulls faces and laughs, making it clear that he and Dennis have a

rapport. Jones then proceeded to sit cross-legged on the floor of the studio and play a long-necked Indian stringed instrument—the sitar. The occasion was likely an overdubbing session for "Paint It Black," the Stones' most adventurous song yet, thanks to the aural exotica that the multi-instrumental Jones brought to it. (The band's bass player, Bill Wyman, said Jones had written the song's Middle Eastern–inflected melody, uncredited.) In about six months, the Indian influence had traveled from Benedict Canyon, where the Byrds and the Beatles had tripped while listening to Ravi Shankar, back to London, where the Beatles recorded the sitar-laced "Norwegian Wood" at Abbey Road in October, and now back to Los Angeles, where Dennis documented a landmark rock moment at RCA.

March 1966 was an incredible month for Dennis to be making the rounds of LA's recording studios, much as he'd made the rounds of artists' studios for years. He and Brooke had been fascinated when art had gone pop; now pop was going art. On March 7, Capitol released a teaser single from the forthcoming Beach Boys album, *Pet Sounds*. The song was "Caroline, No"—beguiling, achy, hypnotic, with an unlikely instrumental palette that included an echoey rhythm tapped out on a Sparkletts water-cooler jug. That the single was credited solely to Brian Wilson, to whom the label "genius" attached itself around this time, suggested that the auteurship Dennis had been seeking in Hollywood was manifesting itself in Los Angeles music making.

The city was looking like the center of the pop universe, a phenomenon brought home on March 14, when the Byrds released "Eight Miles High," a paradigm shifter of a 45 that managed to get itself banned because of its putative druggy subject matter. It was actually a chronicle of the Byrds' tour of England the previous year; even so, it emitted copious signals about expansion on all fronts. In three minutes and thirty-three seconds, the Byrds more or less invented psychedelic rock, jazz rock, and raga rock at one go. They

would never sell as many records as the Beatles (who did?), but they were right alongside them in the experimentation department.

Pioneered by the Byrds, Laurel Canyon, just over the way from 1712, was now a budding bohemian garden of rock stardom, where joints smoldered while money was virtually minted. In the coming years, the winding byways of the Kirkwood Bowl and its environs would give birth to wave upon wave of hit records, as Laurel Canyon became the nursery for the greening of postwar American pop. Along Wonderland Avenue, Ridpath Lane, and Lookout Mountain Avenue, a new roster of American rock royalty sprouted throughout 1966: Frank Zappa and the Mothers of Invention, the Mamas and the Papas, the Turtles, Buffalo Springfield. For the next decade, Laurel Canyon—where Dennis and Brooke often went to visit Ed Kienholz and Rudi Gernreich, among other friends—would continue to generate no end of mythology. It was a flowering of creativity that was sometimes compared to Paris in the 1920s, to Bloomsbury, to fin de siècle Vienna—comparisons, however over-the-top, that also applied to Los Angeles as a whole in the sixties.

"It was a wonderful time," David Hopper remembered. "Everybody had a new song out, and it was just an unbelievably powerful period. People were growing. Marijuana had never been anything special. Suddenly it became very special." One day, David—who now had a wife and daughter—drove up from San Diego to visit his brother. When he walked through the big wooden front door at 1712, he found himself face-to-face with Ike and Tina Turner. Dennis was conducting a portrait shoot, creating a run of madcap images—Ike and Tina in the foyer with the antique organ and carousel horse, in the living room playing around with the giant plastic Coke bottle. Despite Ike Turner's reputation for being, as the music writer Barney Hoskyns put it, "a scary motherfucker," the images are among the most joyous that Dennis ever created. Danna Ruscha remembered Dennis running into the *Artforum* office above Ferus and talking excitedly about his latest portrait subjects.

As was his wont, Dennis took Ike and Tina to Foster & Kleiser. Two of the pictures Dennis took of them at the billboard factory became the cover of their next album, *River Deep—Mountain High*. The album was recorded in March at Gold Star Studios on Santa Monica Boulevard. The producer was Phil Spector, the slight, asthmatic pop Midas who was given to wearing jerkins and shirts with frilly Byronic cuffs. Tom Wolfe labeled Spector "the first tycoon of teen" for the airwave-saturating run of Top 40 hits he conjured up for the Crystals, the Ronettes, and their booming AM radio ilk; he was barely older than the artists he produced. Dennis and the man whose Wall of Sound brought Wagnerian grandiosity to record production had a few traits in common: manic creativity, robust ego, dash of paranoia, Napoleonic tendencies. "We drank and took drugs and did crazy things," Dennis remembered.

Dennis shot the Gold Star sessions, famous for yielding the album's eponymous single, "River Deep—Mountain High," on which Tina sang like a human fireball amid a deafening maelstrom provided by upward of two dozen session musicians crammed tightly into the studio. It was the kind of sonic conflagration that only Spector could create, one that in terms of sixties recording technology was as sprawling and overheated as the Bel Air Fire. "River Deep—Mountain High" was both cataclysm and burst of ecstasy—the full Heaven-and-Hell gamut on a 45. It is one of the greatest pop recordings of all time.

In Dennis's pictures, Tina runs through the song at the mixing console with Spector egging her on; in the studio, she's surrounded by musicians of the famous Wrecking Crew—there's Carol Kaye in her cat-eye sunglasses with her Fender bass. Spector glares out from behind the control room's glass picture window. It looks as though he's about to smash his chinless face right through it. Accounts of the session have Spector screaming like an insane person and Tina shredding her vocal cords. Eventually Tina was stripped

down to her bra at the microphone, slicked with sweat. Ike wasn't even around; he had been told he wasn't needed.

Brian Wilson came to Gold Star to observe Spector, his hero, at work. Like some of Wilson's own best music, "River Deep—Mountain High" would be celebrated in England as pop genius (George Harrison said it was "perfect") and neglected in America. The single bombed, and the album's release was scratched in the United States. (It eventually came out in 1969.) Ike Turner put the epic failure down to segregation: Was the record pop or was it R&B? "The white stations say it was too black," Turner said, "and the black stations say it was too white."

It was Phil Spector's Waterloo. The humiliation brought by the failure of "River Deep—Mountain High" drove him to an early retirement. But Spector was already looking at his next big project: helping Dennis Hopper make *The Last Movie*.

BROOKE AND DENNIS DROVE UP to Malibu on April 23 to attend the "Underground Wedding" of James Elliott, until recently the chief curator of the Los Angeles County Museum, and the British model Judith Algar, held at the architect Frederic P. Lyman's stunning redwood-and-glass house. It was a rollicking bicoastal art-world party. Aside from Brooke and Dennis, the four hundred guests included the Oldenburgs, Ed Kienholz, Ed Ruscha, Irving Blum, Billy Al Bengston, Robert Rauschenberg, Christopher Isherwood, and Rudi Gernreich. The *Los Angeles Times* called it "a happening." "Everyone got drunk on champagne," Patty Mucha recalled, "because the bride was an hour late." Michael McClure, the San Francisco poet, had written the marriage ceremony. Milk and honey were stirred with a silver rod and consumed by the new Mr. and Mrs. Elliott. It was a sun-dappled Saturday, and the decade was in full bloom.

Dennis roamed the festivities with his Nikon, his attention often

pulled back toward Brooke, who looked stunning and cool in her mod equestrian outfit. Oldenburg provided the "cake"—individual slices, cast in plaster, one piece per guest, each one ink-stamped on the bottom WEDDING SOUVENIR CLAES OLDENBURG LOS ANGELES 1966. As Oldenburg was busy stamping slices of plaster wedding cake, Rauschenberg happened by and offered his tongue to be stamped. Oldenburg obliged, and Dennis got the picture.

Dennis then got an idea to apply his knack for appropriation to rounding up enough slices to make an entire Oldenburg cake. "Claes was very impressed," Brooke said. Oldenburg even helped gather up the requisite sixteen pieces. George Herms saw what Dennis was up to. "I stopped him to see what he had," he said. "I did not have even one slice, so I reached in and grabbed one. Dennis, in that voice of his, got hot at me. 'Man, now I don't have a complete cake.'" Dennis found another slice to complete the set. That night, a full sixteen-slice cake, the latest item in Dennis and Brooke's collection, arrived at 1712, where it went into the dining room.

The Los Angeles County Museum of Art, where Elliott had worked, had recently moved into a trio of gleaming new buildings designed by William L. Pereira on Wilshire Boulevard, next to the La Brea tar pits. It was said to be the largest art museum built in the United States in twenty-five years. Not long before the Underground Wedding, the museum opened a major Ed Kienholz exhibition, celebrating the assembleur who was practically a mascot for the LA art renaissance. Ed Moses said it was "the biggest thing that had ever happened for a local artist." He was right: the county Board of Supervisors decided the Kienholz show was pornographic and vowed to shut it down.

It was like the Wallace Berman bust at Ferus in 1957 on a grander scale. *Back Seat Dodge '38*—a grungy Kienholzian tableau that showed a couple going at it inside the vehicle of the title—became the focus of a raucous dispute over obscenity, censorship, and the arts, one that spun into a national news story. *Five Dollar*

Billy, from the *Roxys* show that Brooke and Dennis had seen at Ferus, was also considered problematic. The threat of an out-and-out culture war was defused only when Kienholz agreed to display *Five Dollar Billy* on a large platform that distanced the viewer from the offending work and to have docents open the doors of *Back Seat Dodge '38*. Minors were not to be admitted to the exhibition without adult accompaniment.

The show went on as planned. But the affair roiled Los Angeles, whose conservative, provincial streak—often hidden yet stubbornly a part of the city's identity—was at odds with everything that Brooke and Dennis had been inspired by. Here was the real yin and yang of Los Angeles at work. Fittingly, Ed Ruscha had been working on a canvas of the new County Museum engulfed in flames. "It seemed like the spirit in the L.A. art scene began to deflate," he said. The Underground Wedding, it seemed, was both high-water mark and swan song.

MANY OF THE GUESTS FROM the Underground Wedding converged a week and a half later on the Sunset Strip. The occasion was the arrival of Andy Warhol's Exploding Plastic Inevitable at a club called the Trip, formerly the Crescendo. The Exploding Plastic Inevitable was a sensory overload experience with an all-enveloping light show, S&M-inspired dancing care of the whip-toting Gerard Malanga, and the grinding, tuning-optional sound of a band that Warhol had taken under his wing, the Velvet Underground. The group's founder and singer, Lou Reed, wrote bubblegum melodies and paired them with lyrics about heroin and Sunday-morning comedowns, mordant studies in solipsism, alienation, and human failings. Warhol brought to the band an additional vocalist, the German ice-queen chanteuse Nico, whom Mick Jagger reportedly thought was the next Joan Baez. But there was nothing clarion about Nico; she sang in a deathly, Garbo-esque drone. By

definition, the unabashedly New York–centric Velvets were as far removed as you could get from the ecstatic California sound. Yet there was no animosity on the part of the Velvets toward LA or its radio-dominating music. "The Byrds," Reed declared, "are divine." He thought McGuinn's playing on "Eight Miles High" was the greatest thing he'd ever heard. The band's violist, John Cale, was obsessed with the Beach Boys.

It's hard to imagine that anyone could have been more excited to check out what Warhol was up to with the Exploding Plastic Inevitable than Dennis. Here, after all, was the melding of two realms that had ensnared his imagination: the Factory and the Sunset Strip. He and Brooke made it to opening night at the Trip, bringing along the improbable retinue of Jennifer Jones, Joseph Cotten, and Tuesday Weld. Half of Hollywood showed up, from Ryan O'Neal to John Phillips to Sonny and Cher, along with the Ferus gang. "That show was *mind-blowing*," Danna Ruscha recalled. "The light show—it was fantastical. If only one knew at that time that what one was seeing was historical."

The club was packed, Warhol movies were beamed onto the stage, Malanga cracked his whip, and the Velvets sang about "feeling sick and dirty, more dead than alive." The UCLA film major Jim Morrison was impressed by Malanga's flowing hair, leather pants, and billowing shirt, a look he made his own when his band, the Doors, began playing at the Whisky à Go Go later that month. Cass Elliot of the Mamas and the Papas loved it, returning on subsequent nights. The underground journalist Paul Jay Robbins found Warhol's extravaganza "clean as a gnawed skull and honest as a crap in the can." He seemed to mean it in a good way. Cher hated it, predicting that the Velvet Underground "will replace nothing, except maybe suicide"—a line that Warhol promptly appropriated for promotional purposes. "The Velvets in their wrap-around shades and tight striped pants went right on playing their demented New York music," he remembered.

Ultimately there was to be no East Coast–West Coast love fest at the Trip, where Frank Zappa's Mothers of Invention were also on the bill. It was a musical freak show that rivaled the EPI in outrageousness but with a gonzo satirical streak, which Zappa deployed mercilessly as he skewered the Velvets' affectations and musicianship. "These guys really suck," he announced from the stage, hitting a sore spot for the Factory crew. (Reed later mocked Zappa as a "two-bit, pretentious academic.") The New Yorkers now decided they loathed the so-called mellow California scene.

After three shows, the Trip was shuttered due to an unrelated matter. It was the end of what had been conceived as a multiweek residency for the Exploding Plastic Inevitable. Most of the Warhol entourage holed up in the Castle, a four-story pile surrounded by jade gardens on a gumdrop hill in Los Feliz. The EPI was next booked into the Fillmore in San Francisco, where, in Haight-Ashbury, a strain of the counterculture was sprouting up that prided itself on being more real than the one on the Strip. The Warhol group's booking at the Fillmore, home to Jefferson Airplane and the Grateful Dead, was a culture clash more extreme than the one they had encountered in LA. As the Velvets' drummer, Moe Tucker, put it, "I didn't like that peace-love shit."

"We had vast objections to the whole San Francisco scene," Reed said. "It's just tedious, a lie and untalented. They can't play and they certainly can't write." Reed's objections echoed those of many in Los Angeles, which, like London and New York, prized cogent songwriting and the cachet that came with hits. Los Angeles and San Francisco, separated by four hundred miles, seemed forever doomed to rivalry and mutual disregard. The Los Angeles freaks looked to San Francisco and saw provinciality and self-righteousness, while the San Francisco hippies looked to Los Angeles and saw plastic Disneyland.

Warhol preferred plastic Disneyland. In LA, Irving Blum mounted the third Warhol show at Ferus, timed to correspond

with the Exploding Plastic Inevitable's West Coast trip. It featured the artist's *Silver Clouds*, metallic plastic pillows filled with helium that floated around the gallery. The show signaled Warhol's supposed farewell to painting, as he had decided to focus on film and the Velvet Underground. At the opening, a photographer from *Life* zeroed in on Brooke looking very dolly bird in her checked Leon Bennett cap and hoop earrings, her face reflected in one of the shiny pillows as she balanced it on her fingertips. Warhol sighed and fretted. The *Silver Clouds* weren't floating as intended. "Gerard," he whined, "why can't we get them to hover in the middle?" Compared to Warhol's 1962 and 1963 Ferus shows, this one felt a bit flat—more deflation.

A WEEK AFTER THE EPI appeared at the Trip, Brooke answered the phone at 1712 to find Roddy McDowall on the line, calling from New York. Jane Fonda, he explained, had told him about the film Dennis had been developing with Stewart Stern. Brooke, having put her own money into the project, found the treatment that Dennis and Stern had generated to be "brilliant." She was an all-important second pair of eyes, examining the treatment as she would Dennis's contact sheets. As Buck Henry had observed, Brooke was someone you wanted on your side; she must have been doing a good job of getting the word out about Dennis's movie. She certainly got McDowall excited. That day, May 11, the actor sat down and wrote an effusive letter to "Dear Hop-Head," proclaiming himself over the moon about Dennis's project and practically begging for a role. "It is all like a dream-come-true," he wrote, "and this friend is awash with pride and delight."

The Last Movie was generating buzz in Hollywood. It would be John Ford by way of Pirandello—a western within a western, a movie about movies, the twisted story of a big Hollywood production in a small Mexican town. The treatment took the self-

consciously absurd film-qua-film aspects of *The Yin and the Yang* and cranked them up. As the title intimated, *The Last Movie* was meant to be something of a final word on Hollywood mythmaking, the moment in film history when Hollywood folded back upon itself like a snake devouring its own tail. Dennis's vision was customarily grand. "It's a story about America and how it's destroying itself," he said.

The lead character, Tex, is a middle-aged stuntman, all bumps and bruises. As Dennis explained, "He dreams of big cars, swimming pools, gorgeous girls. He's so innocent. He doesn't realize he's living out a myth, nailing himself to a cross of gold." Tex is also a guy who yearns for escape and simplicity—the country-town idyll of basic people and basic values, far from Hollywood. It was a fantasy that Dennis himself would pursue in the coming years and one the counterculture was beginning to nurture as back-to-the-land communes began sprouting up across the country and Bob Dylan left Manhattan for Woodstock. When the western that Tex is working on wraps, he remains in Durango to make a go of it. He plans to set up a ranch and lease horses to the Hollywood productions that come through: beautiful landscape, soulful people, low overhead, no smog. He falls for a prostitute named Maria; marriage beckons. But Tex's dream of pastoral living turns into a passion play nightmare when the script of the western falls into the hands of a deranged local named Mercado; the movie is reenacted as a demented, quasi-religious ritual, with Durango townies forcing Tex into a Christ-at-Calvary role. In the end, fantasy and reality fuse pathologically as Tex becomes a sacrificial lamb, the unwitting symbol and victim of Hollywood corruption.

The treatment was packed with Dennis's preoccupations. He wanted to use film as film, the way the abstract expressionists used paint as paint, and so there would be bits of leader flapping through a projector, dots and scratches, snatches of old Hollywood movies playing like Bruce Conner montages. There was a sequence featuring

cartonería Judas figures like the one at 1712. David Hopper felt that his brother's proposed film was essentially autobiographical. "*The Last Movie*'s about the destruction of innocence, especially his," he said. The nudity, marijuana use, and profanity that Dennis and Stern wove throughout the treatment indicate that *The Last Movie* proposed to be barrier breaking in 1966 Hollywood. Brooke believed that it would be a "wonderful film"—an art statement that had the potential to make "a lot of money."

In order to identify potential cast, crew, and financing, Dennis brainstormed a long list of would-be backers, allies, producers, and actors, typing out their names on yellow paper. The list contained more than fifty candidates, including Irving Blum, Henry Hathaway, Dominick Dunne, Robert Fraser, Paul Newman, Marlon Brando, Benny Shapiro, even Wallace Berman. Some entries were close to home, even uncomfortably so: there was Leland Hayward, along with Brooke's first husband, Michael Thomas, who was enjoying a lucrative Wall Street career (before becoming a journalist and novelist), and Michael's father, Joe. The Beatles' manager, Brian Epstein, was mentioned as a potential producer.

On May 17, Dennis turned thirty, the age at which no one was to be trusted in the 1960s. He and Stern had begun sending their treatment around, hoping to create an independent production with studio distribution. Bernard Schwartz of Joseph M. Schenck Enterprises floated the idea of pursuing *The Last Movie* as a US-Mexican coproduction, with Columbia Pictures handling the release. But there was a snag: Was Dennis Hopper fit to be a director? His reputation as a rebel and hard nut preceded him. He feared that *The Last Movie* might be taken away from him. Then two things happened. Jason Robards told Dennis that he wanted to play Tex. (Paul Newman read the treatment but thought Tex should be played by someone older than himself; Robards was all of three years older.) And Phil Spector expressed interest in backing the film.

A meeting was held the day after Dennis's birthday to discuss

moving forward with Spector. It was attended by Dennis, Stern, Spector, and a couple of reps, including Dennis's and the Byrds' business manager, Larry Spector (no relation to Phil). The meeting went well enough that Phil Spector committed to finding financing for *The Last Movie*—even backing it with his own money if necessary. The following week, Stern flew to Durango to view the landscape that had inspired Dennis's ideas. Haskell Wexler reportedly signed on as cinematographer. In July, Dennis's top choice to play Tex, Montgomery Clift, died, and so it looked as though Robards was the man. Jennifer Jones, Joseph Cotten, Jane Fonda, Peter Fonda, and Roddy McDowall were said to be filling out the cast.

Having watched "River Deep—Mountain High" sink like a stone, the twenty-six-year-old Spector decided to make a bold play in Hollywood. For a town that lived on stories, this was irresistible: the maestro of "Da-Doo-Ron-Ron" and "Be My Baby" as the godfather of a new dawn of American movies? Movies needed a dose of rock and roll, and Spector placed his bet that Dennis would prove to be America's François Truffaut. "The studios are backward," he told the *New York Times*, echoing Dennis's rejected *Vogue* essay on movies. "Hollywood taught everybody around the world how to make movies. Now they've all passed us by. That's why Hollywood has to make a great art film—to show the rest of the world. 'The Last Movie' will be that film."

But Spector discovered that the interest of production companies could turn all too quickly into "no." It began to look as though it might be necessary for him to carry the picture financially. The conversation between Dennis, Spector, Stern, and their representatives turned to payments, percentages, points, and deferments. Spector tried to reduce his risk, while Stern attempted to protect his original agreement with Dennis, having become convinced that Spector was out to screw him. Stern, who thought that "Spector was a terrifying man, extremely wrapped up in himself," busied himself with a Spanish translation of the treatment, making tweaks to appease the

Mexican authorities. He organized his notes and attended meetings, understanding that he would be paid an agreed-upon $10,000 in advance for the first draft of a screenplay—money that was delayed week after week. He refused to begin the script until he was paid.

The Last Movie ground to a halt. Amid the legal wrangling and casting conversations, the proposed start date was inexplicably bumped up from October 15 to September 15, further elevating everyone's stress level. For a moment, Bob Rafelson looked like a possible savior, guaranteeing $500,000 backing in exchange for 75 percent ownership and allowing Spector to call himself the producer. But Rafelson and his business partner, Bert Schneider, balked at the idea of Dennis directing. Dennis was caught between forces pulling in different directions: Spector playing by his own rules, Stern objecting to deleterious revisions to his deal, and what seemed to be an industrywide hesitation about allowing Dennis Hopper, of all people, to make a movie.

Finally Spector volunteered to back the project with his own money; he wanted to see *The Last Movie* made, come hell or high water. Dennis asked him how much money he had. Spector told him he had about $1.5 million on hand. Dennis thought they needed $1.2 million. He told Spector that he couldn't take that kind of money from him; it was too much responsibility to bear. "It was the hardest thing," he recalled, "because I really wanted to make a movie so bad."

In late September, Spector withdrew Stern's contract offer. *The Last Movie* had reached a dead end, Hollywood moved on, and Dennis sat in the living room of 1712 under the giant glowering Judas, wondering what to do next. "It was tragic, quite tragic," Brooke said. "It destroyed some huge central part of his ego. If it had been made then, he wouldn't have fallen into the abyss."

11

"IF I COULD JUST HELP THAT FLY FIND AN AIR CURRENT"

n its October 1, 1966, issue, *The New Yorker* began running Christopher Rand's three-part profile of Los Angeles. The first sentence was a point-blank declaration: "Los Angeles may be the ultimate city of our age." A helpful pronunciation was provided: "Loss Ann-ja-luss."

Rand took note of the city's protean sprawl, its ethnic diversity, its cultural thrust, its technological prowess: "All modern cities are machines, but L.A. is even more of a machine than the others. It is a humming, smoking, ever-changing contraption, which mechanics are incessantly trying to improve and get the bugs out of." So far in the 1960s, Los Angeles had overtaken Philadelphia to become the third largest city in the United States behind New York and Chicago, hosted a Democratic National Convention, built sports venues and cultural institutions (such as the new Los Angeles County Museum), added seemingly endless miles of freeway, and experienced riots. It had seen a cultural renaissance fueled by the energized art scene clustered around the Ferus Gallery and the revival of the Sunset Strip, which had become a feeding ground for

record-label A&R staff on the prowl for new music, often made by young men and women living in Laurel Canyon.

In 1940, Gertrude Stein, looking back across the four decades of her expat life, wrote, "Paris was where the twentieth century was." In the 1960s, it seemed that the twentieth century had made its home in Los Angeles—the world's sun-drenched, smog-bound symbol of modernity, movement, innovation, lifestyle, and creativity. As the California art critic Peter Plagens wrote in *Artforum*, LA was no longer a frontier outpost whose notoriety stemmed solely from Hollywood (itself no small matter, as Hollywood was the world's top exporter of popular culture) but had "intensified itself into the malignant tumor of a Great American City," that is, a place with all the ambition, attitude, significance, and headaches of its eastern antipode, New York.

In so doing, Los Angeles had inspired Ed Ruscha's street-inspired Pop Art; Joan Didion's revelatory *Saturday Evening Post* pieces, which felt like Greek tragedies in Technicolor; Rudi Gernreich's avant-garde fashions, which championed androgyny, gay rights, and social justice, all while looking cool and feeling comfortable; and Brian Wilson's "teenage symphonies to God," including the Beach Boys' brand-new 45, "Good Vibrations," a transcendent piece of studio wizardry unequaled in the history of recording. The city of Standard stations, palm trees, freeways, neon signs, and billboards also inspired Dennis's ongoing photographic chronicle of artists, musicians, actors, and writers.

That fall, Dennis gave a series of radio interviews from the living room of 1712 about his and Brooke's art collection. He spoke of Pop Art and abstract expressionism, of photography and painting, of the junkyard and antiques shop finds, and of the unusually collaborative nature of the environment that he and Brooke had created. He mentioned his next movie job—"an interesting sort of psychotic part." It was the role of Babalugats in *Cool Hand Luke*, the chaingang drama directed by Stuart Rosenberg, who had cast Dennis in

The Twilight Zone. Just when Dennis should have been sitting in a director's chair making *The Last Movie*, he was on set in Stockton, California, playing a practically subverbal man-child—a near extra, really—in a movie that made his old friend Paul Newman, in the eponymous lead role of an unbreakable prisoner who becomes a folk hero, a bona fide superstar.

Yet as much as Dennis was kept in the background of *Cool Hand Luke*, he was impossible to ignore, much as he had been in *Rebel Without a Cause*. And it was a quality production, one that would be nominated for four Oscars. Playing the sweet, unpredictable, mascotlike Babalugats was no walk in the park; Rosenberg made sure that his cast of jailbirds—including George Kennedy, Harry Dean Stanton, Ralph Waite, and Wayne Rogers—took the job seriously. "We wore our chains and prison clothes all night," Dennis remembered. "We'd go to sleep in this motel with our chains on, go into the restaurant and this little nightclub there, and we'd all be in our chains."

Dennis brought along the Nikon. He took a sunny portrait of Joy Harmon, the vibrant blonde who had appeared with Brooke in *Mad Dog Coll* and who now played *Cool Hand Luke*'s "carwash girl." He snapped a shirtless Newman, squinting in the sun with the interlacing shadow of a chain-link fence covering the actor's back like a net. The photographer Lawrence Schiller, who was documenting the production, stood nearby when Dennis got the shot, marveling at the directness and simplicity of the image. "It just goes to show you what a great eye he had," Schiller said. "He was a real fine-art photographer, whereas I was more of a journalist. I used the camera as a sponge, but he was using it like the tip of a paintbrush. It was as if that chain-link fence on Newman's back was painted on by the light."

Dennis invited Bruce Conner to visit the set. Conner shot a two-and-a-half-minute reel of 8-millimeter film and called it "Luke." "I believe this production cost about three dollars," Conner remarked,

"both for the film and processing." Decades later, Conner dusted off the footage and slowed it down to create a twenty-two-minute movie. With its ghostly parade of actors and crew, it is like a waking dream of *Cool Hand Luke*. You see Newman slow-motion ambling in a field, Harry Dean Stanton breaking into a grin. And you see Dennis, slicked with sweat, walking along a dusty road that feels as though it might go on forever.

ON NOVEMBER 8, RONALD REAGAN was elected governor of California in a landslide victory over the incumbent, Pat Brown, ending an eight-year reign for the Democrats and signaling a white conservative backlash in the wake of the Watts rebellion, the student uprisings at Berkeley, and, in general, the strides being made in President Johnson's Great Society. The day marked the first significant victory of a resurgent right-wing political movement that would influence the course of American politics for decades to come. For Brooke and Dennis, as well as most of their friends, it was not a happy result. Reactionary impulses, such as those on display during the Kienholz controversy at the County Museum, threatened much of what they loved about Los Angeles. They also played out uncomfortably close to home, as the kaleidoscopic transformation of the Sunset Strip provoked a similar backlash.

In the year and a half since the Byrds had premiered at Ciro's, the Strip had boomed. It was now LA's Carnaby Street or Greenwich Village, where young Angelenos escaped the ennui of the city's amoebic sprawl. It was, in fact, one of the few places in Los Angeles where there was any street life at all. Ed Ruscha, in his wry way, celebrated the area with his *Every Building on the Sunset Strip*, a book of intentionally antiseptic photographs that was exactly what the title said it was. The buildings he documented had arguably been saved from a slide into urban decay thanks to the new energy coursing through the Strip. But the owners of dining establishments that

courted an older crowd, along with interests representing the time-honored Strip vices of gambling and burlesque, despised the youth horde crowding the sidewalks. It was bad for business, a social problem: the music fans coming to see the Byrds, the Mothers, Buffalo Springfield, Love, and the Doors represented marijuana, free love, pacifism, nonconformity, left-wing politics—the whole cocktail of paranoia-triggering behaviors and beliefs.

The solution was a 10:00 p.m. curfew on under-eighteens, which enraged the kids, the music club owners, and most of the record industry. The curfew, they argued, would devastate the character and nightlife of the Sunset Strip—which was arguably the intention. Elmer Valentine of the Whisky à Go Go declared the crackdown "insane." Al Mitchell, the proprietor of the Fifth Estate coffeehouse, began working on a documentary to be called *Blue Fascism* about police intimidation on the Strip. There was plenty for Mitchell to document, as the Los Angeles Police Department and county sheriffs aggressively shook down long-haired pedestrians, demanding identification and busting anyone deemed to be loitering—a nebulous offense. Billy clubs were employed, often in a garroting technique that was effective at snapping back heads to achieve compliance.

Word went out that a protest was in the works. On Sunday, November 12, four days after Reagan was elected (and Willie's ninth birthday), it came. The first of the so-called Sunset Strip riots erupted that night outside Pandora's Box, a coffeehouse at Sunset and Crescent Heights, with up to three thousand protesters demonstrating against curfews and police brutality. The demonstrations continued on subsequent Sundays and stretched well into 1967.

Pandora's Box was barely half a mile down the hill from 1712, ten minutes on foot. Dennis brought along his Nikon to document the inchoate mass of protesters, the helmeted police in riot gear, a bearded guy being hauled off by cops in front of the Villa Frascati restaurant, Mayor Yorty attempting a parlay. One demonstra-

tor held a sign reading WE'RE YOUR CHILDREN! DON'T DESTROY US. Paul Jay Robbins described the police action in the *Los Angeles Free Press*: "I saw a kid holding a sign in both hands jerk forward as though struck from behind. He fell into the path of the officers and four or five of them immediately began bludgeoning him with clubs held in one hand." When the protester lapsed into unconciousness, the police went on beating him. Robbins, too, was clubbed by police.

That night, as Dennis clicked his camera, Sunset Boulevard became impassable. Television crews goaded protesters to do something more dramatic than just standing around. They obliged by rocking one of the buses back and forth, scratching the words "Free the 15 Year Olds!" on the windshield, and reportedly trying but failing to set it on fire. (The total damage to the bus and a nearby liquor store came to $158.) Otherwise, it was a peaceful gathering of young people who were more aggressive toward their acne than they were toward the cops.

"Riot is a ridiculous name," said Stephen Stills of Buffalo Springfield. "But it looked like a revolution." He had driven down from Laurel Canyon and seen a police battalion in riot gear arrayed like a phalanx of Roman centurions. He drove home and wrote the classic "For What It's Worth" in fifteen minutes, a song that entwined what he had seen at Pandora's Box with his concerns about the escalation of the war in Vietnam. He famously told of battle lines being drawn. One thing the Sunset Strip riots established was that there were now two sides and it would be necessary to choose which one you were on. In *The New Yorker*, Renata Adler described those opposing, frozen attitudes in tribal terms: "on the one hand, the constellation that is longhair, bohemia, the New Left, individualism, sexual freedom, the East, drugs, the arts; on the other, arms, uniforms, conformity, the Right, convention, Red-baiting, authority, the System." Dennis, Brooke, and their friends

were largely of the former ilk, whether they were game to get close to the front lines or not. Dennis was. "I love a good march, myself," he said.

Several of Brooke and Dennis's friends converged upon the Sunset Strip to observe the action and show support for the protesters, including David Hockney and Jack Nicholson. Jim Dickson, the Byrds' manager, helped organize a concerned citizens' group culled largely from the music business called Community Action for Facts and Freedom, or CAFF, intended as a watchdog group and to help pay legal defense fees. American International Pictures got rolling on the inevitable schlock film, *Riot on Sunset Strip*. Peter Fonda and David Crosby showed up at the second Sunday protest. Peter was clubbed, arrested for loitering, cuffed, and taken to a police station. He was released with a warning. "Man, the kids have had it," he told reporters.

Despite being close to the epicenter of the riots, the mood at the Chateau Marmont, safe behind walls and hedges, was festive. "The peasants are revolting!" could be heard as hotel residents, including Myrna Loy, stood on their balconies to watch the action, sip wine, and nibble Triscuits. Nick and Lenny Dunne and their kids were visiting the well-connected music executive Earl McGrath and his wife, Camilla, at their home, suite 64 of the Chateau, when the chaos unfolded. The eleven-year-old Griffin Dunne absorbed the scene. "We were throwing firecrackers off the balcony," he remembered. "I loved it."

Up the hill at 1712, Jeffrey and Willie sensed foreboding in the air as they tried to get glimpses of the unrest that erupted every weekend down on Sunset. On one of those raucous Sunday nights, the kids were left with one of their favorite babysitters, a blond surfer dude named Jan, who liked to show them 8-millimeter films of Frankenstein and Dracula. "He told us to get our baseball bats ready," Willie remembered.

"It was scary," Jeffrey said. "There was a feeling that things were about to blow up. The revolution was going to happen."

AS THE REVOLUTION ON Sunset Boulevard came to a boil, the scene on North La Cienega was simmering down. Brooke and Dennis had poured money and enthusiasm into Los Angeles art for nearly five years. But the number of local collectors remained scant. "The support system on the West Coast is terribly, terribly fragile," Irving Blum admitted. At Ferus, he had worked to achieve a dynamic balance between the LA artists who were the core of the operation and key players from the behemoth of New York—Warhol, Lichtenstein, Stella. But as the East Coast artists commanded higher and higher prices, Blum began to lose his access to them. The Ferus Gallery's margins, never robust, shrank to gossamer thin. To keep afloat, Blum forged a bicoastal partnership with New York's Pace Gallery. He shuttered Ferus and, on December 13, opened the new Ferus/Pace Gallery up the street in a sleek Craig Ellwood–designed space at 812 North La Cienega.

It was a bold step forward, one that was both apotheosis and undoing. The end of Ferus meant that a sparkling chapter in postwar American art—sun-drenched, irreverent, imbued with frontier spirit and underdog fervor—was over. Important work would continue to roll out of Los Angeles—by Ruscha, Kienholz, Bengston, Bell, Moses, Irwin, Hockney, and the rest. As late as November 1967, *Vogue* would run a portfolio of Dennis's artist portraits with an accompanying essay by John Coplans celebrating Los Angeles as an art-world paradise. But the atmosphere and energy had frayed; there was no longer a nucleus. "What Ferus had more than anything was a 'fuck you' attitude, tempered with a lot of concern," Ed Kienholz said. As 1967 began, the outlaw camaraderie of Ferus was no more, and the incandescent soul of the LA scene dimmed. Blum's Ferus/Pace experiment would prove to be short-lived; he ditched

it and opened a gallery in his own name the following October. That year, *Artforum*, a swaggering redoubt of California sensibilities, took off for New York; the gravitational pull was simply too strong. "It was an extraordinary loss to the West Coast," Blum said.

Henry Geldzahler mourned. "In the early 60's it looked terrific," he said of the crackling LA scene. But, he ultimately concluded, "They just didn't have the habit of supporting art out there." Warhol figured that Angelenos were content to gaze upon their billboards and palm trees. There was also the persistent knee-jerk eastern snobbery toward Los Angeles that had always presented a challenge to gallerists such as Blum and Virginia Dwan. Ivan Karp, the brash lieutenant of Leo Castelli's powerhouse Manhattan gallery, representing the likes of Warhol, Lichtenstein, and Rosenquist, embodied that disregard. He blithely dismissed Kienholz, Irwin, the entire LA milieu. "I didn't think Ruscha was worth anything," he said. History would show him to be very wrong.

During that transitional moment, when even New York was experiencing art doldrums after the rush of Pop Art had dissipated and Warhol had effectively given up painting, 1712 was uncharacteristically denuded of art. But it was for a splendid reason. The Santa Barbara Museum of Art had chosen to spotlight Brooke and Dennis's collection, along with those of Donald and Lynn Factor and André and Dory Previn, for its *Three Young Collections* show, opening January 15, 1967. The institutional stamp of approval confirmed Brooke and Dennis's status as noteworthy patrons of contemporary American art.

They loaned thirty-eight works to the show, including Ruscha's *Standard Station, Amarillo, Texas*, Lichtenstein's *The Mad Scientist*, Stella's *Tetuan III*, Kienholz's trouble-prone *The Quickie*, Larry Bell's *Untitled*, four Warhol pieces (including the tomato soup can), and the Hotel Green sign, as well as works by Jasper Johns, James Rosenquist, Bruce Conner, Wallace Berman, Tom Wesselmann, Larry Poons, Emerson Woelffer, and John McCracken (a fabulous

eight-foot-long rectangular sculpture called *Zapotec*, which hung over the living room fireplace). There were even a few of Dennis's own pieces and a smattering of objects that Brooke had collected, including Égide Rombaux's bronze *Eglantine* and a Tiffany standing lamp. Their collection was the show's centerpiece, a brilliant and idiosyncratic freeze-frame of American art in the mid-1960s. The catalogue celebrated what Brooke and Dennis had created at 1712, much as Terry Southern had done in *Vogue*: "The environment is jumping and intimate, and each masterpiece is just a part of the constant discovery that one experiences everywhere in the Hopper residence." The terminally cantankerous Henry J. Seldis of the *Los Angeles Times* responded with unabashed excitement, lauding Dennis as "an amazing artist-photographer of immense sensitivity and enthusiasm" and declaring his and Brooke's collection "the most swinging and most intimate" of the three.

ON THE DESIGN FRONT, Brooke had forged a bond with Tony Duquette, the self-described "do-it-yourself Medici" and Hollywood Renaissance man who had imbued the sets of movies as far back as the Ziegfeld Follies with panache and the houses of moguls, including Bill Goetz and David O. Selznick, with style. He was a maximalist, unabashedly sybaritic, the rare Hollywood designer who read Herbert Marcuse and had a Wildean flair for aphorisms: "Insects are the leaders of style." "A house should change its skin, like a reptile." "Beauty, not luxury, is what I value."

Those were sentiments that Brooke appreciated, and they described an aesthetic that overlapped with her own. Duquette, too, loved the antiques shops and junk heaps of Los Angeles and made hauls of Edwardian silver, Persian rugs, Chinese porcelains. He had a thing for fashioning sculptural objects from shells and sea fans and bits of rubber flip-flops combed off the beach. He might make table decorations of taxidermied birds in glass boxes. In the 1940s,

Duquette had met Salvador Dalí and driven the surrealist around LA, showing him Watts Towers and the Bradbury Building. Dalí told the designer of his desire to create a room in which the rug was a wheat field and the furniture sleeping sheep. Duquette absorbed that lesson—of design as a magical dream journey—and his own work suggested a realm of Jungian forms with a palette as gilded as Gustav Klimt's. He often wore a Tibetan shaman's robe, as he relished the dual role of seeker and seer.

Their regular invitations to the mad black-tie dinners that Duquette hosted with his wife, Elizabeth, known as "Beegle," at his vast studio at 824 North Robertson Boulevard were another form of validation for Brooke and Dennis and the aesthetics of 1712. In mid-January, the Duquettes again invited Brooke and Dennis to one such dinner. This time, there was a strategic purpose: Dennis would be seated in proximity to the tobacco heiress Doris Duke, one of Duquette's clients and the richest woman in the United States. It was an opportunity for Dennis to make one last attempt to scare up funding for *The Last Movie*. The only problem was that, as the dinner commenced, there was no sign of Dennis; he'd gone to San Francisco for the weekend and had yet to return.

"Traveling up the Coast from the ruins of the Sunset Strip to the Haight is a Dante-esque ascent," the rock critic Richard Goldstein wrote in 1967. Dennis had made this ascent, arriving in San Francisco to partake in the Gathering of the Tribes for a Human Be-In, held Saturday, January 14, in Golden Gate Park.

The tribes in question were the two hemispheres of the Bay Area counterculture: the political, New Left one based in Berkeley and the psychedelic, hippie one based in Haight-Ashbury. Dennis was inclined toward both. "I marched in Selma," he pointed out. "I marched with Martin Luther King. I marched with SNCC and with CORE. I was at Berkeley." But there was also his long-standing affection for mind-altering substances and out-there subcultures. At the Human Be-In, the latter held sway. The event was

quasi-religious—a festival, not a protest—with mantras, robes, plenty of grass and acid. "We were looking for God," Dennis later said, "and looking for a new way to be free and to have free speech and free love."

Dennis, with his Nikon around his neck, staked out an area as close as he could get to the stage. The Zen poet Gary Snyder blew a horn to mark the beginning of the rite, and then a loose program rolled out. Allen Ginsberg clanged his finger cymbals and chanted, "Peace in America, peace in Vietnam, peace in San Francisco, peace in Hanoi"; Michael McClure strummed his autoharp; Dizzy Gillespie blew his trumpet; the Grateful Dead and Jefferson Airplane jammed; and upward of twenty thousand, thirty thousand, maybe fifty thousand hippies, activists, consciousness raisers, and curiosity seekers grooved. Faces were painted, bubbles were blown, drums were pounded, cannabis was inhaled, and one lost little boy ended up onstage as Ginsberg helped him find his parents. San Francisco's guerrilla street theater outfit, the Diggers, helped distribute turkey donated by the LSD manufacturer and Grateful Dead soundman Owsley Stanley. The meat was used to fill sandwiches that had been made with bread sprinkled with lysergic acid. God knows how many people were tucking into their electric sandwiches when Timothy Leary, the Elmer Gantry of LSD, took to the microphone and uttered the famous words "Turn on, tune in, drop out."

To Dennis, taking in the vibrant green of Golden Gate Park, it must have seemed like a vast psychedelic picnic. Through his viewfinder, he caught Leary leaning forward into the crowd and Ginsberg in his flowing white robe. Another photographer, Lisa Law, sat next to Dennis and got the shot of the day: Ginsberg leaping into the air as the Dead played Martha and the Vandellas' "Dancing in the Street." "This was the first time I shook my ass on the electric stage," Ginsberg said. It was like a Beat Generation benediction.

But for some members of the underground, the Be-In was a sham that marked the end of Haight-Ashbury's glory days six months

before the Summer of Love even commenced. "The Human Be-In was publicized as a 'Gathering of the Tribes,'" Emmett Grogan, a cofounder of the Diggers, groused, "but it was actually more a gathering of the suburbs." To him, Ginsberg and the other grandees were narcissists more interested in media attention than mind expansion. When the assembled voices—thousands strong—joined in a chant of "We are one! We are one!," Grogan, as he described himself in his memoir, *Ringolevio*, "sat on the grass and watched them pretend, wondering how long it was going to take before people stopped kidding themselves."

Dennis, a kind of double agent from the establishment realm of mass media, seemed to get a pass from the Diggers. He was a resident of plastic Disneyland, but he walked the counterculture walk. For him, the Human Be-In was an eye-opener. "Young people," he observed, "had stopped going to the movies. They went to love-ins in Golden Gate Park with 80,000 people dropping acid." The question was: How to make movies that would respect their intelligence, show their reality, tell their stories?

Back in LA, the dinner plates had been cleared from the tables at Duquette's studio, and there was still no Dennis. Finally, as Brooke remembered, "Dennis came into the party very late and was wearing the most ghastly outfit—all those beads around his neck. Everybody was appalled. He was drugged out." Instead of black tie, Dennis had ambled in from San Francisco in jeans, with three-days' beard growth and bloodshot eyes. He attempted to charm the party with far-out tales from the Gathering of the Tribes. They didn't go over well. "Nobody really wanted to know," Brooke said. Duquette liked to lay his tables with vermeil insects and creatures—little golden frogs, flies, spiders. Dennis may or may not have been coming down from acid, but those would have been trippy sights.

Duquette suggested that Dennis, Brooke, and Irving give Doris Duke a lift home, which they did, escorting the six-foot-one heiress

back to Falcon Lair, her roost on Bella Drive in Benedict Canyon, a former residence of Rudolph Valentino. It was an opportunity for Dennis to pitch *The Last Movie*, as Duke would literally be a captive audience. Dennis got behind the wheel of the Checker cab, with Duke in the passenger seat and Brooke and Irving in back, and spent the fifteen-minute drive dilating on the glories of socialism. As soon as they pulled up at Falcon Lair, the terrified Duke sprang herself free, sprinted to the gate, pushed a button, and darted in. "She *fled*!" Brooke remembered. "She didn't wait to be driven in."

"She missed a big opportunity to become a film producer, let me tell you!" Dennis joked. "The first socialist film producer!" Brooke said she had never loved anything as much as watching Doris Duke run for safety that night.

THEY LAUGHED THE DINNER PARTY incident off, but Brooke thought that Dennis had been "altered forever" by the Human Be-In. With his hope of becoming Hollywood's auteur on hold, "Turn on, tune in, and drop out" had its allure. There were television roles that he could still knock off, but they certainly didn't communicate to the generation he had been communing with in Golden Gate Park. He played a jazz drummer in ABC's *Combat!*, taking the kids to the filming, which Jeffrey thought was "fantastic." He appeared in ABC's *The Big Valley*, starring Barbara Stanwyck; his character was shot by series regular Lee Majors, the so-called blond Elvis. It was all so straight. *The Gospel of Thomas* said not to do what you hate. If Dennis didn't outright hate those jobs, he approached them with cold, hard masochism. They were to be tackled like a chore, such as mowing the lawn.

But a toll was being taken. "Dennis always had a bottle of Jack Daniel's and always had a Coors or Olympia beer in his hand," Jeffrey recalled of that time. "He smelled like alcohol morning and night." Jeffrey was imprinted with an indelible vision of Dennis

coming home, going straight to the fridge, and pulling out a beer. Dennis had always had a taste for the stuff, going back to his days of Kansas harvests, when cold beer had been a thirst-quenching reward for hours of sweaty work. After arriving in Hollywood, he had been given a different magic elixir. "When I was eighteen years old," he remembered, "my agent gave me a martini. He said, 'This is a martini, extra dry.' I went, 'God this is awful,' and he said, 'It's an acquired taste.' Boy I acquired that taste real quickly." A decade later, Dennis's drinking was getting away from him, and, he later said, it wasn't merely career frustration fueling it. "I was drinking because I was an alcoholic."

By comparison, Brooke got about as wild as a margarita or two would take her. "She wasn't running around being drugged or drunk or out of control," Toby Rafelson said. "That was not the kind of thing that she was interested in at all." By 1967, Brooke realized that her husband's alcohol consumption was out of control and that he was heading into a potentially devastating career funk. Jeffrey remembered her trying to prop him up, spark him, get him going. "Dennis had fucked up his career," he said. "Brooke would challenge him: 'You're drunk again. You're fucking up.' And Dennis would freak out." David Hopper had noted Dennis's tendency to freak out in that kind of situation and considered it an unfortunate effect of his having been raised by the oppressive Marjorie. "If you became at all domineering or hot or whatever," David said, "he would just basically flip out." Misunderstandings and blowups were becoming more frequent at 1712; the kids would hear shouting coming through the walls at night after their bedtime.

Then there was the ever-present marijuana, which Jeffrey was accustomed to finding in his stepfather's film canisters. "I wouldn't *think* of going through a day without smoking at least eight joints," Dennis said. "And I thought I was handling them beautifully, and I probably was; I sure didn't feel like I was stoned out of my head all the time." Pot may have been fairly innocuous, but, like acid, it

was a controlled substance, and in 1967, the possessors of controlled substances, even celebrities, were being targeted by law enforcement. In February, Robert Fraser was caught up in the infamous Redlands bust, in which British officers descended upon Keith Richards's country house, finding a few roaches lying around, along with some uppers and, unfortunately for Fraser, some of the gallerist's heroin. Fraser, Richards, and Mick Jagger were arrested. The Pop artist Richard Hamilton, whom Brooke and Dennis had met at the Duchamp opening in 1963, tweaked a news photo of Fraser and Jagger handcuffed together in a police car, giving the resulting piece the acerbic title *Swingeing London 67*. At 1712, Jeffrey witnessed a bust, complete with wailing police sirens, while he was outside playing with his GI Joes—two guys with a roach. Luckily, it wasn't Dennis who was arrested.

One night, Dennis got into bed and lit up a joint. "Sound asleep, set the bed on fire, went on sleeping," Brooke said. "I woke up, pushed him out of bed. Saved his life. He was furious that I called the fire department." Dennis was terrified that the authorities would find his stash. Marin remembered the firemen coming to the house. "The mattress had caught on fire," she said, "and they extinguished it and put it outside by the jungle gym." It was surreal, the red-hatted fireman addressing the family gathered in the den underneath the enormous Standard station painting and the incinerated mattress languishing in the backyard with the old gas station signs and fake cacti. "Just another piece," she said.

That wasn't the only time the fire department came to 1712. "I was kind of a pyromaniac," Willie said, "and those hills are dry as tinder." He accidentally started a brush fire while playing with matches—a terrifying prospect considering the memory of the Bel Air Fire. When a fire inspector again came to the house, Marin blurted out, "Willie did it!"

Apart from seeing a Fonda or a Monkee in their midst, childhood at 1712 played out with a traditional mixture of adventure,

misconduct, and boredom. There were piles of comic books; endless TV watching; rambles in the chaparral, not unlike what Brooke, Bridget, and Bill had done with the Fondas while they were growing up. "We were running wild through the Hollywood Hills," Marin remembered. The family got another dog, which they named Irving Blum, whom Marin liked to walk around the neighborhood, knocking on doors and saying hello, like a proper lady. For the boys, shoplifting became a minor avocation, with Willie typically providing the diversion and Jeffrey doing the deed. They scooped up model cars, pens, anything they could boost out of drugstores and five-and-dimes. "It was a subtle cry for attention," Jeffrey said. They loved to nick presents for Marin, who saw her stepbrothers as heroes, practically Arthurian knights.

ON MARCH 20, LONNIE DAVIS died in Lemon Grove. He was eighty-five and had been living as a widower for eighteen months. Dennis headed south for the funeral, where David Hopper delivered a ringing eulogy celebrating their grandfather's agrarian values and capacity for love. In the midst of that psychedelic springtime, the Hopper brothers paused to reflect on the adult they'd always felt safest with—a Kansas wheat farmer whose life story could have been written by Hesiod. "He will always be my hero and never die," David said. The brothers left the funeral early, drove to Tijuana, and spent three days getting wasted.

Dennis returned in time for the Easter Sunday Love-In at Elysian Park. It was LA's own Human Be-In. At least four thousand people turned up; the *Los Angeles Times* coverage was headlined "Hippies Fill Glen with Splendors of Love and Miniskirts," and that about covered it. Dennis brought his camera and documented the Haightification of Los Angeles. A smattering of rock stars turned up, including the omnipresent David Crosby, who came away with the inspiration to write, with Chris Hillman, a jazzy number called

"Tribal Gathering" that skipped along in 5/4 time—Dave Brubeck on acid. It was that event at which Dennis remembered meeting the two blond women he photographed nude at 1712; Brooke and the children were likely off spending Easter with Jennifer Jones or Brooke's maternal grandmother, Grandsarah, who lived in Van Nuys.

Dennis was still busy shooting artists at work and play, including Allan Kaprow and his celebrated *Fluids*, a series of melting-ice environments. But in 1967 Dennis's attention had shifted. Music and musicians captivated him, and *Vogue* asked him to submit portraits of some of his favorites—Buffalo Springfield, Jefferson Airplane, the Grateful Dead, and the Lovin' Spoonful. He posed the Byrds at the outdoor plaza of the County Museum in what was something of an ultimate sixties LA tableau: Hollywood actor shoots rock heroes at gleaming modernist art shrine. "I loved that he saw us there, and put us there, among the sculptures," Hillman said. For Roger McGuinn, "Dennis was a spark plug. He was brilliant and undisciplined in a lovable kind of way."

In the first week of June, the Beatles released *Sgt. Pepper's Lonely Hearts Club Band*. The album espoused a style, in sound and in cover art, of bric-a-brac, pastiche, assemblage, nostalgia, camp—the elements of the 1712 sensibility going back to 1963. There was a lot to identify with, and Peter Blake's collagist sleeve design even included the faces of Dennis and Brooke's friends Wallace Berman, Larry Bell, and Terry Southern. The record spun on the turntable at 1712 for weeks, months, as it did around the world, a pop culture product that demanded highbrow critical attention—and got it, from *Partisan Review*, no less. In fact, the very distinction between high and low, which Dennis and Brooke and their Pop Art friends had been toying with for years, now appeared to have been obliterated in the sunniest way imaginable.

For Dennis, Brooke, and their family, it was a music-saturated season. On June 9, they went to see the Monkees at the Hollywood

Bowl. The Beatles knockoff band was the creation of Dennis and Brooke's friends Bob Rafelson and Bert Schneider, who had developed the TV series *The Monkees* for NBC around the concept of a Los Angeles rock group trying to break through. The so-called Prefab Four hijacked prime-time television and the Top 40 as Wrecking Crew session musicians and high-end songwriters were hired to assist in the creation of the Monkees' expertly crafted, infectious, kid-friendly pop. The band had four number one albums in 1967, a *Billboard* chart feat that remains unequaled.

"The biggest thing in the world was the Monkees!" Jeffrey said. "And that was *family*. We knew all the Monkees because they were always hanging around." Marin, too, felt as though she was practically related to the Monkees; for her, Davy Jones, the McCartney-esque singer, held a special appeal. Michael Nesmith, the Texas-born singer-songwriter cast as the band's leader on the show (later to become a music video trailblazer), said of his first visit to 1712, "I walked into that house and I thought, Holy moly! Where have I landed? Who's curating this? And, you know, it was *'Hey, man!'* It was Dennis!" Nesmith was struck by Dennis's Duchampian riff— "In the future, anything an artist points to will become art." At the Hollywood Bowl that Friday night, Ike and Tina Turner opened the show, Micky Dolenz, the Monkees drummer with the incandescent leer, did a stage dive, and the family almost got smothered in a teenybopper crush.

That weekend, Brooke, Dennis, and the kids piled into Dennis's rickety Land Rover and drove the Pacific Coast Highway to San Francisco. "It took *forever*," Willie remembered. "The Land Rover was really loud. And it wasn't very fast. The most uncomfortable vehicle you'd ever experienced in your life." To Jeffrey, it was "a covered wagon, heading to the Haight."

The destination, in fact, was Mount Tamalpais, the site of the Fantasy Fair and Magic Mountain Music Festival. It was considered the first major pop festival, a two-day affair in a wooded grove

that included performances by the likes of the Doors, the Chocolate Watchband, Captain Beefheart, the 5th Dimension, and the Byrds accompanied by the South African trumpeter Hugh Masekela, who had played on the band's recent hit "So You Want to Be a Rock 'n' Roll Star," widely perceived as a put-down of the Monkees but intended as a broader satire of the music industry. Arriving at Golden Gate Park, the site of Dennis's satori at the Human Be-In, the family rendezvoused with Jefferson Airplane, their roadies, and various members of the Grateful Dead. Musical chairs ensued, with some of the entourage, including Grace Slick, piling into the Land Rover, with Dennis still behind the wheel, and others, including Brooke and the kids, into a Buick station wagon, driver unknown. The two-vehicle caravan set off toward Mount Tamalpais via the Golden Gate Bridge.

In the station wagon, a joint was ignited and passed around. When it reached ten-year-old Jeffrey, he brought it to his lips and inhaled. "And so I smoked my first pot with the Jefferson Airplane," he said. Willie remembered Brooke, sitting in front with Marin in her lap, whipping around and saying "Jeffrey, put that down and don't ever do that again!" ("The Dead were probably terrified of her," he said.)

At the festival, the stoned boy ambled off by himself. "I started walking around and all these adults, they were all acting like children! They were dancing and blowing bubbles and riding in cardboard boxes down a hill and there was incense and there was a Renaissance festival thing, and someone gave me a lollipop." When Jeffrey returned to the spot where his family had been, they were gone. "I've been left behind! So I go to the lost and found, and there are these other kids who've been abandoned. And they're crying. And right behind the kids' lost and found is the Hells Angels. And they're gunning up their choppers. And for some reason the word went out that we were going to be kidnapped by these Hells Angels." Jeffrey became terrified as he pondered his fate, but then Den-

nis, Brooke, Willie, and Marin appeared. They'd been searching all over for him. "Why did you leave me?" Jeffrey asked, hysterical.

"Oh, we just wanted to go see the Byrds with Hugh Masekela," Dennis said.

"Brooke must have been pulled to participate in these things Dennis was into," Jeffrey said, "but also completely conflicted by having three kids to look after. So the times she went she would probably feel guilty about it, and the times she got left behind must have been painful."

The next weekend, Dennis traveled up north on his own, equipped with the Nikon, to the festival that was destined to eclipse Mount Tamalpais as the concert everyone remembers from 1967: Monterey Pop. It was organized on the Sunset Strip, its spirit was in San Francisco, and it brought in artists from everywhere. It was an international gathering of the musical tribes, with Memphis soul care of Otis Redding, New York folk from Simon and Garfunkel, the sunny LA pop of the Mamas and the Papas, and the mesmerizing Indian ragas of Ravi Shankar. From London, there were the Who and the expat Jimi Hendrix, who would tour with the Monkees in July.

Dennis was in heaven. "Monterey was a giant musical love-in that galvanized the crowd of students, hippies, straights, soldiers from Fort Ord, the rock 'n' roll press, music industry execs, police, vegetarians, and weirdos like me," he remembered. "It was a perfect experience. To many of us, it was the first and the last. I can't think of anything as special as that moment in my life."

The photographer Jim Marshall shot Dennis in the chaotic backstage area, all shaggy hair, beard, and a chunky necklace that may have been made of human teeth—a convincing enough hippie, even if he lived in the Hollywood Hills. Dennis reconnected with the Velvet Underground's Nico and the Stones' Brian Jones, who, in his frilly finery, looked like Monterey Pop's resplendent Sun King. (Neither of them played at the festival). It was practically an outdoor

costume ball. Micky Dolenz wandered about in a feathered headdress, David Crosby wore a big furry Cossack hat, and the Who's Roger Daltrey did his best to get with the program, draping himself in a cloak fashioned from an ornate tablecloth.

Dennis may have intended to document the proceedings (he is occasionally identified as an "official photographer" of Monterey Pop), but any pictures he might have taken are long lost. As Lisa Law recalled, that may have had something to do with the fact that Michael McClure had provided Dennis with a walloping dose of LSD, which had him hiding out for hours inside the big white tipi-style Trip Tent that Law and her husband, Tom, had set up for just that kind of situation. Dennis remembered Brian Jones being in there with him, similarly indisposed. It was a long afternoon, punctuated at one point by a little boy bursting through the tipi's flap and pretending to machine-gun everybody inside: "You're all dead! You're all dead!"

The musical program was an electrifying marathon, with Hendrix, who also visited the tipi, setting his Stratocaster on fire. Dennis found Michelle Phillips of the Mamas and the Papas just about as mesmerizing. There was one conspicuous downer: the original heroes of the Strip, the Byrds, had a disastrous weekend at Monterey. Their cofounding vocalist, Gene Clark, had long since left— Dennis had photographed him in solo performance—and the band's chemistry, never stable, had become outright volatile. During their Saturday-night set, the ethereal harmonies failed to gel and fractiousness emanated from the stage. There was perhaps a sense among the Summer of Love crowd that the gods of 1965 were passé. David Crosby, enamored of the San Francisco scene, may have felt that way himself. He bigfooted his own band's performance with a vibe-killing monologue about the Warren Commission; Roger McGuinn stood there with his Rickenbacker twelve-string, poker-faced, wondering if the grandstanding would ever end.

Dennis perhaps saw a bit of himself onstage. He and Crosby

were both blessed with outsized egos and a talent for self-sabotage, prone both to brilliance and to going off the rails. Crosby bucked record producers the way Dennis bucked movie directors. Dennis once wrote out interview questions for himself: "Why do you do such stupid things?" "Why do you live on Edge City?" Crosby had a similar line of self-interrogation: "When am I going to realize that it's only my own bullshit that hangs me up?" Those were the kinds of thoughts that could turn into brain worms when you were tripping. And so the Byrds clanged through their set, the Ciro's magic gone. The next night, Crosby sat in with the Byrds' friendly rivals, Buffalo Springfield. It was a last straw that got him kicked out of the Byrds, while, at Monterey, new rock stars, including Jimi Hendrix and Janis Joplin, were born.

BROOKE TOOK A TRIP TO EUROPE on her own that summer, as her and Dennis's interests continued to diverge. Per custom, the boys were with Michael Thomas in Long Island, while Marin went off with Marjorie and Jay, who were ecstatic to have her. "That child meant more to us than any child in the world," Marjorie said. David Hopper recalled that he and his wife, Charlotte, also took care of Marin while Brooke was away, traveling with her to La Bufadora in Baja.

Brooke's European escape took her to England, where she saw her stepfather, Ken Wagg. It was a reprise of a wonderful trip she had made in the summer of 1955, when she had been eighteen and preparing to enter Vassar. Now she was turning the irksome age of thirty. She made her way to Italy, to Jane and Vadim's $1,500-a-month villa on the Appia Antica's "Millionaires' Row" outside Rome. The couple were making *Barbarella* at Cinecittà, she starring and he directing, with a screenplay by Terry Southern. "It's pop art, sex and satire—perfect for Vadim," Jane said at the time. The film would receive mixed reviews, but it made Jane Fonda a sixties

icon. In Rome, there was a crushing production schedule and an onslaught of visitors, who, in addition to Brooke, included Peter Fonda, Gore Vidal, Joan Baez, various Rolling Stones, and Buck Henry, to whom Jane now seemed like "a celebrity with a capital *C.*" Jane entertained as arduously as she worked, popping Dexedrine to keep going, while the role, with its revealing costumes, drove her to bulimia. To top it off, Vadim's drinking had been on the rise. Alcohol had become an issue in their relationship, just as it had in Brooke and Dennis's. If Jane ever found a moment to break away, there was much for the old friends to discuss.

It would not have been easy being Brooke in 1967, as she entered a new decade of life. Her alcoholic husband seesawed between flights of manic enthusiasm and intense funks. He could plunge into brooding despair over what he perceived to be his failures as an actor, photographer, husband, and father. Psychedelics offered Dennis opportunities for escape and expansion, but Brooke, since her bummer of a mescaline trip in 1961, had no interest in accompanying him on those journeys. Feminism was in its energetic second wave, but for Brooke and her friends, it was hard to figure out if it applied to them. They were privileged, progressive, bohemian, had opportunities. As Toby Rafelson put it, "I myself had never felt oppressed or imprisoned, that I needed to be liberated—I was fortunate in that way." There was an urge to be hip, but the rules of the game and a sense of maternal obligation seemed to keep Brooke in place. It was a fabulously exciting time to be alive, but what exactly was she doing?

Dennis claimed that Brooke coped with frustrations and depressions of her own. He said she would shut herself in their bedroom at 1712 and refuse to talk, that she even tried to take her life once or twice, swallowing pills and landing in the hospital, allegations that Brooke has steadfastly denied. Peter Fonda, for one, found such a scenario unlikely. "From what I know about Brooke," he said, "that doesn't suit the M.O." Having lost her mother and sister, Brooke

was determined not to go that route. Even so, Lael McCoy, the babysitter who lived two doors down from 1712, remembered once coming home to find Dennis, who was never much for keeping private dramas private, talking with her mother at the kitchen table, expressing concern about Brooke's emotional well-being and fearing for her safety.

DENNIS'S PREFERRED ESCAPE HATCH CONTINUED to be San Francisco. After the letdowns of *The Yin and the Yang* and *The Last Movie*, his feelings of entrapment had only deepened. "I sat in a chair, and, uh, watched a fly dying on the wall," he later said. "And I thought if I could just help that fly find an air current, that led to a window. . . ." The fly was Dennis, a Hollywood player going nowhere. Photography had been his air current, his creative updraft. In the summer of 1967, so was San Francisco. By his own account, he made the journey north as often as he could. "Everything I was involved with at that time came out of Berkeley and San Francisco more than anywhere else," he said.

In his way, Dennis became a key conduit between the LA and San Francisco cultural scenes. His fellow Kansans Bruce Conner and Michael McClure were important Bay Area friends. McClure's "beast language" poetry took Walt Whitman's barbaric yawp and went one better. That growling argot—"GRAHHH!"—was an invitation to free the wild soul, one that Dennis could hardly have resisted. One rainy dawn, he and McClure hiked together through the Muir Woods. "Dennis and I were very high and he was reciting the Gospel of Thomas," McClure remembered. "Then he put his hand out on a fallen redwood and he showed me how he'd left a burned print of his hand on the bark—and it looked to me that maybe he had." It was a trippy, literal reflection of Dennis's intense need to leave a mark. On another occasion, less transcendental, Dennis and McClure were having lunch with one of the Diggers, Peter Coyote,

who recounted it in a memoir. A guy at the restaurant became enraged by McClure's colorful way with obscenities, walked over to their table, and delivered three punches to McClure's face. "Dennis terminated the matter by jumping onto the table and adroitly dropkicking Michael's assailant into unconsciousness," Coyote remembered. "It's hard *not* to like a guy like that!"

Dennis would occasionally take LA friends along on his Bay Area sojourns. Among them were Ed and Danna Ruscha, who visited San Francisco with Dennis, taking in Quicksilver Messenger Service at Mount Tamalpais and touring the Haight. "Dennis was our guide, and he wanted to show it to us," Danna recalled. "It was like, *Oh my god.*" She recalled Brooke being along for this trip, but Brooke had no recollection of it. "Haight-Ashbury, Monterey Pop—Dennis had gone gung ho into it, and Brooke hadn't," David Hopper said. "Brooke wasn't really in tune with Dennis's emergence in robes and long hair and dropping acid and smoking dope."

In fact, the Haight denizens themselves were growing weary of the Summer of Love. "Rape is as common as bullshit on Haight Street," wrote the Digger Chester Anderson in a ferocious broadside. "Kids are starving on the Street. Minds & bodies are being maimed as we watch, a scale model of Vietnam." The Diggers—more about community engagement than drugged-out bliss blobbery—put the blame on merchants cynically marketing flower child dreams and on acid evangelists such as Timothy Leary, who, Anderson said, had "lured an army of children into a ghastly trap from which there is no visible escape."

The once-enchanted Haight was overrun with runaways, dropouts, hustlers, druggers, and rip-off artists. George Harrison made an obligatory pilgrimage and was bummed out by what he found, as was Brooke and Dennis's friend Joan Didion, who filed a jolting report about the Haight for the *Saturday Evening Post* called "Slouching Towards Bethlehem." "I see a child on the living-room floor, wearing a reefer coat, reading a comic book," she wrote. "She

keeps licking her lips in concentration and the only off thing about her is that she's wearing white lipstick." The girl was five years old, tripping on acid.

Dennis and Brooke often found themselves playing host at 1712 to emissaries from the Bay Area, whether they be a contingent of Black Panthers sacking out in the living room for a night or two or a delegation of Diggers. Late that summer, Coyote, Emmett Grogan, and a few other Diggers showed up in Los Angeles. They were perfect radical chic adornments. "We were young, hip, penniless, and adored for it," Coyote recalled of their reception in Hollywood. One day at 1712, the Diggers were cooking up some heroin in the living room amid the Warhols and Lichtensteins when Brooke came upon them. She was not impressed.

A meeting to talk about movies was arranged between the Diggers and Dennis, along with Peter Fonda and the actor Brandon deWilde. "These guys were our age," Coyote remembered, "sons of the film community, caught somewhere between their home base and their imaginings of free life, seeking to connect with a pure strain of the underground." Of the three actors, only Dennis impressed them. "I came to think of the others as beautiful hothouse flowers that could not withstand the rigors of unprotected environments," Coyote observed. They all sat around, shooting the breeze, with Dennis no doubt delivering his spiel about the need for a new American cinema. As Coyote recalled, one of the Diggers floated the idea that it would be cool to make a movie about two guys just riding around on motorcycles.

Dennis had, in fact, been working on two movies, and one happened to be about motorcycles. The other was about LSD. Both were for American International Pictures, the purveyors of *Queen of Blood*, not to mention *Beach Blanket Bingo*, *I Was a Teenage Werewolf*, and the successful Edgar Allan Poe–based movies starring Vincent Price.

The latter of those two films was *The Trip*, which Roger Corman

directed from a script by Jack Nicholson. Dennis played an acid guru and Peter Fonda a director of TV commercials who drops acid: the eponymous trip, which lasts for most of the picture. Corman met with Dennis before signing him up, explaining that they would be on a tight production schedule—AIP wasn't a big studio like Columbia or Warner Bros., and it couldn't handle any disruptions. Dennis's rap sheet had clearly preceded him. "I will be there every day on time," Dennis assured the director. "I will be totally professional." And he was.

Dennis and Peter were hoping that *The Trip* would be an end-around toward the kind of auteurship they had been aiming for with *The Yin and the Yang* and *The Last Movie*. When Peter read Nicholson's script, he wept. His wife, Susan, asked why he was crying. He told her, "Because I get to play in the first true American art film." He envisioned himself sneaking past the establishment with a part in a movie that finally gave honest testimony about the psychedelic subculture, all in the unlikely guise of a genre movie.

Dennis and Peter loved Corman, who had a knack for delivering pure entertainment on a shoestring budget while addressing social themes, as he had in *The Wild Angels*, the 1966 biker flick that Peter had starred in with Nancy Sinatra. Henry Hathaway and Curtis Harrington had had their influence upon Dennis, and now so did Corman, whose sunny sense of adventure impressed him. "From the LSD movies to motorcycle movies to horror movies, he just hit it right on," Dennis said. "He had a great feel for the times and the audience." Corman represented possibilities, especially for young talent. "We didn't have access to the major studios," Dennis said. "We couldn't go to Paramount or MGM and play around. Those were closed shops to guys like us. But everyone could have access to Roger."

Tom Wolfe had declined to sample LSD when he had written *The Electric Kool-Aid Acid Test*, but Corman decided that if he was going to make a picture about acid, he'd better try it. So he did,

after instructing an assistant to read Timothy Leary's version of *The Tibetan Book of the Dead* and provide a summary. "I had a wonderful trip," Corman recalled. "It was spectacular."

Dennis's own LSD experimentation accelerated as he prepared for *The Trip*. Bruce Dern, cast as a trip guide, was excited to act with him. "Shit, he was big stuff to us!" Dern said. "Dennis was iconic." As the ceremonial acid purveyor, attired in a red robe and what appeared to be the toothy necklace he had worn at Monterey Pop, Dennis was boyish and buoyant, manipulative and creepy—the shaman as small-time con artist. The film gave him a chance to show off his real-life joint-rolling skills and featured an impressively long unbroken shot in which a joint was passed around a crowded, Day-Glo-painted room, a full 360 degrees, while his character recounted an epic acid trip—a minor filmmaking feat that Dennis and Peter would later appropriate. One of the joint passers was Bruce Conner, whom Dennis photographed on set; he also shot Corman, looking like a leisure-loving suburbanite in his white Jack Purcell sneakers. Glimpses of the Angeleno underground brought a hint of street cred to the film, and they became minor touchstones of *The Trip*— Vito Paulekas and Carl Franzoni doing their freak dancing, the baby-faced Gram Parsons, soon to join the Byrds, playing with his International Submarine Band.

Dennis and Peter talked Corman into letting them shoot some acid trip footage, with Dennis taking the directorial lead. Corman, Dennis said, "made me believe I could direct." He and Peter jumped into the Land Rover and motored out to the Salton Sea, where Dennis shot dreamy footage of sand dunes. He also filmed the Sunset Strip: the twirling Tropicana girl on the billboard in front of the Chateau Marmont, the Classic Cat topless club, and the bland slab of 9000 Sunset, LA's version of New York's Brill Building. Peter was knocked out. "The footage was beautiful," he said. "Dennis could have done the whole movie like that. . . . He had the passion, and he had the ability to see form and substance much better than I."

But *The Trip* was far from being the first American art film. A revised ending turned what could have been a daring picture into a cautionary tale suitable for the Rotary Club. Dennis and Peter were furious with Corman for shredding Nicholson's script, while Corman claimed that AIP had demanded the changes. *The Trip* turned out to be another Corman moneymaker, but the reviews were savage. Dennis and Peter's involvement in *The Trip* might have seemed daring to their Hollywood friends, but to the Diggers it would have been a joke.

DENNIS DIDN'T CARE ALL THAT much for motorcycles. He'd earned his aversion the hard way, having skidded out on one in 1960, while shooting *Night Tide*, and landing in the hospital. (He subsequently scaled down to the Vespa.) But he hopped onto the back of a chopper for AIP's biker flick *The Glory Stompers*, playing the sadistic, pistol-wielding Chino, the leader of the marauding Black Souls motorcycle gang. *The Glory Stompers* was a lusty, loud, and loutish saga of abduction and revenge, originally written as a western: out with the horses, in with the Harleys. It had the crass, leering style and cheap, smudged look of classic trash. The violence was gratuitous, the soundtrack loaded with fuzzed-out guitars, and the dialogue ridiculous. Sample Chino line: "Like, we accidentally snuffed out your old man." Drunk on horsepower and beer, Chino's Black Souls weren't just depraved hedonists on choppers, they were sadistic killers and white slavers—human garbage on wheels. As Chino, Dennis went into full-on psycho mode, the first preview of the unhinged menace that eventually became synonymous with his acting career. (Quentin Tarantino later claimed that it was one of his favorite Dennis Hopper performances.)

Dennis, who wore McGuinn-style granny sunglasses for the part, seems to have found *The Glory Stompers* a twisted lark. He acquired the nickname "Grass Hopper" on location near Death Valley

due to his habit of sneaking into the bushes to huff joints. Chris Noel, playing the pretty blonde who is kidnapped by Chino and the Black Souls, remembered that most of the cast and crew were, in fact, stoned for the duration of the shoot.

As he had during the making of *The Trip*, Dennis created directorial opportunities for himself on *The Glory Stompers*. The director, Anthony M. Lanza, was green and perhaps in over his head. "I drove the guy to a nervous breakdown and then I took over the picture," Dennis later claimed. His costar Jody McCrea observed that development warily but said of Dennis, "He was awfully skilled at coaxing a good performance from me." Like *The Trip*, *The Glory Stompers* got terrible reviews but raked in money; produced for next to nothing, it reportedly earned $6 million. (Lanza claimed that Dennis had three and a half points on the picture.)

The Glory Stompers was not alone in turning the motorcycle, a potent symbol of the times, into drive-in movie receipts. Like rock and roll, motorcycles meant noise, freedom, and badassery, and so the decade was awash in biker flicks: *Motorpsycho*, *The Born Losers*, *Devil's Angels*, *The Wild Rebels*. Joan Didion watched them compulsively and wrote of "the senseless insouciance of all the characters in a world of routine stompings and casual death." To her, those exploitation movies were "underground folk literature for adolescents." Their *Citizen Kane* was Corman's *The Wild Angels*, in which Peter Fonda, as the Harley-riding pack leader Heavenly Blues, delivered the most famous of all biker soliloquys: "We wanna be free to ride! We wanna be free to ride our machines without being hassled by the Man! And we wanna get loaded. And we wanna have a good time. And that's what we're gonna do. We're gonna have a good time. We're gonna have a party!"

Actual bike clubs, such as the Hells Angels, lived in opposition to stultifying convention. "We are complete social outcasts—outsiders against society," an Angel from the Oakland chapter told Hunter S. Thompson, writing in the *Nation*. In their refusal to have anything

to do with the Establishment, the Hells Angels were not unlike the hippies. They thus became adjuncts to the counterculture. At the Human Be-In, the Angels had provided security, taking beer as payment. "No half-bohemian party made the grade unless there were strong rumors—circulated by the host—that the Hells Angels would also attend," Thompson wrote.

But it soon became apparent that the Angels were, ideologically speaking, more inclined toward the John Birch Society than, say, Students for a Democratic Society. "It puzzled them to be treated as symbolic heroes by people with whom they had almost nothing in common," Thompson noted. Unlike the peace-loving hippies, the Hells Angels left a wake of destruction in their path. Their readiness to take offense at any perceived provocation—and to meet it with total, obliterating violence—was as fine-tuned as the engines on their gleaming bikes.

Dennis was drawn to them. He loved photographing the Angels at rest and at play. His best outlaw biker image is an on-the-fly portrait of a young, bearded Hells Angel wearing the customary sleeveless denim jacket decorated with insignia and patches. In the unwashed, almost pretty face of that nameless, forgotten Angel, Dennis found openness and innocence.

It was likely around the time that Dennis was working on *The Glory Stompers* that he invited a band of Hells Angels to 1712, where they raised the decibel level of North Crescent Heights Boulevard and ended up bivouacking for the night. "I remember waking up one morning," Marin Hopper said, "and in the living room underneath the clown—they'd moved the furniture back—there were twenty sleeping bags. My mom was like 'Oh, those are the Hells Angels.'"

IN MID-AUGUST, WARNER BROS. RELEASED *Bonnie and Clyde*. It was essentially the American art movie that Dennis had been try-

ing to make for more than two years. With Warren Beatty and Faye Dunaway playing the 1930s gangster couple, the Arthur Penn–directed film, which Beatty had produced, felt like Pop Art, fixing a nonjudgmental Warholian gaze upon its criminal protagonists. It was outlaw chic—comic-book Americana with camp appeal and a French New Wave gloss. It was full of moral ambiguity, ironic remove, kooky nostalgia, weird sexuality, freewheeling violence, and a slanted approach to storytelling—novel elements that Hollywood was now free to play with. (Beatty had considered casting Dennis as the daffy sidekick C. W. Moss, whom Michael J. Pollard played to rubber-faced perfection.)

Bonnie and Clyde provoked a national debate about the state of movies. Concerned citizens and critics gnashed their teeth over violence in film as *Bonnie and Clyde*, with bullets spraying to a Flatt & Scruggs soundtrack, obliterated the limits of acceptability. Pauline Kael came to the rescue. "The audience is alive to it," she wrote of *Bonnie and Clyde* in a *New Yorker* review that made her career and helped establish what would forever be known as the New Hollywood. "Our experience as we watch it has some connection with the way we reacted to movies in childhood: with how we came to love them and to feel they were ours—not an art that we learned over the years to appreciate but simply and immediately ours." Like Dennis, Kael had been waiting for that moment, when Hollywood connected with the age as powerfully as rock and roll and made a new kind of art. *Bonnie and Clyde* landed on the cover of *Time* in the form of a Rauschenberg collage with the tagline "THE NEW CINEMA: VIOLENCE . . . SEX . . . ART."

Dennis and Peter realized that *Bonnie and Clyde* had called their bluff. As Brooke well knew from the endless conversations at 1712, it was everything the two friends had been thinking about. They needed to make something happen, and soon. But what?

The one thing they did know was that they would never do

another biker movie. After *The Glory Stompers* and *The Wild Angels*, they were horrified by the thought of becoming the 1960s version of singing cowboys, a couple of Gene Autrys on Harleys. "Riding motorcycles was like riding horses," Dennis said. "We were going to get stuck in this genre and never get out."

12

"GET THE CHILDREN OUT OF
THE HOUSE"

Peter Fonda decided to try his hand at music. He recorded a single, a Gram Parsons song called "November Nights," coproduced by Hugh Masekela. It was enough to convince him that he needed to make an album. He was musing on the project one afternoon at his Coldwater Canyon house when Dennis rolled up in the Land Rover. The situation turned bizarre. As Peter remembered it, Dennis demanded to be appointed "director" of the album. Peter said, "Dennis, you can't direct the record."

"What do you mean I can't direct the record?"

"You don't *direct* the record."

"Well, I'm gonna direct *this* record."

On it went until Dennis flipped out, yelling, apropos of who knows what, "Everybody steals my ideas!" Peter then threw a reel-to-reel tape recorder to the floor, breaking it into pieces, and told Dennis that if he could reassemble it, maybe he could "direct" the record. "You're out of your fucking mind, man," Dennis said. "I mean, you're really out of your fucking mind! I can't talk to you

anymore." With Peter promising never to talk to *him* again, Dennis made his way back out to the street and drove off.

And with that, one of Dennis's closest and most creative friendships juddered to a halt. It was through Dennis that Peter had come to know what he called "the art of films, the art of literature, the art of painting." At one point later on, he wrote to Dennis, "With you I feel the brotherhood of searching . . . dreaming down the road of possibility, where 'If' is the 'middle-word' of L-I-F-E." The "brotherhood" was deeply felt—Brooke, after all, was still like a sister to Peter. But the dynamic bond between him and Dennis had been broken. Speaking of his brother's penchant for flying off the handle and rupturing relationships, David Hopper said, "Dennis was quite dramatic and very real in his confrontation of things."

Circumstances at 1712 were likewise becoming increasingly real and confrontational. "He and Mom would go at it hammer and tongs, the way they did in *Blue Velvet*," Jeffrey Thomas recalled, citing the 1986 David Lynch film in which Dennis played a rampaging madman named Frank Booth. "That's the way you would have seen Dennis behaving any number of nights in the sixties," Brooke concurred.

"We were having problems," Dennis later reflected. "Problems that I wasn't old enough to understand. I was way out of my league, my tolerance and my understanding and any kind of . . . I didn't have it, you know? I just wanted to make a film, make a movie, get on with things."

By late 1967, Brooke had become fearful. Adding to the apprehension was the fact that Dennis, who had been fascinated by weapons since his Kansas boyhood, was occasionally armed. "He had a six gun," Willie Thomas remembered. "You'd see it now and then. It might be in the car, on the seat, or he'd have it upstairs, next to his bed on a table. We were like, '*Stay away from that.*' I spent a lot of time hiding in closets." According to Jeffrey, on one occasion his stepfather "chased us with a gun to kill all of us. We were go-

ing from house to house, trying to lay low. I mean, it was seriously a psychotic episode." The kids weren't sure what was up. "We all thought it was a great adventure," he said. "I think Mom even put it that way to us."

The combination of guns and domestic turbulence had a ghastly precedent in Brooke and Dennis's circle. In 1962, the actress Saundra Edwards had killed her abusive husband, Tom Gilson, an actor Dennis had known for years, with a shotgun. (Edwards was exonerated.) Miss Mac mentioned the incident in one of her letters home, striking notes that would not have been out of place in a Nathanael West novel. "There seems to be such a disregard for life and death here," she wrote. "I mean especially here in Hollywood."

Marin's memories of these troubles have always been hazy, but she remembered Brooke evacuating her and her brothers to the Chateau Marmont from time to time, whenever Dennis was "on top of the house shrieking or doing something really bizarre." Young Marin found the atmosphere of the Chateau haunting, even a bit scary, permeated as it was with history, mildew, and an aura of self-destructive torpor. Whatever it was that had prompted the escape would blow over after a couple of days and Marin would be relieved to be back home at 1712, at least until the next blowup.

AT 1:30 IN THE MORNING on September 27, the phone at 1712 rang, startling Brooke awake. Her father had been in ill health, having suffered an attack of pancreatitis at the end of 1966. In the past couple of years, his career had been haunted by failures. Considering Pamela's tendency toward extravagance, he must have felt excruciating financial pressures. (Like 1712, Leland and Pamela's "Haywire House" in Westchester had been featured in *Vogue*; unlike 1712, it had been done up in exceedingly conventional style.) As Brooke picked up the phone that night, there would have been good reason for trepidation. To her surprise, it was Peter on the other end,

calling from a motel in Toronto, where it was 4:30; he was there for the Canadian Motion Picture Industry Convention and Tradeshow, promoting *The Trip*. He asked Brooke to put Dennis on the line.

When Dennis grabbed the phone, Peter launched in, ignoring the fact that they were no longer on speaking terms. "Listen to this, Dennis. These two guys, man, they're grease monkeys and they just—they've had it with their lives." He went on to spin a movie-ready story that had come to him while he'd been enjoying a joint and a Heineken in his motel room after a day at the convention. He'd been signing a pile of promotional stills, including one from the *The Wild Angels* showing him and Bruce Dern on a motorcycle. The photograph triggered a tumble of associations, and the pieces of a two-person film narrative snapped together in his mind like a jigsaw puzzle. He had to call the one person who would get it: Dennis.

Now, while Dennis listened, Peter told him his vision: Two bikers make a huge marijuana score in Mexico, unload it in LA at a heavy profit, and embark on a journey across America, surveying the state of the country from the seats of their tricked-out choppers as they cruise along a couple thousand miles of blacktop—the hippies, the rednecks, the squares, the freedom, the paranoia, the bigotry. They would take it all in—not so much Gene Autrys on Harleys as unwashed, outcast Alexis de Tocquevilles. "They don't like us 'cause we're bikers," Peter explained, and suddenly the bikers were Peter and Dennis. They would ride together toward a comfortable retirement in—where else?—Florida.

It was a twisted 1960s dropout version of the American Dream, and it was decidedly not the standard-issue biker flick they had vowed to never be part of again. Whether or not he had subconsciously absorbed the premise that one of the Diggers had allegedly suggested a few weeks before, Peter pictured the two bikers as John Wayne and Ward Bond riding across John Ford's West: *The Searchers* revisited. But they wouldn't be in pursuit of a kidnapped Natalie Wood. *America*, Peter said, would be their Natalie Wood. In the

end, the bikers would be shotgunned by their cultural opposites, a pair of redneck duck poachers in a pickup truck, just when it looked as though the two chopper-riding antiheroes were home free.

Dennis understood right away: "That's great, man! Fucking great! What do you have in mind?"

"You direct, I'll produce, we'll both write and star in it!"

"Man, I sure am glad you called me, because I was never going to speak to you again."

Dennis was flabbergasted that Peter had faith in him to direct. "Peter was the one that finally believed in me enough to give me a chance to do something," he said. The fact that Peter had a three-picture deal with AIP reassured Dennis that this, at last, would be a go. He had one suggestion: the bikers could never haul enough weed on two motorcycles to make the kind of big-money deal that Peter had described. Instead, it should be a more valuable illicit substance: cocaine.

After Peter got back to LA, he told his wife, Susan, about the two bikers riding across America. "That's the corniest story I've ever heard," she said. It's unclear what Brooke made of the early stages of the project that they decided to call *The Loners* and that became, thanks to a suggestion from Terry Southern, *Easy Rider*. She later professed to have found it intriguing despite the difficulties she and Dennis had been going through and despite his propensity for misadventures. "He often got himself involved in nutty stuff," she said. "But *Easy Rider* seemed to me like it would obviously be interesting."

One night, Brooke and Dennis had Peter over for dinner at 1712, along with Toni Basil and Dean Stockwell. Peter and Dennis had been working through their story and talking about how they wanted the movie to look. "Hopper and I talked about the fact, 'Why do they hide lens flare?'" Peter recalled. They were determined to make their movie look different, to "let it shine." Dennis was probably already thinking ahead to the editing—crazy flash cutting, the kind Bruce Conner did. At the dinner, Basil, the

subject of Conner's *Breakaway*, was struck by the energy flowing back and forth as Dennis and Peter talked. Dennis said he wanted to shoot everything at eye level; Peter naturally wanted helicopter shots. "This is why the combination of the two of them was so spectacular," Basil said. "It was the collaboration. And Dennis, he either loved everything or he hated it. There was no in between. His excitement consumed the room. And Peter was so level and rooted and calm. They were just yin and yang."

Basil may or may not have known the title of their previous, failed collaboration, but this one appeared to be on course, full throttle.

AS AUTUMN DEEPENED, THE SUMMER OF LOVE faded into memory. Dennis and Peter spent afternoons on Peter's tennis court, swatting balls and ideas back and forth, working out the story of their movie while Peter's three-year-old daughter, Bridget, zipped around on her tricycle, making figure-eights. Peter pictured himself as a gangly stork and Dennis as a boxer.

Peter then traveled to Brittany to film the omnibus *Spirits of the Dead*—three Poe stories directed by three Europeans, including Roger Vadim, who also cast Jane in one of the roles. There, he ran into Terry Southern. The writer explained that he was consulting with Vadim on *Barbarella*, which was nearing completion. Peter gave his biker movie rap to Southern, who, according to Peter, declared it "the most commercial story I've ever heard" and volunteered to write a treatment and a script: "I'm your man." Peter couldn't believe his luck. As Southern's girlfriend, Gail Gerber, recalled, Peter asked the Oscar-nominated Southern if he would work on deferment. Southern agreed to do it for scale, with a percentage of the picture. When Peter mentioned that Dennis would be directing, Southern said, "Are you sure?!" And when Southern informed Jane that her brother and Dennis had come up with the most commercial story he'd ever heard, she replied, "You're both stoned out of your minds."

After *Spirits of the Dead* wrapped, Peter and Dennis converged in New York to meet with Southern at his house on East 36th Street and get the biker story onto paper. Dennis got swept up in the process, raving, cursing, and generally terrifying the typist they'd hired. At some point, Southern suggested that they make a tape recording of Peter telling the tale of the two bikers. Peter nominated Dennis for the task instead, thinking his telling might provide important directorial insights. When the tape rolled, Dennis uncharacteristically clammed up, so Peter once again spun out the story, addressing it to the one person in the room who had yet to hear it, Michael Cooper, the British photographer who had shot the cover of *Sgt. Pepper's Lonely Hearts Club Band*. The resulting tape, with Southern adding his two cents' worth, was transcribed and then tweaked into a digestible twenty-one-page document. Southern, Peter said, "gave us dark humor and a literary panache that Dennis and I did not have." Peter's character would be called Wyatt, as in Earp (aka Captain America), and Dennis's Billy, as in the Kid, thereby evoking the Wild West. As for the catchy new title, Southern explained that "easy rider" was hipster slang for a prostitute's boyfriend. Dennis and Peter saw a deeper, allegorical meaning in the sleazy phrase. "Liberty's become a whore," Peter said, "and we're all taking an easy ride."

A dinner was arranged at Serendipity 3, the campy Upper East Side restaurant whose aesthetic echoed that of 1712. (Warhol was a regular there.) In attendance were Dennis, Peter, Southern, Gerber, the actor Rip Torn, and the novelist Don Carpenter. Torn was meant to play an alcoholic small-town lawyer in the picture, a role that Dennis had suggested and that Southern claimed to have modeled on Gavin Stevens, a lawyer in a handful of William Faulkner novels. Dennis had wanted a character who came from the Establishment, and who was a motormouth, while Wyatt and Billy tended to communicate enigmatically, with head nods and "Yeah, man"s. He said that George Hanson, the drunkard lawyer, signified "trapped America, killing itself."

What ensued at Serendipity 3 was a Rashomon that serves to illustrate much of the development, production, and afterlife of *Easy Rider*, a film forever enveloped in conflicting recollections, competing agendas, and everlasting grudges.

According to Torn's memory, Dennis entered the restaurant wearing buckskins, already in the process of turning himself into Billy, and proceeded to threaten Torn with a bowie knife, after some jawboning about Torn and Southern's home state of Texas. In other variations of the story, the weapon was one of the restaurant's steak knives. Torn—like Dennis, a hothead who would later attack Norman Mailer with a hammer—was said to have disarmed Dennis using a move he'd learned as a military policeman. At that juncture, Torn remembered, "Dennis jumped back and knocked Peter on the floor, and I said, 'There goes the job.'" In Peter's telling there was no bowie knife or steak knife. Instead, the combatants had brandished relatively harmless tableware—a butter knife and a salad fork.

Decades later, Dennis claimed on *The Tonight Show* that it was Torn who had pulled a knife at Serendipity, not the other way around, thereby triggering a defamation lawsuit by Torn. After years of litigation, Torn won, with Dennis on the hook for $950,000 in damages. Torn never did play George Hanson.

CHRISTMAS 1967 ARRIVED AT 1712. Dennis and Ed Kienholz appropriated a stack of colorful foil-wrapped tires from a service station, likely the Standard station at the corner of Sunset and North Crescent Heights. These were strewn about amid the gifts under the tree, which was placed next to Lichtenstein's *Mad Scientist*. An antique French bottle rack shaped like an evergreen was deployed on the coffee table and topped with a toy Santa, no doubt inspired by Duchamp's famous *Bottle Rack* from 1914: a ready-made Pop Art Christmas. That morning, Dennis came down the stairs in a flowing caftan, with the Pancho Villa–David Crosby mustache he'd

sported in a recent episode of *The Big Valley*, while Brooke wore colorful pajamas. Marjorie Hopper sat on one of Dennis's fake-boulder sculptures, and Marin modeled her new ballerina tutu while Jay Hopper snapped photographs and the boys opened presents. In Jay's pictures, there's no hint of the growing discord at 1712.

The Graduate, cowritten by Brooke and Dennis's friend Buck Henry and directed by Mike Nichols, had come out that week. Like *Bonnie and Clyde*, it was a movie that spoke to the times in the way that Dennis hoped *Easy Rider* might do. In 1965, he and Peter, as would-be auteurs, had been ahead of the curve. As 1968 began, they were falling behind. After the new year, they presented the work they had done so far on *Easy Rider* to AIP executives Samuel Z. Arkoff and James H. Nicholson. The studio heads balked. Drug dealer heroes were not what they had been expecting, and the idea of Dennis directing gave them pause. But Arkoff and Nicholson came up with what they viewed as a compromise: if the production ever fell three days behind schedule, they would have the right to pull Dennis from the director's chair and replace him. Peter said no way.

Roger Corman was at the meeting and stayed behind after Dennis and Peter left to advocate on their behalf. It was all for naught. Dennis and Peter appeared to be back where they had been with *The Yin and the Yang* and *The Last Movie*—nowhere.

AS HAD BECOME DENNIS'S CUSTOM when faced with Hollywood naysaying, he dived into the counterculture. On January 8, the *Los Angeles Times* announced that he was to star with Alexandra Hay in Michael McClure's *The Beard*, opening January 24 at the Warner Playhouse, a funky theater on North La Cienega, close to the new Irving Blum Gallery. The play had grown out of a piece of poster art McClure had made called *Love Lion, Lioness*, which Dennis and Brooke displayed in their den. It depicted Billy the Kid

and Jean Harlow in the style of a fight poster. With *Easy Rider* on hold, Dennis began prepping to play Billy the Kid for his first stage appearance since *Mandingo*.

The Beard was to Beat drama what *Howl* had been to Beat verse. Kenneth Tynan called it "a milestone in the history of heterosexual art." Norman Mailer found it "a mysterious piece of work" in which "ghosts from two periods of the American Past were speaking across decades to each other, and yet at the same time are present in our living room undressing themselves." A commenter in *Newsweek* said it was better than *Bonnie and Clyde*. Andy Warhol shot a film version in 1966. (McClure hated it.) Lewd and surreal, *The Beard* generated notoriety. In Peter Fonda's droll description of the play, Billy the Kid "rips off Jean Harlow's panties and eats her out—in heaven."

One day, Brooke drove down from 1712 to the Warner Playhouse in the Checker cab to observe a rehearsal. Dennis had been nervous about his return to the stage. After the run-through, Brooke told him she had to run—she'd left the kids at home. Dennis begged her not to go. As she remembered it, he became "completely crazy." After she got into the car, he jumped up onto the hood and kicked the windshield in while Brooke sat in the driver's seat, aghast. The small crowd of people looking on were no doubt horrified.

Not long before opening night, Dennis left the production. It's not difficult to imagine that a producer might not want to work with Dennis after such an outburst. And it's not difficult to imagine that Brooke was now having second thoughts about being married to him.

A year after the Human Be-In had celebrated light and hope, life at 1712 darkened. In the master bedroom, there was another Lichtenstein: *Crying Girl*, a lithographed cartoon portrait of a woman looking like a nervous wreck. It's difficult not to see it as a mirror of Brooke in 1968 as she found herself subjected to the mounting stresses of her husband's—and the decade's—accelerating weirdness, along with the needs of three children. Something was going very awry with the man she had fallen in love with in 1961.

Dennis's alcoholism, his propensities for self-flagellation and self-aggrandizement, his endless quest for recognition and the absence of it from the world at large—it was all reaching a breaking point. He had become a human pendulum swinging between the redeeming and the rebarbative: curious, passionate, and sweet one minute, wheedling, Napoleonic, and prone to violence the next. He seemed to be losing his grip on reality.

Not long after the windshield incident, he and Brooke were looking over his latest contact sheets when Dennis made what he called "the gravest mistake."

HE: I'm thinking of printing this. What do you think, Brooke?
SHE: Well, I like *that* photograph.
HE: What a dumbass you are.

Dennis shot out a hand. "He went, *pop*, and broke my nose," Brooke said. "I don't think he meant to. But I had to go pick the children up at school with a broken nose." Jeffrey remembered her saying that she'd walked into a cabinet. Brooke was tough, had lived through her share of pain and distress, but the humiliation she now felt had to have been extreme. Dennis apologized profusely, but it was an act that went beyond the forgivable.

The "halcyon time" at 1712, as Jeffrey put it, was coming to an end. As the arguments between his mother and stepfather escalated, he was left to clutch his little rock collector's hammer in bed at night and wish that the yelling would stop. On the wall of his and Willie's bedroom, Brooke had hung an 1890s theatrical poster emblazoned with the words BLUE JEANS WILL NEVER WEAR OUT, the title of a long-forgotten stage melodrama. It showed an over-the-top sawmill scene in which the villain has placed an unconscious man across a couple of planks and is pushing him toward a whirring sawblade. A distressed woman is seen beating down a locked door with a chair. The dastardliness and desperate heroism depicted on

the poster beamed down upon Jeffrey, who would rouse himself out of bed and dash down the hall toward whatever ruckus was being raised in the master suite, to the amazement of his little brother. "Jeffrey would pound on the door," Willie recalled, "and say, 'Dennis, Dennis, please stop!' I was not the hero, like Jeffrey." The uproar from down the hall would cease.

"I was terrified of the physical stuff," Brooke said. She retaliated with words.

SHE: You're a terrible actor.
HE: Fuck you, Brooke!
SHE: You're fucking awful!

Intimations of disorder at 1712 reached Dennis's family. "Dennis was an asshole," David Hopper said. "He would slap her—or whatever he did—and my mother would just say, 'Well, I can understand it if she woke him up.' And I'm going '*Yeah, right.*'"

In 1968, a year that would be filled with upheaval, violence, and assassinations, Brooke and Dennis's idyllic Pop Art house—so full of color, hope, and love—was turning into a lurid marital drama stage set: *Who's Afraid of Virginia Woolf?* with an acid rock soundtrack. For Brooke, the question of how Dennis would ever right himself was superseded by a more pressing one: How would she and the children get through it? She'd been in therapy sessions with Dr. Lawrence Greenleigh, a well-regarded Hollywood psychiatrist. As she discussed her life with the doctor, he began issuing stern warnings: "You're married to someone you must get a divorce from, who is exceedingly violent. Things are going to get a lot worse." He advised Brooke to get out. She stayed.

WITH *EASY RIDER* IN LIMBO, Dennis and Peter toggled over to another would-be project: a typically out-there McClure piece called

The Queen, which had to do with members of the Kennedy administration in drag. Dennis, Peter, and Michael went over to Bob Rafelson's office to pitch it, asking for all of $60,000. Rafelson and his partner in Raybert Productions, Bert Schneider, were then working up the Monkees movie *Head*, a gleefully surreal and self-destructive romp that Rafelson had written with Jack Nicholson. Rafelson's eyes glazed over during the McClure pitch, and he shifted the conversation to the biker film. What was AIP doing with *Easy Rider*? Not much, Dennis and Peter told him. Rafelson had read what they had put together with Terry Southern and liked it. Now he told Schneider, a charismatic operator with ice-blue eyes, that these two guys were sitting on "the most commercial story I've ever heard." Schneider asked how much they'd need to make the picture. Peter tossed out a number: $360,000.

A few days later, Schneider called Dennis and Peter into his office, grabbed a pen, and dashed off a check for $40,000 so they could get going on *Easy Rider* right away. He asked what they wanted for compensation. Peter said a third of the picture, to be split equally among him, Dennis, and Terry Southern, who, in addition to lending his screenwriting skills would be an on-set production presence. Peter asked if Schneider wanted to be a producer. "I don't want anything," Schneider told him. He had his hands full of other projects. "I'll let you make this movie the way you want to make it and I won't interfere," he said. He would, however, interfere on one important point, convincing the reluctant Dennis and Peter to cast Jack Nicholson as George Hanson. Hiring a guy from New Jersey to play a drunk Texas lawyer sounded like a rotten idea. "Bert, I'll do it for you," Dennis said, "but he's gonna ruin my movie."

And just like that, *Easy Rider* had a production company, financing, and a heartbeat. There was still no screenplay, but Dennis would finally get his shot at directing a movie.

He and Peter hastily made plans to shoot Mardi Gras in New Orleans—parades, voodoo, a perfect midway point for Wyatt and

Billy's cross-country journey and the ideal setting for the acid trip sequences they wanted to film. Unfortunately, Peter had figured on Mardi Gras being in March, a month later than it actually was. When that inconvenient fact was discovered, a mad scramble ensued in order to film the debauchery in time. Peter and Dennis rounded up a last-minute squad of three camera operators (including Dennis's old friend Barry Feinstein), a bare-bones crew, and Toni Basil and Karen Black, who would play a pair of prostitutes who drop acid with Wyatt and Billy. Brooke's wayward brother, Bill, was brought into the fold as a producer. Given the situation at 1712, Brooke had to have been relieved to know that Dennis would be out of the house for a week.

In the days leading up to Dennis's departure, the Pasadena Museum, thanks to Walter Hopps, was preparing to show a piece of original Dennis sculpture called *Bomb Drop*. It was a large-scale, silvery replica—one that moved and lit up—of the comically phallic lever assembly used on bomber planes for dropping destructive payloads. In its size and literalness, it was something like a Gerald Murphy painting from the 1920s transformed into a three-dimensional object and updated for the Vietnam War era. Since the *Bomb Drop* opening jammed right up against the beginning of the Mardi Gras shoot, it's not hard to imagine Dennis being distracted at the invite-only preview as the usual array of Los Angeles art-world people milled around in black tie. Dennis always remembered that not one attendee complimented him on his opus. "Nobody mentioned it," he said. "It was like it didn't exist. And *I* didn't exist." By his own reckoning, he would not make another piece of art for fifteen years.

The night before he left for New Orleans, Dennis met up with Claes Oldenburg at the Chateau Marmont. The artist delighted Dennis by making thirty-seven drawings for him as they talked. Dennis tucked them into a folder with his script, such as it was, for the Mardi Gras shoot. The folder and its contents would be stolen, or lost, in New Orleans. The music executive Earl McGrath and

his wife, Camilla, who often had Brooke and Dennis up to their suite for pot- and food-filled soirees, also hung out with Dennis that night at the Chateau. Camilla had a camera out and photographed Dennis in full-on Billy mode—unshaven and in his fringed buckskin regalia, which McGrath assumed, perhaps based upon olfactory evidence, that Dennis had already been living in for weeks. "He had taken L.S.D.," McGrath noted. When a friend asked McGrath if he'd ever suspected that there was trouble between Brooke and Dennis, he said, "From the minute I laid eyes on them."

ON THURSDAY, FEBRUARY 22, the cast and crew of *Easy Rider* departed Los Angeles. In Dennis's recollection, Brooke drove him to the airport and made it known that she did not believe that he and Peter were on the path to cinematic glory. In his telling, "Brooke said, 'You are going after fool's gold.' That didn't read too well with me. Brooke is groovy, we even have a beautiful little girl, but you don't say that to me, man, about something I've waited 15 years—no, all my life—to do." Dennis said that the lack of spousal encouragement had prompted him to ask for a divorce, which Brooke had granted, right there in the car. "That was the last time we were together as man and wife," he said. Brooke, who had compelling reasons to grant a divorce, has maintained that the incident never happened, going so far as to call the story "completely idiotic."

The next morning in New Orleans, the cast and crew gathered in an airport hotel parking lot at 6:30. It was Peter's twenty-eighth birthday. Dennis embarked on the traditional director's pep talk. It immediately went off the rails. "This is my fucking movie!" he screamed. "And nobody is going to take my fucking movie away from me!" The paranoid harangue went on and on. It was as if he had internalized the worst martinet behavior of Henry Hathaway and was now spitting it back out in a flame-throwing, cathartic rage, leaving his team fully demoralized before a single frame of film ran through

the cameras. Peter, thinking "This is un-fucking-believable," asked the soundmen to secretly record Dennis's rantings.

From that auspicious start, the Mardi Gras shoot went downhill—parades missed, mounting confusion, more screaming. Somewhere in the French Quarter they ran into Tom Mankiewicz, who was shooting a TV special around Herb Alpert and the Tijuana Brass. The contrast between the two productions was stark: one an all-pro paean to easy listening, the other, by all appearances, chaotic youth-culture trash. "They were permanently stoned, totally disorganized," Mankiewicz remembered; to him, *Easy Rider* would always be a "cinematic accident committed by extremely talented potheads."

At the end of the first day, the exhausted Peter went to Toni and Karen's motel room to commiserate. "It's my twenty-eighth birthday," he moaned. "What a fucking present I've given myself! What is this fascist gonna do next?" As if on cue, a fracas erupted outside. It was Dennis and Barry Feinstein, mano a mano. Dennis had been trying to get Barry to shoot reflections of neon lights in a puddle; Barry had had enough of Dennis. They tumbled into Toni and Karen's room. Dennis whacked Barry over the head with Karen's guitar and then heaved a television in Barry's direction.

Peter managed to corral Dennis and bring him back to the room they were sharing. Dennis had apparently been taking speed all day. "Oh, man, have you got anything to help me just relax?" Dennis begged. "Nobody understands, man. Man, it's *primary light*, man. Look, look—*primary colors*. There it is. It's right there on the wall of this motel with me, man." He gave Dennis the sedative Placidyl, which knocked him out. But when he went to take his comatose friend's boots off, Dennis bolted awake with a shout: "Don't ever take my boots off again!" Then Dennis collapsed back onto the bed, over and out.

The rest of the shoot proceeded in more or less the same fashion. Terry Southern and Gail Gerber, who had flown in from New York, were aghast. Even for Terry, an avowed fan of madness, it

was too much. He asked Peter, "What would Dad-Dad think?"—meaning Henry Fonda. To Dennis, whenever he got particularly out of control, he said, "Jimmy wouldn't like that"—meaning James Dean. If Terry Southern is the adult in the room, it probably means you're beyond hope. Worn down by all the chaos, Terry finally told Dennis, "The cacophony of your verbiage is driving me insane." He decided that being on set with Dennis wasn't for him.

Yet somehow, in their guerrilla way, they managed to shoot Mardi Gras, along with an important brothel scene and, most significantly, an acid trip sequence in Saint Louis Cemetery No. 1 in the French Quarter. There, Dennis instructed Peter to get up onto a Madonna statue and pour out his pent-up sorrow and rage over his mother's suicide. Peter was appalled that Dennis would use such personal and privileged information for motivation, but Dennis would not be dissuaded. "That's the Italian statue of liberty, man," he whined. "I want you to go up and sit on her lap, man. I want you to ask your mother why she copped out on you." To Peter's amazement, it was Dennis, not he, who was in tears. Peter swallowed his misgivings and did the scene, overcome with long-deferred grief: "You're such a fool, mother," he improvised. "I hate you so much." The weird mojo Dennis had put on him had worked. Wyatt's acid-triggered emotional breakdown proved to be one of the most vivid moments in *Easy Rider*. Peter admitted that Dennis, despite his paranoid megalomania, was, as he put it, "creative as hell."

Toni Basil agreed. "Dennis was an artist," she said. "His work ethic was very intense." In her memory, the New Orleans shoot was not at all drugged out—at least not when the cameras were on. "We were *working*," she insisted. "It looked like a drugged scene, but it was not." There was disorganization, yes, but Basil thought that there were good reasons for it: Dennis and Peter were in a frantic, multitasking mode that would have fried anyone's nerves. "They were their own prop people," she pointed out, "their own set people, their own, their own, *their own*—and that's exhausting."

The exhaustion was too much for many on the set, including Cliff Vaughs, the Black political activist who had been hired to help create the choppers that Wyatt and Billy rode. "Dennis' imagination and vision are groovy, but his incoherent and emotional efforts to implement them were disastrous," Vaughs told Southern in a letter after the New Orleans shoot. "I am just beginning to understand fully how our collective creative instinct can be thwarted by a single madness."

Back at 1712, Brooke had been receiving updates from New Orleans. "I got a phone call from Peter Fonda," she recalled, "and a second one from my brother, saying 'Brooke, get the children out of the house. *Get out.* Dennis has gone berserk.'"

"What are you talking about?" she'd replied, exasperated. After all, she was the one who'd seen the worst of what Dennis could dish out. How much worse could it get? And where were she and the kids supposed to go? "I stupidly remained," she said.

WHEN DENNIS RETURNED FROM NEW ORLEANS, he was in a state that Brooke described as "vile." The heap of 16-millimeter footage he had managed to create was, as Bill Hayward described it, "an endless parade of shit." Brooke went along with Dennis to a disastrous screening for Rafelson and Schneider and had to admit that her brother's assessment was accurate. Despite everything, she still believed in her husband's eye. Dennis's talent, she thought, was not reflected in the muddy, misty crud everyone saw on the screen. Dennis took to their bed in a sulk and remained there, as Brooke remembered, "the dying swan."

"Obviously," Dennis later acknowledged, "I was a crazy person"— impossible to work with. Peter and Bill went back to Schneider, offering to return the $40,000 and call it a wash. Peter played Schneider the tapes of Dennis freaking out, and the idea was floated to keep going with *Easy Rider* but to remove Dennis from the director's chair.

Schneider said, "Well, he sounds excited, but you know what—I hired this person to direct this movie. He's going to direct this movie." He counseled Peter and Bill to have patience; Dennis hadn't had adequate preparation or an adequate crew. From now on, there would be no more gonzo: they would need to shoot in 35 millimeter with an actual cinematographer: László Kovács. They would need permits, a unionized crew, a shooting schedule, a real script. According to Dennis, Schneider let him know that Peter and Bill had plotted his removal, "So you're not confused about who your friends are."

One evening, Brooke was in the kitchen at 1712, going through the dinner routine, preparing franks and beans for Jeffrey, Willie, and Marin. Just above the sink, a window looked out into the backyard at the phony billboard Chevrolet and the assortment of gas station signs. Above the window hung Art Nouveau advertising posters by Alphonse Mucha and Paul Berthon; they were offset by a Lichtenstein lithograph called *Crak!*, which showed a Frenchwoman in a beret, a Resistance fighter, firing a rifle. Leo Castelli had used it for an opening in 1963. That now seemed like a very long time ago.

Jeffrey, Willie, and Marin were sitting down to their dinner when Dennis burst through the front door with Bruce Conner, who stopped at the organ in the foyer and began pumping out a ditty that reminded Brooke of something out of *The Phantom of the Opera*. Dennis proceeded to the kitchen and angrily demanded dinner.

HE: I want some of that.
SHE: I'm sorry, there is no more.
HE: Well, I want you to make me dinner right now!
SHE: I can't, there's no more food!
HE: Then I'm going to kill you.

The eyes of the children were upon them. Marin began to scream. Brooke understood that way too much had happened already. Escape was imperative.

She went to Conner and asked him to please get Dennis out of the house so she could leave with the kids. It didn't matter where they went, as long as it gave her enough time to pack. Conner got the message. "Dennis," he called out, "let's go get something and we'll be right back." In the living room, underneath the gaze of the Judas, Dennis started to rage again. Eleven-year-old Jeffrey, in his John Thomas Dye School uniform, stood in front of Brooke. "Don't you get near my mother," he warned.

With that, Dennis finally left. Brooke ran upstairs, threw clothes into bags, got everyone into the Checker cab, and drove to Santa Monica Canyon, taking shelter at Jill Schary's house. "There was no sane presence giving Brooke fortitude," Jill said. "And she stayed alive."

"It was a couple of days later," Brooke remembered, "that my brother called and said, 'Brooke, you can come home now. Dennis is in jail.'" He'd been busted on the Sunset Strip for throwing a roach out of his car window. (Dennis insisted he'd been framed.) Brooke relayed the news to her lawyer. "That will keep him out of the house," he told her. "Because it's *your* house—you paid for it. You must start right now filing for divorce." Schneider put up Dennis's bail and immediately sent him on an extended scouting trip for *Easy Rider*, giving Brooke some breathing room to move back into 1712 and begin the process of filing for a restraining order and a divorce—"the most awful thing in the world." She phoned Michael Thomas in New York, forcing herself to ask that he take Jeffrey and Willie back to a more normal world. He agreed. "She was at the end of her rope," he remembered. "She sounded totally beat."

When Brooke called her father to let him know she was divorcing Dennis, he told her, "Congratulations on the first smart move you've made in six years."

13

"A BEDROOM CROWDED WITH GHOSTS"

When you see Dennis in *Easy Rider* as the mustachioed Billy on his hog, he is riding away from 1712 North Crescent Heights forever. Observing the breakup from a remove, Ed Ruscha was philosophical. "He could see that maybe she was from a different world," he said. "And he was destined to push on."

Pending the divorce suit, a judge ordered Dennis to pay $125 a month in child support. As for alimony, Brooke said, "He didn't have any money, so he didn't give me any." With the $500,000 trust fund from Maggie's estate and ownership of 1712, she wanted a clean split; she wasn't after any of the proceeds from *Easy Rider*—if, in fact, there ever would be any. Dennis sought a share of the art collection. "I just wanted half of the paintings," he said. "And I couldn't get any of them." After all, they had largely been bought with Brooke's money.

But Dennis did hold on to certain works, including the Hotel Green sign and pieces by Conner, Berman, and Oldenburg. The agent and producer Michael Gruskoff remembered visiting Dennis

around the time of the divorce proceedings, finding him living like a transient in some Hollywood hovel or another. Dennis showed him a few paintings he'd managed to get out of 1712. "I have to sell these babies," Gruskoff remembered Dennis telling him. "He was broke."

David Hopper said that his brother was then making all of $60 a week. But Dennis would be well compensated soon enough. Having pointed a Duchampian finger at a low-down cinematic found object—the biker movie—and called it art, Dennis intended to elevate it with Pop panache, countercultural swagger, and commercial viability. In time, Hollywood would call *Easy Rider* art, too—and see that an independent film could earn a pile of money.

But the ride proved to be rougher than a chopped Harley on a gravel road. The tensions between Dennis and Peter continued throughout the location shooting that took place in California and the South over the course of seven weeks. During one dispute, Peter retorted, "Well, at least I don't hit women." When Dennis and Peter fiddled with the script, Terry Southern excoriated them for their "dumb-bell dialogue." The editing process was painful and never ending: Dennis estimated that there were eighty hours of footage to plow through. The landscapes that László Kovács had shot were just too beautiful to leave out. Cutting them was torture. Besides, Dennis wanted the audience to be hypnotized, enveloped. His movie would be like *2001: A Space Odyssey*—magisterial, elegiac, balletic. Instead of space exploration, there would be Wyatt and Billy traversing America on their bikes. "Those ride sequences contained a lot of things never before seen in a major feature film," Dennis said. After twenty-two Sisyphean weeks, he had managed a four-hour cut. Then it was editing-by-committee time, with Peter, Bill Hayward, Bob Rafelson, Jack Nicholson, the editor Donn Cambern, and the consultant Henry Jaglom trimming Dennis's opus down to a releasable ninety-six minutes. David Hopper described the difference between the two cuts of *Easy Rider*: "It was like a New Testament. It turned into a pop album."

Dennis and Peter hosted screenings throughout the process. "I got worried that by the time it came out, everybody who could smoke a joint in L.A. would've already seen the movie," Bob Rafelson said. A lot of the old Ferus crowd showed up, including Ed and Danna Ruscha. "It was pretty mind-blowing," Danna said. "You just left the theater, like, *Wow*." Frank Gehry said, "It was spectacular." As Irving Blum recalled, "All the artists I represented were vocal about their love for the movie." Wallace Berman was even *in* the movie, casting seeds in a commune scene.

David Hopper brought along his father and grandfather Hopper to one of the screenings. The seventy-four-year-old James Clarence Hopper, watching a scene in which a joint is being passed around a campfire, called out, "Those boys must be short on tobaccy!" When Marjorie saw the movie, she didn't know what to think. "It got a little better as it went along," she allowed, "but I, uh, I was pretty shocked." Marin went to a screening with Jeffrey and Willie, who pulled off their ultimate shoplifting coup for the occasion, presenting her with a Barbie bus stolen from a drugstore, thinking she might need a comforting distraction. When the movie ended, Marin ran into the projection room and implored Dennis, "Why did they shoot you? You died!" Dennis assured his six-year-old daughter that all was fine.

Leland and Pamela even made an appearance. Pamela pointedly ignored Dennis, but Leland was cordial. His son, Bill, seemed at last to have earned the respect of his father, who understood that *Easy Rider* would have an impact on the business. It was a poised attitude, considering that Dennis and Peter had made a movie designed to obliterate Leland's Old Hollywood. At a dinner party, Dennis had even told George Cukor, "We're going to *bury you!*"

One day, Dennis ran into another Old Hollywood lion, William Wyler, in the Columbia commissary. "How's Brooke?" the Oscar-winning director and Maggie Sullavan's second husband asked. "Well, Willy, we're getting a divorce," Dennis said. Wyler was hard

of hearing, and it took several tries, with escalating volume, before he understood what Dennis was telling him. Thanks to the shouting, the entire Columbia commissary understood, too. "Oh," Wyler finally said. "Guess you couldn't hold on to her any better than I could her mother."

As for Brooke, she went to a few *Easy Rider* screenings at the invitation of her brother and never with Dennis in attendance. She preferred the shorter cut. And she was riveted by Dennis's acting. "I thought that was the best he'd ever been," she said. "I knew how talented he was. I wasn't surprised." Dennis had pulled it off.

ANDY WARHOL THOUGHT THAT *Easy Rider* pinpointed "the exact image millions of kids were fantasizing—being free and on the road, dealing dope and getting persecuted." Taylor Mead found Dennis to be so natural in *Easy Rider* that he wondered whether the goofball fun they'd had making *Tarzan and Jane Regained . . . Sort Of* had loosened up his acting. That might have been a stretch, but the two movies did share the same ready-made approach to their soundtracks, using records instead of a score. The connection might have been apparent to Warhol's aide Paul Morrissey, who, after a screening, joshed, "What a great idea—making a movie about your record collection!" In Dennis and Peter's case, that meant music by the Byrds, the Band, Jimi Hendrix, Steppenwolf, and the like.

Dennis and Peter had, in fact, toyed with the idea of commissioning an original soundtrack. Dennis presented the idea to Michael Nesmith, who blurted out something about brass-band music. "He was courteous and let the subject drop," Nesmith recalled. Dennis also asked Miles Davis, who ended up mailing a tape of some compositions and a letter informing Dennis where to place them. "Tell your producer that I already have fame, good looks, a pretty wife, talent, the regular things people with money have," he wrote, "but I believe in an eye for an eye and a tooth for a tooth. In other words I

believe in making lots of money." He went on about white produc-
ers, Uncle Toms, and stolen copyrights, telling Dennis "The music
is a tribute to your talent and our long-distance friendship. Lets [*sic*]
keep it like that." The music was never used.

Peter had the notion that David Crosby's new supergroup, Crosby,
Stills & Nash, should create the soundtrack, much as Simon and
Garfunkel had provided songs for *The Graduate*. When the trio had
some music to share, they sent a limousine to fetch Dennis. After
the listening session, Dennis told Stills, "You know, Stephen, I can't
use the music of anybody who rides in a limousine." That kind of
person, Dennis reasoned, could not possibly understand the movie.
"And if you try to come into the studio," Dennis added, "I'll have
the guards arrest you." Living like a pauper, Dennis was perhaps
sensitive about rock star grandiosity. But he'd also become stuck
on the found music they had been using in the editing, including
the Byrds' "I Wasn't Born to Follow" and Steppenwolf's "Born to
Be Wild," which gave the movie an electric flow and a huge dose
of street cred. And so the music stayed, making for a new kind of
movie soundtrack, one ensuring that *Easy Rider* would connect vis-
cerally with its intended audience.

But Dennis and Peter did commission one new song, going
to another Byrd, Roger McGuinn, who came up with the elegiac
theme, "The Ballad of Easy Rider." It was developed by way of Bob
Dylan, who, offended that Wyatt and Billy were killed at the end
of the movie, declined to provide his own music. But, as McGuinn
recalled, Dylan "scribbled some lyrics on a cocktail napkin, gave it
to Peter or Dennis, said, 'Give it to McGuinn, he'll know what to
do with it.' I wrote the verse 'All they wanted was to be free and
that's the way it turned out to be.' And Dennis said, 'What's *that*
supposed to mean?' And I said, 'Think about it, Dennis.' And he
went, 'Oh, wow, man, that is really heavy!'"

"I loved the movie," McGuinn said. In fact, he told Peter that
he wished he were actually *in* the movie. Peter said, "You were!"

He explained to McGuinn that Wyatt and Billy were modeled off of him and Crosby, a natural enough leap, given the weird parallels between Peter and Dennis and their Byrdsian heroes. "Dennis was me, right down to the fringed jacket and the pocket knife," Crosby said. Dennis was generally mum on that point, but, as Andee Nathanson recalled, "When he was getting his head together for *Easy Rider*, Dennis and I went over to David Crosby's house." Andee watched Dennis sponging up every Crosby mannerism and inflection. She was later amazed to see it all synthesized on the screen. "*For sure* he got that character from David," she said.

Easy Rider turned out to be the vivid amalgam of so much that Dennis had absorbed during his years with Brooke at 1712: the deadpan Americana of Pop Art, the noise of rock and roll, the flash-cut editing of Bruce Conner's experimental films. Warhol's underground movies were present in *Easy Rider*, along with the art-house spirit of Curtis Harrington, the B-movie verve of Roger Corman, and the cinema verité of D. A. Pennebaker, who had shot *Monterey Pop* while Dennis had been flying on acid in the trip tent. There were onscreen performances by such friends as Bobby Walker, Luana Anders (from *Night Tide*), and Phil Spector, who, having failed to make *The Last Movie*, made a cameo as Billy and Wyatt's coke buyer. Dennis's years as a photographer had refined his framing and composition. His explorations of the Sunset Strip and the Haight made *Easy Rider* the first movie that looked the counterculture in the eye, spoke its dialect, articulated its hopes and fears, and even critiqued it from the inside. As the writer Lee Hill observed, "This was a road movie that drove right through many people's hearts."

It touched their minds as well. *Easy Rider* was a gazetteer of late-sixties America, from towering mesas to shotgun shacks, from communes to bordellos. Its panoramic vision teased at utopianism but delivered something dark and complex. Were Wyatt and Billy hippie heroes on metal steeds? Or high-speed con artists who took whatever they could grab—meals, beds, sex, drugs—from the free

spirits they met along the way? That was the yin-yang of *Easy Rider*, and it played out between the optimistic Wyatt and the cynical, roguish Billy. For Wyatt, the coke deal allowed him to stuff his American flag–painted gas tank full of cash: a promise of freedom. For Billy, it was fuel for a life of hedonism. "Christ, they were criminals," Dennis later said, "they smuggled drugs, they used amoral means to buy their way out of the system." The drug deal was, in fact, their original sin. And so the laconic Wyatt, staring into a campfire toward the end of *Easy Rider*, comes to understand his naiveté. He utters the movie's most famous line, a gnomic pronouncement that would become an object of exegetical dissection: "We blew it." It was an epitaph for the dreams of the 1960s.

Then, out of nowhere, Billy and Wyatt are gunned down in a choreographed burst of brutality that had disquieting echoes on the nightly news. Billy's roadside death tableau evoked memories of Robert Kennedy on the kitchen floor of the Ambassador Hotel; the final helicopter shot of Captain America's bike on fire looked like bombing footage from Vietnam.

Dennis had promised to "bury" Old Hollywood, and it looked as though he might well have succeeded—at least for a moment. At the Cannes Film Festival in May 1969, the film won him a First Film Award as director. Fittingly enough, given Dennis's connections to the art world, *Easy Rider* was previewed in America at the Museum of Modern Art in New York. The movie was released on July 14, a little more than a week after Dennis's friend Brian Jones was found dead in a swimming pool. It was a box-office juggernaut, making more than $19 million during its initial run, off a budget somewhere under $500,000, as it proceeded to rake in an eventual worldwide gross of $60 million—a new kind of Hollywood math.

Easy Rider would forever be part of the summer of 1969, situated in memory alongside the Apollo moon landing, the Beatles crossing Abbey Road, the Stonewall riots, Woodstock, and the Manson murders. (The night Sharon Tate was killed, Dennis was at the

Daisy, reveling in the success of his movie.) It became the cinematic symbol of an era and gave the New Hollywood its momentum going into the 1970s, the decade of Martin Scorsese, Francis Ford Coppola, Steven Spielberg, Robert Altman. Hollywood now realized that profits could be extracted from the youth market—the potential audience that Dennis had rubbed shoulders with at Ciro's and the Human Be-In. The counterculture had viewed Hollywood as straight, irrelevant; but thanks to Dennis and Peter, its members were interested in movies again.

The film sparked a national conversation; it both excited and riled the critics. "I want to believe that 'Easy Rider' is a travel poster for the new America," Richard Goldstein wrote in the *New York Times*. In *The New Yorker*, Pauline Kael said that "the movie conveys the mood of the drug culture with such skill." She found *Easy Rider* to be "an expression and a confirmation of how this audience feels." In the *New York Review of Books*, Ellen Willis celebrated Dennis's Billy as "the only realistic portrayal of a head I've seen on film." She found much to ruminate upon when it came to the film's critique of contemporary America, which had been dismissed elsewhere as arrogant. Such was the take of Paul Schrader, the director and screenwriter who was then a brash twenty-three-year-old critic at the *Los Angeles Free Press*. To him, *Easy Rider* was a "gutless piece of Hollywood marshmallow liberalism." Peter Coyote was enraged by the film, finding it "an inaccurate, smug, and insulting reflection of the life my friends and I were creating out of hard labor." Ever the Digger, Coyote saw *Easy Rider* as "the status quo in hip drag."

At the center of it all, Dennis was now more than just a Hollywood star; he was a counterculture hero, a pop-culture deity, an avatar, the cinema's own Jimi Hendrix or John Lennon. His example meant that movie directors could compete with rock stars as creative role models for the younger crowd. *Easy Rider* signaled that there had been a changing of the Hollywood guard. "Now the children of Dylan were in control," Buck Henry said.

BROOKE, WHOSE DIVORCE FROM DENNIS was granted in April 1969, had started dating Buck Henry. They would remain together for four years, working on a short cult film called "I Miss Sonia Henie" and becoming social fixtures in Los Angeles. Compared to Dennis's unstoppable electricity, Buck, then working on *Catch-22*, was droll and dry with a sharp mind attuned to irony and given to skeptical distance. He viewed the druggy, radical chic goings-on of Hollywood as "immense b.s."

On March 18, 1971, Leland Hayward, who had recently suffered a stroke, died at the age of sixty-eight. Predictably enough, battles raged between Pamela and Leland's surviving offspring over one thing or another. A couple of pearl necklaces that Brooke insisted she'd given Pamela for safekeeping in 1960 had vanished, leaving Brooke to suspect that Pamela had sold them off. Some of Leland's personal effects, of obvious sentimental value to his children, had also mysteriously disappeared. His estate was estimated at $400,000. Pamela received one half; Brooke and Bill split the other. Six months after Leland's death, Pamela married the former New York governor and Democratic party elder Averell Harriman; she eventually became the United States ambassador to France.

Brooke went to work on George McGovern's presidential campaign. In terms of activism, that was more her style than marching in the streets. She threw McGovern parties and designed McGovern T-shirts, which Marin wore to tennis sessions at her school, Westlake. "I got practically bashed in my skull," she said. "I was the only Democrat in the entire school. One girl bit me." Brooke, with her friend Jean Stein vanden Heuvel, organized an art-world McGovern fundraiser at the Pace Gallery in New York and got Andy Warhol to create his famous *Vote McGovern* lithograph, which showed Richard Nixon looking like a toxic green alien. The following year, the artist did a silk-screen portrait of Brooke, which, per Warholian custom, the sitter had commissioned. It placed Brooke in a rainbow-hued pantheon that grew to include the likes of Mick

Jagger, Debbie Harry, Pia Zadora, and her ex-husband Dennis Hopper. The portrait captured Brooke at thirty-five going on thirty-six, the moment she began to question what she'd been doing with her life: "What have I done to test my courage? What have I done that is definitive?"

In early 1973, Brooke, out of a sense of civic curiosity, attended the Daniel Ellsberg Pentagon Papers trial in Los Angeles. There she met the *New York Times* reporter Martin Arnold. At a dinner one night, Arnold probed Brooke about her childhood. As Brooke filled him in, Arnold said, "You should write that!" Brooke demurred, but Arnold kept at it. "Do me a favor," he said. "I want you to sit down and write three pages about what you told me and then hand them over so I can tell you whether to continue." Brooke typed out the requested pages and gave them to Arnold, who insisted that she begin writing a book. "If you ever write again—and you will—write about something you know" had been Maggie Sullavan's admonishment when Brooke had wanted to publish a novel at age twelve. Now Brooke did just that.

As she worked, she showed pages to her old friend Josie Mankiewicz Davis, a writer at *Time* whose novel *Life Signs* was due out that year. She and her husband, Peter Davis, had moved out to California from New York as Peter worked on his Oscar-winning Vietnam War documentary, *Hearts and Minds*. Josie provided exhortation and editing as Brooke put herself through the agonizing process of excavating a past as troubled as it was gilded—the adoration and sense of betrayal she felt for her larger-than-life parents, the sorrow for the loss of her mother and sister, the distress of her brother being committed to institutions. The book would not be the typical Hollywood blather but a gutsy, bracing memoir told in a singular voice, covering her earliest childhood until her sister Bridget's death and stopping short of her meeting Dennis in 1961. Brooke said she wanted to show the cost of the familial carelessness, "the human wreckage it can cause."

Brooke forked sixty manuscript pages over to Knopf. The publisher paid a $5,000 advance. "I wrote in a bedroom crowded with ghosts," she later said—the bedroom at 1712. "My mother would disapprove, and my father would be horrified. The moral of my book is that you pay for everything. They were rich, accomplished, famous and beautiful. We were drowned in privilege, yet it ended in all this hideous tragedy." As Buck Henry remembered, "More than once I saw her typing and crying at the same time." At times Brooke appeared to sink into a dangerous depression as she confronted feelings she could never express when Maggie, Leland, and Bridget had been alive.

"To my sorrow," Brooke said, "Josie and Peter moved back to New York City and then she was killed by a taxi." The accident occurred in July 1974 in front of the couple's West Village apartment building. Josie was thirty-six, with two children. Buck told Brooke that for Josie's sake, she had to keep writing. She interviewed about thirty family friends, including the Fondas, the Mankiewiczes, Jimmy Stewart, and Truman Capote. It took about three years before she had a finished manuscript ready for Robert Gottlieb, the editor in chief at Knopf.

Haywire became a number one best seller when it was published in early 1977. It received praise from Joan Didion and achieved Book of the Month Club status. Mike Nichols declared it Fitzgeraldian. Excerpts ran in *Esquire* and *Vogue*. Brooke was featured in magazines and newspapers, was a guest on *The Tonight Show*. As *People* magazine put it, "a two-coast dilettante with a well-known name but no distinctive persona, has become Brooke Hayward, bestselling author." Andy Warhol ran into Brooke around that time at a party for Mikhail Baryshnikov. As he noted in his diary, "Brooke Hayward was there and threw her arms around me and said, 'I'm so successful, I don't know what to do.' I think she's nutty."

Reading *Haywire*, you have the impression of wounds that might never close, scars that might never heal, but an imperative to go on.

Her closest friends knew well where Brooke was coming from. Jill Schary, herself the author of a harrowing memoir, *Bed/Time/Story*, found *Haywire* wonderful and sad, and Jane Fonda made a point in interviews of saying that she had never been comfortable growing up in the problematically privileged world whose sharp edges Brooke had exposed in *Haywire*.

Over the years, Marjorie Hopper had become obsessed with Brooke's family. She hated *Haywire*. To her, the book was an act of treachery toward Brooke's parents. She couldn't fathom how anyone could do such a thing, especially not to the great Margaret Sullavan—a criticism Dennis's mother shared with the Sullavan-besotted critic Andrew Sarris, who trashed the book in *Harper's*. "Everybody makes mistakes," Marjorie said in what was perhaps an expression of her own insecurities as a parent.

Given the success of *Haywire*, the possibility of a sequel was floated at Knopf; the idea was for Brooke to tell the story of her years with Dennis at 1712. A contract was issued. "Dennis refused to be interviewed," Brooke said, "and he threatened to sue me if I wrote it." She decided to respect Dennis's wishes and get on with her life. She sold 1712 North Crescent Heights to the director Walter Hill, uprooted herself from Los Angeles, and moved back to New York.

THE TRIUMPH OF *EASY RIDER* meant that Dennis finally had money and Hollywood mojo. For whatever reason, it also turned him into a former photographer. With a few exceptions (including an ill-advised *Hustler* shoot in the 1980s), he rarely picked up a camera again for the rest of his life.

In 1970, he relocated to Taos, New Mexico, buying the sprawling adobe estate that had formerly belonged to the early-twentieth-century art patron and *saloniste* Mabel Dodge Luhan; he envisioned reconstituting the bohemian glory of an earlier era in a rugged

outback town that, with its sacred mountain and Native American pueblo, was imbued with cosmic feeling. (The Ferus Gallery artists Larry Bell and Kenneth Price also moved to Taos.) D. H. Lawrence had painted the bathroom windows at the house, which Dennis rechristened the Mud Palace. Like 1712, it became a way station for artists, musicians, writers, filmmakers, and the era's robust supply of freaks. Dennis's *Bomb Drop* found a home in the dining room, where Dennis might host Ed Ruscha, Allen Ginsberg, or Kris Kristofferson.

But the seventies weren't kind to Dennis. Instead of becoming a creative utopia, the Taos scene devolved into drugs, alcohol, guns, orgies, and general mayhem. Amid the chaos, he finally made *The Last Movie*, directing and starring in the picture he'd been so desperate to make since 1965. It was a colossal, self-destructive flop, as he veered from Stewart Stern's punchy script and made an altogether fascinating movie that was nonlinear, metafictional, and, for most viewers, unwatchable—the perfect example of auteurship gone wrong. For that act of moviemaking hubris, he was effectively exiled from the industry all over again barely two years after *Easy Rider* had made him Hollywood's outlaw hero. "I had final cut," he said of *The Last Movie*, "and cut my own throat." He blew it.

After Brooke, there was a series of girlfriends, including Michelle Phillips of the Mamas and the Papas. In 1970, on Halloween, they were married in the solarium at the Mud Palace; their union generated no end of lurid gossip about Dennis's alleged "unnatural" sexual proclivities and acts of violence. The marriage lasted all of eight days. "The first seven days were pretty good," Dennis reportedly said. In 1972, he married the actress Daria Halprin, who had starred in Michelangelo Antonioni's *Zabriskie Point*. They had a daughter, Ruthanna, and divorced in 1976.

From time to time, Marin was sent to Taos to visit her father, who was now given to wearing Stetson hats, denim, and turquoise this and that—the sartorial leanings of, as Marin remembered it, "a

deeply cool American maharaja." The Taos scene fascinated Marin but also frightened her. On one occasion, she found a pistol lying around. "When I told my dad I was scared of guns," she recalled, "he told me, 'Not to worry. I just used the gun to shoot my Andy Warhol "Mao" painting.'" On another occasion the situation at the Mud Palace was deemed too dangerous and Marin had to be smuggled out. She was hidden at Larry Bell's place until she could be taken to Brooke. On yet another occasion, Dennis allegedly fired a gun over her head. "He was pretty crazy at that time and difficult to be around," Bell remembered. "All those crazy friends and the guns."

Dennis was now the ill-fated legend who had made *Easy Rider*, a legacy that had turned torturous. The issue of who had done what and deserved the credit for it was never resolved, creating endless acrimony. The cacophony in New Orleans had not only driven Terry Southern insane, it had driven him to abandon the production duties that had been assigned to him. And so Peter took the compensation he had set aside for Southern—and split it between his production company, Pando, and Bill Hayward. The move left him in a better financial position than Dennis, thereby damaging their already compromised friendship beyond repair. It was enough to trigger in Dennis a lifelong feeling of having been ripped off, that his contributions to *Easy Rider* were being chiseled away, dismissed, forgotten.

For Dennis, it became a battle for recognition and credit. He convinced himself that he alone had written the screenplay for *Easy Rider*. "If Den Hopper improvises a dozen lines and six of them survive the cutting-room floor, he'll put in for screenplay credit," the angry Southern said. "It would be almost impossible to exaggerate his contribution to the film—but, by George, he manages to do it every time." Southern claimed to have given Dennis and Peter co-writing credit merely as a favor. Dennis shot back, "He didn't write anything." After the movie came out, Southern, finding himself "in

the face of monstro financial reverses," wrote to Dennis requesting a sliver of *Easy Rider*'s proceeds. "Could you please put a single point of its action my way?" he asked. Dennis claimed never to have seen the letter. Southern's finances would be a wreck until his death in 1996. "Dennis and Peter completely screwed Terry out of the millions of dollars they made off this film," Southern's partner, Gail Gerber, insisted.

If there was such a thing as karma, Dennis had created a pretty bad version of it for himself. Discord and disturbance continued to haunt his relationships. Aside from his gloriously unhinged performance in Francis Ford Coppola's *Apocalypse Now*, in which he channeled his old photographer self, and the opportunity to direct an intense but virtually unseen Canadian film, *Out of the Blue*, Dennis receded deeper into a boozy and druggy self-exile. "It was half a gallon of rum a day, plus 28 beers on the side," he said of that period. "Then I'd do three grams of cocaine." A reckoning was due. "In my mind, I was an artist and writer," he said. "The reality was that I was just a drunk and a drug addict."

In April 1983, Dennis attempted a symbolic rebirth with a violent piece of performance art at a motor speedway in Houston. He'd decided to replicate a daredevil stunt he'd seen as a boy in Kansas, perhaps at a fair or rodeo. It was known as the Russian Suicide Chair and it involved sitting in a chair encircled with sticks of dynamite and setting them off; the explosion would supposedly create a vacuum that would protect the chair's occupant. "It's a very dangerous act," he said. "If even one stick fails to go off, it's curtains." (He had originally envisioned *Easy Rider* starting with this carnival act.) With Terry Southern, who had, surprisingly, remained friends with Dennis; the German film director Wim Wenders; and Walter Hopps, who had recently become the founding curator of the Menil Collection in Houston, among the crowd of spectators, Dennis blew himself up and survived.

But Dennis was far from reborn. When he went to Mexico to act

in an inane film called *Jungle Warriors*, he suffered what appeared to be a psychotic break. "The Third World War was actually happening," he recalled, "and I was being guided by a spaceship that was controlling my mind and so I wasn't sure whether I was to walk to the United States naked or all the way down to the tip of South America." He was airlifted out of Mexico to Los Angeles, where Rockne Tarkington, who had performed with Brooke and Dennis in *Mandingo*, hauled him into a detox center. It took a few tries and a few facilities. At one point, Dennis developed Parkinson's symptoms due to an antipsychotic drug he'd been put on. At another point, doctors informed Marin that her father might never regain his sanity. Marjorie Hopper, a widow after Jay's death in 1982, was frightened. "We didn't know about his using drugs," she said, suggesting that Dennis had provided his parents with a highly redacted version of his life.

Robby Romero, a young musician and songwriter from Taos, was with Dennis in LA the day he was finally determined to be well enough to go home. He recalled Dennis walking out of the facility in an Armani suit, leaving his denims behind, hanging in a closet, abandoned. Dennis emerged anew as a well-groomed, sober Hollywood star who now embraced conservative politics, an about-face that bewildered his friends. "When he came out of the thorazine and the straightjackets and whatever they did to him," David Hopper said, "I thought they took out his brain and put in Ronald Reagan's." In 1986, when Dennis appeared onscreen as Frank Booth in David Lynch's *Blue Velvet*, winning a National Society of Film Critics Award for his performance, the resurrection was complete.

LIVING IN NEW YORK, BROOKE described herself as "getting older and more eccentric by the minute, and used to stumbling around by myself. I have a series of splintered relationships. Why should I get married again?" But she did. On Christmas Eve 1985, she

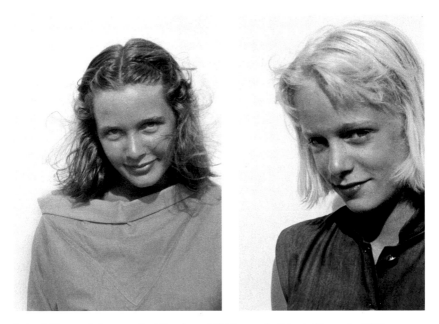

Leland Hayward photographed Brooke and Bridget on holiday in Bermuda, 1952.

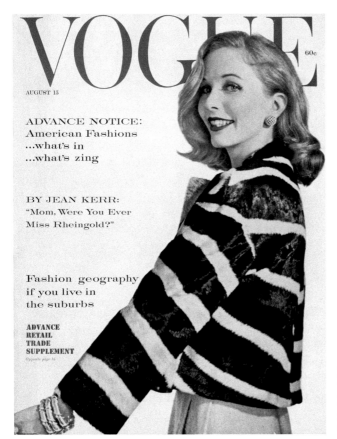

Brooke on the August 15, 1959, cover of *Vogue*, shot by Horst P. Horst.

Dennis's portrait of Ed Ruscha at Koontz Hardware, Santa Monica Boulevard, 1964.
DENNIS HOPPER/HOPPER ART TRUST

William Claxton shot the living room of 1712 for the March 1965 *Cosmopolitan*.
Standing from left: Rudi Gernreich, Peggy Moffitt, Burt Berman, Irving Blum,
Lydia Fields, Billy Al Bengston. *On the floor:* Jeffrey and Dennis.
PHOTOGRAPH BY WILLIAM CLAXTON/COURTESY DEMONT PHOTO MANAGEMENT

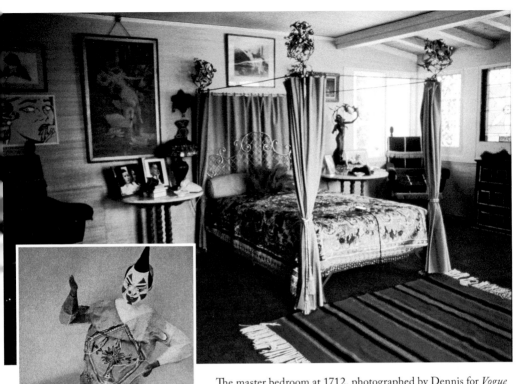

The master bedroom at 1712, photographed by Dennis for *Vogue* in 1965.

DENNIS HOPPER/HOPPER ART TRUST (COURTESY OF CONDÉ NAST)

"A harmonious nightmare of Gothic surrealism": The *cartonería* Judas that hung from the living room ceiling at 1712, shot by Dennis for *Vogue*, 1965. *Background:* Roy Lichtenstein's *Mad Scientist*.

DENNIS HOPPER/HOPPER ART TRUST (COURTESY OF CONDÉ NAST)

Claes Oldenburg at the 1966 "Underground Wedding," with plaster cake slices. Dennis took enough slices to make an entire Oldenburg cake.

DENNIS HOPPER/HOPPER ART TRUST

Irving Blum and Jasper Johns on the front porch of 1712, 1964.

"It was like a dream colony": Jane Fonda and Brooke in Malibu, most likely summer 1965.

Peter Fonda strums his Gibson twelve-string with Bobby Walker at left, circa 1965.

"Can you please turn that music down?" The Byrds at Jane Fonda's Fourth of July party in Malibu, 1965. *From left:* Chris Hillman, David Crosby, Gene Clark, Michael Clarke, and Jim (later Roger) McGuinn.

DENNIS HOPPER/HOPPER ART TRUST

Ike and Tina Turner in the foyer of 1712, part of Dennis's shoot for their *River Deep—Mountain High* album, spring 1966.

DENNIS HOPPER/HOPPER ART TRUST

"A giant musical love-in": Monterey Pop, June 1967.
From left: Brian Jones of the Rolling Stones, Nico,
Dennis, and Judy Collins.
JIM MARSHALL/ © JIM MARSHALL PHOTOGRAPHY LLC

Brian Jones at RCA in Hollywood, March 1966.
DENNIS HOPPER/HOPPER ART TRUST

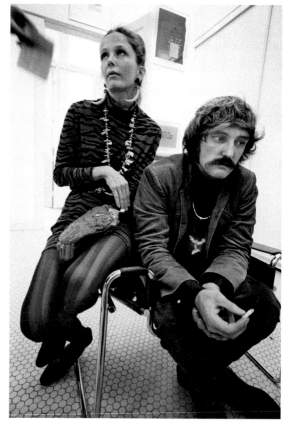

Dennis and Brooke at Rudi
Gernreich's studio, photographed
by Julian Wasser, 1967.
JULIAN WASSER

Christmas morning 1967 at 1712 North Crescent Heights: holiday calm before the storm.
HOPPER ART TRUST

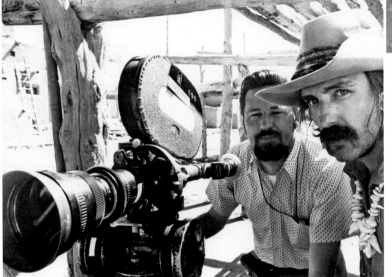

"It was like a New Testament": Dennis Hopper, American auteur, on the set of *Easy Rider* with cinematographer László Kovács, 1968.
THE EVERETT COLLECTION

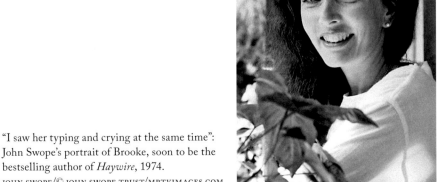

"I saw her typing and crying at the same time": John Swope's portrait of Brooke, soon to be the bestselling author of *Haywire*, 1974.
JOHN SWOPE/© JOHN SWOPE TRUST/MPTVIMAGES.COM

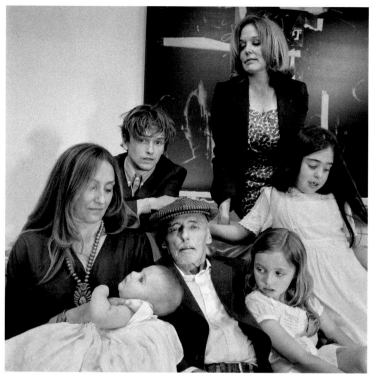

Jonathan Becker's 2010 portrait of Dennis surrounded by his family. *Clockwise from upper right:* Marin Hopper, Violet Goldstone (Marin's daughter), Galen Hopper (Dennis's daughter with Victoria Duffy), Dennis, baby Ella Brill (Ruthanna Hopper's daughter), Ruthanna Hopper (Dennis's daughter with Daria Halprin), and Henry Hopper (Dennis's son with Katherine LaNasa).

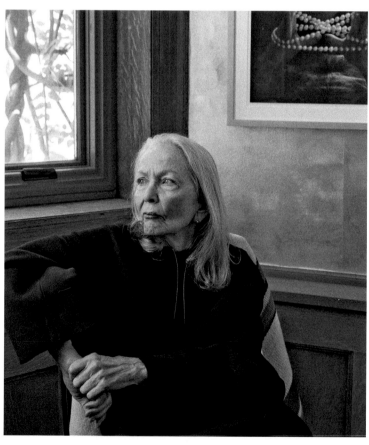

Brooke in New York City, 2015.

married Peter Duchin, the bandleader with the anvil-like chin and ballroom-sized smile who had come to dinner at 1712 twenty years earlier and worried that he was too square. Brooke sold the Campbell's tomato soup can painting and used the proceeds to buy him a Steinway.

In the 1970s, Brooke had sold most of the other pieces from 1712 for a fraction of their eventual value. In 2006, *Sinking Sun*—the Lichtenstein cartoon sunset that had dominated the living room—sold at Sotheby's for $15.7 million. "It could have a $40 million value today," Irving Blum said in 2017. In 2019, Ed Ruscha's *Hurting the Word Radio #2* was hammered down at Christie's for $52.4 million. It had come out of the same 1964 Ferus Gallery show at which Dennis and Brooke had bought *Standard Station, Amarillo, Texas*—the star of the exhibition. In 2015, one of Warhol's *Mona Lisa* paintings from 1963, the year Dennis and Brooke had met the painter and taken home the *Double Mona Lisa* that Warhol had dumped on the floor of his studio, went for $56.2 million at Christie's.

Brooke wrote pieces for *House & Garden* and *Architectural Digest* and continued to amass eccentric *objets*, including the surreal nineteenth-century French glazed ceramics known as Palissy ware, eventually donating a definitive collection to the New Orleans Museum of Art. Shuttling between a loft in Manhattan and a house built over a waterfall in rural Connecticut, she and Duchin were a conspicuous couple—"A perfect blend of Broadway, Hollywood and New York society," it was said—until their separation in 2008, with divorce following three years later.

At the 2004 wedding of Marin to the film producer John Goldstone, Brooke and Dennis were forced into brief proximity. Marin had grown up to be a fashion editor, Jeffrey was an art consultant and curator, and Willie was a landscape designer and tree doctor. The creative atmosphere of 1712 had rubbed off on all three of them. The extended family was a wheel with many spokes. Dennis had had a son, Henry, from a four-year marriage to the ballet

dancer and actress Katherine LaNasa; they divorced in 1992. Four years later, Dennis married the twenty-eight-year-old actress Victoria Duffy. The year before Marin's wedding, they had a daughter, Galen. During the nuptial celebrations, Brooke somewhat mischievously suggested to Dennis, whom she had barely spoken to since 1968, that they cowrite a book about their days together at 1712. Dennis had flirted with the idea of publishing a memoir in the mid-1980s and again in the mid-2000s, but nothing had come of those projects. "He thought it was a great idea," Brooke said, "but then he backed off."

By then, Dennis had assumed the mantle of a living legend—an elder Hollywood statesman with cropped silver hair who retained the aura of the wild man he once had been, the improbable survivor. He'd become a golf enthusiast and had even reconnected with Miss Mac at a 2004 tournament in Scotland. As Brooke was ready to admit, Dennis had finally become the man she believed she had married in 1961: he enjoyed a sustainable career as an actor, had become a successful director (*Colors* and *The Hot Spot*), had maintained his sobriety, and had amassed a blue-chip art collection inside his Frank Gehry–designed compound in Venice Beach—works by a new generation of artists that included Jean-Michel Basquiat, Gerhard Richter, Keith Haring, Julian Schnabel, David Salle, and Banksy, along with pieces by some of his and Brooke's old friends, such as Warhol and Rauschenberg. As an actor, Dennis never won an Oscar. But he managed to create something arguably more important, carving out a singular, indelible place for himself in the Hollywood pantheon. "As charm is to Cary Grant, awkwardness to Jerry Lewis, vulnerability to Montgomery Clift, so malevolence is to Dennis Hopper," the English critic Jenny Diski wrote.

Even so, he nursed regrets. Substance abuse had derailed him for years; it had triggered the violence and paranoia that had ruined his most important relationships, particularly the one with Brooke. Tallying his successes, Dennis found them "minimal in this vast

body of crap—most of the 150 films I've been in—this river of shit that I've tried to make gold out of." He understood that the revolution he had brought to Hollywood with *Easy Rider*—idiosyncratic vision, independent spirit, real American stories—had not been permanent. The New Hollywood had come and gone, an anomalous, vanished golden age of American cinema. In some quarters, *Easy Rider* was glibly dismissed as a 1960s artifact.

As Dennis got older, he began to think that his most important contibution was perhaps not *Easy Rider* or his movie roles; instead, it was the way he had managed to capture the significant events and personalities of his time—from the March on Washington to the Human Be-In, from Andy Warhol to Martin Luther King, Jr.—with his Nikon. "I wanted to document something," he reflected. "I wanted to leave something that I thought would be a record of it." His photographs of the Ferus Gallery scene, the Factory, Ike and Tina Turner, the Sunset Strip riots, art happenings, Malibu, LA streetscapes, and the daily family life at 1712 were, as he put it, "tablets of time." They weren't photojournalism; they were a chronicle of spirit and sensibility, the expression of a singular eye, the story of one life written in light and shadow—in a word, art.

For years, Dennis had kept the memories and contact sheets from the 1712 era in a virtual vault. "I was trying to forget," he wrote. "The photographs represented failure to me. A painful parting from Marin and Brooke, my art collection, the house that I lived in and the life that I had known for those eight years." Given his troubled trajectory, it is something of a miracle that the estimated eighteen thousand images he had created from the time Brooke had given him his Nikon in 1961 until he had begun filming *Easy Rider* survived. Henry T. Hopkins, the estimable curator who in 1970 mounted a show of Dennis's photographs at the Fort Worth Art Center Museum, was, for a while, the custodian of his negatives. In later years, Dennis's rarely seen photography gradually surfaced in gallery shows, museum exhibitions, magazine reprints, and a series

of monographs, championed by such curators and gallerists as Walter Hopps and Tony Shafrazi. In time, Marin emerged as the energetic steward of her father's photographic legacy.

Wim Wenders once said of Dennis that if "he'd only been a photographer, he'd be one of the great photographers of the twentieth century." As successive collections of Dennis's archived photographs became available in the twenty-first, it became easier to say that he was, at the very least, an important, almost supernaturally omnipresent chronicler of his times. Having often viewed the years at 1712 as a period of creative frustration, of not being able to get traction in Hollywood, Dennis came to understand that his photographs might outlive his films. The 1960s, it turned out, were the most creative years Dennis Hopper would ever know.

The feeling you get from Dennis's photography is not of failure at all but of the dreamlike ecstasy he found in image making—the realization, as he liked to say, "that art is everywhere." Being remembered as a serious photographer, Marin said, "was all he spoke about the year before he died."

A NIMBUS OF NOSTALGIA SURROUNDS 1960s Los Angeles as the fascination with the art and artifacts of that time—golden, complex, painful—expands with each passing year. Ed Ruscha's work, for instance, has rocketed skyward in price and renown. In 2018, Christopher Riopelle, the curator of post-1800 paintings at the National Gallery in London, positioned him as "arguably the most important American artist." Documentaries and tribute albums have been made of the Laurel Canyon scene that the Byrds pioneered in 1965. The New Hollywood, including *Easy Rider*, has been celebrated in best-selling books and deluxe-edition rereleases. Dennis's reputation as a photographer is at last flourishing, he and Brooke have been recognized as vanguard collectors, and *Haywire*, reprinted in 2011, continues to win new readers.

Toby Rafelson still drives past 1712 North Crescent Heights, looking up at the stucco facade and taking in what she calls "the eye of the storm around Brooke and Dennis." She thinks about that "brilliant, wild, disturbed culture" of the 1960s: "It's still with us, that era." Marin says, "When I drive by, it looks so little. It looked enormous when I was small." In addition to guiding the Hopper Art Trust, the repository for Dennis's photography, she founded Hopper Goods and Hayward, twin fashion enterprises that express her complex family legacy.

Ed and Danna Ruscha often visited 1712 when Walter Hill lived there. After all of Brooke and Dennis's parties, they were amazed to find it a normal, modest Spanish house—virtually unrecognizable as the larger-than-life carnival it had been when, as Danna remembered, "It had loomed as this huge place with all this art." The house later had a stint as the home of the original *Daily Show* host, Craig Kilborn. In 2017, the British interior designer Martyn Lawrence Bullard bought it.

On a crisp fall day that year, 1712 was empty, like a stage set: a few workers quietly milled around, working on the bare walls, skim coating—the usual stuff of renovation. A single framed photograph was the only thing adorning the famous living room where Warhol had *ooh*ed and *aah*ed, Marin had learned to walk, Hells Angels had crashed in sleeping bags, and Brooke and Dennis had lived, loved, collected art, raised children, fought, and, finally, unraveled. It was Dennis's photograph of Brooke on the steps in front of the house, circa 1965—young, gorgeous, full of can-do spirit, the house fresh, the day bright. Bullard had bought the print for Kilborn, having been hired by him to work on the house in the early 2000s, and there it had remained.

In late 2009, Dennis was estranged from his fifth wife and battling the prostate cancer that would take his life. He got in touch with Brooke, asking her to come visit him at his house in Venice at the earliest opportunity. There was urgency in the request. Aside

from Marin's wedding, they had rarely seen each other since the divorce. The winter holidays came and went. Brooke flew out in January 2010, three years after Marjorie Hopper's death and nearly two since Bill Hayward's suicide. She took Willie along for support, not knowing what she was in for. When the two of them reached Dennis's compound on Indiana Avenue, they were greeted by Marin and ushered upstairs.

Brooke found her former husband, now seventy-three and with only a few months left to live, in bed. He sat up the moment Brooke entered and began apologizing for everything he had put her through. "It's okay," she assured him as she drew near.

HE: Brooke, do you still love me?
SHE: Yes, Dennis, of course.
HE: You're the only woman I ever loved.

ACKNOWLEDGMENTS

In early 2017, I drove from New York City up to Connecticut to meet Brooke Hayward at her house in Litchfield County. I had been toying with the idea of writing about the cultural ferment of LA in the 1960s ever since my tenure as a book reviewer for the *Los Angeles Times* (1998–2005), and more than one person had recommended Brooke as *the* person I needed to talk to. Her 1977 best seller, *Haywire*, was as gutsy a family memoir as could be imagined, a book that set a high bar for anyone who might dare to write about her. So I was nervous to meet her, particularly as my errand consisted of attempting to convince her to allow me to tell the story of her years with Dennis Hopper at 1712 North Crescent Heights for *Vanity Fair*.

A year or two before that, Marin Hopper, Brooke's daughter with Dennis, and her husband, John Goldstone, had sent me the draft of an unpublished essay Brooke had written. It was a continuation of the *Haywire* saga, touching on her eight-year marriage with Dennis—in effect, a three-thousand-word precis of the sequel that Brooke had never written. The essay described the couple's

high-speed courtship in 1961 but tactfully faded out as the marriage got underway, as if, more than five decades later, Brooke still didn't want to revisit the times she described as "the most wonderful and awful of my life."

Marin and John went to Connecticut with me for moral support. Brooke proved to be resistant to the idea of a magazine piece. It was as if all the old stories—of the Bel Air Fire, the La Cienega art walks, the Andy Warhol party, the Malibu weekends, the Sunset Strip nights, Monterey Pop, the Checker cab, the Hells Angels camping out in the living room, and the rest—were merely long-ago stuff that nobody could possibly care about anymore. Yet the more I asked questions, the more Brooke opened up and seemingly began to see how a cultural-historical tapestry could be woven, with her and Dennis as central figures.

She agreed to the piece. I drove off to explore her charming corner of Connecticut. About an hour later, my cell phone rang. It was Brooke. She invited me back to her house, saying enigmatically that she had something to give me. I returned. Brooke materialized at the front door with a version of the essay described above, printed out. She gave it to me with a lack of ceremony that felt unmistakably ceremonial. Afterward, Marin said, "She was literally handing you her story."

I wouldn't go that far. But I did write the piece for *Vanity Fair*, and Brooke was welcoming and open during the process—not to mention mischievous, frank, funny, and occasionally contrary. I received additional input from Marin and from Brooke's son Jeffrey Thomas and her first husband, the late Michael M. Thomas, along with Jane Fonda, Ed Ruscha, Roger McGuinn, the late Michael Nesmith, Toby Rafelson, Irving Blum, and Peggy Moffitt. I managed to get into 1712 North Crescent Heights, the stage set for all of the action, thanks to Martyn Lawrence Bullard, the current owner. There was far more fascinating material than could ever fit into a magazine piece. And so: a book.

The first thanks must go to Brooke, for allowing me to visit her again and again and for patiently answering my queries, usually over BLTs and iced tea at a local tavern or in the living room of her house. As she spoke, we were transported back to West 81st Street, Stone Canyon Road, Tower Grove Drive, and North Crescent Heights Boulevard. We paged through her ex-husband's photography books, and she expanded upon their stenographic captions to spin out stories that resurrected an entire era. It is obvious that this book could not exist without the benefit of Brooke's recollections. Nor could it exist without the continuous supply of memories, insights, guidance, and generosity provided by her children, Jeffrey Thomas, William Thomas, and Marin Hopper.

Dennis Hopper's absence was acutely felt throughout the creation of this book. His brother David Hopper's insights helped bridge the gap in incalculable ways; his mother conjectured that David had been blessed with a photographic memory, and in our conversations there was evidence of such a gift. Special thanks to him for his generosity and for being the greatest guide imaginable during a memorable visit to Taos.

Stepping back to the initial *Vanity Fair* story, I must gratefully acknowledge Graydon Carter for approving my pitch and letting me run with it, along with my editor and friend Aimée Bell, who championed the piece and saw it to the finish line. By the time the story ran, Radhika Jones had become the magazine's editor in chief; I thank her for allowing me to write subsequent stories about Ed Ruscha and Andy Warhol that fed into this book. David Friend edited them with his customary aplomb and sense of adventure; for his work and friendship I'm most thankful. The invaluable contributions of *Vanity Fair* fact checkers Joseph Frischmuth, Matt Kapp, and Mike Sacks must also be noted. At *The New Yorker*, my alma mater, Susan Morrison encouraged me to write about Dennis's photography for the online edition, an essay superbly edited by Ian Crouch. *Galerie* magazine's editor in chief, Jacqueline Terrebonne,

had the wonderful idea to connect me to Larry Bell for a piece about his Taos studio, which Stephen Wallis deftly edited. Each of those stories contributed to the book I wanted to write.

The story of Brooke and Dennis could not have been told without the help of an armada of librarians and archivists, chief among them Christopher Santacroce at the Hopper Art Trust in Los Angeles, the repository of Dennis Hopper's photography, personal files, artifacts, and artwork. John Calhoun, in the Billy Rose Theatre Division of the New York Public Library, at Lincoln Center, provided guidance into the papers of Brooke Hayward, Leland Hayward, and Jack Kirkland. Tal Nadan was a gracious host for many days of encampment at the New York Public Library's Brooke Russell Astor Reading Room for Rare Books and Manuscripts, where, as the first researcher to do so, I wormed my way through the Jean Stein Papers. Lyndsi Barnes of the library's Berg Collection guided me through the Terry Southern Papers and Nile Southern kindly granted permission to quote from his father's work, including the wonderful piece that ran in *Vogue* in 1965. Geraldine Huxley and Patrick Seymour at the Andy Warhol Museum in Pittsburgh kindly granted me access to rarely seen Warhol movies, while Michelle Silva of the Conner Family Trust provided access to Bruce Conner's hypnotic art films. University of Iowa researcher Richard Dana combed Stewart Stern's archive, locating invaluable material related to *The Last Movie*. Curatorial consultant and researcher Gael Newton in Dickson, Australia, illuminated the history of the Photovision exhibition and confirmed Dennis Hopper's winning entries. Mary Kochones at Prometheus Entertainment helped me view an important archival interview with Dennis Hopper. The assistance of Edda Manriquez and Genevieve Maxwell at the Academy of Motion Picture Arts and Sciences, Margaret Herrick Library; John Zarrillo, senior archivist at the New York University Archives, Bobst Library; and Craig Schiffert and Marisa Bourgoin of the Archives of American Art at the Smithsonian Institution in Washington all

deserve sincere mention, as does that of the staffs of the Butler and Avery Libraries at Columbia, the Thomas J. Watson Library at the Metropolitan Museum of Art, the Balch Library at LACMA, and the Getty Research Institute. At the Cortez Theater, in Ranchos de Taos, New Mexico, J. Michelle Martin presided over a memorable afternoon during which David Hopper and I viewed boxes of fascinating material—letters, documents, and mementos known as the Post Office Papers—that Dennis had left behind from his residence there. Back home in New York, Griffin Dunne kindly allowed me to paw through the beautiful scrapbooks that his father, Dominick Dunne, had filled with photographs, clippings, and invitations, while Jack Baxter shared letters and telegrams related to *Mandingo*, the antebellum drama his colorful father, Billy "Silver Dollar" Baxter, had coproduced on Broadway. Jeffrey Thomas shared the evocative letters that Miss Mac wrote to her family in Scotland, which deserve to be collected into a volume of their own.

Fellow writers offered encouragement, advice, exhortation, and open ears. I must extend a profound measure of gratitude to my friend Patricia Bosworth, the crackerjack biographer of Jane Fonda and Montgomery Clift, who was fired up by the idea of this book and peppered me with regular inquiries about my progress; she succumbed to COVID-19 in April 2020, when the pandemic was ravaging New York City, and is missed by so many. It was the film historian and author Peter Biskind who gave me Brooke Hayward's phone number in 2009 after I mentioned my desire to write a book dealing with Los Angeles; he generously made his own interviews with Peter Fonda available to me. John Colapinto—writer, keyboardist, texter nonpareil—was unstinting with reassurance and wry counsel. Thanks as well are due to Michael Lindsay-Hogg, Duncan Hannah, Marie Brenner, Cullen Murphy, Alice Truax, Joe Hagan, Paul Goldberger, James Kaplan, Sheila Weller, James McMullan, Edward Sorel, Michael Hainey, Ash Carter, James Sanders, D. T. Max, David Hajdu, and Ted Widmer. The learned cohort of the

New York University Biography Seminar provided fellowship, conversation, and pasta dinners.

Myriad friends and associates, new and old, helped in myriad ways, whether they realize it or not. Tom Kundig and Gerry Beckley listened to me bang on about the 1960s art scene. Jeff Roth of the *New York Times* kindly connected me with Gerard Malanga. Erik Paparozzi offered lodging in Los Feliz. Sean Coyne, Colin O'Neill, and Tom Curwen (my former editor at the *Los Angeles Times*) shared their knowledge of working with official records. My talented documentary producer friend and coconspirator Annabelle Dunne helped me think the story through like a filmmaker. In Taos, Robby Romero and the good people of the Mabel Dodge Luhan house provided hospitality, companionship, and green chiles. Since 2009, I've had the pleasure of teaching nonfiction in Columbia University's undergraduate department of creative writing; I offer a salute to my friends in Kent Hall, particularly the redoubtable Dorla McIntosh, as well as to the inspiring students of Traditions in Nonfiction who are too numerous to name.

A special salvo to my agent and friend, David McCormick, whom I first got to know more than thirty years ago at 25 West 43rd Street, in the ghost-inhabited offices of *The New Yorker*, where our conversations ranged from John Cheever to Alex Chilton to the finer points of Pennsylvania Dutch charcuterie, a subject dear to our Keystone State hearts. David was the one who emphatically saw this story as a book that had to be written. Luckily for me, the founding editor of Ecco, Daniel Halpern, who visited 1712 North Crescent Heights as a young man, agreed with David and took the project on. At Ecco, two editors, Denise Oswald and Norma Barksdale, guided the book toward the checkered flag. Special thanks to Norma for seeing the book to publication with incisive edits, cheerful fortitude, and marvelous evocations of her literary hometown of Oxford, Mississippi.

To all those who shared their memories of Dennis and Brooke:

This book could not be if not for you. In addition to the immediate family and those thanked above they include Toni Basil, Léon Bing, Derek Boshier, Vinie Burrows, Peter Davis, Pierre Epstein, Jane Fonda, Frank Gehry, Gisela Getty, Michael Gruskoff, the late Buck Henry, Chris Hillman, Lisa Law, Gerard Malanga, Roger McGuinn, Peggy Moffitt, Patty Mucha, Andee Nathanson, the late Michael Nesmith, Amy Sherman-Palladino, Christopher Riopelle, Jill Schary Robinson, Danna Ruscha, Paul Ruscha, Lawrence Schiller, and Lael McCoy Ward. An extra helping of gratitude to those who invited me into their households and studios, sometimes repeatedly: Ed Ruscha (and studio director Mary Dean), Toby Rafelson, Irving Blum, Larry Bell, Billy Al Bengston (and his spouse Wendy Al). The transcription of several of these interviews by the skilled Joanna Parson brought timely assistance and Swiss-watch accuracy. I'd like to add a note of respectful remembrance to those who played significant roles in the drama and departed as I was writing it: Peter Fonda, Michael McClure, and Robert Walker, Jr.

Thanks to the following good souls for helping me find and use photographs, in addition to those at the Hopper Art Trust, to tell this story. For guidance and good sense: the veteran photo researcher Ann Schneider. For providing their own work: Jonathan Becker, Jay Carroll, and Julian Wasser. For providing that of others: Kristin Friedman of the John Weber family, Ivan Shaw and Tiffany Boodram at Condé Nast, Nancy Valenti at the Everett Collection, Tom Lisanti at the New York Public Library, Andrew Howick at MPTV, Jay Blakesberg at the Jim Marshall archives, and Thierry Demont at Demont Photo Management (William Claxton).

This book was written during the pandemic of 2020 in close proximity to my wife and two children in New York City and Vermont. Their forbearance and love are the reasons it exists.

NOTES

ABBREVIATIONS OF FREQUENTLY CITED SOURCES

AAA: Archives of American Art, Smithsonian Institution

AW: Andy Warhol Archives, Andy Warhol Museum, Pittsburgh

BH: Brooke Hayward

BHP: Brooke Hayward Papers, Billy Rose Theatre Division, New York Public Library for the Performing Arts

DH: Dennis Hopper

HAT: Hopper Art Trust, Los Angeles

JKP: Jack Kirkland Papers, Billy Rose Theatre Division, New York Public Library for the Performing Arts

JSP: Jean Stein Papers, Manuscripts and Archives Division, New York Public Library, Astor, Lenox and Tilden Foundations

JTC: Marion McIntyre (Miss Mac) letters, Jeffrey Thomas Collection

LAT: *Los Angeles Times*

LHP: Leland Hayward Papers, Billy Rose Theatre Division, New York Public Library for the Performing Arts

MS: Molly Saltman, "Art and Artists" Interviews, 1966–1967, Archives of American Art, Smithsonian Institution

NYT: *The New York Times*

NYU: My Semina Photography: A Conversation with Dennis Hopper, February 7, 2007, NYU TV and Media Services Videotapes; RG 38.16.01, box 76, New York University Archives (from the *Semina Culture: Wallace Berman & His Circle* exhibition, Grey Art Gallery and Study Center)

POP: Post Office Papers, J. Michelle Martin

SSP: Stewart Stern Papers, University of Iowa Libraries, Iowa City, Iowa

TNY: *The New Yorker*

The author conducted many interviews in the construction of this book. To avoid redundancy, these interviews are not cited in the following notes. All quotations and information from other sources (books, articles, oral histories, archival material, films) are.

PROLOGUE:
LOS ANGELES, NOVEMBER 6, 1961

1 "Transcontinental Blues": Dennis Hopper, *1712 North Crescent Heights: Photographs, 1962–1968* (New York: Greybull Press, 2001), unpaginated.

1 The air: "The Los Angeles Brush Area Conflagration, November 6–7, 1961" (official LAFD report), Los Angeles Fire Department Historical Archive, http://lafire.com/famous_fires/1961–1106_BelAirFire/1961–1106_LAFD-Report_BelAirFire.htm.

1 "suicide and divorce": Joan Didion, *Slouching Towards Bethlehem* (New York: Farrar, Straus & Giroux, 2008), 3.

1 "I missed": Hopper, *1712 North Crescent Heights*, unpaginated.

2 "I won't be": Jane Wilkie, "Rebel from Dodge City," *Modern Screen*, May 1957, 91.

2 That Monday morning: Henry Sutherland and Howard Hertel, "Flammable Conditions Brought Bel-Air Fire, Fanned by Bad Luck," *LAT*, March 11, 1962, M1.

2 Driven by: "The Los Angeles Brush Area Conflagration."

2 While her husband slept: Terry Southern, "The Loved House of the Dennis Hoppers," *Vogue*, August 1, 1965, 162.

3 Chinese tapestries: Hopper, *1712 North Crescent Heights*, unpaginated.

3 What ensued: "The Los Angeles Brush Area Conflagration."

3 Burning shingles: Ibid.

3 "hurricane of fire": Ibid.

3 The family's accounts: Miss Mac, for instance, said that she had driven the boys to school in a letter, dated November 6, 1961, yet her own accounts offered conflicting information about what happened that morning.

4 It was responsible: James O. Haworth, "Prescribed Fire Proves Effective at Urban Interface," *Fire Engineering*, January 1, 1987, https://www.fireengineering.com/1987/01/01/254229/prescribed-fire-proves-effective-at-urban-interface.

4 And it was responsible: Miss Mac, in a letter from late November, estimated that the house "was burned to the ground by 11 o'clock or 12."

4 nearly five hundred houses: "The Los Angeles Brush Area Conflagration."

4 "the coolest kids": Deborah Davis, *The Trip: Andy Warhol's Plastic Fantastic Cross-Country Adventure* (New York: Atria Books, 2015), 75.

5 "Prado of Pop": Brad Darrach, "The Easy Rider Runs Wild in the Andes," *Life*, June 19, 1970, 56.

5 "of such gaiety": Southern, "The Loved House of the Dennis Hoppers," 138.

5 Andy Warhol loved it: Andy Warhol and Pat Hackett, *POPism: The Warhol Sixties* (New York: Houghton Mifflin Harcourt, 2015), 52.

5 Like Gerald and Sara Murphy: Calvin Tomkins, *Living Well Is the Best Revenge* (New York: Viking, 1962), 6–7.

6 "represented failure": Hopper, *1712 North Crescent Heights*, unpaginated.

8 "Those years": Unpublished essay by BH, 2015.

1: "ANY MAN WHO DOESN'T DEVELOP A CRUSH HAS NO SOUL"

9 She still couldn't believe: Brooke Hayward, *Haywire* (New York: Vintage, 2011), 37.

9 "Your mother and father": Ibid.

9 "The kid's got": Leonard Lerner, "Won Job on Own Merits: Stardom for Daughter of Margaret Sullavan," *Boston Daily Globe*, January 10, 1960, A1.

10 "I never asked": Ibid.

10 "The girl is interesting": Walter Kerr, "'Marching Song' by Whiting Presented at Gate Theater," *New York Herald Tribune*, December 29, 1959, 10.

10 "combines in actuality": Barbara Rose, "Andy Warhol's American Women," *Vogue*, June 1974, 115.

10 "looks so soft": "La Cienega," *LAT*, March 13, 1970, D8.

10 "She had from": Scott Eyman, *Hank and Jim: The Fifty-Year Friendship of Henry Fonda and James Stewart* (New York: Simon & Schuster, 2017), 22.

10 In early 1961: Unpublished essay by BH, 2015.

10 She said it was a role: Ibid.

11 "not a Tara": Jack Kirkland, *Mandingo* script, JKP.

11 "a well disciplined": Ibid.

11 "gnarled and rheumatic": Ibid.

11 The men were trained: Unpublished essay by BH, 2015.

11 On April 17: Stuart W. Little, "Genet Disavows Interest in N.Y. Production of Play," *New York Herald Tribune*, April 18, 1961, 18.

11 "The first two weeks": Unpublished essay by BH, 2015.

12 In 1960, Hopper had tried: "Who's Where," *Variety*, April 10, 1960, 2.

12 Tone managed to cut: Unpublished essay by BH, 2015.

12 "It was really unfair": Jean Stein, interview with DH, August 16, 2007, JSP.

12 The new Hammond: Unpublished essay by BH, 2015.

13 "He terrified me": Robert Windeler, "The Eldest Daughter Remembers When Filmland's Golden Family, the Haywards, Went Haywire," *People*, May 23, 1977, https://people.com/archive/the-eldest-daughter-remembers -when-filmlands-golden-family-the-haywards-went-haywire-vol-7-no-20.

13 "Franchot, with whom": Unpublished essay by BH, 2015.

13 "Improvisation being": Ibid.

13 studied with Strasberg: Dennis often spoke of the years he had spent with Strasberg at the Actors Studio after his career in Hollywood began breaking down in the late 1950s. Brooke, in an interview, contended that Dennis had in fact had nothing to do with the Actors Studio, implying that it was part of his self-mythologizing. If so, perhaps it was a way to cast a troublesome chapter of his career in a more productive light.

14 "I was influenced": Joe Finnigan, "Actor Believes 'Rebel' Idea Costs Him Roles," *Austin Statesman*, February 10, 1960, 19.

14 "The worst thing": "Teenage Actor," *Seventeen*, January 1956, 12.

14 "a free spirit": Unpublished essay by BH, 2015.

14 "Oil and water": Judy Klemesrud, "Something Has Gone Haywire," *NYT*, March 9, 1977, 47.

14 "There wasn't": Unpublished essay by BH, 2015.

15 "I wish I could": Ibid.

15 Now "madly in love": Ibid.

15 dropped hundreds of dollars: Receipts from June 1961, LHP. Peerless was at 415 Lexington.

15 She picked out: Unpublished essay by BH, 2015.

15 "God, I wish": Kirkland, *Mandingo* script.

16 "The one thing": NYU.

16 Dennis would talk: Peter L. Winkler, *Dennis Hopper: The Wild Ride of a Hollywood Rebel* (Fort Lee: Barricade Books, 2011), 79.

16 The premiere: Stuart W. Little, "The Ordeal of Hume Cronyn," *New York Herald Tribune*, May 16, 1961, 16.

16 Opening night: Author's correspondence with Jack Baxter , May 15, 2021.

16 such luminaries: Unsigned telegram to Billy Baxter, May 27, 1961, Collection of Jack Baxter.

16 "My worst memory": Unpublished essay by BH, 2015.

17 "a crude, sensationalized": Howard Taubman, "Era of Slavery: Kirkland's 'Mandingo' Stars Franchot Tone," *NYT*, May 23, 1961, 43.

17 "Ten Nights on a Stud Farm": "Critics (3–1) Don't Like Staging of 'Mandingo,'" *Newsday*, May 23, 1961, 5C.

17 "Why most of": Letter from Langston Hughes to Billy Baxter, undated, Collection of Jack Baxter.

17 "repellent and ridiculous": George Oppenheimer, "On Stage: Last but Not Least," *Newsday*, April 31, 1961, 11C.

17 "exciting performance": John Chapman, "Tone Is Splendid in 'Mandingo,' a Rough and Absorbing Melodrama," *New York Daily News*, May 23, 1961, n.p.

17 Robert De Niro: John Parker, *Robert De Niro: Portrait of a Legend* (London: John Blake, 2010), unpaginated.

17 At the Actors Studio: Unpublished essay by BH, 2015.

18 "misbegotten and ill-conceived": Unpublished essay by BH.

18 closed five days: According to Jack Baxter, the premature close of *Mandingo* left his father, coproducer Billy "Silver Dollar" Baxter, bankrupt.

18 9D: Receipt for gift order, August 9, 1961, LHP.

18 1930 building: Christopher Gray, "Streetscapes/The North Side of West 81st Street," *NYT*, February 13, 2000, 9.

18 "shot and donated": Hayward, *Haywire*, 66.

18 The building's lobby: Ibid., 11.

19 In 1959, Dennis: Letter from DH to David Hopper, May 27, 1959, HAT.

19 "with huge canvases": Unpublished essay by BH, 2015.

19 "By my family's": Ibid.

19 "Dennis and I were": Ibid.

2: "THIS IS THE REASON WE'RE ALL CRAZY"

21 "I followed": Dennis Hopper and Michael McClure, *Out of the Sixties* (Santa Fe: Twelvetrees Press, 1986), unpaginated.

21 "Dennis, of course": Jean Stein, interview with Marjorie Hopper, April 10, 1988, JSP.

21 Marjorie had: Ibid.

22 1936 Summer Olympic Games: Jean Stein, interview with DH, March 23, 2010, JSP.

22 Busley Brothers IGA: Listed as place of employment on Jay Hopper's 1940 draft registration card. The photo in question shows Jay looking like a teenager or young adult, and the apron is embroidered with the business name.

22 Jay's father had: United States Census, 1920, 1930, and 1940.

22 August 21, 1935: Legacy.com. https://www.legacy.com/us/obituaries/sandie gouniontribune/name/marjorie-hopper-obituary?pid=86124918.

22 St. Anthony's Hospital: DH baby book, HAT.

22 Jay liked to tease: Jean Stein, interview with Marjorie Hopper, April 10, 1988, JSP.

22 "We all grew up": Ibid.

23 "round as a ball": DH baby book, HAT.

23 "It been I": Ibid.

23 "How do!": Jean Stein, interview with Marjorie Hopper, April 10, 1988, JSP.

23 photograph taken during the Civil War: Family portrait, undated, HAT.

23 By three years of age: DH baby book, HAT.

23 Around that time: Ronald Tanner, "60 Years with IGA; a Saga of American Independence," *Progressive Grocer*, June 1, 1986, https://www.thefree library.com/60+years+with+IGA%3b+a+saga+of+American+independence .-a04264094.

23 505 1/12 10th Avenue: DH baby book, HAT.

23 On September 9, 1941: DH baby book, HAT.

23 "every child's book": Jean Stein, interview with Marjorie Hopper, April 10, 1988, JSP.

23 "I don't care": *The American Dreamer*, directed by L. M. Kit Carson and Lawrence Schiller (Los Angeles: Corda Productions, 1971), posted by sgolowka, YouTube, November 17, 2016, https://www.youtube.com/watch ?v=x8hpYYhLJyc.

23 he would occasionally confess: Lawrence Linderman, "*Gallery* Interview: Dennis Hopper," *Gallery*, December 1972, reprinted in *Dennis Hopper: Interviews*, ed. Nick Dawson (Jackson: University Press of Mississippi, 2012), 87.

24 His first artwork: HAT.

24 At the age of three: Jean Stein, interview with Marjorie Hopper, April 10, 1988, JSP.

24 Now he found: Photograph of Ms. Anders's class, ca. 1941–42, HAT; Jean Stein, interview with Marjorie Hopper, April 10, 1988, JSP.

25 first "white man": "Yellowstone Park. An Interview With a Man Who Visited That Region of Wonders as Far Back as 1863." *Courier-Journal* (Louisville), April 13, 1884, 12; David Hopper interview, December 9, 2019.

25 Lonnie and Nellie Davis: Unidentified newspaper clip, undated, HAT.

25 "The land is flat": Truman Capote, *In Cold Blood* (New York: Modern Library, 2007), 3.

26 He was an unabashed: Jean Stein, interview with Marjorie Hopper, April 10, 1988, JSP.

26 "an infinite capacity": David Hopper, "Eulogy to W. Lonnie Davis," 1967, HAT.

26 "My grandfather and grandmother": DH and McClure, *Out of the Sixties*, unpaginated.

26 wedged between: David Hopper interview, April 10, 2020.

26 "Most of the time": James Stevenson, "Our Local Correspondents: Afternoons with Hopper," *TNY*, November 13, 1971, 116.

26 "Clodhopper": Jane Wilkie, "Rebel from Dodge City," *Modern Screen*, May 1957, 91.

26 If it was: Hopper, *Dennis Hopper: Photographs, 1961–1967*, ed. Tony Shafrazi (Köln: Taschen, 2018), 418.

27 "We did that": Jean Stein, interview with DH, April 12, 1987, JSP.

27 "In Kansas": Ibid.

27 The bright light: Peter L. Winkler, *Dennis Hopper: The Wild Ride of a Hollywood Rebel* (Fort Lee, NJ: Barricade Books, 2011), 4.

27 "I saw a war movie": Jean Stein, interview with DH, April 12, 1987, JSP.

27 "Furry little balls, die!": Ibid.

27 "The world on the screen": Winkler, *Dennis Hopper*, 4.

27 "The Pilgrim, Chapter 33": Thomas Elsaesser, Alexander Horwath, and Noel King, *The Last Great American Picture Show: New Hollywood Cinema in the 1970s* (Netherlands: Amsterdam University Press, 2004), 96. Kristofferson was known to dedicate this song to Dennis in concert.

28 "I ODed": Alex Simon, "Dennis Hopper Is Riding Easy," *Venice Magazine*, Spring 2009, reprinted in *Dennis Hopper: Interviews*, ed. Nick Dawson (Jackson: University Press of Mississippi, 2012), 196.

28 When asked: Jean Stein, interview with Marjorie Hopper, April 10, 1988, JSP.

28 On January 20, 1944: Electronic Army Serial Number Merged File, ca. 1938–46 (Enlistment Records), https://aad.archives.gov/aad/record-detail .jsp?dt=893&mtch=1&cat=all&tf=F&q=37731461&bc=&rpp=10&pg=1& rid=6897138; a photograph of Jay Hopper in the Hopper Art Trust shows him wearing the sleeve badge of the Seventh Service Command.

28 "Dennis was very sad!": Hopper family portrait, 1944, HAT.

29 "We should just": Jean Stein, interview with DH, April 12, 1987, JSP.

29 "Now wouldn't that make": Winkler, *Dennis Hopper*, 5.

29 "He knew all the time": Jean Stein, interview with Marjorie Hopper, April 10, 1988, JSP.

29 "Daddy's dead": Ibid.

29 "As far as him": Ibid.

29 "Mother said": Letter from Jay Hopper to DH, November 24, 1945, HAT.

29 With his flair: Ginny Dougary, "Dennis Hopper," *Times* (London), March 12, 2004, https://www.thetimes.co.uk/article/dennis-hopper-xnzzg09z vdj.

30 In fact, Jay's unit: Jean Stein, interview with Marjorie Hopper, April 10, 1988, JSP.

30 "She was quite wild": Jean Stein, interview with DH, April 12, 1987, JSP.

31 "entertained rather well": Ibid.

31 "Booze, drinks": Ibid.

31 A couple of years: Photograph of Hoppers in 1947 at Kansas City house, HAT. This photograph, showing the four Hoppers, contradicts Dennis's

memory that they lived in a "beat-up house in the tenement district," as he told the journalist Jane Wilkie in 1957.

31 Jay had taken: Jean Stein, interview with DH, April 23, 2010, JSP.

31 "I learned to do": Peter M. Brant and Tony Shafrazi, "Dennis Hopper Complete Interview," *Interview*, July 15, 2010, https://www.interview magazine.com/film/dennis-hopper-complete-interview.

31 "You're not gonna": Dougary, "Dennis Hopper."

32 Dennis bade farewell: Letter from Donna Dover to DH, ca. 1987, HAT.

32 Marjorie volunteered: Marjorie Hopper obituary, *San Diego Union Tribune*, January 23, 2007, https://www.legacy.com/us/obituaries/sandieg ouniontribune/name/marjorie-hopper-obituary?pid=86124918.

32 "I didn't know what": Winkler, *Dennis Hopper*, 6.

33 Young David became infatuated: Jean Stein, interview with Marjorie Hopper, April 10, 1988, JSP.

33 "I don't want": Ibid.

33 vocal and drama coach: Don Savage, *Carpenter: A Personal Look at Professional Wrestling* (Bloomington, IN: iUniverse, 2012), 64.

33 Dennis had shown: Jean Stein, interview with Marjorie Hopper, April 10, 1988, JSP.

33 "An' I ain't kickin'": Edward A. Guest, "Castor Oil," in *When Day Is Done* (Chicago: Reilly & Lee, 1921), 55.

33 "The rest of the time": Jean Stein, interview with Marjorie Hopper, April 10, 1988, JSP.

34 The following year: Ibid.

34 "If you can fill": Rudyard Kipling, "If," Poetry Foundation, www.poetry foundation.org/poems/46473/if.

34 "I was a very sensitive": Don Alpert, "Way of Communicating: Hopper's Career a Search for Love," *LAT*, November 15, 1959, F3.

34 "My parents were": Hopper, *Dennis Hopper: Photographs*, 418.

35 "What kind of kid": Jean Stein, interview with Marjorie Hopper, April 10, 1988, JSP.

35 "We neither one": Ibid.

35 "That was one": Jean Stein, interview with DH, March 23, 2010, JSP.

35 He remembered Marjorie: Richard Stayton, "Waiting for Dennis," *LAT*, May 14, 1995, SM18.

35 "He was really": Dougary, "Dennis Hopper."

36 "They were always screaming": Brad Darrach, "The Easy Rider Runs Wild in the Andes," *Life*, June 19, 1970, 57.

36 "when you couldn't": *The American Dreamer*.

36 "My mother had": Stayton, "Waiting for Dennis."

36 I really wanted": Jean Stein, interview with DH, April 12, 1987, JSP.

37 He claimed: Ron Rosenbaum, "Riding High: Dennis Hopper Bikes Back," *Vanity Fair*, April 1987, 82.

37 "He had a wild soul": Gene Fowler, *Good Night, Sweet Prince: The Life and Times of John Barrymore* (Philadelphia: Blakiston, 1944), 171.

37 "a great artist cannot": Ibid., 340.

37 blowing off French class: Jean Stein, interview with Marjorie Hopper, April 10, 1988, JSP.

37 by eighth grade: Michael Granberry, "Hopper's Hometown Saw a Bright Future for Him," *LAT*, April 26, 1988, Metro 1.

37 His sophomore yearbook: Helix High School yearbook, 1952, HAT.

37 In the fall: Ibid.

38 En route to UCLA: Ibid.

38 "Practically over": Jean Stein, interview with Marjorie Hopper, April 10, 1988, JSP.

38 "driving a prop truck": Kim Bockus, "Double Standards: An Interview with Dennis Hopper," *ArtUS*, March–April 2007, 18.

38 Sixteen-year-old Susan Kohner: Robert Vose (photographer), "Summer Star Dust," *Look*, July 27, 1954, 77.

38 Dennis made $25 a week: Marjorie Hopper interview, April 10, 1988, JSP. Hopper tended to claim that his salary was $25 a week, but his mother told Stein that it was $35.

39 In July, the photographer: Record LC-L9–53–1419-U, no. 32 [P&P] LOOK—Job 53–1419-U, Library of Congress, https://www.loc.gov/item/2021681275.

39 The photos eventually: Vose, "Summer Star Dust."

39 The La Jolla Playhouse: Brant and Shafrazi, "Dennis Hopper Complete Interview."

39 That summer was: Edwin Schallert, "Hollywood in Review: Beach Theaters Have Good Year; 'Gandhi' Praised," *LAT*, September 13, 1953, D4.

39 "There were all these": Winkler, *Dennis Hopper*, 11.

39 Some of the relationships: In some accounts, Dennis had known Milam before working at La Jolla and it was Milam who got him the apprentice job, as Dennis said in a 2007 interview with Kim Bockus for *ArtUS*.

39 One morning at La Jolla: Wilkie, "Rebel from Dodge City."

39 "I was antisocial": Winkler, *Dennis Hopper*, 15.

39 He starred: Marjorie Hopper interview, April 10, 1988, JSP.

40 "You could tell": Granberry, "Hopper's Hometown Saw a Bright Future for Him."

40 In spite of Dennis's: Winkler, *Dennis Hopper*, 15.

40 After graduation: Ibid., 9.

40 "He was one of": Ibid.

40 6212 La Mirada Avenue: Letter from DH to Marjorie and Jay Hopper, 1954, HAT.

40 His father handed him $200: Winkler, *Dennis Hopper*, 19.

41 After Dennis arrived: Jean Stein, interview with DH, August 16, 2007, JSP.

41 Dennis wrote home: Undated letter from DH to family, HAT.

41 Dennis told his family: Ibid.

41 during an audition: Jean Stein, interview with DH, August 16, 2007, JSP.

41 Dennis claimed: Linderman, "*Gallery* Interview: Dennis Hopper," 71. This number tended to vary in Hopper's memory; sometimes it was seven.

41 On January 5: "Wins Col Thespact by Work in Storm," *Variety*, January 1, 1955, 1.

41 Raison had: Jean Stein, interview with DH, August 16, 2007, JSP.

42 "Go fuck yourself": Tom Burke, "Will 'Easy' Do It for Dennis Hopper?," *NYT*, July 20, 1969, D11.

42 Raison then took: Jean Stein, interview with DH, August 16, 2007, JSP.

42 Ten days after: Hedda Hopper, "Berle Still on Top, Columnist Reveals," *LAT*, January 13, 1955, B8. Dennis always claimed that January 7, 1955, was the day he had gone under contract with Warner Bros.

3: "THE MOST BEAUTIFUL, THE MOST BRILLIANT, THE MOST CREATIVE"

43 On July 7, 1937: Hayward, *Haywire* (New York: Vintage, 2011), 86.

43 Cedars of Lebanon Hospital: "Margaret Sullavan Has Child," *NYT*, July 6, 1937, 23.

43 "Two days old": John Swope, *Camera over Hollywood: Photographs by John Swope* (New York: Random House, 1939), unpaginated.

43 "thin, with graying hair": Margaret Case Harriman, "Profiles: Hollywood Agent," *TNY*, July 11, 1936, 20.

44 A colleague said: Sonia Berman, *The Crossing—Adano to Catonsville: Leland Hayward's Producing Career* (New York: Scarecrow Press, 1995), 221.

44 "Toscanini of the telephone": BH, interview with George Axelrod, undated, BHP. The story about Jack & Charlie's is from Harriman, "Profiles: Hollywood Agent."

44 Jack & Charlie's: Harriman, "Profiles: Hollywood Agent," 20.

44 He was known to work: Ibid.

44 the most beautiful baby: Hayward, *Haywire*, 19.

44 Her arrival was noted: "Private Lives," *Life*, July 19, 1937, 74. *Stage Door* closed on March 13, 1937.

44 Five months later: "Air Liner Commuting at Early Age," *LAT*, December 10, 1937, 20.

44 Leland was a pilot: Harriman, "Profiles: Hollywood Agent," 20.

45 her mother was: Michael D. Rinella, *Margaret Sullavan: The Life and Career of a Reluctant Star* (Jefferson, NC: McFarland, 2019), 6.

45 her father, Cornelius Sullavan, worked: United States Census, 1920.

45 In later life: A few of these banknotes, sent to Brooke's brother, Bill Hayward, reside in the BHP.

45 "deep pride about": Hayward, *Haywire*, 180.

45 The young Margaret: Rinella, *Margaret Sullavan*, 6.

45 her senior class portrait: Ibid., 7.

45 "Inwardly, I was an anarchist": Ibid.

45 She discovered: Ibid.

45 showed up for shoots: Hubbard Keavy, "Margaret Sullavan Makes Hit," *Baltimore Sun* (Associated Press), December 17, 1933, TM10.

45 "I don't want to be": John C. Moffitt, "A Movie Star Defies Hollywood," *Baltimore Sun*, August 5, 1934, MSS4.

46 "I had photographs": James Grissom, "Tennessee Williams on Margaret Sullavan: A Constant Gift," 1982, https://jamesgrissom.blogspot.com/2017/07/tennessee-williams-on-margaret-sullavan.html.

46 "that wonderful voice": Stuart Michener, "Margaret Sullavan: Celebrating the Centenary of a Spellbinder," *Town Topics* (Princeton, NJ), May 13, 2009, http://www.towntopics.com/may1309/book.php.

46 "The fairest of sights": Hayward, *Haywire*, 162.

46 "If I've ever known": BH, interview with Henry Fonda, undated, BHP. A version of this is in *Haywire*, 162.

46 "Time after time": Henry Fonda and Howard Teichmann, *Fonda: My Life* (New York: New American Library, 1981), 84.

46 "cream and sugar": Scott Eyman, *Hank and Jim: The Fifty-Year Friendship of Henry Fonda and James Stewart* (New York: Simon & Schuster, 2017), 31.

46 Maggie and Henry Fonda: Patricia Bosworth, *Jane Fonda: The Private Life of a Public Woman* (New York: Houghton Mifflin Harcourt, 2011), 35.

46 Margaret married her agent: "Margaret Sullavan, Actress, Wed to Leland Hayward at Newport," *New York Herald Tribune*, November 16, 1936, 5.

46 Maisie had gained: Jack Forester, "The Juicy, 103-Year History of New York's Famed Cartier Mansion," Bloomberg, January 2, 2019, https://www.bloomberg.com/news/articles/2019–01–02/the-juicy-103-year-history-of-new-york-s-famed-cartier-mansion.

46 Leland's mother: Hayward, *Haywire*, 95, 100; additional information from Ancestry.com.

47 "Dear Maggie—You have just": William J. Mann, *Kate: The Woman Who Was Hepburn* (New York: Henry Holt, 2007), 260.

47 Brooke believed: Hayward, *Haywire*, 69.

47 She recalled: Eyman, *Hank and Jim*, 74.

47 Around the time: Letter from Leland Hayward to William Hayward, August 9, 1940, LHP.

47 In another letter: Letter from Leland Hayward to William Hayward, March 21, 1940, LHP.

47 Words would prove: Hayward, *Haywire*, 64.

48 In 1940, *Vogue* ran: John Swope, "Margaret Sullavan and Leland Hayward," *Vogue*, May 15, 1940, 58.

48 The house was: Swope, "Margaret Sullavan and Leland Hayward."

48 "thoroughly undramatic": Ibid.

48 Maggie and Leland were determined: United States Census, 1940.

48 The butler and the cook: Hayward, *Haywire*, 89.

48 The bachelors: Ibid., 72. Brooke Hayward noted their godfather status in interviews with the author.

48 So did Maggie's ex-husband: Hayward, *Haywire*, 72.

48 Fonda loved visiting: Bosworth, *Jane Fonda*, 36.

49 In Swope's photographs: Swope, "Margaret Sullavan and Leland Hayward."

49 "God knows I hope": Letter from Leland Hayward to Mae Hayward, October 11, 1940, LHP.

49 Around the time: Hayward, *Haywire*, 72–93.

49 One day: Jill Schary Zimmer, *With a Cast of Thousands: A Hollywood Childhood* (New York: Robinson, Stein and Day, 1963), 38.

50 "We derived an enormous": Hayward, *Haywire*, 93.

50 "volatile": Swope, "Margaret Sullavan and Leland Hayward."

50 she needed to be removed: Hayward, *Haywire*, 20.

50 She had recurring nightmares: Ibid., 18.

50 "I was alone": BH, interview with Jane Fonda, undated, BHP.

50 the first long-running: Jordan Schildcrout, *In the Long Run: A Cultural History of Broadway's Hit Plays* (Abingdon-on-Thames, UK: Taylor & Francis, 2019), Google Books, unpaginated.

50 Her absence: Hayward, *Haywire*, 105.

50 He sold his agency to MCA: "Huge Merger of Agencies," *Variety*, April 10, 1945, 1.

50 To her, being an agent: Hayward, *Haywire*, 104.

51 Brooke recalled: Ibid., 78.

51 Maggie had decided: Marjory Adams, "Margaret Sullavan Sees Marriage as Great Career," *Boston Globe*, November 11, 1943, 25.

51 cared about bringing: Sally Bedell Smith, *Reflected Glory: The Life of Pamela Churchill Harriman* (New York: Simon & Schuster, 1996), 198.

51 he told Brooke: Hayward, *Haywire*, 69.

51 In October of that year: Telegram from Mae Hayward to 12928 Evanston Street, October 13, 1944, LHP.

51 On impulse, Maggie: Hayward, *Haywire*, 112–13. The probable address was 17 Old Bridge Road, off Long Meadow Hill Road; Hayward

dated the house to 1781 in *Haywire*; a 1950 *New York Times* article dated it to 1732.

51 "I don't want them": Adams, "Margaret Sullavan Sees Marriage as Great Career."

51 the Hayward kids: Hayward, *Haywire*, 280.

51 Brooke adopted a squirrel: Ibid., 122.

51 Maggie was in heaven: Ibid., 132.

52 MILFORD 1155: Telegram from Margaret Sullavan, July 24, 1945, LHP.

52 looking for any opportunity: Hayward, *Haywire*, 129.

52 The following year: Ibid., 136. In a February 16, 1945, letter, Leland Hayward told Mae Hayward that he had bought a house for $38,000, selling the Evanston Street house for about $75,000; this may be the Cherokee Lane house; LHP.

52 A few years before: Peter Fonda, *Don't Tell Dad: A Memoir* (New York: Hyperion, 1999), 8.

52 "were united": Hayward, *Haywire*, 141.

52 "I feel like a comet": BH, interview with Peter Fonda, undated, BHP.

52 cigarette butts: Hayward, *Haywire*, 142.

53 "We were the *real*": Peter Biskind, interview with Peter Fonda, March 17, 1997.

53 To him, Brooke was: BH, interview with Peter Fonda, undated, BHP.

53 "likable and dreamy": Fonda, *Don't Tell Dad*, 40.

53 would one day: BH, interview with Peter Fonda, undated, BHP.

53 "beautiful, shiny dark hair": Fonda, *Don't Tell Dad*, 40.

53 "the best qualities": BH, interview with Peter Fonda, undated, BHP.

53 Brooke, for her part: BH, interview with Jane Fonda, undated, BHP.

53 "tense and aloof": Helen Lawrenson, *Latins Are Still Lousy Lovers* (New York: Hawthorn Books, 1968), 123.

53 It was a world: Zimmer, *With a Cast of Thousands*, 102ff.

53 "Our Hollywood": Ibid., 250.

54 Jane would grow up: "Show Business: Growing Fonda of Jane," *Time*, October 3, 1977, 90.

54 Peter would feel: BH, interview with Peter Fonda, undated, BHP.

54 "It's very difficult": Judy Klemesrud, "Something Has Gone Haywire," *NYT*, March 9, 1977, 47.

54 Leland had his issues: Smith, *Reflected Glory*, 201.

54 chicken hash: Hayward, *Haywire*, 29.

54 He looked to: Smith, *Reflected Glory*, 201.

54 "There's no question": Ibid.

54 "I would be the first": Ibid., 202.

54 "He was childlike": BH, interview with George Axelrod, undated, BHP.

55 "In a sense he was": BH, interview with Truman Capote, undated, BHP.

55 "totally neurotic": Ibid.

55 a term Maggie herself: Hayward, *Haywire*, 218.

55 With Maggie gone: Rinella, *Margaret Sullavan*, 184.

55 Mainbocher-clad: Hayward, *Haywire*, 229.

55 Lauren Bacall's character: Margo Jefferson, "She Knew How to Whistle," *NYT*, July 24, 1990, 13.

55 "What the hell": Hayward, *Haywire*, 165–66.

55 In October, Maggie returned: Ibid.

56 "I'm not meant": "Margaret Sullavan Divorces a Husband Irked by Marriage," *Chicago Daily Tribune*, April 29, 1948, 2.

56 According to Slim: Slim Keith with Annette Tapert, *Slim: Memories of a Rich and Imperfect Life* (New York: Simon & Schuster, 1990), 123.

56 In April 1948: "Miss Sullavan Wins Divorce from Hayward," *LAT*, April 29, 1948, 5.

56 The following June: Keith and Tapert, *Slim*, 146.

56 The divorce split Brooke's: Hayward, *Haywire*, 159.

56 Echoing words she remembered: Ibid., 156.

56 "Divorce, it's the most awful": Cecelia M. Dobrish, "Brooke Hayward Talks About Her Children," *Parents' Magazine*, October 1977, 52–53.

56 Kenneth Wagg: Kenneth Wagg obituary, *Telegraph*, June 24, 2000, https://www.telegraph.co.uk/news/obituaries/1344643/Kenneth-Wagg.html.

56 a chairman at Horlicks: Rinella, *Margaret Sullavan*, 195.

56 The two would marry: Ibid.

57 Emily Buck: Hayward, *Haywire*, 210.

57 "It even looks": Letter from Margaret Sullavan to Leland Hayward, undated, LHP.

57 Brooke and Jane shared: Hayward, *Haywire*, 204–05.

57 In one hair-raising incident: BH, interview with Peter Fonda, undated, BHP.

57 In another: Fonda, *Don't Tell Dad*, 31–32.

57 "She was enormously": Keith and Tapert, *Slim*, 180.

58 When Brooke was in seventh grade: Hayward, *Haywire*, 206.

58 Maggie added an admonishment: Robert Windeler, "The Eldest Daughter Remembers When Filmland's Golden Family, the Haywards, Went Haywire," *People*, May 23, 1977, https://people.com/archive/the-eldest-daughter-remembers-when-filmlands-golden-family-the-haywards-went-haywire-vol-7-no-20.

58 "Mother was very strong-willed": BH, interview with Jane Fonda, undated, BHP.

58 otosclerosis: Rinella, *Margaret Sullavan*, 186.

58 Jane observed that: BH, interview with Jane Fonda, undated, BHP.

59 "policewoman": Hayward, *Haywire*, 200.

59 Brooke ate: Ibid., 225–26.

59 Then, in June 1953: "Images of Famous Stars," *Life*, June 1, 1953, cover and 96–101. The photographer was John Engstead.

59 To Brooke, it was astonishing: Hayward, *Haywire*, 220.

59 "What a wonderful girl": Letter from John Swope to Leland Hayward, May 29, 1953, LHP.

59 The *Life* cover boosted: Hayward, *Haywire*, 220–21.

59 In April 1950: Bosworth, *Jane Fonda*, 69.

59 "I'll never forget": Lawrenson, *Latins Are Still Lousy Lovers*, 124.

60 In 1953, Maggie decided: Hayward, *Haywire*, 222.

60 Bridget, relieved to escape: LHP; Hayward, *Haywire*, 31.

60 bouncing from: Ibid., 260.

60 At Madeira, Brooke cast: Ibid., 240.

60 Her tastes ran: Ibid., 225.

60 She worked at: Ibid., 240, 242.

60 The girl's inspiration: Ibid., 237.

60 In the summer of 1954: Ibid.

60 "that hulking brute": Bosworth, *Jane Fonda*, 83.

60 But Brooke did: Hayward, *Haywire*, 236–37.

61 "Brooke will be": Bosworth, *Jane Fonda*, 102.

61 Bridget would no longer attend: Hayward, *Haywire*, 264ff.

61 Bill would be sent: Ibid., 29.

61 "We'll never make": Rinella, *Margaret Sullavan*, 210.

61 She checked into Austen Riggs: Ibid., 211.

62 During the Christmas season: "112 Girls to Bow at Fete on Dec. 19," *NYT*, December 11, 1955, 35.

62 "beautiful and icy": Bosworth, *Jane Fonda*, 89.

62 "that she had broken": Ibid.

62 called her father: Telegram from Leland Hayward to BH, April 12, 1945, LHP.

62 Hedda Hopper reported: Hedda Hopper, "Dorothy Malone to Co-star with Cagney in 'Man of 1,000,'" *Chicago Daily Tribune*, September 27, 1956, C6.

63 The newlyweds took up residence: Letter from Leland Hayward to BH, September 10, 1957, LHP.

63 "the product of a relationship": Windeler, "The Eldest Daughter Remembers When Filmland's Golden Family, the Haywards, Went Haywire."

63 During their cocooning period: Bosworth, *Jane Fonda*, 89.

63 "I did study physiology": Lindsay A. Maizel, "The Life and Times of Jane Fonda," *Harvard Crimson*, May 3, 2006, https://www.thecrimson.com/article/2006/5/3/the-life-and-times-of-jane.

63 tucked into the woods: Letter from Marion McIntyre to Jeffrey Thomas, 2010, JTC.

63 Husted Lane: Leonard Lerner, "Won Job on Own Merits: Stardom for Daughter of Margaret Sullavan," *Boston Daily Globe*, January 10, 1960, A1.

63 "This family": Smith, *Reflected Glory*, 197.

63 She'd begun having affairs: Ibid., 203.

64 "I'm spinning": Ibid., 216.

64 "sounded like a mixture": Hayward, *Haywire*, 273.

64 "I am a Slimmite": Smith, *Reflected Glory*, 212.

64 "She didn't know": Ibid., 214.

64 "She was like": Ibid., 215.

64 "She behaved badly": Ibid.

65 In 1958, she'd been: Bosworth, *Jane Fonda*, 112, 120.

65 "We were both": Klemesrud, "Something Has Gone Haywire."

65 Maggie found Michael "difficult": Ibid.

65 In mid-August 1959: *Vogue*, August 15, 1959, cover and 3.

65 "two-page spread": "The Latest Sullavan Style-Setter," *Life*, October 5, 1959, 97.

66 The Ashley-Steiner Agency: Lerner, "Won Job on Own Merits."

66 On December 28: Ibid.

66 Ken had tried: Rinella, *Margaret Sullavan*, 213.

66 Bridget was then residing: Hayward, *Haywire*, 19.

66 "I'll be miserable": Ibid.

66 "Miss Hayward": Walter Kerr, "'Marching Song' by Whiting Presented at Gate Theater," *New York Herald Tribune*, December 29, 1959, 10.

66 Stepping off the train: Hayward, *Haywire*, 15–16.

67 "My mother died tonight": Ibid., 16.

67 At the Gate: Ibid., 17.

67 Carlyle Hotel: Ibid., 20

67 Maggie's death was determined: "Margaret Sullavan Buried," *NYT*, January 6, 1960, 35.

67 "Ya, ya": Hayward, *Haywire*, 22.

67 Logan, who was in Boston: Rinella, *Margaret Sullavan*, 215–16.

67 Maggie's ashes: "Margaret Sullavan Buried."

67 Before flying home: Smith, *Reflected Glory*, 221.

67 had a way with a lamb chop: Manuscript of *Haywire*, BHP.

67 "I was exceedingly lucky": Ibid.

68 "She worked hard": Letter from Marion McIntyre to Jeffrey Thomas, 2010, JTC.

68 On May 4: Hayward, *Haywire*, 44.

68 Three days later: Smith, *Reflected Glory*, 221.

68 At the wedding: Fonda, *Don't Tell Dad*, 134.

68 That summer, Bridget left: Hayward, *Haywire*, 34ff.

68 Jane visited Bridget: Ibid., 34.

69 Tom visited: Ibid., 54.

69 "The only way": Tom Mankiewicz and Robert David Crane, *My Life as a Mankiewicz* (Lexington: University Press of Kentucky, 2012), 57.

69 "It was marvelous": "Second Generation," *Time*, February 3, 1961, 52.

69 Bridget had taken: Smith, *Reflected Glory*, 225.

70 Bill Francisco found her: Hayward, *Haywire*, 55.

70 Earlier in the day: Ibid., 10ff.

70 Peter Fonda recalled: Fonda, *Don't Tell Dad*, 142.

70 The funeral was held: Hayward, *Haywire*, 58.

70 as Truman Capote said: BH, interview with Truman Capote, undated, BHP.

70 Brooke, Leland, and Bill sat: Hayward, *Haywire*, 58–59.

70 Tom Mankiewicz kept: Mankiewicz and Crane, *My Life as a Mankiewicz*, 57.

70 After refusing to come out: Fonda, *Don't Tell Dad*, 142.

70 "She was not of this earth": Keith and Tapert, *Slim*, 217.

70 "It was hard to determine": Manuscript of *Haywire*, BHP.

70 After the funeral: Hayward, *Haywire*, 59.

71 "I'm the daughter": Ibid.

4: "HE SAW THESE MIRACLES EVERYWHERE"

73 "When I went": Dennis Hopper, *Dennis Hopper: Photographs, 1961–1967*, ed. Tony Shafrazi (Köln: Taschen, 2018), 418.

74 "Who is Natalie Wood?": Jean Stein, interview with DH, June 13, 1995, JSP.

74 "I was astonished": Sam Kashner, "Dangerous Talents," *Vanity Fair*, March 2005, https://archive.vanityfair.com/article/2005/3/dangerous-talents.

74 "I love you": Card from Diane Phillips to DH, ca. 1954, HAT.

74 "Oh, no, no": Jean Stein, interview with DH, June 13, 1995, JSP.

74 "Someday you are": Ibid.

75 "I didn't think": John Wisniewski, "Dennis Hopper Needed Our Love: An Interview with Peter Winkler," *Los Angeles Review of Books*, June 6, 2013, https://lareviewofbooks.org/article/dennis-hopper-needed-our-love-an-interview-with-peter-winkler.

75 Natalie, too: Suzanne Finstad, *Natalie Wood: The Complete Biography* (New York: Crown, 2020), 179.

75 "I see an actor": DH lecture, 1990 BFI London Film Festival, HAT.

75 "I want to know": *James Dean: The First American Teenager*, directed by Ray Connolly, (Lutterworth, UK: Odeon Entertainment, 1976), excerpts posted by ladyretro, YouTube, March 22, 2015, https://www.youtube.com/watch?v=dwP-DnsVvUs, and by mcafee63, YouTube, February 11, 2015, https://www.youtube.com/watch?v=D8f4bQq—tw&t=202s.

75 "He said he wanted": *James Dean* (Connolly).

76 "Do it, don't show it": *James Dean* (Connolly).

76 "pop-eyed gasper": Tom Wolfe, "The Luther of Columbus Circle," in *The Kandy-Kolored Tangerine-Flake Streamline Baby* (New York: Noonday Press, 1966), 235.

76 "I really thought": Alex Simon, "Dennis Hopper Is Riding Easy," *Venice Magazine*, Spring 2009, reprinted in *Dennis Hopper: Interviews*, ed. Nick Dawson (Jackson: University Press of Mississippi, 2012), 201.

76 "We found we": Tom Burke, "Dennis Hopper Saves the Movies," *Esquire*, September 1970, 171.

76 "You know, we're sensitive": Jean Stein, interview with DH, October 3, 1973, JSP.

77 "It was a whole group": Ron Rosenbaum, "Riding High: Dennis Hopper Bikes Back," *Vanity Fair*, April 1987, 78.

77 headed over to Villa Capri: Finstad, *Natalie Wood*, 175.

77 Dennis openly worried: Peter L. Winkler, *Dennis Hopper: The Wild Ride of a Hollywood Rebel* (Fort Lee: Barricade Books, 2011), 35.

77 "What we used to": Finstad, *Natalie Wood*, 189.

77 "If people did drugs": Ibid., 191.

77 "Natalie says, 'O.K.": Rosenbaum, "Riding High," 78.

78 "I wasn't in *love*": Finstad, *Natalie Wood*, 170.

78 "It's one of the best": Ibid., 189.

78 She told Dennis: Ibid., 170.

78 She also shared: Ibid., 172.

78 "Those two fight": Jane Wilkie, "Rebel from Dodge City," *Modern Screen*, May 1957, 91.

78 "We can't get along": Ibid.

78 at the end of May: Winkler, *Dennis Hopper*, 36.

78 "totally destroyed": Hopper, *Dennis Hopper: Photographs*, 419.

79 "He was the most": Lawrence Linderman, "*Gallery* Interview: Dennis Hopper," *Gallery*, December 1972, reprinted in *Dennis Hopper: Interviews*, ed. Nick Dawson (Jackson: University Press of Mississippi, 2012), 71.

79 "He can talk": Natalie Wood, "You Haven't Heard the Half About Jimmy," *Photoplay*, November 1955, 84.

79 He and Dennis talked: NYU.

79 paper bags over their heads: Winkler, *Dennis Hopper*, 189.

79 After Dennis shot: Arthur Bell, "Dennis Hopper," *Viva*, March 1974, reprinted in *Dennis Hopper: Interviews*, ed. Nick Dawson (Jackson: University Press of Mississippi, 2012), 95.

79 "got halfway": Don Graham, *Giant: Elizabeth Taylor, Rock Hudson, James Dean, Edna Ferber, and the Making of a Legendary American Film* (New York: St. Martin's Press, 2018), 131.

79 "Dean came to Texas": Ibid., 162.

80 "Everything that Dean did": Ibid., 194.

80 "terrible black-face": Jean Stein, interview with DH, November 3, 1990, JSP.

80 "You're his *real* mother!": Jean Stein, interview with Marjorie Hopper, April 10, 1988, JSP.

80 Dennis and Natalie had participated: Winkler, *Dennis Hopper*, 41.

80 "It was really": Linderman, "*Gallery* Interview: Dennis Hopper," 71.

80 "The whole experience": Hopper, *Dennis Hopper: Photographs*, 419–20.

80 After Dean died: Mark Goodman, "Rebel Without a Pause," *New Times*, October 1978, reprinted in *Dennis Hopper: Interviews*, ed. Nick Dawson (Jackson: University Press of Mississippi, 2012), 106.

80 He clung to a canvas: Tony Shafrazi, "Dennis Hopper with Tony Shafrazi," *Index Magazine*, 1999, reprinted in *Dennis Hopper: Interviews*, ed. Nick Dawson (Jackson: University Press of Mississippi, 2012), 175. A photograph of Dennis with this painting can be found in Hopper, *Dennis Hopper: Photographs*.

80 Dennis was then living: John Gilmore, *Laid Bare: A Memoir of Wrecked Lives and the Hollywood Death Trap* (Los Angeles: Amok Books, 1997), 71.

81 Gilmore remembered Dennis: Gilmore, *Laid Bare*, 101.

81 "It is a violent": Bosley Crowther, "The Screen: Delinquency," *NYT*, October 27, 1955, 28.

81 "when people started": Louis Menand, "Life and Letters: Holden at Fifty," *TNY*, October 1, 2001, 82.

81 Dennis was amazed: Edwin Miller, "Dennis Hopper Makes *The Last Movie* in Peru," *Seventeen*, July 1970, reprinted in *Dennis Hopper: Interviews*, ed. Nick Dawson (Jackson: University Press of Mississippi, 2012), 24.

81 Dennis also claimed: Ray Connolly, *Being Elvis: A Lonely Life* (New York: Liveright, 2017), 92–93.

81 Natalie Wood was amazed: Finstad, *Natalie Wood*, 229.

81 it is alleged: Stanley Booth, *Red Hot and Blue: Fifty Years of Writing About Music, Memphis, and Motherf**kers* (Chicago: Chicago Review Press, 2019), 55.

82 "That just tore": Lisa Law, *Interviews with Icons: Flashing on the Sixties* (Santa Fe: Lumen, 1999), 182.

82 He gobbled: Ibid.

82 "When he isn't working": Manohla Dargis, "Madman, Perhaps; Survivor, Definitely," *NYT*, April 11, 2010, AR 1.

82 "I go on kicks": "No Margin for Error," *Photoplay*, May 1957, 16.

82 wanted Dennis to play: Pat McGilligan, ed., *Backstory 2: Interviews with Screenwriters of the 1940s and 1950s* (Berkeley: University of California Press, 1997), 292.

82 "He saw these miracles": Hopper, *Dennis Hopper: Photographs*, 61.

82 "wonderful little-boy quality": Finstad, *Natalie Wood*, 170.

82 "I crashed this party": Gwen Davis, *Naked in Babylon* (New York: Signet, 1960), 14.

82 "a great melting pot": Law, *Interviews with Icons*, 182.

82 Miles Davis, who became: Winkler, *Dennis Hopper*, 61–62.

82 "I'm really from jazz": Peter Noever, ed., *Dennis Hopper: A System of Moments* (Ostfildern-Ruit, Germany: Hatje Cantz Verlag, 2001), 31.

83 "It was fucking outrageous": Jean Stein, interview with DH, August 16, 2007, JSP.

83 "He was the one": Ibid.

83 But Hopps remembered: Walter Hopps with Deborah Treisman and Anne Doran, *The Dream Colony: A Life in Art* (New York: Bloomsbury, 2017), 59. Hopps, in his essay for *Out of the Sixties*, also recalled the meeting as having taken place at a poetry reading at Stone Brothers Printing.

83 "the obstreperous": Dennis Hopper and Michael McClure, *Out of the Sixties* (Santa Fe: Twelvetrees Press, 1986), unpaginated.

83 Working with furniture scraps: Hopps et al., *The Dream Colony*, 75.

83 "filled the void": NYU.

84 he was a gentle soul: Kristine McKenna, *Talk to Her: Interviews* (Seattle: Fantagraphics, 2004), 91.

84 10426 Crater Lane: Andrew Perchuk et al., eds., *Pacific Standard Time: Los Angeles Art, 1945–1980* (Los Angeles: Getty Research Institute and the J. Paul Getty Museum, 2011), 80.

84 Paul Bowles in Tangier: Anastasia Aukeman, *Welcome to Painterland: Bruce Conner and the Rat Bastard Protective Association* (Berkeley: University of California Press, 2016), 123.

84 "When you couldn't": NYU.

84 He saw Crater Lane: Alexandra Schwartz, *Ed Ruscha's Los Angeles* (Cambridge, MA: MIT Press, 2010), 74.

84 "It was sort of": Ibid.

84 "I stayed in": NYU.

84 "God, what an asshole": Jean Stein, interview with DH, August 16, 2007, JSP.

84 "The spirit of James Dean": Roddy McDowall, *Double Exposure: Take Two* (New York: William Morrow, 1989), 134.

84 They cemented their partnership: Robert L. Pincus, *On a Scale that Competes with the World: The Art of Edward and Nancy Reddin Kienholz* (Berkeley: University of California Press, 1990), 10.

85 Hopps's sporadic employment: Hopps et al., *The Dream Colony*, 279.

85 In June, Dennis went: Jean Stein, interview with DH, August 16, 2007, JSP.

85 A pair of cops: William Hackman, *Out of Sight: The Los Angeles Art Scene of the Sixties* (New York: Other Press, 2015), 51.

85 the Sun God and the Moon Goddess: Hopps et al., *The Dream Colony*, 77.

85 "Oh, is this what": Jean Stein, interview with DH, August 16, 2007, JSP.

85 Stockwell floated him $150: Perchuk et al., *Pacific Standard Time*, 96.

85 The artist left LA: Aukeman, *Welcome to Painterland*, 123.

85 the Cameron drawing: Jean Stein, interview with DH, August 16, 2007, JSP.

85 "There was a period": Rosenbaum, "Riding High."

85 "I saw the whole": splashfin, "Dennis Hopper—Interview Retrospective 2008 | Part 4," YouTube, February 20, 2008, https://www.youtube.com/watch?v=oUWc_xcdC6s.

85 He excitedly read: NYU. Hopper alluded to reading something he remembered as "In Search of the Sacred Mushroom" that prompted his hunt for psychedelic mushrooms in Topanga in the 1950s. No book or article was published under this title. It was likely Robert Gordon Wasson's 1957 *Life* article, although he may have been thinking of the title of a later book from 1959 called *The Sacred Mushroom: Key to the Door of Eternity*, by Andrija Puharich.

85 "Seeking the Magic Mushroom": Robert Gordon Wasson, "Seeking the Magic Mushroom," *Life*, June 10, 1957, 100ff.

85 "'holy communion'": Ibid., 101.

86 Dennis set out: NYU.

86 "This part of life": "No Margin for Error," *Photoplay*, May 1957, 16.

87 "Dennis is a genius": Lynn Barber, "American Psycho," *Observer*, January 13, 2001, 10.

87 with the vague hope: Winkler, *Dennis Hopper*, 52.

87 He began to grouse: Ibid., 54.

87 He even ambushed: Jean Stein, interview with DH, August 16, 2007, JSP.

87 "The part was the weak son": Rosenbaum, "Riding High," 130.

87 "He would lose": Harold N. Pomainville, *Henry Hathaway: The Lives of a Hollywood Director* (Lanham, MD: Rowman & Littlefield, 2016), 194.

87 "I walked off": Rosenbaum, "Riding High," 130.

88 "a fucking idiot": Winkler, *Dennis Hopper*, 55.

88 "He insisted": Brad Darrach, "The Easy Rider Runs Wild in the Andes," *Life*, June 19, 1970, 55.

88 "What the fuck": Rosenbaum, "Riding High," 131.

88 "I have enough film": Linderman, "*Gallery* Interview: Dennis Hopper," 72.

88 Dennis finally broke down: Rosenbaum, "Riding High," 131.

88 "We shot it 85 times": Darrach, "The Easy Rider Runs Wild in the Andes."

88 "He's made a villain": Reminiscences of Henry Hathaway, Oral History, 1971, Rare Books and Manuscripts Library, Butler Library, Columbia University.

88 The director was not: Pomainville, *Henry Hathaway*, 194.

88 According to Hathaway: Ibid.

89 That night, Hathaway got: Ibid.

89 "You humiliated me": Ibid.

89 "There's only one way": Ibid.

89 Hathaway then asked: Ibid.

89 The two had been: Winkler, *Dennis Hopper*, 54.

89 absorbing the Method: Again, this is a staple of the Dennis Hopper biography, but Brooke Hayward indicated that Dennis, in fact, had nothing to do with the Actors Studio. Patricia Bosworth was there around the same time as Dennis would have been and could not recall ever having encountered him.

89 auditioned unsuccessfully: Letter from DH to Marjorie and Jay Hopper, May 27, 1959, HAT.

89 an apartment John Gilmore had: Gilmore, *Laid Bare*, 123.

89 "I started out fast": Don Alpert, "Way of Communicating: Hopper's Career a Search for Love," *LAT*, November 15, 1959, F3.

90 "I was the worst": Linderman, "*Gallery* Interview: Dennis Hopper," 73.

90 "I stink": Letter from DH to Marjorie and Jay Hopper, May 27, 1959, HAT.

90 Dennis had met Harrington: Curtis Harrington, *Nice Guys Don't Work in Hollywood: The Adventures of an Aesthete in the Movie Business* (Chicago: Drag City Incorporated, 2013), 98. One of those was likely *The Wormwood Star*, featuring Cameron.

90 "totally cooperative": Ibid., 101.

90 The only hiccup: Ibid.

91 Dennis came to feel: Amy Greenfield, ed., *Curtis Harrington: Cinema on the Edge* (New York: Anthology Film Archives, 2005), 70.

91 It was eventually paired: Harrington, *Nice Guys Don't Work in Hollywood*, 103.

91 Truman Capote and Dwight Macdonald: Ibid., 1.

91 "uncommon glow": "Poe with a Megaphone," *Time*, December 6, 1963, 119.

91 Around this time: Harrington, *Nice Guys Don't Work in Hollywood*, 117.

91 "I'm a better actor": Ibid.

91 whom Dennis adored: Simon, "Dennis Hopper Is Riding Easy," 198.

91 "Dennis, get well soon": Winkler, *Dennis Hopper*, 84.

91 Harrington drove Dennis home: Harrington, *Nice Guys Don't Work in Hollywood*, 117.

5: "HURRICANE OF FIRE"

94 he shot summer saunterers: Contact sheets, HAT.

94 "people on the streets": Dennis Hopper, Petra Giloy-Hirtz, and Brooke

Hayward, *Dennis Hopper: The Lost Album: Vintage Prints aus den Sechziger Jahren* (Munich: Prestel, 2012), 19.

94 "I started being drawn": Ibid.

95 "Art is everywhere": Hopper et al., *Dennis Hopper: The Lost Album*, 19.

95 "I wondered where": Dennis Hopper and Michael McClure, *Out of the Sixties* (Santa Fe: Twelvetrees Press, 1986), unpaginated.

95 "Dennis made me read": Peter L. Winkler, *Dennis Hopper: The Wild Ride of a Hollywood Rebel* (Fort Lee, NJ: Barricade Books, 2011), 66.

95 Toward the end of June: Dorothy Kilgallen, "'Wildcat' May Not Be Dead Yet," *Washington Post*, June 19, 1961, A17.

96 In early July: Unpublished essay by BH, 2015.

96 "Dennis was living": Ibid.

96 1435 North Havenhurst Drive: Address book of Michael Lindsay-Hogg, ca. 1960–61, care of Michael Lindsay-Hogg.

96 piled up enough infractions: Dennis Hopper, *1712 North Crescent Heights: Photographs, 1962–1968* (New York: Greybull Press, 2001), unpaginated.

96 His brother had the unfortunate: John Arlidge, "Me and My Motors: Dennis Hopper," *Times* (London), January 2, 2005, https://www.thetimes.co.uk/article/me-and-my-motors-dennis-hopper-7f0sb5vbqsc.

97 Brooke's father and stepmother: Various receipts, 1961, LHP.

97 "It was really quite dramatic": Unpublished essay by BH, 2015.

97 Pamela had been going: Various receipts, 1961, LHP.

97 "a squirrel storing": Stephen Beaufort, "The Dame Drain or Where Have All the English Girls Gone?," *Town & Country*, September 1967, 143.

97 There was also: Various receipts, LHP.

97 He'd even tried: Robert Sellers, *Hollywood Hellraisers: The Wild Lives and Fast Times of Marlon Brando, Dennis Hopper, Warren Beatty, and Jack Nicholson* (New York: Skyhorse, 2010), 62.

98 "You guys can't do this": Hopper, *1712 North Crescent Heights*, unpaginated.

98 "What do American women want?": Sally Bedell Smith, *Reflected Glory: The Life of Pamela Churchill Harriman* (New York: Simon & Schuster, 1996), 208.

98 She'd been trying: Hopper, *1712 North Crescent Heights*, unpaginated.

99 Pamela treated Dennis: Unpublished essay by BH, 2015.

99 "She was a class-conscious": Smith, *Reflected Glory*, 236.

99 "She was one": Ibid., 239.

99 Dennis concluded that Pamela: Ibid.

100 "There's no reason": Hopper, *1712 North Crescent Heights*, unpaginated.

100 Reverend John Bartle Everts: Marriage certificate, Christ Church, New York, NY.

100 James Costigan: Ibid.

100 "left us outside": Hopper, *1712 North Crescent Heights*, unpaginated.

100 "The wedding bouquet": Smith, *Reflected Glory*, 236.

100 "Oh, why don't you": Hopper, *1712 North Crescent Heights*, unpaginated.

100 had seen Dennis in *Giant*: Peter Biskind, interview with Peter Fonda, March 17, 1997.

100 "I thought, this guy": Sellers, *Hollywood Hellraisers*, 62.

100 When Brooke and Dennis: Various receipts, LHP.

100 Miss Mac was there: Letter from Marion McIntyre to Jeffrey Thomas, 2010, JTC.

101 1590 Stone Canyon Road: Marion McIntyre letter, undated, JTC.

101 Built in 1948: Advertisement, *LAT*, December 5, 1948, E3.

101 The living room: Marion McIntyre letter, ca. 1961, JTC.

102 "Happy Valley": Candice Bergen, "Is Bel Air Burning?," *Esquire*, December 1967, 138.

102 "He had given us": Hopper, *1712 North Crescent Heights*, unpaginated.

102 Dennis also trucked in: Terry Gross, *All I Did Was Ask: Conversations with Writers, Actors, Musicians, and Artists* (New York: Hachette, 2004), Google Books, unpaginated.

102 Brentwood Town and Country: Brooke Hayward, *Haywire* (New York: Vintage, 2011), 64.

102 When they arrived: Marion McIntyre letter, ca. 1961, JTC.

103 "I'm a compulsive": Ginny Dougary, "Dennis Hopper," *Times* (London), March 12, 2004, https://www.thetimes.co.uk/article/dennis-hopper-xnzz g09zvdj.

103 He showed some prints: Marion McIntyre letter, undated. JTC.

103 Brooke landed a part: "Telecastings," *Variety*, October 27, 1961, 18.

103 the portly, avuncular photographer: Contact sheets, HAT.

104 "Transcontinental Blues": Hopper, *1712 North Crescent Heights*, unpaginated.

104 "blood brothers": Dennis Hopper, *Dennis Hopper: Photographs, 1961–1967*, ed. Tony Shafrazi (Köln: Taschen, 2018), 30.

104 The conflagration began: Henry Sutherland and Howard Hertel, "Flammable Conditions Brought Bel-Air Fire, Fanned by Bad Luck," *LAT*, March 11, 1962, M1.

104 Shortly after nine o'clock: "History & Traditions," John Thomas Dye School, https://www.jtdschool.org/about/history-and-traditions.

105 Half an hour later: Sutherland and Hertel, "Flammable Conditions Brought Bel-Air Fire, Fanned by Bad Luck."

105 What fire officials called: "The Los Angeles Brush Area Conflagration, November 6–7, 1961" (official LAFD report), Los Angeles Fire Department Historical Archive, http://lafire.com/famous_fires/1961–1106_Bel AirFire/1961–1106_LAFD-Report_BelAirFire.htm.

105 Miss Mac remembered: Letter from Marion McIntyre to Jeffrey Thomas, ca. 2010, JTC.

105 "We just started": Marion McIntyre letter, November 6, 1961, JTC.

105 "I saw thick smoke": Marion McIntyre letter, ca. November 1961, JTC.

105 In a flurry: Marion McIntyre letter, November 6, 1961; letter from Marion McIntyre to Jeffrey Thomas, ca. 2010, JTC.

105 At the John Thomas Dye School: "History & Traditions," John Thomas Dye School.

105 Miss Mac found: Marion McIntyre letter, November 6, 1961, JTC.

105 the Hotel Bel-Air, from which: Beverly Beyette, "After the Smoke Cleared," *LAT*, July 3, 1990, E1.

106 Brooke was now almost overcome: Marion McIntyre letter, November 6, 1961, JTC.

106 Against Miss Mac's objections: Ibid.

106 Their house was among: Miss Mac, in a letter from late November, estimated that the house "was burned to the ground by 11 o'clock or 12."

106 484 to burn: "The Los Angeles Brush Area Conflagration."

106 Burt Lancaster's house: Scott Harrison, "Shades of '61 in Bel Air Brush Fire," *LAT*, December 7, 2017, B2.

106 In Brentwood, Richard Nixon: Beyette, "After the Smoke Cleared."

106 "I have seen trouble": "LA Fire Spreads, Perils 3d Colony: Plush Homes of Movie Stars Razed," *Newsday* (AP), November 7, 1961, 1.

106 Zsa Zsa Gabor compared: Beyette, "After the Smoke Cleared."

106 Fred MacMurray brought home: Harrison, "Shades of '61 in Bel Air Brush Fire."

106 The old Fonda place: Peter Fonda, *Don't Tell Dad: A Memoir* (New York: Hyperion, 1999), 159.

106 It was said: "Wealthy Evacuees Find Refuge in Swank Hotels," *LAT*, November 8, 1961, 2.

106 Dennis joined the stampede: Hopper, *1712 North Crescent Heights*, unpaginated.

106 Dennis found one woman: Ibid.

107 "Goddamn it!": Unpublished essay by BH, 2015.

107 Pacific Air Lines: Letter from Leland Hayward to William Goetz, December 9, 1958, LHP.

107 made them soup: Marion McIntyre letter, November 6, 1961, JTC.

107 It was decided: Ibid.

108 "I go outside": David Rensin, "20 Questions: Dennis Hopper," *Playboy*, March 1, 1990, 140.

108 If he hadn't handed: Hopper, *Dennis Hopper: Photographs*, 62.

108 The night after the fire: Dominick Dunne, *The Way We Lived Then: Recollections of a Well-Known Name Dropper* (New York: Crown, 1999), 77.

109 "Her crying": Ibid.

109 merely a case of indigestion: David Thomson, *Showman: The Life of David O. Selznick* (New York: Alfred A. Knopf, 1992), 677.

109 "It was a major tragedy": Hopper, *1712 North Crescent Heights*, unpaginated.

109 Incredibly, not one soul: "The Los Angeles Brush Fire Conflagration."

110 postfire insurance adjusters: Unpublished essay by BH, 2015.

110 Miss Mac implied: Marion McIntyre letter, November 6, 1961, JTC.

110 "The Goetzes had": Angela Fox Dunn, "Bill Goetz: The Greatest of Them All," *LAT*, April 20, 1980, O26.

110 designed in 1938: Jenna Chandler, "'Homeless billionaire' buys Edith Goetz's glamorous 1930s mansion in Holmby Hills," LA Curbed, April 26, 2017, https://la.curbed.com/2017/4/26/15435254/edith-goetz-hollywood -mansion-nicolas-berggruen.

110 the hugeness of it: Marion McIntyre letter, November 6, 1961, JTC.

110 cream satin draperies: Marion McIntyre letter, undated, JTC.

110 Vincent van Gogh self-portrait: Murray Schumach, "Producer Speaks of Art Collection," *TNY*, August 24, 1959, 16; "Van Gogh Portrait Is Held Authentic," *NYT*, October 4, 1950, 1.

110 The Goetzes went all in: Schumach, "Producer Speaks of Art Collection," 16.

110 Leland and Pamela: LHP.

111 had discovered Natalie Wood: Dunn, "Bill Goetz."

111 "I'm going to Madrid": William Stadiem and George Jacobs, *Mr. S: My Life with Frank Sinatra* (Waterville, ME: Thorndike Press), 2003, 222.

111 "On our first date,": A. Scott Berg, "William Goetz: Prolific Producer's Holmby Hills Collection," *Architectural Digest*, April 1992, 223.

111 "Whatever Edie wants": Stadiem, *Mr. S*, 27.

111 "She was the only player": Sydney Ladensohn Stern, *The Brothers Mankiewicz* (Jackson: University Press of Mississippi, 2019), 122.

111 Vincent professed to like: Victoria Price, *Vincent Price: A Daughter's Biography* (New York: St. Martin's Press, 1999), 165ff.

111 "It was like": Ibid., 166.

111 Brooke thought it was: Marion McIntyre letter, ca. 1961, JTC.

112 "enthusiasm plus discrimination": "Price Show Has World Flavor," *The Los Angeles Times*, July 6, 1959, E5.

112 When Dennis first visited: Kim Bockus, "Double Standards: An Interview with Dennis Hopper," *ArtUS*, March–April 2007, 18.

112 "It just tore me apart": NYU.

112 "I didn't know anyone": Jean Stein, interview with DH, August 16, 2007, JSP.

112 "He was intense": Price, *Vincent Price*, 182.

112 "At one point": Bockus, "Double Standards," 18.

112 "That's bullshit": Corey Seymour, "Hopper's Life in Art," *GQ*, May 8, 2009, https://www.gq.com/story/hoppers-life-in-art.

113 In the cavernous living room: Vincent Price, *I Like What I Know: A Visual Autobiography* (New York: Open Road Distribution, 2016).

113 six-foot-high: "(Untitled) Albuquerque," Richard Diebenkorn Foundation, https://diebenkorn.org/objects/86/.

113 A massive gold-leaf cross: Ibid.

113 Throughout the house: Ibid.; Mary and Vincent Price. *A Treasury of Great Recipes: Famous Specialties of the World's Foremost Restaurants Adapted for the American Kitchen* (Pasadena, CA: Ampersand Press, 1965).

113 "We opened our house": Paul Karlstrom, Oral history interview with Vincent Price, August 6–14, 1992, AAA.

113 In the 1950s, Dennis: Victoria Price, *Vincent Price*, 183.

114 The photographer William Claxton: William Claxton, *Photographic Memory* (New York: powerHouse Books, 2002), 35.

114 "The fire didn't stop": Bockus, "Double Standards," 18.

114 which tended toward: Claxton, *Photographic Memory*, 45.

114 "I discovered I was pregnant": Unpublished essay by BH, 2015.

114 John Gilbert: Eve Golden, *John Gilbert: The Last of the Silent Film Stars* (Lexington: University Press of Kentucky, 2013), 99ff.

114 "one of those places": Ibid.

114 He died of a heart attack: "Death Calls to Gilbert, Screen Star," *LAT*, January 10, 1936, 1.

114 Selznick had offered: Letters between David O. Selznick and Leland Hayward, 1949, LHP.

115 In the 1920s: Margaret Case Harriman, "Profiles: Hollywood Agent," *TNY*, July 11, 1936, 22.

115 remake of *Casablanca*: Letter from David O. Selznick to Leland Hayward, August 7, 1956, LHP.

115 musical version of *Rebecca*: Letter from Selznick to Hayward, June 14, 1961, LHP.

115 they hired Tony Duquette: Charles Lockwood, "From John Gilbert to Elton John, the Stars Called It Home," *LAT*, January 4, 1987, B22.

115 discovered a secret passage: Jean Stein, interview with Robert Walker, Jr., August 14, 2007, JSP.

115 The on-site gardener: Ibid.

115 Garbo still popped around: Marion McIntyre letter, undated, JTC.

115 Miss Mac found John: Ibid.

115 John spun tales: Jean Stein, interview with Robert Walker, Jr., August 14, 2007, JSP.

115 "Hollywood, you have": Jean Stein, *West of Eden* (New York: Random House, 2016), 191.

116 I looked at them": Ibid.

116 "I kept thinking": DH interview footage in "Jennifer Jones: Portrait of a Lady," *Biography*, Van Ness Films, 2001, Van Ness Films Collection at the

Academy Film Archive and Prometheus Entertainment, Margaret Herrick Library, Academy of Motion Picture Arts and Sciences.

116 "As a child": Unpublished essay by BH, 2015.

116 "David and Jennifer became": DH interview footage in "Jennifer Jones: Portrait of a Lady."

116 Cary Grant and Gary Cooper: Ibid.

116 "We have seen Brooke": Note from John Swope to Leland Hayward, affixed to note from Hayward to Swope dated December 18, 1961, LHP.

117 "Unlike most of the great": Dunne, *The Way We Lived Then*, 69.

117 "grand, extravagant": Thomson, *Showman*, 496.

117 He and Jennifer: Golden, *John Gilbert*, 122.

117 "We were just guzzling": Stein, *West of Eden*, 211.

117 "Everybody was so erudite": Ibid., 198.

117 Jennifer's well-used dressing room: Lockwood, "From John Gilbert to Elton John, The Stars Called It Home."

117 She spent her days: Stein, *West of Eden*, 209.

117 Dennis was starstruck: DH interview footage in "Jennifer Jones: Portrait of a Lady."

118 He discovered that: Stein, *West of Eden*, 185.

118 "She was totally supportive": Thomson, *Showman*, 581.

118 "The older generation": Stein, *West of Eden*, 210.

118 a "royal pain": DH interview footage in "Jennifer Jones: Portrait of a Lady."

118 David O. gladly met: Ibid.

118 "I want you to always": Ibid.

118 "Keep truckin' it, Dennis!": Tom Folsom, *Hopper: A Journey into the American Dream* (New York: It Books, 2013), 72.

119 "He'd go to these parties": Elena Rodriguez, *Dennis Hopper: A Madness to His Method* (New York: St. Martin's Press, 1988), 49.

119 experiencing his own career frustrations: Thomson, *Showman*, 664–65.

119 "Hollywood's like Egypt": Otto Friedrich, *City of Nets* (New York: Harper Perennial, 2014), xiv.

119 "It was a really strange time": Jean Stein, interview with DH, August 16, 2007, JSP.

119 He considered selling: Thomson, *Showman*, 664–65.

119 Dennis thought that: Stein, *West of Eden*, 212.

119 "He was a brilliant": Susan King, "That Jennifer Jones Glow," *LAT*, October 10, 2010, D4.

119 David O. had shaped: Ibid.

119 Jennifer occasionally threatened suicide: Stein, *West of Eden*, 190.

120 There had been rumors: Thomson, *Showman*, 510.

120 Two years later: Paul Green, *Jennifer Jones: The Life and Films* (Jefferson, NC: McFarland, 2011), 109.

120 In those days: Ibid.

120 Jane Fonda had tried out: Green, *Jennifer Jones*, 177.

120 David O. had instigated: Ibid.

120 Like Dennis, he bemoaned: Ibid.

120 "person after person": Calvin. Tomkins, *Living Well Is the Best Revenge* (New York: Viking Press, 1962), 6–7.

6: "WHAT IN THE HELL? WHERE ARE WE GONNA PUT IT?"

123 *The Investigators*, etc.: IMDB.

123 Brooke and Dennis played: *General Electric Theater*, season 10, episode 17, "The Hold-Out," directed by Charles F. Haas, written by Max Erlich, featuring Groucho Marx, Dennis Hopper, and Brooke Hayward, aired January 14, 1962, posted by Dingervision, YouTube, August 1, 2013, www .youtube.com/watch?v=blCImW5uZXg.

124 "The Hold-Out" aired: TV listings, *LAT*, January 14, 1962, A8.

124 their new house: Marion McIntyre letter, November 24, 1961, JTC. The move-in date was November 25. Miss Mac recalled in a 2010 letter that the house, located on the north side of the street, was rented from the actor and singer Max Showalter, a friend of Margaret Sullavan. The October 1961 Los Angeles city directory lists an "M. Showalter" at 7953 Hollywood Boulevard, indicating that Showalter lived on the block while owning a rental property, as Miss Mac also noted in a letter ca. April 1962.

124 a 1920s-era rental: Listing at Redfin, https://www.redfin.com/CA/Lo s-Angeles/7959-Hollywood-Blvd-90046/home/7116220.

124 Viroque Baker: Jack Alicoate, ed., *The 1931 Film Daily Year Book of Motion Pictures* (New York: Film Daily, 1931), 987, archive.org/stream /filmdailyyearboo00film_1https://archive.org/details/filmdailyyearboo00 film_1/page/986/mode/2up?view=theater.

124 Marie Rappold: Joseph Roger Winterrath and Alice Thor Pianfetti, *And the Champagne Still Flows* (self-published, 2015), Google Books, unpaginated.

124 *Photovision '62* exhibition: Marion McIntyre letter, February 7, 1962, JTC; Molly Saltman, interview with DH, 1966, MS.

124 "They are all very": Marion McIntyre letter, February 7, 1962, JTC. Miss Mac also noted that Dennis had a "one-man show" at the time; it may have been a rescheduling of the show Barry Feinstein was to host at the time of the Bel Air Fire. There is no further documentation of this, and Dennis never alluded to it.

124 Commended status: Photovision '62 catalogue, The Museum of Modern Art of Australia, Melbourne, Australia. The show opened on May 8, 1962.

124 That month, rainstorms: *Geological Survey Research 1972, Professional Paper 850* (Washington, DC: U.S. Government Printing Office, 1973), 33ff.

124 oozed through the back windows: Letter from Marion McIntyre to Jeffrey Thomas, 2010, JTC.

124 The mudslides caused damage: *Geological Survey Research 1972, Professional Paper 850*, 33ff.

125 "every single opening": Alexandra Schwartz, *Ed Ruscha's Los Angeles* (Cambridge, MA: MIT Press, 2010), 75.

125 "wonderful party": Ibid.

125 leaving handwritten messages: "Monday Night on La Cienega," *Time*, July 26, 1963, 50.

125 "world's largest concentration": Mary Lou, Loper, "A Walk on the Wild Side with Gallery Promenade," *LAT*, April 21, 1963, D1.

125 The art walks were: Ibid. This 1963 article says that Robles and Lewinson prompted the Monday night art walks "five years ago." In 1963, *Time* ran a piece saying that the art walks had begun in 1961.

125 The Esther Robles Gallery: "Exhibitions at the Getty Center," Getty Museum, https://blogs.getty.edu/pacificstandardtime/explore-the-era/loca tions/esther-robles-gallery; Esther Robles Gallery records, 1947–1986, AAA. The gallery's address was 665 North La Cienega.

125 The Bertha Lewinson Gallery: "Bertha Lewinson Gallery Sign," Objects USA, http://www.objectsusa.com/?jw_portfolio=bertha-lewinson-gallery -sign. The gallery's address was 740 North La Cienega.

125 Irving Blum: Barbara Isenberg, "An L.A. Art Story," *LAT*, September 22, 2002, Calendar 4.

126 "Most of these guys": Dennis Hopper, *Dennis Hopper: Photographs, 1961–1967*, ed. Tony Shafrazi (Köln: Taschen, 2018), 63.

126 Mondrians, Soutines, and Mirós: Brooke Hayward, *Haywire* (New York: Vintage, 2011), 136.

127 One Sunday in March: "Niki de Saint Phalle—Solo Exhibitions," Niki de Saint Phalle, http://nikidesaintphalle.org/wp-content/uploads/2018/09 /NdSP-Solo-Exhibitions-till-2018.pdf?x56823.

127 "Bonnie and Clyde": Kate Bryan and Asli Yazan, *The Art of Love: The Romantic and Explosive Stories Behind Art's Greatest Couples* (London: White Lion Publishing, 2019), 150.

127 Tinguely and Kienholz: "Niki de Saint Phalle—Solo Exhibitions."

127 Bill Claxton showed up: "Niki de Saint Phalle, *Action de Tir*, 1962," East of Borneo, https://eastofborneo.org/archives/niki-de-saint-phalle-action -de-tir-1962/.

127 Walter Hopps ended up: *Element of Tir Tableau Sunset Strip (Vacuum Cleaner)*, The Menil Collection, https://www.menil.org/collection/objects /16378-element-of-tir-tableau-sunset-strip-vacuum-cleaner.

127 "very, very sexy": Jean Stein, interview with DH, October 3, 1973, JSP.

128 "Is that *John Doe*?": *Edward Kienholz: The Story of an Artist (1961)*, directed by William Kronick, (Hollywood: A Wolper Production, 1962),

posted by L. A. Louver, YouTube, October 23, 2019, https://www.youtube
.com/watch?v=d5T9QpC09ms.

128 "That's one of the reasons": Maurice Tuchman, *Art in Los Angeles: Seventeen Artists in the Sixties* (Los Angeles: Los Angeles County Museum of Art, 1981), 13.

129 When the *Roxys* tableau: Walter Hopps, draft of essay for *Kienholz: A Retrospective*, Whitney Museum of American Art, 1995, JSP.

129 "Marvelously vulgar artist": Walter Hopps with Deborah Treisman and Anne Doran, *The Dream Colony: A Life in Art* (New York: Bloomsbury, 2017), 113.

129 "Well, that's nice": Hopps, draft of essay for *Kienholz: A Retrospective*.

129 "You half expected": William Hackman, *Out of Sight: The Los Angeles Art Scene of the Sixties* (New York: Other Press, 2015), 37.

129 "His almost naïve": Peter Plagens, *The Sunshine Muse: Contemporary Art on the West Coast* (New York: Praeger, 1974), 85.

129 "no aesthetic value": *Edward Kienholz: The Story of an Artist*.

130 Blum had attempted: Hunter Drohojowska-Philp, "Art Dealer Irving Blum on Andy Warhol and the 1960s L.A. Art Scene (Q&A)," *Hollywood Reporter*, November 4, 2013, https://www.hollywoodreporter.com/news/art-dealer-irving-blum-andy-653195.

130 "was the first person": Hopps et al., *The Dream Colony*, 105.

130 THE ONLY ISM: Ibid., 59.

130 "Sometimes there was": Hopper, *Dennis Hopper: Photographs*, 31.

130 almost cloacal canvas: Untitled painting by DH, HAT.

131 Hollywood & Western Building: John Gilmore, *Laid Bare: A Memoir of Wrecked Lives and the Hollywood Death Trap* (Los Angeles: Amok Books, 1997), 171; Kim Bockus, "Double Standards: An Interview with Dennis Hopper," *ArtUS*, March–April 2007, 18.

131 One day Hopps: NYU.

131 "There's no tree": Kristine McKenna, *The Ferus Gallery: A Place to Begin* (Göttingen: Steidl, 2009), 430.

131 Hopps didn't always think: Hopps, *The Dream Colony*, 147.

131 "macho intellectual gang bang": Isenberg, "An L.A. Art Story."

131 "That's it. I'm finished": NYU.

131 Hopps pointed to: It is possible that this work is one that was displayed in a show of Dennis Hopper photographs and artworks at MAK—Museum of Applied Arts in Vienna in 2001, reproduced in the catalogue *Dennis Hopper: A System of Moments*, on page 135. It is a square canvas with a danger-orange ground to which are affixed various objects, including a paintbrush and a paint can lid. Kienholz had been doing similar work in the late 1950s, expressionistic canvases overlaid with objects, including a piece that Dennis and Brooke had bought, *Black with White* (1957), which was hung in the stairwell of 1712 North Crescent Heights Boulevard.

131 "I said that": Bockus, "Double Standards," 18.

131 "We have the great IBM": Molly Saltman, interview with DH, 1966, MS.

132 "A man": Ibid.

132 "return to reality": NYU. The phrase is one that Hopper used often, in many interview situations, throughout his life to express that aesthetic crossroads.

132 They had lately: Molly Saltman, interview with DH, 1966, MS.

132 Formica-topped desk: Hopps et al., *The Dream Colony*, 146.

132 a Jasper Johns light-bulb piece: NYU.

132 Blum told Dennis: Ibid.

132 "That's it!": Ibid.

133 Washington Boulevard at Vermont: Blackstock Negative Collection, Los Angeles Photographers Collection, Los Angeles Public Library Photo Collection.

133 Foster & Kleiser created: "Chevrolet billboard," Los Angeles Public Library Photo Collection, https://tessa.lapl.org/cdm/singleitem/collection/photos/id/117522/rec/1 and "Our Company History," https://company.clearchanneloutdoor.com/our-history.

133 projections, electric pencils: Leroy F. Aarons, "'Pop' Billboards May Not Be Art, but . . . ," *Washington Post*, January 30, 1972, G1.

133 Brooke recalled: In Brooke's memory, they were, improbably, actual preserved human heads.

134 "People in Los Angeles": Lisa Eisner and Román Alonso, "Still Haywire," *T: The New York Times Style Magazine*, August 19, 2001, 200.

135 had divorced Marilla: Sally Bedell Smith, *Reflected Glory: The Life of Pamela Churchill Harriman* (New York: Simon & Schuster, 1996), 236.

135 going from address: Various documents, LHP.

135 Miss Mac found him: Marion McIntyre letter, undated, JTC.

135 "a revelation": Bruce Conner, Robert Dean, and Dennis Hopper, *Bruce Conner: Assemblages, Paintings, Drawings, Engraving Collages, 1960–1990* (Santa Monica, CA: Michael Kohn Gallery, 1990), unpaginated.

135 "I would hate": Philip Leider, "Bruce Conner: A New Sensibility," *Artforum*, November 1962, 30.

136 Stewart Stern visited: Hopper, *Dennis Hopper: Photographs*, 440.

136 delirious with joy: Unpublished essay by BH, 2015.

137 *Glamour*: Tony Scherman and David Dalton, *Pop: The Genius of Andy Warhol* (New York: It Books, 2009), 15.

137 I. Miller: Ibid., 68.

137 "hopeless born loser": Victor Bockris, *Warhol: The Biography* (Boston: Da Capo Press, 2003), 91.

138 "He did it": *Painters Painting*, directed by Emilio de Antonio (New York: New Yorker Films, 1973).

138 Muriel Latow came up: Calvin Tomkins, *The Scene: Reports on Post-modern Art* (New York: Viking Press, 1976), 47.

138 Dennis and Brooke found: Billy Al Bengston recalled hanging the show with fellow Ferus artist Robert Irwin.

138 Blum priced the paintings: Paul Cummings, oral history interview with Irving Blum, May 31–June 23, 1977, AAA.

138 The stark red-white-and-gold: Hilary Greenbaum, "Who Made that Campbell's Soup Label?," *NYT*, May 9, 2011, https://6thfloor.blogs.ny times.com/2011/05/09/who-made-that-campbells-soup-label.

139 Warhol's fastidious craft: Andy Warhol and Sally King-Nero, *The Andy Warhol Catalogue Raisonné* (London: Phaidon, 2002), catalogue nos. 051–067.

139 "I want to be a machine": B.H.D. Buchloh and Andy Warhol, *Andy Warhol* (Cambridge, MA: MIT Press, 2001), 71.

139 "Frankly, the Cream of Asparagus": Hopps et al., *The Dream Colony*, 122.

139 DO NOT BE MISLED: Jack Smith, "Soup Can Painter Uses His Noodle," *LAT*, July 23, 1962, C1.

139 "His tribute to the blank": Robert Hughes, "Blake and Hockney," *London Magazine* 5, no. 10 (January 1, 1966): 68.

140 "I wanted to paint nothing": Bockris, *Warhol*, 154.

140 "He gave me a funny smile": Hopps et al., *The Dream Colony*, 122.

140 "The same lunch": Gene R. Swenson, "What Is Pop Art?," *Artnews*, November 1963, 26.

140 "He could sell": Joanna Weinberg, "It Happened One Night," *Vogue*, September 2002, 492.

141 "a total fabrication": Hopps claimed this in *The Dream Colony*.

141 "a constant source": Warhol and King-Nero, *The Andy Warhol Catalogue Raisonné*, nos. 051–067.

141 "Of their importance": Smith, "Soup Can Painter Uses His Noodle."

141 In 1996, he arranged: Ken Johnson, "Another Serving of Soup," *NYT*, May 8, 2015, C24. In 2012, Blum estimated the combined value to be $200 million, which, if anything, was a lowball. Warhol's *Small Torn Campbell's Soup Can (Pepper Pot)* fetched $11.8 million in 2006.

141 a one-off version: Warhol and King-Nero, *The Andy Warhol Catalogue Raisonné*, no. 053.

141 the painting was hanging above: According to the Warhol catalogue raisonné, this painting originated at Ferus, adding another layer of mystery to the story of how Dennis and Brooke acquired their soup-can painting; the weight of Dennis's, Brooke's, and Irving Blum's memories strongly supports Dennis's recollection that in the end the painting came from Dwan.

141 Dennis inquired: Bockus, "Double Standards."

141 Dennis and Brooke likely: It is possible that Dennis, during this time away from the children, filmed an episode of *The Defenders* called "The Indelible

Silence" in New York at Filmways Studios, 246 East 127th Street, and that he and Brooke flew to New York. Brooke Hayward has no recollection of this.

142 "I wanted to keep her": Jean Stein, interview with Marjorie Hopper, April 10, 1988, JSP.

142 Some months later: Index cards accompanying these contact sheets at the Hopper Art Trust are marked "1963."

142 Lemon Grove Methodist Church: Contact sheets, HAT.

142 It was perhaps: Smith, *Reflected Glory*, 237–38. The date of that infamous dinner has never been determined. A 1962 letter from Miss Mac indicates that Dennis and Brooke were visiting New York at Easter that year, which might also plausibly be when the dinner occurred.

142 "She really insulted me": Ibid.

142 "It was her show": Ibid.

142 "The world has been": Richard Rovere, "Letter from Washington," *TNY*, November 3, 1962, 122.

142 Angelenos were told: Marion McIntyre letter, October 24, 1962, JTC.

143 "Fateful Hour Near": Robert Thompson, "Fateful Hour Near," *LAT*, October 24, 1962, 1.

143 "Who would want": Marion McIntyre letter, October 24, 1962, JTC.

143 "I could have made": Letter from Marion McIntyre to Jeffrey Thomas, 2010, JTC.

143 "it would be the end": Marion McIntyre letter, October 24, 1962, JTC.

143 The term had been coined: Lawrence Alloway, "The Arts and the Mass Media," *Architectural Design*, February 1958, 34.

144 "L.A. was Pop": Dennis Hopper, *1712 North Crescent Heights: Photographs, 1962–1968* (New York: Greybull Press, 2001), unpaginated.

144 "The question for Southern California": Plagens, *The Sunshine Muse*, 139.

144 "The vulgarity of the image": John Coplans, "The New Painting of Common Objects," *Artforum*, November 1962, in *Pop Art: A Critical History*, ed. Steven Henry Madoff (Berkeley: University of California Press, 1997), 44.

144 "Flying through the air": Dennis Hopper, "About Ed Ruscha," in Edward Ruscha, Dennis Hopper, and Jeffrey Deitch, *Edward Ruscha: Early Paintings, October 29 Through November 26, 1988* (New York: Tony Shafrazi Gallery, 1988), unpaginated. Draft copy at HAT.

144 the family who had built: Ed Ruscha, Yve-Alain Bois, and Walter Hopps, *Edward Ruscha: Catalogue Raisonné of the Paintings*, vol. 1, *1958–1970* (Göttingen: Gagosian Gallery/Steidl, 2003), 40–41. C. Bagley Wright and his wife bought the painting.

145 "affixing the object": Julian Schnabel et al., *Dennis Hopper Double Standard* (Los Angeles: MOCA, 2010), 39.

145 "The photographers were": Molly Saltman, interview with DH , 1966, MS.

145 "tour de force": Henry J. Seldis, "Sculpture Featured in La Jolla Show," *LAT*, December 30, 1962, A11. It is unclear which piece this was.

145 Paul Newman and Joanne Woodward: Hopper, *Dennis Hopper: Photographs*, 71.

145 He also shot Brooke: Ibid., 70.

146 *The Dennis Hopper One-Man Show*: Rudolf Frieling and Gary Garrels, *Bruce Conner: It's All True* (Berkeley: University of California Press, 2016), 124. The works were finally shown in the early 1970s.

146 *Wilhold Up the Mirror* was available as of 2021 on 1st Dibs via a seller in Bal Harbour, FL. It had been in the collection of Dr. Pentti Kouri (1949–2009) and shown at MOCA in 2010.

146 ceramic phrenology bust: The bust had likely been designed by the ceramicist Edward Marshall Boehm.

146 "extraordinary and ahead": Dennis Hopper and Michael McClure, *Out of the Sixties* (Santa Fe: Twelvetrees Press, 1986), unpaginated.

146 "We were doing": Molly Saltman, interview with DH, 1966, MS.

146 "a pretentious": Henry J. Seldis, "In the Galleries: Sequin Eyelids, Neon Lips," *LAT*, July 18, 1963, D5.

146 "Henry Seldom": Schwartz, *Ed Ruscha's Los Angeles*, 33.

146 "This show of photo-assemblages": R. G. Wholden, "Dennis Hopper, Primus-Stuart Galleries," *Artforum*, April 1963, 45.

147 "Welcome brave new images!": Ibid.

7: "SOMETHING WAS STRANGE AND WONDERFUL"

149 To Miss Mac: Marion McIntyre letter, undated, JTC.

149 Thanks to money: Brooke noted in an interview with the author, "Mother had left what in those days was a considerable amount of money to my sister, brother, and me. We each got a third of whatever. And my third was about $300,000. Which was, in those days, a lot of money."

150 They moved in: Marion McIntyre letter, ca. January 1963, JTC. The actual move-in date remains a mystery; Brooke recalled that it was April, but the Miss Mac letter suggests otherwise.

150 built in 1927: Original building permit, October 9, 1926.

150 eleven children, a wooden leg: Leslie Evans, "On the Track of the Elusive Baron Long," The Shaggy Man's Place, May 6, 2012, http://www.shaggy man.com/index.php/70-on-the-track-of-the-elusive-baron-long.

150 The neighborhood was filled: "Historic City & Business and Phone Directories," 1960–1965, Los Angeles Public Library, https://rescarta.lapl.org /ResCarta-Web/jsp/RcWebBrowse.jsp;jsessionid=E24BE5448346DDA0 800935FF799062DD.

150 Marlon Brando: Margy Rochlin, "Stewart Stern: Out of the Soul," in *Backstory 2: Interviews with Screenwriters of the 1940s and 1950s*, ed. Pat Mc-Gilligan (Berkeley: University of California Press, 1997), 294.

150 Igor Stravinsky: Dennis Hopper, *1712 North Crescent Heights: Photographs, 1962–1968* (New York: Greybull Press, 200), unpaginated.

150 were both present: Hunter Drohojowska-Philp, *Rebels in Paradise: The Los Angeles Art Scene and the 1960s* (New York: Henry Holt, 2011), 93.

150 "the same as that": Jill Schary Zimmer, *With a Cast of Thousands: A Hollywood Childhood* (New York: Robinson, Stein and Day, 1963), 84.

150 Santa Monica was: Ibid.

150 "Were for people": Ibid., 85.

150 Brentwood, Bel Air: Ibid.

151 "considered smart": Ibid.

151 "You could buy": Lisa Eisner and Román Alonso, "Still Haywire," *T: The New York Times Style Magazine*, August 19, 2001, 200.

151 Curtis Harrington: Curtis Harrington, *Nice Guys Don't Work in Hollywood: The Adventures of an Aesthete in the Movie Business* (Chicago: Drag City Incorporated, 2013), 119.

151 At Fire House Antiques: Hopper, *1712 North Crescent Heights*, unpaginated.

151 barbershop chair: Unpublished essay by BH, 2015.

151 carousel horses: Classifieds, *LAT*, August 16, 1964, 48.

151 Don Badertscher: Bevis Hillier, "Mix It Up: Making the Old Work Along with the New," *LAT*, June 14, 1987, I7.

152 "I've only ever": Eisner and Alonso, "Still Haywire."

152 Vincent and Mary Price: Gary Klein, "Anything but Junk," *LAT*, November 3, 1988, B14.

152 Brooke bought stacks: Hopper, *1712 North Crescent Heights*, unpaginated.

152 "What was banal": Susan Sontag, "Notes on 'Camp,'" in *Against Interpretation and Other Essays* (New York: Farrar, Straus and Giroux, 1966), 285.

152 Égide Rombaux: Thomas Leavitt, *Three Young Collections: Selections from the Collections of Donald and Lynn Factor, Dennis and Brooke Hopper, André and Dory Previn (January 15–February 26, 1967)* (Santa Barbara, CA: Santa Barbara Museum of Art, 1967), unpaginated.

152 bronze fountain: Unpublished essay by BH, 2015.

153 In 2018, a rare Tiffany lamp: "Collecting Guide: 10 Things to Know About Tiffany Lamps." Christie's, November 2, 2020, http://www.christies.com/features/Tiffany-lamps-10-things-you-need-to-know-9542-3.aspx.

153 A Tiffany show: Lisa Hammel, "Real or a Copy, Tiffany Lamp Is 'In,'" *NYT*, April 1, 1965, 40.

153 "Tiffany made what": Jean Stein, interview with DH , October 3, 1973, JSP.

153 *Justice League of America*: Roy Lichtenstein Foundation, Image Duplicator, https://www.imageduplicator.com/main.php?decade=60&year=63&work_id=733.

153 "everybody thought": Molly Saltman, interview with DH, 1966, MS.

153 "The art she really": Ibid.

154 One day, Dennis fetched: Contact sheet, undated, HAT.

154 "Brooke did an amazing": Hopper, *1712 North Crescent Heights*, unpaginated.

154 "very rare": Molly Saltman, interview with DH, 1966, MS.

154 in the spring she posed: "Casual Clothes from California," *TV Guide*, April 20, 1963, 20–23.

154 Dennis earned $2,250: Steven Jay Rubin, *The Twilight Zone Encyclopedia* (Chicago: Chicago Review Press, 2017), Google Books, unpaginated.

155 Dennis remembered: NYU.

155 The public's response: Don Presnell and Marty McGee, *A Critical History of Television's The Twilight Zone, 1959–1964* (Jefferson, NC: McFarland, 2015), 141.

155 "The impression left": Rubin, *The Twilight Zone Encyclopedia*.

156 his arrest on April 30: *Jewish Telegraphic Agency Daily News Bulletin*, April 30, 1963, 2.

156 Irving Blum had arranged: Jean Stein, interview with BH, March 30, 1977, JSP.

156 curator in the Metropolitan Museum's: Calvin Tomkins, *The Scene: Reports on Post-modern Art* (New York: Viking Press, 1976), 13.

156 The Antwerp-born: Ibid., 19.

157 "It's all wonderfully connected": Ibid.

157 "sexy friend": Christopher Sykes, *David Hockney: A Rake's Progress, the Biography, 1937–1975* (New York: Nan A. Talese/Doubleday, 2011), 113.

157 "invited us": Ibid., 128–29.

157 Hockney told Warhol: Ibid.

157 at the Selwyn: Howard Thompson, "'Night Tide,' a Mood Piece, Is Shown at the Selwyn Theater," *NYT*, June 7, 1963, 26.

157 Warhol had taken them: Jean Stein, interview with BH, March 20, 1977, JSP.

157 a 2,500-square-foot space: Dana Schultz, "UES Firehouse Studio That Andy Warhol Rented for $150/Month Is Now Listed for $10M," 6sqft, April 5, 2016, https://www.6sqft.com/firehouse-studio-that-andy-warhol-rented-for-150month-is-now-listed-for-10m/.

157 Warhol had been daubing: Jean Stein, interview with BH, March 20, 1977, JSP.

157 Miss Mac was scandalized: Marion McIntyre letter, undated, JTC.

157 "Paintings are too hard": Victor Bockris, *Warhol: The Biography* (Boston: Da Capo Press, 2003), 163.

157 Brooke was mesmerized: Jean Stein, interview with BH, March 20, 1977, JSP.

158 "That is fantastic": Ibid.

158 "I will give it to you": Ibid.

158 Warhol also gave: Patrick S. Smith, *Andy Warhol's Art and Films* (Ann Arbor, MI: UMI Research Press, 1986), 307.

158 "collected antiques": Jean Stein, interview with BH, March 20, 1977, JSP.

158 "American junk": Tony Scherman and David Dalton, *Pop: The Genius of Andy Warhol* (New York: It Books, 2009), 62.

158 Walter Hopps had noticed: Jean Stein, interview with Walter Hopps, September 1, 1974, JSP.

158 "Andy," she ventured: Jean Stein, interview with BH, March 20, 1977, JSP.

158 Filmways Studio: "The Defenders . . . ," Getty Images, June 11, 1963, getty images.com/detail/news-photo/the-defenders-television-show-episode -the-weeping-baboon-news-photo/586217512.

159 "I remember thinking": Andy Warhol and Pat Hackett, *POPism: The Warhol Sixties* (New York: Houghton Mifflin Harcourt, 2015), 53.

159 Charles Manson: Jean Stein, interview with DH, June 4, 1995, JSP. During the making of the documentary *The American Dreamer* in 1971, co-director Lawrence Schiller arranged for Dennis to meet Manson in prison. According to Dennis, that was when Manson told him that he had watched that episode of *The Defenders*. "I did it for you," Manson told Dennis of his own courtroom performance. "I did exactly what you did on that show!" Manson hoped that Dennis would direct a movie about him; Dennis, disturbed by the encounter, declined.

159 On that day: Jean Stein, interview with BH, March 20, 1977, JSP.

159 "that kind of shadowy": Jean Stein, interview with Walter Hopps, September 1, 1974, JSP.

159 "I knew": Jean Stein, interview with BH, March 20, 1977, JSP.

160 Harry Belafonte had mustered: Michael Fletcher, "An Oral History of the March on Washington," *Smithsonian Magazine*, July 2013, https://www .smithsonianmag.com/history/oral-history-march-washington-180953863/.

160 "To mobilize": Ibid.

160 Heston assured skeptics: Mike McGrady, "Stars March but It's Not Their Show," *Newsday*, August 29, 1963, 3C.

160 Gallup Poll: Emilie Raymond, *Stars for Freedom* (Seattle: University of Washington Press, 2015), 127.

160 He flew from LA: Passenger list, Joseph L. Mankiewicz Papers, Margaret Herrick Library, Academy of Motion Picture Arts and Sciences.

160 to hear Ossie Davis: Calvin Trillin, "March on Washington," *TNY*, September 7, 1963, in *The '60s: The Story of a Decade*, ed. Henry Finder (New York: Random House, 2016), 149–50. The *Paris Match* photographer Paul Slade took pictures of Dennis in the crowd, holding his Nikon; Dennis's own film of the event does not seem to have survived.

160 "What was a white boy": David Hajdu, *Positively 4th Street: The Lives and Times of Joan Baez, Bob Dylan, Mimi Baez Fariña, and Richard Fariña* (New York: Picador, 2011), 183.

161 "Hope and harmony": John Lewis and Michael D'Orso, *Walking with the Wind: A Memoir of the Movement* (New York: Harvest Books, 1999), 224.

161 "to deprive the city": Reyner Banham, *Los Angeles: The Architecture of Four Ecologies* (Berkeley: University of California Press, 2001), 121.

162 Hand-painted billboards: Jean Stein, interview with BH, March 20, 1977, JSP.

162 hot dog vendor: Ibid.

162 Wallace Berman's RSVP: *The Dennis Hopper Collection* (New York: Christie's New York, 2021).

162 Warhol had never been: Scherman and Dalton, *Pop*, 172.

162 "Vacant, vacuous Hollywood": Warhol and Hackett, *POPism*, 51–52.

162 who conveniently owned: Deborah Davis, *The Trip: Andy Warhol's Plastic Fantastic Cross-Country Adventure* (New York: Atria Books, 2015), 8.

162 Having been introduced: Steven Watson, *Factory Made* (New York: Pantheon, 2003), 107.

162 "The farther West": Warhol and Hackett, *POPism*, 50.

163 They cruised along: Davis, *The Trip*, 175–76.

163 "electro-graphic architecture": Tom Wolfe, "I Drove Around Los Angeles and It's Crazy! The Art World Is Upside Down," *LAT*, December 1, 1968, Q18.

163 "Oh, this is America": Watson, *Factory Made*, 111.

163 "It was like this invasion": Steven Watson, *Factory Made: Warhol and the Sixties* (New York: Pantheon, 2003), 111.

163 Hollywood players who looked: Warhol and Hackett, *POPism*, 53.

163 "Andy and I were both": Watson, *Factory Made*, 111.

163 "Ooh! Aah!": Hopper, *1712 North Crescent Heights*, unpaginated.

163 "Andy comes to Hollywood": Ibid.

164 "This was before": Warhol and Hackett, *POPism*, 52.

164 sweltering hot: Jean Stein, interview with BH, March 20, 1977, JSP.

164 Mead found the Hollywood crowd: Jean Stein, interview with Taylor Mead, 1975, JSP.

164 "Joints were going around": Warhol and Hackett, *POPism*, 53.

164 Chamberlain claimed: Scherman and Dalton, *Pop*, 174.

164 Malanga said: "If Brooke objected to that situation, it would be weird,"

Malanga said in an interview with the author on September 13, 2019. Brooke herself has no recollection of it. Perhaps the objection was about Chamberlain and Hecht being in a closet together.

164 had bought for $350: Jean Stein, interview with BH, March 20, 1977, JSP. In that interview, Brooke also said that Patty tried to make light of the incident, joking that she and Dennis should be buying Oldenburgs instead. "She was probably right," Brooke remarked.

164 "It was a high point": Hopper, *1712 North Crescent Heights*, unpaginated.

164 "I thought it was": Patty Mucha interview, June 6, 2019.

165 Kienholz repaired the piece: Jean Stein, interview with BH, March 20, 1977, JSP.

165 Beverly Hills Hotel: Warhol and Hackett, *POPism*, 52. Warhol and his friends also stayed at the Surf Rider Inn in Santa Monica during the trip. Recollections vary as to whether the entourage stayed at the Beverly Hills Hotel and then moved to the Surf Rider Inn or vice versa. An incident that Malanga relays has Warhol on the beach reading a sour review of his Ferus show, having walked there from the Surf Rider Inn the morning after a party on the Santa Monica Pier. The review would most likely be the one by Henry J. Seldis that ran in the *Los Angeles Times* on October 4. That would date the pier party as October 3 and indicate that the group stayed at the Beverly Hills Hotel early in the trip before decamping to Santa Monica.

165 "The Hoppers were wonderful": Ibid., 53.

165 As a thank-you: Jean Stein, interview with BH, March 20, 1977, JSP.

165 "When I met Andy": Ibid.

165 Warhol arrived: Photographs of exhibition by John Weber, AW.

165 16-millimeter Bolex: Scherman and Dalton, *Pop*, 167.

166 "complete boredom": Larry Bell, "From a Statement Written by Larry Bell in September, 1963, upon First Seeing an Exhibition of Warhol's Work," *Artforum*, February 1965, 28.

166 Blum managed: Davis, *The Trip*, 199.

166 "This crowd lived": Ibid.

166 "Pop art banality": Henry J. Seldis, "In the Galleries: Sir Swivel Reigns in Pop Art Display," *LAT*, October 4, 1963, D11.

166 "The press for my show": Warhol and Hackett, *POPism*, 54.

166 "It was a great moment": "'I Was Very Fortunate in Coming to New York at a Time Before Things Got Out of Control.' Robert Ayers in Conversation with Claes Oldenburg," A Sky Filled with Shooting Stars, September 21, 2010, http://www.askyfilledwithshootingstars.com/wordpress/?p=1371.

166 "Poopy": Alessandra Nicifero, interview with Patty Mucha, August 12, 2015, Rauschenberg Oral History Project, Rauschenberg Foundation.

166 responsible for sewing: Patty Mucha, "Sewing in the Sixties," *Art in America*, November 2002, 79ff.

167 Dennis was dying: Jean Stein, interview with DH, October 3, 1973, JSP.

167 "My work makes": Rose, Barbara. *Claes Oldenburg* (New York: Museum of Modern Art, 1970), 193.

167 "That Claes chose": Mucha, "Sewing in the Sixties," 81.

167 It was an anecdote: Jean Stein, interview with DH, October 3, 1973, JSP.

167 he shot a portrait: Rose, *Claes Oldenburg*, 144.

167 "They *squoze!*": Ibid., 85.

167 "I thought he was": Jean Stein, interview with DH, October 3, 1973, JSP.

167 "Andy was like": DH interview, London BFI Film Festival, 1990, HAT.

168 "an eight-hour hard on": Watson, *Factory Made*, 161.

168 The day after: *Tarzan and Jane Regained... Sort Of*, directed by Andy Warhol (Pittsburgh, PA: Andy Warhol Museum, 1964). The date October 2 appears on a production clapboard near the beginning of the film.

168 "It opened up": Warhol and Hackett, *POPism*, 57.

168 Dennis thought Warhol: Jean Stein, interview with DH, ca. 1975, JSP.

168 *Tarzan and Jane*: *Tarzan and Jane Regained*.

169 114 works by Duchamp: Calvin Tomkins, *Duchamp: A Biography* (New York: Henry Holt, 1996), 422.

169 "probably the most": Henry Geldzahler, "Los Angeles: The Second City of Art," *Vogue*, September 15, 1964, 62.

170 Oklahoma girlfriend: Paul Karlstrom, oral history interview with Eve Babitz, June 14, 2000, AAA.

170 He'd seemingly given up art: The famous Wasser photograph of Duchamp playing chess with the nude Eve Babitz at the Pasadena Art Museum was taken a week or so after the opening.

170 "Oh, I'm a breather": Calvin Tomkins, *Marcel Duchamp: The Afternoon Interviews* (New York: Badlands Unlimited, 2013), 3.

170 "a life-changing experience": Ibid., 422.

170 "He's not giving": Ruscha's observations here, from an interview with the author on March 20, 2018, echo one of his best-known statements about what he aims to achieve in his art, as he explained in 1973: "a kind of a 'Huh?'"

170 In addition to: Tomkins, *Marcel Duchamp*, 422; author interviews; event photographs by Julian Wasser.

171 "He was like": Jean Stein, interview with DH, August 16, 2007, JSP.

171 "He said the artist": Chris Hodenfield, "Citizen Hopper," *Film Comment*, November–December 1986, reprinted in *Dennis Hopper: Interviews*, ed. Nick Dawson (Jackson: University Press of Mississippi, 2012), 129.

171 Dennis had brought: Contact sheets, HAT. Dennis also made a wonderful portrait of Walter Hopps in the shadowy lobby of the Hotel Green around that time.

171 The vernissage: Mary Matthew, "They Came, They Saw—Duchamp Conquered," *LAT*, October 9, 1963, E1.

171 Mead found it odd: Jean Stein, interview with Taylor Mead, 1975, JSP.

171 Then everyone headed: Matthew, "They Came, They Saw—Duchamp Conquered."

171 By 1963: Minor Willman, "Green Hotel: Faded but Still Proud," *LAT*, November 15, 1964, SG_C1.

171 A girlfriend of his: Walter Hopps and Dennis Hopper, "A Readymade in the Making," *Étant Donné Marcel Duchamp*, no. 6 (2005): 186.

171 "I saw the Hotel Green": Ibid., 187.

172 Mead hadn't packed: Jean Stein, interview with Taylor Mead, 1975, JSP.

172 "carrying on": Jean Stein, interview with Walter Hopps, September 22, 1974, JSP.

172 *"une semaine de"*: Letter from Duchamp to Robert Lebel, October 18, 1963, in Paul B. Franklin, *The Artist and His Critic Stripped Bare: The Correspondence of Marcel Duchamp and Robert Lobel* (Los Angeles: Getty Research Institute, 2016), 219.

173 Duchamp likewise seemed: Warhol and Hackett, *POPism*, 55.

173 And so the evening: Jean Stein, interview with Walter Hopps, September 22, 1974, JSP.

173 Warhol drank too much: Warhol and Hackett, *POPism*, 55.

173 For Brooke, the Duchamp party: Jean Stein, interview with BH, March 20, 1977, JSP.

173 In 2010, it sold: "Marcel Duchamp (1887–1968), Signed Sign," Christie's, https://www.christies.com/lotfinder/Lot/marcel-duchamp-1887–1968-signed-sign-5373977-details.aspx.

173 Inspired by Duchamp: Julian Schnabel et al., *Dennis Hopper Double Standard* (Los Angeles: MOCA, 2010), 40.

174 working on a piece: Jean Stein, interview with Gerard Malanga, November 16, 1976, JSP. In *POPism*, Warhol said he was painting alone that day; *Pop* has Malanga and Warhol walking through Grand Central Terminal when they heard the news.

174 "KO the Kennedys": Scherman and Dalton, *Pop*, 178.

174 "the aspect of a national": Michael Arlen, "The Air: Life and Death in the Global Village," *TNY*, April 13, 1968, 157.

174 "What bothered me": Warhol and Hackett, *POPism*, 77.

175 Christmas season arrived: Hopper family Christmas card, 1963, in Dominick Dunne scrapbook, Griffin Dunne Collection.

175 In New York: Jansen shop receipts, December 11, 1963, LHP.

175 Jansen housewares boutique: Sally Bedell Smith, *Reflected Glory: The Life of Pamela Churchill Harriman* (New York: Simon & Schuster, 1996), 239.

175 On the nights: Michael Kirby, *Happenings* (New York: E. P. Dutton, 1966), 262ff.

175 *Autobodys*, with its: Kristine McKenna, "When Bigger Was Better," *LAT*, July 2, 1995, Calendar 3.

176 Oldenburg had "auditioned": Kirby, *Happenings*, 273.

176 The twenty "players": Mucha, "Sewing in the Sixties," 87. In a 1975 interview with Jean Stein, Dennis claimed to have been one of the players in *Autobodys*; Mucha has no recollection of this.

176 black sweater and white slacks: Kirby, *Happenings*, 275; Claes Oldenburg, script for *Autobodys*, in *Happenings*, 262.

176 Cars rolled in: Ibid.

176 The Gilmore Drive-In: Movie listings, *LAT*, December 10, 1963, D20.

176 "We're going to lose": Art Seidenbaum, "Autobodys—Horsepowerful Art Composition on a Parking Lot," *LAT*, December 24, 1963, A1.

176 Two vehicles: Patty Mucha interview, June 6, 2019.

176 "At the final moment": Mucha, "Sewing in the Sixties," 87.

8: "HE TOOK IT EVERYWHERE HE WENT"

177 It was a particularly: Fernando Gamboa, *Master Works of Mexican Art from Pre-Columbian Times to the Present* (Los Angeles: Los Angeles County Museum of Art, 1963), vii.

177 When the show: Molly Saltman, interview with DH, MS.

178 Don Pedro Linares: Eli Bartra, *Women in Mexican Folk Art* (Cardiff: University of Wales Press, 2011), 47–48. Dennis collected Linares *cartonería* later in life, according to Galería Atotonilco, a Linares dealer.

178 Dennis liked to tell: Molly Saltman, interview with DH, MS.

178 As it was too big: Ibid.

178 "Bobbie Jo and the Beatnik": *Petticoat Junction*, season 1, episode 16, "Bobbie Jo and the Beatnik," directed by Jean Yarbrough, written by Bill Manhoff, featuring Pat Woodell, Bea Benaderet, and Dennis Hopper, aired January 7, 1964, posted by PizzaFlix, YouTube, August 4, 2013, https://www.youtube.com/watch?v=4OW5vyWaP1Y.

178 Dennis always claimed: Terry Southern, "The Loved House of the Dennis Hoppers," *Vogue*, August 21, 1965, 153, 162.

178 a sizable sheaf: DH poetry manuscript, HAT.

179 "Ode to a Comic Book": Ibid.

179 Kienholz, for one: Edward Kienholz interview, October 4, 1986, Sandra Leonard Starr papers related to California assemblage art, 1960–1995 (bulk 1986–1988), Getty Research Institute, Los Angeles, accession no. 2011.M.22.

179 "To Kienholz": Robert Hughes, *American Visions: The Epic History of Art in America* (New York: Alfred A. Knopf, 2009), 607.

179 "In golden books": DH poetry manuscript, HAT.

179 earning $750: Steven Jay Rubin, *The Twilight Zone Encyclopedia* (Chicago: Chicago Review Press, 2017), 125.

180 "Man is least": Oscar Wilde, "The Critic as Artist," in *Intentions* (New York: Dodd, Mead, 1894), 185.

180 Ida Lupino: Rubin, *The Twilight Zone Encyclopedia*, 200.

180 "I love them": Marion McIntyre letter, 1964, JTC.

181 "I was an avid": Dennis Hopper, *1712 North Crescent Heights: Photographs, 1962–1968* (New York: Greybull Press, 2001), unpaginated.

181 "went right through": Simon Warner, *Text and Drugs and Rock 'n' Roll: The Beats and Rock Culture* (London: Bloomsbury Publishing, 2013), 244.

181 "Fuck! Man": David Hajdu, *Positively 4th Street: The Lives and Times of Joan Baez, Bob Dylan, Mimi Baez Fariña, and Richard Fariña* (New York: Picador, 2011), 197.

181 "Hollywood": Tracy Daugherty, *The Last Love Song: A Biography of Joan Didion* (New York: St. Martin's Press, 2015), 236.

181 On the last Friday: Dominick Dunne, *The Way We Lived Then: Recollections of a Well-Known Name Dropper* (New York: Crown, 1999), 114ff.

182 the pages of *Town & Country*: Undated clippings in Dominick Dunne scrapbooks, Griffin Dunne Collection.

182 Balmain and Bugnand: "Eye," *Women's Wear Daily*, April 29, 1964, 14.

182 "There were trellises": Ruth La Ferla, "An Opera Troupe Sings for Its Crudités," *NYT*, June 1, 2003, ST8.

182 "We were in": Hopper, *1712 North Crescent Heights*, unpaginated.

183 The writer was staying: Curtis Harrington, *Nice Guys Don't Work in Hollywood: The Adventures of an Aesthete in the Movie Business* (Chicago: Drag City Incorporated, 2013), 1–2.

183 Capote brought along: Dunne, *The Way We Lived Then*, 122.

183 Leland and Pamela Hayward: Deborah Davis, *Party of the Century: The Fabulous Story of Truman Capote and His Black and White Ball* (Hoboken, NJ: Wiley, 2016), 227.

183 Andy Warhol and Henry: Andy Warhol and Pat Hackett, *POPism: The Warhol Sixties* (New York: Houghton Mifflin Harcourt, 2015), 244.

183 five hundred–something: Amy Fine Collins, "A Night to Remember," *Vanity Fair*, July 1996, https://archive.vanityfair.com/article/1996/7/a-night-to-remember.

183 Brooke had zero doubt: La Ferla, "An Opera Troupe Sings for Its Crudités."

183 had not invited: Dunne, *The Way We Lived Then*, 124.

183 "There was this garage door": Peter Noever, ed., *Dennis Hopper: A System of Moments* (Ostfildern-Ruit, Germany: Hatje Cantz Verlag, 2001), 127.

184 worked for Leland Hayward: Brooke Hayward, *Haywire* (New York: Vintage, 2011), xiii.

184 Mount St. Mary's College: Constance Perkins, "Fusion of Paint, Sculpture," *LAT*, April 13, 1964, E18.

184 *Los Angeles Scene*: Advertisement, *Artforum*, Summer 1964, 84.

184 *Artforum*'s summer issue: Donald Factor, "Assemblage," *Artforum*, Summer 1964, 38.

185 "Photographers always": James Stevenson, "Our Local Correspondents: Afternoons with Hopper," *TNY*, November 13, 1971, 124–25.

185 He'd been given the nickname: Chris Hodenfield, "Citizen Hopper," *Film Comment*, November–December 1986, reprinted in *Dennis Hopper: Interviews*, ed. Nick Dawson (Jackson: University Press of Mississippi, 2012), 128.

185 done at a lab: Jessica Hundley, interview with DH, undated, HAT.

185 "I was really interested": Alexandra Schwartz, *Ed Ruscha's Los Angeles* (Cambridge, MA: MIT Press, 2010), 81.

185 Rosenquist's *Study for Marilyn*: Thomas Leavitt, *Three Young Collections: Selections from the Collections of Donald and Lynn Factor, Dennis and Brooke Hopper, André and Dory Previn (January 15–February 26, 1967)* (Santa Barbara, CA: Santa Barbara Museum of Art, 1967), unpaginated.

186 George Herms and his family: Noever, *Dennis Hopper: A System of Moments*, 130.

186 Bell was wearing: Larry Bell, *Zones of Experience: The Art of Larry Bell* (Albuquerque, NM: Albuquerque Museum, 1997), 24.

186 "I take somebody": Dennis Hopper, Petra Giloy-Hirtz, and Brooke Hayward, *Dennis Hopper: The Lost Album: Vintage Prints aus den Sechziger Jahren* (Munich: Prestel, 2012), 19.

187 "were always relaxed": Julie Belcove, "Off Camera, Hopper Wielded His Own Lens," *NYT*, May 3, 2013, C34.

187 "the idea": Hopper et al., *Dennis Hopper: The Lost Album*, 19.

187 "there's only so much": Schwartz, *Ed Ruscha's Los Angeles*, 80.

187 "started really becoming": Peter L. Winkler, *Dennis Hopper: The Wild Ride of a Hollywood Rebel* (Fort Lee, NJ: Barricade Books, 2011), 75.

187 Hopps remembered: Edward Ruscha, *Leave Any Information at the Signal: Writings, Interviews, Bits, Pages* (Cambridge, MA: MIT Press, 2004), 324.

187 The space had been lined with: Steven Watson, *Factory Made: Warhol and the Sixties* (New York: Pantheon, 2003), 123.

188 Brooke imagined: Jean Stein, interview with BH, March 20, 1977, JSP.

188 Brooke cavorted with Henry: Mary Lea Bandy, Andy Warhol, and Callie Angell, *Andy Warhol Screen Tests: The Films of Andy Warhol: Catalogue Raisonné* (New York: Harry N. Abrams, 2006), 90.

188 Warhol also shot: Ibid., 89, 101.

188 "Andy just told": Ibid., 101.

188 Warhol did four: Ibid., 90.

188 "Being the egomaniac": Ibid., 101.

188 "I'm sure that": Jean Stein, interview with DH, October 3, 1973, JSP.

189 When Irving Blum sat: Bandy et al., *Andy Warhol Screen Tests*, 38.

189 "When someone turns": Calvin Tomkins, *The Scene: Reports on Post-modern Art* (New York: Viking Press, 1976), 20.

189 In September: Dennis's contact sheets at HAT are labeled with these dates. The photograph of the Factory denizens on the couch is often mistakenly dated to 1963, but the evidence indicates that it was taken in 1964 during the time frame of this visit to New York.

189 an idea Warhol had gotten: Tomkins, *The Scene*, 19.

189 Dennis bought one: Marjorie Hopper photo album, HAT. It is jarring to see this piece on the wall of a very normal-looking suburban house. David Hopper could not remember if the piece had hung in his parents' house or in his own. He was married on July 18, 1964, to Charlotte Uranga; perhaps it was a belated wedding gift from Dennis and Brooke.

189 "Dennis wanted": Dennis Hopper, *Dennis Hopper: Photographs, 1961–1967*, ed. Tony Shafrazi (Köln: Taschen, 2018), 407.

189 "a fascistic type": Jean Stein, interview with Gerard Malanga, November 16, 1976, JSP.

190 "We were going up": Belcove, "Off Camera, Hopper Wielded His Own Lens."

190 mahogany desk: Sally Bedell Smith, *Reflected Glory: The Life of Pamela Churchill Harriman* (New York: Simon & Schuster, 1996), 241.

190 Calder mobile: Allene Talmey, "Leland Hayward," *Vogue*, May 15, 1953, 49.

191 On the gallery's back wall: Ed Ruscha, Yve-Alain Bois, and Walter Hopps, *Edward Ruscha: Catalogue Raisonné of the Paintings*, vol. 1, *1958–1970* (Göttingen: Gagosian Gallery/Steidl, 2003), 357.

191 "It sort of aggrandizes": Ruscha, *Leave Any Information at the Signal*, 158.

191 paying $780: Hopper et al., *Dennis Hopper: A System of Moments*, 32. Ruscha remembered that the amount was around $1,500, which is, intriguingly, about double the number that Dennis always provided in interviews. It's possible that he and Brooke paid Blum $1,540, with half going to Ruscha, or that they paid in two installments of $780.

192 "To walk down": Southern, "The Loved House of the Dennis Hoppers," 164.

192 "master of evasion": Calvin Tomkins, "Ed Ruscha's L.A.," *TNY*, July 1, 1913, 48.

192 "Child of Pop": Edward Ruscha, Dave Hickey, and Peter Plagens, *The Works of Edward Ruscha* (New York: Hudson Hills Press, 1982), 20.

192 "atomic bomb": Ruscha, *Leave Any Information at the Signal*, 11.

193 He realized that: Ibid., 263.

193 *Oof*: Ruscha et al., *Edward Ruscha: Catalogue Raisonné of the Paintings*, vol. 1, *1958–1970*, 110.

193 "When I look": Dennis Hopper and Ed Ruscha, "The Pop Fathers," *Independent* (London), April 30, 2000, Features 1.

193 "Commercial America": Edward Ruscha, Dennis Hopper, and Jeffrey Deitch, *Edward Ruscha, Early Paintings: October 29 Through November 26, 1988* (New York: Tony Shafrazi Gallery, 1988), unpaginated.

193 "Ooh, I love": Hunter Drohojowska-Philp, *Rebels in Paradise: The Los Angeles Art Scene and the 1960s* (New York: Henry Holt, 2011), 77.

193 Michelangelo Antonioni: Ruscha, *Leave Any Information at the Signal*, 196.

193 John Lennon bought: Harriet Vyner, *Groovy Bob: The Life and Times of Robert Fraser* (London: Faber & Faber, 1999), 115. The piece is identified in Ruscha et al., *Edward Ruscha: Catalogue Raisonné of the Works on Paper*, vol. 1, *1956–1976*, 140.

193 Dennis walked the artist: Schwartz, *Ed Ruscha's Los Angeles*, 81.

194 Another photograph: "From the Archive," Pacific Standard Time at the Getty Center, http://blogs.getty.edu/pacificstandardtime/explore-the-era/archives/i55/.

194 "the best distillation": Cécile Whiting, *Pop L.A.: Art and the City in the 1960s* (Berkeley: University of California Press, 2008), 91.

195 he might be able: Hopper, *Dennis Hopper: Photographs*, 86.

195 "The excitement": Henry Geldzahler, "Los Angeles: The Second City of Art," *Vogue*, September 15, 1964, 42.

195 Brooke and Dennis: Ibid.

196 In *City of Night*: Barney Hoskyns, *Waiting for the Sun: Strange Days, Weird Scenes, and the Sound of Los Angeles* (New York: St. Martin's Griffin, 1996), 70.

196 "The sun is a joke": Nathanael West, *Miss Lonelyhearts & The Day of the Locust* (New York: New Directions, 2009), 178.

196 Dennis claimed: Dan Glaister, "'I'm Just an Art Bum . . .': Dennis Hopper's Photographs Are like a Who's Who of the 1960s. But Do They Belong in a Gallery?," *Guardian*, April 5, 2006, 18.

196 These works were inspired: Calvin Tomkins, *The Scene: Reports on Postmodern Art* (New York: Viking Press, 1976), 22.

196 Six and a half feet: *New York: The Second Breakthrough, 1959–1964: Exhibition March 18 to April 27, 1969* (Irvine: University of California, Irvine, 1969), Google Books, unpaginated.

197 On November 9: Telegram from Leland Hayward to BH, November 9, 1961, LHP.

199 "I, for one, certainly": Draft of *Haywire*, BHP.

199 "We are stuck": Marion McIntyre letter, undated, JTC.

200 *Attorneys at War*: Army Archerd, "Just for Variety," *Variety*, December 15, 1964, 4.

200 "a big trip": Hopper, *Dennis Hopper: Photographs*, 404.

200 He hung out: Contact sheets, HAT.

200 "The British": Hopper and Ruscha, "The Pop Fathers."

201 "It seemed he had": Vyner, *Groovy Bob*, 88.

201 *Breakaway* had been shot: Conner finished *Breakaway* in 1966, using as the soundtrack a song of that name performed by Basil and written by Ed Cobb.

201 "His are the most": NYU.

202 Upon Dennis's return: Jean Stein, interview with Marjorie Hopper, 4/10/88, JSP.

9: "THEY WERE ALL KIND OF NAKED, DANCING AROUND HENRY FONDA"

204 Curtis Harrington: Curtis Harrington, *Nice Guys Don't Work in Hollywood: The Adventures of an Aesthete in the Movie Business* (Chicago: Drag City Incorporated, 2013), 117–18.

204 "It was a collection": Peter Duchin with Charles Michener, *Ghost of a Chance: A Memoir* (New York: Random House, 1996), 344.

204 In 1964, Gernreich had: Booth Moore, "Rudi Gernreich Exhibition to Bow at Skirball Cultural Center," *WWD*, January 28, 2019, https://wwd.com/fashion-news/fashion-scoops/rudi-gernreich-exhibition-opening-at-skirball-cultural-center-1202990345.

205 The *Cosmo* feature: Harriet La Barre, "The Gernreich Girls: A New Pop Way of Living," *Cosmopolitan*, March 1965, 54.

207 Early in Dennis's career: "Actor Dennis Hopper, on Art," posted by Eardog Productions, YouTube, December 11, 2007, https://www.youtube.com/watch?v=0lZk4ABm_g8.

207 "I need an actor": Richard Boleslavsky, *Acting: The First Six Lessons* (New York: Theatre Arts, 1933), 26.

207 "I went off": "Actor Dennis Hopper, on Art."

207 "When he's older": John Gilmore, *Laid Bare: A Memoir of Wrecked Lives and the Hollywood Death Trap* (Los Angeles: Amok Books, 1997), 171.

207 "I got this part": Lawrence Linderman, "*Gallery* Interview: Dennis Hopper," *Gallery*, December 1972, reprinted in *Dennis Hopper: Interviews*, ed. Nick Dawson (Jackson: University Press of Mississippi, 2012), 73.

208 Dennis always said: Peter L. Winkler, "Tripping Toward Stardom: The Life and Career of Dennis Hopper," *Los Angeles Review of Books*, January 26, 2018, https://www.lareviewofbooks.org/article/tripping-toward-stardom-the-life-and-career-of-dennis-hopper/.

208 "So it was about time": Ibid.

208 "Tighten up!": Harold N. Pomainville, *Henry Hathaway: The Lives of a Hollywood Director* (Lanham, MD: Rowman & Littlefield, 2016), 227.

208 Dennis thought he: Linderman, *"Gallery* Interview: Dennis Hopper," 73.

208 "I learned more": Peter L. Winkler, *Dennis Hopper: The Wild Ride of a Hollywood Rebel* (Fort Lee, NJ: Barricade Books, 2011), 82.

208 Wayne had been battling: Pomainville, *Henry Hathaway*, 226.

209 Alamo Courts: Ibid.

209 "He thought of me": Scott Eyman, *John Wayne: The Life and Legend* (New York: Simon & Schuster, 2014), 395.

209 "Durango": Joan Didion, *Slouching Towards Bethlehem* (New York: Farrar, Straus & Giroux, 2008), 35.

209 "I was sitting there": Jean Stein, interview with DH, May 7, 1995, JSP.

210 After the Durango shoot wrapped: Josh Karp, "Dennis Hopper's Mad Vision," *Esquire,* October 1, 2018, https://www.esquire.com/entertainment/movies/a23287946/the-last-movie-dennis-hopper.

210 "a tyrant": Pomainville, *Henry Hathaway*, 227.

210 Two months after: Terry Southern, "The Loved House of the Dennis Hoppers," *Vogue,* August 21, 1965, 142.

210 "looks like a walking hangover": Jane Howard, "A Creative Capacity to Astonish," *Life,* August 21, 1964, 39.

210 "the most profoundly witty": Mark Singer, "Annals of Authorship: Whose Movie Is This?," *TNY,* June 22 and 29, 1998, 112.

210 "Where you find smugness": Ibid.

210 "We'd go to the house": Gail Gerber and Tom Lisanti, *Trippin' with Terry Southern: What I Think I Remember* (Jefferson, NC: McFarland, 2014), 90.

210 Marlon Brando: Dennis Hopper, *Dennis Hopper: Photographs, 1961–1967,* ed. Tony Shafrazi (Köln: Taschen, 2018), 411.

211 "Hopper, take care!": Southern, "The Loved House of the Dennis Hoppers," 142.

211 "Taking those photos": Hopper, *Dennis Hopper: Photographs,* 443.

211 urinate on the protesters: L. M. Kit Carson, *"Easy Rider*: A Very American Thing," *Evergreen,* November 1969, reprinted in *Dennis Hopper: Interviews,* ed. Nick Dawson (Jackson: University Press of Mississippi, 2012), 16.

211 "Let us march": Martin Luther, King, Jr., "Address at the Conclusion of the Selma to Montgomery March," March 25, 1965, The Martin Luther King, Jr., Research and Education Institute, Stanford University, https://kinginstitute.stanford.edu/our-god-marching.

212 Three nights before: Johnny Rogan, *Byrds: Requiem for the Timeless* (London: Rogan House, 2011), 98.

212 "The dancefloor was": Derek Taylor, "Behind Byrdmania—an Archive Piece from 1965," *Guardian,* July 15, 2015, https://www.theguardian.com/music/2015/jul/15/behind-byrdmania-an-archive-piece-from-1965, reprinted from *Melody Maker,* July 17, 2015.

212 *"Newsweek* called them": Anthony DeCurtis, James Henke, and Holly

George-Warren, *The Rolling Stone Illustrated History of Rock & Roll: The Definitive History of the Most Important Artists and Their Music* (New York: Random House, 1992), 116.

212 "five bland Apollonians": Barney Hoskyns, *Waiting for the Sun: Strange Days, Weird Scenes, and the Sound of Los Angeles* (New York: St. Martin's Griffin, 1996), 78.

213 Karen Yum Yum: Rogan, *Byrds: Requiem for the Timeless*, 99.

213 Johnny Fuck Fuck: Domenic Priore, *Riot on Sunset Strip: Rock 'n' Roll's Last Stand In Hollywood*, rev. ed (London: Jawbone Press, 2015), 86.

213 the Byrds rehearsed: Ibid., 86.

213 "dance hall slut": Hunter Drohojowska-Philp, *Rebels in Paradise: The Los Angeles Art Scene and the 1960s* (New York: Henry Holt, 2011), 88.

213 The artist Craig Kauffman: Ibid., 182.

213 "newness, postcard sunset color": Peter Plagens, *The Sunshine Muse: Contemporary Art on the West Coast* (New York: Praeger, 1974), 120.

213 Along with Dennis: Hoskyns, *Waiting for the Sun*, 78; John Einarson, *Mr. Tambourine Man: The Life and Legacy of the Byrds' Gene Clark* (New York: Backbeat Books, 2005), 60.

213 The women Dennis had photographed: Drohojowska-Philp, *Rebels in Paradise*, 89.

214 "They could have started": Priore, *Riot on Sunset Strip*, 88.

214 The crowd was: Einarson, *Mr. Tambourine Man*, 59.

214 "The floor was full": Art Seidenbaum, "Natives Quite Restless," *LAT*, April 28, 1965, C1.

214 "virtually having sex": Hoskyns, *Waiting for the Sun*, 78.

215 "From then on": Michael Walker, *Laurel Canyon: The Inside Story of Rock-and-Roll's Legendary Neighborhood* (New York: Faber & Faber, 2006), 15.

215 "That was a critical": Hopper, Dennis, *1712 North Crescent Heights: Photographs, 1962–1968* (New York: Greybull Press, 2001), unpaginated.

215 $240 to join: Harlan Ellison, *Harlan Ellison's Watching* (Los Angeles: Underwood-Miller, 1989), 478.

215 "It was the place": Hopper, *1712 North Crescent Heights*, unpaginated.

215 "television producers": Ellison, *Harlan Ellison's Watching*, 471–72.

215 "insults, gossip": Ibid., 472.

216 The centerpiece: Ibid.

216 In 1965, it was hard: Joyce Haber, "Everything Rosy for Daisy," *LAT*, May 6, 1966, C2.

216 "Compared to": Dan Jenkins, "Life with the Jax Pack," *Sports Illustrated*, July 10, 1967, https://vault.si.com/vault/1967/07/10/life-with-the-jax-pack.

216 Gay Talese stopped in: Gay Talese, "Frank Sinatra Has a Cold," *Esquire*, April 1966, 89. Dominick Dunne related a more sadistic example of Sinatra throwing his weight around in the Daisy in *The Way We Lived Then*

(pages 131–133), claiming that, at Sinatra's direction, an employee gratu-itously punched him in the face at the club in 1966. Dunne never returned to the Daisy.

216 On June 22: David Thomson, *Showman: The Life of David O. Selznick* (New York: Alfred A. Knopf, 1992), 691.

216 Dennis believed: Jean Stein, interview with DH, August 16, 2007, JSP.

216 addicted to Benzedrine: Jean Stein, *West of Eden* (New York: Random House, 2016), 221.

217 his attorney: Thomson, *Showman*, 691.

217 "Why can't I": Sally Bedell Smith, *Reflected Glory: The Life of Pamela Churchill Harriman* (New York: Simon & Schuster, 1996), 238.

217 "Man, he was never": Alix Jeffry, "D-e-n-n-i-s. H-o-p-p-e-r!," *NYT*, October 18, 1970, D13.

217 a framed portrait: Southern, "The Loved House of the Dennis Hop-pers," *Vogue*, 141.

217 "almost like my own": Brooke Hayward, *Haywire* (New York: Vintage, 2011), 302.

218 Truman Capote provided: Dominick Dunne scrapbook, 1965, Griffin Dunne Collection.

218 Joseph Cotton, Cary Grant: Peter Bart, "Film Stars Speak at Selznick Rites," *NYT*, June 25, 1965, 29.

218 "I've never seen": Hilton Als, "Profiles: Queen Jane, Approximately," *TNY*, May 9, 2011, 58.

218 "She's the only girl": Helen Lawrenson, *Latins Are Still Lousy Lovers* (New York: Hawthorn Books, 1968), 117.

218 Jane and her partner: Jane Fonda, *My Life So Far* (New York: Random House, 2005), 161. Adjusted for inflation, $200 in 1965 was equal to $1,650 in 2020, the year the house Jane and Vadim rented in 1965 was available to lease at $100,000 a month.

218 23816 Malibu Road: Dominick Dunne scrapbook, Griffin Dunne Col-lection.

219 "It was like a": Hopper, *Dennis Hopper: Photographs*, 233.

219 Bobby Walker: Jean Stein, interview with Robert Walker, Jr., August 27, 2007, JSP.

219 Gibson twelve-string: Peter Fonda, *Don't Tell Dad: A Memoir* (New York: Hyperion, 1999), 194.

219 Toby and Bob liked: Peter Biskind, *Easy Riders, Raging Bulls: How the Sex-Drugs-and-Rock'n'Roll Generation Saved Hollywood* (New York: Simon & Schuster, 1998), 57–59.

219 a robust supply: Stein, *West of Eden*, 218.

219 "Wog-hemp": Gerber and Lisanti, *Trippin' with Terry Southern*, 37.

219 The Dunnes rented: Dominick Dunne scrapbook, Griffin Dunne Collection.

220 gorilla suit: Jane Fonda, *My Life*, 161.

220 Warren Beatty, Steve McQueen: Ibid., 163ff.

220 Jill Schary remembered: Patricia Bosworth, *Jane Fonda: The Private Life of a Public Woman* (New York: Houghton Mifflin Harcourt, 2011), 229.

220 "Byrd Heads": Jane Fonda, *My Life*, 163.

221 "I still had": Rogan, *Byrds*, 139.

221 During a set break: Stein, *West of Eden*, 218.

221 "We were all": Ibid.

221 "Everything was": Ibid., 216.

221 "We were free!": Peter Fonda, *Don't Tell Dad*, 196.

222 In the sand: Jill Robinson, *Bed/Time/Story* (Los Angeles: Wimpole Street Books, 2015), 52.

222 She later admitted: Bosworth, *Jane Fonda*, 231.

223 Jane and Vadim were married: Rose Apodaca, "'I Do,' Vegas Style," *LAT*, July 15, 2007, https://www.latimes.com/style/la-ig-lookback15jul15-story .html.

223 Brooke and Dennis: Jane Fonda, *My Life*, 168.

223 "We looked down": Hopper, *1712 North Crescent Heights*, unpaginated.

223 In Las Vegas: Lawrenson, *Latins Are Still Lousy Lovers*, 119.

223 Donovan's "Colours": Peter Fonda, *Don't Tell Dad*, 206.

223 "He spent much": Apodaca, "'I Do,' Vegas Style."

223 Jane cried: Bosworth, *Jane Fonda*, 236.

223 Dennis was eager: Apodaca, "'I Do,' Vegas Style."

223 Motorcycle cop: Jill Lepore, "The History of the 'Riot' Report," *TNY*, June 22, 2020, https://www.newyorker.com/magazine/2020/06/22/the -history-of-the-riot-report.

223 Thirty-four people died: Sean O'Hagan, "Set the Night on Fire by Mike Davis and Jon Weiner—Review," *Guardian*, April 26, 2020, https://www .theguardian.com/books/2020/apr/26/set-the-night-on-fire-la-in-the -sixties-mike-davis-jon-wiener-review-.

224 One man: Lepore, "The History of the 'Riot' Report."

224 "an anarchistic holocaust": Morrie Ryskind, "All Riot on the Western Front," *LAT*, August 18, 1965, A5.

224 "L.A.'s racial sickness": Thomas Pynchon, "A Journey into the Mind of Watts," *NYT*, June 12, 1966, 264.

224 Teri Garr remembered: Teri Garr and Henriette Mantel, *Speedbumps: Flooring It Through Hollywood* (New York: Penguin, 2006), 51.

224 "Watts riots nationalized": Alexandra Schwartz, *Ed Ruscha's Los Angeles* (Cambridge, MA: MIT Press, 2010), 225.

224 "The city burning": Didion, *Slouching Towards Bethlehem*, 220.

224 Dennis hopped into: Garr and Mantel, *Speedbumps*, 51.

225 Martin Luther King, Jr.: Lepore, "The History of the 'Riot' Report."

225 The August issue of *Vogue*: Southern, "The Loved House of the Dennis Hoppers," 137ff.

225 The unsigned captions: In a November 14, 2017, interview with the author, Brooke said that that was when she had first met Didion.

225 Allene Talmey: Linda Kuehl, "Joan Didion, The Art of Fiction No. 71," *Paris Review*, Fall–Winter 1978, https://theparisreview.org/interviews /3439/the-art-of-fiction-no-71-joan-didion.

225 "To visit the Hopper house": Southern, "The Loved House of the Dennis Hoppers," 141. In 1964, *Vogue* did a story about Leland and Pamela's West-chester residence, Haywire House; the contrast between the conventional, "good life" taste of Haywire House and the outré fantasia of 1712 is strik-ing. The issue containing the piece about 1712 also ran Pamela's recipe for a Buck's Fizz.

226 "My lens is fast": Ibid., 142.

226 Southern wrote: Ibid.

227 She came to see: Jean Stein, interview with Marin Hopper, March 24, 2008, JSP.

228 "I tried to create": Judy Klemesrud, "Something Has Gone Haywire," *TNY*, March 9, 1977, 47.

228 In one of Roddy McDowall's: "Roddy McDowall Liz Ashley Lauren Bacall G Axelrod Dennis Hopper Brooke Hayward," posted by soap-bxprod, YouTube, September 7, 2011, https://www.youtube.com/watch ?v=c81Z1P47G1c.

228 In late August: "Month: August 1965," The Beatles Bible, https://www .beatlesbible.com/1965/08.

228 The moment he: Peter Fonda, *Don't Tell Dad*, 207–09.

229 It was the famous: Ibid.

229 "He was showing us": Brian Roylance, *The Beatles Anthology* (San Fran-cisco: Chronicle Books, 2000), 190.

229 "Who put all": Peter Fonda, *Don't Tell Dad*, 208.

229 "I was swimming": Roylance, *The Beatles Anthology*, 190.

229 McGuinn showed Harrison: Legs McNeil and Gillian McCain, "The Oral History of the First Two Times the Beatles Took Acid," Vice, Decem-ber 4, 2016, https://www.vice.com/en_us/article/ppawq9/the-oral-history -of-the-beatles-first-two-acids-trips-legs-mcneil-gillian-mccain.

229 McCartney, meanwhile: Roylance, *The Beatles Anthology*, 190.

229 The actress Peggy Lipton: McNeil and McCain, "The Oral History of the First Two Times the Beatles Took Acid."

229 As evening came on: Roylance, *The Beatles Anthology*, 190.

229 "Kids aren't so stupid": Charles Champlin, "Byrds Have Yet to Lay an Egg," *LAT*, June 7, 1965, D16.

230 He claimed: Arthur Bell, "Dennis Hopper," *Viva*, March 1974, reprinted in *Dennis Hopper: Interviews*, ed. Nick Dawson (Jackson: University Press of Mississippi, 2012), 96.

230 "a rock and roll motorcycle trip": David Hajdu, *Positively 4th Street: The*

Lives and Times of Joan Baez, Bob Dylan, Mimi Baez Fariña, and Richard Fariña (New York: Picador, 2011), 277. Jeffrey Thomas still has Dennis's copy of this album.

230 Andy Warhol had always found: Victor Bockris, *The Life and Death of Andy Warhol* (London: Fourth Estate, 1998), 229.

230 along with McGuinn: Rogan, *Byrds*, 182–83.

231 Robert Fraser flew in: Harriet Vyner, *Groovy Bob: The Life and Times of Robert Fraser* (London: Faber & Faber, 1999), 112. Dennis's contact sheets show the events overlapping.

231 Fraser was conceiving: Vyner, *Groovy Bob*, 113.

231 "a very seductive character": Ibid.

231 "It was the first time": Ibid., 112.

231 "some kind of weird speed": Ibid., 113.

10: "MAN, NOW I DON'T HAVE A COMPLETE CAKE"

233 He had the cover: *Artforum*, September 1965.

233 "Eddie Russia": Cécile Whiting, *Pop L.A.: Art and the City in the 1960s* (Berkeley: University of California Press, 2008), 73.

234 "Letter-Agreement": Stewart Stern, "The Last Movie: History and Documentation of Events," 1966, SSP. Stern dated the letter-agreement August 2, 1965.

234 "marvellously inventive": Ibid.

234 Brooke was excited: Ibid.

234 "He fascinated me": Pat McGilligan, ed., *Backstory 2: Interviews with Screenwriters of the 1940s and 1950s* (Berkeley: University of California Press, 1997), 303.

234 "I can't believe": NYU. This is an oft-cited anecdote in Dennis Hopper lore and one that Dennis was fond of relating. Who the agent could have been, though, is a mystery. Indications are that Dennis maintained his relationship with Robert Raison through that period.

234 ninety-seven-page treatment: Stewart Stern and Dennis Hopper, *The Last Movie Or: (Boo-Hoo in Tinseltown)*, 1965, SSP.

234 "Dennis would stride": Michael Bonner, "'An Incredible Assortment of Freaks': The Making of Dennis Hopper's The Last Movie," Uncut, May 16, 2014, https://www.uncut.co.uk/features/an-incredible-assortment-of-freaks-the-making-of-dennis-hopper-s-the-last-movie-8901/2.

235 The lead character: Stern and Hopper, *The Last Movie Or: (Boo-Hoo in Tinseltown)*.

235 Dennis envisioned: Jean Stein, interview with DH, May 7, 1995, JSP.

235 They came up with: Stern and Hopper, *The Last Movie Or: (Boo-Hoo in Tinseltown)*.

235 "Film is an art-form": Dennis Hopper, "Into the Issue of the Good Old

Time Movie Versus the Good Old Time," undated manuscript, ca. 1965, POP. *Vogue* rejected the piece; it would eventually be published in a 1972 book called *The Popular Culture Explosion*.

235 "What we need": Ibid.

235 *Vogue* rejected it: Rejection letter from Kate Rand Lloyd, associate feature editor, to DH, October 15, 1965, POP.

235 two-thirds scale: Lawrence Weschler, "Onward and Upward with the Arts: Cars and Carcasses," *TNY*, May 13, 1996, 54.

236 "I guess Barney's": Edward Ruscha, "Ed Ruscha: Artist," conducted by Martin Meeker, Andrew Perchuk, and James Cuno in 2015, Oral History Center of the Bancroft Library, The Bancroft Library, University of California, Berkeley, under the auspices of the J. Paul Getty Trust, 2016.

236 It was said: Domenic Priore, *Riot on Sunset Strip: Rock 'n' Roll's Last Stand in Hollywood*, rev. ed (London: Jawbone Press, 2015), 179.

236 "beatniks, neighborhood time wasters": "A Catalogue of Horrors: Suzi Gablik on Edward Keinholz, in 1965," *ARTnews*, August 26, 2016, https://www.artnews.com/art-news/retrospective/a-catalogue-of-horrors-suzi-gablik-on-edward-kienholz-in-1965–6866.

236 Kienholz used Dennis: Robert Dean and Roberta Bernstein, *Ferus* (New York: Gagosian Gallery, 2002), 287.

236 One day, he went: Peter Fonda, *Don't Tell Dad: A Memoir* (New York: Hyperion, 1999), 209.

236 Peter Fonda's place: The full address was 9551 Hidden Valley Road, per references in the online guide to the Roland Eli Coate archives at the University of California, Santa Barbara.

236 The circa-1936 house: Fonda, *Don't Tell Dad*, 162–63. Additional information from Zillow, https://www.zillow.com/homedetails/9551-Hidden-Valley-Rd-Beverly-Hills-CA-90210/20533709_zpid/.

236 When he had tried out: Ibid., 162.

236 Peter now told Dennis: Ibid., 209.

237 The "unsolved insanity": Eugenia Sheppard, "Another Fonda Generation Is Established," *Hartford Courant*, February 27, 1966, 11E.

237 Dennis said that: Fonda, *Don't Tell Dad*, 162–63.

237 "They came": Kliph Nesteroff, "An Interview with Joey Bishop's Gag Writer—Don Sherman—Part Two," Classic Television Showbiz, June 4, 2011, http://classicshowbiz.blogspot.com/2011/06/interview-with-joey-bishops-gag-writer.html.

237 "They wanted to see": Ibid.

237 Peter put Sherman: Fonda, *Don't Tell Dad*, 209.

237 Sherman was paid: Nesteroff, "An Interview with Joey Bishop's Gag Writer—Don Sherman—Part Two."

237 By mid-December: Fonda, *Don't Tell Dad*, 210.

237 The movie centered: Dennis Hopper, Peter Fonda, and Don Sherman, *The*

Yin and the Yang, screenplay, 1966, Wallace Berman papers, 1907–1979, bulk 1955–1979, AAA.

238 Peter claimed: Fonda, *Don't Tell Dad*, 210.

238 "There was such": Ibid.

238 Dennis's photograph *Double Standard*: Whiting, *Pop L.A.: Art and the City in the 1960s*, 92.

238 The foam sculptures: Harriet Vyner, *Groovy Bob: The Life and Times of Robert Fraser* (London: Faber & Faber, 1999), 115.

238 "treated almost like": Ibid.

238 "One of the more outré": Grace Glueck, "Art Notes: For Better Vision, Optacles," *TNY*, February 13, 1966, 110.

239 For some reason: Vyner, *Groovy Bob*, 116.

239 "Mr. Thomas": Michael M. Thomas, "A Golf Lesson from Dennis Hopper," *Travel & Leisure Golf*, March–April 1998, 98. According to Dennis's FBI files, made available under the Freedom of Information Act, he actually *was* being tailed by agents—but years later, in the early 1970s, the result of his activism on behalf of Native American causes.

239 "My biggest drive": Peter L. Winkler, "Anyone for Dennis," *Times* (London), November 27, 2011, https://www.thetimes.co.uk/article/anyone-for -dennis-njc0gfczf6t.

240 "I do enjoy group sex": Dennis Hopper, *Dennis Hopper: Photographs, 1961–1967*, ed. Tony Shafrazi (Köln: Taschen, 2018), 487.

240 "Sex has been": Philip K. Scheuer, "Vadim Is Frank on, off Screen," *LAT*, July 20, 1965, C8.

240 "It was not": Patricia Bosworth, *Jane Fonda: The Private Life of a Public Woman* (New York: Houghton Mifflin Harcourt, 2011), 240.

240 "Whether it's Goya": Hopper, *Dennis Hopper: Photographs*, 505.

240 Dennis and Peter made: Fonda, *Don't Tell Dad*, 211. The timing of this trip cannot be verified with exactitude. Most accounts, perhaps proceeding from Fonda's, say it happened soon after New Year's 1966. A copy of the screenplay on eBay has the date 1966. An item in the February 23, 1966, *Variety* has Dennis and Peter taking in Woody Allen's stand-up act at the Americana Hotel, strongly suggesting that the trip may have occurred at that time. Fonda also participated in Salvador Dalí's "happening" at Lincoln Center on February 23, and gave an interview to Eugenia Sheppard, much of which was incorporated into *The Yin(g) and the Yang*, that ran on February 27; in his memoir, he said he had *returned* to New York at that later time for a follow-up visit. In 1970, Dennis told *Esquire*'s Tom Burke that the trip had happened "the year the Pope" was in New York; Pope Paul VI visited in October 1965. Dennis, however, was consistently inconsistent when it came to assigning dates and years to his recollections. Fonda said he and Dennis stayed in a hotel that was being demolished, getting great rates. It could have been the Savoy Plaza, which closed in the fall of 1965.

Fonda also said that the script for *The Yin(g) and the Yang* was completed in December 1965, which indicates a New York trip in early 1966. Mick Jagger, whom they purportedly met up with in New York, appeared with the Rolling Stones on *The Ed Sullivan Show* on February 13. Ultimately, it may be that there were a couple of trips and/or that Dennis bookended his 1966 trip to London with New York visits.

240 *The Yin and the Yang*: Hopper et al., *The Yin and the Yang*, screenplay. The title on this copy was preceded with the words "Dennis Hopper's."

240 They bought new suits: Ibid.

241 It was possibly: Jean Stein, interview with DH, October 3, 1973, JSP.

241 In their search: Tom Burke, "Dennis Hopper Saves the Movies," *Esquire*, September 1970, 139.

241 "Huntington Hartford": James Stevenson, "Our Local Correspondents: Afternoons with Hopper," *TNY*, November 13, 1971, 127. Dennis, in Burke's 1970 *Esquire* profile, gave the location of the meeting with Baldwin as the Russian Tea Room.

241 In the lobby: Stevenson, "Our Local Correspondents," 127.

241 "Don't lie": Letter from DH to Clayton E. Carlson (editor of religious books at Harper & Row), August 13, 1970, HAT.

242 "What you hear": Mark Cousins, *Scene by Scene: Film Actors and Directors Discuss Their Work* (London: Laurence King, 2002), 90.

242 "Whoever does not": Jean-Yves Leloup, *The Gospel of Thomas: The Gnostic Wisdom of Jesus* (Rochester, VT: Inner Traditions/Bear, 2005), 101.

242 The unexpected theological detour: Fonda, *Don't Tell Dad*, 213ff.

242 De Sedle agreed: Ibid.

243 "Don't you get it": Ibid., 215. Intriguingly, the altarpiece at the Cloisters is now attributed to "Workshop of Robert Campin," not to Campin himself.

243 He and Peter declined: Ibid.

243 "I devised a tale": Curtis Harrington, *Nice Guys Don't Work in Hollywood: The Adventures of an Aesthete in the Movie Business* (Chicago: Drag City Incorporated, 2013), 109.

243 "was trying very hard": Louis Paul, *Tales from the Cult Film Trenches: Interviews with 36 Actors* (Jefferson, NC: McFarland, 2014), 207.

244 The band's bass player: Paul Trynka, *Brian Jones: The Making of the Rolling Stones* (New York: Penguin, 2015), 187.

244 Sparkletts water-cooler jug: Peter Ames Carlin, *Catch a Wave: The Rise, Fall, and Redemption of the Beach Boys' Brian Wilson* (Emmaus, PA: Rodale Books, 2007), 82.

245 "a scary motherfucker": Barney Hoskyns, *Waiting for the Sun: Strange Days, Weird Scenes, and the Sound of Los Angeles* (New York: St. Martin's Griffin, 1996), 102.

246 "the first tycoon of teen": Tom Wolfe, *The Kandy-Kolored Tangerine-Flake Streamline Baby* (New York: Noonday Press, 1966), 58.

246 "We drank": Jean Stein, interview with DH, November 3, 1990, JSP.

246 two dozen session musicians: Mark Ribowsky, *He's a Rebel: Phil Spector— Rock and Roll's Legendary Producer* (New York: Cooper Square Press, 2000), 2.

246 Accounts of the session: Hoskyns, *Waiting for the Sun*, 102.

246 Eventually Tina: Ibid.

247 Ike wasn't even around: William McKeen, *Everybody Had an Ocean: Music and Mayhem in 1960s Los Angeles* (Chicago: Chicago Review Press, 2017), 229.

247 Brian Wilson came: Ibid.

247 George Harrison said: "Shake," *Berkeley Tribe*, September 12–18, 1969, 21.

247 "The white stations": Mick Brown, *Tearing Down the Wall of Sound* (London: Bloomsbury, 2012), 212.

247 The humiliation: McKeen, *Everybody Had an Ocean*, 229.

247 architect Frederic P. Lyman's: Cory Buckner, *The Lyman House and the Work of Frederic P. Lyman: Drawing and Building* (Los Angeles: Crestwood Hills Press, 2016).

247 "a happening": Dave Felton, "'Underground' Wedding Celebrated," *LAT*, April 27, 1966, D5.

247 Michael McClure: Felton, "'Underground' Wedding."

247 Milk and honey: Felton, "'Underground' Wedding."

248 WEDDING SOUVENIR: "Claes Oldenburg, Wedding Souvenir," 1966, MoMA, https://www.moma.org/collection/works/77004.

248 "Claes was very impressed": Julie L. Belcove, "Off Camera, Hopper Wielded His Own Lens," *TNY*, May 3, 2013, 34.

248 Oldenburg even helped: Jean Stein, interview with DH, May 6, 1987, JSP.

248 "I stopped him": Belcove, "Off Camera, Hopper Wielded His Own Lens."

248 Los Angeles County Museum of Art: "County Museum of Art to Be Opened March 31: 3-Building Complex Is Largest Structure of Kind Erected in U.S. in Last 25 Years," *LAT*, January 24, 1965, 1.

248 "the biggest thing": Dean and Bernstein, *Ferus*, 293.

249 Kienholz agreed: Maurice Tuchman, *Art in Los Angeles: Seventeen Artists in the Sixties* (Los Angeles: Los Angeles County Museum of Art, 1981), 16.

249 "It seemed": Dean and Bernstein, *Ferus*, 309.

249 Many of the guests: Andy Warhol and Pat Hackett, *POPism: The Warhol Sixties* (New York: Houghton Mifflin Harcourt, 2015), 209ff.

249 Nico, whom Mick Jagger: Louise Criscione, "On the Beat," *KRLA Beat*, May 28, 1966, 2.

250 "The Byrds": Clinton Heylin, ed., *All Yesterdays' Parties: The Velvet Underground in Print, 1966–1971* (New York: Hachette, 2009), 111.

250 The band's violist: Carlin, *Catch a Wave*, 276.

250 He and Brooke: Tony Scherman and David Dalton, *Pop: The Genius of Andy Warhol* (New York: It Books, 2009), 332.

250 Jim Morrison: Legs McNeil and Gillian McCain, *Please Kill Me: The Uncensored Oral History of Punk* (New York: Grove Press, 1996), 17.

250 Cass Elliot: "Megamama with the Papas," *Datebook*, September 1966, reprinted in Alfredo García, *The Inevitable World of the Velvet Underground* (Madrid: Alfredo García, 2012), 64.

250 "clean as a gnawed skull": Paul Jay Robbins, "Andy Warhol and the Night on Fire," *Los Angeles Free Press*, May 13, 1966, reprinted in Clinton Heylin, ed., *All Yesterdays' Parties: The Velvet Underground in Print, 1966–1971* (New York: Hachette, 2009), 15. Dennis had photographed Robbins at a small anti–Vietnam War protest at the Cinerama Dome movie theater in December 1965; he also shot Peter Fonda and David Crosby at that event.

250 Cher hated it: Warhol and Hackett, *POPism*, 210.

250 "The Velvets": Ibid., 209–10.

251 "These guys": Heylin, *All Yesterdays' Parties*, 153.

251 "two-bit, pretentious": Victor Bockris and Gerard Malanga, *Up-tight: The Velvet Underground Story* (London: Omnibus Press, 2009), 65.

251 After three shows: Scherman and Dalton, *Pop*, 333.

251 Most of the Warhol entourage: Ibid.

251 "I didn't like": McNeil and McCain, *Please Kill Me*, 17.

251 "We had vast objections": Rob Jovanovic, *Seeing the Light: Inside the Velvet Underground* (New York: St. Martin's Press, 2012), 85.

252 The show signaled: Andy Warhol, *I'll Be Your Mirror: The Selected Andy Warhol Interviews*, ed. Kenneth Goldsmith (New York: Hachette, 2004), 96.

252 At the opening: "Youthful Caprice for Caps," *Life*, July 15, 1966, 84.

252 "Gerard," he whined: Mary Woronov, *Swimming Underground: My Years in the Warhol Factory* (Boston: Journey Editions, 1995), 39.

252 A week after: Letter from Roddy McDowall to DH, May 11, 1966, POP. As Jeffrey Thomas recalled, the phone number at 1712 was OL6–3309; the area code was 213.

252 "brilliant": Ron Rosenbaum, "Riding High: Dennis Hopper Bikes Back," *Vanity Fair*, April 1987, 133.

252 That day: Letter from Roddy McDowall to DH, May 11, 1966, POP.

252 The treatment took: The treatment of *The Last Movie* predated the screenplay of *The Yin and the Yang* slightly, but both were created during the same time frame, the fall of 1965. The relationship between Dennis and Stewart Stern was formalized in August 1965, and the initial payment of $4,000 from Brooke—the first installment of a proposed $25,000 fee—was payable on August 30, according to a 1969 deposition given by Stern. Stern recalled completing the treatment, or "screen story," by November 1, 1965. Accord-

ing to some sources, a screenplay of *The Last Movie* was also produced in 1965–1966. But in the deposition, Stern testifies that there was no screenplay written at that time. Given the subsequent tussles over a contract for Stern, it is likely that no screenplay was written until ca. 1969, when Dennis revived the project. In a copy of the script in the Stewart Stern Papers, references to Durango have been expunged and the original treatment's mention of a film choosing Spain over Durango as a shooting location has been altered. The project has decided to go to "Mexico" in this version, suggesting that the alterations had been made according to Dennis's decision to move the setting of *The Last Movie* from Durango to Peru. (Dennis would also write an undated film treatment called "The Second Chance" about an assemblage artist teaching at a San Francisco college; the treatment resides in the Hopper Art Trust. In Tom Burke's 1970 *Esquire* piece, Dennis said that he and Peter Fonda had been planning to make "The Second Chance" upon completion of *The Last Movie*.)

253 "It's a story about": Brad Darrach, "The Easy Rider Runs Wild in the Andes," *Life*, June 19, 1970, 51.

253 "He dreams of big cars": Ibid.

253 He wanted to use: Jean Stein, interview with DH, November 3, 1990, JSP.

254 The nudity, marijuana use, and profanity: Stewart Stern and Dennis Hopper, *The Last Movie Or: (Boo-Hoo in Tinsel Town)*, 1965, SSP. The racier elements of the treatment caused considerable consternation with authorities in Mexico when a translated version was sent to Mexico City in an effort to achieve a US-Mexican coproduction and to shoot the movie in Durango, as Stewart Stern testified in his 1969 deposition regarding the project.

254 "wonderful film": Rosenbaum, "Riding High."

254 In order to identify: Undated document, SSP.

254 He and Stern: Deposition, *Stewart Stern v. Phil Spector, Phil Spector Productions*, January 22, 1969, SSP.

254 A meeting was held: Ibid., 21ff., SSP.

255 The meeting went well enough: Ibid., 21. SSP.

255 Haskell Wexler: Peter Bart, "A Groovy Kind of Genius?," *NYT*, July 10, 1966, D9.

255 Robards was the man: Rosenbaum, "Riding High," 133.

255 Jennifer Jones, Joseph Cotten: Ibid.

255 Peter Fonda: "At 27, Peter Fonda Parades His Bit: Nonconformity," *Variety*, June 22, 1966, 18.

255 "The studios are backward": Bart, "A Groovy Kind of Genius?"

255 But Spector discovered: Letter from Phil Spector to DH, June 1966, SSP.

255 It began to look: Ibid.; Deposition, *Stewart Stern v. Phil Spector, Phil Spector Productions*, January 22, 1969, SSP.

255 "Spector was a terrifying": Michael Bonner, "'An Incredible Assortment of Freaks': The Making of Dennis Hopper's The Last Movie," Uncut, May 16, 2014, https://www.uncut.co.uk/features/an-incredible-assortment-of -freaks-the-making-of-dennis-hopper-s-the-last-movie-8901/2.

255 busied himself with: Deposition, *Stewart Stern v. Phil Spector, Phil Spector Productions*, January 22, 1969, 21; "The Last Movie: History and Documentation of Events Compiled by Stewart Stern," 1966, SSP.

256 *The Last Movie* ground: Ibid.

256 Dennis asked him: Dennis Hopper, *1712 North Crescent Heights, Photographs, 1962–1968* (New York: Greybull Press, 2001), unpaginated.

256 "It was the hardest": Jean Stein, interview with DH, November 3, 1990, JSP.

256 In late September: Letter from Phil Spector to Joel Steinberger, September 22, 1966, SSP.

256 "It was tragic": Rosenbaum, "Riding High," 133.

11: "IF I COULD JUST HELP THAT FLY FIND AN AIR CURRENT"

257 "Los Angeles may be": Christopher Rand, "Profiles: The Ulimate City," *TNY*, October 1, 1966, 56.

257 "Loss Ann-ja-luss": Ibid.

257 "All modern cities": Ibid., 74.

258 "Paris was where": Calvin Tomkins, "Profiles: Living Well Is the Best Revenge," *TNY*, July 28, 1962, 38.

258 As the California art critic: Peter Plagens, "Los Angeles: The Ecology of Evil," *Artforum*, December 1972, http://www.artforum.com/print/197210 /los-angeles-the-ecology-of-evil-36172.

258 Dennis gave a series: Molly Saltman, interviews with DH, MS. These were conducted by Molly Saltman and broadcast on station KPAL in Palm Springs.

258 "an interesting sort": Ibid.

259 "We wore our chains": Dennis Hopper, *Dennis Hopper: Photographs, 1961– 1967*, ed. Tony Shafrazi (Köln: Taschen, 2018), 484.

259 Conner shot: Bruce Conner, "Luke," http://michelle-silva.squarespace.com /luke.

259 "I believe this": "Bruce Conner with John Yao," The Brooklyn Rail, November 2004, https://brooklynrail.org/2004/11/art/bruce-conner-in -conversation.

260 Decades later: Bruce Conner, "Luke."

260 With its ghostly parade: Bruce Conner, *Luke*, 1967–2004, Conner Family Trust.

260 It was, in fact: Dave Gardetta, "The Strip: Something's Happening; What It Is Ain't Exactly Clear," *LAT*, December 15, 1996, 24.

260 The buildings he documented: Edgar Z. Friedenberg and Anthony Bernhard, "The Battle of the Sunset Strip," *New York Review of Books*, March 9, 1967, reprinted in Dennis Hale and Jonathan Eisen, eds., *The California Dream* (New York: Collier, 1968), 262ff.

261 The solution was: Renata Adler, "Fly Trans-Love Airways," *TNY*, February 25, 1967, https://www.newyorker.com/magazine/1967/02/25/fly-trans -love-airways.

261 "insane.": Mike Tuck, "Chaos on the Sunset Strip," *KRLA Beat*, December 17, 1966, 9.

261 Al Mitchell: Domenic Priore, *Riot on Sunset Strip: Rock 'n' Roll's Last Stand in Hollywood*, rev. ed. (London: Jawbone Press, 2015), 337.

261 There was plenty: Friedenberg and Bernhard, "The Battle of the Sunset Strip," 266.

262 "We're Your Children!": Cara Mia DiMassa, "Clash of Rowdy, Refined," *LAT*, October 11, 2008, B1, https://www.latimes.com/archives/la-xpm -2008-oct-11-me-strip11-story.html.

262 "I saw a kid holding": Mike Davis, "Riot Nights on the Sunset Strip," *Labour/Le Travail* 59, Spring 2007, 201.

262 Television crews: Friedenberg and Bernhard, "The Battle of the Sunset Strip," 268.

262 They obliged: Davis, "Riot Nights on the Sunset Strip," 205.

262 The total damage: Adler, "Fly Trans-Love Airways."

262 "Riot is a": Cecilia Rasmussen, "Closing of Club Ignited the 'Sunset Strip Riots,'" *LAT*, August 5, 2007, B2.

262 Roman centurions: Priore, *Riot on Sunset Strip*, 365.

262 "on the one hand": Adler, "Fly Trans-Love Airways."

263 "I love": Guy Flatley, "D-e-n-n-i-s. H-o-p-p-e-r!," *TNY*, October 18, 1970, D13.

263 David Hockney: Priore, *Riot on Sunset Strip*, 337.

263 Jack Nicholson: Rasmussen, "Closing of Club Ignited the 'Sunset Strip Riots.'"

263 Jim Dickson: Ibid.

263 Peter Fonda: Peter Fonda, *Don't Tell Dad: A Memoir* (New York: Hyperion, 1999), 232–33.

263 "Man, the kids": Jon Savage, *1966: The Year the Decade Exploded* (London: Faber & Faber), 2015, 490.

263 "The peasants": Raymond R. Sarlot and Fred E. Basten, *Life at the Marmont: The Inside Story of Hollywood's Legendary Hotel of the Stars—Chateau Marmont* (Santa Monica, CA: Roundtable, 1987), 247.

264 "The support system": Paul Cummings, Oral history interview with Irving Blum, May 31–June 23, 1977, AAA.

264 But as the East Coast: Barbara Isenberg, "An L.A. Art Story," *LAT*, September 22, 2002, Calendar 4.

264 on December 13: "Art News: Mural Stands in Claremont," *LAT*, December 11, 1966, B43.

264 Craig Ellwood–designed: Henry J. Seldis, "In the Galleries: Nevelson Turns to Greater Clarity," *LAT*, December 16, 1966, E12.

264 *Vogue* would run: John Coplans, "Art Bloom," *Vogue*, November 1, 1967, 184.

264 "What Ferus had": Ibid., 311.

264 Blum's Ferus/Pace experiment: Irving Blum Gallery opening advertisement, *LAT*, October 1, 1967, D43.

265 That year, *Artforum*: Rebecca Peabody et al., eds., *Pacific Standard Time: Los Angeles Art, 1945–1980* (Los Angeles: Getty Research Institute/J. Paul Getty Museum, 2011), 134.

265 "It was an extraordinary": Paul Cummings, Oral history interview with Irving Blum, May 31–June 23, 1977, AAA.

265 "In the early 60's": Paul Cummings, Oral history interview with Henry Geldzahler, January 27, 1970, AAA.

265 Warhol figured: Andy Warhol and Pat Hackett, *POPism: The Warhol Sixties* (New York: Houghton Mifflin Harcourt, 2015), 58.

265 Ivan Karp: Kristine McKenna, *The Ferus Gallery: A Place to Begin* (Göttingen: Steidl, 2009), 260.

265 "I didn't think": Ibid., 263.

265 art doldrums: Calvin Tomkins, *The Scene: Reports on Post-modern Art* (New York: Viking, 1976), 27.

265 *Three Young Collections* show: Thomas Leavitt, *Three Young Collections: Selections from the Collections of Donald and Lynn Factor, Dennis and Brooke Hopper, and André and Dory Previn (January 15–February 26, 1967)* (Santa Barbara, CA: Santa Barbara Museum of Art, 1967).

266 "an amazing artist-photographer": Henry J. Seldis, "In the Galleries: Last Chance to See Collection," *LAT*, February 17, 1967, D6.

266 "do-it-yourself Medici": Wendy Goodman, "A Jeweled Setting," *House & Garden*, December 1990, 140.

266 read Herbert Marcuse: Hutton Wilkinson, *More Is More: Tony Duquette* (New York: Harry N. Abrams, 2009), 49.

266 "Insects are the leaders": Ibid., 20.

266 "A house should": Ibid.

266 "Beauty, not luxury": Goodman, "A Jeweled Setting," 139.

266 Duquette, too, loved: Wilkinson, *More Is More*, 54–55.

266 fashioning sculptural objects: Ibid., 20.

266 taxidermied birds: Ibid., 21.

266 In the 1940s: Ibid., 11.

267 He often wore: Ibid., 26.

267 In mid-January: Dennis Hopper, *1712 North Crescent Heights: Photographs, 1962–1968* (New York: Greybull Press, 2001), unpaginated.

267 "Traveling up": Barney Hoskyns, *Waiting for the Sun: Strange Days, Weird Scenes, and the Sound of Los Angeles* (New York: St. Martin's Griffin, 1996), 144.

267 "I marched": Flatley, "D-e-n-n-i-s. H-o-p-p-e-r!"

268 "We were looking": Jack Tewksbury, "Oral History: Dennis Hopper Goes Back to the Sixties," Golden Globe Awards, May 8, 2019, https://www.goldenglobes.com/articles/oral-history-dennis-hopper-goes-back-sixties.

268 Gary Snyder: "Human Be-In—Full Program—1/14/1967—Polo Fields, Golden Gate Park (Official)," posted by Docs&Interviews on MV, You-Tube, September 25, 2014, https://www.youtube.com/watch?v=HTGyFgyB5Q8.

268 San Francisco's guerrilla: Peter Coyote, *Sleeping Where I Fall: A Chronicle* (Berkeley, CA: Counterpoint, 2015), 75.

268 The meat was used: Emmett Grogan, *Ringolevio: A Life Played for Keeps* (New York: New York Review Books, 2008), 274.

268 "Turn on": Michael Pollan, *How to Change Your Mind: What the New Science of Psychedelics Teaches Us About Consciousness, Dying, Addiction, Depression, and Transcendence* (New York: Penguin, 2018), 204.

268 "This was the": Lisa Law, *Flashing on the Sixties: Photographs* (San Francisco: Chronicle Books, 1987, 54.

269 "The Human Be-In": Grogan, *Ringolevio*, 274.

269 To him, Ginsberg: Ibid., 275.

269 "sat on the grass": Ibid.

269 a pass from the Diggers: Coyote, *Sleeping Where I Fall*, 100.

269 "Young people": Elizabeth Snead, "Dennis Hopper: Renaissance Rebel," *Cigar Aficionado*, January–February 2001, https://www.cigaraficionado.com/article/dennis-hopper-rennaissance-rebel-6017.

269 "Dennis came": It is unclear how Dennis traveled on that trip, whether by air or by car.

269 Duquette liked to lay: Wilkinson, *More Is More*, 17.

269 Duquette suggested: Hopper, *1712 North Crescent Heights*, unpaginated.

270 Dennis got behind: Ibid.

270 "She missed a big": Hopper, *1712 North Crescent Heights*, unpaginated.

270 Brooke said she: Ibid.

270 "altered forever": Peter Biskind, *Easy Riders, Raging Bulls: How the Sex-Drugs-and-Rock 'n' Roll Generation Saved Hollywood* (New York: Simon & Schuster, 1999), 44.

270 "Dennis always had": Tai Babilonia and David Dodd, "Dennis Hopper," in *Playing It Straight: Personal Conversations on Recovery, Transformation and Success* (Deerfield Beach, FL: Health Communications, 1996), reprinted in *Dennis Hopper: Interviews*, ed. Nick Dawson (Jackson: University Press of Mississippi, 2012), 169.

271 "When I was": Ibid.

271 "I was drinking": Ibid.

271 "I wouldn't *think*": Lawrence Linderman, "*Gallery* Interview: Dennis Hopper," *Gallery*, December 1972, reprinted in *Dennis Hopper: Interviews*, ed. Nick Dawson (Jackson: University Press of Mississippi, 2012), 77.

273 "He will always be": David Hopper, "Eulogy to W. Lonnie Davis," 1967, HAT.

273 At least four thousand: Dave Larsen, "Hippies Fill Glen with Splendors of Love and Miniskirts," *LAT*, March 27, 1967, 3.

274 "Tribal Gathering": Johnny Rogan, *Byrds: Requiem for the Timeless* (London: Rogan House, 2011), 337–38.

274 Grandsarah: Various documents and communications, LHP.

274 *Vogue* asked him: Chris Hodenfield, "Citizen Hopper," *Film Comment*, November–December 1986, reprinted in *Dennis Hopper: Interviews*, ed. Nick Dawson (Jackson: University Press of Mississippi, 2012), 128.

274 *Partisan Review*: Richard Poirier, "Learning from the Beatles," *Partisan Review*, November 1967, 526.

274 at the Hollywood Bowl: Pete Johnson, "Hollywood Bowl Plays Host to the Monkees," *LAT*, June 12, 1967, D25.

277 "Monterey was a giant": Harvey Kubernik and Kenneth Kubernik, *A Perfect Haze: The Illustrated History of the Monterey International Pop Festival* (Solana Beach, CA: Santa Monica Press), 2011, Google Books, unpaginated.

277 The photographer Jim Marshall: Jim Marshall contact sheets at Gotta Have Rock and Roll, https://www.gottahaverockandroll.com.

277 chunky necklace: Robert Sellers, *Hollywood Hellraisers: The Wild Lives and Fast Times of Marlon Brando, Dennis Hopper, Warren Beatty, and Jack Nicholson* (New York: Skyhorse, 2010), 99. In Jim Marshall's photographs, this appears to be the same necklace Dennis had worn in *The Trip*.

278 the Who's Roger Daltrey: Ibid.

278 Dennis may have intended: Andy Gill, "ALBUMS—It Happened in Monterey," *Independent*, February 24, 1994, 26.

278 Dennis remembered: Andy Baybutt, "Rare Dennis Hopper interview by Andy Baybutt part 1," June 14, 2010, https://www.youtube.com/watch?v=Ln8AWS7eD4s.

278 Dennis found Michelle Phillips: Jean Stein, interview with DH, June 13, 1995, JSP.

278 During their Saturday-night set: *The Complete Monterey Pop Festival*, directed by D. A. Pennebaker (New York: Criterion Collection, 2002), Criterion Collection channel (expanded edition of *Monterey Pop*, 1968, directed by Pennebaker).

279 "Why do you do": DH self-interview questions, 1970, HAT.

279 "When am I going": Rogan, *Byrds*, 135.

279 The next night: Barney Hoskyns, *Waiting for the Sun: Strange Days, Weird Scenes, and the Sound of Los Angeles* (New York: St. Martin's Griffin, 1996), 148.

279 "That child meant": Jean Stein, interview with Marjorie Hopper, April 10, 1988, JSP.

279 Brooke's European escape: Memo from Kathleen Malley to Leland Hayward, August 29, 1967, LHP. This note from Leland's secretary alludes to Brooke having been in England "some weeks ago."

279 She made her way: Helen Lawrenson, *Latins Are Still Lousy Lovers* (New York: Hawthorn Books, 1968), 117–18.

280 In Rome, there was: Patricia Bosworth, *Jane Fonda: The Private Life of a Public Woman* (New York: Houghton Mifflin Harcourt, 2011), 252–56.

280 He said she would shut: Peter Biskind, *Easy Riders, Raging Bulls: How the Sex-Drugs-and-Rock 'n' Roll Generation Saved Hollywood* (New York: Simon & Schuster, 1999), 44–45.

280 "From what I know": Peter Biskind, interview with Peter Fonda, March 17, 1997.

281 "I sat in a chair": Tom Burke, "Dennis Hopper Saves the Movies," *Esquire*, September 1970, 139.

281 By his own account: Peter L. Winkler, *Dennis Hopper: The Wild Ride of a Hollywood Rebel* (Fort Lee, NJ: Barricade Books, 2011), 90.

281 One rainy dawn: Dennis Hopper and Michael McClure, *Out of the Sixties* (Santa Fe: Twelvetrees Press, 1986), unpaginated.

281 On another occasion: Coyote, *Sleeping Where I Fall*, 101.

282 "Rape is as common": Chester Anderson, "Uncle Tim'$ Children," April 14, 1967, The Digger Archives, https://www.diggers.org/comco/cc paps2b.html.

282 George Harrison made: Pattie Boyd and Penny Junor, *Wonderful Tonight: George Harrison, Eric Clapton, and Me* (New York: Crown, 2008), 104.

283 "I see a child": Joan Didion, *Slouching Towards Bethlehem* (New York: Farrar, Straus & Giroux, 2008), 127.

283 "We were young": Coyote, *Sleeping Where I Fall*, 100.

283 One day at 1712: Ibid., 101.

283 "These guys": Ibid., 100.

283 "I came to think": Ibid., 101.

283 one of the Diggers: Ibid.

283 The latter: *The Trip*, directed by Roger Corman (Los Angeles: American International Pictures, 1967).

284 Corman met with Dennis: Chris Nashawaty, *Crab Monsters, Teenage Cavemen, and Candy Stripe Nurses: Roger Corman: King of the B Movie* (New York: Harry N. Abrams, 2013), 83.

284 When Peter read: Peter Biskind, interview with Peter Fonda, March 17, 1997.

284 "From the LSD movies": Nashawaty, *Crab Monsters, Teenage Cavemen, and Candy Stripe Nurses*, 80.

284 "We didn't have access": Ibid.

284 Tom Wolfe had declined: David Browne, "Tom Wolfe on the Secret to Great Reporting and Why He Never Tried Acid," *Rolling Stone*, May 15, 2018, https://www.rollingstone.com/culture/culture-features/tom-wolfe -on-the-secret-to-great-reporting-and-why-he-never-tried-acid-627881.

284 So he did: Nashawaty, *Crab Monsters, Teenage Cavemen, and Candy Stripe Nurses*, 78–79.

285 Dennis's own LSD experimentation: "Dennis Hopper—Interview Retrospective 2008 | Part 4," Arte television interview, Vernissage in the Cinémathèque de Paris, 2008, posted posted by splashfin, YouTube, December 20, 2008, https://www.youtube.com/watch?v=oUWc_xcdC6s. In this interview, Dennis claimed that he had dropped acid for the first time in preparation for *The Trip*, having previously held off because he'd already done mushrooms and peyote. He said that Bob Rafelson had supplied the LSD for the trip, during which he had seen himself as a caveman.

285 "Shit, he was big": Nashawaty, *Crab Monsters, Teenage Cavemen, and Candy Stripe Nurses*, 81.

285 Glimpses of the Angeleno underground: *The Trip*.

285 Dennis and Peter talked Corman: Nashawaty, *Crab Monsters, Teenage Cavemen, and Candy Stripe Nurses*, 79.

285 Dennis shot dreamy footage: Hopper, *Dennis Hopper: Photographs*, 462.

285 "The footage was beautiful": John Wisniewski, "Dennis Hopper Needed Our Love: An Interview with Peter Winkler," *Los Angeles Review of Books*, 6/1/13, https://lareviewofbooks.org/article/dennis-hopper-needed -our-love-an-interview-with-peter-winkler.

286 Dennis and Peter were furious: Fonda, *Don't Tell Dad*, 238.

286 Corman claimed: Nashawaty, *Crab Monsters, Teenage Cavemen, and Candy Stripe Nurses*, 83.

286 *The Trip* turned out: "All-Time Film Rental Champs," *Variety*, January 7, 1976, 46. This report claims that the movie, with a widely reported budget of $100,000, made $5.1 million in North American rentals.

286 Dennis didn't care: Peter Winkler, "5 Things You Never Knew About Dennis Hopper," HuffPost, November 7, 2012. https://huffpost.com /entry/dennis-hopper-life-_b_1865204.

286 *The Glory Stompers*: Brian Albright, *Wild Beyond Belief! Interviews with Exploitation Filmmakers of the 1960s and 1970s* (Jefferson, NC: McFarland, 2008), 211.

286 "Like, we accidentally": *The Glory Stompers*, directed by Anthony M. Lanza (Beverly Hills: Metro Goldwyn Mayer, 2011).

286 Quentin Tarantino later claimed: Dennis Hopper, "Blood Lust Snicker Snicker in Wide Screen," *Grand Street* no. 49 (1994), reprinted in *Dennis*

Hopper: Interviews, ed. Nick Dawson (Jackson: University Press of Mississippi, 2012), 161.

286 He acquired the nickname: Albright, *Wild Beyond Belief!*, 212.

287 "I drove the guy": Hopper, "Blood Lust Snicker Snicker in Wide Screen."

287 His costar Jody McCrea: Thomas Lisanti, *Hollywood Surf and Beach Movies: The First Wave, 1959–1969* (Jefferson, NC: McFarland, 2015), 395.

287 earned $6 million: Gene Freese, *Jock Mahoney: The Life and Films of a Hollywood Stuntman* (Jefferson, NC: McFarland, 2013), 143.

287 Lanza claimed: Albright, *Wild Beyond Belief!*, 153.

287 "the senseless insouciance": Joan Didion, *The White Album* (New York: Farrar, Straus and Giroux, 1990), 100.

287 "underground folk literature": Ibid.

287 "We wanna be free": *The Wild Angels*, directed by Roger Corman (Los Angeles: American International Pictures, 1966).

287 "We are complete": Hunter S. Thompson, "Motorcycle Gangs," *Nation*, May 17, 1965, https://www.thenation.com/article/archive/motorcycle-gangs.

288 At the Human Be-In: Michael W. Flamm and David Steigerwald, *Debating the 1960s: Liberal, Conservative, and Radical Perspectives* (New York: Rowman & Littlefield, 2008), 67.

288 "No half-bohemian party": Hunter S. Thompson, "From *Hells Angels*: The Dope Cabala and a Wall of Fire," in *The Portable Sixties Reader*, ed. Ann Charters (New York: Penguin, 2003), 213.

288 "It puzzled them": Ibid., 214.

289 Beatty had considered: Suzanne Finstad, *Warren Beatty: A Private Man* (New York: Crown/Archetype, 2006), 362.

289 "The audience is alive": Pauline Kael, "Onward and Upward with the Arts: 'Bonnie and Clyde,'" *TNY*, October 21, 1967, 147.

289 *Bonnie and Clyde* landed: *Time*, December 8, 1967, cover.

290 "Riding motorcycles": Jean Stein, interview with DH, May 7, 1995, JSP.

12: "GET THE CHILDREN OUT OF THE HOUSE"

291 He recorded a single: Peter Fonda, *Don't Tell Dad: A Memoir* (New York: Hyperion, 1999), 239.

291 On it went: Peter Biskind, interview with Peter Fonda, March 17, 1997.

291 "You're out": Fonda, *Don't Tell Dad*, 239–40.

292 With Peter promising: Peter Biskind, interview with Peter Fonda, March 17, 1997.

292 "the art of films": Fonda, *Don't Tell Dad*, 239–40.

292 "With you I": Note from Peter Fonda to DH, May 31, 1973, HAT.

292 "We were having problems": Dennis Hopper, *1712 North Crescent Heights: Photographs, 1962–1968* (New York: Greybull Press, 2001), unpaginated.

293 "There seems to be": Marion McIntyre letter, October 11, 1962, JTC.

293 Marin's memories: Jean Stein, interview with Marin Hopper, February 6, 1984, JSP.

293 At 1:30 in the morning: Fonda, *Don't Tell Dad*, 242–43. Fonda always remembered the date of his phone call to Dennis; he claimed that it was inscribed on a gold Zippo lighter that was given to him that day in Toronto when he returned to his official duties after telling Dennis the narrative outline of the movie that became *Easy Rider*.

293 Her father had been: Sally Bedell Smith, *Reflected Glory: The Life of Pamela Churchill Harriman* (New York: Simon & Schuster, 1996), 241–43.

293 "Haywire House": Valentine Lawford, "The Leland Haywards of the 'Haywire House,'" *Vogue*, February 15, 1964, 124.

294 calling from a motel: Fonda, *Don't Tell Dad*, 240–41, and "Escalation of 'Pix' Violence Hit by Theatre Owners at Convention." *Variety*, September 27, 1967, 1.

294 He asked Brooke: Steven Bingen, *Easy Rider: 50 Years Looking for America* (New York: Lyons Press, 2019), 6.

294 "Listen to this": Peter Biskind, interview with Peter Fonda, March 17, 1997.

294 He went on: Fonda, *Don't Tell Dad*, 241–42.

294 "They don't like us": Peter Biskind, interview with Peter Fonda, March 17, 1997.

294 Peter pictured: Nathan Rabin, "Interview: Peter Fonda," AV Club, 10/01/03, https://www.avclub.com/peter-fonda-1798208296.

294 *America*, Peter said: Peter Biskind, interview with Peter Fonda, March 17, 1997.

295 "That's great, man!": Fonda, *Don't Tell Dad*, 242.

295 "Man, I sure am glad": Peter Biskind, interview with Peter Fonda, March 17, 1997.

295 "Peter was the one": *The American Dreamer*, directed by L. M. Kit Carson and Lawrence Schiller (Los Angeles: Corda Productions, 1971), posted by sgolowka, YouTube, November 17, 2016, https://www.youtube.com /watch?v=x8hpYYhLJyc.

295 He had one suggestion: Peter Biskind, *Easy Riders, Raging Bulls: How the Sex-Drugs-and-Rock 'n' Roll Generation Saved Hollywood* (New York: Simon & Schuster, 1998), 42.

295 "That's the corniest story": Fonda, *Don't Tell Dad*, 243.

295 *The Loners*: Biskind, *Easy Riders, Raging Bulls*, 45.

295 thanks to a suggestion: Rabin, "Interview: Peter Fonda."

295 "Hopper and I talked": Peter Biskind, interview with Peter Fonda, March 17, 1997.

296 Dennis and Peter spent: Ibid.

296 "the most commercial story": Fonda, *Don't Tell Dad*, 245. Dennis corroborated

this account in a conversation with Peter M. Brant and Tony Shafrazi that ran in *Interview* magazine, July 15, 2010.

296 As Southern's girlfriend: Gail Gerber and Tom Lisanti, *Trippin' with Terry Southern: What I Think I Remember* (Jefferson, NC: McFarland, 2014), 89. Gerber placed the encounter in Rome, not in France.

296 "You're both stoned": Fonda, *Don't Tell Dad*, 246.

297 After *Spirits of the Dead* wrapped: Ibid., 245–46.

297 Dennis got swept up: Gerber and Lisanti, *Trippin' with Terry*, 90.

297 Southern suggested: Fonda, *Don't Tell Dad*, 249.

297 "gave us dark humor": Rabin, "Interview: Peter Fonda."

297 As for the catchy new title: Ibid.

297 "Liberty's become a whore": Patrick McGilligan, *Jack's Life: A Biography of Jack Nicholson* (New York: W. W. Norton, 1996), 20.

297 A dinner was arranged: Peter Biskind, interview with Peter Fonda, March 17, 1997. Fonda dated the dinner at Serendipity to late 1967, while Gerber remembered it as 1968.

297 In attendance: Fonda, *Don't Tell Dad*, 248.

297 Torn was meant: Gerber and Lisanti, *Trippin' with Terry*, 90.

297 a role that Dennis: McGilligan, *Jack's Life*, 19–20.

298 According to Torn's memory: Janet Shprintz, "Appeals Court Upholds Judgment vs. Hopper," *Variety*, 4/2/98, https://variety.com/1998/film/news/appeals-court-upholds-judgment-vs-hopper-1117469436/; Biskind, *Easy Riders, Raging Bulls*, 67–68.

298 In other variations: Biskind, *Easy Riders, Raging Bulls*, 67–68.

298 disarmed Dennis: Mark Singer, "Annals of Authorship: Whose Movie Is This?," *TNY*, June 22 and 29, 1998, 118.

298 At that juncture: Susan Dominus, "Rip Torn Won't Go Gentle into That Good Night," *New York Times Magazine*, May 7, 2006, 56.

298 In Peter's telling: Peter Biskind, interview with Peter Fonda, March 17, 1997.

298 After years of litigation: Adam Sandler, "Torn Rips Hopper Coin," *Variety*, May 11, 1999, https://variety.com/1999/biz/news/torn-rips-hopper-coin-1117500225/. The decision was reached in 1998.

298 These were strewn: Christmas 1967 photographs, Marjorie Hopper photo album, HAT.

299 After the new year: Fonda, *Don't Tell Dad*, 249.

299 Roger Corman was: Chris Nashawaty, *Crab Monsters, Teenage Cavemen, and Candy Stripe Nurses: Roger Corman, King of the B Movie* (New York: Harry N. Abrams, 2013), 83.

299 On January 8: "Dennis Hopper to Star in 'Beard,'" *LAT*, January 8, 1968, C27.

300 "a milestone": Clive Barnes, "Theater: Two-Character 'The Beard': Billie Dixon and Bright in McClure's Play," *NYT*, October 25, 1967, 40.

300 "a mysterious piece of work": Norman Mailer, introduction to Michael McClure, *The Beard* (New York: Grove Press, 1967), xx.

300 A commenter in *Newsweek*: Display ad, *LAT*, January 21, 1968, WS6.

300 Andy Warhol shot: Kurt Hemmer, "Outlaw Tongues: The Stimuli for Michael McClure's *The Beard*," in *Beat Drama: Playwrights and Performances of the 'Howl' Generation*, ed. Deborah R. Geis (London: Bloomsbury, 2016), Google Books, unpaginated. Through the San Francisco lawyer Melvin Belli, McClure sent a letter to Warhol requesting that his version of *The Beard* never be screened. In 1971, Bruce Conner attempted to make a film version of *The Beard*, asking Dennis to star in it (letter from Conner to Hopper, January 13, 1971, HAT); Agnès Varda included elements of *The Beard* in her 1969 film, *Lions Love (. . . and Lies)*.

300 "rips off Jean Harlow's panties": Biskind, *Easy Riders, Raging Bulls*, 44.

300 One day, Brooke drove: Ibid.

300 Dennis left the production: In an ad that ran in the *Los Angeles Times* three days before the premiere, Dennis was still listed as the star. He would be replaced at the last minute by Richard Bright, an actor who had previously played the role of Billy.

301 "the gravest mistake": Hopper, *1712 North Crescent Heights*, unpaginated.

301 On the wall: Dennis Hopper photographs, HAT.

301 1890s theatrical poster: Joseph Arthur, *Blue Jeans "Will Never Wear Out": by Joseph Arthur, Author of "The Still Alarm*," lithograph, 1899, Library of Congress, https://www.loc.gov/item/2014636407/.

302 She'd been in therapy sessions: Unpublished BH essay, 2015.

302 With *Easy Rider* in limbo: Peter Biskind, interview with Peter Fonda, March 17, 1997.

303 A few days later: Ibid.

303 He would, however: Biskind, *Easy Riders, Raging Bulls*, 68.

303 "Bert, I'll do it": Patrick Goldstein, "Man What a Trip That Was," *LAT*, August 15, 1999, Calendar 8.

304 Unfortunately, Peter had figured: Singer, "Annals of Authorship: Whose Movie Is This?"

304 In the days leading up: The *Bomb Drop* exhibition ran from February 24 to March 17, 1968; there's no record of the date of the opening party.

304 It was a large-scale: *Bomb Drop* appeared to be modeled upon the US Navy's Mark 29 bomb release lever assembly; see "Bomb Release Lever Assembly US Navy Mk 29," AeroAntique, aeroantique.com/products/bomb-release-lever-us-navy-mk-29?variant=16519878410329.

304 "Nobody mentioned it": NYU.

304 The night before: Jean Stein, interview with DH, October 3, 1973, JSP.

305 Camilla had a camera out: Camilla McGrath et al., *Face to Face: The Photographs of Camilla McGrath* (New York: Alfred A. Knopf, 2020), 195. McGrath dated the photo of Dennis February 19, 1968. Dennis may have left for New Orleans ahead of the cast and crew on February 20 or just got the dates wrong.

305 When a friend asked McGrath: Jean Stein, interview with Earl McGrath, October 10, 2005, JSP.

305 On Thursday, February 22: Fonda, *Don't Tell Dad*, 253.

305 "Brooke said, 'You are going'": Tom Burke, "Will 'Easy' Do It for Dennis Hopper?," *TNY*, July 20, 1969, D11.

305 Dennis said that the lack: Biskind, *Easy Riders, Raging Bulls*, 62.

305 "That was the last time": Jerry Bauer, "Dennis Hopper," *Nineteen*, January 1972, reprinted in *Dennis Hopper: Interviews*, ed. Nick Dawson (Jackson: University Press of Mississippi, 2012), 58.

305 "completely idiotic": Bob Colacello, "The City of Warring Angels," *Vanity Fair*, August 2010, 130. In *Don't Tell Dad*, Peter Fonda recalled that the entire cast and crew gathered in a Beverly Hills office before boarding a chartered bus to the airport.

305 The next morning: Biskind, *Easy Riders, Raging Bulls*, 63.

305 "This is my fucking movie!": Singer, "Whose Movie Is This?," 113.

306 Peter, thinking: Biskind, *Easy Riders, Raging Bulls*, 63.

306 Somewhere in the French Quarter: Tom Mankiewicz and Robert David Crane, *My Life as a Mankiewicz* (Lexington: University Press of Kentucky), 2012, 113.

306 At the end of the first day: Peter Biskind, interview with Peter Fonda, March 17, 1997.

306 Peter managed to corral: Ibid.

306 Terry Southern and Gail Gerber: Gerber and Lisanti, *Trippin' with Terry*, 91.

307 "What would Dad-Dad think?": Fonda, *Don't Tell Dad*, 256.

307 "Jimmy wouldn't like that": Tom Folsom, *Hopper: A Journey into the American Dream* (New York: It Books, 2013), 115.

307 "The cacophony of your verbiage": Singer, "Whose Movie Is This?," 114.

307 "That's the Italian": Biskind, *Easy Riders, Raging Bulls*, 64.

307 "creative as hell": Peter Biskind, interview with Peter Fonda, March 17, 1997.

308 "Dennis' imagination and vision": Letter from Cliff Vaughs to Terry Southern, March 6, 1968, Terry Southern Papers, New York Public Library.

308 "an endless parade": Biskind, *Easy Riders, Raging Bulls*, 65.

308 Dennis took to their bed: Ibid.

308 "Obviously": *Easy Riders, Raging Bulls*, directed by Kenneth Bowser (London: BBC, 2003).

308 Peter and Bill went back: Fonda, *Don't Tell Dad*, 258.

308 Peter played Schneider: Biskind, *Easy Riders, Raging Bulls*, 65.

309 "Well, he sounds excited": *Easy Riders, Raging Bulls*.

309 He counseled: Biskind, *Easy Riders, Raging Bulls*, 65.

309 From now on: Bingen, *Easy Rider*, 26.

309 According to Dennis: Biskind, *Easy Riders, Raging Bulls*, 65.

309 preparing franks and beans: Ibid., 67.

309 lithograph called *Crak!*: Roy Lichtenstein Foundation, Image Duplicator, https://www.imageduplicator.com/main.php?work_id=3783&year=1963/1 964&decade=60.

309 Bruce Conner: Biskind, *Easy Riders, Raging Bulls*, 65.

310 "Dennis," he called out: Ibid.

310 In the living room: Peter Biskind, interview with BH, undated.

310 He'd been busted: Biskind, *Easy Riders, Raging Bulls*, 66.

310 "Congratulations on": Brooke Hayward, *Haywire* (New York: Vintage, 2011), 284.

13: "A BEDROOM CROWDED WITH GHOSTS"

311 Pending the divorce suit: "Actor Ordered to Pay Support of $125 Monthly," *LAT*, July 16, 1968, A8.

311 $500,000 trust fund: Ibid.

311 "I just wanted half": David Rensin, "20 Questions: Dennis Hopper," *Playboy*, March 1990, 140.

311 But Dennis did hold on: *The Dennis Hopper Collection* (New York: Christie's New York, 2021).

312 The tensions between: Peter Biskind, *Easy Riders, Raging Bulls: How the Sex-Drugs-and-Rock 'n' Roll Generation Saved Hollywood* (New York: Simon & Schuster, 1998), 69–70.

312 "dumb-bell dialogue": Lee Hill, *Easy Rider* (London: British Film Institute, 1996), 26.

312 eighty hours of footage: Peter M. Brant and Tony Shafrazi, "Dennis Hopper Complete Interview," *Interview*, July 15, 2010, https://www.inter viewmagazine.com/film/dennis-hopper-complete-interview.

312 His movie would be like: Dennis Hopper, *Dennis Hopper: Photographs, 1961–1967*, ed. Tony Shafrazi (Köln: Taschen, 2018), 410.

312 "Those ride sequences": Lawrence Linderman, "*Gallery* Interview: Dennis Hopper," *Gallery*, December 1972, reprinted in *Dennis Hopper: Interviews*, ed. Nick Dawson (Jackson: University Press of Mississippi, 2012), 65.

312 After twenty-two Sisyphean weeks: Susan King, "'Tell Me We Haven't Blown It': Peter Fonda Reflects on 'Easy Rider' and Its Unanswered Question," *Hollywood Reporter*, July 12, 2019, https://www.hollywoodreporter

.com/news/making-easy-rider-peter-fonda-reflects-films-unanswered
-question-1223889.

313 "I got worried": Patrick Goldstein, "Man What a Trip That Was," *LAT*, August 15, 1999, Calendar 8.

313 "It got a little better": Jean Stein, interview with Marjorie Hopper, April 10, 1988, JSP.

313 Leland and Pamela: Sally Bedell Smith, *Reflected Glory: The Life of Pamela Churchill Harriman* (New York: Simon & Schuster, 1996), 245.

313 "We're going to *bury you!*": Peter Bogdanovich, *Who the Devil Made It* (New York: Ballantine, 1998), 12.

313 One day, Dennis: Scott Eyman, *Hank and Jim: The Fifty-Year Friendship of Henry Fonda and James Stewart* (New York: Simon & Schuster, 2017), 314–15.

314 "the exact image": Andy Warhol and Pat Hackett, *POPism: The Warhol Sixties* (New York: Harvest, 1980), 374.

314 Taylor Mead found: Ibid., 57.

314 "What a great idea": Ibid., 374.

314 Dennis presented: Michael Nesmith, *Infinite Tuesday: An Autobiographical Riff* (New York: Crown Archetype, 2017), 103.

314 "Tell your producer": Letter from Miles Davis to Dennis Hopper, February 20, 1969, POP. Dennis and Miles would finally have their soundtrack collaboration in 1990, on *The Hot Spot*, a neo-noir thriller directed by Dennis.

315 Peter had the notion: Bingen, *Easy Rider*, 62–63.

315 When the trio had: Nick Roddick, "Dennis Hopper: The Last Maverick," *Sight & Sound*, July 2010, 24. Crosby has claimed that the main reason Crosby, Stills & Nash didn't do the music for *Easy Rider* was a scheduling conflict; see Rogan, *Requiem*, 512. It should be noted that *2001: A Space Odyssey* (1968) had also used preexisting recordings for its soundtrack, drawing upon classical music, not pop.

315 Dennis and Peter did commission: Bingen, *Easy Rider*, 52–53.

316 "Dennis was me": Ibid.

316 "This was a road movie": Hill, *Easy Rider*, 31.

317 "Christ, they were criminals": Ron Rosenbaum, "Riding High: Dennis Hopper Bikes Back," *Vanity Fair*, April 1987, 134.

317 "We blew it": Those also happened to be the final words in Tom Wolfe's *The Electric Kool-Aid Acid Test*, published shortly after *Easy Rider* was filmed.

317 *Easy Rider* was previewed: Press release, Museum of Modern Art, July 7, 1969.

317 It was a box-office juggernaut: Bingen, *Easy Rider*, 75–76.

317 The night Sharon Tate: Goldstein, "Man What a Trip That Was."

318 "I want to believe": Richard Goldstein, "Captain America, the Beautiful," *NYT*, August 3, 1969, D13.

318 "the movie conveys": Pauline Kael, "Current Cinema: The Bottom of the Pit" (review of *Butch Cassidy and the Sundance Kid*), *TNY*, September 27, 1969, 127.

318 "the only realistic:" Ellen Willis, "See America First," *New York Review of Books*, January 1, 1970, https://www.nybooks.com/articles/1970/01/01 /see-america-first.

318 "gutless piece": Paul Schrader, "Easy Rider," *Los Angeles Free Press*, July 25, 1969, 26.

318 "an inaccurate, smug": Peter Coyote, *Sleeping Where I Fall: A Chronicle* (Berkeley, CA: Counterpoint, 1998), 102–03.

318 "Now the children": Biskind, *Easy Riders, Raging Bulls*, 1999, 75.

319 "immense b.s.": Goldstein, "Man What a Trip That Was."

319 On March 18, 1971: Smith, *Reflected Glory*, 247–51.

319 Six months after Leland's death: Marilyn Berger, "Pamela Harriman Is Dead at 76; An Ardent Political Personality," *NYT*, February 6, 1997, A1.

319 "I got practically bashed": Lisa Eisner and Román Alonso, "Still Haywire," *T: The New York Times Style Magazine*, August 19, 2001, 200.

319 Brooke, with her friend: Letter from Jean vanden Heuvel and Brooke Hayward Hopper to Andy Warhol, August 11, 1972, JSP.

319 The following year: Andy Warhol, "Brooke Hayward, 1973," Tate, https://www.tate.org.uk/art/artworks/warhol-brooke-hayward-t12600.

320 "What have I done": Judy Klemesrud, "Something Has Gone Haywire," *TNY*, March 9, 1977, C1.

320 "If you ever write again": Robert Windeler, "The Eldest Daughter Remembers When Filmland's Golden Family, the Haywards, Went Haywire," *People*, May 23, 1977, https://people.com/archive/the-eldest-daughter -remembers-when-filmlands-golden-family-the-haywards-went-haywire -vol-7-no-20.

320 "the human wreckage": Klemesrud, "Something Has Gone Haywire."

321 Brooke forked sixty: Ibid.

321 "I wrote in a bedroom": Windeler, "The Eldest Daughter Remembers When Filmland's Golden Family, the Haywards, Went Haywire."

321 "More than once": Brooke Hayward, *Haywire* (New York: Vintage, 2011), xv.

321 The accident occurred: Robert D. McFadden, "Writer Is Killed by a Taxi Here," *TNY*, July 27, 1974, 30.

321 *Haywire* became: Andrew Sarris, "Spoiled Children," *Harper's*, June 1977, 77.

321 Mike Nichols: Hayward, *Haywire*, frontispiece.

321 Excerpts ran: Sarris, "Spoiled Children."

321 "a two-coast dilettante": Windeler, "The Eldest Daughter Remembers When Filmland's Golden Family, the Haywards, Went Haywire."

321 Andy Warhol ran into Brooke: Andy Warhol, *The Andy Warhol Diaries*,

ed. Pat Hackett (New York: Grand Central Publishing, 2009), March 18, 1977 entry.

322 Jane Fonda made a point: "Growing Fonda of Jane," *Time*, October 3, 1977, 90.

322 Over the years: Jean Stein, interview with Marjorie Hopper, April 10, 1988, JSP.

322 Andrew Sarris: Sarris, "Spoiled Children," 77.

322 "Everybody makes mistakes": Jean Stein, interview with Marjorie Hopper, April 10, 1988, JSP.

322 Given the success: Sian Ballen, Lesley Hauge, and Jeff Hirsch, "Brooke Duchin," New York Social Diary, February 5, 2021, https://newyorksocial diary.com/brooke-duchin/.

322 In 1970, he relocated: Michael Schmelling, ed., *Dennis Hopper: Drugstore Camera* (Bologna, Italy: Damiani, 2015), unpaginated.

323 Dennis might host: Marin Hopper, "Destiny in Taos," *T: The New York Times Style Magazine*, September 14, 2014, 130.

323 "I had final cut": Peter L. Winkler, *Dennis Hopper: The Wild Ride of a Hollywood Rebel* (Fort Lee, NJ: Barricade Books, 2011), 176.

323 "The first seven days": Ronald Bergan, "Obituary: Dennis Hopper," *Guardian*, March 31, 2010, 28.

323 From time to time: Schmelling, *Dennis Hopper: Drugstore Camera*, unpaginated.

323 "a deeply cool": Hopper, "Destiny in Taos," 130.

324 On another occasion: Steven Travers, *Coppola's Monster Film: The Making of Apocalypse Now* (Jefferson, NC: McFarland, 2016), 145.

324 The cacophony: Hill, *Easy Rider*, 22.

324 And so Peter: Peter Biskind, interview with Peter Fonda, March 17, 1997.

324 "If Den Hopper improvises": Mike Golden, "A Conversation with Terry Southern," *Paris Review*, Spring 1996, 227.

324 "He didn't write anything": Peter M. Brant and Tony Shafrazi, "Dennis Hopper Part Two," *Interview*, July 15, 2010, https://www.interview magazine.com/film/dennis-hopper-part-two.

324 After the movie: Mark Singer, "Annals of Authorship: Whose Movie Is This?," *TNY*, June 22, 1998. 115.

325 "Dennis and Peter": Tom Lisanti, *Drive-in Dream Girls: A Galaxy of B-Movie Starlets of the Sixties* (Jefferson, NC: McFarland, 2003), 30–31.

325 "It was half a gallon": Garth Pearce, "Dennis Hopper's Life: A Hell of a Ride," *Times* (London), August 31, 2008, https://www.thetimes.co.uk /article/dennis-hoppers-life-a-hell-of-a-ride-mt9ltclhgd2.

325 "In my mind": Ibid.

325 In April 1983: Michael Bergeron, "Dennis Hopper Is 'Reborn,'" *Houston Chronicle*, October 5, 2018, D030.

325 it involved sitting: Kim Bockus, "Double Standards: An Interview with Dennis Hopper," *ArtUS*, March–April 2007, 18.

325 He had originally envisioned: David Rensin, "20 Questions: Dennis Hopper," *Playboy*, March 1, 1990, 140.

325 With Terry Southern: Bergeron, "Dennis Hopper Is 'Reborn.'"

326 "The Third World War": Richard Stayton, "Waiting for Dennis," *LAT*, May 14, 1995, 18.

326 He was airlifted: DH lecture, 1990 BFI London Film Festival.

326 Parkinson's symptoms: David Dodd, "Dennis Hopper," in *Playing It Straight: Personal Conversations on Recovery, Transformation and Success* (1996), reprinted in *Dennis Hopper: Interviews*, ed. Nick Dawson (Jackson: University Press of Mississippi, 2012), 168.

326 At another point: Peter L. Winkler, *Dennis Hopper: The Wild Ride of a Hollywood Rebel*. (Fort Lee, NJ: Barricade Books, 2011), 237.

326 "We didn't know": Jean Stein, interview with Marjorie Hopper, April 10, 1988, JSP.

326 "getting older": Windeler, "The Eldest Daughter Remembers When Filmland's Golden Family, the Haywards, Went Haywire."

326 On Christmas Eve 1985: "Peter Duchin Weds Brooke Hayward," *NYT*, December 26, 1985, C19.

327 Brooke sold: Peter Duchin with Charles Michener, *Ghost of a Chance: A Memoir* (New York: Random House, 1996), 347.

327 In 2006, *Sinking Sun*: "Roy Lichtenstein, *Sinking Sun*," Sotheby's, http://www.sothebys.com/en/auctions/ecatalogue/2006/contemporary-art-evening-sale-n08201/lot.21.html.

327 In 2019: "Ed Ruscha (b. 1937), *Hurting the Word Radio #2*," Christie's, https://www.christies.com/lotfinder/Paintings/ed-ruscha-hurting-the-word-radio-2-6236034-details.aspx.

327 It had come: Ibid.

327 In 2015: "Andy Warhol (1928–1987), *Colored Mona Lisa*," Christie's, https://www.christies.com/lotfinder/Lot/andy-warhol-1928–1987-colored-mona-lisa-5896014-details.aspx.

327 Palissy ware: Brooke Hayward Duchin, *Grotesquerie: Form, Fantasy and Function in 19th Century European Ceramics; the Collection of Brooke Hayward Duchin* (New Orleans: New Orleans Museum of Art, 1997).

327 "A perfect blend": PageSix.com Staff, "Sad Marital Split," *New York Post*, September 7, 2008, https://pagesix.com/2008/09/07/sad-marital-split/.

328 Dennis had flirted: Richard Stayton, "Waiting for Dennis," *LAT*, May 14, 1995, 18; "Dennis Hopper Schedules Memoirs," Associated Press, May 8, 2006. Dennis began collaborating with Stayton on a memoir for Doubleday in 1985; he scrapped it when his movie career picked back up. In 2006, he was contracted by Little, Brown to write an autobiography to be called *Out Takes*.

328 "He thought it was": Ballen et al., "Brooke Duchin."

328 reconnected with Miss Mac: "Dennis Hopper at the Old Course St Andrews," October 8, 2004, Getty Images, https://www.gettyimages.com.au/detail/news-photo/american-actor-dennis-hopper-is-reunited-with-his-former-news-photo/829351780. Miss Mac—Marion Paul—died in 2012.

328 amassed a blue-chip art collection: *The Dennis Hopper Collection.*

328 "As charm is": Jenny Diski, "Zeitgeist Man," *London Review of Books,* March 22, 2012, https://www.lrb.co.uk/the-paper/v34/n06/jenny-diski/zeitgeist-man.

328 "minimal in": Ginny Dougary, "Dennis Hopper," *Times* (London), March 12, 2004, https://www.thetimes.co.uk/article/dennis-hopper-xnzzg09zvdj.

329 As Dennis got older: Lisa Law, *Interviews with Icons: Flashing on the Sixties* (Santa Fe: Lumen, 1999), 191.

329 "I wanted to document": Dennis Hopper, Petra Giloy-Hirtz, and Brooke Hayward, *Dennis Hopper: The Lost Album: Vintage Prints aus den Sechziger Jahren* (Munich: Prestel, 2012), 19.

329 "tablets of time": Ibid.

329 "I was trying": Dennis Hopper, *1712 North Crescent Heights: Photographs, 1962–1968* (New York: Greybull Press, 2001), unpaginated.

329 The photographs: Law, *Interviews with Icons,* 191.

329 eighteen thousand images: HAT. Whatever became of the Nikon itself remains a mystery.

329 Henry T. Hopkins: Peter Noever, ed., *Dennis Hopper: A System of Moments* (Ostfildern-Ruit, Germany: Hatje Cantz Verlag, 2001), 22.

330 "he'd only been": *Dennis Hopper: Create (or Die),* directed by Henning Lohner and Ariane Riecker (Saarbrücken: Telefilm Saar, 2003), posted by Port Film Co-op, YouTube, March 20, 2018, https://www.youtube.com/watch?v=lwKrS2EHTG4.

330 "that art is everywhere": Hopper, *The Lost Album,* unpaginated.

330 "was all he spoke about": Julie L. Belcove, "Off Camera, Hopper Wielded His Own Lens," *TNY,* May 3, 2013, C34.

SELECTED BIBLIOGRAPHY

BOOKS

Aukeman, Anastasia. *Welcome to Painterland: Bruce Conner and the Rat Bastard Protective Association.* Berkeley, CA: University of California Press, 2016.

Bandy, Mary Lea, Andy Warhol, and Callie Angell. *Andy Warhol Screen Tests: The Films of Andy Warhol: Catalogue Raisonné.* New York: Harry N. Abrams, 2006.

Banham, Reyner. *Los Angeles: The Architecture of Four Ecologies.* Berkeley: University of California Press, 2001.

Bell, Larry. *Zones of Experience: The Art of Larry Bell.* Albuquerque, NM: Albuquerque Museum, 1997.

Berman, Sonia. *The Crossing—Adano to Catonsville: Leland Hayward's Producing Career.* New York: Scarecrow Press, 1995.

Bingen, Steven. *Easy Rider: 50 Years Looking for America.* New York: Lyons Press, 2019.

Biskind, Peter. *Easy Riders, Raging Bulls: How the Sex-Drugs-and-Rock 'n' Roll Generation Saved Hollywood.* New York: Simon & Schuster, 1998.

Bockris, Victor. *Warhol: The Biography.* Boston: Da Capo Press, 2003.

Bockris, Victor, and Gerard Malanga. *Up-tight: The Velvet Underground Story.* London: Omnibus Press, 2009.

Boleslavsky, Richard. *Acting: The First Six Lessons.* New York: Theatre Arts Inc, 1933.

Bosworth, Patricia. *Jane Fonda: The Private Life of a Public Woman.* New York: Houghton Mifflin Harcourt, 2011.

Brown, Mick. *Tearing Down the Wall of Sound.* London: Bloomsbury, 2012.

Buchloh, B.H.D., and Andy Warhol. *Andy Warhol.* Cambridge, MA: The MIT Press, 2001.

Capote, Truman. *In Cold Blood.* New York: Modern Library, 2007.

Charters, Ann, ed. *The Portable Sixties Reader.* New York: Penguin Books, 2003.

Claxton, William. *Photographic Memory.* New York: powerHouse Books, 2002.

Coyote, Peter. *Sleeping Where I Fall: A Chronicle.* Berkeley, CA: Counterpoint, 2015.

Daugherty, Tracy. *The Last Love Song: A Biography of Joan Didion.* New York: St. Martin's Press, 2015.

Davis, Deborah. *The Trip: Andy Warhol's Plastic Fantastic Cross-Country Adventure.* New York: Atria Books, 2015.

Davis, Gwen. *Naked in Babylon.* New York: Signet, 1960.

Dawson, Nick, ed. *Dennis Hopper: Interviews.* Jackson: University Press of Mississippi, 2012.

Dean, Robert, and Roberta Bernstein. *Ferus.* New York: Gagosian Gallery, 2002.

Dean, Robert, and Dennis Hopper. *Bruce Conner: Assemblages, Paintings, Drawings, Engraving Collages, 1960–1990.* Santa Monica: Michael Kohn Gallery, 1990.

Didion, Joan. *Slouching Towards Bethlehem.* New York: Farrar, Straus and Giroux, 2008.

———. *The White Album.* New York: Farrar, Straus and Giroux, 1990.

Drohojowska-Philp, Hunter. *Rebels in Paradise: The Los Angeles Art Scene and the 1960s.* New York: Henry Holt, 2011.

Duchin, Brooke Hayward. *Grotesquerie: Form, Fantasy and Function in 19th Century European Ceramics; the Collection of Brooke Hayward Duchin.* New Orleans: New Orleans Museum of Art, 1997.

Duchin, Peter, with Charles Michener. *Ghost of a Chance: A Memoir.* New York: Random House, 1996.

Dunne, Dominick. *The Way We Lived Then: Recollections of a Well-Known Name Dropper.* New York: Crown, 1999.

Einarson, John. *Mr. Tambourine Man: The Life and Legacy of the Byrds' Gene Clark.* New York: Backbeat Books, 2005.

Ellison, Harlan. *Harlan Ellison's Watching.* Los Angeles: Underwood-Miller, 1989.

Eyman, Scott. *Hank and Jim: The Fifty-Year Friendship of Henry Fonda and James Stewart.* New York: Simon & Schuster, 2017.

———. *John Wayne: The Life and Legend.* New York: Simon & Schuster, 2014.

Finstad, Suzanne. *Natalie Wood: The Complete Biography.* New York: Crown, 2020.

Folsom, Tom. *Hopper: A Journey into the American Dream.* New York: It Books, 2013.

Fonda, Henry, and Howard Teichmann. *Fonda: My Life.* New York: New American Library, 1981.

Fonda, Jane. *My Life So Far.* New York: Random House, 2005.

Fonda, Peter. *Don't Tell Dad: A Memoir.* New York: Hyperion, 1999.

Fowler, Gene. *Good Night, Sweet Prince.* Philadelphia: The Blakiston Company, 1944.

Franklin, Paul B. *The Artist and His Critic Stripped Bare: The Correspondence of Marcel Duchamp and Robert Lebel.* Los Angeles: The Getty Research Institute, 2016.

Frei, Georg, and Neil Printz, eds. *The Andy Warhol Catalogue Raisonné: Paintings, Sculptures, and Drawings.* Vol. 1, *Paintings and Sculptures 1961–1963.* New York: Phaidon, 2002.

Friedrich, Otto. *City of Nets.* New York: Harper Perennial, 2014.

Frieling, Rudolf, and Gary Garrel. *Bruce Conner: It's All True.* Berkeley, CA: University of California Press, 2016.

Gamboa, Fernando. *Master Works of Mexican Art from Pre-Columbian Times to the Present.* Los Angeles: Los Angeles County Museum of Art, 1963.

Garr, Teri, and Henriette Mantel. *Speedbumps: Flooring It Through Hollywood.* New York: Penguin, 2006.

Gerber, Gail, and Tom Lisanti. *Trippin' with Terry Southern: What I Think I Remember.* Jefferson, NC: McFarland Incorporated Publishers, 2014.

Gilmore, John. *Laid Bare: A Memoir of Wrecked Lives and the Hollywood Death Trap.* Los Angeles: Amok Books, 1997.

Goodman, Wendy, Dominick Dunne, and Hutton Wilkinson. *Tony Duquette.* New York: Harry N. Abrams, 2007.

Graham, Don. *Giant: Elizabeth Taylor, Rock Hudson, James Dean, Edna Ferber, and the Making of a Legendary American Film.* New York: St. Martin's Press, 2018.

Greenfield, Amy, ed. *Curtis Harrington: Cinema on the Edge.* New York: Anthology Film Archives, 2005.

Grogan, Emmett. *Ringolevio: A Life Played for Keeps.* New York: New York Review Books, 2008.

Hackman, William. *Out of Sight: The Los Angeles Art Scene of the Sixties.* New York: Other Press, 2015.

Hajdu, David. *Positively 4th Street: The Lives and Times of Joan Baez, Bob Dylan, Mimi Baez Fariña, and Richard Fariña.* New York: Picador, 2011.

Hale, Dennis, and Jonathan Eisen, eds. *The California Dream.* New York: Collier Books, 1968.

Harrington, Curtis. *Nice Guys Don't Work in Hollywood: The Adventures of an Aesthete in the Movie Business.* Chicago: Drag City Incorporated, 2013.

Hayward, Brooke. *Haywire.* New York: Vintage, 2011.

Hill, Lee. *Easy Rider.* London: British Film Institute, 1996.

Hopper, Dennis. *1712 North Crescent Heights: Photographs, 1962–1968.* New York: Greybull Press, 2001.

Hopper, Dennis. *Dennis Hopper: Photographs, 1961–1967.* Tony Shafrazi, ed. Köln: Taschen, 2018.

Hopper, Dennis, Petra Giloy-Hirtz, and Brooke Hayward. *Dennis Hopper: The Lost Album: Vintage Prints from the Sixties.* Munich: Prestel, 2012.

Hopper, Dennis, and Michael McClure. *Out of the Sixties.* Santa Fe: Twelvetrees Press, 1986.

Hopps, Walter, with Deborah Treisman and Anne Doran. *The Dream Colony: A Life in Art.* New York: Bloomsbury, 2017.

Hoskyns, Barney. *Waiting for the Sun: Strange Days, Weird Scenes, and the Sound of Los Angeles.* New York: St. Martin's Griffin, 1996.

Hughes, Robert. *American Visions: The Epic History of Art in America.* New York: Alfred A. Knopf, 2009.

Indiana, Gary. *Andy Warhol and the Can That Sold the World.* New York: Basic Books, 2010.

Jones, William P. *The March on Washington.* New York: W.W. Norton, 2013.

Keith, Slim, with Annette Tapert. *Slim: Memories of a Rich and Imperfect Life.* New York: Simon & Schuster, 1990.

Kirby, Michael. *Happenings.* New York: E. P., 1966.

Law, Lisa. *Flashing on the Sixties: Photographs.* San Francisco: Chronicle Books, 1987.

———. *Interviews with Icons: Flashing on the Sixties.* Santa Fe: Lumen Inc., 1999.

Lawrenson, Helen. *Latins Are Still Lousy Lovers.* New York: Hawthorn Books, 1968.

Leavitt, Thomas. *Three Young Collections: Selections from the Collections of Donald and Lynn Factor, Dennis and Brooke Hopper, and André and Dory Previn (January 15–February 26, 1967).* Santa Barbara, CA: Santa Barbara Museum of Art, 1967.

Madoff, Steven Henry, ed. *Pop Art: A Critical History.* Berkeley: University of California Press, 1997.

Mankiewicz, Tom, and Robert David Crane. *My Life as a Mankiewicz.* Lexington: University Press of Kentucky, 2012.

McDowall, Roddy. *Double Exposure: Take Two.* New York: William Morrow, 1989.

McKeen, William. *Everybody Had an Ocean: Music and Mayhem in 1960s Los Angeles.* Chicago: Chicago Review Press, 2017.

McKenna, Kristine. *The Ferus Gallery: A Place to Begin.* Göttingen: Steidl, 2009.

Moffitt, Peggy. *The Rudi Gernreich Book.* New York: Rizzoli, 1991.

Nashawaty, Chris. *Crab Monsters, Teenage Cavemen, and Candy Stripe Nurses: Roger Corman: King of the B Movie.* New York: Harry N. Abrams, 2013.

Nesmith, Michael. *Infinite Tuesday: An Autobiographical Riff.* New York: Crown Archetype, 2017.

Noever, Peter, ed. *Dennis Hopper: A System of Moments.* Ostfildern-Ruit, Germany: Hatje Cantz Verlag, 2001.

Peabody, Rebecca, Andrew Perchuk, Glenn Phillips, and Rani Singh, with Lucy Bradnock, eds. *Pacific Standard Time: Los Angeles Art, 1945–1980.* Los Angeles: Getty Research Institute/J. Paul Getty Museum, 2011.

Plagens, Peter. *The Sunshine Muse: Contemporary Art on the West Coast.* New York: Praeger, 1974.

Pollan, Michael. *How to Change Your Mind: What the New Science of*

Psychedelics Teaches Us About Consciousness, Dying, Addiction, Depression, and Transcendence. New York: Penguin Publishing Group, 2018.

Pomainville, Harold N. *Henry Hathaway: The Lives of a Hollywood Director.* Lanham, MD: Rowman & Littlefield, 2016.

Price, Victoria. *Vincent Price: A Daughter's Biography.* New York: St. Martin's Press, 1999.

Price, Vincent. *I Like What I Know: A Visual Autobiography.* New York: Open Road, 2016.

Priore, Domenic. *Riot on Sunset Strip: Rock 'n' Roll's Last Stand in Hollywood.* Rev. ed. London: Jawbone Press, 2015.

Rinella, Michael D. *Margaret Sullavan: The Life and Career of a Reluctant Star.* Jefferson, NC: McFarland, 2019.

Robinson, Jill. *Bed/Time/Story.* Los Angeles: Wimpole Street Books, 2015.

Rodriguez, Elena. *Dennis Hopper: A Madness to His Method.* New York: St. Martin's Press, 1988.

Rogan, Johnny. *Byrds: Requiem for the Timeless.* London: Rogan House, 2011.

Rose, Barbara. *Claes Oldenburg.* New York: Museum of Modern Art, 1970.

Rosenquist, James, with David Dalton. *Painting Below Zero: Notes on a Life in Art.* New York: Knopf, 2009.

Roylance, Brian. *The Beatles Anthology.* San Francisco: Chronicle Books, 2000.

Rubin, Steven Jay. *The Twilight Zone Encyclopedia.* Chicago: Chicago Review Press, 2017.

Ruscha, Edward, Yve-Alain Bois, and Walter Hopps. *Edward Ruscha: Catalogue Raisonné of the Paintings.* Vol. 1, *1958–1970.* Göttingen: Gagosian Gallery/Steidl, 2003.

Ruscha, Edward, and Lisa Turvey. *Edward Ruscha: Catalogue Raisonné of the Works on Paper*, Vol. 1, *1956–1976.* New York: Gagosian Gallery/Yale University Press, 2014.

Ruscha, Edward. *Leave Any Information at the Signal: Writings, Interviews, Bits, Pages.* Cambridge, MA: MIT Press, 2004.

Ruscha, Edward, Dave Hickey, and Peter Plagens. *The Works of Edward Ruscha.* New York: Hudson Hills Press, 1982.

Ruscha, Edward, Dennis Hopper, and Jeffrey Deitch. *Edward Ruscha, Early Paintings: October 29 Through November 26, 1988.* New York: Tony Shafrazi Gallery, 1988.

Sarlot, Raymond R., and Basten, Fred E. *Life at the Marmont: The Inside Story of Hollywood's Legendary Hotel of the Stars—Chateau Marmont.* Santa Monica, CA: Roundtable, 1987.

Savage, Jon. *1966: The Year the Decade Exploded.* London: Faber & Faber, 2015.

Scherman, Tony, and David Dalton. *Pop: The Genius of Andy Warhol.* New York: It Books, 2009.

Schnabel, Julian, Alexandra Schwartz, TakeshiTanikawa, and Daniela Zyman. *Dennis Hopper Double Standard.* Los Angeles: MOCA, 2010.

Schmelling, Michael, ed. *Dennis Hopper: Drugstore Camera*. Bologna, Italy: Damiani, 2015.

Schwartz, Alexandra. *Ed Ruscha's Los Angeles*. Cambridge, MA: MIT Press, 2010.

Sellers, Robert. *Hollywood Hellraisers: The Wild Lives and Fast Times of Marlon Brando, Dennis Hopper, Warren Beatyy, and Jack Nicholson*. New York: Skyhorse, 2010.

Smith, Patrick S. *Andy Warhol's Art and Films*. Ann Arbor, MI: UMI Research Press, 1986.

Smith, Sally Bedell. *Reflected Glory: The Life of Pamela Churchill Harriman*. New York: Simon & Schuster, 1996.

Sontag, Susan. *Against Interpretation and Other Essays*. New York: Farrar, Straus and Giroux, 1966.

Stein, Jean. *West of Eden*. New York: Random House, 2016.

Stern, Sydney Ladensohn. *The Brothers Mankiewicz*. Jackson: University Press of Mississippi, 2019.

Swope, John. *Camera over Hollywood: Photographs by John Swope*. New York: Random House, 1939.

Sykes, Christopher. *David Hockney: A Rake's Progress, the Biography, 1937–1975*. New York: Nan A. Talese/Doubleday, 2011.

Thomson, David. *Showman: The Life of David O. Selznick*. New York: Knopf, 1992.

Tomkins, Calvin. *Duchamp: A Biography*. New York: Henry Holt, 1996.

———. *Living Well Is the Best Revenge*. New York: Viking, 1962.

———. *The Scene: Reports on Post-modern Art*. New York: Viking, 1976.

Tuchman, Maurice. *Art in Los Angeles: Seventeen Artists in the Sixties*. Los Angeles: Los Angeles County Museum of Art, 1981.

Varnedoe, Kirk. *Ferus*. New York: Rizzoli, 2009.

Vyner, Harriet. *Groovy Bob: The Life and Times of Robert Fraser*. London: Faber & Faber, 1999.

Walker, Michael. *Laurel Canyon: The Inside Story of Rock-and-Roll's Legendary Neighborhood*. New York: Faber & Faber, 2006.

Warhol, Andy. *I'll Be Your Mirror: The Selected Andy Warhol Interviews*. Edited by Kenneth Goldsmith. New York: Hachette Books, 2004.

Warhol, Andy, and Pat Hackett. *POPism: The Warhol Sixties*. New York: Houghton Mifflin Harcourt, 2015.

Watson, Steven. *Factory Made: Warhol and the Sixties*. New York: Pantheon, 2003.

West, Nathanael. *Miss Lonelyhearts & The Day of the Locust*. New York: New Directions, 2009.

Whiting, Cécile. *Pop L.A.: Art and the City in the 1960s*. Berkeley: University of California Press, 2008.

Wilkinson, Hutton. *More Is More: Tony Duquette*. New York: Harry N. Abrams, 2009.

Winkler, Peter L. *Dennis Hopper: The Wild Ride of a Hollywood Rebel.* Fort Lee, NJ: Barricade Books, 2011.
———, ed. *The Real James Dean: Intimate Memories from Those Who Knew Him Best.* Chicago: Chicago Review Press, 2016.
Wolfe, Tom. *The Kandy-Kolored Tangerine-Flake Streamline Baby.* New York: Noonday Press, 1966.
Zimmer, Jill Schary. *With a Cast of Thousands: A Hollywood Childhood.* New York: Robinson, Stein and Day, 1963.

FILM, TELEVISION, VIDEO

Allen, Lewis, dir. *Bonanza.* Season 3, episode 19, "The Storm." Aired January 28, 1962.
Balaban, Burt, dir. *Mad Dog Coll.* 1961; Los Angeles, CA: Columbia Pictures.
Baybutt, Andy, "Rare Dennis Hopper interview by Andy Baybutt part 1." Posted by Andy Baybutt, YouTube, June 14, 2010, www.youtube.com /watch?v=Ln8AWS7eD4s.
Bowser, Kenneth, dir. *Easy Riders, Raging Bulls.* 2003; London: BBC.
Caffey, Michael, dir. *Combat!* Season 5, episode 22, "A Little Jazz." Aired February 21, 1967.
Carson, L. M. Kit, and Lawrence Schiller, dir. *The American Dreamer.* 1971; Los Angeles: Corda Productions.
Conner, Bruce, dir. *Breakaway.* 1966; San Francisco: Bruce Conner. Conner Family Trust.
———, dir. *London One Man Show.* 1964; San Francisco: Bruce Conner. Conner Family Trust.
———, dir. *Luke.* 1967/2004; San Francisco: Bruce Conner. Conner Family Trust.
Corman, Roger, dir. *The Trip.* 1967; Los Angeles: American International Pictures.
———, dir. *The Wild Angels.* 1966; Los Angeles: American International Pictures.
de Antonio, Emilio, dir. *Painters Painting.* 1973; New York: New Yorker Films.
"Dennis Hopper—Interview Retrospective 2008 Part 4" (Arte television interview, Vernissage in the Cinémathèque de Paris, 2008). Posted by splashfin, YouTube, February 20, 2008, www.youtube.com/watch ?v=oUWc_xcdC6s.
Haas, Charles F., dir. *General Electric Theater.* Season 10, episode 17, "The Hold-Out." Written by Max Erlich. Aired January 14, 1962.
Golden, Murray, dir. *Bonanza.* Season 5, episode 31, "The Dark Past." Aired May 3, 1964.

Harrington, Curtis, dir. *Night Tide*. 1961; Los Angeles: American International Pictures.

———, dir. *Queen of Blood*. 1966; Los Angeles: American International Pictures.

Hathaway, Henry, dir. *From Hell to Texas*. 1958; Los Angeles: 20th Century Fox.

———, dir. *The Sons of Katie Elder*. 1965; Los Angeles: Paramount Pictures.

Hopper, Dennis, dir. *Easy Rider*. 1969; Los Angeles: Raybert Productions, Pando Company.

———, dir. *The Last Movie*. 1971; Universal City, CA: Alta-Light /Universal Pictures.

Hopper, Dennis, interview footage. In "Jennifer Jones: Portrait of a Lady." 2001; Los Angeles: Van Ness Films. Van Ness Films Collection at the Academy Film Archive and Prometheus Entertainment, Margaret Herrick Library, Academy of Motion Picture Arts and Sciences.

"Human Be-In—Full Program—1/14/1967—Polo Fields, Golden Gate Park (Official)." Posted by Docs&Interviews on MV, YouTube, September 25, 2014, www.youtube.com/watch?v=HTGyFgyB5Q8.

Jones, Nick Freand, dir. *Born to Be Wild: The Story of Easy Rider*. 1995; London: BBC2.

Kronick, William, dir. *Edward Kienholz: The Story of an Artist*. 1962; Hollywood: A Wolper Production.

Lanza, Anthony M., dir. *The Glory Stompers*. 1967; Beverly Hills, CA: Metro Goldwyn Mayer, 2011. DVD.

Lohner, Henning, and Ariane Riecker, dir. *Dennis Hopper: Create (or Die)*. 2003; Saarbrücken, Germany: Telefilm Saar. Posted by Port Film Co-op, YouTube, March 20, 2018, www.youtube.com/watch?v=lwKrS2EHTG4.

Lupino, Ida, dir. *The Twilight Zone*. Season 5, episode 25, "The Masks." Aired March 20, 1964.

McDowall, Roddy, dir. "Roddy McDowall Liz Ashley Lauren Bacall G Axelrod Dennis Hopper Brooke Hayward" (home movie, 1965). Posted by soapbxprod, YouTube, September 7, 2011, www.youtube.com/watch?v=c81Z1P47G1c.

Miller, Robert Ellis, dir. *The Rogues*. Season 1, episode 8, "Two of a Kind." Aired November 8, 1964.

Moser, James E., dir. *Medic*. Season 1, episode 14, "The Boy in the Storm." Aired January 3, 15955.

Pennebaker, D. A., dir. *The Complete Monterey Pop Festival*. New York: Criterion Collection. 2002. Criterion Collection channel. (Expanded edition of *Monterey Pop*, 1968; Pennebaker).

Ray, Nicholas, dir. *Rebel Without a Cause*. 1955; Burbank, CA: Warner Bros.

Rosenberg, Stuart, dir. *Cool Hand Luke*. 1967; Burbank, CA: Warner Bros. Seven Arts.

————, dir. *The Twilight Zone.* Season 4, episode 4, "He's Alive." Aired
 January 24, 1963.
Stevens, George, dir. *Giant.* 1956; Burbank, CA: Warner Bros.
Warhol, Andy, dir. "Screen Test: Dennis Hopper." 1964; Pittsburgh: The Andy
 Warhol Museum.
————, dir. *Tarzan and Jane Regained . . . Sort Of.* 1964; Pittsburgh: The Andy
 Warhol Museum.
Yarbrough, Jean, dir. *Petticoat Junction.* Season 1, episode 16, "Bobbie Jo and
 the Beatnik." Aired January 7, 1964.

ARTICLES AND ESSAYS

In addition to the items listed here, dozens more from the *New York Times, Los
 Angeles Times, Washington Post, Guardian, Variety, Hollywood Reporter, Vanity
 Fair, Time, Life, The New Yorker,* and other periodicals were consulted, many
 of them via ProQuest Historical Newspapers.
Adler, Renata. "Fly Trans-Love Airways." *The New Yorker,* February 25, 1967,
 116.
Alpert, Don. "Way of Communicating: Hopper's Career a Search for Love."
 Los Angeles Times, November 15, 1959, F3.
Als, Hilton. "Queen Jane, Approximately." *The New Yorker,* May 9, 2011, 58.
Anderson, Chester. "Uncle Tim'$ Children," April 16, 1967. The Digger
 Archives, https://www.diggers.org/comco/ccpaps2b.html.
Arlen, Michael. "The Air: Life and Death in the Global Village." *The New
 Yorker,* April 13, 1968, 157.
Bart, Peter. "A Groovy Kind of Genius?" *New York Times,* July 10, 1966, D9.
Belcove, Julie. "Off Camera, Hopper Wielded His Own Lens." *New York Times,*
 May 3, 2013, C34.
Bell, Larry. "From a Statement Written by Larry Bell in September, 1963, upon
 First Seeing an Exhibition of Warhol's Work." *Artforum,* February 1965, 28.
Berg, A. Scott. "William Goetz: Prolific Producer's Holmby Hills Collection,"
 Architectural Digest, April 1992, 223.
Bergen, Candice. "Is Bel Air Burning?" *Esquire,* December 1967, 138.
Bockus, Kim. "Double Standards: An Interview with Dennis Hopper." *ArtUS,*
 March–April 2007, 18.
Bonner, Michael. "'An Incredible Assortment of Freaks': The Making of
 Dennis Hopper's The Last Movie." *Uncut,* May 16, 2014, https://www.
 uncut.co.uk/features/an-incredible-assortment-of-freaks-the-making-of
 -dennis-hopper-s-the-last-movie-8901/2.
Brant, Peter M. and Tony Shafrazi. "Dennis Hopper Complete Interview."
 Interview, July 15, 2010, https://www.interviewmagazine.com/film/dennis
 -hopper-complete-interview.

Burke, Tom. "Dennis Hopper Saves the Movies." *Esquire*, September 1970, 171.

Colacello, Bob. "The City of Warring Angels." *Vanity Fair*, August 2010, 130.

Coplans, John. "The New Painting of Common Objects," *Artforum*, November 1962. In *Pop Art: A Critical History*, edited by Steven Henry Madoff, 43. Berkeley: University of California Press, 1997.

Darrach, Brad. "The Easy Rider Runs Wild in the Andes." *Life*, June 19, 1970, 57.

Davis, Mike. "Riot Nights on the Sunset Strip." *Labour/Le Travail*, Spring 2007, 201.

Diski, Jenny. "Zeitgeist Man." *London Review of Books*, March 22, 2012, https://www.lrb.co.uk/the-paper/v34/n06/jenny-diski/zeitgeist-man.

Dobrish, Cecelia M. "Brooke Hayward Talks About Her Children." *Parents' Magazine*, October 1977, 52.

Dougary, Ginny. "Dennis Hopper." *Times* (London), March 12, 2004, https://www.thetimes.co.uk/article/dennis-hopper-xnzzg09zvdj.

Drohojowska-Philp, Hunter. "Art Dealer Irving Blum on Andy Warhol and the 1960s L.A. Art Scene (Q&A)." *Hollywood Reporter*, November 4, 2013, https://www.hollywoodreporter.com/news/art-dealer-irving-blum-andy -653195.

Edwards, Anne. "Jennifer Jones and David O. Selznick at Tower Grove." *Architectural Digest*, April 1992, 168.

Eisner, Lisa, and Román Alonso. "Still Haywire." *T: The New York Times Style Magazine*, August 19, 2001, 200.

Factor, Donald. "Assemblage." *Artforum*, Summer 1964, 38.

Flatley, Guy. "D-e-n-n-i-s. H-o-p-p-e-r!" *New York Times*, October 18, 1970, D13.

Geldzahler, Henry. "Dennis Hopper, Photographer." *Vanity Fair*, September 1986, 127.

——. "Los Angeles: The Second City of Art." *Vogue*, September 15, 1964, 42.

Ginsberg, Allen. "Allen Ginsberg—to the Angels." *Berkeley Barb*, November 19, 1965, 1.

Golden, Mike. "A Conversation with Terry Southern." *Paris Review*, Spring 1996, 227.

Goldstein, Richard. "Captain America, The Beautiful." *New York Times*, August 3, 1969, D13.

Goodman, Mark. "Rebel Without a Pause." *New Times*, October 1978. In *Dennis Hopper: Interviews*, edited by Nick Dawson. Jackson: University Press of Mississippi, 2012, 100.

Goodman, Wendy. "A Jeweled Setting." *House & Garden*, December 1990, 136.

Harriman, Margaret Case. "Profiles: Hollywood Agent." *The New Yorker*, July 11, 1936, 20.

Hopkins, Henry T. "Andy Warhol: Ferus Gallery." *Artforum*, September 1962, 15.

Hopper, Dennis, and Ed Ruscha. "The Pop Fathers." *Independent* (London), April 30, 2000, Features 1.

Hopper, Marin. "Destiny in Taos." *T: The New York Times Style Magazine*, September 14, 2014, 130.

Hopps, Walter, and Dennis Hopper. "A Readymade in the Making." *Étant Donné Marcel Duchamp*, no. 6 (2005): 184.

Howard, Jane. "A Creative Capacity to Astonish." *Life*, August 21, 1964, 39.

Hughes, Robert. "Blake and Hockney." *London Magazine* 5, no. 10 (January 1, 1966): 68.

Jefferson, Margo. "She Knew How to Whistle." *New York Times*, June 24, 1990, 13.

Jenkins, Dan. "Life with the Jax Pack." *Sports Illustrated*, July 10, 1967, https://vault.si.com/vault/1967/07/10/life-with-the-jax-pack.

Kael, Pauline. "'Bonnie and Clyde.'" *The New Yorker*, October 21, 1967, 147.

———. "The Bottom of the Pit." *The New Yorker*, September 27, 1969, 127.

Karp, Josh. "Dennis Hopper's Mad Vision." *Esquire*, October 2018, https://www.esquire.com/entertainment/movies/a23287946/the-last-movie-dennis-hopper.

Kashner, Sam. "Dangerous Talents." *Vanity Fair*, March 2005, https://archive.vanityfair.com/article/2005/3/dangerous-talents.

King, Susan. "That Jennifer Jones Glow." *Los Angeles Times*, October 10, 2010, D4.

Klemesrud, Judy. "Something Has Gone Haywire." *New York Times*, March 9, 1977. 47.

Kuehl, Linda. "Joan Didion, The Art of Fiction No. 71." *Paris Review*, Fall–Winter 1978, https://theparisreview.org/interviews/3439/the-art-of-fiction-no-71-joan-didion.

Lawford, Valentine. "The Leland Haywards of the 'Haywire House.'" *Vogue*, February 15, 1964, 124.

Leider, Philip. "Bruce Conner: A New Sensibility." *Artforum*, November 1962, 30.

Leonard, John. "End of a Joy Ride." *New York Times*, February 28, 1977, 25.

Lepore, Jill. "The History of the 'Riot' Report," *The New Yorker*, June 22, 2020, 24.

Lockwood, Charles. "From John Gilbert to Elton John, The Stars Called It Home." *Los Angeles Times*, January 4, 1987, B22.

Loper, Mary Lou. "A Walk on the Wild Side with Gallery Promenade," *Los Angeles Times*, April 21, 1963, D1.

Matthew, Mary. "They Came, They Saw—Duchamp Conquered." *Los Angeles Times*, October 9, 1963, E1.

Mucha, Patty. "Sewing in the Sixties." *Art in America*, November 2002, 79.

Perry, Charles. "From Eternity to Here." *Rolling Stone*, February 26, 1976,

https://www.rollingstone.com/culture/culture-news/from-eternity-to
-here-62660.

Poirier, Richard. "Learning from the Beatles." *Partisan Review*, Fall 1967, 526.

Pynchon, Thomas. "A Journey into the Mind of Watts." *New York Times*, June 12, 1966, 264.

Rand, Christopher. "The Ulimate City." *The New Yorker*, October 1, 1966, 56.

Rensin, David. "20 Questions: Dennis Hopper." *Playboy*, March 1, 1990, 140.

Roddick, Nick. "Dennis Hopper: The Last Maverick." *Sight & Sound*, July 2010, 24.

Rose, Barbara. "Andy Warhol's American Women." *Vogue*, June 1974, 115.

Rosenbaum, Ron. "Riding High: Dennis Hopper Bikes Back." *Vanity Fair*, April 1987, 76.

Rovere, Richard. "Letter from Washington." *The New Yorker*, November 3, 1962, 122.

Sarris, Andrew. "Spoiled Children." *Harper's*, June 1977, 77.

Schrader, Paul. "Easy Rider." *Los Angeles Free Press*, July 25, 1969, 26.

Seidenbaum, Art. "Autobodys—Horsepowerful Art Composition on a Parking Lot." *Los Angeles Times*, December 24, 1963, A1.

Sheppard, Eugenia. "Another Fonda Generation Is Established." *Hartford Courant*, February 27, 1966, 11E.

Singer, Mark. "Annals of Authorship: Whose Movie Is This?" *The New Yorker*, June 22 and 29, 1998, 110.

Smith, Jack. "Soup Can Painter Uses His Noodle." *Los Angeles Times*, July 23, 1962, C1.

Southern, Terry. "The Loved House of the Dennis Hoppers." *Vogue*, August 21, 1965, 137.

Stayton, Richard. "Waiting for Dennis." *Los Angeles Times*, May 14, 1995, SM18.

Stevenson, James. "Our Local Correspondents: Afternoons with Hopper." *The New Yorker*, November 13, 1971, 116.

Swope, John. "Margaret Sullavan and Leland Hayward." *Vogue*, May 15, 1940, 58.

Talese, Gay. "Frank Sinatra Has a Cold." *Esquire*, April 1966, 89. In Gay Talese, *Fame and Obscurity*. New York: World Publishing, 1970.

Talmey, Allene. "Leland Hayward." *Vogue*, May 15, 1953, 49.

Taylor, Derek. "Behind Byrdmania." *Guardian* (London), July 15, 2015, https://theguardian.com/music/2015/jul/15/behind-byrdmania-an-archive-piece-from-1965. Reprinted from *Melody Maker*, July 17, 1965.

Thomas, Michael M. "A Golf Lesson from Dennis Hopper." *Travel & Leisure Golf*, March–April 1998, 98.

Thompson, Hunter S. "Motorcycle Gangs." *Nation*, May 15, 1965, https://www.thenation.com/article/archive/motorcycle-gangs.

Tomkins, Calvin. "Ed Ruscha's L.A." *The New Yorker*, July 1, 2013, 48.

———. "No More Boring Art." *The New Yorker*, October 18, 2010, 42.

Trillin, Calvin. "The March," *The New Yorker*, September 7, 1963, 30.

Wasson, Robert Gordon. "Seeking the Magic Mushroom." *Life*, June 10, 1957, 100.

Weschler, Lawrence. "Onward and Upward with the Arts: Cars and Carcasses." *The New Yorker*, May 13, 1996, 49.

Wholden, R. G. "Dennis Hopper, Primus-Stuart Galleries," *Artforum*, April 1963, 45.

Wilkie, Jane. "Rebel from Dodge City." *Modern Screen*, May 1957, 58.

Willis, Ellen. "See America First." *New York Review of Books*, January 1, 1970, https://nybooks.com/articles/1970/01/01/see-america-first.

Windeler, Robert. "The Eldest Daughter Remembers When Filmland's Golden Family, the Haywards, Went Haywire." *People*, May 23, 1977, https:// people.com/archive/the-eldest-daughter-remembers-when-filmlands -golden-family-the-haywards-went-haywire-vol-7-no-20.

Winkler, Peter L. "Anyone for Dennis." *Times* (London), November 27, 2011, https://www.thetimes.co.uk/article/anyone-for-dennis-njc0gfczf6t.

———. "Tripping Toward Stardom: The Life and Career of Dennis Hopper." *Los Angeles Review of Books*, January 26, 2018, https://lareviewofbooks.org /article/tripping-toward-stardom-the-life-and-career-of-dennis-hopper.

Wolfe, Bernard. "Manners and Morals of the Sunset Strip." *Esquire*, August 1961, 47.

Wolfe, Tom. "I Drove Around Los Angeles and It's Crazy! The Art World Is Upside Down." *Los Angeles Times*, December 1, 1968, Q18.

ORAL HISTORIES AND ARCHIVAL INTERVIEWS

Dennis Hopper interviews, 1966. Molly Saltman "Art and Artists" Interviews, 1966–1967. Archives of American Art, Smithsonian Institution.

Dennis Hopper lecture, 1990. BFI London Film Festival. Audio recording. The Hopper Art Trust.

Dennis Hopper interview with Jessica Hundley, undated. The Hopper Art Trust.

Edward Kienholz interview, November 24, 1986, Sandra Leonard Starr papers related to California assemblage art, 1960–1995 (bulk 1986–1988), the Getty Research Institute, Los Angeles, Accession no. 2011.M.22.

"Ed Ruscha: Artist." Interview conducted by Martin Meeker, Andrew Perchuk, and James Cuno, 2015. Oral History Center of the Bancroft Library, the Bancroft Library, University of California, Berkeley, under the auspices of the J. Paul Getty Trust, 2016.

My Semina Photography: A Conversation with Dennis Hopper, February 7, 2007. NYU TV and Media Services Videotapes; RG 38.16.01; box 76, New

York University Archives (from *Semina Culture: Wallace Berman & His Circle* exhibition, Grey Art Gallery and Study Center).

Oral history interview with Bruce Conner, August 12, 1974. Archives of American Art, Smithsonian Institution.

Oral history interview with Henry Geldzahler, January 27, 1970. Archives of American Art, Smithsonian Institution.

Oral history interview with Henry Hathaway, 1971. (Interviewed by Charles Higham on June 18, 1971.) Rare Books and Manuscripts Library, Butler Library, Columbia University.

Oral history interview with Irving Blum, May 31–June 23, 1977. Archives of American Art, Smithsonian Institution.

Oral history interview with Vincent Price, August 6–14, 1992. Archives of American Art, Smithsonian Institution.

"The Reminiscences of Patty Mucha (8/12/15)." Rauschenberg Oral History Project. Conducted in collaboration with INCITE/Columbia Center for Oral History Research. Robert Rauschenberg Foundation Archives.

UNPUBLISHED MATERIALS

Hayward, Brooke. Unpublished essay, 2015.

Hopper, Dennis. "Into the Issue of the Good Old Time Movie Versus the Good Old Time," ca. 1965. Post Office Papers, J. Michelle Martin.

———. "The Second Chance" treatment, undated. The Hopper Art Trust.

———. Untitled poetry manuscript, undated. The Hopper Art Trust.

Kirkland, Jack. *Mandingo* script, 1961. Jack Kirkland Papers. Billy Rose Theatre Division, The New York Public Library for the Performing Arts.

Sherman, Don, Hopper, Dennis, and Fonda, Peter. "The Yin and the Yang" screenplay, 1966. Wallace Berman Papers, 1907–1979, bulk 1955–1979. Archives of American Art, Smithsonian Institution.

Stern, Stewart. *The Last Movie* screenplay, undated. Stewart Stern Papers, The University of Iowa Libraries, Iowa City, Iowa.

———. "The Last Movie: History and Documentation of Events," 1966. Stewart Stern Papers, The University of Iowa Libraries, Iowa City, Iowa.

———(writer), and Hopper, Dennis (story). "The Last Movie Or: (Boo-Hoo in Tinsel Town" treatment, 1965. Stewart Stern Papers, The University of Iowa Libraries, Iowa City, Iowa.

ARCHIVES

Andy Warhol Archives, the Andy Warhol Museum, Pittsburgh.

Archives of American Art, Smithsonian Institution.

Brooke Hayward Papers. Billy Rose Theatre Collection, the New York Public Library for the Performing Arts.

Dominick Dunne scrapbooks. Collection of Griffin Dunne.

The Hopper Art Trust, Los Angeles.

Jack Kirkland Papers. Billy Rose Theatre Division, the New York Public Library for the Performing Arts.

Jean Stein Papers, Manuscripts and Archives Division, the New York Public Library, Astor, Lenox and Tilden Foundations.

Leland Hayward Papers. Billy Rose Theatre Division, the New York Public Library for the Performing Arts.

Marion McIntyre (Miss Mac) letters. Collection of Jeffrey Thomas.

Norton Simon Museum, Pasadena.

NYU TV and Media Services Videotapes; RG 38.16.01; box 76; New York University Archives, New York University.

Post Office Papers, J. Michelle Martin, El Cortez Theater, Ranchos de Taos, New Mexico.

Rare Book and Manuscript Library, Columbia University, New York.

Sandra Leonard Starr papers related to California assemblage art, 1960–1995 (bulk 1986–1988), the Getty Research Institute, Los Angeles, Accession no. 2011.M.22.

Stewart Stern Papers, the University of Iowa Libraries, Iowa City, Iowa.

Terry Southern Papers, Henry W. and Albert A. Berg Collection of English and American Literature, the New York Public Library, Astor, Lenox and Tilden Foundations.

PUBLIC RECORDS

Various archives, databases, and sources were consulted, including Ancestry .com, Federal Bureau of Investigation, Los Angeles County Archives and Research Center, Los Angeles County Office of the Assessor, Los Angeles Public Library, National Archives, Internet Archive, and NexisLexis.

INDEX